Gauguin
and Impressionism

Published in conjunction with an exhibition organized by

Kimbell Art Museum, Fort Worth,

and

Ordrupgaard, Copenhagen

Yale University Press, New Haven and London,

in association with

Kimbell Art Museum, Fort Worth

Richard R. Brettell and Anne-Birgitte Fonsmark

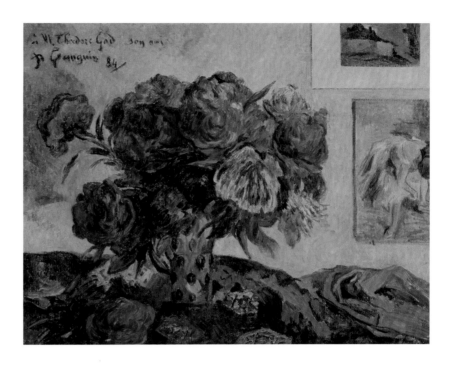

Gauguin
and Impressionism

THIS BOOK IS PUBLISHED in conjunction with the exhibition *Gauguin and Impressionism*, organized by the Kimbell Art Museum, Fort Worth, and Ordrupgaard, Copenhagen.

EXHIBITION DATES
Ordrupgaard, Copenhagen
August 30 – November 20, 2005

Kimbell Art Museum, Fort Worth
December 18, 2005 – March 26, 2006

The exhibition is supported by an indemnity from the Federal Council on the Arts and the Humanities, Washington, D.C.

Edited at the Kimbell Art Museum by Malcolm Warner, Senior Curator, and Wendy P. Gottlieb, Manager of Publications, assisted by Lindsay E. Askins and Samantha Sizemore

Translated by W. Glyn Jones, with modifications by Malcolm Warner

Designed by Gillian Malpass

Printed and bound in Italy by Conti Tipocolor

First published in hardcover by Yale University Press, 2005

Page iii illustration: Paul Gauguin, *Vase of Peonies I* (detail of cat. 41)

Library of Congress Control Number: 2005926550

Catalogue records are available for this book from the Library of Congress and the British Library

ISBN 0-300-11003-0 (hardcover)
ISBN 0-912804-44-0 (Kimbell softcover)
ISBN 87-88692-47-7 (Ordrupgaard softcover)

EDITORIAL NOTE

Measurements are given height before width. Abbreviations refer to the following catalogues of artists' works, which are cited in full in the Selected Bibliography:

W I: Wildenstein 1964 (Gauguin)
W II: Wildenstein 2002, originally published in French in 2001 (Gauguin)
PV: Pissarro-Venturi 1939 (Pissarro)
R: Rewald 1996 (Cézanne)

Contents

Lenders to the Exhibition

CANADA
National Gallery of Canada, Ottawa: 28, 71

DENMARK
The Danish Museum of Decorative Art,
 Copenhagen: 59, 66, 67
Ny Carlsberg Glyptotek, Copenhagen: 11, 14,
 19, 21, 30, 46, 47, 49, 61–64, 68
Ordrupgaard, Copenhagen: 23, 26

EGYPT
Museum of Mohamed Mahmoud Khalil and
 His Wife, Giza: fig. 211

FRANCE
Musée des Beaux-Arts, Rennes: 27
Musée Départemental Maurice Denis, Saint
 Germain-en-Laye: 54
Musée d'Orsay, Paris: 2, 24, 45, 60

GERMANY
Museum für Kunst und Gewerbe, Hamburg: 15
Wallraf-Richartz-Museum, Fondation
 Corboud, Cologne: 37

HUNGARY
Szépmüvészeti Museum, Budapest: 12

ISRAEL
The Israel Museum, Jerusalem: 16

JAPAN
Bridgestone Museum of Art, Tokyo: 57
Hiroshima Museum of Art: 69

THE NETHERLANDS
Collection Groninger Museum on loan from
 Stichting J. B. Scholtenfonds, Groningen: 20

NORWAY
National Museum of Art, Architecture, and
 Design—National Gallery, Oslo: 25

SPAIN
Carmen Thyssen-Bornemisza Collection on
 loan at the Museo Thyssen-Bornemisza,
 Madrid: 36, 40
Museo Thyssen-Bornemisza, Madrid: 39

SWEDEN
Göteborgs Kontsmuseum, Göteborg: 4, 74

SWITZERLAND
Aargauer Kunsthaus Aarau, Aarau: 8
Bührle Collection Foundation, Zurich: 18
Kunsthaus, Zurich: 29
Kunstmuseum, Basel: 53
Collection Rudolf Staechelin, Basel: 51

UNITED KINGDOM
The Samuel Courtauld Trust, Courtauld
 Institute of Art Gallery, London: 7
Thomas Gibson Fine Art Limited, London: 52
Laing Art Gallery (Tyne and Wear Museums),
 Newcastle-Upon-Tyne: 72

UNITED STATES
The Art Institute of Chicago: 13
Carouso Family Revocable Trust: 35
Indianapolis Museum of Art: 1, 75
The Fred Jones Jr. Museum of Art, University
 of Oklahoma, Norman: 56
The Kelton Foundation: 5, 22, 32, 43, 44
Kimbell Art Museum, Fort Worth: 48
Los Angeles County Museum of Art: 70
The Metropolitan Museum of Art,
 New York: 6
Museum of Art, Rhode Island School of
 Design, Providence: 31
Museum of Fine Arts, Boston: 33
National Gallery of Art, Washington: 41
The Newark Museum: 55
Philadelphia Museum of Art: 42
Portland Museum of Art, Maine: 50
Private collection. Courtesy of Wildenstein and
 Co., Inc.: 34
Private collection, United States. Courtesy of
 Kristin Gary Fine Art: 76
Smith College Museum of Art, Northampton,
 Massachusetts: 10
James E. Sowell Collection: 77
Virginia Museum of Fine Arts, Richmond: 3

Anonymous lenders: 9, 17, 38
Artrix International Inc.: 73

facing page Paul Gauguin, *Interior, Rue Carcel* (detail of
cat. 25)

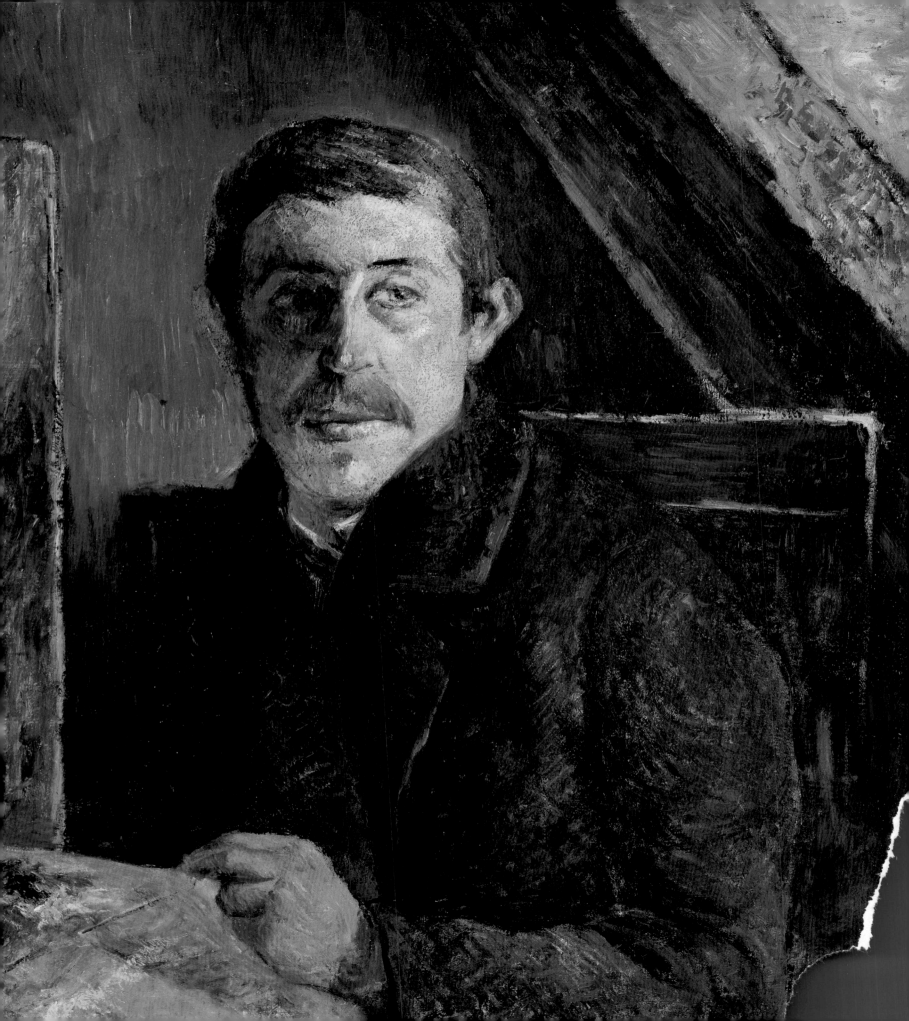

Directors' Foreword

AFTER MORE THAN A CENTURY of critical assessment and scholarship on Impressionism, and almost as much attention on Paul Gauguin as one of the greatest successors to that style, it may seem surprising that an exhibition should attempt a fundamental reappraisal of the relationship between the two. How can the intersection between such a great artist and the defining movement of his day still be at issue? Yet this is what *Gauguin and Impressionism* sets out to do. It is an exhibition with a thesis: that Gauguin, as well as being one of the greatest *Post*-Impressionists was, for a significant part of his career, also a central and important figure in the Impressionist movement.

The facts of Gauguin's participation in five of the Impressionists' eight exhibitions (contributing a total of nearly sixty works), and of his close relationships with Pissarro and others of the inner circle, is of course well known. But Gauguin's involvement with Impressionism has almost invariably been seen as an accident of his time and place in history, an incidental prelude to the emergence of his true style after the flight from Paris, culminating in the magnificent Symbolist works from Tahiti and the Marquesas. And since Impressionism was of only marginal relevance to understanding the mature Gauguin (as this line of thought runs), it stands to reason that Gauguin likewise was of only marginal relevance to understanding Impressionism. This exhibition takes direct issue with the second of these theses, and thereby throws incendiary doubt on the first.

A prerequisite of achieving this new perspective is to provide a broader appreciation of the early Gauguin in his various roles and aspects, a task that has rarely been attempted and never with the degree of focus here. He was an artist of unusual complexity, both in the range of his experimentation and achievement across so many media, working simultaneously in apparently incongruent modes of representation; and in the multiple levels on which he engaged with the art community of his day—as traveler, as collector, as artist, as theorist, as writer, and as the lapsed stockbroker whose connections and business expertise at times helped keep the Impressionist exhibitions viable. On top of all this Gauguin was a troubled, restless, and ambitious personality, qualities that inflected his art as much as they did his life.

In making this case, the exhibition spotlights the unique and sometimes radical versatility of Gauguin as a painter and as a sculptor, ceramicist, and maker of "hybrid" decorative arts. In the past, far more attention has been given to the paintings than to Gauguin's three-dimensional creations, a situation that obscures the latter's radical originality and stridently modernist spirit. Indeed, collecting taste, which has long since accorded Gauguin's paintings a high rank in the pantheon of proto-modernism, has yet to come to terms with his sculptural works' often unlovely forms and ambivalently utilitarian/artistic status. This neglect has been reinforced by the shadow of Gauguin's later career, in which the paintings reign supreme. One of the few scholars to give

Gauguin's three-dimensional work detailed and sensitive treatment has been Anne-Birgitte Fonsmark, who brings the fruits of her research to the current exhibition.

Underlying this study is the conviction that any satisfying understanding of Gauguin (and indeed of any other artist) is possible only through an immersion in his intellectual and aesthetic development, the places and things he saw, the people he knew and admired, the ambitions he harbored, and the frustrations he battled. This is a brief that extends well beyond the analysis of works of art in themselves, however detailed or perceptive. To read this study is to take a journey through the "thick narrative" of Gauguin's life and world, as best it can be reconstructed. As subjects on a syllabus we may separate (and sometimes choose to ignore) Gauguin's activities as traveler, collector, artist, businessman, family man, writer, and so on; but the works of art were made by an individual who was simultaneously all of these things and more. The insights that stem from recognizing this fact are, we hope, justification for the effort it involves.

It should also be said that, presiding over this project and its interpretive orientation is the conviction that the work of Gauguin's earlier career is, at its best, very good indeed. Previous survey exhibitions have presented only a small fraction of his work from the Impressionist years, far less than the current show. Whereas viewers before could be forgiven for thinking that his first decade of concentrated artistic effort must have been largely in vain, *Gauguin and Impressionism* demonstrates how many ambitious, important, and very beautiful works he made. Gauguin's career does not become notable only when he leaves Impressionism behind.

Gauguin and Impressionism, jointly organized by the Kimbell Art Museum and Ordrupgaard, debuts in Copenhagen as the first exhibition to be held in Ordrupgaard's newly built visiting exhibition galleries. Designed by Zaha Hadid, these new galleries provide a superb environment in which to appreciate Gauguin's work, and indeed represent something of a new beginning for Ordrupgaard as an organizer of major exhibitions. Appropriately, its counterpoint for the exhibition in Fort Worth is the acknowledged architectural masterpiece by Louis Kahn. The Kimbell's gentle natural light and travertine walls lend themselves equally well to the display of paintings and sculpture, a versatility that happily mirrors that of the artist.

The exhibition was jointly conceived and curated by Richard R. Brettell, Margaret McDermott Distinguished Professor of Art and Aesthetics, University of Texas at Dallas, and Anne-Birgitte Fonsmark, director of Ordrupgaard, and previously curator of nineteenth-century French art at Ny Carlsberg Glyptotek, Copenhagen. The selection of works and writing of the catalogue have been collaborative throughout, with emphasis by Dr. Fonsmark on the sculpture and ceramics,

Gauguin's ideas on art, and his sojourns in Rouen and Denmark, and by Dr. Brettell on the paintings and his years in France. The entire text benefited greatly from the skillful editing of Malcolm Warner, senior curator at the Kimbell Art Museum. To all of them we extend our warm thanks and congratulations.

The origins of *Gauguin and Impressionism* lie in the curators' shared fascination with Gauguin's early work, and their desire to see this manifested in an exhibition of him as an Impressionist. Almost ten years after the idea was first floated, that exhibition is now being realized through a collaboration between Ordrupgaard and the Kimbell Art Museum. Both institutions bring to the project a history of interest in the artist through their recent collecting, and in the case of Ordrupgaard through its publications and scholarship. For Ordrupgaard, as a museum of French Impressionist art, *Gauguin and Impressionism* has an obvious appropriateness reinforced by its ownership of two major works by the artist from his Impressionist years—the painting *The Little Dreamer* (cat. 26), and a previously unknown bust of a child in wax (cat. 23). Dr. Fonsmark acquired the bust for Ordrupgaard from a private collection only a few years ago and it is in this exhibition that it will be presented to the public for the first time. In 1997 the Kimbell likewise acquired Gauguin's self-portrait of 1885 (cat. 48), the first of a series of intense self-images through which the artist explored his compulsive artistic ambitions. Reconnecting Gauguin to the Impressionist movement also brings us into contact with the primary evidence, year by year and place by place, of how Gauguin became the great artist of his later career—in effect, how Gauguin became Gauguin. This is a lens the

Kimbell has employed before on artists as diverse as Poussin and Mondrian,* and here again the reassembling of a substantial number of works in one gallery allows new insights to emerge.

The exhibition is made possible by the generosity of many museums and individuals around the world who have made their paintings and sculptures available for loan. The absence of cherished works as popular and important as these is never an easy sacrifice to bear, and we greatly appreciate their willingness nonetheless to support the advance in scholarship and connoisseurship that the assembly of such works in one place makes possible. Of the public lenders, it is appropriate to recognize the exceptional generosity of two Copenhagen museums, the Danish Museum of Decorative Art and Ny Carlsberg Glyptotek, who agreed to contribute with so many key works, without which an exhibition on the Impressionist Gauguin would be inconceivable, including his masterpiece of 1880, *Nude Study (Woman Sewing)*. To all lenders we extend our most profound thanks and appreciation.

An exhibition and a catalogue of this ambition would not have been possible without substantial financial support. Therefore, we would like to express our thanks to the foundations and sponsors for their generous contributions to this project.

Timothy Potts
Director, Kimbell Art Museum, Fort Worth

Anne-Birgitte Fonsmark
Director, Ordrupgaard, Copenhagen

* Konrad Oberhuber, *Poussin: The Early Years in Rome*, exh. cat. Kimbell Art Museum, Fort Worth (New York, 1988); Hans Janssen and Joop M. Joosten, *Mondrian, 1892–1914: The Path to Abstraction*, exh. cat. Musée d'Orsay, Paris; Kimbell Art Museum, Fort Worth (Zwolle, Fort Worth, and Paris, 2002).

Curators' Acknowledgments

T HE STUDY OF IMPRESSIONISM has been an enormously fertile and productive branch of the history of art during the last generation. As contributors to this glut of new ideas, information, interpretations, and documentation, we have worked in a highly collegial and competitive environment of other scholars, in museums and universities, as well as in "the trade" and independent. All of these women and men have helped in the creation of this book. They are, in no particular order, Françoise Cachin, the late Daniel Wildenstein, Guy Wildenstein, Claire Frèches-Thory, Joachim Pissarro, Claire Durand-Ruel, Rodolphe Rapetti, Lionel Pissarro, the late Philippe Brame, Anne Distel, Yve-Alain Bois, Michael Zimmermann, Andreas Bluhm, Stephen F. Eisenman, Charles F. Stuckey, Charles S. Moffett, Nick Maclean, Christopher Burge, John House, Richard Thomson, Belinda Thomson, Anthea Callen, Griselda Pollock, Tamar Garb, Richard Shiff, George T. M. Shackelford, Douglas W. Druick, Peter Kort Zegers, Gloria Groom, Gary Tinterow, Philip Conisbee, Joseph J. Rishel, Scott Schaefer, Ellen Wardwell Lee, Dorothy M. Kosinski, Cornelia Homburg, David S. Rubin, the late George Heard Hamilton, Polly Hamilton, Richard Rand, John Leighton, Kathy Adler, Richard Kendall, Miranda Marvin, Anne Pingeot, and Christopher Riopelle.

For Gauguin, our work would not be possible without the extraordinary research of Sylvie Crussard and Martine Heudron at the Wildenstein Institute in Paris. Together with the independent scholar Victor Merlhès, they have added substance to the Gauguin bibliography. To this, the contribution of the great Danish scholar Merete Bodelsen is essential to a full understanding of this enigmatic artist.

Our fervent thanks must go to our faithful, hard-working, and brilliant colleagues at the Kimbell Art Museum and Ordrupgaard. For Rick Brettell, who served as a "guest curator," and for Anne-Birgitte Fonsmark, who had the highly unusual role of both director and curator, we both know that our work would not get done without the museum colleagues who work with us. At the Kimbell, Timothy Potts is much more than a figurehead director, involving himself in every level of the exhibition. The book would not exist without the work of Malcolm Warner, senior curator at the Kimbell, who turned translated Danish and rough American into flowing English; Wendy P. Gottlieb, manager of publications, who shepherded every aspect of the publication; Lindsay E. Askins, publications and PR assistant, who wrote hundreds of letters requesting images and photographic rights; and Samantha Sizemore, curatorial assistant, who coordinated the project. We also always benefit from the advice of Claire M. Barry, the Kimbell's chief conservator.

The same thanks are due the small, intensely devoted, and hard-working staff of the Ordrupgaard. Sine Lebech, assistant to the director, helped coordinate every aspect of the project and now knows her colleagues at the Kimbell without ever having met them face to face. We also thank the three registrars—Patty Decoster and Michelle Bennett Gibson at the Kimbell, and Lene Christiansen at Ordrupgaard—who have worked together for the first time and hopefully not the last. And the curatorial assistant at Ordrupgaard, Gry Hedin, performed such extraordinary service in relation to the work on the catalogue that her name is as well known in Fort Worth as it is in Copenhagen!

No curators could have a better publisher/designer/friend than Gillian Malpass at Yale University Press in London. With hair-raising deadlines and issues of language, culture, and timing, she is imperturbable and superb.

For Rick, at his university in Dallas, his work would be hampered without his superb assistant, Pierrette Lacour, and his dean, Dr. Dennis Kratz, at the School of Arts and Humanities, University of Texas at Dallas. He also benefited enormously from discussions about Gauguin with his colleagues and students, Fred Curchack, Fred Turner, Thomas Riccio, Chad Airhart, Karen Weiner, and Stephen Lapthisophon. He would also like to thank Elizabeth Rohatyn and William D. Barrett of FRAME (French Regional and American Museums Exchange) for giving him slack on that job!

The curators of the exhibition worked very happily—both independently and together as Fellows—at the Sterling and Francine Clark Art Institute in Williamstown, Massachusetts, in the summer of 2004. We were given offices and staff support in the Clark's outstanding libraries. And we would like formally to thank Michael Conforti and Michael Ann Holly for their support.

Richard R. Brettell
Margaret McDermott Distinguished Professor of Art and Aesthetics,
University of Texas at Dallas

Anne-Birgitte Fonsmark
Director, Ordrupgaard, Copenhagen

Introduction

Richard R. Brettell Was Gauguin an Impressionist?
A Prelude to Post-Impressionism

Gauguin would have loved an introduction entitled with a question. Throughout his life he posed questions to himself and others and was, perhaps, the first great artist in the Western tradition to entitle paintings themselves with questions. Although most of his early works have the descriptive titles so common in Impressionism (*Still Life with Oysters, Portrait of M. Favre, The Seine, Pont d'Iena*, for example), he loved enigmatic and questioning titles in the last decade of his production: "*Why Are You Angry?*" "*Why Are You Jealous?*" "*Where Do We Come From? What Are We? Where Are We Going?*" By whom, we must wonder, are these questions asked? The figures in the painting? The painter? An unidentified other? For Gauguin, neither the questions nor the identities of the questioners had simple answers, and neither does the question of this essay: Was Gauguin an Impressionist?

The most deceptively easy answer is the monosyllabic "Yes!" Gauguin was an Impressionist because he exhibited with the group of artists who were publicly labeled "Impressionists" in 1874 and who, on occasion, accepted the name as their own. Of the fifty-nine men and women who were included in one or more of the eight exhibitions organized by this loosely defined coalition of artists between 1874 and 1886, Gauguin was among the most faithful. Although it is likely that he saw one or more of the first three exhibitions, held in 1874, 1876, and 1877, he was not formally part of the group until 1879, when he was invited to join the fourth exhibition and submitted his work too late to be included in its catalogue. But he sent important works to each of the remaining four exhibitions. Indeed, if fidelity to the exhibitions was the criterion for membership, Gauguin was more Impressionist than either Pierre-Auguste Renoir or Alfred Sisley, each included in four, and as Impressionist as Claude Monet, who, like Gauguin, was included in five. Of the major artists, only Edgar Degas, Berthe Morisot, and Camille Pissarro exhibited more frequently than he did.

Yet this easy, positive answer is not good enough for an artist of the complexity—and the importance—of Gauguin. The numerous critics and historians of his career are united in treating its Impressionist phase as what Charles F. Stuckey called "a yeomanlike prologue, largely irrelevant, to a brilliant career."[1] Even Gauguin's most sympathetic biographer, David Sweetman, referred to the artist during this decade-long portion of his career as "the temporary Impressionist."[2] In the first and most detailed account of the movement ever written, John Rewald's *The History of Impressionism*, published by the Museum of Modern Art in 1946, the citations in the index for Gauguin are dwarfed by those for Paul Cézanne, who exhibited with the group only twice, and Edouard Manet, who never did. If the mammoth Gauguin bibliography is to be believed, the question "Was Gauguin an Impressionist?," even if asked, is an unimportant one.

Clearly, the present study and the exhibition it documents want to raise and answer the question in new ways. Past exhibitions of Gauguin's work either slight or ignore the early work. The great 1988–89 exhibition in Washington, Chicago, and Paris included only 16 works made before the final Impressionist exhibition among 280 in the entire exhibition, and this pattern can be found in every other Gauguin exhibition. Indeed, it

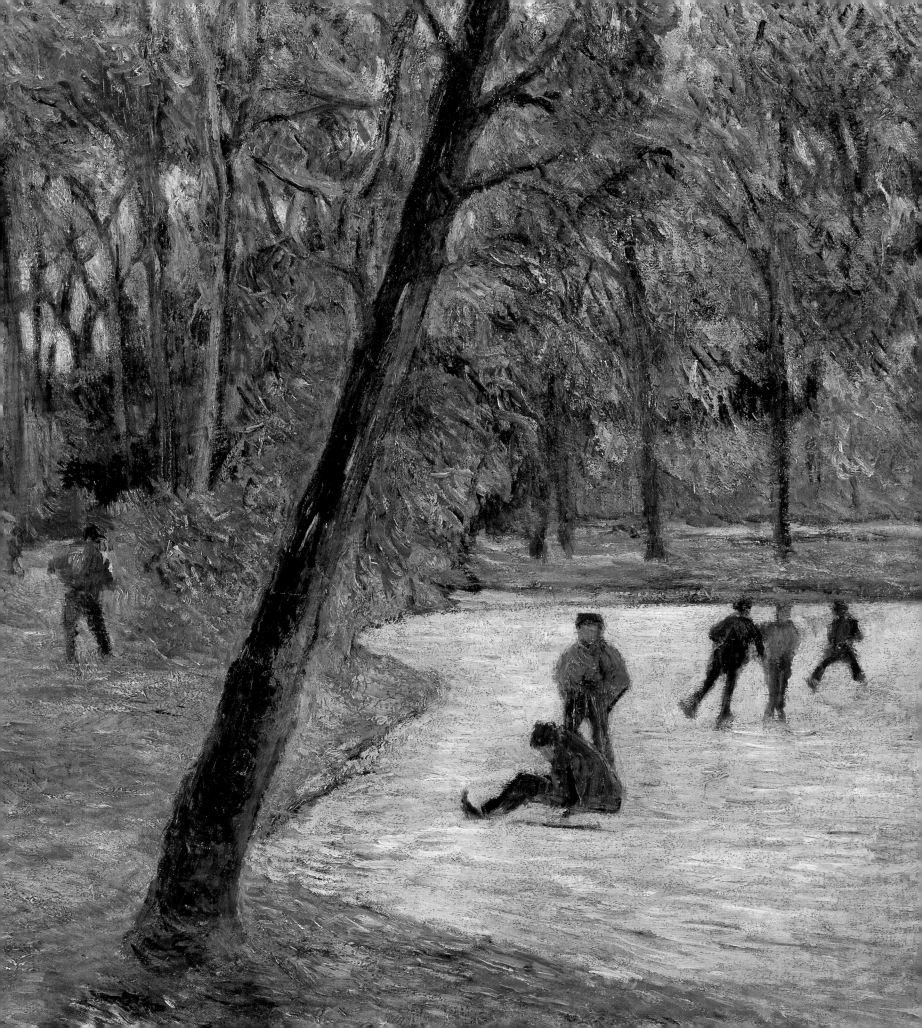

is almost as if Gauguin were not actually Gauguin until he fled Paris for Brittany just after the closing of the final Impressionist exhibition. The "temporary Impressionist" is all but absent from any but the most complete of books and exhibitions about Gauguin. His time in Brittany, Arles, Tahiti, and the Marquesas Islands so overwhelm his Impressionist phase in books and exhibitions that it is surely time to redress the balance, looking carefully and dispassionately at the first decade of his career. The only exhibition that has so far focused on this period of his life was Anne-Birgitte Fonsmark's exhibition *Gauguin and Denmark*, held in 1985 at the Ny Carlsberg Glyptotek, Copenhagen.

What do we know of Gauguin's first decade as an artist? Georges Wildenstein's first catalogue of the artist's oeuvre, published in 1964, included 191 works made before the 1886 Impressionist exhibition. These were reproduced in tiny black-and-white photographs with adequate, though not definitive, information about their exhibition history, provenance, and physical characteristics. Certainly the appearance of the 1964 catalogue, which was much contested by Gauguin scholars, did little to turn anyone's eye to the early career, in spite of the sheer number of works from those years.[3] And it seems that this would have been perfectly fine with the painter himself, who wrote to a collector in 1900: "I estimate the number of [my] canvases since I began to paint as 300 at most, which is not counting a hundred or so from the beginning of my career."[4] We now know that Gauguin got it wrong. The most recent installment of an immense scholarly catalogue raisonné by the Wildenstein Institute, published in 2001 in French and in 2002 in English, includes 216 paintings—more than twice as many as Gauguin himself remembered—that can be plausibly dated before the final Impressionist exhibition in 1886. They constitute an early oeuvre—a debut, if you will—that is large, impressive, and varied. And this does not count the drawings, ceramics, and wooden sculptures recorded in other sources.

In the depth of its documentation and in its publication of the majority of the paintings in recent color reproduction, the 2001 Wildenstein catalogue makes up what the 1964 volume lacked. We have elected to bring together for the first time in history the most important and enigmatic of the paintings, sculptures, and ceramics of these years and to place them in the context of the experimental, avant-garde movement to which they made a major contribution. Seen in their totality, Gauguin's Impressionist canvases and sculptures grapple with the thorniest issues debated by Manet, Degas, Pissarro, Seurat, and others in the cafés of Paris and its suburbs. Their emotional and artistic range is much greater than that of Sisley, or even Renoir or Monet, although the latter two are undeniably greater as Impressionist painters. Indeed, it is simply impossible to think of another artist—man or woman—whose achievement among the Impressionists was as wide-ranging and enigmatic as that of Gauguin. What Gauguin did as an Impressionist was ceaselessly to question the nature of Impressionism itself. He asked questions of a movement that was itself always asking questions about the nature and role of art in modern society.

The place of Gauguin in the grand narrative of Impressionism was recognized by Rewald in 1946, although few scholars of Gauguin took up his lead. It was not really

until 1986, when the Fine Arts Museums of San Francisco and the National Gallery of Art, Washington, mounted a major exhibition devoted to the eight Impressionist exhibitions that Gauguin was allowed a foot in the door of the latter-day Impressionist exhibitions. The 1986 exhibition contained 160 paintings, of which 5 were by Gauguin. These were selected from the 53 works by the artist known to have been included in the eight exhibitions. From this larger group, 4 additional works were included as illustrations in the excellent catalogue. No visitor to the exhibition would have had much of a sense of Gauguin's contribution to the movement, but a careful reader of the catalogue might have been curious to learn more.

Ten years after the 1986 exhibition, the Fine Arts Museums of San Francisco published a major two-volume catalogue of the eight Impressionist exhibitions together with all the surviving reviews of the exhibitions, gathered by a team of scholars.[5] In this magisterial publication, Gauguin played a larger role. Forty-six of the 53 works shown by Gauguin were identified, most conclusively and some provisionally, and the numerous mentions of Gauguin in the critical press were made readily available to scholars.[6] The publication also recognized Gauguin's important role as a lender of works by other artists to the exhibitions, beginning with his loan of three works by Pissarro to the exhibition of 1879. Gauguin's dual role as artist-collector was clearly recognized. In this, he can be compared to Gustave Caillebotte, who played both roles with equal or greater élan.

Clearly, Gauguin was among the handful of artists and collectors who were crucial to the very definition of Impressionism. A skeptic might note that his paintings received far fewer critical notices than those of Monet, Renoir, Degas, Pissarro, or even Caillebotte, and that his sculpture was overshadowed by that of Degas. And his collecting was known only to the inner circle of the movement and to his friends in the financial world. But, when his achievements as a painter, sculptor, ceramicist, theorist, and collector are considered together, he can be said to have been among the most important figures in the movement. As a painter, he would rank with Pissarro and Caillebotte and above such well-known figures as Berthe Morisot, Mary Cassatt, and Alfred Sisley. As a sculptor, he was second only to Degas, whom he actually surpassed in the sheer originality of his submissions to the Impressionist exhibitions. Given this, it is time to reevaluate his Impressionist oeuvre carefully.

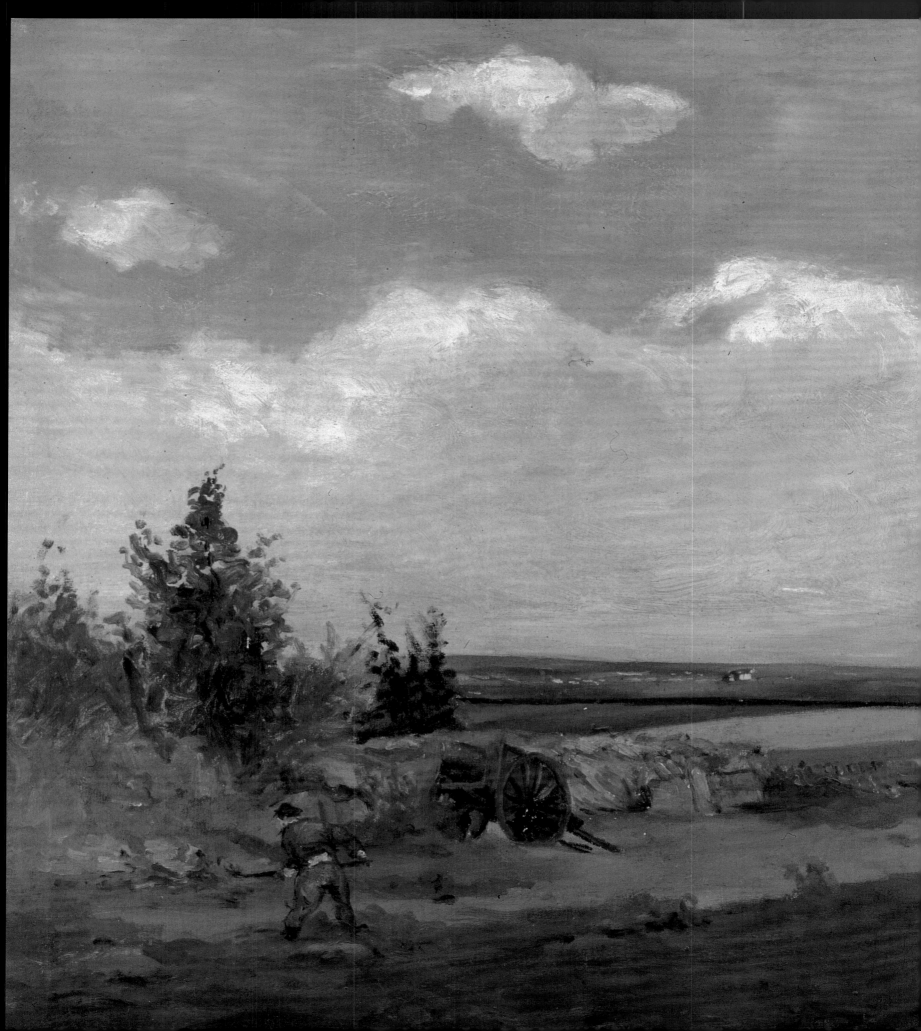

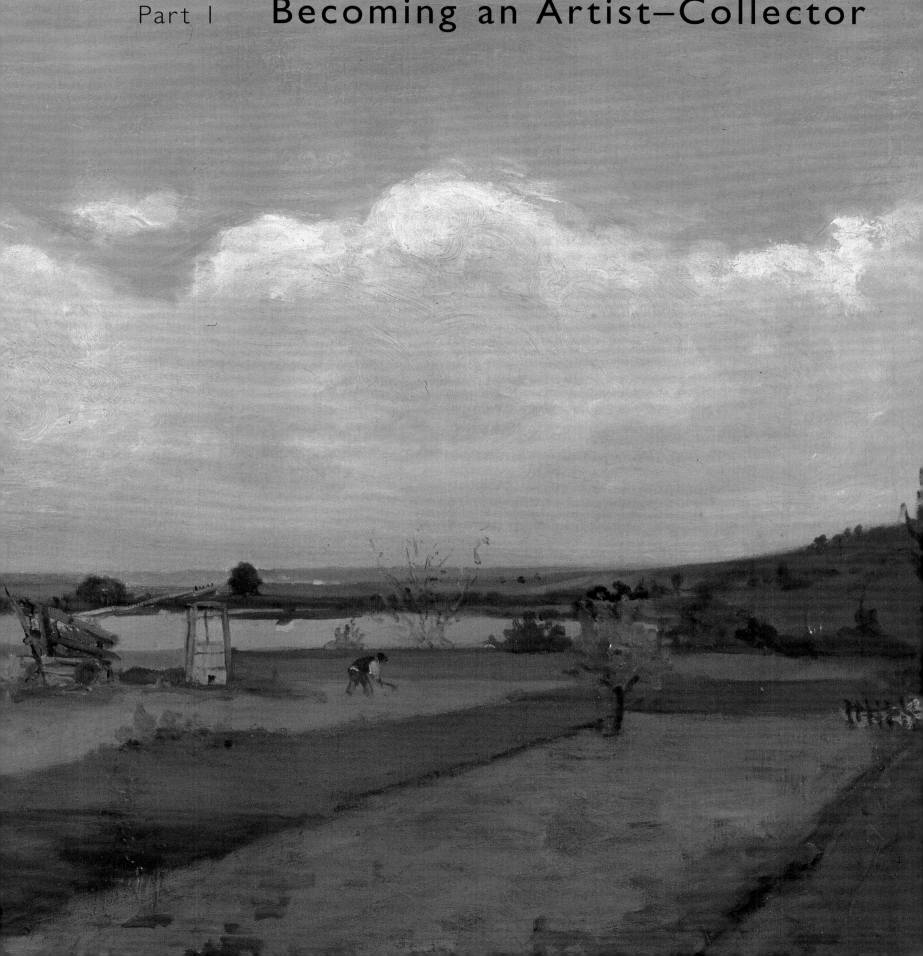

Becoming an Artist–Collector

Richard R. Brettell Gauguin's Life and Visual World, 1848–1872

Tackling the Impressionist Gauguin means dealing seriously with the
various visual experiences and ideas of art he brought to the movement when he
entered it in the late 1870s. Of all great artists, Gauguin lived perhaps the most
compelling life. Not one page of his autobiography or any of his various biographies is
boring. From his Spanish and French ancestry to his peripatetic childhood, from his
fascinating education to his sea voyages as a young man, from his protection by an art-
collecting guardian to his career in the Paris stock market, from his tumultuous
marriage to a Danish woman to his participation in radical Spanish politics, Gauguin's
early years surpass in variety and interest even those of the poly-cultural and much
traveled Pissarro or Degas. By comparison, Monet and Renoir seem downright dull.

On Gauguin's father's side, the family was linked to radical journalism and, on his
mother's, to both popular art and vanguard feminism. Before he made his first recorded
work of art in 1873, he had seen hundreds of others. These ranged from pre-Hispanic
Peruvian ceramics from the Cupisnique, Moche, and Nazca cultures, silver figurines of
Inca manufacture, Catholic altarpieces in both Spanish and Portuguese parts of South
America, Asian and Western ceramics in his guardian's collection, and modern French
paintings by artists from Delacroix to Pissarro. Even this partial list of works suggests
that what he saw was larger and more diverse than a comparable list would be for
Monet, Renoir, Sisley, or Pissarro and forces us to realize that Gauguin's very idea of art
was broader, more various, and less hierarchical than that of any other major artist of
his generation, Impressionist or otherwise.

Even the geography of Gauguin's first three decades is diverse and fascinating. Born in
Paris in the year of revolutions, 1848, he spent his early childhood in a palace in Lima,
Peru, where he learned and spoke Spanish.[1] Returning to provincial Orléans, France, at
the age of seven and a half, he was schooled under the direction of a liberal cleric who
linked the latest developments in science with the dedicated study of languages, history,
and religion. Though an indifferent student, he took from school a lifelong curiosity
about the relationship between science and religion. His childhood travels clearly gave
him a wanderlust, which he expressed for more than five years, between late 1865 and
early 1871, when he was a low-ranking sailor in the merchant marine and then the
French navy. During those years he traveled twice to Brazil; again crossed the south
Atlantic and reached Chile and Peru, then perhaps sailing around the world; passed the
Arctic Circle via England, Scotland, and Norway; did two stints in the Mediterranean,
where he traveled as far as the Greek Islands, Constantinople, and the Black Sea; and
served in the Franco-Prussian War on a ship that captured four enemy German vessels.
This is hardly the kind of life that leads inexorably to a career as an artist.

Personally, Gauguin's life was anything but easy. His mother was abused by her
mentally anguished father, who was sent to prison for his cruelty. His own father died
at the tip of South America shortly after his son's first birthday (the infant Gauguin was
in the boat with his father when the latter had an aneurism and died), and the future
artist learned of the death of his mother when he was nineteen and on the other side
of the world with the merchant marine. His male guardians were a diverse lot—first

previous pages Paul Gauguin, *Working the Land* (detail of
fig. 14)

facing page Camille Pissarro, *The Edge of the Woods Near
l'Hermitage* (detail of fig. 33)

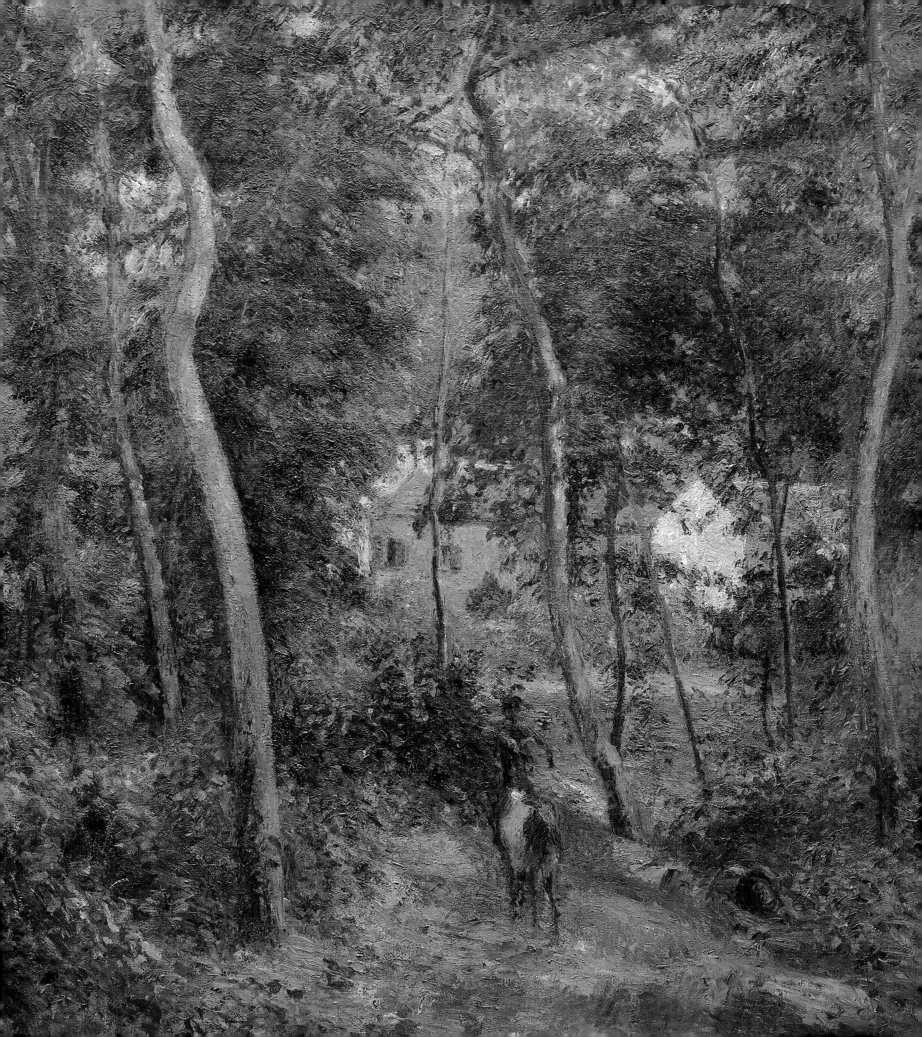

his distant cousin, the fabulously wealthy José Rufino Enchinique, president of Peru, with whom the family lived in Lima; then his modestly bourgeois uncle Isidore (Zizi) Gauguin in Orléans, and, finally, after the death of his uncle and mother, the Sephardic Jewish Parisian capitalist Gustave Arosa, who was a major collector of modern French painting and art ceramics. Gauguin's biographer David Sweetman has proved that he was on board ships at one time or another with a remarkable group of notables, including the scholar-theologian Ernest Renan and his son, the future artist Ari Renan, as well as Julien Viaud, who wrote under the nom-de-plume Pierre Loti and popularized Tahiti for the French long before Gauguin's decision to paint there in later life. Again, one must search hard through the lives of nineteenth-century artists and writers to find someone whose experiences match those of the young Gauguin. He seems destined more to have been an explorer, an archaeologist, or an adventurer than an artist.

Art museums were not much in evidence in the places the young Gauguin visited. Unlike Manet, Degas, Caillebotte, and most of the other Impressionists, who were effectively cultural travelers to famous European cities (Manet did, one must admit, go to Rio as a young man), Gauguin preferred places without museums or major artistic institutions. Yet, he did not travel in a world devoid of art, and the relative eccentricity of the art to which he was exposed as a child and young adult had a profound effect on his later ideas about the nature of art. His family, even his mother, is often reported to have owned pre-Hispanic Peruvian ceramics and artifacts, and he clearly visited one or more of the churches and chapels of colonial Lima.[2] Indeed, there was an elaborate private chapel in the vast house of Don Enchinique, where Gauguin lived as a child in Peru.

Yet, for purposes of his future career, the single most important source for the young Gauguin was the art collected by his adult guardian, Gustave (in Spanish, Gustavo) Arosa, and his brother, Achille Arosa. Both men were important collectors of contemporary painting. Both were accomplished photographers, and both were acquainted, probably through family business connections, with the future Impressionist Camille Pissarro. Like them, Pissarro came from a Sephardic family with Spanish roots and business interests in Latin America (the origin of the Arosa fortune is reported to have been in South American guano). The Arosas and the Pissarros were fluent in Spanish and French, as was the young Gauguin, and, although we have no direct proof that Gauguin met Pissarro before the mid-1870s, it is not only possible but likely that he did. Their meeting would have occurred in the physical and cultural context of the Arosa collections, and the shape and character of these collections are so important for Gauguin that they deserve detailed discussion.

The art collections of Gustave and Achille Arosa are well documented because the paintings in them were sold at auction in Paris—in 1878 and 1891, respectively. The earlier sale was documented by an illustrated catalogue known to have been owned by Gauguin, and the illustrations were photographs of the paintings produced under the direction of Gustave Arosa. The effect of the Arosa collection on Gauguin has generally been studied in relation to the later part of the artist's career, particularly the second

Tahitian period of 1896–1901, when he actually borrowed material for his paintings from photographs in the Arosa sale catalogue. In the present context we will direct our attention to the links between Gauguin and the Arosa brothers earlier in his life, when the future artist was beginning to make works of art and to engage actively with the art world.

Gustave and Achille Arosa were the sons of a highly successful financier named François-Ezéchiel Arosa, a Spaniard of Sephardic Jewish roots who moved his family from Madrid to Paris in 1818, after the fall of Napoleon. His sons became effectively French, but the entire family had close business connections with two other important Jewish families in Paris, the Rothschilds and the Pereires. Indeed, the Arosas were directly involved in the business dealings of the Rothschild family. There are many ways in which Gauguin's widowed mother could have come into contact with the Arosa family. Because a good deal of the Arosa fortune was based on the guano trade with South America, it is likely that the family had dealings with the Enchinique family, with whom the Gauguins had lived in Peru. Certainly Gauguin's mother was in direct contact with the Arosa family by the time she moved her children from Orléans to Paris and set herself up as a seamstress (probably with funding from Gustave Arosa). Her shop was not far from the family's Parisian house, and there is delicate speculation in the Gauguin literature, particularly in Sweetman's biography, that there may have been intimate relationships between the long-widowed Mme Gauguin and Gustave Arosa. This would have been mirrored in a similar relationship between another seamstress, Clementine de Bussy (the godmother and aunt of Claude Debussy) and Gustave's brother, Achille Arosa.[3] Yet, such a relationship for Gustave Arosa and Mme Gauguin seems unlikely, given the facts that the Gauguin children had direct access to the entire Arosa family, including his wife and children (unusual for children of a mistress!), and that Gauguin's sister was raised by the family, living effectively as an Arosa daughter, after the death of her mother in 1867.

What can be said with certainty is that Gauguin and his sister were the legal responsibility of Gustave Arosa after 1867. Gauguin was at sea for much of the time but, on his release from the navy, he took up with the Arosas, probably living with them for short periods and certainly becoming a protégé of Gustave. Thanks to the patient work of David Sweetman, we now know a good deal more about Gauguin's shadowy business career in the 1870s and early 1880s. It is clear that the future painter made every business move with the advice and backing of his guardian, who assured his proper placement in the complex world of the Bourse—the Paris Stock Exchange—so that he both earned a steady salary and received generous commissions on transactions made for others on and off the floor. It is important to recognize the links between the worlds of art and business that were intrinsic to the Arosas' way of life. Both Gustave and his brother, Achille, transacted business, collected art, made art (in both cases photographs), and maintained a social web of artists, critics, musicians, literary figures, politicians, and businessmen. They were also effectively "multicultural," with friends in the Spanish, Portuguese, Latin American, and British communities. There is little doubt

that their world also included the parents and brother of Pissarro, who were also in the Parisian business community, as well as the painter himself. As we shall see, both Gustave and Achille Arosa owned Pissarros.

This short biographical excursion is intended to evoke, in brief, the social, physical, and psychic "geographies" of Gauguin's childhood, adolescence, and young adulthood. Before his marriage to the Danish Mette Gad in 1873, he had slept more nights away from any of his temporary "homes" in France than in them. He had been rocked to sleep and tossed from his bed by waves and had endured the physical confinement of nineteenth-century ships, only to be "released" to the endlessness of the sea. By contrast, his childhood in Peru was spent in the maze of a vast urban palace with carved doorways, internal courtyards, fountains, walled gardens, scores of rooms, and large ceremonial spaces.[4] There he saw furniture, works of art, textiles, ceramics, and carpets, made mostly in Peru itself or in Europe, either Spain or France, that would have seemed completely alien to the young French children with whom he studied in Orléans.[5] The same French children, well educated as they no doubt were, would have been equally mystified by the Arosa brothers' Parisian apartments and conveniently located country house in Saint-Cloud. Filled with ceramics, highly elaborate furniture, sculpture on pedestals, and hung frame-to-frame with paintings, drawings, and watercolors, these haute-bourgeois environments were used for frequent entertaining.

The Arosas shared a taste for vanguard art of the middle nineteenth century, and their art collections were each of sufficient size and quality for individual sales with expensively produced catalogues introduced by learned prefaces. Gustave's sale occurred after his financial reversals of 1877 and seems to have been motivated by his need to raise capital. Its catalogue preface was written by no less a critic than Philippe Burty, who reviewed several of the Impressionist exhibitions and was a close friend of Edouard Manet and Degas as well as a member of Gustave Arosa's own circle. The rather reserved Burty was anything but that when he wrote about Arosa, whom he called "a loyal amateur, of an original and always artistic judgment, faithful in his likes and dislikes, and resolute in his purchases."[6] The collection contained seventy-four lots, of which fifty-six were illustrated in the deluxe edition of the catalogue. The works illustrated include nine by Camille Corot, seven by Gustave Courbet, and a startling sixteen by Eugène Delacroix. Other artists represented in quantity were Johan Barthold Jongkind and Octave Tassaert, each with six works, and there were paintings by Eugène Boudin, Antoine Chintreuil, Honoré Daumier, Narcisse Diaz, Henri-Joseph Harpignies, Charles Jacque, Théodule Ribot, and Théodore Rousseau. A good deal of the collection consisted of works of small format, which, within their heavy gilt frames, must have been hung throughout the major formal rooms of the Parisian apartment and the country house in Saint-Cloud.

In the midst of many works that today would probably rarely be displayed in a great art museum, there were a number of outright masterpieces, which, given the fact that they were seen repeatedly over several years by the young Gauguin, are worth discussion. (Certain of the finest and most important works are illustrated here,

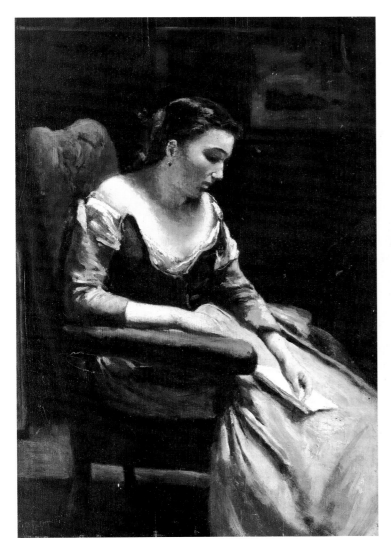

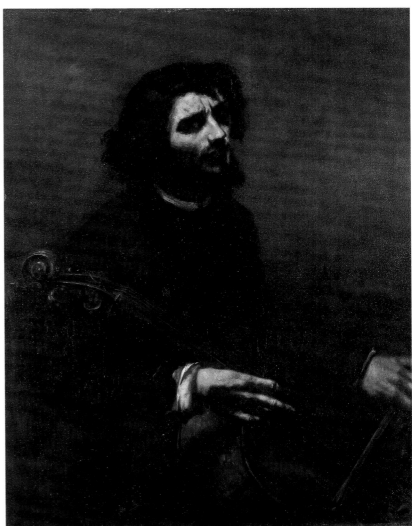

Fig. 1 (*above left*) Jean-Baptiste-Camille Corot, *The Letter*, 1865. Oil on wood, 21¹/₂ × 14¹/₄ in. (54.6 × 36.2 cm). The Metropolitan Museum of Art, New York. H. O. Havemeyer Collection, Gift of Horace Havemeyer, 1929 (29.160.33)

Fig. 2 (*above right*) Gustave Courbet, *The Cellist, Self-Portrait*, 1847. Oil on canvas, 46¹/₈ × 35¹/₈ in. (117 × 89 cm). Nationalmuseum, Stockholm (NM 3105)

including a number that are not currently recognized as having been in Arosa's collection; works that were specific sources for Gauguin will be illustrated in the relevant catalogue entries.) The collection contained two of Corot's greatest late figure paintings. *The Letter* (fig. 1), a splendidly melancholic studio picture, was snapped up at the Arosa sale by none other than Mary Cassatt's friend, Louisine Havemeyer, and is now in the Metropolitan Museum of Art, New York. *Italian Woman Playing the Mandolin* is now in the Sammlung Oskar Reinhart "Am Römerholz," Winterthur (see fig. 85). Both these paintings represent costumed women alone in interiors, and each cast a spell on the future painter's imagination that lasted until his death, in 1903. So too the figure paintings by Courbet, which included the great *Cellist (Self-Portrait)*, now in the Nationalmuseum, Stockholm (fig. 2), and *Young Woman Sleeping*, one of Courbet's earliest erotic nudes (see fig. 86).

These four works alone would have made the collection of Gauguin's guardian a goldmine for the young man. We have no way of knowing whether either Arosa or Gauguin recognized that Courbet's apparent genre scene representing a cellist was in fact a self-portrait. It was not identified as such in the 1878 sale catalogue (it is simply

titled *The Cellist* and referred to as a "painting with very tight execution and powerful color"!). Yet, the engagement between the full-scale male cellist and the viewer, and the wild intensity of his gaze give the painting a hypnotic quality unknown in genre painting. The Courbet nude had perhaps the most powerful impact on the young Gauguin, for it deals overtly with two subjects—sleep and female eroticism—that were to affect him repeatedly. Looking at this work even in the small photograph in the sale catalogue owned by Gauguin, any historian of Gauguin's oeuvre makes a mental "fast forward" to his images of sleeping children in the 1880s and *Manao tupapau (The Spirit of the Dead Watching)* of 1892 (Albright-Knox Art Gallery, Buffalo). (The latter has consistently been related to Manet's great *Olympia*, in the Musée d'Orsay, Paris, which Gauguin did not even see until Manet's posthumous retrospective in 1884.) Courbet's pale sleeping nude, alone and virtually out-of-doors, seems to move in erotic ecstasy, dreaming her lover. Gauguin probably spent the most time with this highly charged work of art when he was courting his future wife, Mette, and how it must have played on his imagination. Like the lifelong bachelor Corot, Gauguin retained throughout his life what might be called a "muse complex," constantly searching for young women to inspire him to create. He used these muse-women as both subject and audience for works of an intensely personal nature.

The veritable cache of paintings and watercolors by Delacroix was even more important for Gauguin's subsequent development as an artist (figs. 3, 4). These included accomplished copies of two paintings by Rubens in the Louvre and a seventeenth-century portrait from Versailles; three studies for the library decorations in the Chambre des Députés of the Palais Bourbon; three orientalist, three Christian, and one mythological subject; and literary subjects from texts by Shakespeare, Sir Walter Scott, and Robert Burns.[7] Although mostly small in scale, these works showed an emotional and intellectual range unmatched by any other artist in the collection. It took Gauguin almost two decades to develop to the point at which he could sustain even self-comparison with Delacroix, but the foundations of his ambitious and literary art rested on the major Delacroix collection owned by his guardian. We must remember that he was familiar not only with the catalogue of the collection, but also with the paintings themselves. Delacroix's complex and subtly interwoven strokes of paint were deeply important for Gauguin's development of what might be called his "woven" facture in 1879–80, while he worked under the direction of Pissarro. Because of his access to the Arosa collection, he brought to Impressionism a more detailed and profound knowledge of Delacroix's paint handling than any other artist of the group.

Gauguin was liberated to become a collector himself only after the Arosa sale. Although we do not know precisely when he began to buy paintings, it was later in 1878 and in 1879 that his activities as a collector really took off. It was perhaps the economic gains made by Arosa in "speculating" on art that allowed Gauguin to begin to speculate on his own, and, when we know that Gauguin and his absent family were later to live largely off proceeds from the sale of his collection, the Arosa paradigm becomes even clearer. For the amateur Gauguin, art and money were inextricably linked.

Fig. 3 (*right*) Eugène Delacroix, *Encampment of Arab Mule Drivers*, 1839. Oil on canvas, 15 × 18¹/₄ in. (38.1 × 46.4 cm). Milwaukee Art Museum. Gift of Mr. and Mrs. Theodore Ball (M1960.46)

Fig. 4 (*below right*) Eugène Delacroix, *Moroccan Landscape*, 1893. Oil on canvas, 13 × 16¹/₈ in. (32.8 × 41 cm). Kunsthalle, Bremen (1327–1991/24)

Before discussing the collection of Gustave's brother, Achille, it is interesting to speculate about other works owned by Gustave that were included in the sale but remained unillustrated in its catalogue. Among these were four paintings by the only recently deceased Honoré Daumier[8] and three important early paintings by Pissarro. Although Arosa included illustrations of minor paintings by artists like Gustave Boulanger, Charles Chaplin, Antoine Chintreuil, and Ignacio Merino in his selection, he failed to illustrate works by Boudin, Daumier, and Pissarro, none of whom was well known enough to the amateur collectors who would compete for the works in the collection. Of the four works by Daumier in the Arosa sale of 1878, three were to appear with new owners just months later in the first exhibition devoted to Daumier's paintings and watercolors, at the Durand-Ruel gallery, Paris. Two were of high quality

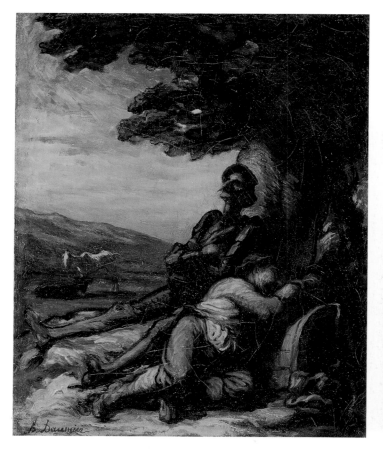

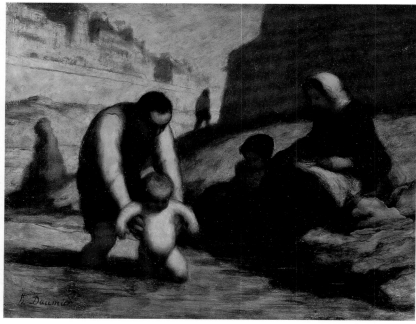

Fig. 5 (*above left*) Honoré Daumier, *Don Quixote and Sancho Panza Under a Tree*, c. 1855. Oil on canvas, 16⅛ × 13 in. (41 × 33 cm). Ny Carlsberg Glyptotek, Copenhagen

Fig. 6 (*above right*) Honoré Daumier, *The First Bath*, c. 1852–55. Oil on panel, 9⅞ × 12¾ in. (25.1 × 32.4 cm). The Detroit Institute of Arts. Bequest of Robert H. Tannahill (70.166)

and sold for considerably greater sums than the three larger paintings by Pissarro. They were *The First Bath* (fig. 6) and *Don Quixote and Sancho Panza Under a Tree* (fig. 5). Daumier's name occurs so rarely in the vast Gauguin bibliography that one might assume that this great artist had no effect on the younger painter's career. There is not a single surviving Gauguin letter from 1878—the year of both the Arosa sale and the Daumier exhibition at Durand-Ruel. But this accident of history should not prevent us from considering Daumier's effect on the impressionable amateur painter.

It is fascinating that Pissarro's name, frequently misspelled in the press during the artist's lifetime, was also misspelled in the Arosa sale catalogue (as "Pissaro"), both in the entries for the three works and in the eloquent comments about the artist in Philippe Burty's introduction. This is unexpected, given the clear probability that Arosa and probably Burty actually knew Pissarro. The works by Pissarro in the Arosa collection were each of real quality. They included one outright masterpiece, *The Orchard, Springtime* (fig. 7). This large and beautifully composed springtime landscape was painted in Louveciennes in 1870, in the months after Pissarro painted with Monet along the Route de Versailles and, as a result, began to graft flickering elements of Impressionist facture to the sturdy trunk of his own classical landscape aesthetic. It is the earliest of the three works—the others being dated to the two subsequent years— that represent landscapes in spring (fig. 7), summer (fig. 8), and winter (fig. 9), and, although we do not know when and how they were acquired, it is likely that they can be linked with Achille Arosa's commission to Pissarro to paint four seasonal landscape overdoors for his city apartment in 1872 (figs. 10–13).

Fig. 7 Camille Pissarro, *The Orchard, Springtime,* 1870. Oil on canvas, 22¼ × 33⅛ in. (56.5 × 84 cm). Private collection (PV 94)

Fig. 8 (*below right*) Camille Pissarro, *The Road to Louveciennes, at the Outskirts of the Forest,* 1871. Oil on canvas, 15 × 18⅛ in. (38 × 46 cm). Private collection (PV 120)

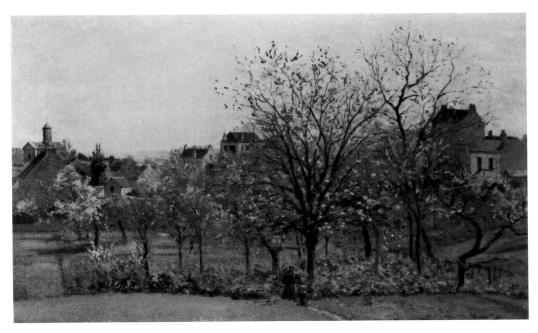

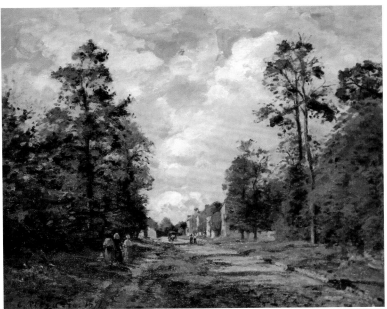

Among Impressionist collectors, only the opera singer Jean-Baptiste Faure, the doctor Paul Gachet, the pastry cook Eugène Murer, and the painter Caillebotte had more impressive groups of paintings by Pissarro in 1878, when Gustave Arosa's collection was sold, and the likelihood that the Arosa brothers bought their eight landscapes (one from Achille's collection eludes identification) by 1873 places them among the first

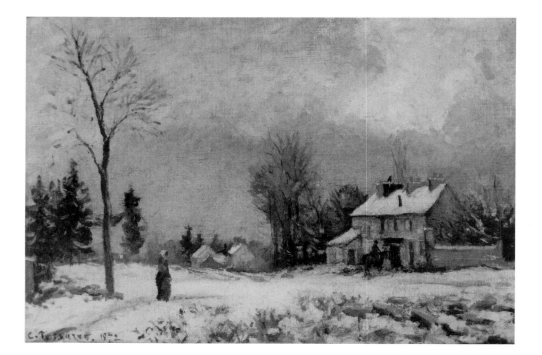

important collectors of Impressionism—before the first exhibition and before even Faure and Caillebotte, whose collections were formed a little later. The importance of these paintings for Gauguin's development as an artist cannot be overstressed. Although he was later to grapple with the implications of the great figural paintings by Corot, Courbet, and Delacroix, in the 1870s and 1880s he devoted himself almost exclusively to landscape painting. It was to the landscapes in Arosa's collection, by Pissarro and his artistic forebears Corot, Courbet, Rousseau, Chintreuil, Boudin, and Jongkind, that he turned to develop his own landscape aesthetic.

We know little about the display of Arosa's collection or the order in which it was purchased. Did he own all the works of Corot and Delacroix before he acquired the Courbets and Pissarros? That seems likely, given what we know of the history of French private collecting from studies by Anne Distel and others, and the careful records of Delacroix's sales in the 1850s and 1860s show that Arosa acquired most of his works by Delacroix in those decades. It is fascinating, looking at the annotated copy of the Arosa sale catalogue in the Getty Research Library, to learn that Arosa made a considerable profit from the sale at a time that was quite depressed for the art market. Handwritten notes in the back of the catalogue indicate that Arosa had paid about 11,000 francs for the collection. It sold for 90,710 francs, which, even after the ten percent commission, was a good return on the investment. The collector Ernest Hoschedé was forced to sell his entire collection—bought as a form of speculation—after his bankruptcy in 1877. His sale, held on June 6, 1878, less than six months after Arosa's, brought in about 70,000 francs for one hundred works (Arosa had seventy-four), which was considerably less than Hoschedé had paid for the works in the previous three years! In the world of capitalist speculation, works of contemporary art were no more dependable than stocks. Arosa won; Hoschedé lost. The financial success of his guardian must surely have influenced the young Gauguin to begin acquiring art himself in the months following the Arosa sale.

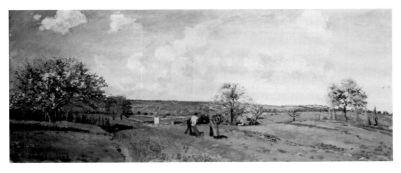 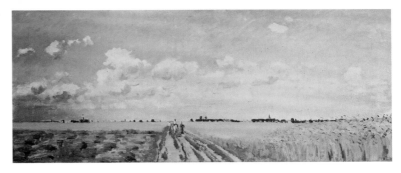

Fig. 10 (*top left*) Camille Pissarro, *Spring,* 1872. Oil on canvas, 21³/₄ × 51¹/₄ in. (55 × 130 cm). Private collection (PV 183)

Fig. 11 (*top right*) Camille Pissarro, *Summer,* 1873. Oil on canvas, 21³/₄ × 47¹/₄ in. (55 × 120 cm). Private collection (PV 184)

Fig. 12 (*above left*) Camille Pissarro, *Autumn,* 1873. Oil on canvas, 21³/₄ × 51¹/₄ in. (55 × 130 cm). Private collection (PV 185)

Fig. 13 (*above right*) Camille Pissarro, *Winter,* 1873. Oil on canvas, 21³/₄ × 51¹/₄ in. (55 × 130 cm). Private collection (PV 186)

Gustave Arosa's younger brother, Achille, kept his collection (including at least one Delacroix from his brother's collection) until 1891, when his smaller sale of sixty-one works (thirty-three paintings, twenty-one drawings and watercolors, and seven bronzes) was conducted. The taste of the two men was not appreciably different—both had works by Boudin, Corot, Courbet, Delacroix, Jongkind, Pissarro, and Tassaert. Achille did own one early Sisley and two paintings by Charles-François Daubigny, both artists absent from his older brother's collection.[9] Because the sale was held so much later than the dates of most of the works, we have no way of knowing when he bought them. For the purposes of our discussion of Gauguin, his most significant act as a collector was to commission the four seasonal overdoors by Pissarro in 1872. As we shall see, these made a lasting impact on the young Gauguin.

It was the Arosas' patronage of Pissarro's early work that was to be Gauguin's introduction to the Impressionists. Their group of paintings—all but one of which were made in or before 1873—was probably the earliest to be found in private hands outside the painter's own family. Clearly Gauguin had intimate knowledge of Pissarro's landscape aesthetic even before the first group exhibition of the future Impressionist painters held in the spring of 1874. The web of family, social, economic, and artistic ties that linked Pissarro to Gauguin was centered on the Arosas.

Fʀᴏᴍ ᴛʜᴇ ғɪʀsᴛ ᴘᴀɢᴇs ᴏғ Victor Merlhès's brilliantly annotated gathering of Gauguin's correspondence, we know that the future Parisian businessman was engaged with art.[10] Merlhès publishes letters from Gauguin's Danish friend Marie Heegaard to various members of her family in 1872 and 1873. The letters are not published in their entirety, so we cannot measure Gauguin's importance in the larger context of this wealthy young Danish woman's view of Paris. Yet we learn a good deal about the Arosa circle, in which they met, and about Gauguin's centrality in that circle from Marie's point of view. She reports Gauguin's secret admiration for her companion, Mette Gad, in a letter written on Christmas day of 1872 that describes a reception filled with Spaniards at the Arosa home in Paris. She describes a costume ball at the Arosas' held in February of 1873 for which Gauguin designed the paper costumes of several of the participants, who appeared as a bottle of champagne, a chandelier, a wrapped candy, a fan, and a soldier (the last was the artist himself). Gauguin also designed paper dresses that were painted by Marguerite Arosa, as well as a pair of costumes representing a nurse and baby, the latter being played by his future wife, Mette Gad.

In a letter to her sister in mid-July of 1873, Marie notes that Gauguin is "miserably in love and fills his spare moments by painting; he has made great progress. Last Sunday, he painted for ten hours."[11] At the end of July or early August, while staying at the Arosas', Marie reports that she posed for Gauguin for three hours. With that, the story of Gauguin as a passionate amateur artist begins. He met his future brother-in-law, the Danish painter Frits Thaulow, in April of 1874 (during the first Impressionist exhibition, of which he made no mention in a long letter), and he wasted no time introducing Thaulow to the Arosas. Painting had already become his preferred pastime by 1874, and both the Arosas and his circle of Danish friends encouraged him in this. With his sister living with the Arosas, Gauguin visited with such frequency that, in the first half of the 1870s, he was virtually part of the family—and we must remember that Marguerite Arosa, the elder of Gustave's two daughters, was to have an important professional career as a painter, both in France and Spain.

As if the Arosas were not stimulating enough, the future painter had met a young stockbroker, Emile Schuffenecker, who would become a lifelong friend and who had already seriously studied painting under Paul Baudry. Here again, as with the Arosas, the world of stock trading and moneylending intersected with that of art. Schuffenecker was working at Paul Bertin, the same firm as Gauguin, and they met in February of 1872, just when Gauguin came to work at the firm on the recommendation of Gustave Arosa, one of its largest shareholders. Schuffenecker, of Alsacian origins and also an orphan, seems almost to have been destined to be Gauguin's friend, and the two were essentially inseparable for more than a decade. Their friendship cemented Gauguin's artistic inclinations, and the two young men spent much of their leisure time looking at or making art in Paris and its suburbs. Gauguin's access to the Arosas was beneficial for the more decidedly middle-class Schuffenecker. He also became closely attached to Mette, Gauguin's future wife.

Gauguin completed his earliest major painting to survive, *Working the Land*, in September of 1873 (fig. 14). It represents an immense, flat agricultural landscape being

facing page Paul Gauguin, *Daisies and Peonies in a Blue Vase* (detail of fig. 20)

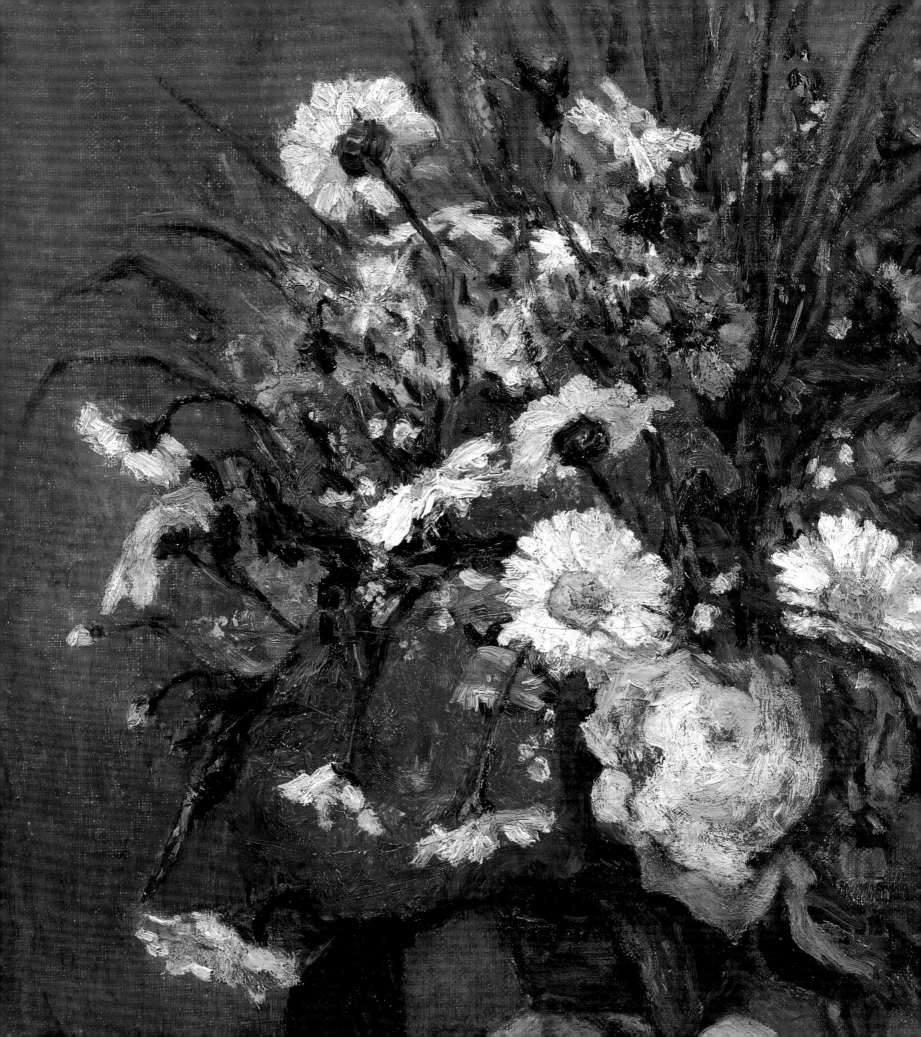

Fig. 14 Paul Gauguin, *Working the Land*, 1873. Oil on canvas, 19⁷/₈ × 32¹/₈ in. (50.5 × 81.5 cm). Fitzwilliam Museum, University of Cambridge (PD.20–1952) (WII 4)

worked by two male peasants. Its closest aesthetic alliances are with Pissarro and his associate Antoine Chintreuil, each of whom painted similarly panoramic horizontal landscapes in the environs of Paris. The brilliant blue of its sky and the brightness of the greens and yellows in the fields relate to the recently completed landscapes of the four seasons that Pissarro painted for Achille Arosa. One of these, the spring landscape, to which the Gauguin is most closely related, is dated 1872 (see fig. 10); the remaining three were completed in the early months of 1873 (see figs. 11–13). With the exception of the awkwardly painted sky, Gauguin's painting is of a remarkably high quality, virtually equal to that of Pissarro, indicating that he was already more than an amateur. Its large, deliberate signature and date are proof that he considered himself on a level with professional artists.

We do not know where Gauguin painted this accomplished work. It is not at all like the hilly and wooded landscape around Saint-Cloud, where the Arosas had their country house. Rather, it resembles the agricultural areas north and southeast of Paris, where Pissarro and Chintreuil painted. Unfortunately, not a single document tells us about Gauguin's travels in the spring and summer of 1873, and, judging by the formality of his first surviving letter to Pissarro in 1879, we cannot presume an earlier friendship. Pissarro was in Paris in a rented pied-à-terre in Montmartre for a good deal of the summer of 1873. Yet Gauguin was to loan a Pissarro of 1873 to the 1879 Impressionist exhibition, and it is possible that he purchased the work in the year it was

Fig. 15 Alfred Sisley, *The Banks of the Seine in Winter*, 1872. Oil on canvas, 18³/₈ × 25⁷/₈ in. (46.5 × 65.5 cm). Musée des Beaux–Arts, Lille

painted. With its clear connection to the autumn painting in the Arosa commission, Pissarro's *Les Meules (The Haystacks)*[12] may well have been Gauguin's first acquisition when he was a young stockbroker connected with the Arosas.

The remarkably consistent feature of Gauguin's other paintings from 1873–75 is that they were made in pairs—a small "sketch" version followed by a larger "finished" version. There are five surviving pairs included in the 2001 Wildenstein catalogue raisonné. The implication of this is that Gauguin worked in what we would call a "traditional" manner for a landscape painter, working *en plein air* on a small scale to achieve a "picture-able" result. The study would then be transformed, probably both in the studio and on the spot, into a finished painting. In only one pair among the five are both versions signed, and in only two cases are the two versions more or less the same size. The method Gauguin was using derived from landscape practice of the mid-nineteenth century, making allowances for the importance of plein air observation, but reserving for the studio careful chromatic work and integration of the picture's facture.

Gauguin's landscape world of the mid-1870s straddled that of midcentury artists like Charles-François Daubigny or Corot and artists associated with the Impressionists, including Boudin and Jongkind in addition to Pissarro. Indeed, many of Gauguin's paintings from 1875, when he worked on the banks of the Seine west of central Paris, have close affinities to Jongkind and Stanislas Lépine as well as Armand Guillaumin—a friend of Pissarro and future associate of Gauguin. Their relatively high-keyed palette, their fascination with the industrial activity on the river, and their modernity all relate them to the modernist landscape practice then sweeping Paris. In one case, Gauguin painted an "effet de neige" or snow effect at the Pont d'Iéna (see cat. 2), just blocks from his apartment in the 8th arrondissement. Although conventional in its composition —with a low horizon line, a distant vantage point, and clear pictorial recession—the painting responded clearly to the landscapes of Sisley, Monet, and Pissarro of the previous years. It is possible that Gauguin was responding specifically to one of Sisley's five submissions to the 1874 Impressionist exhibition, *Port Marly, soirée d'hiver (Port Marly, Winter Evening)* (fig. 15), now known as *The Banks of the Seine in Winter*.

What is clear is that Gauguin's ambitions as a painter were becoming stronger and stronger. He added still-life painting and portraiture to his arsenal, effectively mastering

the three types of modern bourgeois painting before attempting to exhibit his work. As for his ambitions in the area of exhibition, we have no evidence that he approached the Impressionists before 1879 or that he was approached by them. He was not a lender to any of the first three exhibitions, in spite of the fact that he may already have owned a Pissarro and other works as well. One of his surviving early paintings, *Landscape with Poplars* of 1875 (cat. 1)—the largest of his career until 1879—has the grandeur of a reputation-making exhibition landscape. Its family provenance and complete lack of exhibition history during Gauguin's life make it frustratingly difficult to discuss in terms of the 1870s. Yet its sheer scale and ambition suggest that it was made for submission to an exhibition—probably the Salon. Because Salon records contain only mention of works accepted, we have no way of knowing when Gauguin began to submit his work to the Salon. It is likely that he had already done so before being accepted in 1876, and it is even possible that he did so afterwards. What we can say conclusively is that, if he did, the work was rejected. Given the fact that the Salon was held in the spring of every year and the scene represented is clearly a summer landscape, it is likely that Gauguin would have submitted this painting to the Salon of 1876. Had it been included in the second exhibition of the Impressionists, held at the same time as the Salon, it would have been the single largest landscape in the exhibition (though several by Monet approached its dimensions). At the same time its wide tonal range—from very light to very dark—and the sheer darkness of its green foliage against the sky would have made it look old-fashioned. Gauguin's great 1875 masterpiece was an attempt to work completely within the mode of midcentury landscape painting favored by his guardian, Gustave Arosa. Arosa's collection included works by Corot, Daubigny, and Rousseau that stood firmly behind it. Did Gauguin actually paint it for Arosa? There is, of course, no documentary evidence to support this. But it is clear that Gauguin made the painting to prove his mastery to a person of precisely his guardian's taste.

Whatever the fate of the great Indianapolis landscape, Gauguin did have a painting accepted by the Salon of 1876. Called *In the Forest, Viroflay—Seine-et-Oise* (WII 31), it was loaned to the exhibition by the artist's sister and brother-in-law, the Uribes. It received no notice that has been discovered by the assiduous students of early Gauguin, but its inclusion must have pleased him. Unfortunately, the exhibited painting is lost. We cannot link its title with the Indianapolis landscape, which, although it includes trees, could never be entitled *In the Forest*. Moreover, the smaller version of the composition, also owned by Gauguin's sister, does survive (WII 14); it bears the inscription "Viroflay" and accords with the lost painting's title. This bears a strong resemblance to Monet's experimental vertical landscapes of the mid-1860s, particularly those painted in and around Honfleur. When Gauguin gained success as an amateur at the Salon, he did so with a work that was about a decade out of step with the most advanced trends in Parisian landscape.

Other paintings from Gauguin's days as an amateur show aesthetic debts to Manet, Théodule Ribot, Henri Fantin-Latour, and Renoir. Yet there is a curious group of floral still lifes from 1876 (figs. 17, 20)[13] that can be most closely linked to similar subjects painted in the mid-1870s by Cézanne. The Cézannes, a first group from 1873 and a

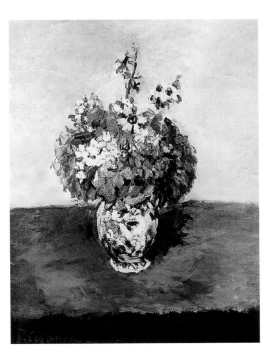

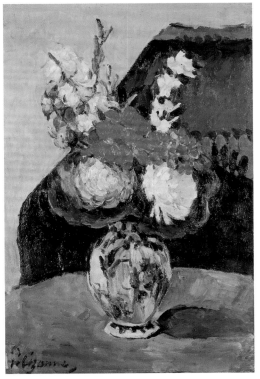

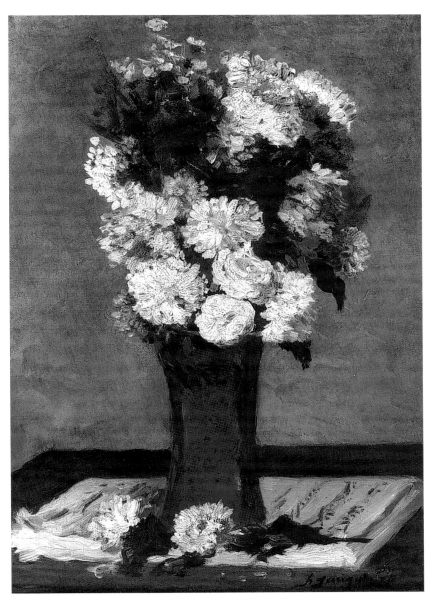

second from 1876/77, would certainly have been accessible to Gauguin *if* he maintained a friendship with Pissarro. Pissarro's friend Dr. Paul Gachet, the Auvers-based homeopathic physician, owned two Cézanne floral still lifes from the first group (figs. 16, 18), and Pissarro himself owned the finest and most ambitious one from the second group (fig. 19). All of these paintings place a tightly constricted bunch of summer flowers in a ceramic vase placed exactly in the center of the composition. All are painted with thick, crusty paint and present the flowers not as objects of great delicacy but as masses of color erupting from the center of the composition. Indeed, they have a conscious crudity of execution that is at odds with their subject. If Gauguin saw Cézanne's paintings of flowers on a trip to Auvers in 1875 or 1876, he immediately subsumed them into his own practice.

The years 1877 and 1878 were among the least productive of Gauguin's career. The deep depression of 1878 was surely among the reasons for this. Only one portrait, of a

Fig. 19 Paul Cézanne, *Vases of Flowers*, c. 1877. Oil on canvas, 21 1/4 × 17 3/8 in. (54 × 44 cm). Private collection (R 313)

Fig. 20 (*facing page*) Paul Gauguin, *Daisies and Peonies in a Blue Vase*, 1876. Oil on canvas, 21 3/4 × 15 in. (55 × 38 cm). Private collection (WII 35)

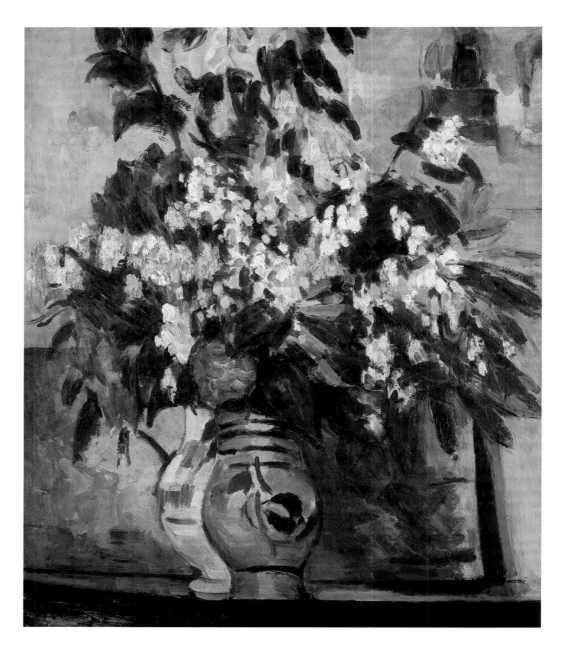

man who must have been a navy friend, Claude-Antoine-Charles Favre (fig. 21), and a large, highly conventional landscape painting (*Farm and Pond*, private collection; WII 38) bear dates that seem to read 1877. Nothing survives from 1878, and it seems clear that Gauguin's pictorial ambitions all but died in those years. There were two causes for this: the first was that, by 1877, he had lost his job at Bertin and seems to have been freelancing as a deal maker on the fringes of the Bourse. The second is that he moved his family from a luxurious apartment near that of his wealthy brother-in-law and the equally well-off Thaulows in the 8th arrondissement to an apartment and studio in an old building located in a small impasse in the decidedly working-class district around the Gare Montparnasse, then used almost completely for freight.

His landlord there was a young sculptor named Jules-Ernest Bouillot, and Gauguin seems to have thrown himself as eagerly into the three-dimensional medium of sculpture

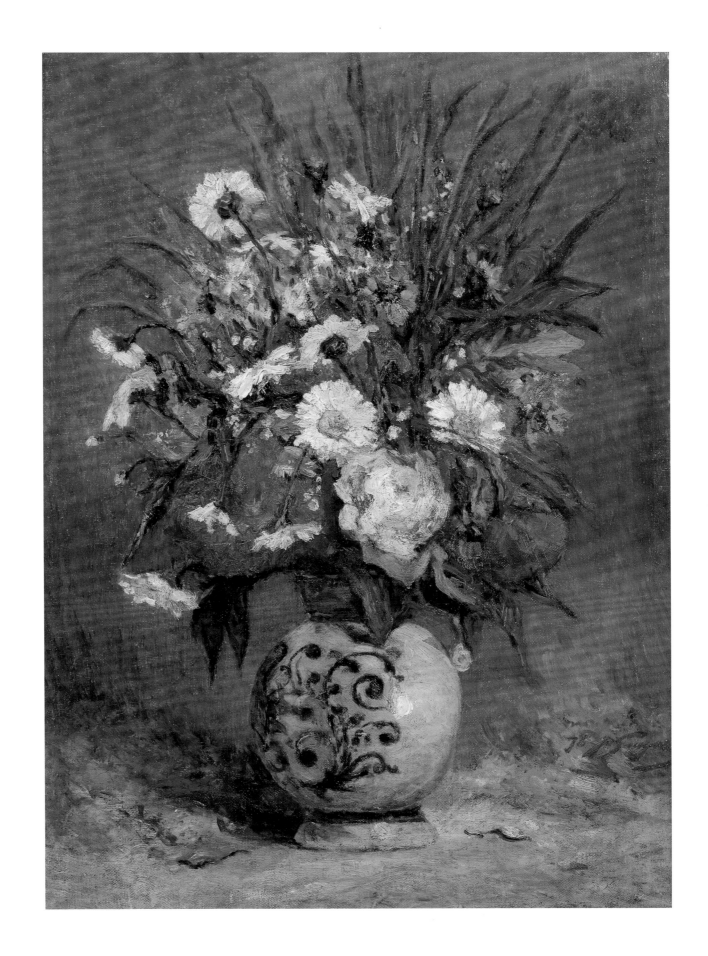

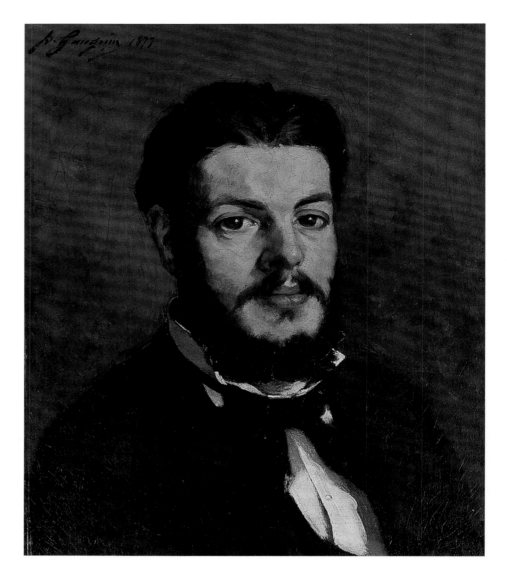

Fig. 21 Paul Gauguin, *Portrait of Claude-Antoine-Charles Favre*. 1877. Oil on canvas, 18 × 15 in. (45.5 × 38 cm). Private collection (WII 43)

as he had into painting in the five previous years. It was also in this area that Gauguin met ceramic artists, notably Ernest Chaplet, who would take Gauguin's instinctive understanding of ceramics and help him transform it. The move must have been a decisive one both for Gauguin the artist and for his marriage. Although he seems not to have suffered a significant diminution in income in 1877 and 1878, he completely changed what we today would call his "lifestyle," forever leaving the world of the haute-bourgeoisie for a bohemian and art-centered life much more like that of the Pissarros than that of the Arosas. We do not know what role, if any, Pissarro played in this move, but his example of a simple life with a large family was clearly known to Gauguin, who adopted it immediately.

When we look collectively at Gauguin's production before the spring of 1879, we find a good deal of promise, but nothing that suggests the kind of commitment and sustained achievement required of a major artist. The Cambridge and Indianapolis landscapes (fig. 14 and cat. 1) and the Richmond and Göteborg still lifes (cats. 3, 4) are the most accomplished among the forty-six works known from these years. Any of them would have been completely respectable additions to the Impressionist exhibitions of

1874, 1876, and 1877, but none would have signaled Gauguin as a talent even of the level of Caillebotte, another wealthy "amateur" admitted to the group in 1876 and dominating it by 1877. Interestingly, it was not Caillebotte who brought Gauguin into the fold of the Impressionists for their fourth exhibition of 1879, but Pissarro and Degas, both of whom met him and considered him important enough to submit in April of 1879. Their invitation forever changed Gauguin as a man and as an artist, forcing him to reckon with his talent and to measure his achievement by higher standards.

This fascinating, brooding landscape is among Gauguin's first outright masterpieces. Although its dark tonality and relatively conservative, premodern landscape motif might suggest otherwise, it could never be mistaken for a work by any of the earlier painters who were its inspiration, Corot, Courbet, or Daubigny—all artists in the collections of the Arosa brothers at this time. It is the largest painting that survives from Gauguin's early years as a painter, and, although it was painted a year before he was successfully admitted to the official Salon as an amateur painter, it is a work that seems to have been destined for the Salon.[14] Its scale, relatively conservative palette, and clear signature and date make it clear that, by 1875, Gauguin was confident in his status as a professional painter.

The painting's most important debts were to Daubigny. The idea of a virtually featureless horizontal motif with a low horizon line, including both water and trees, was so completely associated with Daubigny in the 1860s and 1870s that one could find scores of examples. Daubigny was a liberating precursor, since he produced typologically consistent landscapes that were not burdensome to the follower. If one carefully peruses the pages of Robert Hellebranth's Daubigny catalogue raisonné for parallels, there are so many paintings that are similar without being quite the same, that one speaks of Daubigny as an "influence" upon the young Gauguin rather than as the painter of a particular source.[15] Daubigny adored ducks and geese; Gauguin included three of the latter. Daubigny painted literally hundreds of washerwomen on the banks of the Oise, the Seine, and the Marne; Gauguin included one too—tiny and almost invisible as she is. Daubigny represented trees more for their foliage than for the structure of their trunks and limbs; so, too, Gauguin in the treatment of the fluttering green foliage in the trees on the right.

Yet, given all the similarities of motif, composition, and palette, what is it about Gauguin's Daubigny-like painting that makes it so obvious, even from a distance, that this is not a Daubigny? There are several answers, and they are clear even when one compares the Gauguin with what one might call a "typical" Daubigny that he could have seen (fig. 22). One is the fairly squarish format; Daubigny was resolute in his preference for panoramic horizontal canvases. Another is the restriction of the water to a tiny area in the left foreground; Daubigny gloried in water, whether a pool or a river, and preferred compositions that allowed it to reflect the sky. A third is the spatial character of the composition; whereas Daubigny allowed the viewer easy access to all planes of his landscapes, Gauguin placed a rise of land directly behind the small pond, so that the viewer has no idea what lies beyond the poplar trees at left. A fourth is the sky; for Daubigny,

cat. 1

the sky was the keynote of the entire painting. He relished morning mists, sunrises and sunsets, dusk, and other subtle, fleeting effects of light and cloud. Gauguin's streaky sky is covered by thin cirrus clouds that seem windblown and featureless, and the picture has no distinct temporal indicators. We cannot tell if it is morning or afternoon, and the landscape is devoid of shadows, cast or otherwise.

Given Gauguin's fascination for the landscape world of Pissarro as early as 1873,

it is interesting that the Impressionist whose work the young amateur may already have owned had so little effect on this ambitious landscape. Instead, Gauguin seems almost to have been courting the aesthetic approval of amateurs like the Arosas. His submission of a *sous-bois* (a type of motif closely linked to Barbizon landscape practice) to the Salon of 1876 shows him demonstrating to himself and others his mastery of French landscape painting of the earlier generation. Gustave

Arosa owned paintings by Corot, Courbet, and Harpignies that can be linked to this landscape. Yet, Gauguin's composition was larger than any of them: the closest were Corot's *Le petit pêcheur (The Little Fisherman)* (37 × 45 cm), the same artist's *Paysage (Landscape)* (21 × 33 cm), and Harpignies's *Paysage avec cours d'eau (Landscape with Stretch of Water)* (19 × 32 cm). Gauguin's ambitions were both to learn from and to supercede his chosen antecedents.

The Indianapolis painting conveys a remarkable sense of isolation. The washerwoman is so tiny and so involved in her task that she seems unaware of our presence (as we are, at first, of hers), and there is not a single indicator of a path, a village, a farm, or any other human presence. We seem to be in a sunken section of a large plain, escaping the wind that whips above our heads. For Gauguin, even as an amateur trying to prove his mastery, paintings raised questions of the viewer. Where are we? Why are we here? What is being painted? How are we to find meaning in this landscape? How do we escape? As we look at it and reflect on its relationship to its sources, what seems at first to be an utterly "typical" mid-nineteenth-century landscape by a young amateur emerges as a work that uses landscape to set up a psychic distance between painter and viewer.—RRB

2

The Seine, Pont d'Iéna, 1875
Oil on canvas, 25⅝ × 36⅜ in. (65 × 92.5 cm)
Signed and dated lower right: *P. Gauguin 1875*
Musée d'Orsay, Paris. Bequest of Paul Jamot, 1941
WII 12

In January of 1875, Gauguin, his pregnant wife, Mette, and their first child, Emil, moved to a new apartment at 54 Rue de Chaillot in the fashionable 8th arrondissement. This was a move away from the Place Saint-George—in the historic neighborhood of north-central Paris where the Arosas lived and where Gauguin worked at the Bourse—to a new, haute-bourgeois area of the city without commerce or industry. Shortly afterwards, his sister and brother-in-law moved to an immense three-story apartment on the nearby Avenue d'Iéna, and Mette's sister and brother-in-law, the Danish painter Frits Thaulow, also rented a nearby apartment. Gauguin immediately began a campaign of painting on the nearby Seine, both to escape the house and to begin to master the urban scene as he had the suburban and rural.

The Seine, Pont d'Iéna is among the most successful representations of Parisian winter.[16] Its featureless green water painted wet-on-wet,

its isolated barges or *péniches*, its oppressively heavy sky, its distant and isolated figures, its sense of chilly desolation—all force us to accept the young painter's mastery of landscape "effect." The work is resolutely antipicturesque. One can hardly imagine a wealthy English or American tourist buying it as a "souvenir" of Paris as they might a Parisian river view by Stanislas Lépine, the "little master" of the genre. It is much too leaden and unattractive to have appealed to the increasingly important tourist market.

In its embrace of winter as a season for the painter, it follows the Impressionists, almost all of whom had painted important winter landscapes for at least a decade and would continue to do so throughout the rest of their working lives. Their winter effects are confined, in the main, to attractive rural landscape motifs, where the weight, colors, and character of snow can be observed from the window. But Gauguin sets the view squarely on the quai along the right bank of the Seine, looking downriver toward the hills of Passy. The compositional prototype for the painting lies with Jongkind, the Dutch artist much admired both by the Impressionists and by Gauguin's guardian, Gustave Arosa, who sold six Jongkinds in his 1878 sale. Two of these represented Paris, and *Loading a Boat, Quai de la Rapée* (fig. 23), which is basically the kind of cityscape painted by Gauguin, was clearly known to him. Like *The Seine, Pont d'Iéna*, it shows a panoramic urban landscape organized pictorially by the distant bridge and more proximate boats and dominated by the sky.

There are also links between this painting and the somewhat earlier views of the Seine in and around Paris by Pissarro's friend Armand Guillaumin, who exhibited at least two such paintings in the first Impressionist exhibition of

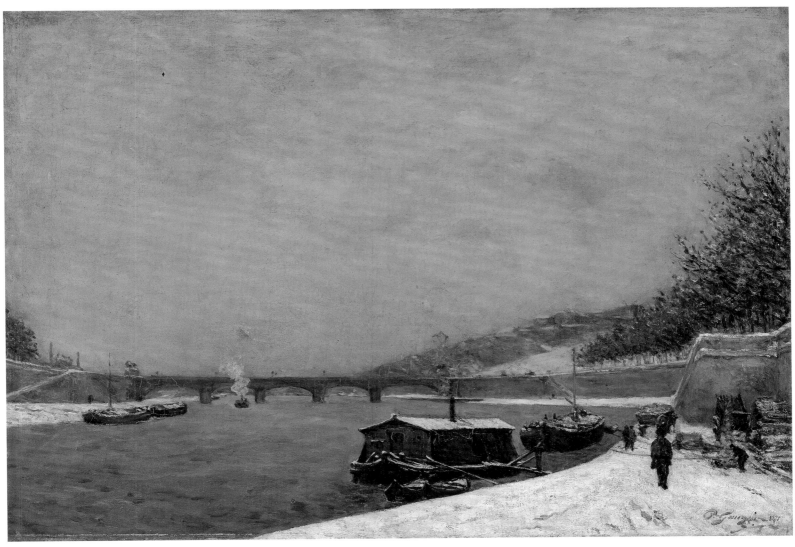

cat. 2

1874 (fig. 24).[17] The project of recording the modern quais and ports in and around Paris had its roots in Jongkind, particularly his Seine views of the 1850s and 1860s. Guillaumin and Gauguin made significant attempts to modernize and monumentalize this kind of urban genre painting in the early and mid-1870s. Gauguin painted several other views along the Seine in 1875, making the river-landscape near his apartment his first major artistic motif. Three small canvases recorded the factories along the Quai de Grenelle, another the Seine in front of the Quai de Passy.[18]

All of these culminated in his largest canvas to date, the so-called *Crane on the Banks of the Seine* of the same year (fig. 28). Although known to scholars since its publication by Wildenstein in 1964 and exhibited to diverse publics in Copenhagen (1948), Houston (1954), Edinburgh and London (1955), and Munich (1960), this painting was not considered seriously in the Gauguin literature until the 2001 catalogue raisonné, where it was published for the first time in color and discussed at some length.[19] It can be linked to a sequence of industrial views along the Seine painted by diverse topographical artists since

Fig. 24 (*above left*) Armand Guillaumin, *Sunset at Ivry*, 1874. Oil on canvas, 25⅝ × 31⅞ in. (65 × 81 cm). Musée d'Orsay, Paris (RF 1951–34)

Fig. 25 (*above right*) Johan Barthold Jongkind, *The Quai d'Orsay*, 1852. Oil on canvas, 12⅝ × 20⅛ in. (32 × 51 cm). Musée Salies, Bagnères-de-Bigorre, France

Fig. 26 (*below left*) Claude Monet, *Tow-Path at Argenteuil, Winter*, c. 1875. Oil on canvas, 23⅝ × 39⅜ in. (60 × 100 cm). Albright–Knox Art Gallery, Buffalo. Gift of Charles Clifton, 1919 (1919:8)

Fig. 27 (*below right*) Alfred Sisley, *The Watering Place at Marly-le-Roi*, probably 1875. Oil on canvas, 19½ × 25¾ in. (49.5 × 65.4 cm). The National Gallery, London (NG 4138)

 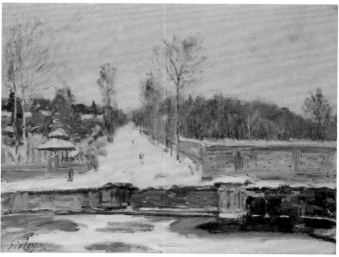

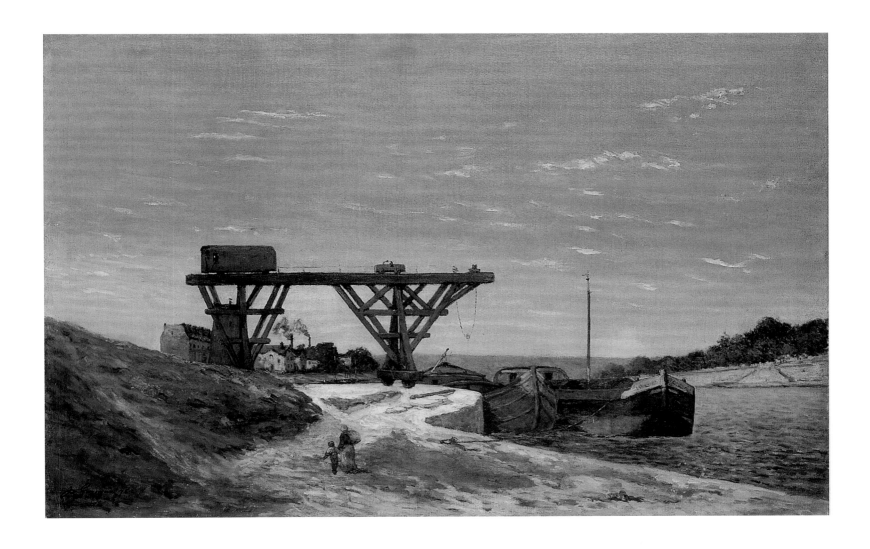

Fig. 28 Paul Gauguin, *Crane on the Banks of the Seine*, 1875. Oil on canvas, 31⅞ × 45¾ in. (81 × 116 cm). Private collection (WII 20)

the early 1850s, perhaps the closest being Jongkind's *Quai d'Orsay* of 1852 (fig. 25). Although it is unlikely that Gauguin himself saw this particular Jongkind, its early date and comparable pictorial structure suggest that the devices for loading and unloading *péniches* in the industrial ports of Paris had been studied for some time by landscape painters interested in modernity. In painting such a large and forthright landscape, Gauguin was showing his modernity and, most likely, his knowledge of the paintings of Guillaumin. The scale and ambition of the painting suggest that it might

have been submitted to the Salon of 1876 along with the lost *sous-bois* referred to above. If so, it was rejected. Given the standing of this kind of modern painting in that year, we can easily understand why.

Unfortunately, Gauguin was not yet taken seriously enough as a painter by Pissarro and Degas to be invited to join the Impressionists in their second or third exhibitions of 1876 and 1877. Had he been bold enough to show them his paintings in 1875, they would surely have invited him to submit, and the Seine landscapes of that year would have found a fitting home in the exhibitions. *The Seine, Pont d'Iéna* would have hung in perfect sympathy at the 1876 exhibition with Monet's *Tow-Path at Argenteuil, Winter* (fig. 26) and with Sisley's two winter effects, including *The Watering-*

Place at Marly-le-Roi (fig. 27). Gauguin's winter landscape is as successful in its capturing of seasonal effects as the better-known efforts of Monet and Sisley—and it competes in scale with Monet's large canvas. In addition, there were many canvases by Monet, Morisot, and Sisley in the 1876 and 1877 Impressionist exhibitions that dealt as frankly as Gauguin had in his *Crane on the Banks of the Seine* with the modernizing ports and quais of industrial France.—RRB

3

Still Life with Oysters, 1876
Oil on canvas, 20⅞ × 36⅝ in. (53 × 93 cm)
Signed and dated lower left: *P. Gauguin. 1876.*
Virginia Museum of Fine Arts, Richmond.
 Collection of Mr. and Mrs. Paul Mellon
 (83.23)
WII 32
Kimbell only

Although it has in it more than a whiff of the 1860s still-life paintings of François Bonvin and Théodule Ribot, this work is nothing less than a pictorial homage to Manet. The great vanguard artist had painted similar subjects since 1864, and the great Musée d'Orsay still life of 1864 (fig. 29) and the Shelburne *Salmon* of 1869 (fig. 30) are directly comparable in mood, composition, and bourgeois luxury.[20] We know of no way that Gauguin could have seen the 1864 still life without knowing Manet himself (which he most likely did not), but he could have seen the 1869 painting either at the Durand-Ruel gallery, where it was until 1872,

or in the collection of the opera singer Jean-Baptiste Faure, who was friendly with the Arosas and whose collection was both larger and considerably more advanced than theirs. Gauguin's still life is like Manet in its sharp value contrasts, in its tightly integrated facture, and in its confident use of thick impasto to build up the forms.

Still the student, Gauguin was not capable of Manet's studied informality, and the almost aggressive orderliness of the younger painter's still life suggests that it was made to impress others with his skill. He managed the fruits, oysters, bread, bottles, and glasses with an ability that, if imitative of Manet, is not lower in level, at least at first glance. The dead pheasant is another matter, largely because Gauguin had no direct prototype in Manet's painting and succeeded only in making a dark, lifeless shape, with none of the shivering informality that we find in other French hunting still lifes of the eighteenth and nineteenth centuries. The principal oddity of Gauguin's painting is its panoramic, landscapelike format. Indeed, it has almost the proportions of an "overdoor" painting, such as those commissioned from Pissarro by Achille Arosa in 1872–73 (see figs. 10–13). Was it intended for Gauguin's own dining room on the Rue de Chaillot or, perhaps more likely, for that of his sister and brother-in-law in their sumptuous apartment on the Avenue d'Iéna? Unfortunately, the painting appeared with no previous record in Paris in 1960, and we can

Fig. 29 (*above left*) Edouard Manet, *Still Life: Fruit on a Table*, 1864. Oil on canvas, 18⅛ × 29 in. (46 × 73.5 cm). Musée d'Orsay, Paris (RF 1670)

Fig. 30 (*left*) Edouard Manet, *Salmon*, 1869. Oil on canvas, 28⅜ × 36¼ in. (72 × 92 cm). Shelburne Museum, Vermont. Electra Havemeyer Webb Fund (27.1.3–024)

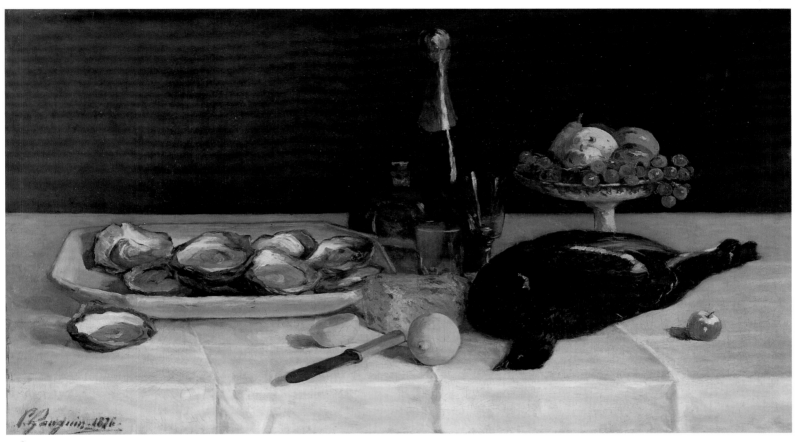

cat. 3

do no more than speculate on its history during Gauguin's lifetime.

What is clear is that the painting is at once modern and haute-bourgeois. Its aesthetic has all but nothing to do with the Arosas. Neither Achille nor Gustave Arosa's sale included a still life (with the exception of floral paintings by Courbet and Delacroix), suggesting that either they retained such informal, "dining-room-pictures" for their private use or—more likely, given the marketability of still lifes—they never had them. The imagery of Gauguin's still life seems more generally associated with luxury than chosen to invoke a specific meal, time of day, or occasion. The authors of the Gauguin catalogue raisonné of

2001 interpreted the work as evocative of autumn, when both pheasants and oysters are plentiful. But the fruits have no such specificity, and the ensemble might better be considered as an assemblage of types of nature—the sea, the air, the trees, and the earth. The stout little bottle of armagnac or eau de vie, with its reddish wax-sealed stopper and adjacent short glass, is juxtaposed with a bottle of either champagne or sparkling cider (the little red crab apple on the right hints at the latter), setting up a contrast of heavy and light, earthbound and air-filled.

We know from David Sweetman's biography that at this period Gauguin was politically torn between the left-wing politics of the Spanish

revolutionaries he knew through the Arosas (and the painters of his acquaintance and aesthetic proclivities) and the haute-bourgeois grandeur sought by his wife and sister.[21] This painting weighs decidedly in the latter tendency, but we must remember that Gauguin's own political heritage lay in the former. Both his grandmother the feminist Flora Tristan and his father, the republican journalist Clovis Gauguin, would have abhorred the world of conspicuous consumption evoked by this still life of abundance. In considering its significance, we should also remember that 1876 was a year of crisis in the capitalist markets of Third Republic France.—RRB

Still Life with Jug and Red Mullet, 1876
Oil on canvas, 18 1/8 × 22 in. (46 × 56 cm)
Signed lower left: *p. Gauguin*
Göteborgs Konstmuseum, Göteborg, Sweden
WII 27

If the literal translation of the French word for still life is "dead nature," this small still life certainly qualifies as a "nature morte." It represents a catch of mussels, a red mullet, two small fish, and a sardine arranged in front of a fish basket and a ceramic jug on what seems to be the north coast of France. Ropes from some invisible rigging are slung across the top of the painting, arranged behind a large piece of heavy red fabric. The painting evokes the life of a working fisherman, and the fish are so grotesque, so unpicturesque, that they seem closer to the group of red mullets painted by Goya (fig. 31) than anything in French painting of the 1860s or 1870s. The jug, its handle reaching enticingly out to the viewer, invites us to take a swig of an unknown alcoholic beverage. The painting is awkward, unconventional, and brutal in its directness, showing a fascination with tactility that is almost vulgar.

The seacoast setting reminds us both of Gauguin's own seafaring days and of the seascapes produced on the north coast of France in the 1860s by Courbet, two of which were owned by Gauguin's guardian, Gustave Arosa. For all one's desire to link Gauguin to Courbet in this painting, however, it remains a stubbornly original work of art—deriving from neither Courbet, nor Manet, nor Cézanne, nor Bonvin, nor anybody else. Its chromatic structure is fascinating—with contrasting green orange and red blue interacting with the light-dark contrasts of the fish and the basket. It is a

Fig. 31 (*above left*) Francisco de Goya, *Still Life with Golden Bream,* 1808–12. Oil on canvas, 17 5/8 × 24 5/8 in. (44.8 × 62.5 cm). The Museum of Fine Arts, Houston. Museum purchase with funds provided by the Alice Pratt Brown Museum Fund and the Brown Foundation Accessions Endowment Fund (94.245)

Fig. 32 (*left*) Edouard Manet, *Fish (Still Life),* 1864. Oil on canvas, 29 × 36 1/4 in. (73.4 × 92.1 cm). The Art Institute of Chicago. Mr. and Mrs. Lewis Larned Coburn Memorial Collection (1942.311)

cat. 4

virtual symphony of textures, most of which are uninviting, even in a tactile sense. We have little desire to pick up the basket, to rearrange the wet fish, or to walk off with the mussels. Gauguin uses the power of the painter to evoke a tactile and visual world that has no place in a bourgeois household. This is clear when we contrast the picture with Manet's otherwise comparable marine still life of 1864 in the Art Institute of Chicago (fig. 32). For Manet, the challenge of painting wet, freshly caught fish is made aesthetically acceptable because he depicts them as having just been purchased and arranged on a kitchen table before they are prepared for meals. The context for the work of art is the bourgeois kitchen, and the sheer fact of knowing this frees the viewer to look knowingly at the subject. Gauguin, by contrast, casts the viewer in the role of a fisherman—and one who likes to drink at that!

In the complete absence of direct evidence, this work has been dated 1876 because of its coastal origins. Gauguin painted a small seascape signed and dated to that year, surely on the same, otherwise unrecorded visit to the north coast of France.—RRB

5

Mette Asleep on a Sofa, 1873 or c. 1875
Oil on canvas, 9³⁄₈ × 13 in. (24 × 33 cm)
Signed lower right: *p. Gauguin*
The Kelton Foundation
WII 22

This small canvas is as close as Gauguin ever came to the aesthetic of Corot. Although both Arosas owned works by Corot, neither had any of the small studio paintings of the 1820s and 1830s, done from various models in both Rome and Paris, on which this painting is perhaps based. Its almost monochrome tonality, casual character, deceptively simple composition, and controlled facture all hark back to the model of Corot. And *The Letter* (see fig. 1), in Gustave's collection, was certainly in Gauguin's mind when he conceived of this painting.

Yet, the painting has two qualities that separate it from the practice of the earlier painter. First, its model appears to be sleeping, which gives the work an essentially languorous quality and looks forward to Gauguin's later interest in both sleep and dreams. Secondly, on the floor of the studio to the right of the sleeping woman, Gauguin arranges a "still life" of small canvases. As is often the case with Gauguin, they face toward the wall, as inaccessible to the viewer as the woman herself. Yet we are encouraged to notice them quickly by the touches of red orange paint on the floor in front of them, apparently a rag. Though artfully simple, each element in this painting evokes a mood of poetic reverie. What at first seems to be a part of the canapé emerges, on closer inspection, as a large, green, circular pillow with black braiding that surrounds the model's head like a halo.

This painting was unknown to Daniel Wildenstein or Merete Bodelsen and was first published in a sale catalogue in 1992. In the 2001 catalogue raisonné it was dated to 1875 and "placed" in the large new apartment on the Rue de Chaillot in the 8th arrondissement. Because Gauguin did not have a known studio in the 1870s, and the family's apartment on the Place Saint-Georges had only three rooms, this seems a likely guess; and it can be argued that the painting may even have been made in connection with the Gauguins' move early in 1875, the model being the artist's wife, Mette. If so, his inclusion of the back of a small stretched canvas with cross-shaped stretcher bars might well prefigure his future battles for a higher art in front of mundane reality. Is the crossed stretcher Gauguin's first "self-portrait?" Is the red cloth his blood? Unfortunately, there is no evidence for this tantalizing suggestion.[22]

In light of Marie Heegaard's letters to her family from the summer of 1873, however—particularly that in which she talks of posing for Gauguin for four hours—it seems at least possible that this small painting might result from that session and represent not Mette but Marie Heegaard.[23] If so, it would be among the first surviving works from the painter's hands.—RRB

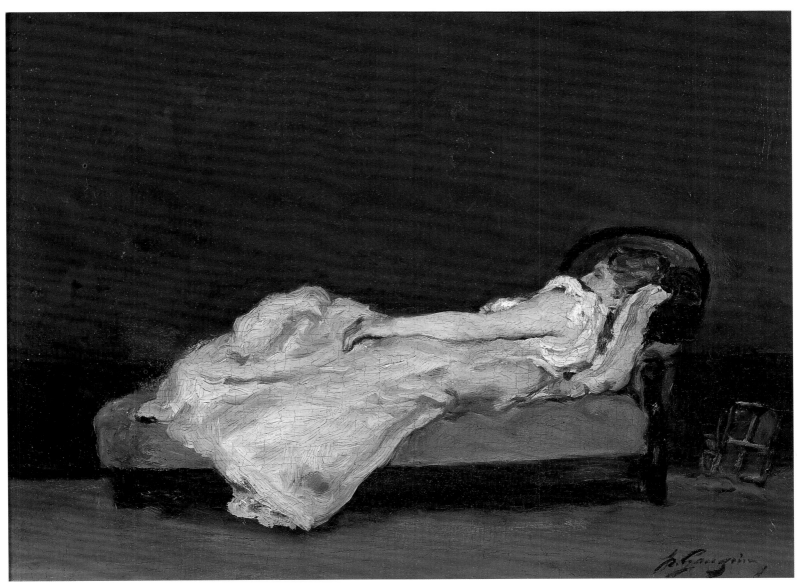

cat. 5

THE AROSA SALE IN 1878 and Gauguin's apparent financial windfalls in 1879 combined to push the failed amateur painter into the fold of the Impressionists in the spring of the latter year. As Gauguin began seriously to collect in late 1878 and early 1879, he followed the lead of his guardian and mentor, Gustave Arosa, and collected the work of Pissarro. Yet, rather than to snap up one of the three Pissarros of the early 1870s in the Arosa sale, he chose to speculate aesthetically and purchase more recent works—undoubtedly for lower prices. That his motivations were in large part financial cannot come as a complete surprise to us today, and his reasoning, like that of his guardian, proved in the end to be financially successful. He and his wife, Mette, sold works acquired in 1879–83 to finance a good deal of their respective needs for the remainder of their lives, and Gauguin made almost as much money from the sale of his collection as he did from a lifetime of sales of his own works.

The relationship between Gauguin and Pissarro—most likely arising in the Arosa household—became central to Impressionism. Oddly enough, considering that both were prolific writers, we do not know when or where they met, and can document the beginnings of their relationship to only 1879, when Gauguin wrote a formal letter to Pissarro accepting the latter's invitation to exhibit with the Impressionists. The letter was written and sent on Tuesday, April 3, 1879, only seven days before the formal opening of the exhibition.[24] Although it made clear that the invitation to join with the group came from both Pissarro and Degas, it made no mention of the particular works Gauguin submitted. It has long been known, however, that he did include a marble bust of a boy—the critic Louis-Emile-Edmond Duranty mentioned it as "a pleasant little sculpture" in his review of the exhibition.[25] Because no other works by Gauguin were mentioned—and because it is clear that his submission was late—no one has speculated about paintings by him that might also have been included. Although none is mentioned in the many reviews, even in passing, this does not mean that he sent none. Indeed, it seems more likely that he did than did not, given the invitation and the fact that he had only recently turned to sculpture (his was the only sculpture in the exhibition). We should remember that a minority of works were mentioned individually in reviews and that certain critics did not discuss individual works at all.

Had Gauguin shown paintings in the 1879 exhibition, what might they have been? The answer is not easily found. Because the exhibition was held in April—early in the year—few works dated 1879 are candidates, and, of course, all the most ambitious ones were sent to the next Impressionist exhibition in the spring of 1880. There is just one canvas from 1879 that *might* have been made before April, the small *Snow at Vaugirard I* (cat. 11). This was perhaps made in the same winter as the snowy landscapes in the exhibition by Monet and Pissarro. We know, however, that Gauguin submitted the later and larger version of the composition, *Snow at Vaugirard II* (cat. 12), signed and dated 1879, to the exhibition of 1880, and several scholars have already identified the smaller version as the work called simply *Etude* in the 1880 exhibition catalogue.

The most ambitious and important paintings by Gauguin dated before April 1879 were made well before the exhibition, in 1875 or 1876, and the gap between their

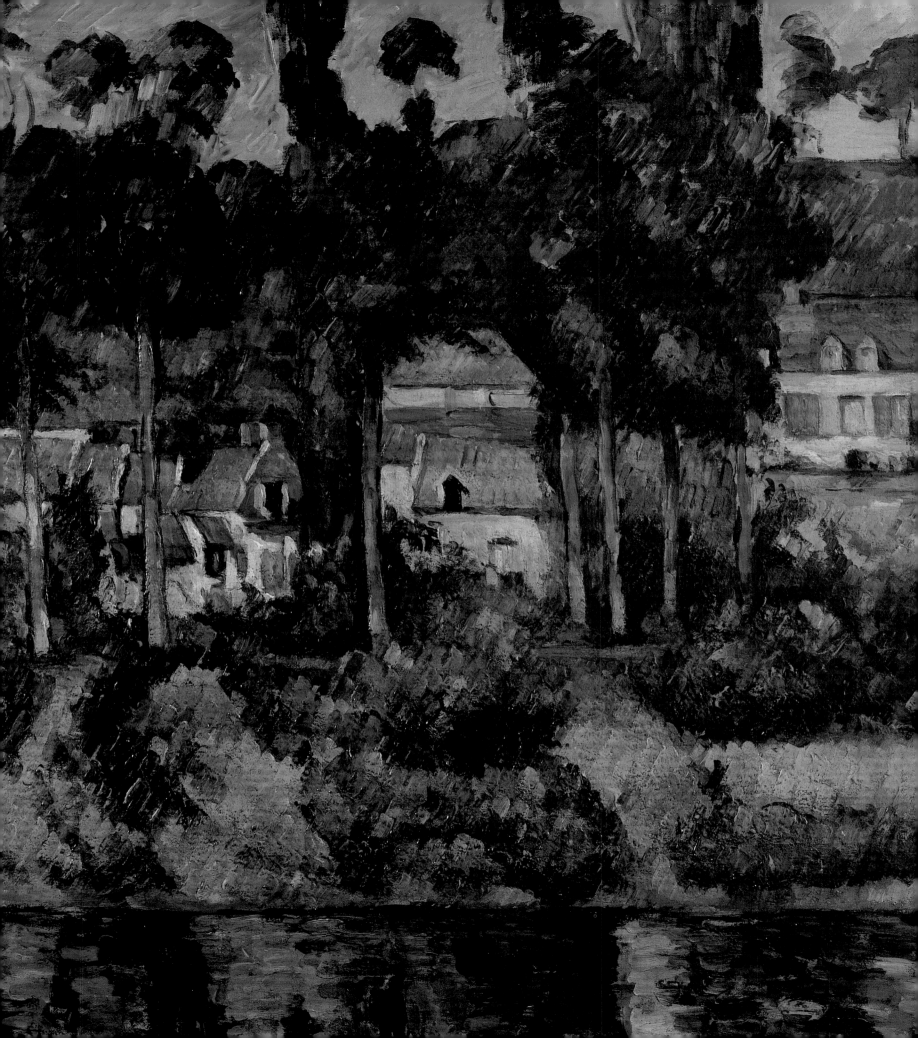

production and the veritable plenitude of such works produced after April 1879 makes it clear that Gauguin began to contribute major works of art to Impressionism only after the 1879 exhibition. He would have done so following a profound immersion in the works by Caillebotte, Cassatt, Degas, Monet, and Pissarro that were shown in it, each in some quantity. Students of the 1879 exhibition have succeeded in identifying the majority of works by the first four of these artists—largely from their titles and the lenders. We are able to measure Gauguin's response—or lack thereof—to the works of Caillebotte, Cassatt, Degas, and Monet, a large number of which were already in private collections at the time of the exhibition. This latter point is crucial because it shows that the exhibition was not conceived primarily as a venue for sales. Rather, the artists wanted to prove to a wary public that their works were already successfully placed in private collections.

Pissarro's submissions to the crucial exhibition of 1879 are much less well understood. He played a large role in the formation of the exhibition and submitted twenty-two oil paintings, twelve fan-shaped paintings in watercolor, and four pastels. Of these, only seven paintings have been identified (the success rate is higher for the fans: eleven of the twelve are plausibly identified, and three of the four pastels). The paintings submitted by Pissarro call out for further scholarly research. Their effect on other artists—particularly on Gauguin—was immense.

Of the twenty-two paintings by Pissarro in the 1879 exhibition, two were loaned by Gauguin himself (signified in the catalogue by "M. G."), five by Pissarro's friend Eugène Murer ("M. M."), six by the painter Caillebotte ("M. C. G."), one by an unknown "Mlle T.," and the remaining eight by the artist himself or his dealer, Paul Durand-Ruel. Considering the importance of this group of paintings to Gauguin's career, we should try to do a better job of identifying them, through detailed analyses of early provenance, titles, and dates. Pissarro's fan paintings, along with those of his friend Degas, were described in the critical literature more frequently, if not more flatteringly, than his paintings. We strongly suspect, however, that the great 1879 landscape now known as *The Edge of the Woods Near l'Hermitage* (fig. 33) was among the paintings, probably under the title *Sous bois en éte (Summer in the Forest)*. Two reviewers mentioned a large landscape by Pissarro, and this, the largest painting made by him in 1878–79, is the best candidate because it matches at least one of the titles in the list perfectly and had not yet been exhibited or sold. Naturally, artists would want their most ambitious works to be included, and Pissarro was no exception. This was the most ambitious landscape painting produced by any Impressionist in the last years of the 1870s.[26] It set a standard to which, as we will see from his submissions to the Impressionist exhibition of 1880, Gauguin attempted to rise.

We know from one review that all of Pissarro's paintings were hung in the same gallery—the final one in the exhibition—along with those of Monet.[27] Monet's own submissions were gathered from a wide variety of sources, hung without his participation (he never even visited the exhibition), and ranged throughout his career of the past two decades.[28] The 1879 Impressionist exhibition was Monet's first

Fig. 33 Camille Pissarro, *The Edge of the Woods Near l'Hermitage*, 1879. Oil on canvas. 49⅝ × 63⅞ in. (126 × 162 cm). The Cleveland Museum of Art. Gift of the Hanna Fund (1951.356) (PV 489)

"retrospective," with major canvases from the 1860s, superb works from the early and mid-1870s, and several recently completed landscapes of the Seine done in series. Pissarro's submission of oil paintings was numerically fewer than Monet's twenty-nine, but his large landscape must have dominated the room. Critics were less effusive about his landscapes than those of Monet and singled out only four paintings that can be identified. One of these, a small canvas representing Port-Marly, then owned by Caillebotte, was painted in 1872 (fig. 34), but there is little other evidence that Pissarro's submissions formed any kind of "retrospective." What is frustrating for the student of Pissarro and Gauguin is that, even among Pissarro's exhibited paintings owned by Gauguin, Murer, and Caillebotte, we can conclusively identify only a minority—and these from collections that are reasonably well documented. We know that Murer owned twenty-five Pissarros when his collection was published in the late 1880s, but only eleven are identified in the Pissarro catalogue raisonné.[29] Of these, two

can be linked to the titles of the five works Murer lent to the exhibition, forcing us to guess about the other three.[30] The percentage is even worse for Caillebotte; sixteen paintings owned by him are included in the 1939 Pissarro catalogue raisonné (several with no photographs), and only one of these is easily linkable to a title listed in the exhibition catalogue. To make matters worse, the rather detailed titles for Pissarro's paintings in the exhibition catalogue do not match well with the works we know Murer and Caillebotte owned.

The same uncertainty surrounds the two paintings loaned by Gauguin. One of them, called *Les Meules (The Haystacks)* (no. 179), has completely eluded identification. What *could* this painting have been? We know that Gauguin was later to purchase a painting of haystacks by Pissarro, but this was painted in 1883 (*Paysage avec Meules, Osny*; PV 589). We also know from a passage in a Gauguin letter to Pissarro from the summer of 1880 that Gauguin had the opportunity to sell a Pissarro painting of haystacks that he owned.[31] Pissarro rarely painted haystacks, and, in several cases, the haystacks are part of a harvest scene rather than a motif on their own. From the plural title, we know that there were two or more haystacks in the painting and, because it was entitled *Les Meules* rather than *La Moisson (The Harvest)*, there is only one painting in the current catalogue raisonné that it could have been. This work, inelegantly titled *Landscape, Plain with Haystacks on the Left* (fig. 35), was painted in 1873, but relates closely to the autumn landscape of the four seasons made as over-door decorations for Achille Arosa, the brother of Gauguin's guardian. Although there is no documentary evidence that either Arosa or Gauguin owned this painting, the series of coincidences together with the fact that the painting has no recorded appearance until the end of the nineteenth century suggests that it may well have been the one loaned by Gauguin to the 1879 exhibition. If so, there were two Pissarros in the exhibition made at the

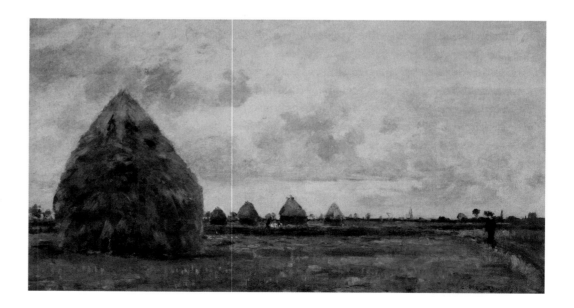

beginning of the 1870s, Caillebotte's *Port-Marly* and Gauguin's *Les Meules*, and these would have hung well with paintings by Monet from the same years.

After a rigorous process of elimination, it is possible to make a partial reconstruction of the works by Pissarro in the 1879 exhibition. The list, published here in a note, indicates whether the identification of each number is definite, highly likely, or possible. Certain works have eluded even those categories.[32] The result is five works that can be identified with certainty, nine with a high degree of probability, and three others with some possibility. The seventeen works in question can be assessed as a group and related both to those submitted by Monet and to the subsequent work of Gauguin. We must remember that it was Pissarro who, with the help and advice of Degas and Caillebotte, hung the works by Monet and himself in the large gallery called by the critic Henry Havard the final room of the exhibition.[33] As a result, the two landscape painters were discussed together, often to the detriment of Pissarro, in the critical press. Havard was perhaps the most incisive:

> The last room belongs to the high priests of Impressionism. Monet and Pissarro [Havard, like others, spelled it with one "s"] reign there as masters. I confess humbly I do not see nature as they do, never having seen those skies fluffy with pink cotton, these opaque and moiré waters, this multi-colored foliage. Maybe they do exist. I do not know them. As for technique, it . . . seems difficult and overworked. Using impasto excessively, they work for an ease of appearance that is earned only by effort. Here again some curious works are produced—instructive, but not decisive.[34]

Gauguin spent a good deal of time in this room in April of 1879. For the thirty-one-year-old artist, it was the first time he had "belonged" to any group (except of students or sailors). As both a lender and an amateur who had submitted works to the exhibition, he must have felt a certain pride. His surviving correspondence in the next years is almost exclusively with Pissarro, who saved Gauguin's letters unfailingly even after the two artists ceased to admire each other's work in the late 1880s. From 1879 onward Gauguin's paintings were more dependent on his experience of Pissarro than on that of any other artist. There is no doubt that Pissarro's and Monet's gallery in the 1879 exhibition was the single most important room of works of art in Gauguin's life to that point.

The room must have been very large indeed to accommodate fifty paintings, several of them large in their own right. Pissarro's largest painting (see fig. 33) must have dominated the room, but there were plenty of other major works of art. Because each of the "independent" artists was his or her own curator, the works were chosen with care both for their individual quality and for their use in powerful ensembles. As we identify works toward a modern reconstruction of the room, the ambition and quality of each is as important as other clues like titles, critical descriptions, and early owners. The artists were effectively competing with each other, and Pissarro's decision to hang his landscapes with Monet rather than minor figures such as Adolphe-Félix Cals, Albert Lebourg, or Ludovic Piette raised the stakes, particularly considering that Monet's

submissions included works that were already considered masterpieces. Pissarro most likely included a group of winter landscapes and two urban landscapes because Monet did.

With the exception of the two paintings from the early 1870s, Pissarro's works in the exhibition were most likely all completed after the previous Impressionist exhibition, held almost exactly two years earlier. He had not been able to exhibit at all in 1878, and the disastrous sale of the large Impressionist collection of Ernest Hoschedé in June of 1878 had had a terrible effect on the Impressionist market, forcing the artists into a kind of internal exile. Unlike Monet, who remained in Vétheuil and allowed others to gather his paintings for the 1879 "retrospective," Pissarro, Caillebotte, Degas, and the latter's protégé, Mary Cassatt, decided to include the best of their most recent work. They wanted to project an image of both continuity and vitality to the public, which had been deprived of Impressionism for almost two years. The inclusion of Cassatt and Gauguin was clearly a part of this strategy. As with Caillebotte, whom they had brought into the fold in 1876, Degas and Pissarro were keen to identify prosperous and talented younger artists so as to ensure the movement's future—both aesthetically and financially.

Pissarro's submissions to the 1879 exhibition were almost all rural landscapes dominated by vegetation, the exceptions being the two urban landscapes and the single view of central Pontoise (*Le Pont de Pontoise*, no. 167). They were painted mainly around the hamlet of l'Hermitage, just east of Pontoise, where he had lived for several years. Most of their aesthetic impetus came from the artist's experimental paintings of 1876–77, in which he began to allow vegetation to dominate architecture and to create scumbled, crusty, and awkward pictorial surfaces that dominate our perception of the painting. For Pissarro in 1877, picture making became a process of structuring the pictorial surface to form a thick-colored relief of paint that projected from the canvas into the space of the viewer. Several of his paintings in the 1877 exhibition had such rough and difficult surfaces that they confounded even professional viewers. Perhaps as a result, he spent a good deal of the next two years attempting to regularize his facture so as to produce a harmoniously unified, if still rugged pictorial surface.

This process occurred in Pontoise, very much in isolation. Cézanne, Pissarro's professional colleague of several years, had left the north of France for a period of artistic experimentation in his native Provence, and it is clear that Pissarro had not yet begun to work intensively with Gauguin. The younger artist had, however, begun to acquire paintings by him, and it was perhaps this that brought the two men back in contact. As we have seen, they must have known each other—or, at the very least, known about each other. But it is clear that they did not become painter-collaborators until 1879, most likely after the exhibition. Gauguin's inclusion in the group undoubtedly gave him closer access to both Pissarro and his paintings than he had ever had with a major professional artist.

The boldest and greatest contemporary paintings in the 1879 exhibition were Degas's portrait of the great Italian art critic Diego Martelli (fig. 36) and Pissarro's *Sous bois en*

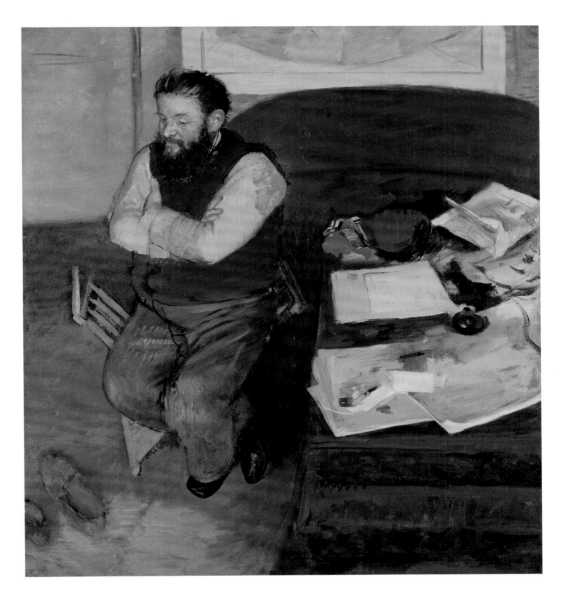

été (see fig. 33). Just after these, one would rank the pair of urban views painted in the previous summer by Monet. Together with the wonderful urban views of Caillebotte and Pissarro's urban views that are now lost, these would have formed a dazzling ensemble.[35] The urban figure paintings of Degas, Caillebotte, and Cassatt formed what was without a doubt the most important such ensemble yet included in an Impressionist exhibition. This latter group was much discussed in the critical press, as were several of the stronger—and usually earlier—paintings by Monet. In general, viewers were puzzled by the rural landscapes submitted by Pissarro and Monet. The latter included a series of paintings representing virtually identical views on the Seine looking from Vétheuil toward the neighboring village of Lavacourt.[36] Although unremarked in the press, this was perhaps the first true "series" of paintings that he exhibited—a series of greater compositional cohesion than his five variously composed views of the Gare Saint-Lazare in the 1877 exhibition.

Pissarro, on the other hand, seems to have decided to exhibit a wide variety of works—seasonally and compositionally (figs. 37–40). Though painting in a small

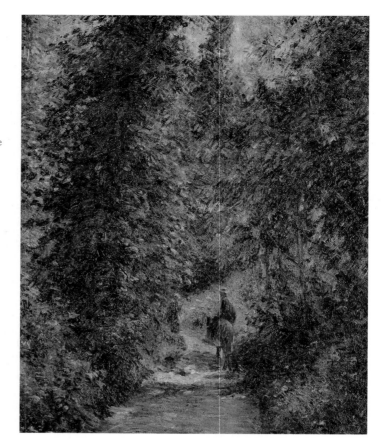

Fig. 37 Camille Pissarro, *Road in the Woods, in Summer*, 1877. Oil on canvas, 31⁷/₈ × 25⁷/₈ in. (81 × 65.7 cm). Musée d'Orsay, Paris (PV 416)

geographic area, he mined the landscape for motifs that contrasted with each other. What linked all the landscape paintings submitted by Pissarro to the 1879 exhibition was their complex and rugged pictorial surface. Indeed, it seems that the aggressive quality of Pissarro's surfaces acted as a barrier to all but a few critics, and even those who praised him wrote more about his surfaces than about his compositions or motifs. Havard's description of Pissarro's "trying and overworked" technique and his "excessive impasto" was echoed in the words of other critics. Although Paul Sébillot correctly pointed out that Pissarro's working method was "less tortured . . . than in his previous exhibition,"[37] others were less sanguine. Martelli, whose portraits by Degas and Federico Zandomeneghi made him the "house critic" of the exhibition, was perhaps the most eloquent on this point. Calling Pissarro "as strong as Monet," he went on to say: "Always rude and monotonous in his technique, Pissarro seems to pour the excess of his rage and honesty into all his paintings."[38] In his final review of an Impressionist exhibition for the Russian press, Emile Zola spoke of "Pissarro, whose scrupulous research sometimes produces an impression of hallucinogenic truth."[39]

"Hallucinogenic truth"—this pair of words would perhaps be more at home in the drug-addled Haight Ashbury of the 1960s than in the Paris of the 1870s. Yet Zola, the wordsmith, seems to have hit upon something essential to Pissarro's aesthetic of 1878–79. Virtually all of Pissarro's pictorial surfaces of this period quiver with the vibrating energy of hundreds of tiny gestures. These daubs, commas, or, more commonly, simply "touches" of paint evoke a visual realm of complete banality. Pissarro's hillsides, rural dwellings, cottage gardens, well-worn paths, little groups of

Fig. 38 (*right*) Camille Pissarro, *Vegetable Garden and Trees in Flower: Spring, Pontoise*, 1877. Oil on canvas, 25⅝ × 31⅞ in. (65 × 81 cm). Musée d'Orsay, Paris. Bequest of Gustave Caillebotte, 1894 (RF 2733) (PV 387)

Fig. 39 (*below right*) Camille Pissarro, *Orchard at Pontoise, Sunset*, 1878. Oil on canvas, 18⅛ × 21¾ in. (46 × 55 cm). Wallraff-Richartz-Museum, Cologne (WRM/FC Dep. 712) (PV 440)

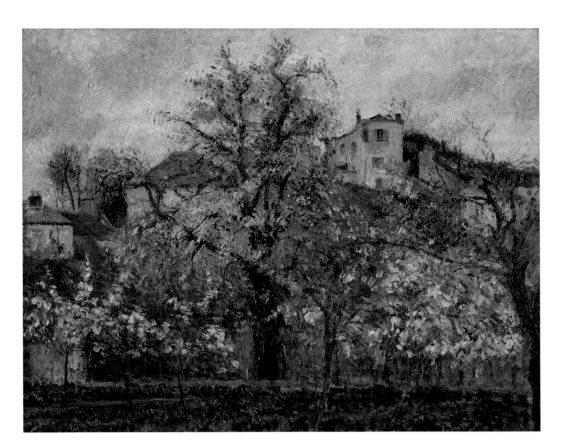

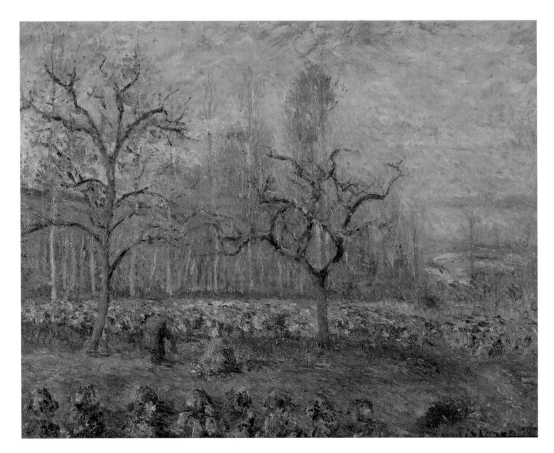

Fig. 40 Camille Pissarro, *Les Mathurins, Pontoise*, 1877. Oil on canvas, 28³/₄ × 23⁵/₈ in. (73 × 60 cm). Location unknown (PV 397)

trees—none of these "motifs" has any intrinsic beauty. They are merely "true" in their stubbornly quotidian actuality. Zola's Pissarro wrenches a kind of beauty from this "truth" by creating a representational surface of such intensity and complexity that it actually becomes something like a "hallucination." The fact that Pissarro's surfaces have a uniformly active, all-over aspect reinforces this hallucinogenic quality. Nothing recedes; everything is equally interesting to the painter-viewer. These paintings are, in a way, startlingly—even terrifyingly—original: so much so that they almost escaped notice in 1879. The banality of their subjects won out over the brilliant qualities of their surfaces.

One of the people who did notice them, and studied them intently, was Gauguin. Still a businessman, he had left the employ of Paul Bertin, with whom he had worked for

years, as a result of Bertin's business dealings with Gustave Arosa. His new alliance with André Bourdon was profitable: in spite of the slowly improving economy after the stock market crash of 1878, he is said to have earned a career record amount of 30,000 francs in 1879.[40] This was to be the pinnacle of Gauguin's economic achievement as a businessman, and it must have impressed even his guardian Arosa, who, as we know, had been forced to sell a good deal of his own art collection in 1878 due to economic reversals. Gauguin was living so easily in 1879 that he had both the time and the resources to involve himself more actively in the art world—both as an amateur painter who could envision himself living on investments in the manner of his friend Emile Schuffenecker and as a collector-investor. Even from the slight evidence of Gauguin's letters, we know that he was both buying and selling paintings in 1879 and 1880—a time when his mentor Pissarro's economic position reached a new low.[41]

It is easy for us today to forget just how difficult it was for an artist to see works by a fellow artist without visiting the studio. We suspect that Gauguin had met Pissarro before the 1879 exhibition and had, in all likelihood, visited the latter's new apartment in Montmartre on the Rue des Trois-Frères. (Though quite distant from Gauguin's home in Montparnasse, it was reasonably near his place of work.) He would have seen few works of art in Pissarro's studio, however. The 1879 exhibition, with its twenty-two Pissarros, was his real chance to study his mentor's work—both in quantity and in conditions of light and space that were optimal. It is likely that Gauguin had visited one or more of the three previous Impressionist exhibitions, including the magisterial third exhibition of 1877, but never had he been so primed to study the works in real detail.

The extraordinary surfaces of Pissarro's paintings and their banal rural imagery must immediately have struck Gauguin in 1879, and there is little doubt that he began to act on the artistic impulses unleashed by his newfound role within Impressionism. His oeuvre for that year, though not large by the standards of his subsequent career, is larger than any previous year. He also managed to complete, sign, and date five large-scale paintings that can be interpreted only as a direct reaction to the ambitions of Pissarro's landscapes in the 1879 exhibition. Four of these will be analyzed in detailed entries in the present catalogue and also as part of Gauguin's submission to the 1880 Impressionist exhibition, which included four of the large canvases from 1879. Of these, two represent Pissarro's rural landscape around Pontoise, in which Gauguin painted intensively in the summer of 1879 and favored as a motif for weekend painting in subsequent years. The others represent the semirural landscape around Gauguin's rented house in Montparnasse. These latter have absolutely no "Parisian" quality and are much more dependent on Pissarro's rural landscapes than on the "modern" urban painting of Monet, Degas, and Caillebotte. In 1879 Gauguin was most definitely an ambitious follower of Pissarro.

As we follow Gauguin's commitment to the difficult aesthetic of Impressionism in subsequent years, it is vital to remember that he was purchasing works of Impressionist painting at the same time he was making his own. Like Caillebotte and to an extent Degas and Manet, Gauguin lived with works by artists who were important to him.

Unlike Pissarro, Cézanne, Monet, and others who tended to acquire works by their colleagues through exchange, Gauguin bought his from various dealers, intermediaries, and even what we today call "runners." He seems to have thought carefully about prices, realizing the value of the axiom "Buy low, sell high." Unlike Caillebotte or Murer, or even Jean-Baptiste Faure, he would never buy as a form of charitable subsidy to artists with fewer assets. He seems to have thought very much more on the Arosa than on the Caillebotte model. His wisdom in this choice is obvious: while Caillebotte bought work with excess capital, Gauguin had no real wealth on which to depend. For him, avant-garde art was as much about financial as about aesthetic "speculation."

Fortunately, Gauguin's collection was meticulously recreated in printed form by the Danish scholar Merete Bodelsen in 1970.[42] With its detailed scholarship and small black-and-white reproductions, this article appears regularly in scholarly bibliographies but is not widely read by the educated public. For that reason, we are publishing photographs in color of the most important paintings acquired by Gauguin from 1878 until 1883, when his collecting essentially stopped. Our aim is to raise again the vital questions involved with artist-collectors. Among the Impressionists, we know a good deal about the collecting of Degas and Caillebotte and a fair amount about the collecting of Manet and Monet. The others are much less well known, even to specialists; given the closeness of their personal and aesthetic relationships, this is a pity.

Gauguin's collecting activities are particularly important to understand because, unlike most of his colleagues, even Caillebotte, he was raised in a milieu of collectors and recognized clearly the relationships between art and money in capitalist society. Even a casual reader of the vast Gauguin literature knows that, even as his career declined in Tahiti and the Marquesas, he was always devising art-business schemes to create some cash—schemes involving inexpensive prints, paintings in series, investors, and the like. In 1893–95, he tried his hand at writing to create an ancillary market for his work among literary aesthetes. The notion of art as a commodity and avant-gardism as a kind of "risk commodity" with low costs and possibly high gains kept him afloat, both financially and psychologically, throughout his life. Like the most ardent of capitalists, Gauguin almost always believed that he could reinvent himself financially through art.

What did he buy for himself? We know from his own paintings that he owned works by Degas and Cézanne, and the inclusion of his one Degas pastel in a still life (cat. 41), his greatest Cézanne still life in two works, and his transformation of one of his Cézanne landscapes into a Gauguin fan, tell us who mattered most to him. Yet his collection was far larger and more varied than this little list would indicate. He owned a painting by Eugene Boudin, a pastel by Cassatt, six paintings by Cézanne, two Daumier drawings, pastels by Degas and Jean-Louis Forain, another drawing by Forain, ten paintings and one pastel by Guillaumin, two drawings by Jongkind, a pastel and a major seascape by Manet, ten paintings, a pastel, and at least two etchings by Pissarro, two paintings by Renoir, and two by Sisley, a majority of which have been plausibly identified by Bodelsen. Only rarely do we know precisely when he bought these,

but most are recorded in some way or another as having been brought by him to Copenhagen in 1884 and, tragically for him, left there when he returned to France in 1885. In addition to these fascinating works in his own collection, Gauguin was involved through his wife, Mette, with the collection of her Danish brother-in-law Alfred Brandes, which included works by both Gauguin and other Impressionists. Because of Gauguin and Brandes, Denmark was among the first countries to have significant representations of Impressionist painting before the movement became well known in the 1890s.

How remarkable was Gauguin's collection? Though smaller (fifty works) and less historically important than those of Caillebotte, Victor Choquet, Ernest Hoschedé, or Jean-Baptiste Faure, it was among a mere handful of private collections formed in Paris in the late 1870s and early 1880s to include important works by almost all of the Impressionists. It contained a rich group of pastels by Cassatt, Degas, Forain, Guillaumin, and Manet; drawings by Daumier, Forain, and Pissarro; and paintings that vary in scale and importance from cabinet paintings for small rooms to major masterpieces. Only one of the paintings Gauguin owned was of a large scale, Cézanne's *Femme Nue* (130 by 162 centimeters), and this has unfortunately been lost (see fig. 88). We have no precise idea when he bought it or where it was displayed in his various apartments or rented homes. This is because, with the exception of the Degas and the Cézanne mentioned above, he rigorously avoided the inclusion of works from his own collection in the various domestic paintings he made in the early 1880s.

Let us look at the works of the major artists one by one. The six paintings by Cézanne were notable for being so varied in scale, subject, and facture. For Gauguin, Cézanne was an experimental artist, afraid of nothing. The earliest work was the immense nude mentioned above, submitted unsuccessfully to the Salon of 1870. This painting must have looked aggressively odd to the Gauguins' bourgeois friends when they bought it, and it is among the few works in the collection that seems to have caused the younger artist to create a true masterpiece of his own, *Nude Study (Woman Sewing)* (cat. 19). Indeed, Gauguin's decision in 1880–81 to paint a subject—a female nude—that he had never before attempted must surely have resulted from his acquisition of the now lost Cézanne.

Fig. 41 Paul Cézanne, *The Harvest*, c. 1877. Oil on canvas, 18 × 21³/₄ in. (45.7 × 55.2 cm). Private collection (R 301)

The remaining paintings, all of a smaller scale, are as varied as any group of Cézannes from the period could be—a major still life (see fig. 269), a Provençal mountainous landscape (fig. 42), an allegorical genre scene (fig. 41), a vertical landscape with trees (see fig. 204), and a horizontal river landscape painted in the Ile de France (fig. 43). "Gauguin's Cézanne," if that odd phrase is permissible, is at once northern and southern, a figure and a landscape painter, a "realist" and an artist of imaginative invention. All that is lacking in Gauguin's small group of paintings by Cézanne is a bather composition and a portrait; had his fortunes continued, he could have completed his Cézanne collection with just a few strategic additions.

As we have seen, Gauguin made active use of three of the works by other artists that he owned—the Degas and two of the Cézannes—and based one of his principal

Fig. 42 Paul Cézanne, *Mountains, l'Estaque*, c. 1879. Oil on canvas, 21⅛ × 28½ in. (53.5 × 72.4 cm). National Museums and Galleries of Wales, Cardiff (R 391)

masterpieces, at least in part, on the large Cézanne nude. As for the other paintings in the collection, he quoted none of them directly, either in whole or in part. Yet he studied carefully their facture, chromatic structure, and compositional strategies. He seems to have been aware of Cézanne's propensity for hiding forms or suggesting faces or bodies in wallpaper, drapery, trees, water, or sky. This strategy, the subject of a controversial study by Sydney Geist,[43] is much more widely accepted by scholars of Gauguin, many of whom routinely find eyes, ears, faces, bodies, and animals in what is, at first glance, only water, sky, vegetation, or drapery. After purchasing the Cézanne still life now at the Museum of Modern Art, New York (see fig. 269), Gauguin made liberal use of Cézanne's pictorially ambiguous patterned wallpaper to enliven the background of various portraits and still lifes (see cats. 54 and 75).

Perhaps the most remarkable aspect of Gauguin's collection was the inclusion of two works by the great god of the Parisian avant-garde, Edouard Manet. Gauguin was reported to have acquired his single Manet pastel (fig. 45) from Manet himself in 1880, perhaps after its exhibition at the Galerie de la Vie Moderne in Paris in April that year.

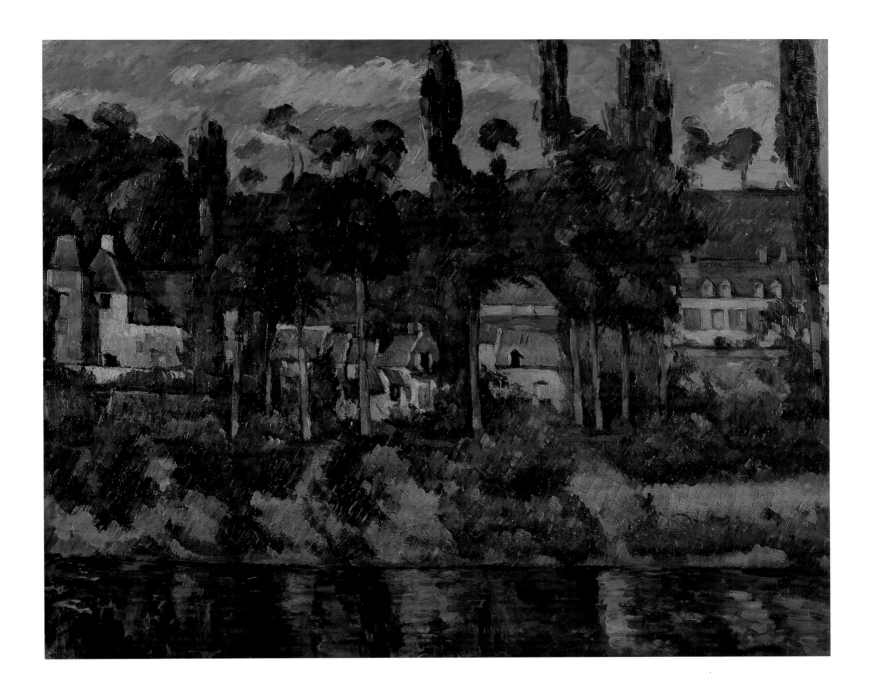

Gauguin quoted freely from this pastel when he posed his model for the *Nude Study (Woman Sewing)*. He acquired his other Manet, the boldly composed *View in Holland* of 1872, a seascape now in the Philadelphia Museum of Art (fig. 46), for the spectacular sum (for him) of 1,200 francs in March of 1881. Both these purchases went against the grain of Gauguin's strategy—to buy works by vanguard artists for very low prices—and, as Merete Bodelsen has shown, he did not do very well in the sale of either work. In *Nude Study (Woman Sewing)* he subverted the Manet pastel to great effect— by undressing the model!—and he toyed with the compositional boldness of the older artist in an 1883 view of the *Seine at Rouen* (fig. 44).

To early twenty-first-century eyes, Gauguin's passionate gamble on the quality of Guillaumin's paintings was, perhaps, his single failure. Yet the sheer power and

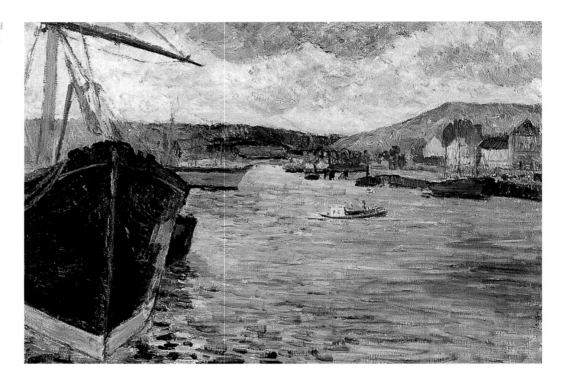

originality of certain of these works cannot be denied; one might even be persuaded by "Gauguin's Guillaumins" to upgrade Guillaumin's reputation a bit. The superb *Autumn Landscape* (fig. 47) and the brilliantly composed *View towards the Panthéon from a Window on the Ile Saint-Louis* (fig. 48) are "best-of-kind" works by a painter who, like Renoir and Sisley, made works of wildly varying quality. The sole pastel in the group, *Woman Reading in a Landscape* (fig. 49), invests a charming subject and composition reminiscent of Morisot with an almost savage gesturing—of which Gauguin himself was utterly incapable. None of the other paintings in the group is weak, and some have an intensity and surface complexity unique to Guillaumin in the late 1870s and early 1880s, when he was at the top of his game. Indeed, Gauguin's highly selective group of works by Guillaumin makes us yearn for a well-selected small exhibition of the latter's paintings and pastels of the 1870s and early 1880s.

The artist of which Gauguin had the most profound understanding was Pissarro, and the group of works by the older Impressionist that he acquired was extraordinary. We have already seen that it most likely included an early haystack painting from the classic Pontoise years of 1872–73 (see fig. 35), as well as a small rural painting from 1875 (*Cowherd, Montfoucault*; PV 323). Far from being a comprehensive collection of all types of works by the master, however, it focused on his landscapes and figure paintings of 1879–82, the same years as Gauguin's own engagement with Impressionism. The most important painting of the group was a large canvas completed by Pissarro in the

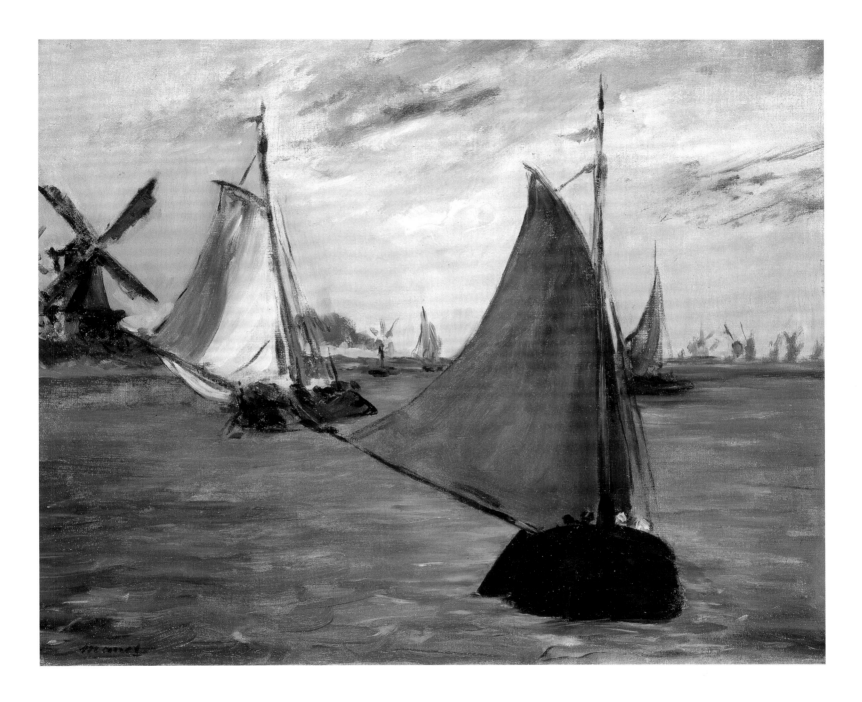

Fig. 46 Edouard Manet, *View in Holland*, 1872.
Oil on canvas, 19³/₄ × 23³/₄ in. (50.2 × 60.3 cm).
Philadelphia Museum of Art. Purchased with the
W. P. Wilstach Fund, 1921 (1921-1-4)

nine months following the closing of the 1879 exhibition, signed and dated 1879, and submitted by the older artist from Gauguin's collection to the Impressionist exhibition of 1880—at which Gauguin made his debut as a painter. This work, *Woodcutter* (fig. 50), remains by far the most important painting of a male rural worker made after Millet, and the dynamism and energy of both the figure and Pissarro's facture make it one of the sheer masterpieces of Impressionist figure painting. Interestingly, neither Gauguin nor Pissarro favored male figures, and it is surely no accident that the younger painter's greatest Tahitian painting of a male figure represents a man cutting wood, obviously made in deference to Pissarro.

Of the landscapes and figure paintings that formed the rest of Gauguin's Pissarro collection, half were vertical compositions. Given that the vast majority of landscape

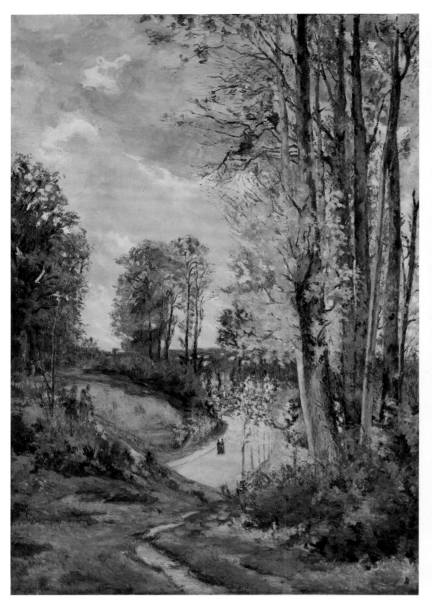

paintings of the nineteenth century were painted on horizontal canvases, it is remarkable that both Pissarro and, after him, Gauguin conceived landscape compositions in the vertical formats usually reserved for portraits and genre scenes. The most notable vertical landscapes of the group were *Woodland Scene, Spring* (fig. 51), which Gauguin loaned to the 1879 Impressionist exhibition, and the wonderfully eerie Osny landscape in Valenciennes (see fig. 52). The most ambitious of the figure paintings was *Peasant Woman Warming Herself* (fig. 53)—which, as Sylvie Crussard has pointed out, had a delayed effect on Gauguin's oeuvre, particularly during the years 1886–87, when he worked in both Brittany and Paris.[44] The almost caricatural profile head in Pissarro's painting reappears hardly changed in Gauguin's greatest figure paintings of 1886 and 1887, *Breton Women Chatting* (fig. 253) and *Two Women Bathing* (fig. 258).

Oddly, we know very little of the way in which Gauguin lived with his collection. Apart from the handful that show works from the collection, most of his own paintings,

Part II Becoming an Impressionist
Painter–Sculptor

"THE CRAZE FOR SCULPTURE REALLY IS growing. Degas (it seems) is making sculptures of horses, and you are making cows . . ."[1] It was in a letter to Pissarro, written in the autumn of 1882, that Gauguin commented on the growing interest in sculpture among the Impressionist painters—perhaps one of various outcomes of the irresolute self-questioning and artistic soul-searching that were tormenting the group at this time.

Together with Auguste Rodin and Degas, Gauguin made the most radical bid for a renewal of sculpture, and he did so in a manner all his own—in a series of works in wood and wax that he executed from about 1880 to 1882. They showed no signs of academic training, and their radical quality was unmistakable in both motif and technique. Almost from the time of his first known experiments, he was one of the nineteenth century's most revolutionary innovators in three-dimensional art.

This had been preceded in the late 1870s by a brief intermezzo when he tried his skill at a more academic approach. The result was a few relatively conventional but splendidly executed marble busts of his wife, Mette, and their first child, Emil (see cats. 6, 7). In 1877 the family moved from the affluent district near the Bourse to Impasse Frémin at Vaugirard. Here, for the first time, Gauguin experienced a truly artistic environment, living in close proximity to a couple of academic sculptors, Jules-Ernest Bouillot, who was his landlord, and Jean-Paul Aubé. The three years or so he was to live in this district, which was home to a broad range of sculptors, stimulated his interest in sculpture, and Bouillot and Aubé came to be of great significance to him, each in his own way. It was perhaps Aubé who introduced him to the world of sculpture, but it is assumed that it was Bouillot who helped him with the practical execution of the two marble busts and thereby gave him an introduction to the academic workshop tradition.

Despite its academic qualities, the bust of Emil already shows something of the dreaming introspection that was to characterize the entire series of portraits that Gauguin made of his five children over the next few years (see cats. 6, 23, 24, and figs. 93, 112). He must have been quite satisfied with this work; in 1879, when he received an invitation from Degas and Pissarro to participate in the fourth Impressionist exhibition—after the time limit for printing the catalogue had expired—in all probability he chose this little work with which to make his first appearance among the avant-garde artists. It was a choice that is all the more surprising as the group was not known for its sculptures. In his review of the exhibition, Duranty referred to "a pleasant little sculpture by M. Gauguin—the only sculpture at the exhibition that aroused interest among visitors," and the work that best fits this description is his bust of Emil.[2]

Gauguin set great store by his sculptural works, and while Pissarro never showed his attempts at sculpture in public and Degas only once, when he exhibited the *Little Dancer Aged Fourteen* (see fig. 92), Gauguin showed examples of his three-dimensional works in all the Impressionist exhibitions in which he took part. At the fifth exhibition in 1880, the work he showed was his second attempt in marble, the bust of Mette, in

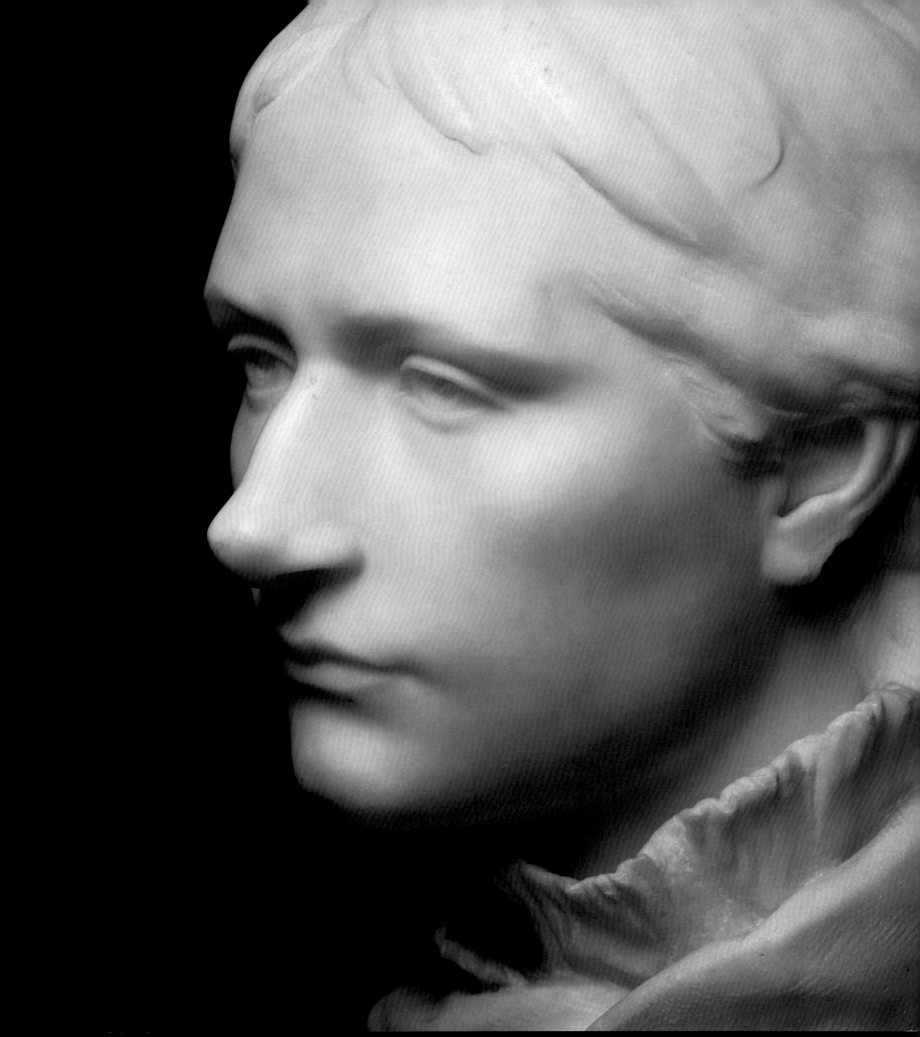

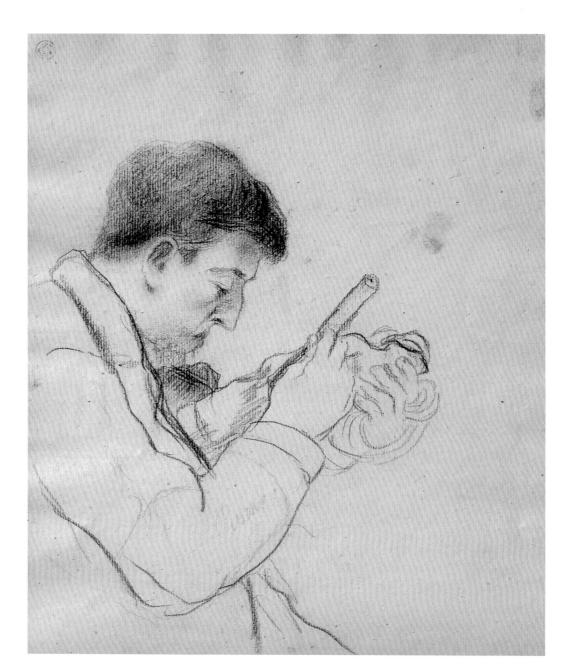

Fig. 54 Camille Pissarro, *Gauguin Carving Lady Strolling*, c. 1880. Black chalk, $11^5/_8 \times 9^1/_4$ in. (29.5 × 23.3 cm). Nationalmuseum, Stockholm (NM 22/1936)

the same, rather smooth Neoclassical style (cat. 7). He was not to continue with marble, and it was mainly with wood as his material that he was to show himself one of the nineteenth century's most important rejuvenators of the three-dimensional work of art. He had an immediate affinity with wood. The literature on his youth tells us that one of his favorite ways of passing the time, both as a child and as a young sailor, was to work a piece of wood with a knife.[3] Wood was cheap and easy to fashion without the need for a large workshop, and it was associated not with classical art but with the Egyptians, the Middle Ages, church sculpture, folk art—in brief, periods and forms that his age identified as "primitive."

What was sculpture to Gauguin? In his use of the very word he revealed his radical views. For him there was no distinction between sculpture and the so-called decorative

arts that throughout his life were to be a passionate interest to him. Both in his references to these two branches of art and in the way in which he dealt with them there was no more than a vague distinction between them. Later he was often to talk of his ceramics as "sculpture." He worked in a completely different sphere from Rodin and Degas. What interested him was the iconic rather than the plastic. It was surface as opposed to volume, decoration as opposed to shape, detail rather than spatial definition. So his works are reliefs rather than sculptures in the round; they often have the character of decorated "containers." Often the sources of his inspiration are found in two-dimensional models. The emphasis is on idea and concept, and the works begin to deal with the question of what sculpture is. They ask questions of themselves just as his paintings ask questions of painting as an artistic genre—questions that Gauguin also asked himself in words in one of his letters: "What are paintings?"[4] In the same way his sculptures ask the question: What is sculpture?

In sculpture he found a refuge, where tradition seemed less binding. Here he could more freely enter into a dialogue with new sources of influence and satisfy his need to experiment. Here he showed an early interest in seemingly archaic qualities. His sculpture and decorative art developed side by side with his painting—although he was never to carry out quite such radical experiments in painting—and several of the problems facing him in painting were to be solved in three dimensions.

A number of his wood carvings show an element of utility, even quite concrete functions. From his years as an Impressionist we know a medallion (cat. 21), a cabinet (cat. 15), a box (cat. 43), a fan handle (cat. 44), and a few picture frames (cat. 45 and fig. 202), but there were undoubtedly more. They resulted from a general archaizing effort that can be related to the English Arts and Crafts Movement and William Morris's attempt to renew the harmony between fine and decorative art—part of a struggle against the Industrial Revolution, soulless mass production, the advance of machinery, and the resulting decline in craftsmanship and materials. In France, the move to link fine and decorative art gathered pace in the 1880s, and the Union Centrale des Art Décoratifs was founded in 1882. Gauguin was to play a major part in this whole trend.[5]

6

Bust of Emil Gauguin, probably 1878
Marble, height 17 in. (43.2 cm)
The Metropolitan Museum of Art, New York.
 Gift of the Joseph M. May Memorial
 Association, Inc., 1963 (63.113)

Fig. 55 Paul Gauguin. *Emil Gauguin as a Baby*, c. 1875–76.
Black crayon, 3⁷/₈ × 2⁷/₈ in. (9.8 × 7.1 cm). The Cleveland
Museum of Art. Gift of Leonard C. Hanna, Jr. (1936.661)

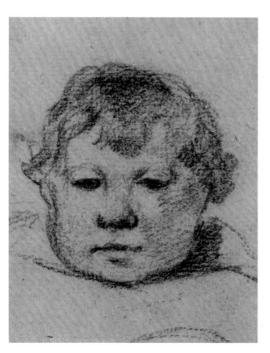

The work with which Gauguin chose to introduce himself in the Impressionist milieu was not a painting but a sculpture.[6] The invitation from Degas and Pissarro to participate in the fourth Impressionist exhibition in the spring of 1879[7] arrived so late that it was impossible to include his name in the exhibition catalogue, but thanks to a review by the art critic Duranty we know that he did participate. At the end of the review, which appeared in *La Chronique des Arts et de la Curiosité*, Duranty referred quite briefly to certain works: "Excellent charcoal drawings by M. Lebourg, and a pleasant little sculpture by M. Gauguin—the only sculpture at the exhibition that aroused interest among visitors, especially the first ones."[8] Doubts have been expressed as to whether this debut piece was his bust of Emil or that of Mette (cat. 7).[9] But it is highly likely that it was the bust of Emil, partly because it is unlikely that the one of Mette would be described as "a pleasant little sculpture," and partly because in his review of the fifth exhibition in the following year Henry Trianon clearly identified the bust exhibited then as that of Mette.

Emil was Paul and Mette Gauguin's first child. He was born in Paris on August 31, 1874, roughly nine months after his parents married. Perhaps they named him Emil after one of Gauguin's best friends, the painter Emile Schuffenecker, although they spelled the name in the Danish manner—without the final "e"—which is said to have given some problems to the French authorities.[10] The proud new father mentioned him by name for the first time a month or so after the birth: in a letter he reproached Marie Heegaard for not having come to Paris, where Mette would have been so happy to show her "her baby": "You should know how beautiful he is: it's not just our paternal and maternal hearts that judge

him so, it's everyone. White as a swan, strong as a Hercules, but I don't know whether he is amiable—he has every chance of not being so, his father is so grumpy."[11]

Of Emil's childhood it is known that from summer 1880—when he was six years old—he grew up in Denmark at the home of one of Mette's friends, Karen Wiehe, whose married name was Lehmann.[12] The reason for this is not known, but it might have had to do with the growth of the Gauguin family. The fourth of their children, Jean-René, was born on April 12 that year (see cat. 23).[13] Gauguin apparently did not see his eldest son again until the end of 1884, and he was obviously happy about the way the boy was developing. In March 1885 he wrote to Schuffenecker: "Emil has become very amusing, and I have taken him under my wing with regard to drawing." He thought the boy would have a "very interesting eye" and hoped he would "successfully" continue on this path.[14] But the time they spent together was short, and after Gauguin left his family in June 1885 to embark on a life as an artist in Paris, Emil is mentioned only occasionally in the correspondence between his parents. In a letter of August 1886, Gauguin revealed a specific aspect of his interest in portraying his children: it derived from his fascination with physiognomies. Mette had sent him a photograph of their daughter Aline, and he remarked how her physiognomy was developing in the same way as Emil's: her teeth were growing incorrectly. "I'm not surprised that she is beginning to turn after Emil. Remember my view on this subject. I've seen her physiognomy take on this character."[15]

As a baby, Emil served as a model for several of his father's drawings (fig. 55),[16] and his round cheeks are also seen in a small oil sketch dated 1875.[17] Another sketch was

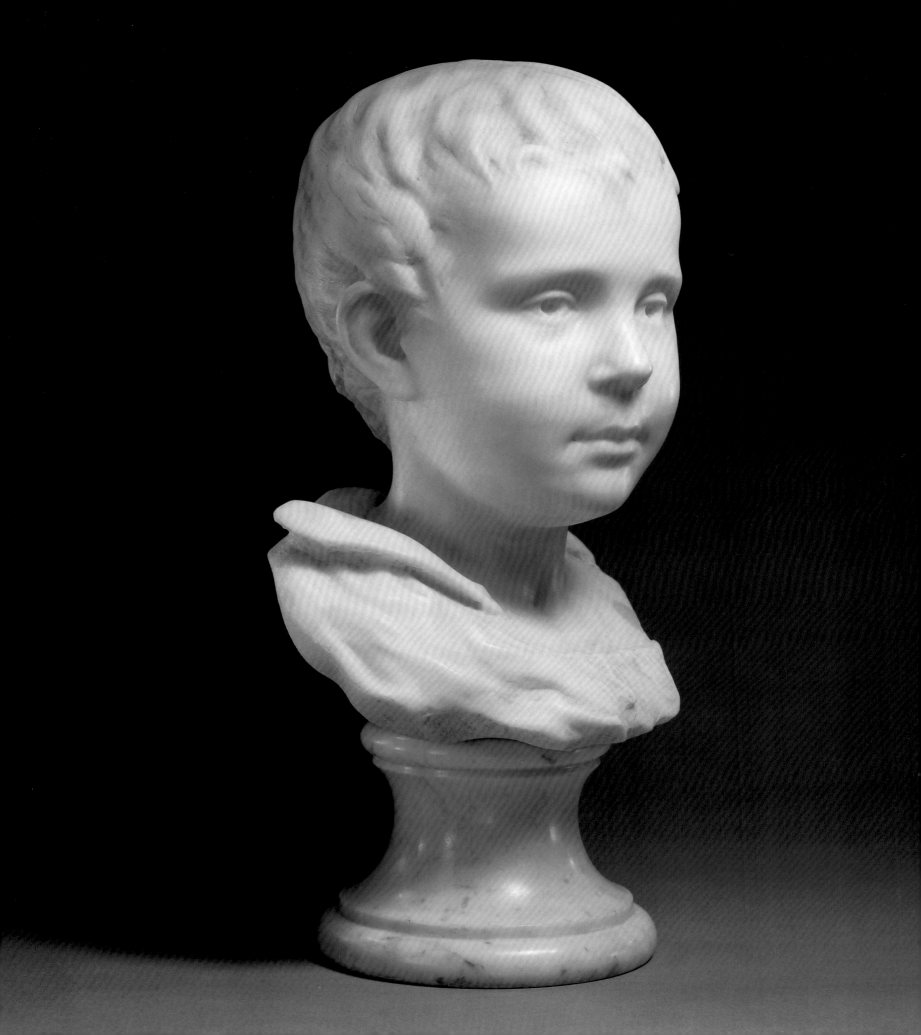

probably made about 1877–78 and shows him at roughly the same stage of development as the marble bust.[18] The bust portrays him in a representational style reminiscent of Carpeaux. The intensely white and very delicate marble bust was worked with traditional sculptural tools such as a drill, and the surface has a smooth finish. The technical refinement of the work raises the question of Gauguin's part in its execution[19]—did he merely make a sketch to be translated into marble by a professional sculptor?—but there is much to suggest that in fact he played a considerable part in the work.

On moving to the Impasse Fremin near 74 Rue des Fourneaux (now Rue Falguière) in 1877, the Gauguin family were in a district that was the home of several sculptors. Judith Cladel described the street as comprised of "low-built houses, factories, butchers' shops, and joiners' shops with, here and there, some places where artists lived."[20] From 1877, Rodin also had a studio at 36 Rue des Fourneaux. However, it was another of the district's sculptors, the academic Jules-Ernest Bouillot, who was Gauguin's new landlord. At this time, Bouillot was about forty years old and active in the profession as a *praticien*, i.e., one who realized the clay or wax models of other sculptors in more durable materials such as marble. He made his first appearance in the Salon in 1880 and regularly exhibited his works—not least busts[21]—until the middle of the 1890s. Perhaps Bouillot carved the bust of Emil. On the other hand, we know that he introduced Gauguin to stone dressing, and the latter's subsequent thoughts of earning his living as a monumental mason suggest that he himself would at least have helped to carve the work.[22] In 1885, when he was short of an occupation after returning from Denmark, Gauguin even offered to work for Bouillot as a *praticien*,[23] although nothing came of the idea.

Another sculptor might also have played a part in Gauguin's first sculptural efforts. Bouillot owned three studios in the street and rented out two of them. The other sculptor renting from him was Aubé, who also moved in during 1877. Gauguin established a close relationship with Aubé and was to portray him in a pastel alongside one of his vases. It is possible that he presented the pastel to Aubé in 1882 as thanks for helping to introduce him to the world of sculpture.[24]

In his book on his father, Pola Gauguin wrote that the bust of Emil was made after that of Mette.[25] However, it has been argued convincingly that the lack of a signature on the bust might indicate that he played a lesser role in its execution than in that of the signed bust of Mette, which he made after gaining more experience in carving marble.[26] In all likelihood the bust of Emil was made in 1878 and that of Mette in 1879, each reflecting a different level of technical mastery and involvement in the execution on Gauguin's part.[27] Whatever the case, the bust of Emil seems to be Gauguin's earliest known sculpture.

Then owned by Mette Gauguin, the bust was exhibited in Copenhagen in the Gauguin and van Gogh exhibition in Den Frie Udstilling in 1893.[28] The press responded warmly. *Aarhus Amtstidende* wrote: "None of our sculptors could compete with his lovely head of a boy."[29] *Nationaltidende*—which noted the enormous stylistic leap from the earliest works in the exhibition in 1878 to those of 1892—commented: "The best things here are the beautiful marble busts of a child, 'Emile,' and of a woman. They are charming works that show a fine sensitivity and sense of form, and they make us wonder whether it might be a mistake that Gauguin has become a painter; he ought probably to have been a sculptor."[30] —A-BF

7

Bust of Mette Gauguin, 1879
White marble; height 13³⁄₈ in. (34.5 cm)
Signed: *P. GAUGUIN* (carved beneath the collar)
The Samuel Courtauld Trust, Courtauld Institute of Art Gallery, London

Gauguin created the bust of his Danish wife, Mette Gauguin, like that of their first son, Emil (cat. 6), during the period when they were renting accommodation from the sculptor Bouillot in the Rue des Fourneaux (now Rue Falguière).[31] During his early years, Gauguin often turned to his rapidly growing family for models, and portraiture as a genre was quite prominent in his work. This was probably due to practical circumstances. For an artist only able to paint in his spare time, the home and family members were obvious motifs. What distinguishes the bust of Mette from most of Gauguin's family works, which are largely informal in character, is that—along with the painting *Mette in Evening Dress*, from the Rouen period (fig. 153)[32]—it represents a serious attempt at portraiture in the usual, more public sense of the term.

The bust was exhibited in the fifth Impressionist exhibition in 1880, as no. 62, under the title *Buste marbre*. It was probably executed during the previous year.[33] As with the bust of Emil, how much Gauguin himself was responsible for the actual carving of the marble is a matter for speculation. The art historian Merete Bodelsen was of the opinion that he merely made a model, which Bouillot translated into marble "in an adroitly conventional Salon style."[34] Although the style is indeed conventional,[35] however, it is likely that Gauguin himself was responsible for the carving—albeit under Bouillot's guidance.[36] The fact that he sought to work for Bouillot as a *praticien* on his return to Paris from

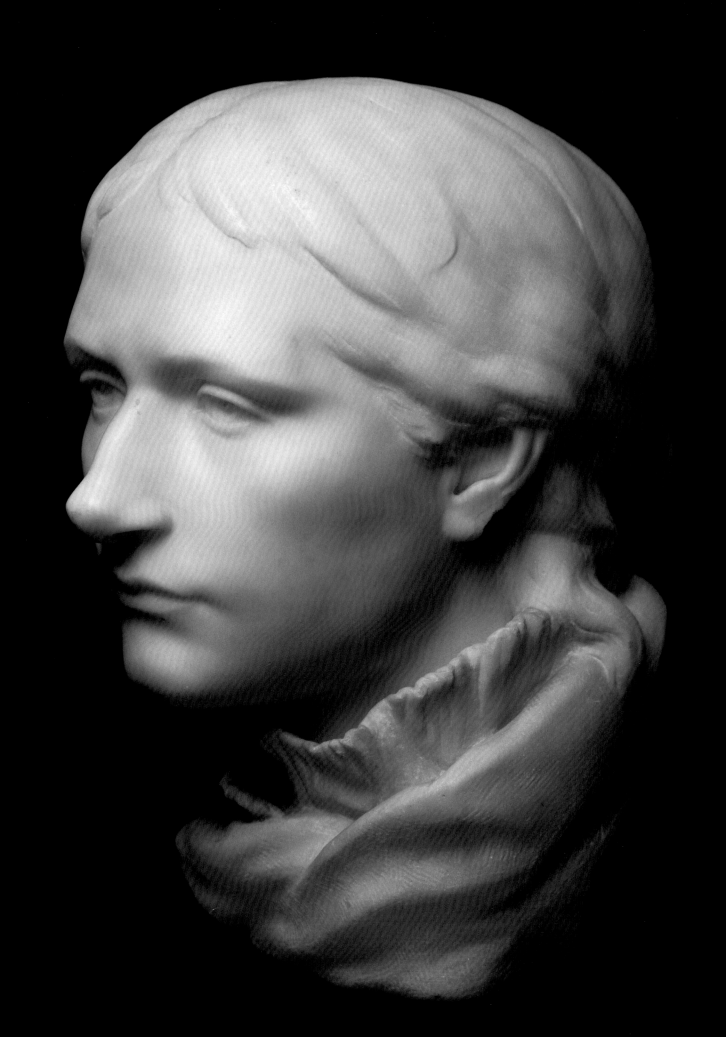

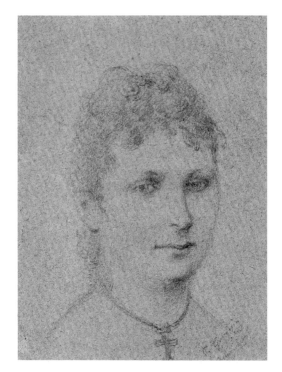

Fig. 56 Paul Gauguin, *Portrait of Mette Gad*, 1873. Pencil on paper, 3³/₈ × 2³/₈ in. (8.5 × 6 cm). Ny Carlsberg Glyptotek, Copenhagen (I.N. 3232)

Fig. 57 *Mette Gad*, 1873. Le Musée Départemental Maurice Denis, Saint-Germain-en-Laye, France

Denmark in 1885 indicates that he had learned the craft, and this must have been through working on the busts of Emil and Mette.[37]

The busts share some characteristics of professional sculptors' work. The eyes are given depth and life by drilling, a technique used also to create the illusion of the lacework of the collar in the bust of Mette. But the bust is less idealized. There are more nuances in the depiction of character and signs of the interest in physiognomy that is found in Gauguin's later work.[38] Her striking profile confirms what was said at the time—that Mette was fundamentally more characterful than good looking. Her youngest son, Pola, compared his mother's appearance to that of her two beautiful sisters: "Mette was slightly too big and powerful, and her face had very pronounced, perhaps almost masculine features, strong and full of character."[39] The classical qualities of the bust of Emil have given way to a greater realism. To contemporaries, however, the bust lacked illusionistic detail, and one critic faulted the treatment of the hair as too summary.[40]

Mette Sophie Gad was born in 1850 on the outlying Danish island of Læsø. Her father, Theodor Gad, was the island's judge, and Mette was the oldest of five children. At the age of seventeen she became a governess to the children of the Prime Minister, J. S. B. Estrup, and three years later she went abroad as a companion to Marie Heegaard, a woman of her own age who was the daughter of a wealthy factory owner. In October 1872 the pair arrived in Paris, and it was here, probably through the Arosa family, that Mette encountered the young Gauguin. Though knowing little about his personality and character, in January 1873 she agreed to become engaged to him and abandon the comfortable life she had known in Denmark.

At the time of the engagement, her fond fiancé made a small pencil portrait that shows her characteristic, slightly sunken eyes in a face that is still young and unmarked by life (fig. 56).[41] At about the same time Marie Heegaard wrote home saying that Mette had become more beautiful during her stay in Paris. She was twenty-three years old (fig. 57).[42] The wedding took place on November 22, 1873, in the Lutheran Church in the Rue Chauchat.[43]

If the bust was made in 1879, this means that we see Mette's personality frozen at the age of twenty-nine. Her features have become more striking, her eyes deeper, and her expression has acquired more character. She was now the mother of three children—or of two and expecting a third: Emil was born first, about nine months after the wedding, in August 1874; their only daughter, Aline, was born on December 24, 1877; and Clovis on May 20, 1879. Mette was living in her third Parisian home and had once and for all left the more fashionable neighborhoods for a suburb associated with sculptors and kitchen gardens. "They live a dreadfully long way away," a worried Marie Heegaard reported home from a visit to Paris in 1876. "At the moment there seem to be problems with Paul's affairs; I do not think his position is secure; that is terrible for Mette."[44] By the time of the bust the mundane realities of Mette's married life and an incipient crisis in her marriage were both making themselves felt.[45]

The bust's features suggest a strong personality and complex feelings. But what we know about Mette's personality is mixed. From her original Danish friends we have the picture of an unusual, independent person with a good-natured repartee bordering on the controversial—a person who by virtue of her amusing ideas and quick wit attracted attention to herself and easily became the

central figure at a party. Among those with whom she consorted were artists and journalists from radical cultural circles, and it was said of her that she was "the *enfant terrible* beloved of all in a snobbish and narrow-minded Victorian age!" The words are those of the Danish author Otto Rung, who knew her well and wanted to contradict the French and English authors who "completely misunderstood her role in the marital complex and presented Mette Gauguin and her relatives, the highly cultured and understanding Gad family, as arrogant and narrow-minded bourgeoisie."[46] The daughter of Mogens Ballin, a Danish artist who became a close friend, described Mette as a thoroughly remarkable person with unusual human qualities—fearless, helpful, caring, incorruptible, and honorable: "For me, as for all who have known her, Mette Gauguin was a figure of such stature that we shall never forget her." In all respects, she was unconventional and "completely indifferent to the respectable middle classes," and with "her fervent, astounding bluntness she took the breath away from her more staid fellow citizens." She was admired for her brave struggle to maintain a life for herself and her five children, and for her independence and pride with regard to money. To offer "to lend her money was inconceivable."[47]

One of Eugène Murer's letters also refers to her in sympathetic terms: "The woman is charming, very likable, refuses to put on airs, and is quite simple in her taste."[48] But the art history of a later age—keeping in step with Gauguin's growing fame—drew an increasingly negative picture of her. René Huyghe referred to her as "narrow-minded and deeply conventional."[49] Her critics have claimed that she thoughtlessly wasted her husband's hard-earned income.[50] Her sense of art has been the

subject of similarly negative comments when it may in fact have been reasonably well developed. Gauguin quoted her incisive remark about the painting *L'Amour au Village* by the Salon artist Jules Bastien-Lepage, which she called "the seduction of an under-age girl" ("un détournement de mineure").[51]

Unlike the general response of the press to Gauguin and his Impressionist colleagues, the reviews of the bust of Mette were succinct but positive. Four critics reviewed the work in connection with the Impressionist exhibition of 1880. The anonymous "J. L." commented soberly in *L'Ordre* that "Gauguin, the creator of a marble bust and numerous oil paintings" was one of the artists who should not be overlooked. Elie de Mont, writing in *La Civilisation*, remarked that "M. Gauguin, who seems to me to be very sensitive in his sculpture, judging by his marble bust, loses his head when he embarks on painting." Achilles de Lauzières de Thémines, at the end of a long and negative review in *La Patrie*, included the bust in a brief reference to what he saw as the more successful works in the exhibition, those that were "in no way *independent*."[52] It can be assumed that Gauguin—despite the praise—would rather have had his work classified as independent. He would surely have been more gratified to read the review by the art critic Henry Trianon in *Le Constitutionnel*. Like de Thémines, Trianon omitted to mention his name, but clearly he had taken the time to study the bust in detail: "There is only a single piece of sculpture, and that submission deserves consideration. It is entitled Mette. It is the head of a young woman, finishing at the lower part of her neck. It reveals an able and sincere use of the chisel. The model has the fleeting, rounded shapes and the softened lines of youth. If the hair had been treated in a less summary fashion there would hardly be

anything to which to take exception in this pretty piece."[53]

When the busts of Emil and Mette were exhibited in Copenhagen in 1893, the reception given by the press was similarly positive. In *Nationaltidende*, the "beautiful marble busts" were praised in contrast to later "synthetic" works: "They are charming works that show a fine sensitivity and sense of form, and they make us wonder whether it might be a mistake that Gauguin has become a painter; he ought probably to have been a sculptor."[54]

Gauguin's two early marble busts have long been overshadowed by the rest of his oeuvre. What was his intention in them? Why did he choose to make his first appearance among the most vociferous of the avant-garde with works that were so traditional in nature? Do they merely express the young father's desire to create lasting memories of those closest to him? If it is correct that they were made in the period 1878–79, they were broadly contemporary with paintings that were far more original and with radical wood carvings such as *The Singer* (cat. 21) and *Lady Strolling* (cat. 22) that were in most ways their antithesis. It would be simplistic to view the busts as a stage in Gauguin's development from which he quickly moved on. They were not made as family portraits in the usual sense; they were by no means private but representative or even official in nature, like the above-mentioned painting of Mette in evening dress from the time the couple spent in Rouen. Portraits of such a character are few and far between in Gauguin's oeuvre. But we know that during the periods he spent in Rouen and Panama he considered taking up portraiture as a business. The existence of the two early marble busts and their relatively "market-oriented" character may reflect thoughts along the same lines.—A-BF

WHEN GAUGUIN BEGAN TO EXHIBIT WITH THE Impressionists in 1879, it is probable that he was considered by his colleagues—as Caillebotte had been earlier—to be a wealthy amateur-artist more important to the financial than to the artistic future of the group. Most of the other artists in the Impressionist group had works by other artists in their collections, but these were most often obtained through trade rather than through purchase on the open market. Of the artists in the Impressionist circle, only Caillebotte, Signac, and Degas surpassed Gauguin as collectors—Caillebotte in the early years of the movement, Signac after 1886, and Degas only at the end of his career, after 1890. There is no doubt that Gauguin was among the most important painter-collectors in France in the first half of the 1880s. He bought from dealers and directly from the artists. He was able to study the works in his collection at will and to measure his own work against the example of others. Although he owned fewer paintings by Cézanne than did Pissarro, his were acquired deliberately rather than from convenient trades. In this sense he was the first great artist-collector of Cézanne—who, with the exception of Victor Chocquet and Joachim Gasquet, had no other important collectors in the 1870s and 1880s.

The prominence given to Guillaumin and Cézanne in Gauguin's collection makes even clearer the younger artist's reliance on Pissarro for his aesthetic impetus. Gauguin would most likely never have met these two artists had he not known and collected works by Pissarro. There is a famous drawing by Pissarro's son Georges of all these artists working together in the landscape around Pontoise in the summer of 1881, after the Impressionist exhibition of that year (see fig. 135). It was this small group who sustained Gauguin, both personally and aesthetically, at a crucial time in his career. Although Gauguin was—and is—frequently criticized for his amateur vacillation between artist and businessman, it is clear that he was attempting the sort of professional artistic career made possible by private investments or inherited wealth. Artists like Manet, Cézanne, Morisot, and even Pissarro were able to continue their careers without much income from their work because of the private wealth of their families. Having had to split a middle-class inheritance with his sister at the death of his mother, Gauguin cannot be blamed for wanting to have achieved that same stability before embarking upon an avant-garde career. It is, in fact, likely that he worked as hard in 1879 at maximizing his investments as he did at creating paintings for the Impressionist exhibition of 1880—at which he made his true "debut."

The debut was extraordinary, even by the standard set by Caillebotte in 1876, when his group of paintings did more to help major critics define the aesthetics of the group than those of the better-known artists. However, because Gauguin chose to enter the group as a follower of Pissarro rather than Degas and Manet (as did Caillebotte), he submitted a group of large landscapes, and these failed to attract the same critical attention as Caillebotte's extraordinary figure paintings did in 1876 and again in 1877. They met with the same tepid response as the Pissarro landscapes of 1879 that were their primary source. But this should not lead us to be too harsh when we judge Gauguin's debut today. Rather than applying the imagery of modernism to the

facing page Paul Gauguin, *Snow at Vaugirard II* (detail of cat. 12)

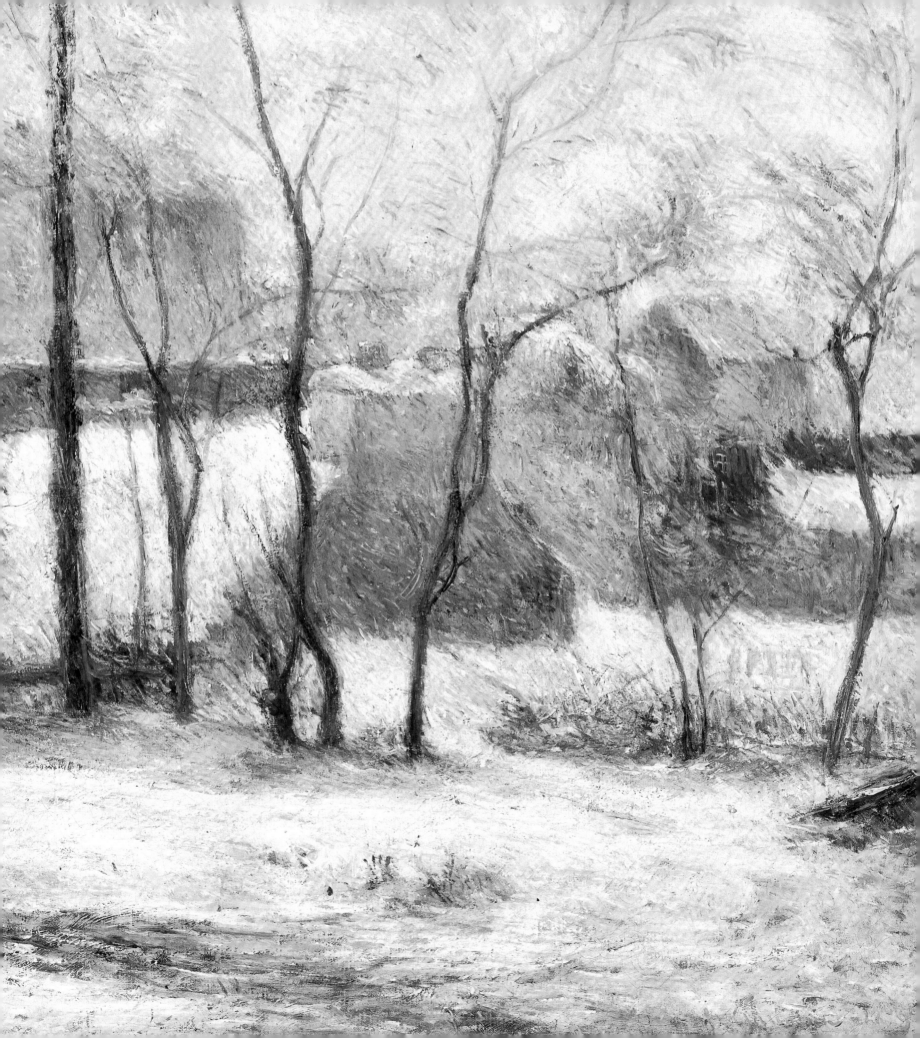

standards of picture making that were codified by the academy—as Caillebotte had done in 1876—Gauguin grappled with the thorniest problems of pictorial representation at the time. His subjects were banal, and his surfaces roughly worked in thousands of gestural touches.

Fortunately, we can today identify seven—and, provisionally, all eight—of the works that he submitted to the 1880 exhibition, and most are included in the present exhibition and catalogue. Four were landscapes of a large scale, one of which has only recently been discovered and published. Although none of the reviewers described the installation in any detail, some implied that the artists were each given their own area, where their works were arranged as they saw fit. If this is so, Gauguin must not have been given wall space in a very important room, because his paintings were scarcely mentioned in the press. There are several reasons outside the paintings themselves. This, the fifth of the "Impressionist" or "independent" exhibitions, was held just one year after the fourth exhibition. As a result, it was generally reviewed in comparative terms by critics who had seen or read about the earlier exhibitions; they followed the artists who had gained most publicity in the earlier exhibitions rather than discussing new talent. The absence of Renoir, Monet, Sisley, and, of course, Manet was more discussed than the presence of Gauguin. The lion's share of press coverage went to Caillebotte, who had galvanized the press since 1876 and whose work was dominated by large-scale human figures. The longest and most complex review of the exhibition, by the great novelist and critic Joris-Karl Huysmans, failed even to mention Gauguin's name!

Yet, Gauguin must have gotten some consolation from reading the press carefully. Renoir's brother, Edmond, reviewed the exhibition in *La Presse* and paid particular attention to Gauguin's landscapes, which he called "admirable 'impressions' of an artist at once sincere and original. What talent, spirit, observation in these exquisite works! . . . The gleam on materials, the delicate touches in the flesh, everything down to the pose of the figures and the 'note' they sound in nature, make them masterpieces of grace and charm."[55]

For a first critical notice, this was one that Gauguin could cheerfully clip out and send to his friends and family. Although he was yet to develop a set of collectors, he was also beginning to sell work. Durand-Ruel bought one of the large landscapes from him in the next year, and Mary Cassatt—who, with her friend Berthe Morisot, received much more critical attention than Gauguin—traded a pastel for his large snowscape. This was in spite of the fact that one critic, after praising the effect achieved by the painting, remarked that "its crusty technique is dreadfully heavy."[56]

Gauguin also loaned the largest and most important painting by Pissarro to the 1880 exhibition, *Woodcutter* (see fig. 50). In the catalogue it was listed first among Pissarro's works, with Gauguin's entire name as lender rather than simply the discreet initials. Thus Gauguin aligned himself doubly with Pissarro, whose relationship with his protégé in that year must have been very close. Unfortunately, we cannot measure it completely, because only five of the ten canvases by Pissarro submitted to the exhibition have been identified. Given the fact that none of them, save Gauguin's own loan, is linked to a

Fig. 58 Paul Gauguin, *Geese on the Farm*, 1879. Oil on canvas, 23⅝ × 39⅜ in. (60 × 100 cm). Private collection (WII 47)

particular collector, their precise identification is a shell game. Even with only the titles of Pissarro's submissions to go on, however, we can tell that both he and Gauguin were interested in seasonal rather than diurnal time.

The only large and important landscape not included in the present exhibition, *Geese on the Farm* (fig. 58), has only recently been published and is a major new work to enter the Gauguin canon. Its complete lack of documentary connection to Gauguin's early career is frustrating, and neither its early provenance nor its exhibition history is documented. However, its evident importance, its undoubted authenticity, and its date of 1879 provided an opportunity for the authors of the 2001 catalogue raisonné to link the painting with a work known only by title as *Ferme à Pontoise*, listed as no. 61 in the catalogue of the 1880 Impressionist exhibition. We know that Gauguin strengthened his link with Pissarro in connection with the 1879 Impressionist exhibition and that he spent a good deal of time with the older painter in the summer of 1879. All of this makes one *want* the present painting to be *Ferme à Pontoise*. Yet there is not a single work by Pissarro, nor a single house in any of the numerous nineteenth-century photographs and prints of Pontoise, nor a single cadastral map, that makes it possible for us to say without doubt that the painting was made in Pontoise.

Should this lack of what might be called "positive evidence" force us to disagree with the excellent cataloguers? The answer is decidedly no. Gauguin may have painted it in Pontoise. What is clear, however, is that it has little to do with the pictorial concerns

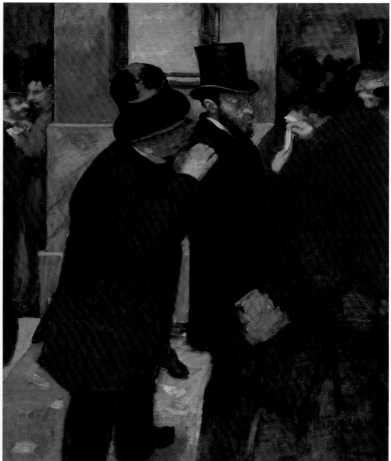

then being explored by Pissarro. As we have seen, Gauguin had ample chance to study Pissarro's landscapes carefully in the 1879 Impressionist exhibition, held in April of that year. He also had more than a little chance to work with the older painter in the summer and autumn, when he made more ambitious paintings than he ever had before. Yet, of all the canvases from that period, this one has the fewest links with Pissarro's current landscape practice.

If Gauguin began this large painting in Pontoise, it was certainly not in the company of Pissarro. None of Pissarro's numerous paintings of 1879 and 1880 has any direct relationship with it, and none was made at the same site. Although Gauguin was emboldened by the example of Pissarro to make important rural landscapes in the summer and fall of 1879, either he did so on his own terms or he had already completed this large landscape before the 1879 Impressionist exhibition. The latter explanation seems the likelier for two reasons: his other 1879–80 landscapes are closer to works by Pissarro, and he must have had at least one important painting on hand to convince Pissarro and Degas to invite him to participate in the 1879 exhibition. It is even possible that the present landscape was included in that exhibition along with the marble bust of Gauguin's son Emil, but that it escaped any critical notice.

What is most surprising about Gauguin's painting is that it makes dramatic use of perspectival spatial construction, but that it also places most of the landscape space

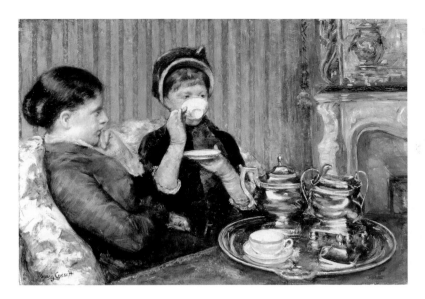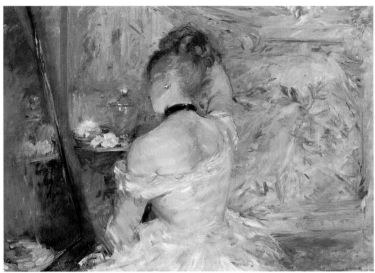

Fig. 61 (*above left*) Mary Cassatt, *The Tea*, c. 1880.
Oil on canvas, 25¹/₂ × 36¹/₄ in. (64.7 × 92.1 cm). Museum
of Fine Arts, Boston. M. Theresa B. Hopkins Fund (42.178)

Fig. 62 (*above right*) Berthe Morisot, *Woman at Her
Toilette*, c. 1875. Oil on canvas, 23³/₄ × 31³/₄ in.
(60.3 × 80.4 cm). The Art Institute of Chicago. The
Stickney Fund (1924.127)

behind a long stone wall with no apparent apertures. In this way, it at once entices the viewer to enter and denies any satisfying access to deep pictorial space. The farm buildings lie beyond the wall, with only one tiny shuttered window and two smokeless chimneys as indicators of interiority. By contrast, the foreground is alive with activity and detail. A group of three geese, who give the painting its rather odd modern title, cavort unself-consciously in the left foreground; one drinks from a metal pail, another noses a heavy sack, while the third seems simply to preen in front of a neatly stacked group of boards, poles, and wooden palettes. In the middle ground, a tall and remarkably thin male worker, wearing a white shirt rather than the blue *blouson* of custom, prods at an as yet unidentified agricultural contraption on a tripod. This is not the backbreaking work of Millet's peasants, but a planned activity that can be managed by a single worker, the modernity of which is accentuated by the appearance of a factory chimney directly behind the man and his work. What, we ask, is he doing? He appears to be bundling recently cut hay or straw so that he can lay the newly created sheaves around a pole to form a stack. The almost glaringly bright yellow of the hay or straw is organized into a chromatic barrier that effectively keeps the viewer out of the deep space suggested by the diagonally positioned wall.

A rapid perusal of the catalogue for the 1880 exhibition makes it clear that the urban realism of Degas, Caillebotte, Cassatt, Jean-Louis Forain, and Jean-François Raffaëlli won out over the rural landscape of Pissarro and Gauguin. Because neither Monet nor Sisley was present, the landscape component of the exhibition was left to Pissarro and his best follower. Even Pissarro submitted more works on paper, including a group of major etchings, than painted landscapes or rural genre scenes. Indeed, if ever an Impressionist exhibition eschewed landscape in favor of the modern figure, it was the exhibition of 1880, and Gauguin surely noticed that fact. His greatest competition as a painter that year was figure painting. His complex and ambitious landscapes may have outdone those of Pissarro. Yet, when compared to the superb figures of Caillebotte (fig. 59), Cassatt (fig. 61), Degas (fig. 60), or Morisot (fig. 62), they seem decidedly un-modern. After the 1880 exhibition, he was left with little choice but to paint his first major figure painting, and, when he decided to do just that, he looked outside the exhibition for models.

8

Apple Trees at l'Hermitage II, 1879
Oil on canvas, 25³/₄ × 39¹/₂ in. (65.5 × 100.5 cm)
Neither signed nor dated
Aargauer Kunsthaus Aarau, Aarau, Switzerland.
 Bequest of Dr. Max Fretz
WII 51

9

Apple Trees at l'Hermitage III, 1879
Oil on canvas, 34⁵/₈ × 45¹/₄ in. (88 × 115 cm)
Signed and dated lower right: *p. Gauguin 1879*
Private collection
WII 52

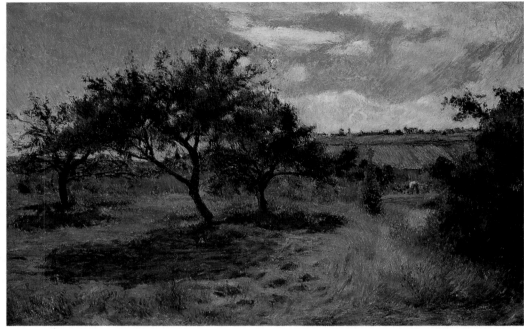

cat. 8

There is no group of paintings that Gauguin made more clearly in homage to Pissarro than the three versions of *Apple Trees at l'Hermitage* of 1879.[57] It is tempting to look for a direct prototype in the older painter's career. Yet, when one tries, it becomes obvious that, even when he closely approached another master, Gauguin did so on his own terms. In this case, the motif is obviously from Pontoise: the paintings represent a small orchard on the top of the long hill on the east side of the hamlet l'Hermitage, where Pissarro lived throughout much of the 1870s. Technically speaking, the title of the painting is incorrect, because l'Hermitage was in fact in the small valley below the orchard. Pissarro himself had painted orchards many times. Gauguin's guardian, Gustave Arosa, owned a particularly important and distinguished orchard painting from 1870 and Gustave's brother owned another (see figs. 7, 10). Yet, most of Pissarro's orchard scenes were painted in the springtime, when the blossoms acted as a seasonal indicator, and he tended to avoid fruit trees as a motif in other seasons.

The three versions of the present composition must all have been painted in the same year while Gauguin worked with Pissarro. It is likely that he first completed the smallest one (its present whereabouts are unknown) and worked on both of the larger versions simultaneously in the studio, either in Pontoise or in Vaugirard. Version II is so large that it can in no way be considered an "intermediary" work. In fact, it seems that in versions I and III Gauguin attempted to adapt his composition to two different pictorial formats, with different chromatic and value structures, so as to get as much as possible from one motif. It is also possible that he undertook two large versions as the result of direct critiques by Pissarro, who himself was working in a highly structured manner in 1879–80.

It is tempting to be critical of Gauguin for being "academic" in his decision to paint a "study" for a larger finished painting. Yet, it is important to recognize that this was an established part of Impressionist practice, particularly for Pissarro and Monet. Pissarro had begun to paint small-scale color and composition studies for later pictures as early as 1876, not because he wanted to finish works in the studio but in order to minimize the number of pictorial decisions to be made *en plein air*: if the painter had refined his composition and palette, his work in front of the motif could be much more efficiently accomplished. Working at the same time on a large-scale painting for the Salon, Monet used smaller scale plein-air paintings effectively as "sketches." This did not mean that larger versions were worked exclusively in the studio, as some have suggested, but that the artist could take them out into nature at several points in the process of painting without necessitating long and inconvenient

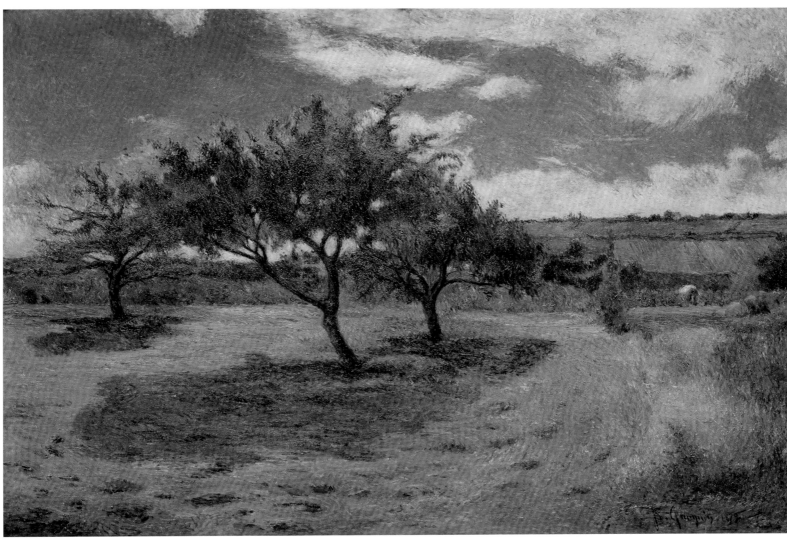

cat. 9

working periods with works of unwieldy dimension.

If they all lacked signatures, how could we know that these Pissarro-like landscapes were not actually painted by Pissarro? The answers to this important question involve issues of surface quality and composition. For Gauguin, the pictorial surface, though covered with small touches of paint, was a good deal more regular and consistent than it was for Pissarro in the same period. Where Pissarro would lay on his paint with small brushes in touches, commas, thick strokes, and whipped lines depending on the pictorial character of the motif, Gauguin treated all portions of the surface in a similar manner. Sky, foliage, and

grass are evoked with comparable strokes of paint; although the painting is roughly textured, its surface has an almost polite uniformity. By contrast, Pissarro's surfaces vary in thickness, number of strokes per surface unit, and direction of touch. The second aspect of Gauguin's apple-tree paintings that separates them from Pissarro is the younger artist's use of strong shadows and his interest in the three-dimensional integrity of the trees motif. The strength of the shadows almost makes it seem as if they, rather than the trees themselves, were Gauguin's motif. Both in version II and version III, the shadows dominate the foreground as large, definite shapes. They have a greater solidity of form even than the

relatively open and intricately patterned foliage to which they correspond.

The role of shadow in Impressionist painting is in need of serious study. Since the artists tended to conceive of their pictorial realms as "fields of vision" rather than as flat transcriptions of three-dimensional forms in space, the role of the shadow in Impressionist landscape is not nearly as great as it was in either classical or realist landscape aesthetics. Nevertheless, shadows, of forms both within and outside the pictorial realm, are as important to the structure of Impressionist paintings as the shading of large, solid forms within. The real issue with shadows was not so much their existence as a part of the visual

Fig. 63 Rembrandt van Rijn, *The Three Trees*, 1643. Etching with drypoint and burin, 8³/₈ × 11 in. (21.3 × 27.9 cm). The British Museum, London (1973-U-967)

field, however, but their color. For academic painters, shadows were defined by adding black to the color of the surface on which the shadow was cast. Shadows contributed nothing chromatically to the pictorial structure of pre-Impressionist landscapes. For many critics of Impressionist painting, the fact that Impressionist shadows were blue, purple, or mauve in their own right rather than darker versions of the surface on which they played was shocking. Gauguin seems to have wanted to deal forthrightly with the issue. In these paintings of 1879, he succeeded almost in fetishizing the shadow—to the point at which it becomes the motif of the picture.

The awkwardness and artificiality of Gauguin's pictorial world is most evident when we contrast his apple-tree paintings with a slightly earlier painting of a fruit tree by Pissarro, most likely the work included in the Impressionist exhibition of 1879 as *Vegetable Garden and Trees in Flower: Spring, Pontoise* (see fig. 38). This painting, then owned by Gustave Caillebotte, quivers with the life of gesture across the entire pictorial surface. The placement of the huge plum tree directly in the center of the canvas and the absence of shadows or even much shading of the described forms contrast so much with Gauguin's attempts at a similar subject that we are clearly in the presence of two very different artists. For Gauguin, the particular character

of the branches, the deliberately decorative forms of the bunched foliage, and the mysterious materiality of the trees make them much more powerful as motifs. For Pissarro, the "motif" is more the artist's response to the landscape than the landscape itself. Gauguin allows his apple trees to sway, dancelike, above the great shadows that make them fully independent of the picture plane.

Given the fact that Gauguin named both the type of tree and the place in which the trees are found, it is fascinating that not a single apple is visible in any of the three versions. This is a seasonal allusion; in Gauguin's world, it is surely understood that the apples have been picked and eaten already. There is, as yet, no serpent in that world. Considering the imagery of trees in the art of the past, it is tempting to evoke Rembrandt's famous etching *The Three Trees* (fig. 63). Placed similarly left of the center of his composition, Rembrandt's trees have a mythic presence in the landscape, receiving rain and weather in their planted grandeur. Gauguin, like all nineteenth-century artists, knew the work of Rembandt well, but we shall never know whether he intended this parallel.—RRB

10

Vaugirard Market Gardens, 1879
Oil on canvas, 26 × 39³/₈ in. (66 × 100 cm)
Signed and dated: *p Gauguin 79*
Smith College Museum of Art, Northampton, Massachusetts. Purchased
WII 55

The single aspect of this painting that is shocking to careful historians of Impressionism is its date, 1879. Its strictly planar and geometric composition, its relatively bright accent colors, and its detached point of view all link it unmistakably to the paintings of Cézanne, and particularly to *The Château of Medan* (see fig. 43), which was to be in Gauguin's own collection.[58] There is absolutely no connection however, since in 1879 Cézanne had not yet painted *The Château of Medan*! All serious historians of Cézanne's career have related this work to the painter's lengthy visit with Emile Zola in the summer of 1880. When

Fig. 64 Camille Pissarro, *View of l'Hermitage, Côte du Jallais, Pontoise*, 1867. Oil on canvas, 27⁵/₈ × 39³/₈ in. (70 × 100 cm). Rau Collection—UNICEF Foundation, Cologne (PV 57)

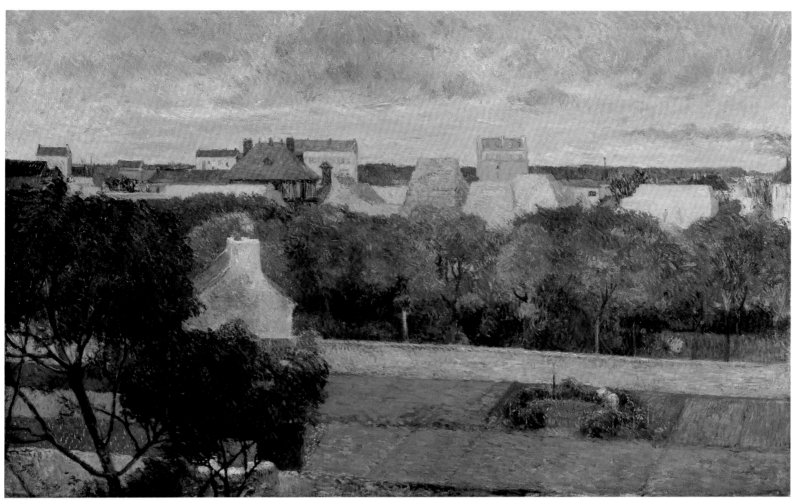

cat. 10

he painted the brilliantly original *Vaugirard Market Gardens*, it is likely that Gauguin had not yet acquired a Cézanne or even met the artist. This fact, the clearly legible date of 1879, and the connection of the painting to a work in the 1880 Impressionist exhibition mean that Gauguin conceived of this orderly composition by himself, without access to Cézanne.

Sylvie Crussard has identified the motif as a view from the window of Gauguin's home and studio on the Impasse Frémin, which he rented for his family in June of 1877.[59] The sheer detail of her analysis and her publication of a contemporary plan of the area of Vaugirard suggest almost that the painting is a topographical view. Yet in spite of his fidelity to the motif, his compressed and banded order

of vegetation, architecture, vegetation, and sky suggests that he was interested less in topography than in rigorous pictorial construction. His minute strokes of paint, neatly segregated into areas, have nothing to do with the strong, thick, diagonal strokes that were to be used by Cézanne in Medan a year later, but Gauguin's composition is equally ordered and rational.

As in his earlier Pontoise landscape, Gauguin omitted or deemphasized any apertures in the numerous buildings in the middle ground. This gives the painting the character of an architectural massing model rather than a study of urban social realities. Its rigor harks back to Pissarro's extraordinary series of paintings of l'Hermitage done in 1867 and 1868, particularly to *View of l'Hermitage,*

Côte du Jallais, Pontoise (fig. 64) which had not yet been sold by the older painter. It has no clear precedents in Gauguin's own work and seems to be an experiment in an abstract picture making that he never repeated in quite the same way.

Perhaps the most pictorially disturbing aspect of the painting is its almost obsessive small-scale facture. Given the fact that the composition is clear and simple, the painter's decision to employ an almost knitted facture, with literally hundreds of small-scale touches, perhaps thousands, separates the acts of conception and execution in a way that is antithetical to Impressionist landscape practice. This explains the odd ambivalence of the painting—at once strong and weak, simple and complex, masculine and feminine.—RRB

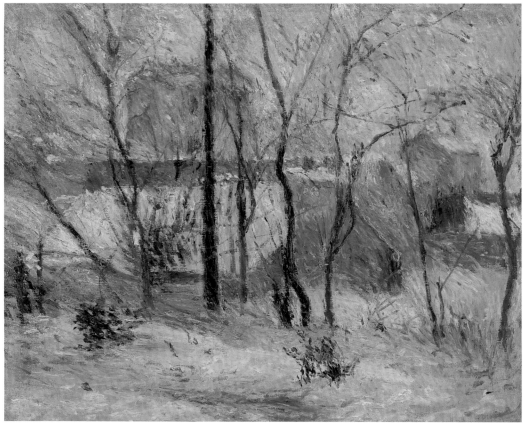

cat. | |

In northern France the winter of 1879–80 was among the most severe of the nineteenth century. Its effects were painted by scores of artists, including Gauguin—who, as we have seen, had already shown interest in urban winter effects (see cat. 2). He had seen an important group of winter landscapes by Monet in the 1879 Impressionist exhibition (fig. 65), which must have been in his mind when the great snowstorms of December 1879 moved through his Vaugirard neighborhood in Paris. He seems immediately to have painted the Copenhagen "sketch," most probably from a window as described in detail by Sylvie Crussard, using the deft blue, brown, yellow, and white oil sketch as the basis for a larger and more time-consuming composition.[60] The final painting, now in Budapest, is the first of Gauguin's snowscapes to be exhibited in his lifetime—it appeared as *Effet de Neige* in the Impressionist exhibition of 1880. It is even possible, as some have suggested, that the Copenhagen painting was also included in the exhibition under the generic title *Etude*.

Both paintings provide structure for the composition with a large, virtually plumb-straight tree trunk placed somewhat to the left of center. Directly behind this plane-defining form is a tall house, which anchors the background just as the tree does the middle ground. This device has its roots in the vertical screen landscapes of Gauguin's mentor, Pissarro, most notably the famous *Côte des Boeufs at l'Hermitage*, in the National Gallery, London (fig. 66), which Pissarro included in the 1877 Impressionist exhibition. More recently, Gauguin had seen an even more closely comparable Pissarro, *The Sente des Pouilleux, Pontoise (with Chickens in the Foreground)* (private collection), loaned by Eugène Murer to the 1879 Impressionist exhibition; though a vertical composition, this has an arrangement of vegetation and architecture similar to that employed by

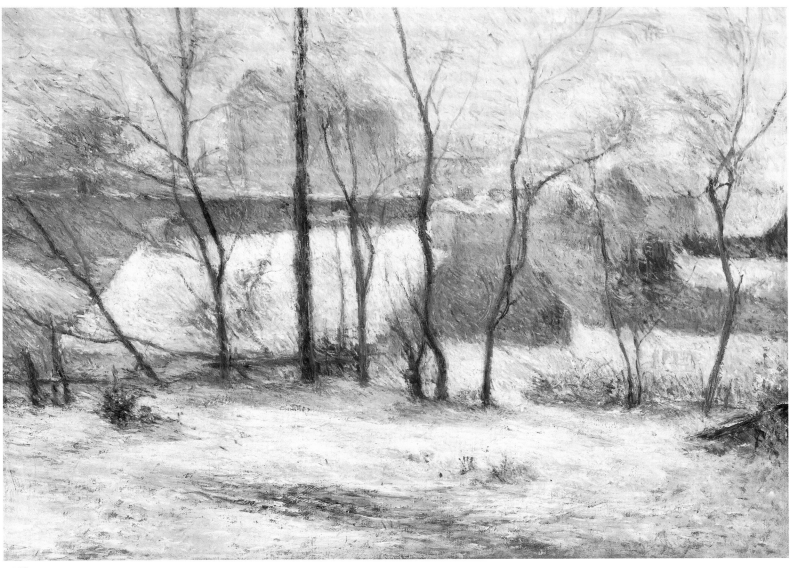

cat. 12

Gauguin. To the complex screen landscape compositions of his mentor, Pissarro—whose great landscape in Cleveland (see fig. 33) was among the largest and most important landscape paintings in the 1879 exhibition— Gauguin seems to have applied chromatic lessons learned from Monet. But the most direct prototype for Gauguin's experiment was the Pissarro now known as *Snow Effect near Pontoise*, probably no. 171 in the catalogue of the 1879 exhibition, entitled *Effet de neige et glace (effet de soleil)* (fig. 67). The banded structure, palette, and horizontal composition of this work were certainly in Gauguin's mind

as he painted the view from his home-studio window during a snowstorm in December of 1879.

In both the "direct" painting of the Copenhagen version and its almost infinitely patient translation into an exhibition picture in the Budapest version, Gauguin well conveyed both the softness and the silence of a winter storm, which blankets all pictorial planes in white and creates a dispersed, shadowless realm of blurred forms. Gauguin's decision to create a contrast of geometric and organic structures makes both versions at once subtle and original. In every aspect but this, Gauguin

rooted his practice in Impressionist precedent, and it is perfectly clear that his first Impressionist study of snow emerged directly from a careful study of paintings by Monet and Pissarro in the 1879 exhibition. Yet the painting could be mistaken for neither a Monet nor a Pissarro. Gauguin was temperamentally unsuited for the kind of compositional messiness in which Pissarro revels in a winter landscape such as *Rabbit Warren at Pontoise, Snow* (fig. 68), and his carefully ordered observations show no real connection to the thick strokes of viscous paint that Monet used in his contemporary snowscapes and studies of ice floes on the river.—RRB

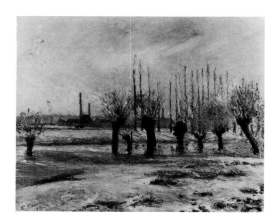

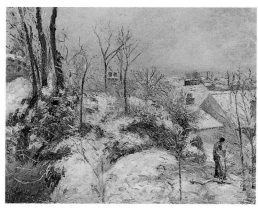

Fig. 67 (*above*) Camille Pissarro, *Snow Effect near Pontoise*, 1879. Oil on canvas, 20¹/₂ × 25 in. (52 × 63.5 cm). Private collection, Switzerland (PV 477)

Fig. 65 (*top left*) Claude Monet, *The Church at Vétheuil, Snow*, 1879. Oil on canvas, 20⁷/₈ × 28 in. (53 × 71 cm). Musée d'Orsay, Paris (RF 3755)

Fig. 68 (*above*) Camille Pissarro, *Rabbit Warren at Pontoise, Snow*, 1879. Oil on canvas, 23³/₈ × 28¹/₂ in. (59.2 × 72.3 cm). The Art Institute of Chicago. Gift of Marshall Field (1964.200) (PV 478)

Fig. 66 (*top right*) Camille Pissarro, *The Côte des Boeufs at l'Hermitage*, 1877. Oil on canvas, 45¹/₄ × 34¹/₂ in. (114.9 × 87.6 cm). The National Gallery, London. Presented by C. S. Carstairs to the Tate Gallery through the National Art Collections Fund, 1926; transferred 1950 (NG 4197) (PV 380)

13

Jug and Mug, 1880
Oil on canvas, 21$^1/_4$ × 25$^5/_8$ in. (54 × 65 cm)
Signed and dated lower left: *p Gauguin 80*
The Art Institute of Chicago. Millennium Gift of
 Sara Lee Corporation (1999.362)
WII 60

Gauguin included one still life among his eight
submissions to the 1880 Impressionist
exhibition, calling it simply *Nature Morte*.
Which among his known still lifes might this
have been? There are no still lifes dated to
1878 or 1879. Among the candidates from
1880, we can identify three as having been
included in the 1881 exhibition, and he is
unlikely to have submitted any of these twice.
This leaves two possibilities: the small, undated
still life with oranges in Rennes (fig. 69) and
the larger and more ambitious Chicago still life
now called *Jug and Mug*. In the catalogue
raisonné Sylvie Crussard argues for the latter
simply by including the information for the
Nature Morte in the 1880 Impressionist
exhibition as the first entry in the exhibition
history of the Chicago painting—with a
question mark, signifying, correctly, that one
cannot be sure. Her reasoning is rigorous and
logical. She concludes that the work was most
likely painted in Vaugirard—in the Impasse
Frémin apartment, where the painter lived for
three-quarters of the year in 1880 rather than
in the larger apartment with its garden on the
Rue Carcel.[61] Hence, it would have been
painted early enough in the year to have been
included in the April exhibition. One would
also argue for the Chicago painting over the
Rennes painting because of the two it is the
more ambitious and accomplished. Had he
completed it after the 1880 exhibition,
Gauguin would surely have included it in the
1881 exhibition, but there is no such evidence.

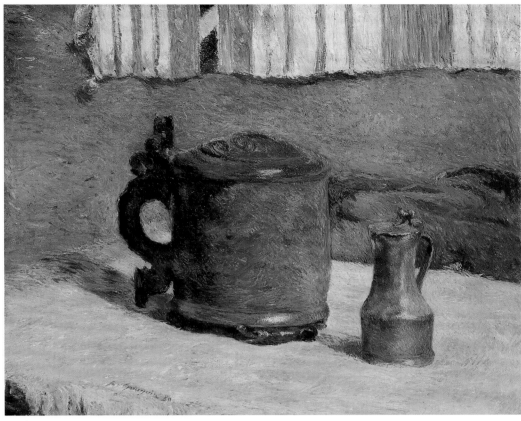

cat. 13

Like many of Gauguin's works in this genre
of painting, the Chicago still life is profoundly
original in that it has no direct prototypes in
the painting of any other artist. When he
painted landscapes, Gauguin seems to have
been more burdened by the example of others
and wrestled with motifs, compositions, and
factures that can be directly linked to
prototypes. When he was arranging forms in
his apartment or studio for patient still-life
study, he did so without bothering very much
about Manet or Cézanne, or even Chardin. In
the case of the Chicago still life, this is
distinctly the case. It is difficult to find an
earlier still-life painting of any importance that
is composed simply by juxtaposing two
contrasting vessels in the center of a table. We
see similar tankards and pitchers in northern
still-life painting from the seventeenth century
forward but, in each case, they are included
among a group of contrasting forms in an
arrangement that emphasizes volumes and
textures. There is perhaps a precedent—but

only one, and an unlikely one at that—in the
numerous still-life paintings of the 1870s by
Cézanne, *Jug and Cup* (fig. 70). This small
painting places a vertical tin pail with a round,
handleless ceramic cup on a ledge or table. It is
perhaps the baldest contrast of cylinder and
sphere in all of Cézanne's still-life practice; it is
also a contrast between metal and clay. Could
Gauguin have known it? The answer is
probably no, because he did not work actively
with Cézanne until the next year. Moreover,
although the works are similar in their bold
juxtaposition of contrasting forms, they are
compositionally, chromatically, and stylistically
unrelated.

Sylvie Crussard, following other scholars,
has identified one vessel (preferable to the
word "pot") as an eighteenth-century wooden
tankard (or, in Norwegian, *tine*) from Mette
Gauguin's family (see fig. 72). Gauguin used
this several times in later still-life paintings.
The second vessel has never been carefully
studied, although Gauguin also used it in a

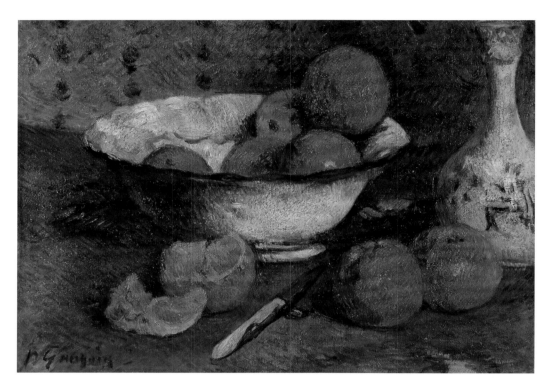

Fig. 69 (above) Paul Gauguin, *Still Life with Oranges*, 1880. Oil on canvas, 13 × 18¹/₈ in. (33 × 46 cm). Musée des Beaux-Arts, Rennes (D.55.5.1) (WII 59)

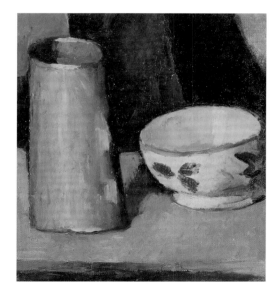

Fig. 70 Paul Cézanne, *Jug and Cup*, c. 1873–77. Oil on canvas, 7⁷/₈ × 7¹/₈ in. (20 × 18.1 cm). Bridgestone Museum of Art, Ishibashi Foundation, Tokyo (R 425)

later painting, this time in juxtaposition to a plate of tomatoes. It is a tin or pewter pitcher—a kitchen vessel rather than something that would be used in the dining room. It is represented as used and dented, and turned so that its small spout faces the viewer. Both vessels are set on a piece of yellow, fringed cloth, and Gauguin has placed an unfolded green cloth in a pile behind them. His signature and the picture's date are placed at an angle in keeping with that of the yellow cloth and, by extension, of the table on which the elements of the still life are placed. Thus the artist subtly affirms his role as the arranger of the pictorial elements as much as he does

his role as their painter. The final element is a woven, striped and fringed cloth, here making its first appearance in a painting by Gauguin, that has generally been referred to as Peruvian. To the present author's knowledge, no one has actually proven the latter point, but it is clear that the cloth is not European, and that, therefore, its origins are exotic.

Chromatically, the painting is arranged in subtle contrasts—violet blue and yellow, green and orange—and the inclusion of the woven cloth makes a link between the painting and the well-known theories of pictorial color derived from textiles by Michel-Eugène Chevreul. The pictorial evidence here suggests that, by the time he painted this still life, Gauguin had read or heard a passable summary of Chevreul's theories. Many artists, Pissarro included, were familiar with these theories—which originated in lectures at the Ecole des Beaux-Arts almost two generations earlier. It is nonetheless interesting to see Gauguin showing evidence of an interest in pictorial theory rather than simply imitating the advanced artists of his acquaintance.

What did Gauguin intend to signify through the juxtaposition of two hard vessels in a setting dominated by textiles? The most intriguing explanation that has been proposed involves Gauguin's interest in fables and the visual connection between the still life and the fable of La Fontaine (and Aesop) called in French *Le pot de fer et le pot de terre* (the iron pot and the clay pot). Sylvie Crussard has correctly pointed out that it is rather difficult to establish a direct connection because the larger vessel is made not of clay, but wood. Yet, the idea of a fable that contrasts the aspirations and fates of two vessels of diverse material is clearly relevant. It might, in a certain sense, be interpreted as a "portrait of a marriage," in which Gauguin embodied the

character and national origins of his wife in the large Danish drinking vessel and set that in contrast to a small, dented pitcher that has known a different kind of wear. If the textile is Peruvian, as many have asserted, this could also be applied to the cloths, making *Jug and Mug* among the most complex "domestic" still-life paintings in the history of art. The Scandinavian vessel is turned so that it could be readily picked up only by a left-handed viewer, while the little pitcher actually resists being visually "handled." Perhaps one is intended to be filled with beer and the other with milk or cream, in which case there is as great a contrast in their contents as in their forms.

This unprecedented and extraordinarily inventive still life strives for mysteries through contrast—of colors, materials, shapes, nations, and textures. As viewers, we are forced for the first time in Gauguin's oeuvre to come away asking unanswerable questions.—RRB

Anne-Birgitte Fonsmark **Gauguin Makes Objects**

GAUGUIN WAS ACUTELY CONSCIOUS OF THE LOW STATUS and quality of contemporary decorative art. He lamented the decadence and lack of soul in industrial mass production and dreamed of creating a new solidarity between the fine and decorative arts. He had much in common with British artists of the Arts and Crafts Movement. There were comparable developments in France in the early 1880s and Gauguin became part of them. At the same time he was well aware of the fact that there was no longer much of a market for this type of work, and his frustration at this was great. Nevertheless, his work and method became profoundly unique and his way of solving problems very personal.

From some of his letters it is obvious that his relationship to decorative art in general was colored by these tendencies. In November 1882 he wrote to Pissarro complaining that sculptural work had no meaning or justification in their age,[62] and in one of the long, reflective letters from his period in Copenhagen—again to Pissarro—he connected the decline in decorative art to the broader development of society and culture in the nineteenth century. The letter was directed at Pissarro as a socialist, and it was not without a touch of polemical banter that he wrote of the price to be paid for socialization and democratization and the cost of equalizing the social classes. Lurking behind this long—and hitherto overlooked—attack was a dream of feudal times. "In short," he concluded, "I believe that the more uniform the masses are, the less is their need for art. These needs presuppose contemplation, a love of luxury born amid grandeur, a sense of the irregular in social rank and little calculation. . . . *Carton-pierre* in the apartments has destroyed sculpture; gilded paneling, family photographs, and café mirrors occupy all the space on the walls. . . ."[63] In affluent homes such as those of his granduncle in Peru and his guardian, Gustave Arosa, in Paris, he had himself developed a love of such luxurious surroundings.

Although Pissarro did not always agree with Gauguin's political views, he was to a certain extent drawn into the younger artist's dream of reviving the decorative arts. In 1882 they discussed a dining-room panel that Pissarro might possibly leave with Gauguin,[64] and in the following year they undertook a major project creating models for "Impressionist tapestries." Apparently the two artists occasionally exchanged works for mutual evaluation, and in a letter to Pissarro from November 1882 Gauguin put forward some general considerations concerning sculpture and decorative art in wood. He had sent Pissarro the wood relief that was later to become known as *La Toilette* (see fig. 143), and Pissarro had acknowledged this in a letter (now lost) that not only contained "compliments," but apparently the suggestion that Gauguin's talent could become a source of income. Gauguin's reply was devoid of illusion: "You are singularly mistaken if you think that it's possible to earn money with wood sculpture (I mean intelligent sculpture). Wrong! Does good painting sell easily?"[65]

It emerges from the rest of the letter's contents, which gradually also come to deal with furniture design, that Gauguin attached no importance to the distinction between sculpture and decorative art that had arisen in the academies. Sculpture in wood, "intelligent sculpture," is mentioned in the same breath as furniture design. In this latter

area, too, he makes it clear that he has no illusions as regards sales: "Apart from some very rare exceptions, are there any rich people who are prepared to pay for an original work? People will have beautiful furniture reproduced from the old models, but who will consider furniture as a potentially high art form?" Designing furniture would be a waste of time for an artist since there would be neither customers to buy the product nor craftsmen to produce it. "You must come across this whenever you want to order a simple frame of an unfamiliar design. What difficulties you face! No, these days everything is routine, and to escape from it requires such *unity* among the artists and such openness of opinion that it's like throwing yourself in the water merely to think of it."[66]



Objets trouvés
—as fascination and
source of inspiration



Gauguin's activities in the field of furniture design were indeed to be confined to his own home, but through his quite unique pearwood cabinet (cat. 15) we can gain an idea of how he imagined furniture could be rejuvenated. The cabinet must be seen in the context of his dream of reviving the design virtues of a former age and as an answer to the decline of contemporary furniture and decorative art in general. Apparently created around 1881 for the dining room in the Gauguin family's new home in the Rue Carcel, it must—in its day—have been provocative in its simplicity. Its plain, rustic character, its simple sectional construction, and the handles for moving it around all belonged to a preindustrial culture.

The kind of art he admired suddenly became very distinct. The construction of the cabinet's central section might be influenced by Oriental furniture,[67] and its partly painted and gilded wood carvings draw on sources of influence from several cultures. The decorative program has a hierarchy of motifs rising from the exotic, abstract patterns in the flat relief of the cupboard doors by way of the naturalistic children's profiles and festoons of fruit in the low relief of the upper cupboard to the sculpture in the round at the top. In this climactic position Gauguin placed an independent object in the shape of a fine piece of carving from the seventeenth century—a basket of fruit— which became part of the work and at the same time not part of the work (cat. 14). This was the first example of an *objet trouvé* (found object) in Gauguin's work.[68] It signaled a revolutionary renewal of the idea of sculpture and the idea of artist as creator. The basket of fruit was not created by Gauguin but found; as we shall see, it was also adapted or modified by him.

Somewhere or other, he had found this basket of fruit along with three relief planks with which it formed a seventeenth-century newel (fig. 73). With its profusion of fruit and its foliation the work is a delight to the eye. It shows a striking quality of craftsmanship in its interplay between sophistication and primitiveness. But Gauguin was not content merely to own and admire it; in addition came the desire to take it over in an artistic sense—to work further on it. On top of the subdued shades of the original paint we find a layer that was clearly applied by Gauguin himself—red, green, yellow, and gilt.[69] By painting and gilding the basket of fruit he underlined its naïve

right Paul Gauguin, cabinet (detail of cat. 15)

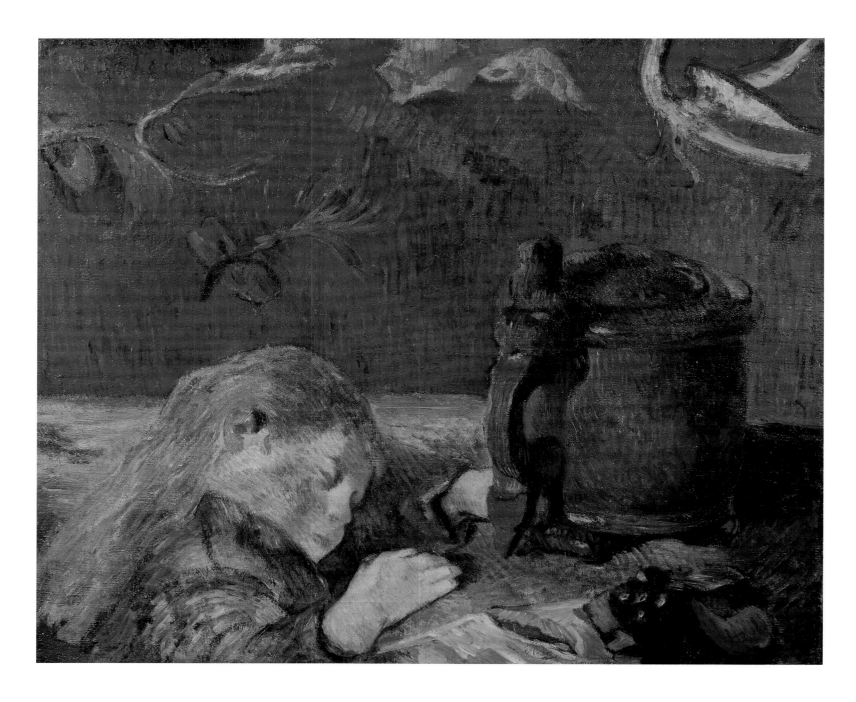

carving and anticipated some central concepts of twentieth-century avant-gardism, the found object and modification.

There is no doubt that the old carvings that Gauguin owned—which remained in his possession until he left them behind in Denmark in 1885, along with the cabinet and all the rest of his earthly possessions—were of enormous significance for the development of his own style in carving. The rustic and unsophisticated features that he admired in them soon appear in his own decorative works and domestic utensils. Certainly they inspired the festoons in the upper part of the cabinet, with all their asymmetrical, Rococo-like charm. Their importance for Gauguin comes through again in his portrait of his son Clovis from 1886 (cat. 55), where he painted the carved basket of fruit in the background, from memory. In this last record of his favorite son, the almost sculptural

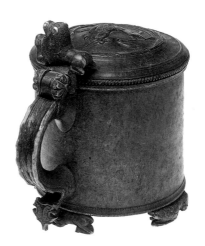

Fig. 72 A *tine* (Norwegian lidded tankard), 1740. Wood, height 9 in. (22.9 cm). Collection: Ronald Cohen, London

quality of the boy's features seems to take shape in accordance with the memory of the carving.[70] This parallels an earlier portrait of his son, *Clovis Asleep* (1884; fig. 71), in which he painted the boy alongside another wooden object that was important to him in his Impressionist years, the large Norwegian *tine*—a lidded vessel with carved lion motifs on the surface (fig. 72).[71]

The basket of fruit on the cabinet is the first obvious example of Gauguin's revolutionary use of found objects but it is scarcely the only one. The small rosebuds on the cabinet doors were probably created by someone other than Gauguin himself and could be from the eighteenth century. He also found them somewhere and, as a complete matter of course, without scruples concerning the creator, incorporated them in his own work—perhaps after first freshening the gilt.

The cabinet was perhaps Gauguin's first truly composite work—with the Oriental starting point in its construction, the possible models for the abstract patterns in South American art, and the European element of found objects. East and West were mixed, but one feature bound them together and became typical of all Gauguin's work: the inspiration of "primitive" and folk art—art before the academies and art outside the academies. Gauguin was to formulate his rejection of the Western academic tradition in a famous letter to Daniel de Monfreid, in which he emphasized Oriental and Egyptian models and warned against classical antiquity: "The great error is Greece, beautiful as it might be."[72] He visualized the opposition of East and West, academic and "primitive," in a still life that he painted in 1886 as a kind of visual manifesto (cat. 57). The famous horse's head from the Parthenon, an icon of Western sculpture, is contrasted with a couple of Oriental objects—a Japanese fan and a Chinese doll—that represent the artistic frame of reference of the avant-garde.

14

Basket of Fruit, 1880
Unknown wood-carver and Paul Gauguin, early
 17th century/c. 1880
Painted and gilded oak, height 13⅝ in. (34.6 cm)
Ny Carlsberg Glyptotek, Copenhagen

Fig. 73 (*right*) Three plank reliefs, seventeenth century.
Ny Carlsberg Glyptotek, Copenhagen

Fig. 74 (*below*) The handrail of the Hôtel Richelieu-
Bassompierre, Paris

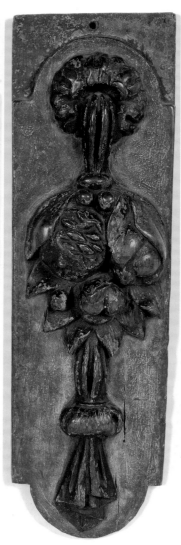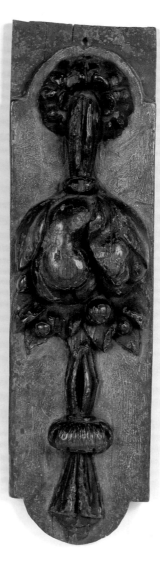

Gauguin's fascination with the object, and his view of sculpture and decorative art as closely related, found expression in his mania for collecting. It is well known that during the first half of the 1880s he assembled a fine collection of Impressionist paintings—and that he used them as something in the nature of practice pieces for his own early attempts at painting in the Impressionist manner.[73] But he also made other remarkable acquisitions, mainly of decorative art. While still a broker and amateur painter, he purchased Oriental rugs and Rouen faience of the type found in any middle-class home.[74] More remarkably, he had an early appreciation for unpretentious rustic

art, of which he acquired examples. Some appear as still-life objects in his paintings: a green enameled earthenware jug;[75] a splendid Norwegian lidded tankard from the eighteenth century (a type known as a *tine*);[76] a pair of simple wooden clogs, the position of which, hanging beside the piano in the artist's new home in the Rue Carcel, is almost an act of confession to craft traditions (see figs. 71, 72 and cats. 13, 25).[77]

The present carving was among the more important pieces of decorative art in Gauguin's collection. It consists of three similarly fashioned relief planks (fig. 73) and a freely sculpted basket of fruit and vegetables.[78] It

102 Becoming an Impressionist Painter–Sculptor cat. 14

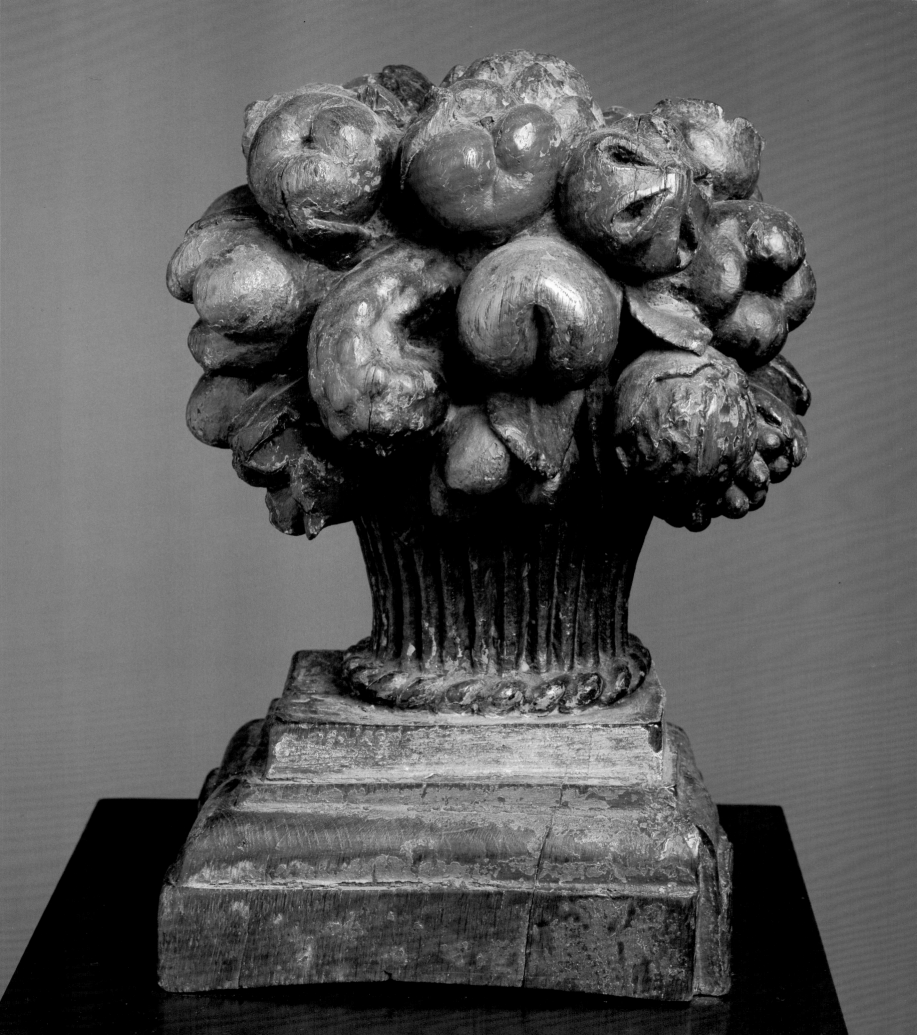

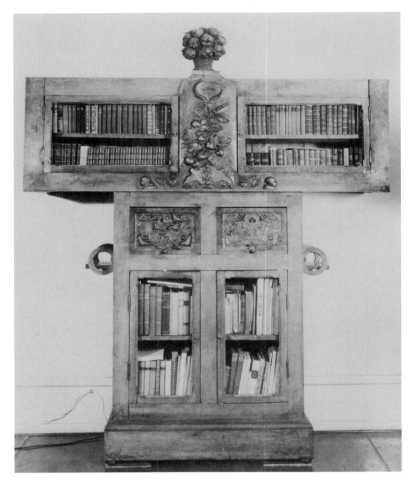

Fig. 75 Cabinet with *Basket of Fruit*. From Gray 1963, no. 5

Gauguin made around 1881 (cat. 15), and the basket of fruit was given its natural position at the top, where it undoubtedly stood for many years (fig. 75). Both the display cabinet and the basket of fruit came to Denmark when the family moved there in 1884, and there they remained when Gauguin left in June 1885. The portrait he painted of his son Clovis in 1886 (cat. 55) shows that he did not forget the piece; his inclusion of the basket of fruit beside the boy must be seen as a recognition of its significance for him. Melissa MacQuillan wrote of the basket of fruit as a bouquet: "Even the fruitlike flowers and the half-cross . . . seem pregnant with sense, but their meaning is imprecise,"[83] and the authors of the recent Wildenstein catalogue of Gauguin's paintings referred to "the 'floral' composition in the background" with its "strange and almost emblematic appearance."[84] The Wildenstein authors wrote that this element was "painted from life," but this cannot be the case. In fact, it must have been painted from memory, which explains why it differs from the actual object both in shape and color.
—A-BF

15

Cabinet, 1881
Pearwood, $78^{3}/_{8} \times 71^{5}/_{8}$ in. (199×182 cm)
Signed on top section: *GAUGUIN FECIT*
Museum für Kunst und Gewerbe, Hamburg
 (1978.90/St. 334)
Ordrupgaard only

Gauguin's fascination with the basket of fruit and the newel can be seen in quite concrete terms in the imaginative display cabinet that he made for his own home in about 1881.[85] Formed in an idiosyncratic "T" shape, the

must have been made in the first half of the seventeenth century, and probably constituted the newel of a staircase surmounted with the basket of fruit (fig. 74).[79] The relief planks are adorned with elegant fruit vines, while the basket—which was placed at the top of the newel—overflows with ripe produce. Beautiful, rounded apples, pears, and squash compete for space with pineapples, bunches of grapes, and fantasy fruits, and there is a mass of foliage among them. The wood is oak, and there remain traces of the original paint, which was black, brown, and pale green. The newel was to become of crucial importance for the development of Gauguin's own wood carving. It was a source of inspiration for the pseudo-primitive style that was to be characteristic of his work in wood in Martinique and the South Sea Islands—the first signs of which manifest themselves in the Impressionist years.

The powerful aura of the newel and its obvious importance for Gauguin's style of wood carving come as a surprise, but still more extraordinary is the fact that the painted surface represents a hitherto unknown work by him.[80] On top of the subdued shades of the original paint there is a coat that, without any doubt, he himself applied.[81] The pigments are identical to those on the relief *The Singer*, which dates from the same period (cat. 21). Gauguin must have found the idea of adding his own colors to the piece irresistible. He painted the fruits and foliage in bright yellow, red, and green, and gave the basket and the pineapple at the top a touch of gilt. The red and the gilt are found in *The Singer* and seen with the green in a number of Gauguin's later wooden artifacts and other works.[82]

The newel was the starting point for the wood-carving style in the display cabinet that

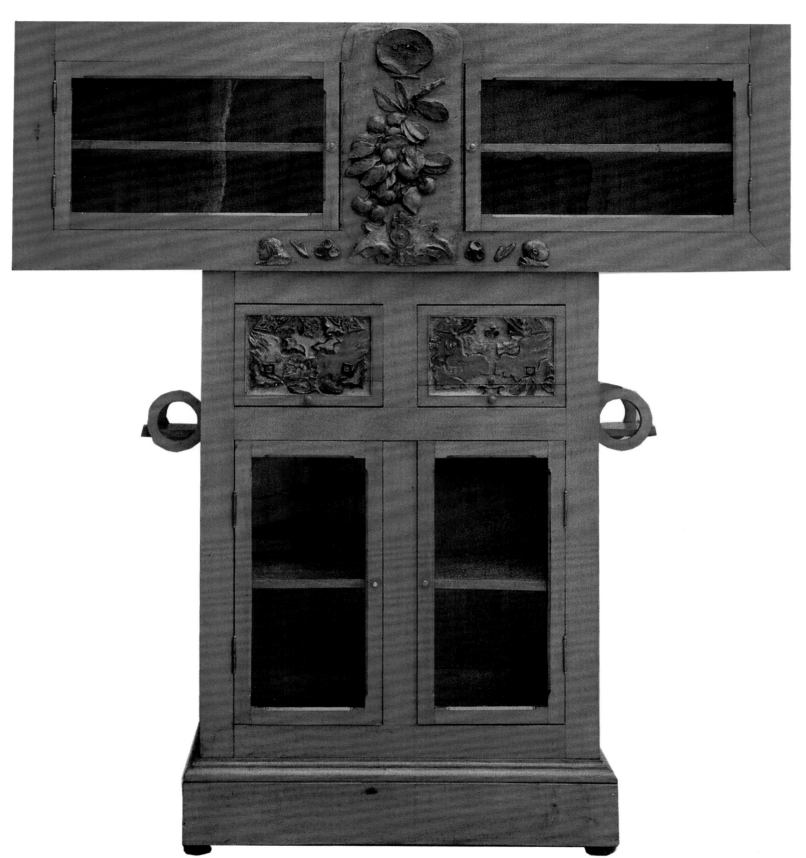

cat. 15

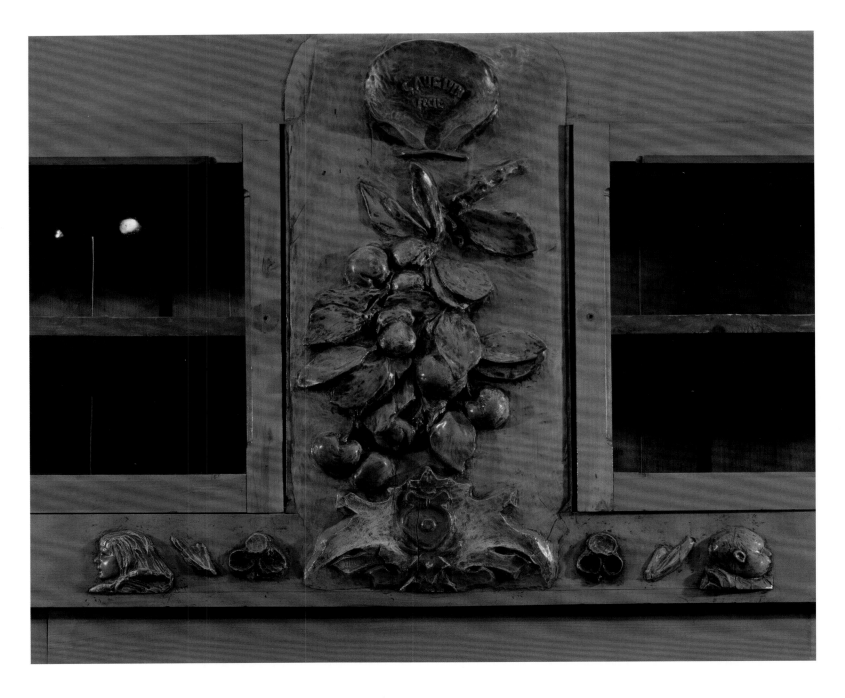

Fig. 76 Paul Gauguin, cabinet (detail of cat. 15 showing fruit festoon of the top section)

cabinet is decorated with carving that in various places is painted in bright colors.[86] Gauguin must already have possessed the newel by this time, and the style of carving in the basket of fruit inspired him in the decoration of the upper part of the cabinet and the garland of flowers and foliage that he carved for the broad central bar (fig. 76).[87]

The boxlike structure of the display cabinet owes much to the influence of Oriental furniture. It shows certain similarities, for instance, to Alphonse Giroux's japoniste cabinet of 1880, the wood of which is inlaid with bronze, silver, and cloisonné enamel.[88] But Gauguin drew upon more than just one source. Under the multitude of fruits—among the small leaves and a couple of portrait medallions of the artist's sons Clovis and Jean[89]—there is a more idiosyncratic ornament that Merete Bodelsen interpreted as being of Peruvian origin.[90] This serves as a transition between the Western decoration in the upper

Figs. 78a and b (*right*) Paul Gauguin, cabinet (details of cat. 15 showing the doors of the middle section)

Fig. 77 Paul and Mette Gauguin, cross-stitch embroidery (detail), 1879. Height 6¹/₂ in. (16.5 cm). Formerly Marie Heegaard's collection

part of the cabinet and the two doors of the lower part, the painted, abstract patterns of which also seem to have their ancestry in "primitive," non-European cultures, matching those in the embroidery that Gauguin made together with his wife Mette (fig. 77).[91] Gauguin disturbs the stylized unity of these doors by adding a couple of naturalistic roses (figs. 78a and b). Meticulously carved and gilded, these are undoubtedly another example of the incorporation of found objects in his early work.[92] Somewhere or other, he came across these two small pieces of carving and, as in the case of the newel, was unable to resist working on them and establishing a dialogue between them and his own carving. The incorporation of found objects assumes a programmatic character, paying tribute to the times when craft still enjoyed general respect.

Gauguin signed his cabinet in the shell in the upper section. The Latin inscription "Gauguin fecit" emphasizes that this was not to be regarded as merely a piece of furniture, but as a work of art.[93]—A-BF

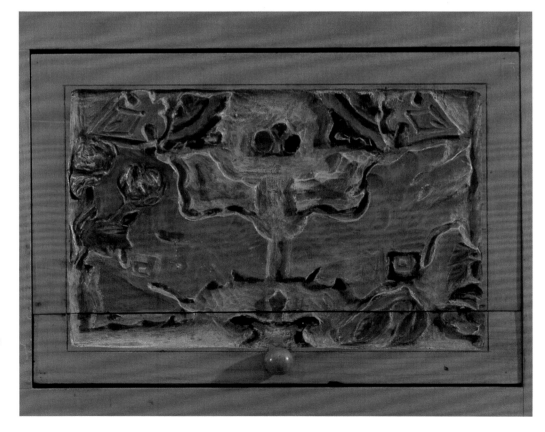

Fig. 79 Edgar Degas, *Little Dancer Aged Fourteen*, 1879–81. Yellow wax, hair, ribbon, linen bodice, satin shoes, muslin tutu, wood base, height 39 in. (99.1 cm). National Gallery of Art, Washington. Collection of Mr. and Mrs. Paul Mellon (1999.80.28)

facing page Paul Gauguin, *Nude Study (Woman Sewing)* (detail of cat. 19)

THE SIXTH IMPRESSIONIST EXHIBITION WAS Gauguin's debut both as an avant-garde sculptor and as a painter of the human figure. He also exhibited an important group of still-life paintings, perhaps the most original—if not the most ambitious— works of his career. The exhibition was the least successful and important of the eight group exhibitions in the short history of the movement. It included major works by Cassatt, Degas, Morisot, and Pissarro in addition to Gauguin, and minor works by Jean-Louis Forain, Armand Guillaumin, Jean-François Raffaëlli, Stanislas-Henri Rouart, Charles Tillot, Eugène Vidal, Paul-Victor Vignon, and Federico Zandomeneghi. It was most notable, however, for being boycotted by Monet, Renoir, Sisley, and Caillebotte, all of whom were perceived by the press and the public at large as central to the movement's identity. For a relatively new artist like Gauguin this was an opportunity to play a more important role than would have been possible in their presence.

If earlier Impressionist exhibitions were known for what became, in effect, dominating critics—Duranty and Mallarmé in 1876, Rivière in 1877, Martelli in 1879—the critic who played the role in both 1880 and 1881 was Joris-Karl Huysmans, whose reviews of each exhibition were the longest and most complex. His reviews of the 1880 exhibition could be classified as a diatribe, but by 1881 he had honed his critical skills (if not learned to restrain his pen!) and was the first critic of note to recognize the importance of Gauguin to Impressionism. There were two works of art that dominated the discourse, Huysmanian and otherwise, around the 1881 exhibition: Degas's *Little Dancer Aged Fourteen* (fig. 79) and Gauguin's *Nude Study (Woman Sewing)* (cat. 19). These works were considered essential to the developing naturalist aesthetic of the late 1870s and, although they were rarely discussed comparatively, each was singled out for its formal and iconographic innovations. Each dealt forthrightly with the contemporary figure, Degas stressing the public realm and Gauguin the private. Degas approached life in every sense but scale. The little dancer was little in two senses, at once three-quarter-life in scale and small of stature; although her body was made of tinted wax, however, her dress, hair, ribbon, and shoes were "real." Gauguin's woman was precisely life-size and rendered with a fidelity to the particularities of the model that made certain viewers feel almost as if they were in her presence. Her complete disregard for the existence of the viewer as well as her absorption in a mundane task made her "presence" in the gallery all the more disturbing.

Because of Huysmans, Gauguin's presence in the 1881 exhibition was felt more strongly than it had been before or would be again. Briefly, in that year—and because of a single major painting—he was central to the discourse around Impressionism. Mysteriously, he seems to have retreated from this role and was almost as recessive in the next exhibition as he had been dominant in 1881. Unfortunately, we can only speculate as to his reasons for the retreat. Did they come from economic troubles, doubts from his wife, or, more likely, criticisms from Pissarro or Degas? Whatever the reason, Gauguin failed to complete another major figure painting until 1886, when he painted *Breton Women Chatting* (see fig. 253). This is particularly unexpected since his large, almost empty *Interior, Rue Carcel* (see cat. 25), shown at the 1882 Impressionist exhibition, was dominated by the figure paintings of Pissarro, Caillebotte, and Renoir.

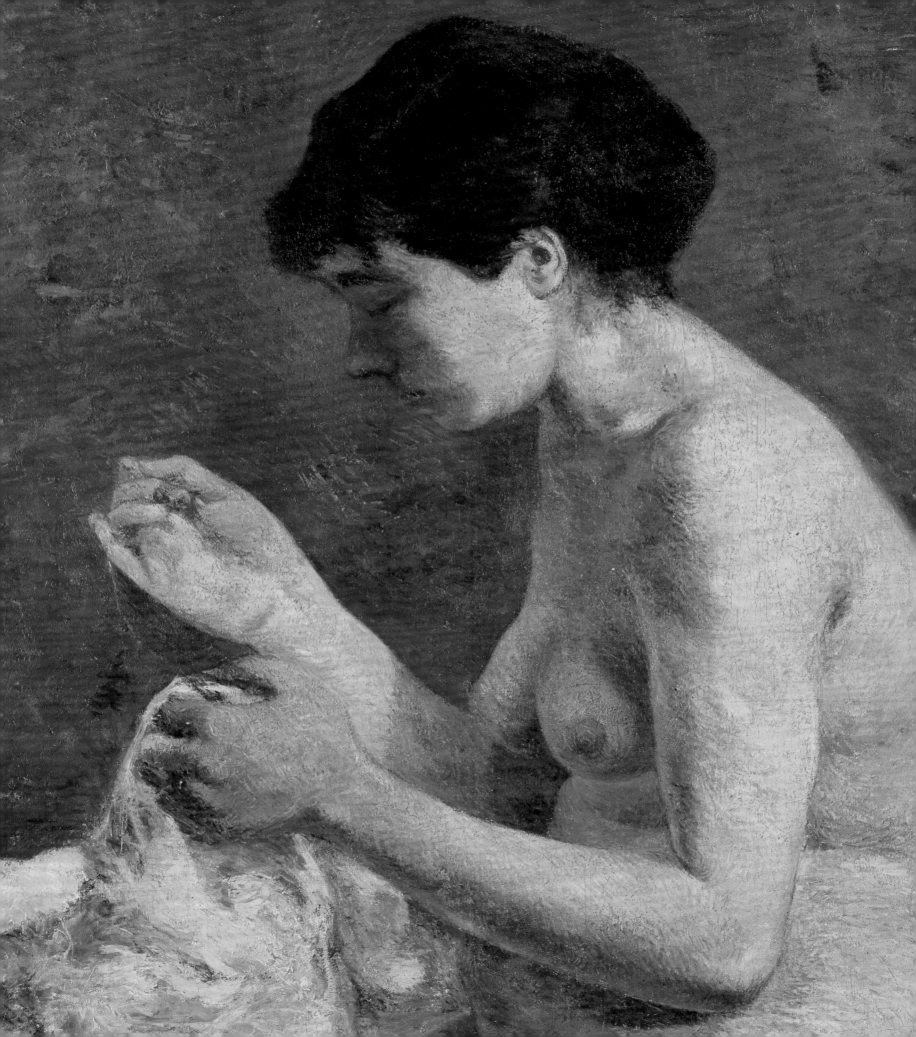

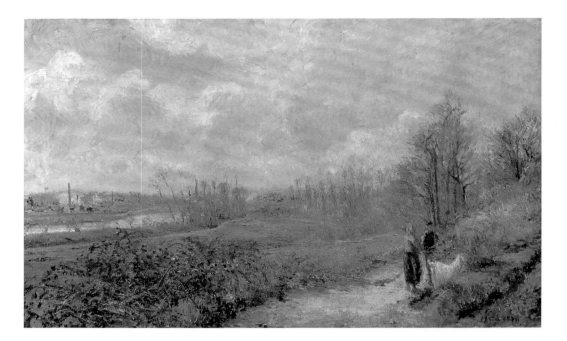

16

Houses, Vaugirard, 1880
Oil on canvas, 31⁷/₈ × 45¹/₄ in. (81 × 115 cm)
Signed and dated lower left: *p Gauguin 1880*
The Israel Museum, Jerusalem. The Sam Spiegel
 Collection
WII 58

The site represented in this ambitious and important landscape eluded historians of Gauguin's oeuvre until the publication of Sylvie Crussard's entry in the 2001 catalogue raisonné. Crussard identified the site as the suburban landscape seen from the yard of Gauguin's apartment on the Impasse Frémin in Vaugirard. Thus she correctly connects the work to the series of large-scale Vaugirard landscapes made in 1879–80 for the Impressionist exhibitions of 1880 and 1881.[94] Like Charles F. Stuckey earlier, she identified the work as *Le Terrain de ma propriétaire (Property of my Landlady)* (no. 31) in the catalogue of the 1881 Impressionist exhibition.[95] If this is correct, the painting must have been completed too late in 1880 for inclusion in the exhibition held in April that

Fig. 81 Paul Cézanne, *L'Hermitage, Pontoise*, 1877. Oil on canvas, 18¹/₄ × 22 in. (46.5 × 56 cm). Von der Heydt Museum, Wuppertal. Gift of Julius Schmits, 1912 (R 484)

year, but before Gauguin's move from the Impasse Frémin to a nearby apartment on the Rue Carcel.

The title that Gauguin gave the painting, like most of his other titles at the 1881 exhibition, is fascinating and unusual. He decided directly to link the painting to his own life, boldly asserting that he rented his home and was not a landowner. Many Impressionist paintings were given titles that indicated precisely the landscape represented and, as precisely, the season or time of day at which they were painted. But there were few if any titles before this one in the catalogues of the Impressionist exhibitions that dealt with personal ownership. Indeed, what has always perplexed scholars about the painting is that Gauguin tells us not where it was painted, only that the property was owned by a woman. Crussard states that this was probably not the case, for Gauguin seems to have rented the Impasse Frémin apartment from a man, Auguste-Achille Boucard. But surely it is likelier that Gauguin sublet from a man a property owned by a woman than that he inverted the gender of his landlord! Whatever the case, we, as viewers, are asked to think not about place and time, but ownership.

This landscape was among the largest of Gauguin's career to date. It shares almost identical dimensions with his first important figure painting, *Nude Study (Woman Sewing)* (see cat. 19), with which it appeared in the 1881 Impressionist exhibition. The two works are, in every other sense, opposites—horizontal as against vertical; complex as against simple; unpeopled as against figural; exterior as against interior. But they were equally ambitious. Not accidentally, the laconically entitled figure painting has received the vast majority of commentary since its appearance in 1881. Huysmans, who started his long commentary about Gauguin by calling his landscapes in the 1880 exhibition "a dilution of the landscapes of Pissarro," rhapsodized about the female nude to such an extent that it shared with Degas's *Little Dancer Aged Fourteen* the defining role in the discourse about the sixth Impressionist exhibition. For Huysmans, as for others, the equally scaled landscape was, for all its size, rendered

cat. 16

invisible by its similarity to works by Pissarro. It was impossible, he asserted, to separate Gauguin the landscape painter from "the embraces of Pissarro, his master."[96]

How like Pissarro's landscapes is the Jerusalem canvas? First, it is larger and more ambitious than any Pissarro in the 1881 exhibition, including his largest, the wonderful painting then called *The Pathway at Le Chou, Pontoise* (fig. 80). Even if these two paintings hung in the same room, as they may well have done in 1881, they contrasted in many important ways. Pissarro's is full of deep space and peopled by a pair of figures chatting in the left foreground while a goat nibbles on adjacent greenery. In the background, two

factories alongside the Oise river send steam and smoke busily into the cloud-filled sky, a pictorial hymn to the beauty of a humid spring day. The river moves lazily through the background, its edges defined by two earthen roads that stand out in the green fields. If Pissarro invites us into a vast, modern, rural panorama, Gauguin offers a suburban scene filled not with space but mass, from which the viewer is resolutely shut out. We stand on the same slight incline from which Gauguin represented the winter landscapes he included in the 1880 exhibition. Here, it is simply a balding, grassy knoll with scrublike vegetation that ends in a wall of farm buildings without opening to the adjacent property. We see no

figures, animals, or even hints of human activity like the smoke from Pissarro's factory chimneys. Pissarro opens up and renders human a rural world, while Gauguin closes down a suburban one.

The painting courts an almost tragic banality, and we have no difficulty relating it to Gauguin's own sense of "otherness," which was beginning again to dominate his life. Even his sky—a band that straggles along the top of the painting—is covered by thin clouds that are themselves described by horizontal strokes of thin paint that turn even space into wall. There is, however, a loving particularity to Gauguin's observations—each cemented tile atop the foreground roofs is carefully

delineated (based on a drawing), and the black water tank and nearby yellow silage cannot but be unique. The painting evokes not isolation or alienation in general but the painter's personal alienation from a landscape he did not—and perhaps could not—own. It partakes of the landscape of emptiness that was, at that time, the province of Cézanne—who included a human figure in a pure landscape only once, when he copied a painting by Pissarro.

Again, Gauguin's painting has few stylistic or compositional affinities with paintings by Cézanne that he might have known; the most direct links are to the two views Cézanne painted in Pontoise in the summer of 1877 (figs. 81, 171), both of which he left with Pissarro before he returned to Paris and eventually Provence, and to another urban painting he made from his own window on the Rue de l'Ouest (now lost). In describing his personal sense of alienation, Gauguin relied on Cézanne at most in an indirect manner—never quoting from his work or alluding to specific aspects. It is not surprising at all, however, that, within a year of the completion of this painting, he was beginning to buy Cézannes—from the dealer Père Tanguy—and that he was to use these six works as a touchstone of pictorial achievement throughout his life.—RRB

17

To Make a Bouquet, 1880
Oil on canvas, 21⅝ × 25⅝ in. (55 × 65 cm)
Signed and dated lower left: *p. Gauguin. 1880*
Private collection
WII 62

Gauguin exhibited three still-life paintings in the 1881 Impressionist exhibition, each of which has a delightfully original title. Discarding the *nature morte* of tradition—used by him for a work in the 1880 exhibition—he called the first of his submissions *Fleurs et tapis (Flowers and Carpet)* (fig. 82). This small painting represents pansies stuffed into a proto-modern, white, ceramic cube-vase set on a woven carpet whose brilliant blue, white, red, and black pattern runs across almost the entire pictorial field. The lower edge of the

painting is nothing but the yellow threads of the carpet's fringe, which seem almost to dance. Interestingly, Gauguin's descriptive title omits reference to the small carpet broom that sits next to the vase of flowers and functions in ways similar to the knife often included in a still life with fruits or vegetables. In spite of its modest proportions, there is simply no true precedent for this remarkable painting, and the fact that it was loaned to the exhibition by no less a collector of Impressionism than the Romanian homeopathic physician Dr. Georges de Bellio gives it an added caché. The 1881 exhibition was the first time that Gauguin included mention of his collectors in the catalogue, an indication that by now he thought of himself as a professional artist.[97]

The painting has been linked to the later still-life paintings of the Nabis and, of course,

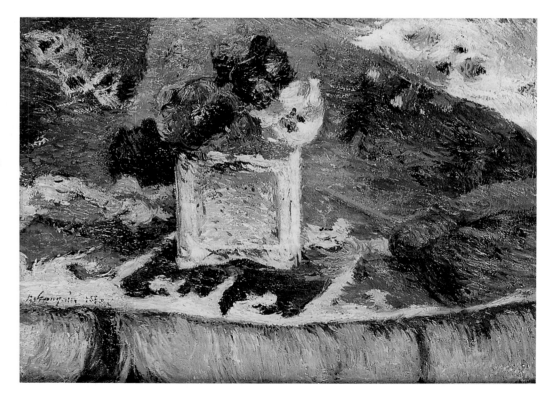

Fig. 82 Paul Gauguin, *Flowers and Carpet (Pansies)*, 1880. Oil on wood, 9½ × 14¼ in. (24 × 36 cm). Private collection (WII 61)

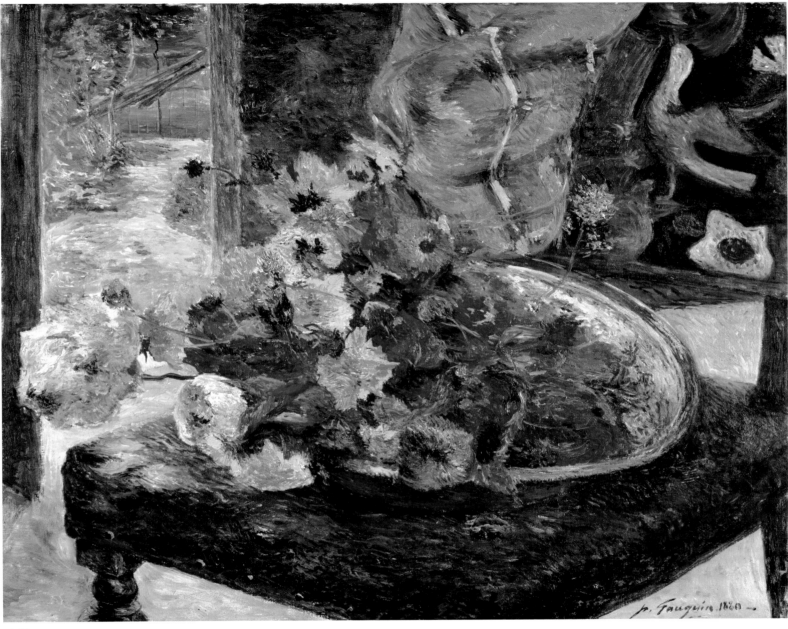

cat. 17

to Matisse. Both the Nabis and Matisse could have known the work because from 1895 it was owned by the dealer Ambroise Vollard. Yet, its sheer originality can best be demonstrated by linking it to its two companions in the 1881 exhibition. One of them, *To Make a Bouquet*, has one of the most charming titles in the history of still-life painting; it may, in addition, be the first modern still life in which the subject is arranged not on a ledge or a table, but on the seat of a chair. What we see is a still life not of balance and arrangement, but of process. With the title as a hint, Gauguin casts the viewer as a woman who has come in from the garden we see through the open door, having just cut a group of diverse seasonal flowers and placed them in a ceramic plate on the nearest chair before going to the kitchen to fill a vase with water. We are offered not a floral still life but the ingredients for one, and asked to imagine it. The resulting pictorial casualness was all but unprecedented in still-life painting—an art form that is generally about refinement and subtlety of arrangement, whether of flowers, fruits, food, or tableware. Its chromatic vivacity comes from Gauguin's use of complementary colors—purple and yellow, orange and green—which are given added intensity through browns and blacks shot through with color.

On a Chair (fig. 83), the third of the still lifes in the catalogue of the 1881 exhibition,

tuning pegs, perhaps because, without visible strings, such details would be extraneous. Again, one struggles to find a prototype in the history of still-life painting: when he worked on a small scale in the genre of still life, Gauguin unleashed his greatest powers of invention.

The mandolin is visually unsupported, its neck rising in a diagonal off the left edge of the painting with no indication of how it is held in place. Does the chair have arms? Gauguin hints at the possibility by positioning the folds of a woven textile on the right in such a way as to suggest an arm underneath. On the other hand, if the chair did have arms, the vertical support would surely be apparent above the easily legible corner of the chair at lower left. The chair itself is more evoked than described. We know that its construction is wood, and it seems to have an upholstered seat and back. The back has clear floral forms, suggesting that it is covered in fabric, but the largely brownish color of both back and seat makes us think more readily of embossed leather than printed fabric. Wood, leather, heavy woven fabric, ivory—these are the materials of this evocative still life, and they return us to the studio still lifes painted by Corot in the last twenty years of his career— two of which were in the collection of Gustave Arosa and included in his 1878 sale.—RRB

was loaned by Degas, who, we learn from his own notebook, had traded a pastel of a ballet dancer to Gauguin in exchange (see fig. 174); this was the first of several Gauguins acquired by the older Impressionist.[98] It must have given Gauguin a certain pride to mention its ownership in the exhibition catalogue, both as an homage and as proof that important artists and collectors were acquiring his works. If the floral still lifes were about the drama of brilliant colors in active contrast, this is, at first glance, a virtually monochromatic, warm brown still life—although, when we look more closely, it is in fact shot through with color.

The title, though less evocative than *To Make a Bouquet*, is equally original, because it calls attention to the fact that the subject, a mandolin, rests not on a table or music cabinet, but on a chair. Visitors to the exhibition had only to look across the gallery to see the same mandolin in Gauguin's most notable painting in the exhibition, *Nude Study (Woman Sewing)* (cat. 19). The mandolin is rendered without strings or, with two subtle exceptions, frets—but it does have the cord from which it hangs in the other painting, dangling useless on the seat of the chair. We are not permitted to see its angled head and

Fig. 83 (*above*) Paul Gauguin, *On a Chair*, 1880. Oil on canvas, 18¹/₂ × 12¹/₄ in. (47 × 31 cm). Private collection (WII 63)

facing page Paul Gauguin, *To Make a Bouquet* (detail of cat. 17)

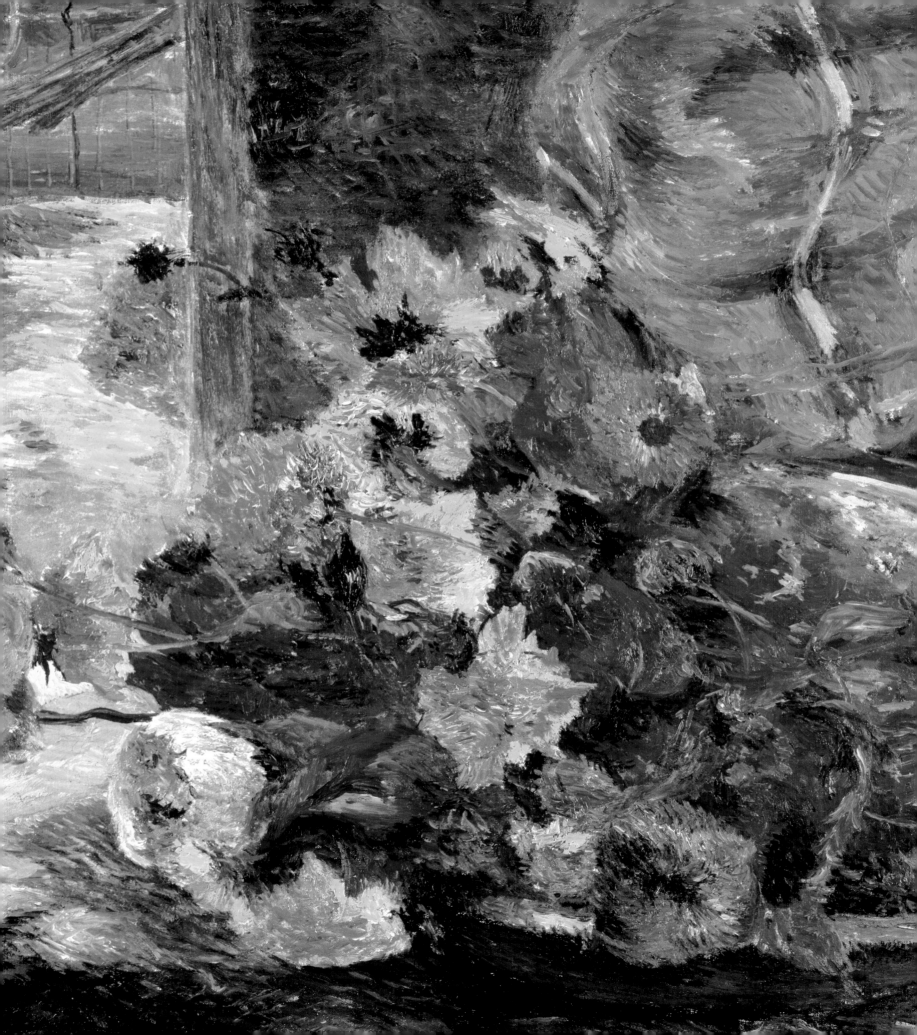

18

Woman Embroidering, 1879–80
Oil on canvas, 45⅝ × 31⅞ in. (116 × 81 cm)
Extensive inscription, lower right, by the artist's
 son Pola
Bührle Collection Foundation, Zurich
WII 65
Ordrupgaard only

Fig. 84 Berthe Morisot, *Young Woman at the Window*,
1879–80. Oil on canvas, 30 × 24 in. (76 × 61 cm). Musée
Fabre, Montpellier

This ambitious figure painting has not been in a Gauguin exhibition since 1926, when it appeared among the large group of other paintings by him then in Scandinavia.[99] Although it was published by the artist's son Pola in his monograph of 1938,[100] it was little known to scholars until its acquisition by Emil Bührle in 1964, the year of its publication in Wildenstein's first catalogue raisonné.[101] In the latter it was dated 1878 and, following Pola Gauguin's identification, treated as a portrait of the artist's wife, Mette.

The authors of the recent catalogue raisonné accepted neither the date of 1878 nor the identification of the sitter as Mette. On the former point, there is no doubt that Sylvie Crussard was correct; through her detective work, she has provided a range of date between September 1879, when Gauguin acquired several canvases of this large size, and the early summer of 1880, before the family moved from the Impasse Frémin—the painting's probable setting—to the Rue Carcel. The identification of the sitter as Mette does not seem as troublesome as Crussard suggests, however. Gauguin is more likely to have used Mette as a model than a professional or the maid he posed for *Nude Study (Woman Sewing)* (cat. 19)—and the artist's son had no doubt that the painting represented his mother.

The painting is of precisely the same dimensions as the *Nude Study (Woman Sewing)*, which Gauguin completed later in 1880. It could well have been conceived on such a scale for inclusion in the 1880 Impressionist exhibition, although no title in the catalogue except the generic *Etude* (no. 60) would fit the subject. On the whole it seems likely that Gauguin struggled with the painting without being able to resolve it, and that it was never exhibited in his lifetime. It owes considerable debts to the figure paintings that

Caillebotte, Degas, and Mary Cassatt showed in the Impressionist exhibition of 1879, which Gauguin studied so carefully. Its freely painted and apparently multilayered background— which clearly suggests that the painting is unfinished—looks much like the backgrounds in exactly contemporary figure paintings by Morisot (fig. 84). There are also many affinities with the figure paintings of Gauguin's closest advisor, Pissarro—a large series that the older artist began in earnest in 1879 and continued until 1882.

Given the picture's relationship to works by Gauguin's Impressionist colleagues, as well as its evident ambitiousness, it is striking that he elected to abandon it. Even a cursory examination of the surface reveals that he completely repainted the background at least once, if not twice, switching from a diagonally receding wall whose plane is defined by a wooden shelf, mostly visible in the upper-left corner, to a dramatically striped wall roughly parallel to the picture plane. Indeed, as Gauguin reworked the painting, he seems to have turned his attention away from the figure at the center, filling most of the canvas around her with brilliant color. He also chose a *contre-jour* light effect that renders the figure a dark silhouette against the wallpaper. In this way the painting eschews the tradition of portraiture with its customary focus on a well-lit head and face, and becomes a genre scene of a woman sewing set against the daylight.

In spite of its unevenness of finish and internal compositional struggles, the painting is a fascinating visual document of Gauguin's Impressionist ambitions. After abandoning it, apparently by the summer of 1880, he turned his attentions forthrightly to the figure painting that was to make him a star of the Impressionist movement at the exhibition of 1881, *Nude Study (Woman Sewing)*.—RRB

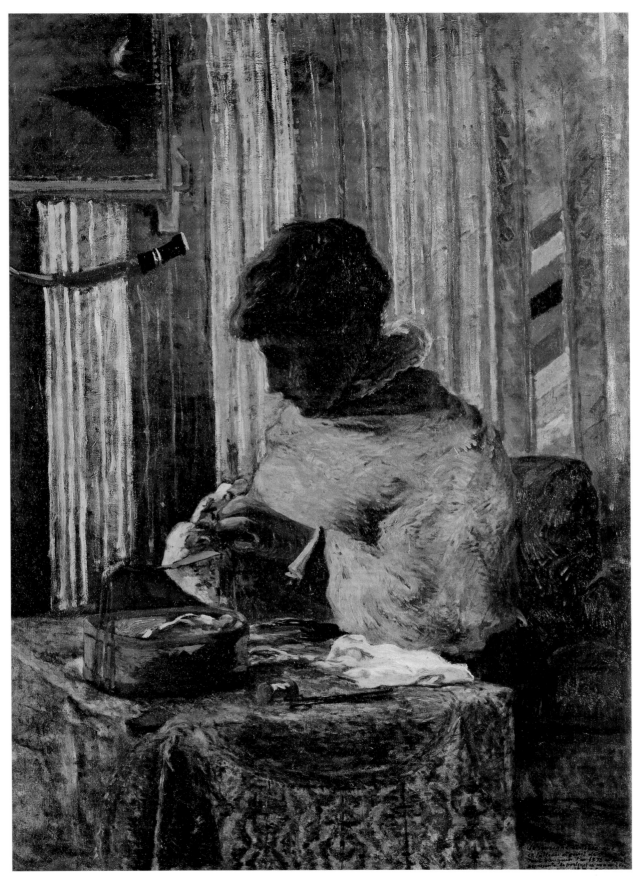

cat. 18

19

Nude Study (Woman Sewing), 1880
Oil on canvas, 45 × 31¼ in. (114.5 × 79.5 cm)
Signed and dated upper left: *Gauguin / 1880*
Ny Carlsberg Glyptotek, Copenhagen
WII 64

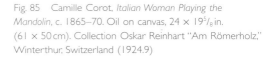

Fig. 85 Camille Corot, *Italian Woman Playing the Mandolin*, c. 1865–70. Oil on canvas, 24 × 19⅝ in. (61 × 50 cm). Collection Oskar Reinhart "Am Römerholz," Winterthur, Switzerland (1924.9)

There is little doubt that this was Gauguin's first true masterpiece. Its appearance in the 1881 exhibition ensured his reputation as a rising vanguard painter, and the essay-length discussion of the painting and its effect on the modern viewer by Huysmans is one of the single most important texts about a specific painting in the history of art.[102] Huysmans himself was going through an aesthetic transition in the early 1880s that is among the most extreme and best known of the period—from naturalist to Symbolist. He was, in this sense, an ideal critic for Gauguin, and wrote with such familiarity and ease about the artist that it seems they must have known each other. The work he evoked in such scintillating prose was the most important figure painting in the exhibition. This distinction was rather a hollow one, though, because Caillebotte and Renoir failed to exhibit that year, and neither Degas nor Pissarro included an important figure painting. The small group of portraits submitted by Degas—in each case simply as *Portrait*—has not been identified; Degas provided no clues as to the sitters' identities and, perhaps because of that, they made no impact on the press. The single nude by Degas was a small monotype, and, after his "debut" as a figure painter the previous year (with a major work loaned by Gauguin), Pissarro failed to submit an important figure painting to the 1881 exhibition in spite of the fact that he was working on several. It was, thus, an ideal situation in which to make an "entrée" for an artist who had never before exhibited anything but landscapes and a single still life. *Nude Study (Woman Sewing)* was Gauguin's earliest surviving painting of a nude and, like all of his debuts, it was spectacularly successful.

The title of the work, *Etude de nu*, was as original and thoughtful as any of his titles in

the exhibition. No one who looked at such an ambitious and finished painting would have called it an *étude* (or study), and the presence of a signature and date signified that it was no such thing. It most certainly was a "nu" (or nude), but one with few real precedents in the history of Western art. Unlike Courbet's nudes, who pose coyly, recline, or writhe with erotic abandon, Gauguin's sits almost primly on a bed and sews. Indeed, she is antierotic in her leaden particularity and, because of her devotion to her mundane task, makes no allowances for any lothario of a viewer. Even if Gauguin was to refer to her as "Suzanne" in a letter to his wife, as viewers we are surely not cast in the voyeuristic role of the elders in a *Susanna and the Elders*. There is a quiet resoluteness to the model and, hence, to the painting over which she presides.

When we look at the work today, it is fascinating to remember two paintings in Gustave Arosa's collection that had been sold in 1878, Corot's *Italian Woman Playing the Mandolin* (fig. 85) and Courbet's *Young Woman Sleeping* (fig. 86). Each held a place in Gauguin's pictorial imagination, both in memory and through the visual aid of the illustrated sale catalogue, of which he possessed a copy. The Corot represents a completely clothed model in the painter's Parisian studio, seated alone and playing a mandolin of striking similarity to the one in the background of Gauguin's painting. Like Gauguin's nude, she sits absorbed in an activity, unaware of the attentions of the viewer; and she occupies a similar position on Corot's vertical canvas. Courbet's figure, by contrast, is completely nude, of a similarly corpulent proportion to Gauguin's, and lying in autoerotic ecstasy while apparently sleeping. The rumpled white sheets add to a mood of restlessness balanced only by the calm and

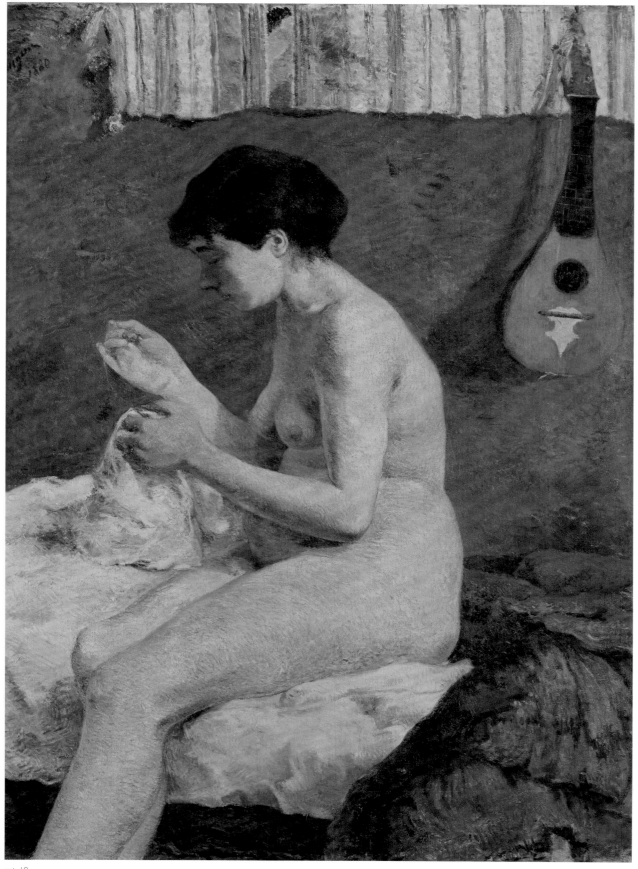

cat. 19

Fig. 86 (*below*) Gustave Courbet, *Young Woman Sleeping,*
1860. Oil on canvas, 19¹⁄₄ × 24³⁄₈ in. (48.7 × 61.7 cm).
Private collection

Fig. 87 (*bottom*) Pierre-Auguste Renoir, *Study: Torso,*
Sunlight Effect, c. 1876. Oil on canvas, 31⁷⁄₈ × 25⁵⁄₈ in.
(81 × 65 cm). Musée d'Orsay, Paris. Bequest of Gustave
Caillebotte, 1894 (RF 2740)

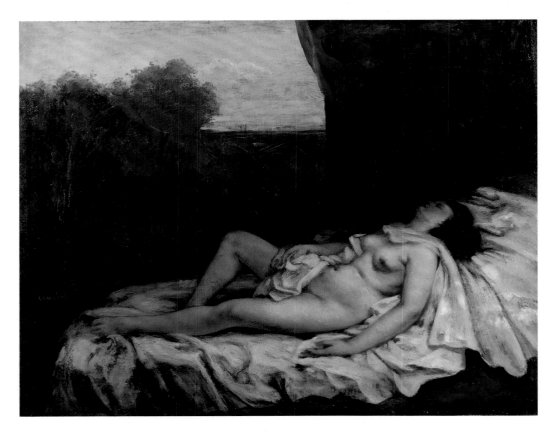

naturalist nudes of Manet, Renoir, and Degas,
we fail. Gauguin seems to have been less
responsive to these precedents than he was to
be later in his career. For Manet, the nude was
only conceivable as modern if she were a
courtesan—perhaps because the courtesan
would have been the only "real" nude outside
of art that an upper-class Frenchman would
ever see. For Degas, who was to turn more
urgently to the nude as a subject only after
Gauguin's *Nude Study (Woman Sewing)*, the
nude was to be shown bathing, either alone or
with an attendant, in a way that was not
blatantly erotic. One can argue, in fact, that
Gauguin's painting was the first important
representation of the nude in an Impressionist
exhibition and that it was to set the stage for
the last—Degas's *Suite de nuds de femmes se*
baignant, se lavant, se séchant, s'essuyant, se
peignant ou se faisant peigner (Suite of Nude
Figures of Women Bathing, Washing, Drying,
or Wiping Themselves, Combing Their Hair, or
Getting It Combed) in the final exhibition of
1886. Its only real prototype was the glorious
nude that Renoir submitted to the
Impressionist exhibition of 1876, where it was
called simply *Etude* (fig. 87). Yet Renoir
represented the nude with a kind of fluency
one associates with Fragonard and adopted an
almost eighteenth-century attitude toward
nudity. One critic called his nude a
"baigneuse," and she placidly receives the gaze
of the viewer amidst a flutter of brushstrokes
that evoke an almost mythological summer
landscape. Realism and Renoir's nude do not
connect.

grandeur of the landscape out the window. If
Courbet's bed is arranged in a studied erotic
disarray, Gauguin's is rumpled in an utterly
mundane fashion, almost as if the nude has
just gotten out of bed. The sheet is tucked into
the mattress, and the greenish duvet has been
pulled back just as it would be every morning.
In attempting to create a modern nude, it is
almost as if Gauguin has simply conflated the
two earlier pictures, accepting Corot's props,
pose, and studio fantasy, while replacing his
clothed model with a nude of Courbet-like
proportions. His "solution" to a pictorial
problem is what might be called an "anti-
homage."

When we search closer to Gauguin's own
time for a prototype, in the realist and

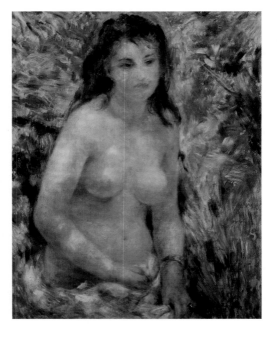

There were two prototypes for the *Nude*
Study (Woman Sewing) in Gauguin's own
collection. The first was a Manet pastel
representing a similarly posed, clothed woman
knitting in a garden (see fig. 45) that was
purchased by Gauguin in 1880, the very year

of *Nude Study (Woman Sewing)*. The second was a lost work by Cézanne representing a large-scale reclining nude that the artist had submitted unsuccessfully to the Salon of 1870; it is known only from a violently satirical print by the artist Stock (fig. 88). Gauguin seems to have borrowed what witnesses described as the startling realism of Cézanne's nude and the decorous pose of the Manet. Each work was a direct source and, in another sense, neither was. This mode of burying or masking sources, used masterfully for the first time in *Nude Study (Woman Sewing)*, was to serve Gauguin well throughout his life.

Remarkably, no painted or drawn studies for Gauguin's first major figure painting have survived. Like Renoir's great *Luncheon of the Boating Party* (see fig. 122) it seems to have been created in many laborious sessions and directly on the canvas. Its setting is probably the apartment on the Impasse Frémin, which Gauguin also used as the setting for his still life *Jug and Mug*, also of 1880 (cat. 13). This suggests that the painting was completed before October, when the family moved to the Rue Carcel.—RRB

right Paul Gauguin, *Nude Study (Woman Sewing)* (detail of cat. 19)

20

Vaugirard Church by Night, 1881
Oil on canvas, 19⅝ × 13⅝ in. (50 × 34.5 cm)
Signed lower left: *p. Gauguin* [an old photograph
 shows that the signature was formerly followed
 by the date *1881*]
Collection Groninger Museum on loan from
 Stichting J. B. Scholtenfonds, Groningen, The
 Netherlands
WII 69

Fig. 89 Paul Gauguin, *Vaugirard Church, Seen from the Rue
Carcel*, c. 1881. Black chalk on yellowish paper.
Nationalmuseum, Stockholm (NM 21/1936)

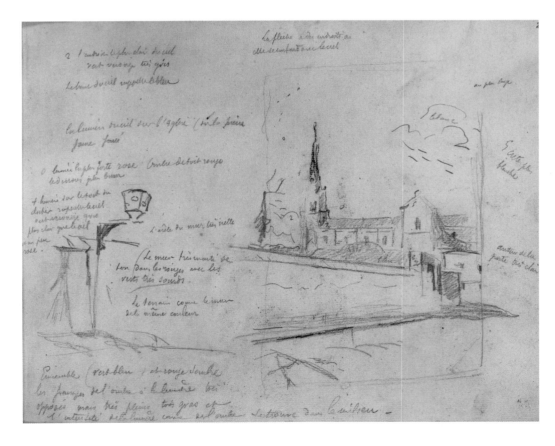

There is no more original urban painting from
the early 1880s than this small canvas by
Gauguin, exhibited to great effect—in spite of
its small size—at the 1881 Impressionist
exhibition as *Une nuit à Vaugirard (A Night in
Vaugirard)* (no. 30). An old photograph of the
work by Giraudon shows a date of 1881, to
the right of Gauguin's signature, which has
been either effaced or overpainted.[103] In his
brilliant review of the 1881 exhibition,
Huysmans was moved to a Baudelairian
melancholy, describing the subject as "a
splenetic church in an industrial town."[104]
Gustave Geoffroy, who was unenthusiastic
about the exhibition as a whole, described the
work as "a luminous and tranquil painting"
and treated it very much in the context of the
Impressionist project of painting particular
"effects."[105]

The painting is based largely on a detailed
drawing made by Gauguin in an early
sketchbook, now in the Nationalmuseum in
Stockholm (fig. 89). The drawing is covered
with chromatic annotations, and all of the
salient elements of the composition were
evidently arrived at on the spot. Though never
a practicing Catholic and resolutely
anticlerical, Gauguin had a lifelong fascination
with religion and its history. Here he chose to
represent an almost new, neo-Romanesque
church for the population of a burgeoning
Parisian suburb. He deliberately cropped the
composition to exclude the tree to the left and
behind the wall but created an almost
festishized shadow from it that animates the
lower-left corner. Shadows play throughout the
composition, which is Gauguin's earliest
surviving representation of night—a subject
that would interest him a good deal in the
South Seas.

Its starkly simple composition, fascinating
evocations of both artificial and natural light,
mysterious shadows, and lack of any human
presence give the painting a proto-Symbolist
quality that surely appealed to the developing
antinaturalist aesthetic of Huysmans. It also
signaled Gauguin's interest in developing a
kind of painting that projects a mysterious
artificiality in its effects. Indeed, the
contemporary works that spring most readily
to mind when we look at this painting are the
evocative conté crayon drawings made by
Georges Seurat beginning in 1881, particularly
the effects of night, dusk, or even artificial
light. The *House on Rising Ground* of
1881–83 (fig. 90) or the later *Lighthouse at
Honfleur* (fig. 91) share essential formal and
aesthetic qualities with Gauguin's small
painting—and it is not out of the question that

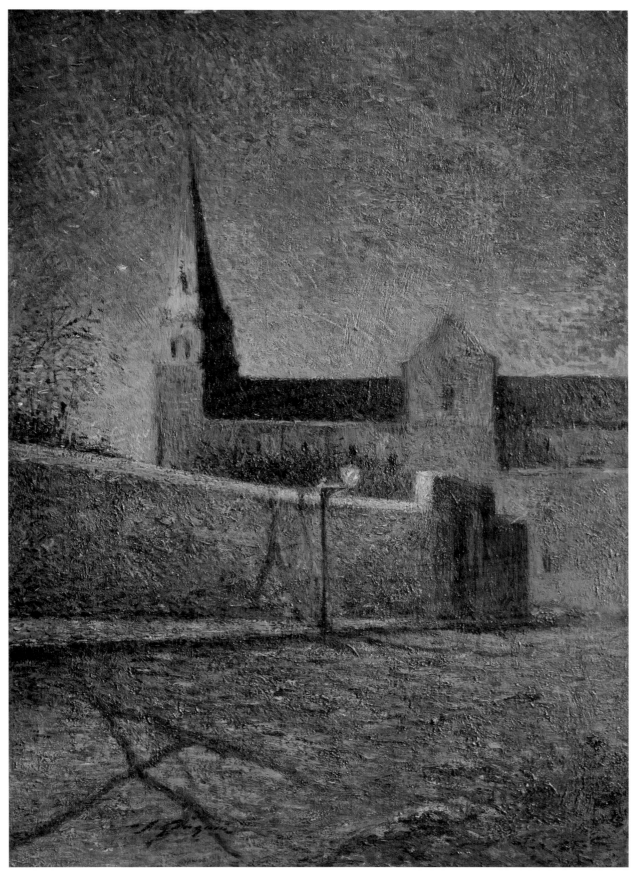

cat. 20

Fig. 90 Georges Seurat, *House on Rising Ground*, 1881–83. Black chalk, conté crayon, and verge paper, 9⅝ × 12½ in. (24.5 × 31.8 cm). Museum Boijmans van Beuningen, Rotterdam (MB 1951/T-1)

Fig. 91 Georges Seurat, *The Lighthouse at Honfleur*, 1886. Conté crayon with gouache, 9¼ × 12¼ in. (23.5 × 31.1 cm). The Metropolitan Museum of Art, New York. Robert Lehman Collection, 1975. (1975.1.705)

right Paul Gauguin, *Vaurigard Church by Night* (detail of cat. 20)

Seurat saw the 1881 exhibition, held just four months after his twenty-first birthday.

Gauguin's mentor, Pissarro, also included a representation of a nineteenth-century church, this one in England—and painted in gouache—in the Impressionist exhibition of 1881. For Pissarro, as for Gauguin, Impressionism was no longer limited to work "en face du motif." He based his gouache on drawings, paintings, and watercolors made a decade earlier in England, just as Gauguin based his carefully structured small painting not on "life" but on a detailed drawing, whose verbal inscriptions were as important as the visual "sketch" in determining the look of the final, studio-based work.—RRB

Anne-Birgitte Fonsmark Gauguin and "Impressionist Sculptors"

Gauguin's interest in "primitive" art emerged slowly in his painting, but in his wood sculptures it was apparent from the start. For one of the two sculptures that he showed at the sixth Impressionist exhibition in 1881, the critics pointed to both Gothic and Egyptian models. The works in question were his earliest known wooden sculptures, the medallion relief *The Singer* (cat. 21) and the statuette *Lady Strolling* (cat. 22). Both relate to the traditional use of sculpture as an architectonic element—as wall decoration and column shaft—and are to be seen just as much as "objects" as sculpture. But both were equally unthinkable without the stimulus of Gauguin's knowledge—and likewise for those in artistic circles—of Degas's planned presentation of a controversial work, the *Little Dancer Aged Fourteen* (fig. 92), the first and only sculpture Degas was ever to exhibit.

The radical artists' experiments with three-dimensional art were to attract a great deal of attention in the 1881 Impressionist exhibition. It was a surprise to see sculptures among the group's paintings. Only one of the four previous exhibitions had featured sculpture—other than any works not included in the catalogues, like Gauguin's bust in 1879. At the first exhibition in 1874 the artists presented themselves as a group of sculptors and graphic artists as well as painters, and August-Louis-Marie Ottin exhibited a number of works in marble, plaster, and terracotta.[106] But the use of the title *Exposition de peinture* over the following years clearly emphasized painting. So Gauguin's decision to introduce himself with a sculpture in 1879—and to show sculpture again in 1880 with the marble bust of Mette—must have been all the more remarkable. Apparently he did not mind standing out as different even in his debut in the avant-garde context.

In 1881 the Impressionist exhibition drew attention to itself with plastic works—by both Gauguin and Degas.[107] The initiative attracted a great deal of attention, both negative and positive, in the press, and Paul Mantz wrote in *Le Temps*: "To be honest, the new element in the exhibition on the Boulevard des Capucines, the fact that should be remembered, is the appearance, more or less triumphal, of the independents in an art form that they had not yet thought of rejuvenating: sculpture. And when we speak of sculpture, we are not thinking at all of Monsieur Paul Gauguin. The true sculptor, the sole sculptor in this intransigent academy is Monsieur Degas."[108] Jules Claretie also emphasized Degas and hit out indirectly at Gauguin: "Here is the originality of this Exposition des Indépendants—they are starting to affirm their independence in the form of sculpture. Color was not enough. They must have wax or plaster or bronze. *Good God*, we are going to see *Impressionist* sculptors! I am not complaining if it is a matter of Monsieur Degas, but I know of sculptors who already are doing Fortuny in terracotta! Can one imagine what that might be like, and what a school of torsion, contortion, deviation, and boning it could give us?—We must protest, they say, against these stuffy people, the *traditional artists* from the Institut! And, to escape the traditional artists, they commit themselves to zephyrs and companies of *indiscipline*."[109]

The Singer and *Lady Strolling* depended in several ways on Degas. As for their motifs, they are Gauguin's only sculptures to address "modern life." The model for the

singer was even a public figure of the time, a singer from Montmartre named Valérie Roumy. The story was told that at the previous year's exhibition Degas had kept the showcase for his *Little Dancer Aged Fourteen* empty and thereby created a hush of anticipation to greet its appearance.[110] Gauguin doubtless felt encouraged by the expectant atmosphere and wanted to play up to it with plastic works that were just as radical.

Together with the cabinet (cat. 15), the reliefs of the singer and the strolling lady are the earliest Gauguin sculptures we know with polychrome features, and there is a touch of the archaic about all of them. They denote the future by entering into a dialogue with the past. *The Singer* contains numerous references to the art of the past. Models can be found in ancient sarcophagi, French sepulchral sculptures, and Byzantine gold-ground paintings. But Gauguin's most palpable starting point seems to have been the many reproductions of works of art made in "phototype" by Gustave Arosa. Among these were the illustrations in Wilhelm Froehner's splendid book on Trajan's column, which included a vignette that clearly served as the starting-point for the composition of *The Singer* (fig. 98). Gauguin's interest in the singer's modernity was superficial, and his venture into Degas-like motifs an experiment that was never to be repeated.

Throughout his life, wood was to remain the material Gauguin liked best for sculptural work. His using it now for a major work, apparently for the first time, has been explained by his removal to the Rue Carcel. He no longer had ready access to Bouillot's studio, and wood was a material that was easily carried around.[111] For an artist like Gauguin, the move into wood must have been more than a matter of convenience, however, and his choice should be seen as part of his whole relationship with the avant-garde. There was apparently a renewed interest in wood—and in wax—at this time. Huysmans paid tribute to wood in his review of the 1881 exhibition—not with Gauguin's wood carvings as his starting point, paradoxically enough, but Degas's wax dancer—and wrote of the great sculptural qualities of wood, looking back to the art of the Middle Ages. Sculpture, he asserted, must reject antiquity and the use of marble, stone, and bronze. For thousands of years sculptors had undervalued wood, but "the painted sculptures of the Middle Ages, the retables in Amiens Cathedral" demonstrated its great qualities as a material. He regretted that artists of the present did not use it and recommended they should take it up: "So transfer this procedure, this material, to Paris; put it now in the hands of an artist who has a sense of modernity like Monsieur Degas . . ."[112] Degas was never to work in wood. Given that Gauguin's two bids for a revival of wood sculpture were actually present in the exhibition, he cannot but have felt ignored and humiliated, and this perhaps partly explains his later hostility to Huysmans.

Gauguin's strolling lady has often been mentioned in the same breath as Degas's dancer. The Degas was the much-discussed central feature of the 1881 exhibition, "standing like a sentinel at the center of one of the galleries."[113] Its empty showcase in the exhibition of the previous year had, of course, created enormous expectations for it; here was the "statuette in wax promised to us long ago."[114] This much-heralded but

Fig. 92 Edgar Degas, *Little Dancer Aged Fourteen*, 1879–81. Yellow wax, hair, ribbon, linen bodice, satin shoes, muslin tutu, wood base, height 39 in. (99.1 cm). National Gallery of Art, Washington. Collection of Mr. and Mrs. Paul Mellon (1999.80.28)

long-unknown work must have been of great significance to Gauguin. Although he was never to express himself in writing on the controversial sculpture, he had surely followed the most disputed art event of the year intently and contributed to it energetically. A work he made in the wake of the event and intended for the group's next exhibition, in 1882, is a striking response to the Degas work and is part of his continuous "debate" with Degas at this time. The work is the *Bust of Clovis* (fig. 93), and in many ways it became a key work in his oeuvre from the early 1880s.

The art-loving Parisian public that had received Degas's statuette with consternation was thus to be presented the following year with a work based on a similar principle. Painted wax and incorporated found objects were part of its provocative agenda. Gauguin placed a painted wax head above a slightly woebegone wooden torso—which

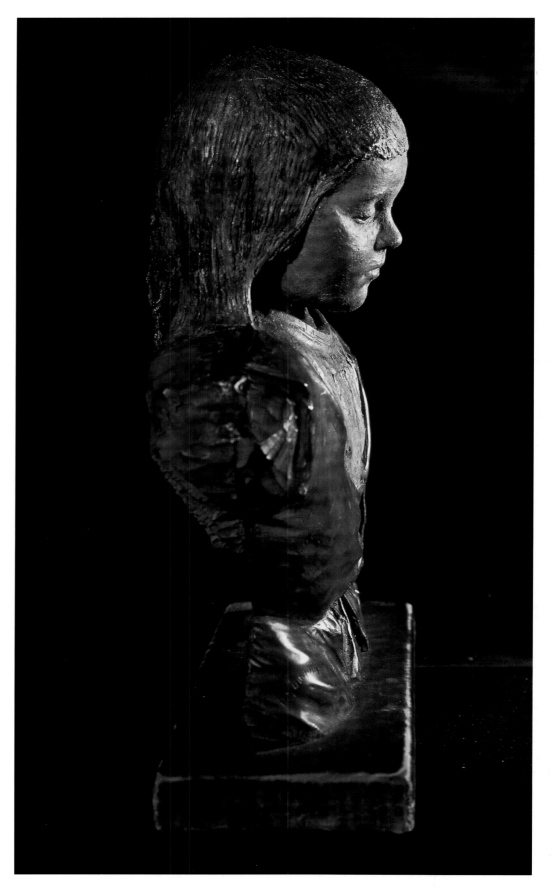

Fig. 93 Paul Gauguin, *Bust of Clovis*, right profile, 1881.
Wax, torso of carved walnut, height 15³/₄ in. (40 cm).
Location unknown

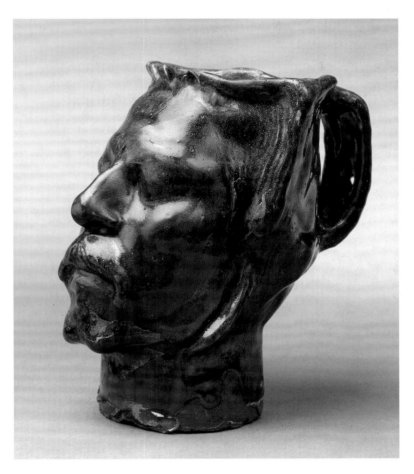

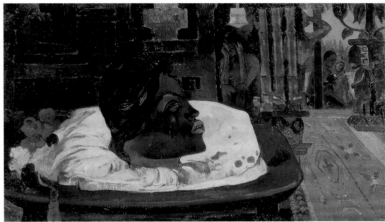

Fig. 94 (*above left*) Paul Gauguin, *Self-Portrait Vase*, 1889. Stoneware, height 7³/₄ in. (19.5 cm). Museum of Decorative Arts, Copenhagen

Fig. 95 (*above right*) Paul Gauguin, *Arii Matamoe (The Royal End)*, 1892. Oil on canvas, 17³/₄ × 29⁵/₈ in. (45 × 75 cm). Private collection

in all probability was again the work of some unknown artist far back in time.[115] As we shall see, the art critic Nina de Villars regarded Degas's statuette as fulfilling her dream of a modern art derived from the painted wooden Virgins and saints in village churches. Her review was published on April 23, 1881, and Gauguin—consciously or not—took her at her word. We have seen him incorporate the newel into his cabinet. This time, the "found" fragment—probably from an old church sculpture—was to be made into part of a sculpture. In this connection it must be remembered that from Arosa's home Gauguin had been familiar with simple or ecclesiastical wooden carvings. His guardian owned a couple of examples, one of which—showing Saint Anne—was both painted and gilded. None of the critics at the exhibition seems to have noticed this provocative aspect of Gauguin's bust of Clovis, which Philippe Burty called "ponderous and pretentious."[116]

Gauguin had the whole year to prepare his "riposte" to Degas in the 1882 exhibition. But he also reacted more quickly and spontaneously in the shape of a small piece of sculpture. The sixth Impressionist exhibition opened on April 2, 1881. Ten days later his fourth child, Jean, was born, and just a few weeks after this he made a small, tenderly modeled, wax portrait-head of the infant (cat. 23).[117] Around this time Gauguin might very well have made more works in wax that are no longer known, like the small, sketchlike bust of his daughter, Aline, that has recently been added to the collection of the Musée d'Orsay (cat. 24).[118] The portrait head of the newborn Jean is more carefully finished than the latter work, which is summarily modeled in black wax,

and the surface is lightly treated with paint and shellac. Not only in the technique employed, but also in the backward tilt of the profile, this child's head shows some striking similarities to Degas's dancer. But Gauguin added just a touch of the macabre, allowing stripes of reddish brown color to run down over the back of the head in a way that anticipates the later *Self-Portrait Vase*, with its streaks of blood (fig. 94).[119] Later Gauguin was to show a fascination, typical of its time, with the idea of the severed head—for instance in the painting *Arii Matamoe (The Royal End)* of 1892 (fig. 95).

Whereas Gauguin created the bust of the newborn son under the immediate inspiration of Degas's statuette—probably as the result of a desire to try out his technique—the bust of Clovis was a considered reply to Degas's work as a concept. In several ways he actually succeeded in creating a work that was at least as stunningly modern as his challenger's work. Not only did he incorporate found objects in his work in the modernist spirit of Degas, he even incorporated another work of art, exploiting the fragmentary nature of the old wood carving in the service of creativity. Provocatively, he left it with its scars, its gashes, and the stumps where its arms had been. One wonders whether by now he knew those works by Rodin in which the sculptor expressed himself by means of fragmentation. At all events, he would have seen *The Man with the Broken Nose* in the Salon in 1878, as well as the works Rodin showed in the World's Fair of that same year.[120]

The bust is dominated by retrospective or archaic features: the stylized and gilded hair,[121] the way in which the bust is cut at the waist, and the innocence in the expression, with its half-downcast eyes. In Degas's dancer the eyes had been one of the causes of offense, supposedly expressing depravity in the young girl. In the Gauguin, on the other hand, they are used in the service of innocence in a way that recalls "primitive" Italian sculpture. The archaic character of the work is underlined by the naively lettered inscription "CLOVIS." In addition to providing the boy's unusual name, this inevitably evokes the great Merovingian king, suggesting a dialogue with the historical sculpture of the time practiced by such artists as Aubé.[122]

In its engagement with Degas's far-reaching naturalism, the work cannot but appear in the light of a criticism. Each artist used found objects for his own purpose; while Degas took his from real life in the service of illusion,[123] Gauguin chose ones that were already art—in this work as in his other early creations in wood.

The bust of Clovis also related to another, equally spectacular phenomenon of the time—the wax panorama, in which lifelike figures dressed in real clothes were arranged in front of a painted backdrop. At the start of the 1880s such panoramas became a popular form of entertainment. One of the galleries close to Gauguin's workplace was named after them as the *Galerie des Panoramas*. Famous battles from the Franco-Prussian War were recreated, and the illusionistic effects were taken to considerable lengths. The journalist Jules Claretie wrote in *Le Temps* in 1881: "It is the mixture of the Morgue and the Luxembourg Museum, of a painting Salon and a Madame Tussaud's Exhibition, that will insure the popularity of these panoramas."[124] Gauguin touched on them briefly in a couple of his letters. In the autumn of 1881, when he was

looking for premises for the seventh Impressionist exhibition—in which he was to present his *riposte* to Degas—he saw that it would be to the group's advantage to rent a room in the Rue Saint-Honoré alongside the Salle Valentino where the *Panorama of the Reichshoffen Cuirassiers* had been constructed. In this location—where it did indeed take place—Gauguin calculated that an Impressionist exhibition would have "a good chance of attracting 20,000 visitors."[125]

We do not know Gauguin's attitude to the wax panorama beyond his hope that it would benefit attendance at the Impressionist exhibition. In one of his letters of 1884, however, there is an ironic comment on the extremely popular Musée Grevin, which opened to a great fanfare in June 1882, some six months after the Salle Valentino panorama, as a modern version of Madame Tussaud's.[126] In the course of some scathing comments on *L'Evénement*'s account of the sculptures in a Raffaëlli exhibition, he wrote: "What a dentist; and they expect me to believe that the man ridiculous enough to think that up could have artistic ideas. Come on, that would be as big a curiosity as the Musée Grevin."[127]

Gauguin's work as an artist often took the form of a reaction—sometimes ironical—to some kind of provocation. It was as though he was best able to bring out his artistic personality when he was in opposition to something. The bust of Clovis is an example. In this case the provocation was the appearance of extreme forms of naturalism. Degas's dancer and the Salle Valentino panorama were, at opposite ends of the quality scale, remarkable expressions of the same phenomenon. The fashion also manifested itself in the often macabre wax dolls to be found in ethnological and pathological collections—notably at the Trocadéro Museum and the Musée Dupuytren, both of which had opened a short time previously.[128] With these attractions of the time as stimulants, Gauguin's bust represented a leap forward in his confrontation with naturalism and in his development of a personal view of art. Perhaps he was inspired in part by Charles Blanc, writing in his textbook *Grammaire des arts du dessin*, who condemned the clothed figures in the waxwork shows and discussed the use of real objects in sculpture critically: "Let us suppose that the sculptor decides to give a figure of a hero a real cap, a real sword, real underwear, and real fabrics, he will not be making an imitation, but a pure redundancy . . ."[129]

21

The Singer, 1880
Mahogany, plaster, paint, and gilt, diameter
 20⁷/₈ in. (53 cm) × depth 5¹/₈ in. (13 cm)
Inscribed in the bunch of flowers bottom left: *P
 Gauguin 1880*
Ny Carlsberg Glyptotek, Copenhagen
Ordrupgaard only

Fig. 96 Jean-Louis Forain, *Portrait of Cabaret Singer Valéry Roumy*, c. 1880. Pastel, 10¹/₈ × 10¹/₄ in. (25.7 × 25.8 cm). Statens Museum for Kunst, Copenhagen

This wood relief must be viewed as one of the most significant works of Gauguin's early years. It is widely considered to be his first known work in wood,[130] although it is impossible to say with certainty whether it was made before or after some of the other early wood carvings, for instance *Lady Strolling* (cat. 22) or the sculptural parts of the display cabinet (cat. 15). The finely sanded treatment of the singer's face and breast relate closely to the marble bust of Mette Gauguin (cat. 7), and in that sense the work looks back to Gauguin's friendship with the sculptor Jules-Ernest Bouillot.

The Singer was not only one of the earliest of Gauguin's wood carvings. It may also have been his first relief and the first example of his use of mixed materials: the flowers are not part of the wooden core but fashioned in plaster.[131] However, the change of material is not emphasized, and the work blends together as a whole thanks to its being painted.[132] Perhaps the plaster additions were a correction to an unsuccessful section of the relief; perhaps the wood was always too thin in this area to allow the carving of the flower motif. It is also here that the signature and date of the work are to be found: "P Gauguin 1880."[133] The relief is also among the first known examples of polychromy and gilding in Gauguin's work.[134] The clasp holding the singer's hair is decorated in red, while the heavy ring in her right ear shows signs of having been painted a reddish gold. In the gilding of the rough carving of the background and the bouquet of flowers, Gauguin anticipated the gilded ceramics he was to make in the winter of 1886–87.

The wood relief and the marble bust of Mette are related by virtue of the finely polished, naturalistic treatment of the facial features—which was to be found again much later in another painted and gilded work in wood, the *Head of Tehura (Tehamana)* (1892; Musée d'Orsay, Paris) from the Tahitian period.[135] The traditional use of the sculptor's drill for the eyes and hair is a further link between the bust and the wood relief. In these parts of the relief there is more of the marble sculptor's technique than that of the wood-carver; they contrast with the roughly carved background and the plaster section, which are more impressionistic and reminiscent of the *non-finito* with which Rodin was experimenting. While the bust follows an existing form, the relief expresses an avant-garde confrontation with tradition. It is a free experiment in an untraditional material (wood was associated with "primitive" and rustic art), in polychromy, and in mixed materials, challenging the borderline between pictorial and decorative art. These built-in tensions led Christopher Gray to argue that the work lacked conceptual unity,[136] but it should be added that unity is less characteristic of Gauguin than complexity and heterogeneity. The differences between these two almost contemporary works cannot be ascribed simply to a developmental leap. They are rather the expressions of different attitudes to art: while the bust of Mette can be seen as testing a possible career—as a portrait sculptor—the wood relief is testing a new artistic approach.

The singer's face and her bouquet of flowers are the opposite poles of the composition, held in place in a tense balance. Both suggest movement beyond the frame of the relief, the woman in her outward gaze, the flowers in extending to the edge of the wood. This gives the composition a certain dynamism and centrifugal force. Gauguin used a file and sandpaper on the smooth skin of the face, and the golden color of the wood has been polished to create a gloss—this is where

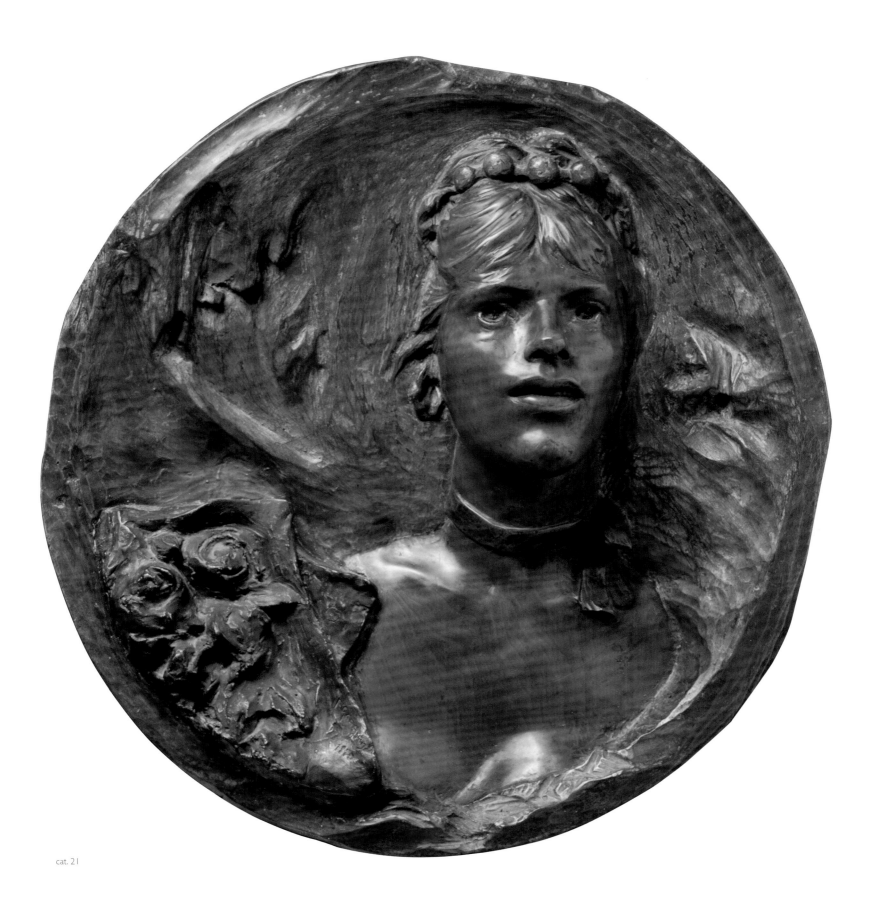

cat. 21

Bouillot's influence makes itself felt. By contrast, the flowers are sketched roughly in the plaster. The soft material allowed Gauguin to work freely and imaginatively, playing with the enigma of what is hinted at without being stated.

At the sixth Impressionist exhibition in 1881 the relief was one of three sculptures, all with modern woman as theme. The second was another work by Gauguin, *Lady Strolling* (cat. 22), and the third was Degas's *Little Dancer Aged Fourteen* (fig. 92). With his large *Nude Study (Woman Sewing)* (cat. 19), Gauguin also raised eyebrows with an ambitious attempt at the interpretation of modern woman in paint. His works at the 1881 exhibition were his most conspicuous attempt to address "modern life" as a subject.

With them he introduced into his work the professional model. He explicitly names the model for the *Nude Study* in a letter, and—despite the anonymous description in the 1881 exhibition catalogue ("La Chanteuse. Médaillon. Sculpture.")[137]—the model for *The Singer* was a specific, known person. The art historian Merete Bodelsen was able to identify *The Singer* with a work listed in the catalogue of the Gauguin and van Gogh exhibition held in Copenhagen in 1893 as "Valerie Roumi."[138] Valérie Roumy (as the name was also spelled) was a cabaret singer in Montmartre. In support of this identification, Bodelsen referred to Jean-Louis Forain's pastel portrait of Roumy (fig. 96),[139] which Gauguin owned; the reverse bears the inscription "Valery Roumy (montmartroise) ca. 1880 donné par Forain au peintre Paul Gauguin"—probably in Mette's handwriting.

The source of the identification of Roumy as the model for the relief shown in the 1893 exhibition was Mette, who presumably remembered Roumy's coming to their home

for sittings. Roumy seems to have been in the Parisian limelight around 1880, and Gauguin and Forain were not the only artists to associate with her. Degas jotted down her name and address in the notebook containing sketches, names, and addresses of models relating to his sculptures from the beginning of the 1880s.[140] After a note concerning Marie van Gutten—the model for the fourteen-year-old dancer—we find the following: "Valérie Romi / 104 Quai [de] Jemmapes."

With *The Singer*, Gauguin was close to the motifs used by Degas, but in his review of the 1881 exhibition, Huysmans associated *The Singer* with the Belgian painter and graphic artist Félicien Rops: "a singer slightly reminiscent of the type of woman adopted by Rops."[141] In connection with the relief and Gauguin's other work in wood at this time, it should be noted that Huysmans emphasized wood as a material and, looking back at medieval works of art, praised its great sculptural qualities: "In these works, which are so realistic and so human, there is a play in the features, a life in the body, which have never been rediscovered in sculpture. Then, see how malleable the wood is, how supple, docile, and almost unctuous beneath the will of these masters . . . And then, transfer this procedure, this material, to Paris and put them in the hands of an artist who has a feeling for modern life like M. Degas . . . "[142]

With its connection to "la vie moderne," Gauguin's relief of the singer has for obvious reasons been compared with Degas—and especially with the pastel *Café Singer*, which Gauguin would have seen in the Impressionist exhibition of 1879 (fig. 97).[143] Both works mix portraiture and genre by focusing on a particular person in a situation—the cabaret—that is not seen but suggested. But there the similarity ends. While Degas's singer is singing

Fig. 97 Edgar Degas, *Café Singer*, c. 1878. Pastel on canvas, 20⅞ × 16¼ in. (52.9 × 41.1 cm). Courtesy of the Fogg Art Museum, Harvard University Art Museums, Cambridge, Massachusetts. Bequest from the Collection of Maurice Wertheim, Class of 1906 (1951.68)

aloud and forms an integral part of the surrounding space, Gauguin's is characterized by dreaming introspection—the consummate illusionism of the face is set against a background of gilded abstraction—reminding us that images of the interior life were to be essential to his art.

Gauguin's interest in "la vie moderne" was in fact superficial. He shows no interest in capturing the atmosphere of one of the popular café-concerts of the time, and the illusion of reality is suspended by the roughly carved and gilded background; like a halo, this element distances the singer and places her in her own sphere. When the work appeared in the Impressionist exhibition in 1881, some critics commented that the model looked thin and sickly.[144] So she may have been; in 1886 Degas asked his friend Ludovic Halévy for help in tending to Roumy as she lay sick with the disease of the lungs that would kill her.[145] Whether she was already marked by illness when Gauguin made his relief is something at which we can only guess. In view of her fate, it certainly seems telling that the relief has been compared to a sepulchral sculpture.[146] In this context, it may also be significant to point to the archaic character of the gilded background, which recalls the gold ground in portrayals of saints in Byzantine art.

The medallion form is common in portraiture, and was much used by nineteenth-century sculptors such as David d'Angers, Auguste Préault, and Antoine-Laurent Dantan. The heads in medallion portraits are normally in profile, however, whereas Gauguin shows his singer from the front. This type is more familiar as an architectonic element on the large official buildings of the time with their allegorical decorative displays. The predilection of the age for severed heads like that of John the Baptist has been cited as a context for the

Fig. 98 *Clio, Muse of History*, mosaic from Santiponce. Vignette from Wilhelm Froehner, *La Colonne Trajane* (Paris, 1872)

imagery.[147] The sepulchral sculpture of the time is another, along with Roman and early Christian sarcophagi adorned with bust portraits of the deceased, and Hellenistic silver and gold medallions that Gauguin might have known in the Louvre.[148]

But besides this general reference, there is a very direct model for Gauguin's work in the richly illustrated set of books for which Gustave Arosa made the phototypes in the beginning of the 1870s, Wilhelm Froehner's *La Colonne Trajane*, a work from which Gauguin used several models for paintings during his years in the South Sea Islands. *The Singer* has a striking resemblance to one of the vignettes that shows a damaged mosaic in the shape of a tondo with the description "Clio, muse de l'Histoire. Mosaïque de Santiponce" (fig. 98).[149] Here as well, the female bust is placed on the right side and—as in the relief—the

cubes form concentric lines around the woman's face. However, the vegetation that penetrates the mosaic at the woman's chest on the right side of the antique tondo has become the singer's bouquet on the left side of the relief.

When the relief appeared in public for the first time in 1881, its critical reception was generally negative. Paul Mantz wrote in *Le Temps*: "It is true that he has exhibited a medallion which, according to the catalogue, should represent a singer. This audacious piece seems to be inspired by the idea that reality is only a chimera that a truly free artist need not bother about too much. Applied to an art that lives by shape, this principle leads to strange consequences. Where ignorant nature has put a protrusion, M. Gauguin indicates not a depression but a hollow heroine. Let us not insist: suffice it to say that this female musician, who would find it difficult to suckle an infant, has disturbing hollows in her chest."[150] Henry Trianon was not positive either, and he pointed out the difficulty in seeing the medallion, which was "almost in round shapes, however not round enough, resulting in a shocking effect on anyone looking from an oblique angle. For example, she is so ugly and thin that it makes one cry out." The placement of the bouquet did not please him: "The bouquet of flowers, which the artist has brutally planted on her right side, looks more like an disgraceful projectile than a token of satisfied admiration."[151]—A-BF

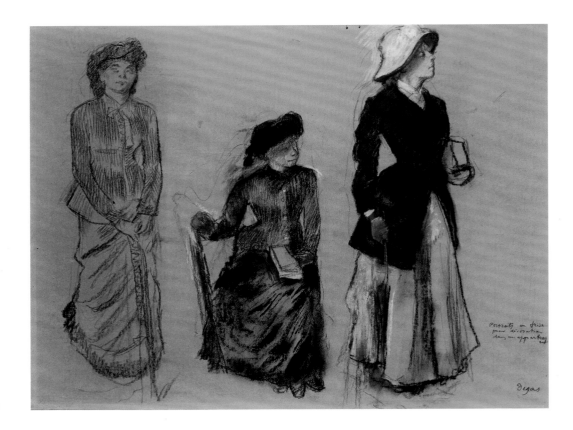

22

Lady Strolling, c. 1880
Tropical laurel (Terminalia), stained red and
 black, height 9³/₄ in. (25 cm)
The Kelton Foundation

Fig. 100 (*right*) Edgar Degas, *Project for Portraits in a
Frieze: Three Women*, 1879. Black chalk with pastel and
white highlights on gray wove paper, 19³/₄ × 25⁵/₈ in.
(50 × 65 cm). Private collection, Switzerland

Fig. 99 (*below*) Phototype by Gustave Arosa of ancient
terracotta figurine, from Wilhelm Froehner, *Terres cuites
d'Asie Mineure* (Paris. 1881). pl. 22

Experimentation in painted wood and wax were associated with progressive sculpture in the 1880s. In his review of the last Impressionist exhibition in 1886, the art critic Félix Fénéon was to look back admiringly at the works that Gauguin had exhibited at the Impressionist exhibition in 1881. These included *The Singer* (cat. 19) and *Lady Strolling*, "a figurine in colored wood."[152] To Fénéon this stiff little wooden statuette betokened a step on the road to a modern sculpture.

Many sculptors of the day made genre statuettes with motifs taken from modern life. They were more or less realistic and made of various materials, and the revival of polychromy was a characteristic feature of late nineteenth-century sculpture.[153] The ancient terracotta figurines discovered from 1874 onward on the west coast of Asia Minor and at Tanagra in Greece excited keen interest. Gauguin undoubtedly knew them, since Arosa made phototypes for Wilhelm Froehner's book on them (fig. 99)—which was published in

1881.[154] Many artists were interested in these living figures from the distant past. Inspired by new acquisitions at the Louvre, the painter Jean-Léon Gérôme made a number of statuettes that he sought to endow with an illusion of life by coloring marble and enameling bronze. Gauguin naturally despised this professor and leading figure in the stronghold of academicism and spoke disparagingly of his "archaeological accuracy."[155] His own, modern figurine can be seen as an ironical comment on this entire tendency. He would also have known the porcelain figures that Aubé was making for Haviland at Limoges, where the polychrome tradition was still alive.[156]

Clearly there was some kind of dialogue between Gauguin's little wooden figure and works by Degas—*Sketch for Portraits in a Frieze* (fig. 100), a drawing of three modern female types shown in the 1879 exhibition, as well as the sculptures *The Schoolgirl* (c. 1880–81; National Gallery of Art, Washington) and the *Little Dancer Aged*

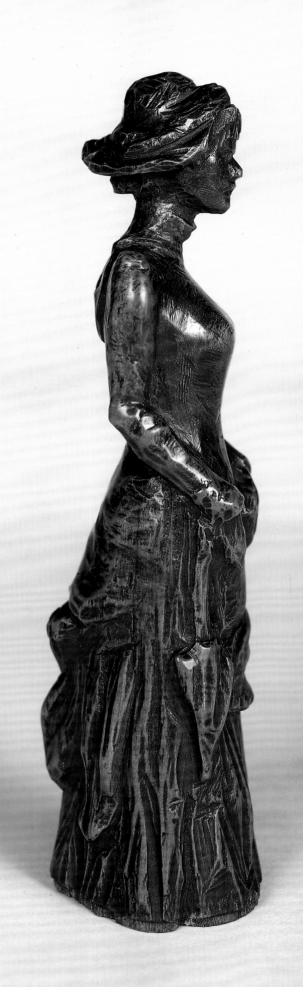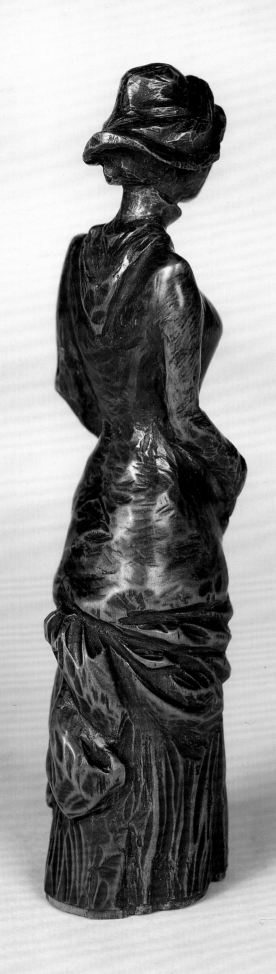

Fourteen.[157] On the other hand, the features common to these figures may simply have been typical of the age. In about 1882 Seurat made several drawings of figures with a similarly stiff and columnlike body language that can also be seen as expressions of the dawning neo-primitivism of the time.[158] With its simplified idiom, fairly rough, archaic carving, and summary coloring, *Lady Strolling* was certainly an insult to the ideals of academicism. When shown in the sixth Impressionist exhibition it was viewed as a provocation—just as ugly as the main attraction of the exhibition, Degas's figure of the fourteen-year-old dancer. "I will say nothing of the *Lady Strolling*, which they have had the audacity to show to the public," wrote Elie de Mont. "In my country I have known more than one little shepherd boy who could carve more interesting figurines on the end of a club."[159]

By associating the figure with Egyptian art, the critic Henry Trianon indirectly emphasized one of its innovative aspects. It must have been its statuesque stiffness that made him think of "the elegant figures in the Egyptian frescoes and papyri."[160] Clearly the archaic features of Gauguin's fashionably dressed Parisienne were obvious to people of the time. In this connection, Huysmans's reflections on the need for modern art to create an up-to-date image of the woman must be noted. They contained a remarkable passage in which he argued for the equality of different cultures and periods, attacked academicism, and emphasized that the concept of beauty varied with time and place: "The Venus de Milo . . . is neither more interesting nor more beautiful now than those ancient statues from the New World, arrayed with tattoos and with heads covered with feathers."[161]

Huysmans succinctly described *Lady Strolling* as "a statuette in wood that is Gothic in its modernity."[162] Like Trianon, he associated the work with "primitive" art. Meanwhile, in the extensive press discussion of Degas's dancer, contemporary ideas about polychromy found expression. Jules Claretie was reminded of "the realism of Spanish polychrome sculptures,"[163] while Nina de Villars saw a realization of the dreams of modern art inspired in her by the clothed and bejeweled painted wooden Virgins and saints in village churches.[164] There was a clear tendency to see the folk and church art of medieval tradition as a tacit model for contemporary trends.

Huysmans's interest in the Gothic was shared by Pissarro. In one of the artist's many letters to his son Lucien, he wrote in November 1883: "I have also sketched some little motifs for a wooden sculpture, in pure Gothic with little ornaments. It's marvelous. This is where one perceives the realism of that time. . . ."[165] Gothic had become a frame of reference in the search for new artistic directions, and Pissarro finished his letter to his son by encouraging him to copy similar figures in the museums—advice he undoubtedly also gave to Gauguin. The fact that *Lady Strolling* originally stood on a high base that formed part of the sculpture must have underlined the Gothic reference. It was the first time that the Gothic manifested itself as a source of inspiration in Gauguin's art, and the figure could be seen as a modern version of medieval portal sculptures. Later, Gauguin was to become fascinated by a polychrome, late-Gothic wooden crucifix in the Trémalo chapel near Pont-Aven.

At the same time as artists like Rodin and Degas sought to eliminate the base—in order to let the figure stand literally on an equal footing with its living counterpart—Gauguin was giving *his* figure a base that was relatively high and dominant. It was a reaction against the illusionism and extreme naturalism that sought to blur the distinction between a work of art and its motif. Gauguin was keen to acknowledge his work as the sculpture or object that it was. He created distance, whereas Degas and other naturalistic artists sought to eliminate boundaries. Not only with its material and summary coloring, but also with its tall base, *Lady Strolling* anticipated Gauguin's later work in Le Pouldu and the South Sea Islands.[166] —A-BF

23

Bust of Jean Gauguin, probably April 1881
Wax and surface treatment, height 5³/₈ in.
 (13.8 cm)
Inscribed in the wax: *P. Gauguin*
Ordrupgaard, Copenhagen

In 1880–81, when Gauguin was working on
the two radical works in wood that he was to
show at the Impressionist exhibition of the
latter year, he was affected by a work he had
heard of but never seen, Degas's *Little Dancer
Aged Fourteen* (fig. 92), a wax figure whose
nervous illusionism was underscored by the use
of real hair and real clothing. Awaited eagerly
but in vain at the exhibition of 1880, it must
have seemed something of a spectral presence.
When it finally appeared in the following year,
it caused nothing less than a revolution in the
idea of what a sculpture is and can be. Much
of the scandal surrounding the work concerned
the dancer's manipulated facial features and
profile. It was felt that their similarity to the
physiognomies of criminals, which were being
studied with such great interest at the time,
endowed the girl with a depraved quality that
was only enhanced by the ambiguous eroticism
of her half-closed eyes.

 The appearance of Degas's sculpture caused
turmoil in artistic circles. Everyone was talking
about it, and Gauguin—whose own sculptures
in the 1881 exhibition were similarly greeted
as avant-garde provocations—undoubtedly
had views on the subject. He left nothing in
writing, but some of his works imply an
attitude of deep fascination mixed with
ironical dissociation. One of these is a small
bust of an almost newborn baby that can be
identified as his fourth child, Jean-René.
Another is the bust of his son Clovis (figs. 93,
112), which he was to show in the exhibition
of 1882. A third work, a bust of his daughter,

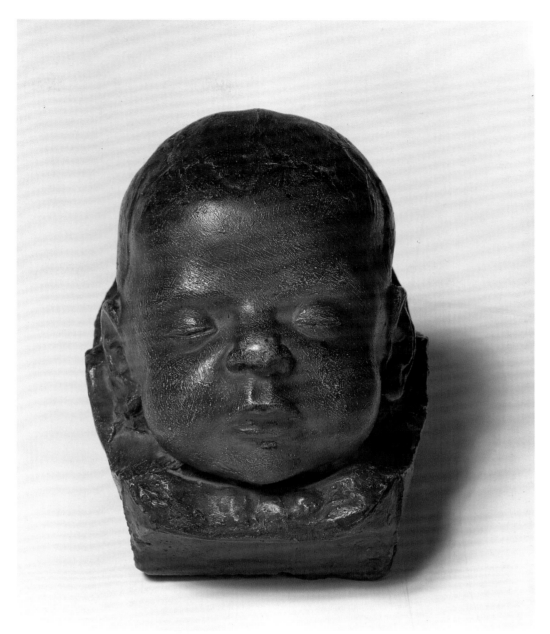

cat. 23

Aline, also belongs in this group (cat. 24).
Gauguin made his first known busts in marble,
but the Degas inspired him to make all three
of these busts of his children in wax.

 The bust of Jean-René Gauguin was
discovered a few years ago by the present
author in a Danish private collection and
published as a previously unknown Gauguin.
It is signed "P. Gauguin" on the collar in
which the head rests.[167] The "P" is difficult to
read but the rest of the signature is clear,

resembling that on the wax bust of Aline.[168]
The work was Gauguin's spontaneous reaction
to Degas's sculpture of the little dancer. The
sixth Impressionist exhibition opened on
April 2, 1881. Gauguin's son Jean-René—
usually called simply Jean—was born on
April 12, and the bust must have been made in
the second half of that month. Doubtless
Gauguin wanted to try out Degas's technique
and avant-garde approach. One can imagine
him going home with an impression of the

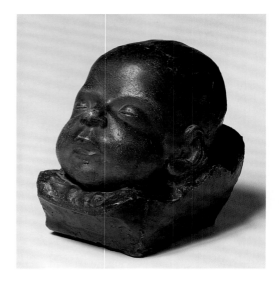

Fig. 101 Paul Gauguin, *Bust of Jean Gauguin* (alternative view of cat. 23)

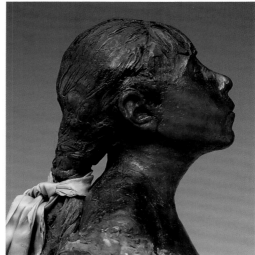

Fig. 102 Edgar Degas, *Little Dancer Aged Fourteen* (detail of fig. 92)

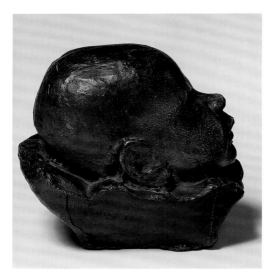

Fig. 103 Paul Gauguin, *Bust of Jean Gauguin* (alternative view of cat. 23)

little dancer fresh in his mind, and modeling his newborn son's features in a Degas-like manner—hence the experimental use of wax as a material, the idiosyncratic profile, the way in which the head is held back, the closed eyes, and the treatment of the surface to produce a "complexion," with the lips showing a hint of pink (figs. 101–3).

Fig. 104 Odilon Redon, *Head of a Martyr*, c. 1894. Charcoal and ink on buff paper, 15½ × 14 in. (39.4 × 35.6 cm). Collection Jasper Johns

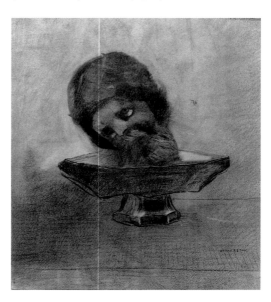

The detached head with closed eyes was to become one of the favorite motifs of the Symbolist movement, notably in works by Odilon Redon such as the *Head of a Martyr* of c. 1894 (fig. 104).[169] In the realm of sculpture, one thinks of Rodin's archetypal *Head of Sorrow* of 1882 (for example, at the Musée Rodin, Paris), and Degas's *Head Resting on One Hand, Bust* (National Gallery of Art, Washington), probably a portrait of the sleeping Madame Bartholomé made before her death in 1887.[170] The most familiar variation on the theme by Gauguin himself is the *Self-Portrait Vase* of 1888–89, with its streaks of blood (see fig. 94).[171] This latter feature is adumbrated in the head of Jean: down the left part of the back of the head there are traces of some red material,[172] a rather macabre touch in the likeness of a peacefully sleeping child (fig. 106). Several other later Gauguins seem to echo the work in one way or another, most strikingly—despite the obvious references to Precolumbian pottery—the anthropomorphic *Vase in the Form of a Head* (fig. 105).[173]

Jean is known from several of his father's works and appears as an infant in his pram alongside his older siblings Aline and Clovis in the large painting *Gauguin's Family, Rue Carcel* (see fig. 119).[174] It is perhaps also he

who appears in an unassuming small oil sketch of a baby viewed from an angle that shows no distinctive features.[175] He is seen in more detail in a pastel that shows his little face and pointed nose from in front (fig. 107).[176] In a charcoal drawing, he still has a baby's hairless head but is big enough to sit up by himself and must therefore be about six months old (fig. 108).[177] The latter drawing resembles one of the portrait profiles in relief with which Gauguin decorated his display cabinet of about

Fig. 105 Paul Gauguin, *Vase in the Form of a Head*, 1893–94. Clay, varnished and heightened in places with dark red pigment, 6 × 10⅜ in. (15.2 × 26.2 cm). Carmen Thyssen-Bornemisza Collection on loan at the Museo Thyssen-Bornemisza, Madrid

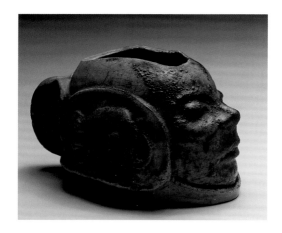

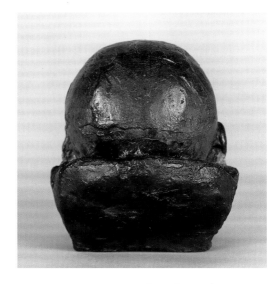

Fig. 106 Paul Gauguin, *Bust of Jean Gauguin* (alternative view of cat. 23)

Fig. 109 (*below top*) Paul Gauguin, cabinet (detail of cat. 15 showing head of Jean Gauguin)

Fig. 110 (*below center*) Paul Gauguin, *Jean*, 1881. Plaster cast of detail of cabinet (cat. 15). Location unknown

1881 (figs. 109, 110),[178] and this is also probably a portrait of Jean. In the wax bust we see the same long curve of the head, the fine, small ears, and the thick, protruding upper lip. Indeed, the profile portrait on the cabinet echoes the bust right down to the "collar" on which the head rests. A sketch in the Stockholm sketchbook shows a similar bust of a child; the child is a little older but may still be Jean (fig. 111).[179]—A-BF

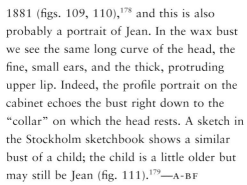

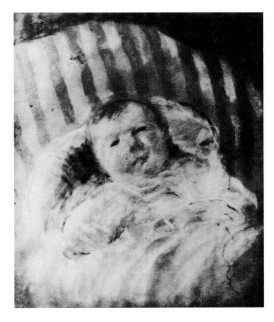

Fig. 107 Paul Gauguin, *Jean Gauguin*, 1881. Pastel. Location unknown (W 53)

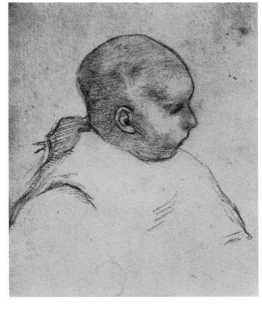

Fig. 108 Paul Gauguin, *Jean Gauguin*, 1881. Charcoal, $15^{3}/_{8} \times 13^{3}/_{8}$ in. (39 × 34 cm). Private collection.

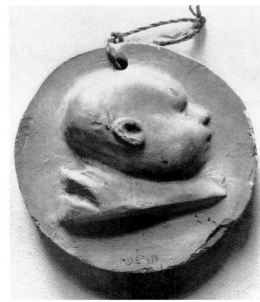

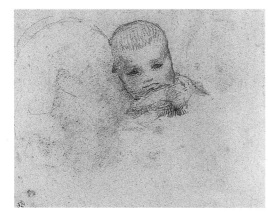

Fig. 111 (*right*) Paul Gauguin, *Woman's Profile and an Infant, Jean*, 1881. Black chalk on yellowish paper, $9^{1}/_{4} \times 11^{3}/_{4}$ in. (23.4 × 29.7 cm). Nationalmuseum, Stockholm (NM H 26/1936 recto)

24

Bust of Aline Gauguin, 1881
Wax, pedestal in wood, 11¾ × 8⅛ × 6⅝ in. with
 pedestal (30 × 20.8 × 16.8 cm)
Signed: *P. Gauguin*
Musée d'Orsay, Paris. Gift from Corinne Peterson,
 2003 (RF 4697)
Ordrupgaard only

For many years, Gauguin's bust of his only daughter, Aline, has been known only from an old photograph, and thought to date from as early as 1877, and believed to be a portrait of his firstborn child, Emil.[180] After its rediscovery in a private collection in France in 2003, Anne Pingeot found a signature and date inscribed in the wax in the middle of the chest ("P. Gauguin 1881") and published the work as a bust of Aline—who was born on Christmas Eve 1877 and was to die at the early age of nineteen.[181]

The bust underlines the importance of wax as a material in Gauguin's project of renewing sculpture, and bears witness to his constant desire to try out new kinds of artistic expression. It shows Aline when she was about three and a half years old. Despite her youth she has a look of reserve that is reminiscent of a classical portrait head. Here Gauguin experimented with a black wax, the darkness of which has a certain distancing effect. The modeling is summary and far less meticulous than that of the bust of Jean, and the surface is not painted. Nevertheless the work is no sketch but, as the mounting and signature would suggest, a finished work. The bust is placed asymmetrically on a small, low, tablelike pedestal. Already Gauguin was consciously incorporating the plinth into the overall artistic effect of the work, another distancing device that focuses attention on the sculpture as a sculpture rather than an illusion of reality. The effect is underlined by the traces of wax that he allowed to remain on its surface. The whole work testifies to the fascination with wax as a material that Degas's dancer inspired in Gauguin, although its blackness also reminds one of a bronze bust by Rodin.[182]

The third known work in this group of related wax busts is the bust of Clovis (see fig.

93). The bust is one of Gauguin's most original and least discussed works from these years. It was made in 1881–82 as a portrait of his third child, then aged between two and three years; he was born in May 1879.[183] Combining a wax head with a torso of wood, the bust is a work strangely lacking in homogeneity. The head with its delicate features and the long hair hardly harmonizes with the painted torso, the chest of which seems too developed for a child of this age; nor does the child's clothing, with its deep cut and asymmetrical fastening, resemble either children's dress of the time or the clothing that Gauguin's paintings and photographs show that his children wore.[184] Another remarkable feature about the torso is its striking fragmentation at the back, while at the bottom it consists of only a narrow shell (fig. 112). The torso cannot have been carved by Gauguin himself. It is surely the remains of an older figure[185] perhaps one intended for a village church—the kind of which Nina de Villars was thinking when she compared Degas's *Little Dancer Aged Fourteen* to figures of saints and virgins in painted wood.[186] Everything points to this wooden element's being one of Gauguin's found objects. He probably made just some small alterations, adjusting the arm stumps and the lower part of the waist before adding the wax head. The red of the jacket and the white of the shirt might also have been painted—or touched up—by him.

Gauguin gave the bust the character of a modern assemblage, and signed the finished work at the bottom left on the wooden torso. The flat modeling of the face, with eyes downcast (anticipating the closed eyes of Symbolism),[187] the frontal view, the cropping at the waist, the expression of innocence, and indeed the overall effect are reminiscent of "primitive" Italian sculpture of the Middle

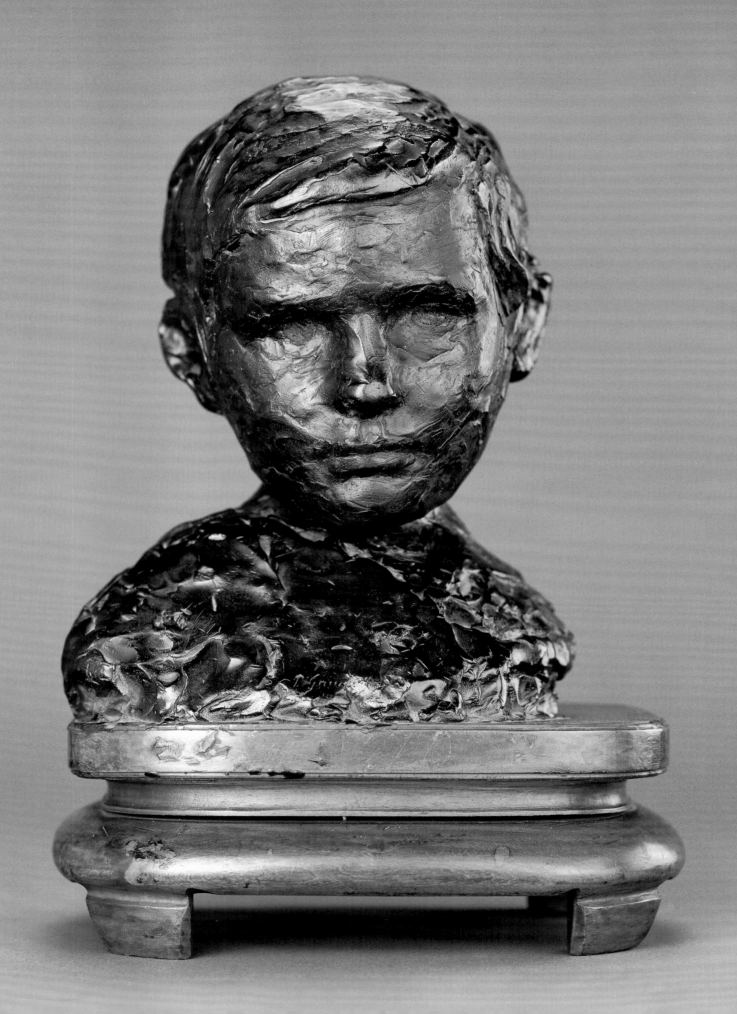

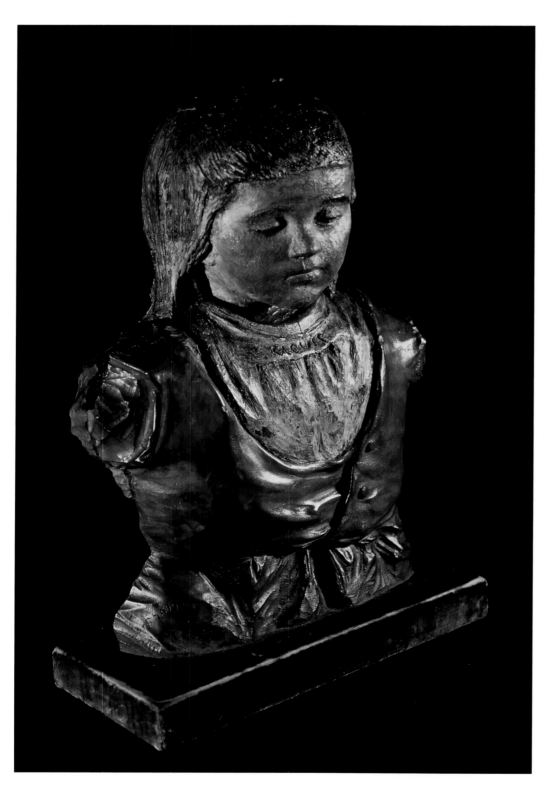

Ages and early Renaissance. Gauguin inscribed the name Clovis in capital letters along the neckband of the shirt, underlining the retrospective quality of the work. (The boy was named after Gauguin's father.) This unusual and archaic-sounding name was most commonly associated with the legendary Merovingian king.[188] Augustin Thierry's popular history book *Récits des temps mérovingiens*, which had appeared in 1840, gave rise to several historical paintings and illustrations that took their subjects from the Merovingian age.[189] Antoine-Jean Gros included King Clovis in his paintings in the dome of the Pantheon in 1824,[190] showing him with virtuously downcast eyes—perhaps as a sign of his conversion to Catholicism—and long hair. Gauguin's son also had long hair.[191] Given the archaic quality of the bust—and the name so strikingly inscribed on it—it seems possible that Gauguin was consciously playing on the identity of name between his Clovis and the famous Clovis of history.

The bust appeared in the seventh Impressionist exhibition in 1882 and should be seen as a comment on the renewal of sculpture that Degas had achieved in the previous year with his fourteen-year-old dancer. As in the case of the bust of Jean, it was this work that inspired the use of painted wax for the flat modeling of the child's face, which differs markedly from Gauguin's earlier portrait busts. The same is true of the half-closed eyes, but whereas this feature was interpreted as an expression of moral turpitude in Degas's dancer, Gauguin used it to suggest innocence; he later said that Clovis had "the intelligence of the heart" and should be treated as "fragile goods."[192]

While Degas provided his dancer with a real wig, Gauguin chose the opposite course and gave Clovis a stylized, almost helmetlike

Fig. 113 Edgar Degas, *Sketch after Gauguin's Bust of Clovis*, 1882. Pencil. Bibliothéque Nationale, Paris

coiffure, modeled in the wax itself and originally gilded (Clovis had very fair hair).[193] While Degas dressed his dancer in a real tutu, Gauguin gave Clovis a piece of wood as his body—apparently an old, slightly adapted piece of decorative art. The highly original use of found objects was something Gauguin and Degas had in common, but each used them in his own way.

Gauguin's bust was a criticism of the path towards extreme illusionism taken by Degas, and it is not at all unlikely that Degas recognized it as such. On the one hand, we know that he was affected enough by the work to record its appearance in one of his sketchbooks (fig. 113);[194] on the other, he was never to repeat the far-reaching naturalism of his fourteen-year-old dancer. Further, the bust of Clovis was to influence his bust of Hortense Valpinçon, which was similarly cropped at the waist in a manner unusual at the time.[195]

In the twentieth century, the found object was to foster debate about the very nature of art. Gauguin seems to look forward to this as early as the first half of the 1880s. His early sculptural works are in many ways more reified than actually sculptural. They demand to be seen as objects in the modern sense of the word.—A-BF

Richard R. Brettell Gauguin's Paintings in the Impressionist Exhibition of 1882

AMONG THE EIGHT IMPRESSIONIST EXHIBITIONS, those of 1877 and 1882 stand out as the most unified and important. They featured larger groups of important works by single artists, most of whom are today considered essential to the movement. In comparison, the other exhibitions were aesthetically confused and disjointed. Gauguin was much involved in the politics of the 1882 exhibition, most likely because he had been so successful the year before with his *Nude Study (Woman Sewing)* (cat. 19) and because of his efforts as a collector-lender on the model of Caillebotte. The exhibition he worked so hard to shape was the smallest of all the Impressionist exhibitions and the only one to be held in a single, large hall with artificial lighting, which enabled the artists to open to the public at night. Of the nine artists included— Caillebotte, Gauguin, Guillaumin, Monet, Morisot, Pissarro, Renoir, Sisley, and Paul-Victor Vignon—only the last was truly minor, and the selection of works by each of the others was strong. Indeed, only Gauguin could be said to have been "off form" that year. His submissions included his largest painting to date (cat. 25), but the remainder were comparatively small and even minor, almost as though he were more interested in ready sales than in impressing his colleagues.

Caillebotte, Monet, Pissarro, Renoir, and Sisley sent important works to the exhibition, and Pissarro made his public debut as a significant painter of the human figure. Following on from the large painting of a male peasant that was in Gauguin's collection and had been shown in the exhibition of 1881, and perhaps also from the success of Gauguin's own figure painting in the same exhibition, Pissarro completed a large number of rural genre paintings, fourteen of which he sent to the 1882 exhibition. These appeared along with a superb group of figure compositions by Caillebotte and Renoir in an exhibition that, despite the absence of Degas and Cassatt, was more seriously devoted to figure painting than any other Impressionist exhibition.

As we shall see, the exhibition was dominated by three large paintings by Caillebotte, Gauguin, and Renoir, respectively—each scaled to occupy the center of a large wall in the exhibition hall. Monet sent two large landscape paintings as well, *Floating Ice* (fig. 114) and *Setting Sun, on the Seine at Lavacourt, Winter Effect* (fig. 115). In their bold facture and unpeopled grandeur, both contrasted with Monet's submission to the Salon of that year, the smoothly finished and elegant *Seine at Lavacourt* (Dallas Museum of Art), which the painter himself referred to as "bourgeois." Caillebotte, Pissarro, and Renoir also submitted ambitiously scaled paintings—vertical figure compositions of almost identical dimension that ran the gamut of Impressionist subjects, from rural harvesting in Pissarro's *Girl Picking Herbs* (fig. 116) to an urban model asleep in her chair by Renoir (fig. 117) to Caillebotte's dramatically masculine study of urban bourgeois power, the *Man on the Balcony* (fig. 118). Smaller canvases by all nine artists were arranged in rows around these focal works in what must have been the most Salon-like installation of any Impressionist exhibition.

There is no doubt that Gauguin's reputation, which had reached its Impressionist apogee the year before, suffered a decline in this formidable exhibition. He expressed his ambivalence about his own participation in a moving letter to Pissarro written on

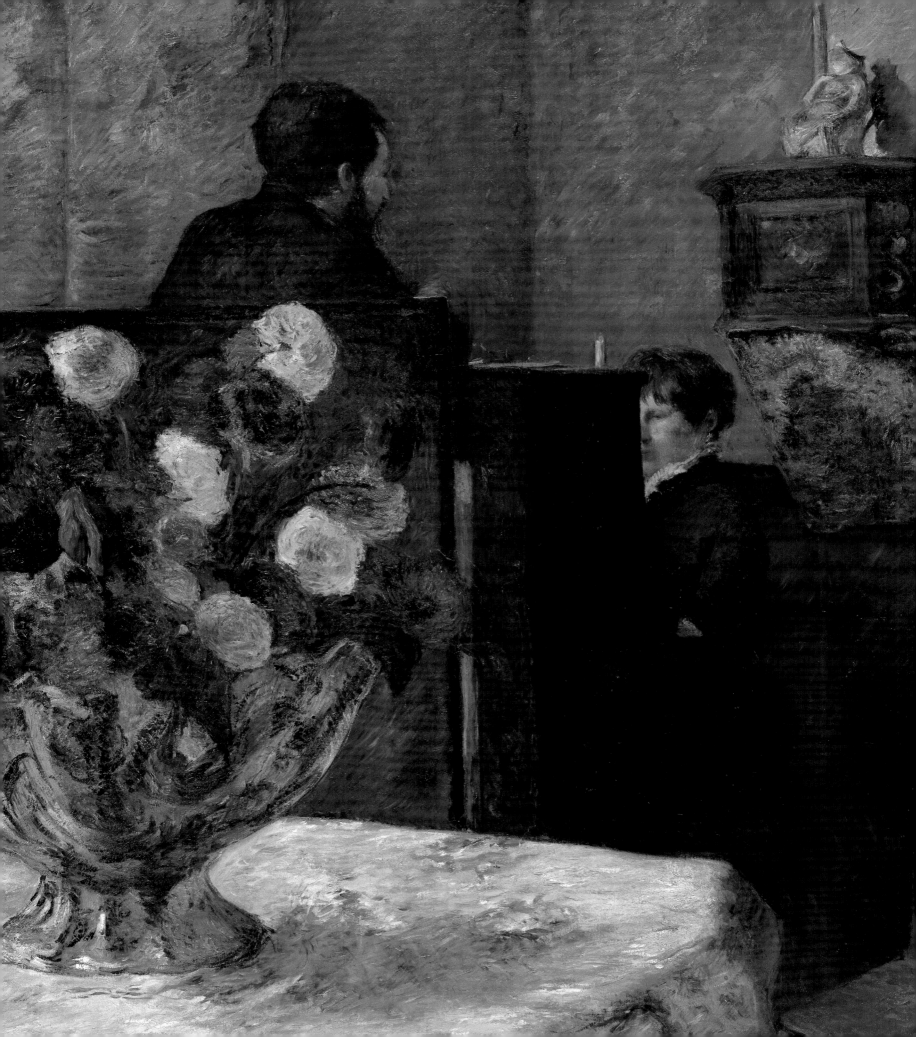

Fig. 114 (*right*) Claude Monet, *Floating Ice*, 1880.
Oil on canvas, 38¼ × 59¼ in. (97 × 150.5 cm). Shelburne
Museum, Shelburne, Vermont (27.1.2.108)

Fig. 115 (*below right*) Claude Monet, *Sunset on the Seine
at Lavacourt, Winter Effect*, 1880. Oil on canvas,
39⅜ × 59⅞ in. (100 × 152 cm). Musée du Petit Palais,
Paris (439)

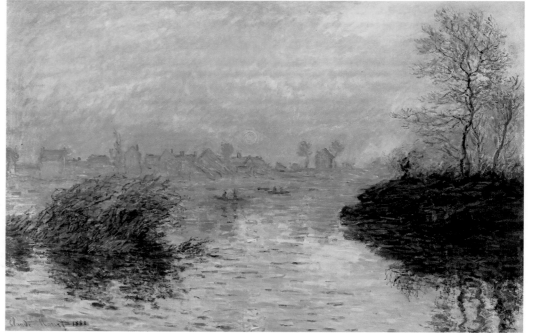

Fig. 116 Camille Pissarro, *Girl Picking Herbs*, 1881. Oil on
canvas, 45¾ × 35½ in. (116 × 90 cm). Private collection
(PV 543)

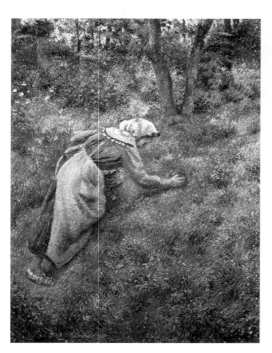

January 25, 1882.[196] In it, he pushed Pissarro not to join Degas and Raffaëlli in their
planned boycott of the exhibition and even proposed an exhibition of only five artists—
Caillebotte, Guillaumin, Monet, Pissarro, and Renoir—omitting himself. Clearly, he
believed in the enterprise of Impressionism and in what he saw as the strongest of the
artists, and regarded Pissarro as the essential figure in convincing Caillebotte, Monet,
and Renoir to remain. His stubborn belief in the quality of Guillaumin's art remains a
mystery to this day, and perhaps because Guillaumin had trouble finding the money to
frame his own submissions, Gauguin loaned work by his friend from his own collection

to the exhibition. It is difficult to read between the lines of the artists' correspondence and assess the extent of Gauguin's role in creating the 1882 exhibition. We know that he worked hard to make it happen and that, when it did, he himself was scarcely ready—beyond his one large canvas—to participate.

What can be said of Gauguin's submissions to the exhibition as a group? First, his pictorial world is dominated by his children and the family apartment in Paris. Neither the artist nor his wife, Mette, makes an appearance. Instead we see their daughter, Aline, sleeping or playing, one or another of their infant sons, and the apartment and garden. Sylvie Crussard has suggested that the submissions included the unfinished and unsigned canvas now called *Gauguin's Family, Rue Carcel* (fig. 119). The scale and ambition of this painting make us want to accept her view, along with her identification of the work as no. 20 in the catalogue, *Un morceau de jardin*. Yet the treatment of the figures—the family maid and three of the children—is so cursory and crude that it is difficult to imagine Gauguin submitting it in the same company as the large *Interior, Rue Carcel* (cat. 25), which is so beautifully and subtly painted. It seems likelier that he worked on the canvas for the exhibition but realizing its relative weakness, decided not to send it. It remains in an "incomplete" condition, a pictorial document to both the fragility of Gauguin's family life and his inability to deal with it easily in his art. The

contrast with the garden landscapes by Morisot and Renoir in the same exhibition is complete. Morisot's garden is always peopled by her husband, her daughter, and their female servants, but with an ease and intimacy that Gauguin was pictorially—and emotionally—incapable of expressing. Comparing Gauguin's awkwardly posed and painted work to Morisot's apparently effortless *Child in the Roses* (fig. 120) makes the Gauguin seem a visual denial of family. For him, the true subject of the painting was the spindly tree, with its meandering branches and skimpy leaves, that dominates the center of the composition. The shadowy doorway at the left seems distant and empty. Both Gauguin and Mette are absent, and no one seems to notice.

Few artists ever submitted such personal works to the Impressionist exhibitions. Morisot could compete, with her devotion to her daughter, her servants, her husband, and her city and country homes as primary subjects. Cassatt and Caillebotte also painted their families in Paris, as members of a patrician expatriate colony and as

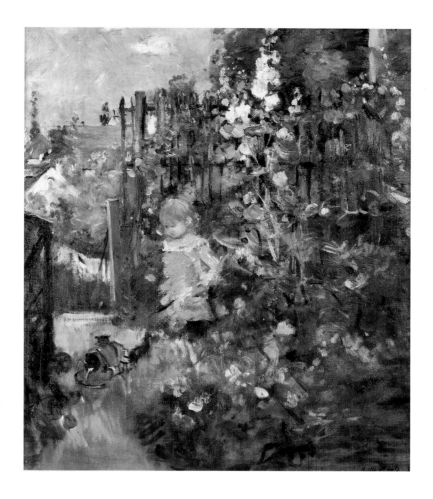

Fig. 120 Berthe Morisot, *Child in the Roses*, 1881.
Oil on canvas, 19⁷/₈ × 16³/₄ in. (50.5 × 42.6 cm).
Wallraff-Richartz-Museum, Cologne

members of the grand bourgeoisie. Cassatt touchingly recorded the slow decline of her sister Lydia in paintings at the Impressionist exhibitions of 1879, 1880, and 1881. Yet all these works share a buoyant intimacy—a belief that the world disclosed to the anonymous exhibition-goer possessed an emotional wholeness for the painter. Gauguin, by contrast, mined the shadows, corners, and dreams of his family, creating a pictorial world that seems to foreshadow the plays of Strindberg and Ibsen. Perhaps because of this, the critics failed to recognize, amidst the bonhomie of the Impressionist exhibition of 1882, the stirrings of a new aesthetic.

25

Interior, Rue Carcel, 1881
Oil on canvas, 51⅛ × 63¾ in. (130 × 162 cm)
Signed and dated lower right: *P. Gauguin 1881*
National Museum of Art, Architecture, and
 Design—National Gallery, Oslo
WII 76
Kimbell only

Gauguin painted this work to be the masterpiece among his thirteen submissions to the penultimate Impressionist exhibition in 1882. Listed first of the thirteen in the handwritten catalogue, it carried the laconic and obfuscating title *Fleurs, nature morte* (Flowers, Still Life), which was to be a source of confusion to scholars until the publication of the 1964 catalogue raisonné.[197] Like all the most important works exhibited by Gauguin in the Impressionist exhibitions, it was omitted from his first great retrospective, held in Paris in 1906.[198] This was perhaps because of the fact that, with the exception of *Nude Study (Woman Sewing)* (cat. 19), none of his paintings in these exhibitions received very positive critical notice or recognition as essential to the Impressionist movement. In rethinking this one, we must fully consider its place within the movement in which it made its appearance.

Unfortunately for Gauguin's reputation as an Impressionist, the 1882 exhibition was—like its predecessor in 1877—a defining moment for Impressionism. His largest painting to date was first seen in formidably strong company that included major works by some of the greatest artists of the group. Although Degas and Cassatt failed to exhibit, there were large groups of paintings by Caillebotte, Gauguin, Guillaumin, Monet, Morisot, Pissarro, Renoir, Sisley, and Vignon. Had Degas and Cassatt replaced Guillaumin and Vignon, it would have been the single finest Impressionist exhibition. Gauguin had made such a strong showing in the exhibitions of 1880 and 1881 that no one would have worried about his submissions in 1882. With his usual sense of professional opportunism, this year he decided to make another "entrance"—not as a landscapist as in 1880, nor as a figure painter-sculptor as in 1881, but as a painter of modern genre and still life.

His large painting of that year could be described as an amalgam of genre and still life. The subject, indicated in its original title, *Fleurs, nature morte*, is a huge arrangement of what seem to be dahlias in a vulgarly shaped and decorated ceramic vessel that rests on a table to the left of center—and, if we accept the latter part of the original title, even the figures are part of a "still life." We have seen that Gauguin thought carefully, even subversively, about his titles and that those in the previous Impressionist exhibition were particularly original and provocative. In this case, the title reads as a repudiation of the subject, which is in fact a domestic interior with a woman playing a piano while a man listens.

It is perhaps easiest to get at the work's originality by comparing it to paintings of similar dimensions by Caillebotte and Renoir that played analogous roles in the groups of works they submitted to the 1882 exhibition. Caillebotte's *The Game of Bézique* (fig. 121), the dimensions of which differ only fractionally from those of the Gauguin, along with the *Man on the Balcony* (see fig. 118), were the dominant works among his submissions, both in scale and in the number of critical notices they attracted. Both these large paintings represent the social world of haute-bourgeois men, the former embodying the seriousness and mental concentration brought to the world of "play." We see two men playing the relatively new game of bézique, each with a witness-advisor, while a fifth stands by and a sixth sits in a kind of stupor on a sofa at the back of the room. The four men at the felt-covered card table sit on various chairs, including a large red-velvet armchair, rather than a set arranged deliberately for cards. The group has clearly been "arranged" by the painter to be pictured, and we are asked to play a spectator's role

facing page Paul Gauguin, *Interior, Rue Carcel* (detail of cat. 25)

analogous to that of the standing man. Each figure is a portrait of a particular man, but the work is clearly a genre scene rather than a group portrait in the tradition of Frans Hals and others. It shows an authentic and contemporary occasion in a rather grand Parisian apartment, with painted, gilded paneling and new furniture. However serious the men are about their play, they are caught in a private, bourgeois social ritual of leisure. The precise time is not clear because the scene includes no light fixtures or windows, conveying a langorous sense of life as leisure unending.

Renoir chose a canvas somewhat larger than either Gauguin's or Caillebotte's to paint a visual hymn to bourgeois outdoor leisure in which the genders play equal roles. Now called *Luncheon of the Boating Party* (fig. 122), his painting was then entitled *Un déjeuner à Bougival*—in spite of the fact that it represents a restaurant in nearby Chatou. Though a display of raw talent that makes Caillebotte pale by comparison, Renoir's painting received fewer favorable critical notices than Caillebotte's. Both were centered on a table, one with the game and six figures, the other with the glorious remains of a meal and fifteen figures. In the Caillebotte, the game is in progress, its conclusion not yet decided; as viewers, we are asked to read the scene like amateur psychologists. Renoir chose a moment at the end of lunch, when the participants have begun to move about freely, chatting with those with whom they were not seated and relaxing before their afternoon activities. There is a healthy, warm sensuality that pervades the group, something altogether absent from the competitive concentration of Caillebotte's bézique players. The two works are in many ways opposite: all male as against male and female together; indoor as against outdoor;

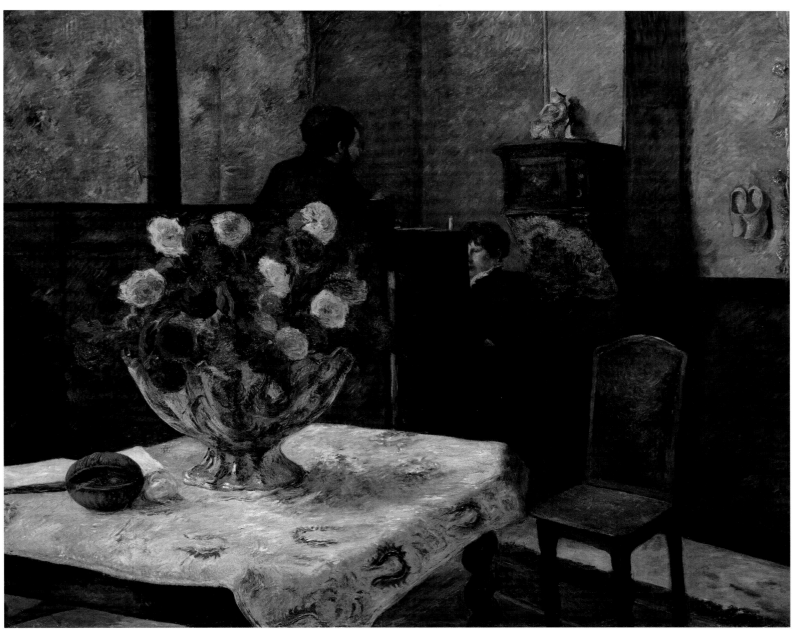

cat. 25

focused as against dispersed; tight as against loose. Yet each embodies the success of bourgeois socialization and at the same time its suitability as a subject for modern art.

This easy acceptance of the dominant bourgeoisie and its social rituals sets the Caillebotte and the Renoir quite apart from the Gauguin. As was often the case in the Impressionist exhibitions, one work of art broke every rule set by the others. The three paintings in question are strictly comparable in scale, modernity, and ambition, but that is as far as the comparison goes. Both Caillebotte and Renoir used titles that tell us precisely what is going on and, in the case of Renoir, where the scene is fictionally set. On both those counts, Gauguin is elusive. His title is precisely *not* descriptive of the subject of the painting, and we are given no verbal clues as to its meaning or location. From the deep shadows, the relatively bright, yellowish light, and the fact that the single candle is unlit, we are encouraged to place the scene in the daytime. Yet we see neither windows nor curtains, and no door allows us knowledge of the dimension or location of the room in relation to others in the house or apartment. The figures are physically isolated; unlike those in the Caillebotte and the Renoir, they cannot touch one another. The woman is an active participant in the subject as she is clearly playing an upright piano. She looks steadfastly at her music, "reading" as much as "playing." There is what we take to be another sheet of music on top of the piano and in front of the bearded man, whose right hand is just visible enough to suggest that he is beating time or following the woman's performance through gesture. He looks down at her, while she is completely absorbed in her activity.

This human presence is confined to corners, set in the background, behind a screen—

marginalized to a degree that was essentially unprecedented in genre painting. The majestic vessel of flowers so dominates the pictorial realm—and the original title—that we feel almost furtive looking into the corners for the figures. So often the primary elements in a genre composition, here the figures are secondary or even tertiary. The inanimate props arranged throughout the "nature morte" do little to help us decode what seems to be a suppressed message. We see a small sewing-basket, some yarn, and sheets of paper on the embroidered table cloth, but they are not associated in any direct ways with the figures absorbed in their music. Near the woman is a small, carved wall cupboard on which a blue-and-white Chinese figurine sits in the sun. Beneath it is a strange woven or embroidered cloth attached to both the cupboard and the wall. What does it cover? Is the lower part of the cupboard open to the air through a mesh, hence the cloth? Why is it so elaborate? On the wall to the right hangs a pair of sabots or wooden shoes like those worn by peasants and fishermen in Brittany and some parts of Normandy. This pair is rather small and, since the soft wood is so pale and yellow, must have been carved recently. On the far right, we see the wonderfully rendered orange fringe of a woven cloth similar to the one in *Nude Study (Woman Sewing)* (cat. 19).

In some ways, the most potent form in the painting other than the flowers is the empty chair pulled back from the table. Like the table, it is of recent, industrial manufacture and no particular distinction. Its combination of a padded back and a hard seat seems odd, and we look in vain for the other dining-room chairs that were surely part of the set. On the right we see the chimney of a cast-iron stove that warmed the room in winter, with its handle to control the flue. Gauguin hides most

of the stove and the male figure by placing a dark gray folding screen, probably made of paper mounted on an armature in the manner of a Japanese screen, directly in front of them. The folds in the screen—it seems to have only three wide segments—are echoed in the "folds" in the wall as it moves back and forth from shadow to light in the background.

Like so many later works by Gauguin, the painting at once forces the viewer to ask questions and refuses to give answers. What music is the woman playing? Who is she? What is in the cupboard? Who wears the wooden shoes? What kind of hanging is on the wall? Who was sitting in the chair? Who was sewing? A plausible "before and after" narrative could be constructed in which the woman was sewing and the man reading before getting bored and going to the piano, although the absence of a second chair discourages even this reading. If Caillebotte's painting is crowded but almost silent, if Renoir's is crowded and alive with conversation, Gauguin's is almost empty and silent except for the piano, and we have no sense of what the woman might be playing. How different this pianist is from Renoir's gloriously dressed young woman in *Woman at the Piano* (fig. 123), shown in the Impressionist exhibition of 1876, or from Cézanne's wonderful rendition of his sister playing Wagner transcriptions (*Young Woman at the Piano: Overture from Tännhauser*, 1869–70; State Hermitage Museum, Saint Petersburg).

Scholars have long tried to identify the figures in Gauguin's enigmatic genre painting but no one has succeeded. In her entry in the Wildenstein catalogue, Sylvie Crussard refuses even to play the game, asserting simply that the woman is not Mette and the man neither Gauguin nor Schuffenecker.[199] Perhaps

Gauguin intended to evoke actual people but also to withhold their identities. In this sense, his figures are almost like characters in a story or novel, and one could scour French realist and naturalist literature of the 1870s and early 1880s to find a "matching" passage. By refusing us so much already, however, he seems to discourage even this interpretative approach. One would find several passages with two figures and one piano, but none with the other key attributes of this particular scene.

We return to the flowers that were, according to the original title, the main subject of the painting. They are gloriously formal and arranged with great care. They seem to have been chosen to mimic the shapes and colors of the painted design of the vessel. The result is more than a little stilted and deliberate, but effective as proof of the artistic ambitions of the householder. If the furniture and décor in this room are more "interesting" than important or status-affirming, the flowers strive for a bourgeois civility that seems overdone. Both Monet and Renoir included superb floral still lifes in the 1882 exhibition, all but one of which must have appeared as effortless and delightful as this one was pretentious. Monet exhibited three views of his flower garden in Vétheuil along with three still lifes of daisies, white chrysanthemums, and sunflowers from the same garden. In each case the flowers were cut simply and shoved with little effort and less artifice into water-filled containers, two of them plain ceramic vessels from the kitchen (fig. 124). Renoir showed one haute-bourgeois still life of geraniums growing in a glorious blue-and-white ceramic tub, but also included seasonally specific still lifes of lilacs and peonies that are as artfully simple as Gauguin's dahlias are "overdressed" (see fig. 173).

In the end, Gauguin's painting is about enigma and evasion. It is neither still life nor

genre, neither bourgeois nor bohemian. It hides as much as it reveals and glories in corners, crannies, and edges. The longer one looks— and the work forces a lengthy encounter—the more haunting the empty chair becomes, the more the scene seems to involve the painter-viewer in an open narrative. But what is he or she to do? Caillebotte and Renoir invite us into their worlds with real enthusiasm, the former by creating a place for us, the latter by regaling us with such good food and bonhomie that we want to pull up a chair and join the party. Gauguin includes an empty chair but it is anything but an enticement, and its placement and hard seat almost make us want to flee from the painting's enigmas.

It is important to remember that Caillebotte, like Manet, was perfectly capable of creating visual embodiments of social anomie. Not all his paintings are optimistic representations of bourgeois affability and leisure. The comfortably, if not happily married couple whom he showed in his *Interior, Woman at the Window* (fig. 125) at the Impressionist exhibition of 1880 are wrapped in individual thoughts though sharing a physical space, and *In a café* (see fig. 59) at the same exhibition parsed figures, spaces, and reflections to the

Fig. 123 (*above left*) Pierre-Auguste Renoir, *Woman at the Piano*, 1875–76. Oil on canvas, 36³/₄ × 29¹/₄ in. (93.2 × 74.2 cm). The Art Institute of Chicago. Mr. and Mrs. Martin A. Ryerson Collection (1937.1025)

above right Paul Gauguin, *Interior, Rue Carcel* (detail of cat. 25)

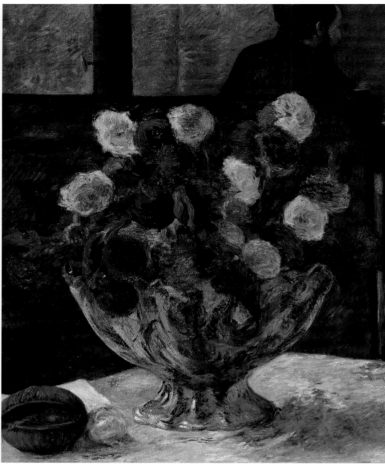

Fig. 124 (*above left*) Claude Monet, *Bouquet of Sunflowers*, 1881. Oil on canvas, 39³/₄ × 32 in. (101 × 81.3 cm). The Metropolitan Museum of Art, New York. H. O. Havemeyer Collection. Bequest of Mrs. H. O. Havemeyer, 1929 (29.100.107)

above right Paul Gauguin, *Interior, Rue Carcel* (detail of cat. 25)

disorientation of all. In *Interior, Woman at the Window*, J.-K. Huysmans recognized the "whiff of the household in a situation of easy money." He could hardly have made the same claim for the Gauguin. This self-conscious masterpiece elicited only two specific mentions among all the reviews of the 1882 exhibition and both were negative. Even Huysmans, who had been so completely seduced by Gauguin's ugly nude of the previous year, turned against him, calling his painting "moth-eaten and dull."[200] Jean de Nivelle inexplicably called it "a shop in London seen through the fog."[201] No one, not even the artist's friends, saw the work for what it was—a new kind of painting, at once complex and elusive, that sprang from reality and found not clarity but fragmentary allusions and mystery.

For a moment, we should consider the large paintings shown by Caillebotte, Renoir, and Gauguin at the 1882 exhibition neither as genre scenes nor as presentations of modern social conditions, but as pictorial surfaces. The problem of the surface had raged within Impressionism for years already, and the artists made various attempts to create unified surfaces on a large scale without giving up the materiality of the oil sketch; for them and their critics of all stripes, this last was essential to the Impressionist aesthetic. In each of the three paintings in question, the artist strove for a unified surface. Caillebotte varied the thickness and facture of the surface slightly to allow for the textural differences of cloth, wood, skin, paper, and hair. In *The Luncheon of the Boating Party*—made with no known preparatory paintings or drawings—Renoir worked wet-on-wet with brushes of different sizes to create a surface alive with incident but without great variations of thin and thick

Fig. 125 Gustave Caillebotte, *Interior, Woman at the Window*, 1880. Oil on canvas, 45³/₄ × 35¹/₈ in. (116 × 89 cm). Private collection

paint, allowing the eye to jump across it. Gauguin, on the contrary, created an almost completely unified surface in which every form—from flower petal to wall, to wood, to skin—consists of hundreds of small, interlocking, flickering strokes. His surface is equally complex and equally interesting across its entirety, no matter what the status of the form described. To some early critics the result looked overworked and anxious—as it does to many viewers today. Its complexity and consistency of surface certainly cannot have worked in its favor in the installation of the 1882 exhibition. The paintings were hung in one enormous room in three rows with the largest on top, in the usual French fashion. Caillebotte's and Renoir's would have "worked" at this distance, but Gauguin's haunting pictorial digression evidently suffered.—RRB

The Little Dreamer, 1881
Oil on canvas, 23³/₈ × 29³/₈ in. (59.5 × 74.5 cm)
Signed and dated upper left: *1881 p Gauguin*
Ordrupgaard, Copenhagen
WII 75

Was Gauguin the first artist to paint the dreams of a child? Sleeping figures are hardly common in the history of art and, with the exception of the Christ child in a cradle, they are rarely children. The sleeping children of northern European painting sleep the sleep of death in tragically lifelike posthumous portraits. The dominant image of a sleeper in Gauguin's mind would probably have been Courbet's great erotic masterpiece in the Arosa collection, the so-called *Young Woman Sleeping* (see fig. 86). Courbet also painted sleeping spinners, men who have been wounded, nymphs, and nudes, creating in his viewers a fascinated unease at their own voyeurism.

There is essentially no iconography of sleep in Impressionism. The movement was all but obsessed by the waking state, by the mobility of vision, by the "real world" viewed. Degas's nudes, even in the most informal of the monotypes, are almost always in motion, and even the great reclining nude in the dark monotype made by him for Gustave Arosa's friend Philippe Burty has just put down a newspaper and spread her legs in anticipation (fig. 127). If she has nodded off to sleep, it is only to come back to life at any moment. Caillebotte's most erotic female nude, like Courbet's, either sleeps or feigns sleep—but he never exhibited the painting in his lifetime (fig. 126).

Fig. 126 (*above left*) Gustave Caillebotte, *Nude on a Couch*, c. 1880. Oil on canvas, 51 × 77 in. (129.5 × 195.6 cm). The Minneapolis Institute of Arts. The John R. Van Derlip Fund (67.67)

Fig. 127 (*left*) Edgar Degas, *Female Nude Reclining on Her Bed*, 1880–85. Monotype in black, on ivory laid paper, 7⁷/₈ × 16¹/₄ in. (19.9 × 41.3 cm). The Art Institute of Chicago. The Clarence Buckingham Collection (1970.590)

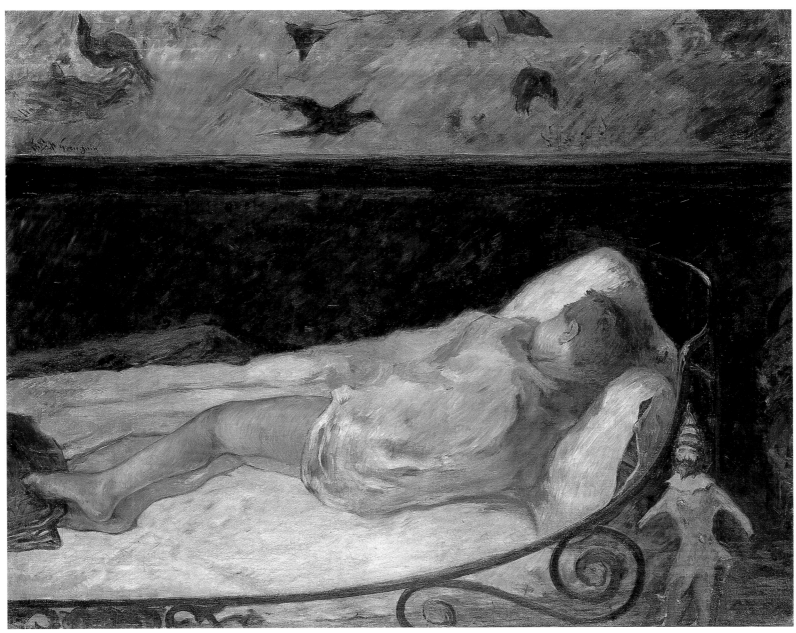

cat. 26

Fig. 128 Pierre-Auguste Renoir, *Young Woman Sleeping*, 1880. Oil on canvas, 19¼ × 23⅝ in. (49 × 60 cm). Private collection, Switzerland

In this light Gauguin's small painting—sent to the 1882 Impressionist exhibition as *La Petite rêve. Etude (Little Girl Dreaming, Study)*—takes on real art-historical significance. In a certain way, it is forthrightly realist in its intentions. It represents the painter's only daughter, Aline, her hair cropped androgynously short, sleeping in a metal sleigh bed, as her toy clown hangs as a perpetually wakeful guardian from its prow. Birds glide serenely through the flattened spaces of the greenish wallpaper, and the girl's head and upper torso make such a deep indentation in the pillow that we can almost feel her weight. Her ear rises alertly from her hair, but we can see nothing of the rest of her face, and the prominence of the little ear makes us want to be quiet, lest she awake. It is clearly summer, because she sleeps without a cover, her cotton nightshirt gathered around her, rendering what should be her shoulder and arm invisible. Are her hands pushed together in prayer behind her sleeping head?

This richly enigmatic picture was not the only representation of sleep in the 1882

Impressionist exhibition. The other was by Renoir, who gave the work a title like Arosa's Courbet, *Jeune femme endormie (Young Woman Sleeping)*, but with "fille" in place of "femme" (fig. 128). Whereas Courbet called his sexy model a "femme" or "woman," Renoir turned who must have been a model in her late teens into a "fille" or "girl." Renoir's sleeping girl is nonetheless the occasion for erotic reverie on the part of a presumed male viewer, and in this he followed Courbet. Gauguin called his figure simply a little girl or "petite" and showed her in what is clearly her nursery, adrift in a world of slumber. As viewers, we are cast in the role of watchful parent rather than lascivious searcher after sexual gratification. The painting implies a loving and protective relationship: the girl's head and limbs are treated with a patient particularity, and her feet curl around a wool blanket folded at the foot of the bed in case she becomes cold.

Gauguin liberates us from our libido in two ways. First, he shows a prepubescent child asleep, and, second, he assures us that his painting represents not just a sleeper but a dreamer. In this way he introduced into Impressionism a painting whose subject is an invisible activity. That the painting appeared to show merely a sleeping figure meant that no critic of the 1882 exhibition appreciated its radical aim—to use the visual to evoke the invisible. Not even Huysmans, who was already at work on his novel *A Rebours (Against Nature)*, understood its originality.

With four children, thee at home, by the time the 1882 exhibition opened to the public in March 1882, Gauguin was as much a "family man" as any artist in the exhibition. Children of various ages surrounded him daily and, like Morisot, Monet, and Pissarro, he turned to them as subjects for his art.—RRB

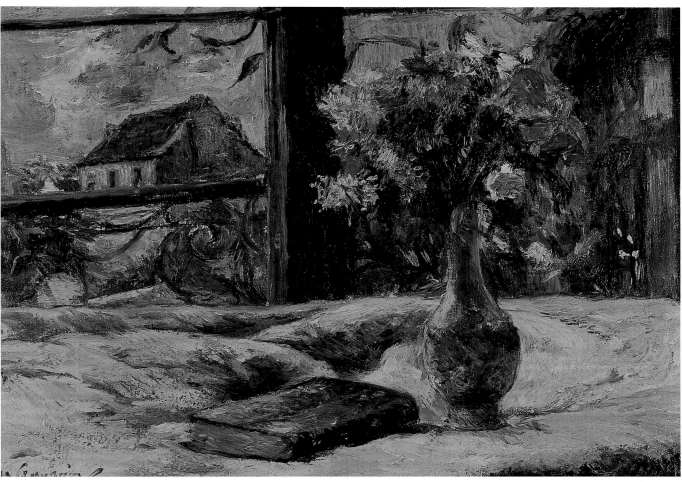

cat. 27

27

Vase of Flowers and Window, 1881
Oil on canvas, $7^1/_2 \times 10^5/_8$ in. (19 × 27 cm)
Signed lower left: *p Gauguin*
Musée des Beaux-Arts, Rennes
WII 80

This tiny still life is the only surviving work that matches the title of the painting by Gauguin listed as no. 23 in the handwritten catalogue of the Impressionist exhibition of 1881, *A la fenêtre, nature morte*. Sylvie Crussard has shown conclusively that he painted it from a window facing the garden of his rented apartment on the Rue Carcel, thereby dating it to 1881 and linking it to other works in the 1882 exhibition that show the painter's apartment and garden.[202] Its relatively thick facture is extraordinarily varied for such a small canvas. It relates to earlier still lifes by Renoir, Sisley, and Pissarro but has no precise relationship to any in particular. What is remarkable is that it has no real affinity with Cézanne, whose still-life aesthetic was so important for Gauguin in other works of the same period. Gauguin's stylistic ambivalence is manifest.

Considered along with his other small paintings in the Impressionist exhibition of 1882, the work makes clear Gauguin's desire to create charming cabinet paintings for a middle-class clientele—in a manner that harks back to Arosa and his amateur-collector friends of the 1850s and 1860s.—RRB

An Interlude

Richard R. Brettell The Impressionist Breakdown:
Gauguin in Paris, Pontoise, and Osny, 1882–1883

I N JANUARY 1882, GAUGUIN'S BUSINESS EMPIRE began to collapse. L'Union
Générale declared bankruptcy, sending the stock market into a downward spiral and
rendering almost valueless many of the businessman-artist's personal stocks. The needs
of his growing family, the material desires of his wife, Mette, and his increasing
obsession with what one might call his "anticareer" as an artist must have collided in
the face of financial uncertainty. He spent countless hours and many of his weekends on
his art, and was working just as hard at the artistic politics of the seventh Impressionist
exhibition. His submissions to that toweringly important exhibition were not, with two
exceptions, up to his own standard. By the spring of 1882 he stood on the brink of a
crisis—personal, professional, financial, and moral. It was a crisis that was to last the
rest of his life.

What could he do in these circumstances? He was most likely too proud to turn to
his wealthy brother-in-law and sister or to the Arosas, all of whom seem to have
weathered the downturn as they had others before. He had a wellspring of good advice
in his artistic mentor Pissarro, who had endured similar travails for more than twenty
years and managed to live with a large family on little money while working
committedly on his art. Pissarro's strategy was to live cheaply away from Paris, keeping
a tiny pied à terre there for business. Gauguin's, on the other hand, was to glide
through his problems by operating as a small-scale businessman, an art dealer (both in
his own work and in that of his colleagues), and a debtor. He confided frequently in
both Pissarro and Guillaumin, although the latter failed to save his letters. These friends
played an essential part in Gauguin's transition from businessman-artist to artist-
businessman and finally to artist, which occurred gradually but steadily between 1882
and 1886.

The letters he wrote to Pissarro in 1882 reveal Gauguin's sheer ambition as an artist.
Already, he was beginning to write with intellectual breadth, forshadowing the mature
artistic theory of the *Notes Synthétiques* of 1885. He made impressive and experimental
forays into sculpture, using both theory and practice to construct a modern idea of
sculpture that furthered the *paragone* of Renaissance theory. He also began to dabble in
what he called "Impressionist tapestries," although apparently none of these has
survived. The tapestries project relates in a fascinating way to the practice of his
Impressionist colleagues, who were beginning to regularize their facture using color
weaving as a model.

We have seen that Gauguin owned some vernacular textiles from Peru, several of
which he included conspicuously as wall hangings and table decorations in his
paintings. We have also seen his development of what one might call a "woven" facture
in his paintings, and several still lifes of 1882 seem almost to unravel into strands or
threads of color as we look at them. In *Flowers and Carpet* (fig. 129), which he
included in the 1882 Impressionist exhibition, he made a visual fetish of some textile
fringe in the lower-right corner, and in the ambitious *Still Life with Tine and Carafon*
(fig. 130) he exaggerated the device. The entire lower edge of the latter painting
represents a long, gloriously painted golden fringe, each strand of which is a separate

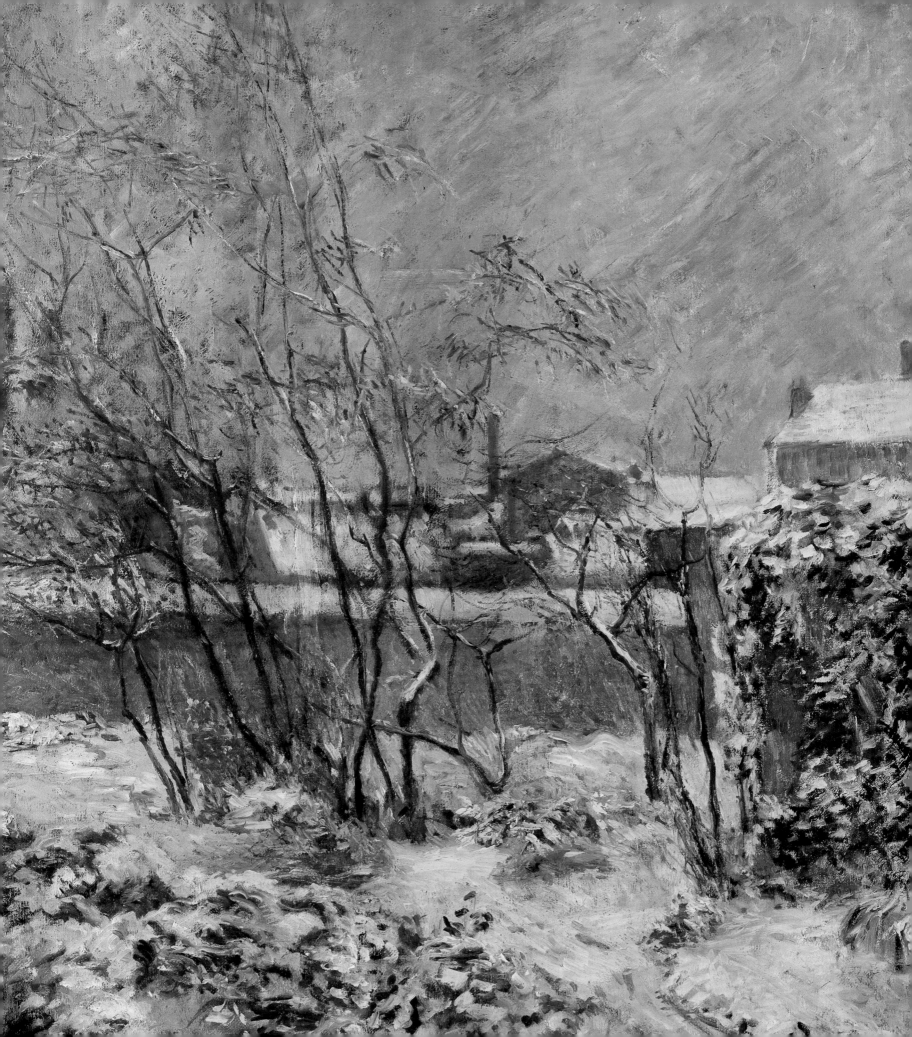

Fig. 129 Paul Gauguin, *Flowers and Carpet*, 1881. Oil on canvas, 7½ × 10⅝ in. (19 × 27 cm). Private collection, France (WII 81)

stroke in a tour de force of brushwork. There is also the orange fringe that erupts along the upper-right edge of his masterpiece of the 1882 Impressionist exhibition, *Interior, Rue Carcel* (cat. 25).

Gauguin's fascination with the chromatic structure of woven textiles must be seen in the larger context of French nineteenth-century art theory. The scientist Michel-Eugène Chevreul's famous lecture on color, used by painters of all persuasions throughout the middle and later parts of the century, derived from his work with tapestry weaving.[1] In spite of the fact that none of Gauguin's "Impressionist tapestries" survives, and no preparatory works can be identified, it is clear that they had a profound effect on his paintings. His interest in the relationships between tapestry, color, and painting looked back to Chevreul and forward to Vincent van Gogh in 1886–87.

Gauguin's earliest extended piece of writing on aesthetic matters forms the substance of a letter to Pissarro plausibly dated by Victor Merlhès to May-June 1882.[2] The most important aspect of this dating, if correct, is that the letter followed the 1882 Impressionist exhibition and was among the earliest indications of Gauguin's developing anti-Impressionism. In it, he speculated on the training of "the Masters," all of whom learned their practice when they were young and were therefore in possession of "a sure hand and a precise memory." He went on to discuss the achievement of Delacroix in a way that prefigured his numerous later discussions of this artist, whose work was more important to him than that of any other figure of the nineteenth century.[3] After this, he made an assertion that was truly extraordinary for a committed Impressionist painter: "In conclusion, easel paintings that succeed as 'great painting' are derived from

literature." Thus he condemned painters such as Courbet, Corot, and Millet to a mediocrity explained by their adherence to the mundane reality of genre and landscape. How, one might ask, could he sincerely make such a pronouncement while himself continuing to paint nonliterary subjects rooted in the observation of his own quite ordinary surroundings?

The answer to this apparent conundrum lies in his increasing commitment to studio practice. He made enlarged and adjusted "copies" or "versions" of his own paintings in the studio throughout his Impressionist career, a practice he affirmed in the letter: "I believe it is time (if this fits with your temperament) to work *more in the studio*, but to allow things to mature from the point of view of arrangement and of the scene."[4] In this endorsement of compositional repetition achieved indirectly and from memory, he might sound more like an academician than an Impressionist. Yet we should beware of reading academic sympathies into his words. After all, he was writing to none other than Pissarro, and what he was advocating was the reinvigoration of studio practice by applying lessons learned from the direct painting of the Impressionists. As he wrote in the same letter, "it is necessary to have a dose of youth and stubbornness."[5]

Gauguin's achievements as an artist in the period following the 1882 exhibition were tied to those of Pissarro. Indeed, never again was he to be closer to his mentor. Not only did he write frequently to Pissarro (unfortunately for us, Gauguin failed to save Pissarro's replies); he also worked in the company of the older artist, as well as with Cézanne and Guillaumin in the final years of the "Ecole de Pontoise." He became stronger as an artist because he worked patiently with others, constantly testing his paintings against those of his colleagues. This is not to say that, in quality, the paintings matched those of Cézanne or even Pissarro in the same period. But Gauguin's willingness to struggle competitively with others and to suppress his own strong will in collaborative working sessions surely contributed to the growing maturity of both his art and his theory.

The importance of Cézanne in this equation cannot be underestimated. Unfortunately, we know almost nothing of the encounters of the two men in 1882, although they must have been together in Pontoise during the summer of that year. Oddly, Gauguin continued to misspell Cézanne's name (as Césanne) in his letters to Pissarro from 1882 and 1883. But we know that he owned at least three of Cézanne's paintings by the summer of 1883 and referred to others he saw at Père Tanguy's in a letter of July 1884.[6] Cézanne's own career of the early 1880s is little studied, and the dating of his works painted in Pontoise and its environs in the most recent catalogue raisonné varies from 1879 to 1882 with no documentary and little visual evidence.[7] It is clear, however, that in the paintings they made in and around Pontoise in the early 1880s Gauguin and Cézanne struggled to create works with very different factures and chromatic structures. Rarely did Gauguin approach the "constructivist stroke" of Cézanne, preferring his "woven" facture. In their obsession with compositional experimentation and their devotion to still life, Gauguin and Cézanne were more like each other than they were like Pissarro. Probably they met only in Pontoise with Pissarro, in spite of the fact that

Fig. 131 Camille Pissarro, *Poultry Market at Pontoise*, 1882. Oil on canvas, 31⅞ × 25⅝ in. (81 × 65 cm). Norton Simon Museum, Pasadena, California (M.1984.2.P) (PV 576)

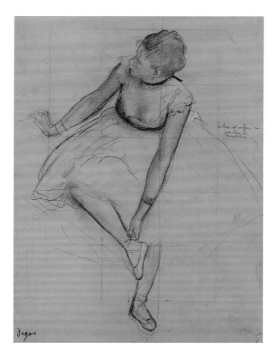

Fig. 132 Edgar Degas, *Dancer Adjusting Her Slipper*, 1874. Graphite heightened with white chalk on faded pink paper; squared for transfer; 13 × 9⅝ in. (33 × 24 cm). The Metropolitan Museum of Art, New York. H. O. Havemeyer Collection, Bequest of Mrs. H. O. Havemeyer, 1929. (29.100.941)

Fig. 133 *(facing page)* Paul Gauguin, *Snow, Rue Carcel II*, 1883. Oil on canvas, 46⅛ × 35½ in. (117 × 90 cm). Private collection (WII 98)

they lived a short distance from each other in Paris. Cézanne's two apartments on the Rue de l'Ouest were, like Gauguin's apartment nearby, familial and aesthetic laboratories for the artist. Each represented his family and rooted his Parisian paintings in his private realm, but each seems to have done so alone, without any impetus from the other.

The ambitious, delicate dance of art and theory, Pissarro and Cézanne, painting and sculpture defined Gauguin's career in 1882 and 1883, preparing him for his separation from Paris, first in Rouen and then in Copenhagen. Of the paintings of 1882 and 1883, almost all must be interpreted in the context of Impressionism and the "Ecole de Pontoise."[8] Only one large painting seems to stand apart from the Pissarro-Cézanne axis, the masterful *Snow, Rue Carcel II* (fig. 133). On a canvas larger than any Pissarro used in the same years, Gauguin painted this work in Paris, not from life but from an unsigned smaller study (cat. 30). No painting of 1882–83 by either Cézanne or Pissarro compares to it. Crussard dates the smaller canvas to some time during the documented snowfalls in Paris in December 1882 and January and March of 1883.[9] The complex, interwoven surface of the large painting attests to a lengthy process of gestation, like that recommended by the artist in his letter of 1882 to Pissarro. He probably completed it in a period of about three months.[10]

In painting the large version, Gauguin took the composition of the landscape setting directly from the smaller work, copying virtually every aspect exactly. The larger canvas had a taller format, so he simply increased the amount of gray sky at the top. He regularized and completed parts of the architectural setting from the smaller painting and omitted a small tree on the right of the clump of foliage in the left middle-ground. He then added two female figures to the lower-left corner, in a way that destabilizes— and modernizes—the composition. They seem to have jumped out of a rural painting by Pissarro; at first glance, the subject might even appear to be a country scene. Although Pissarro represented several young female peasants from the back, however, none of them can be identified as sources for Gauguin, except in the most generic of ways (fig. 131). Many scholars have related the figure adjusting her shoe in the lower-left corner to Degas, a painter Gauguin admired even though the difficult older artist had attempted to sabotage the 1882 exhibition. If we mentally redress this figure in a tutu and move her in our minds to a dance studio in Paris, she becomes a "dancer adjusting her shoe." Yet, again, there is no specific connection. The closest figure in Degas's work is in a drawing of 1874 (fig. 132). But it is unlikely that Gauguin knew this sheet, and in any case the correspondence of pose is by no means a precise one.

What we have are figures placed in a corner à la Degas, but dressed as if they had walked out of a Pissarro. One is posed in homage to Degas, the other to Pissarro, and each takes its place in a landscape associated with Gauguin himself. Though utterly personal, the painting toys with the sensibilities of others and succeeds more in subverting or disguising than in glorifying its sources. Again, Gauguin evades our efforts to interpret his work, teasing us into asking unanswerable questions and looking for nonexistent sources.

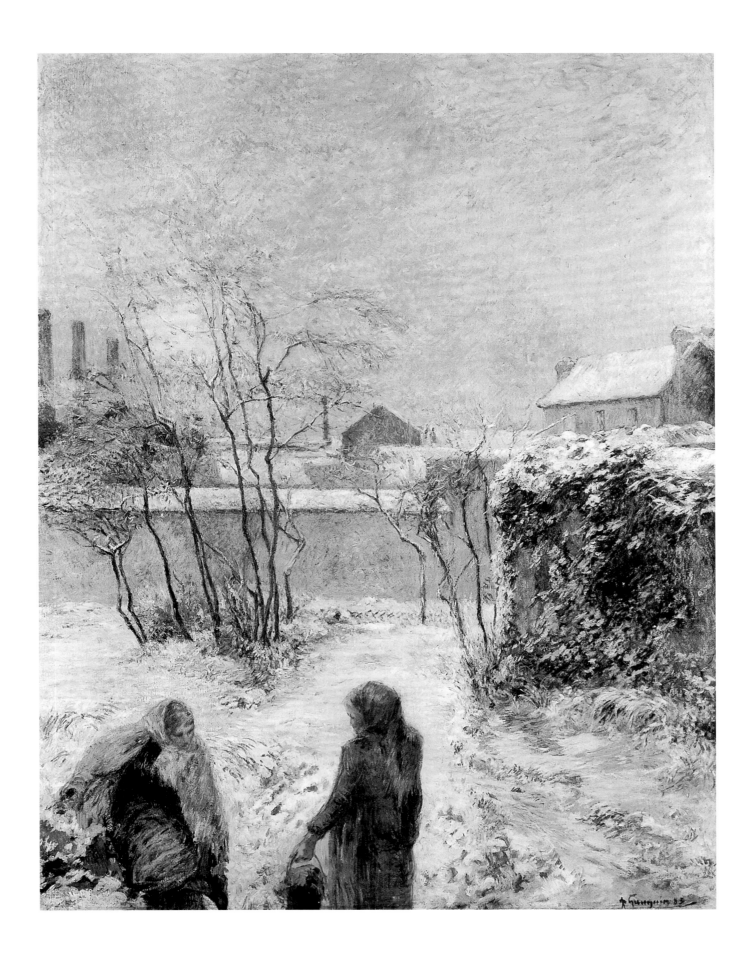

This important painting was a completely successful integration of the aesthetics of Monet, Pissarro, and Degas, yet none of those artists could have painted it. For this reason it would have made an enormous impact in an Impressionist exhibition, had the artists been able to organize one in 1883. It has the same awkward intensity and complexity of the *Interior, Rue Carcel* (cat. 25), exhibited the previous year, but its subtle color harmonies and bravura brushwork make it much easier to love. By adding the figures, Gauguin created pockets of space missing from the unpeopled smaller version and assured us a superior viewpoint, looking down at them. Gauguin's entrapment of a small moment of conversational exchange forces us to speculate about these two attractive young women outside on a winter day. Soon, they will be on their way, as their peripheral position in the landscape makes clear. Neither of them is young enough to be Gauguin's daughter or old enough to be his wife. They function simply as young women, in the same way as their counterparts in Pissarro's paintings of this period.

Unfortunately, no one outside Gauguin's immediate circle saw this masterful painting during his lifetime. It appeared in a private exhibition in Rouen in July 1884, but was refused from the regional Salon in that same city. Gauguin took it to Copenhagen in November of the same year and it seems never to have been publicly exhibited there until 1917, years after the artist's death. So it occupies a liminal place in the history of Impressionism, in spite of the fact that it is among the most subtle and accomplished of all Impressionist winter paintings. The effect is like looking into the inside of a conch shell at the thousands of pale colors that flicker in the light. Pinks, apricots, celadons, touches of bright orange, lilacs, ivories, mint greens—the colors seem to tremble in a facture of interwoven dabs, lines, and touches of paint that must have taken the painter months to achieve. It is a highly controlled composition with little spontaneity, a structured response to Impressionism rather than an impression.

28

Chou Quarries at Pontoise II, 1882
Oil on canvas, 23⅝ × 28¾ in. (60 × 73 cm)
Signed lower left: *p Gauguin*
National Gallery of Canada, Ottawa
WII 86

29

Chou Quarry, Hole in the Cliff, 1882
Oil on canvas, 35 × 45⅝ in. (89 × 116 cm)
Signed and dated lower left: *p Gauguin 1882*
Kunsthaus, Zurich. Vereinigung Zürcher
 Kunstfreunde
WII 88
[*Illustrated p. 181 below*]

Gauguin spent much of the summer of 1882 in Pontoise, where he worked with Pissarro, Guillaumin, Cézanne, and others in a collective effort to transcribe the hilly landscape to the east of the town. The old quarries in this area between Pontoise and Auvers had been abandoned after the Second Empire, during which they had provided a good deal of the building material for Paris. They were far from the rail line and isolated from the agricultural areas on the alluvial plains of the Oise and the plains of Vexin above them. The four artists could work there without fear of interruption.

The paintings they made have often been published, but never physically grouped, and even Gauguin's work of that summer is relatively little known. Each of the present landscapes included in this exhibition raises different questions about his landscape aesthetic and relationship to the work of his Impressionist colleagues. The smaller of them, *Chou Quarries at Pontoise II*, is part of a sequence of paintings with identical compositions and formats but different "effects" of light and atmosphere. For Gauguin, this was a departure from his earlier practice of making smaller versions of a composition before creating a large-scale exhibition version. Not since 1875 had he made similarly sized versions of the same motif under different conditions—and in the earlier case, the versions of *Port de Grenelle*, the paintings varied somewhat in size and composition, and were clearly not intended to be seen together.[11]

In the case of the 1882 sequence, we know of two paintings (fig. 134 and the present work), and Gauguin referred to what was apparently a third in a larger size in a letter to Pissarro of November 9, 1882. He mentioned a "temps gris" effect in the quarry landscape and a canvas size of "50." Because neither of

the two known works could be called a "gray weather effect," Sylvie Crussard has created a number in the Wildenstein catalogue for this supposed lost work.[12] If her hypothesis is true, there were at least three different paintings of the same landscape. This separates Gauguin's landscape aesthetic in the summer of 1882 from those of his immediate colleagues and connects him with the practice of Monet—whose work he admired but never collected. Neither Pissarro, Cézanne, nor Guillaumin ever repeated a composition under different chromatic and temporal conditions. For each of them, the easel picture was unique and unrepeatable, even compositionally, no matter how long it took to paint.

Among the thirty-four paintings by Monet in the 1882 Impressionist exhibition were three representing the cliffs and sea at Fécamp, two identically sized and the third of slightly larger dimensions, all three closely similar in composition.[13] In addition, Gauguin surely remembered the large group of paintings by Monet in the Impressionist exhibition of 1879—Gauguin's first—among which were two pairs of urban views and a trio of views of the Seine at Lavacourt.[14] There is no doubt that the precedent for Gauguin's trio of quarry landscapes was the absent Monet, not the artists with whom he was actually working.

A lively drawing by Pissarro's son Georges "Manzana" Pissarro shows the four painters, along with Mme Pissarro and Manzana himself, in the very landscape Gauguin was painting (fig. 135). Guillaumin and Pissarro are seated while eating, Gauguin walks purposefully towards them, and Cézanne continues to paint as Mme Pissarro cooks a hot lunch in an iron skillet over a fire. There are three easels with paintings facing different directions in the landscape. The drawing is one of the best that survive showing the collective

Fig. 134 (*right*) Paul Gauguin, *Chou Quarries at Pontoise I*, 1882. Oil on canvas, 23⅝ × 28¾ in. (60 × 73 cm). Private collection (WII 85)

Fig. 135 (*below right*) Georges "Manzana" Pissarro, *The Impressionist Picnic*. Drawing. Private collection

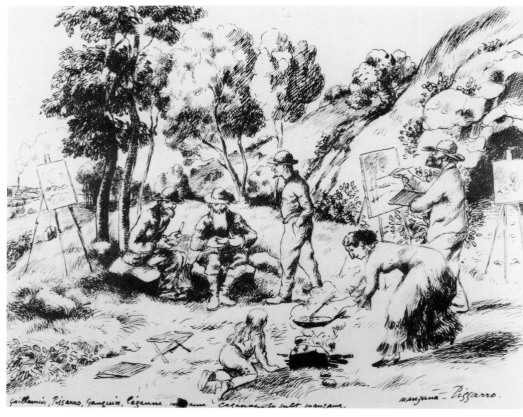

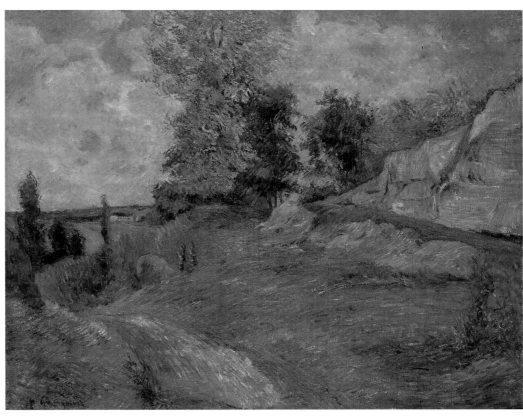

cat. 28

enterprise of Impressionist painting and the fact that the artists maintained their individuality while working together. As one looks at the paintings, one can imagine the mutual critiques.

The best known of the Gauguins to survive from this campaign is the Ottawa painting. Pissarro's analogous work, *Chou Quarries* (fig. 136), is somewhat smaller and Cézanne's *Valley of the Oise* (fig. 137), decidedly larger. Not a single canvas from the campaign by Guillaumin survives, although further work on this understudied painter will undoubtedly uncover something. Cézanne's *Houses at Valhermeil, Looking toward Auvers-sur-Oise* (fig. 138) and Pissarro's *Paths and Slopes, Auvers* (fig. 139) show views from the same

hill but looking the other direction, toward the hamlet of Valhermeil. Gauguin's paintings from the campaign make the tightest group (if we imagine the third landscape) and Cézanne's are the most ambitious, in both scale and aesthetic innovation.

The Ottawa landscape survives in a remarkable state. Its dry and active surface preserves the artist's touch, and we can easily imagine him working directly on the site on a warm, windy summer day—or, perhaps more likely, a succession of days. We suspect that Gauguin spent the weekends in Pontoise in that summer and autumn, leaving his wife and children at home on the Rue Carcel. In this way he could work concertedly in the landscape and discuss the results of his labor

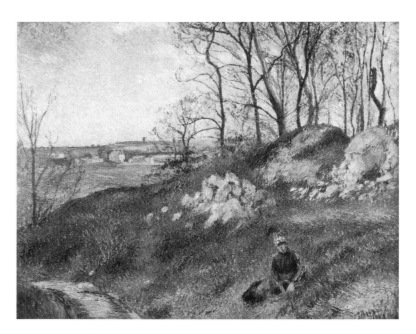

Fig. 136 (*right*) Camille Pissarro, *Chou Quarries*, 1882.
Oil on canvas, 21¼ × 25⅝ in. (54 × 65 cm). Private
collection (PV 559)

Fig. 137 (*below*) Paul Cézanne, *Valley of the Oise*,
c. 1880. Oil on canvas, 28⅜ × 35⅞ in. (72 × 91 cm).
Private collection (R 434)

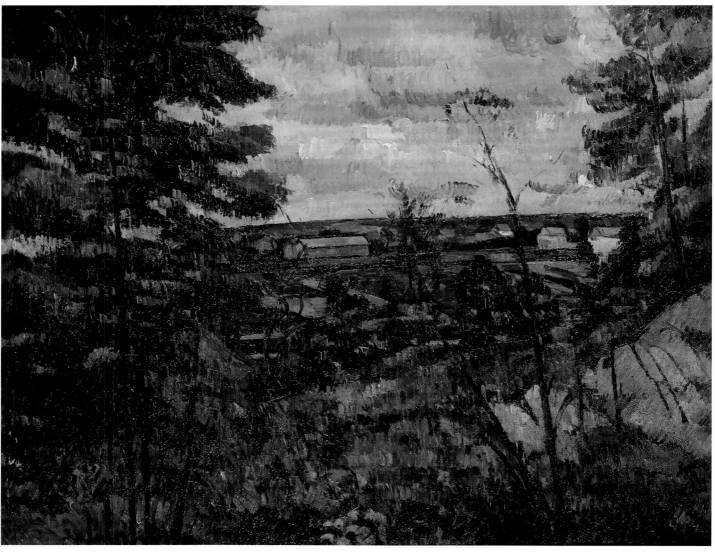

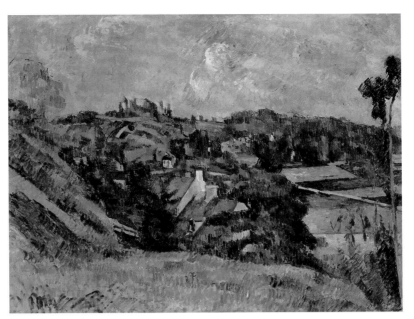

Fig. 138 (*right*) Paul Cézanne, *Houses at Valhermeil, Looking toward Auvers-sur-Oise*, 1882. Oil on canvas, 28³/₄ × 36¹/₄ in. (73 × 92 cm). Private collection, Japan (R 493)

Fig. 139 (*below*) Camille Pissarro, *Path and Slopes, Auvers*, 1882. Oil on canvas, 23⁵/₈ × 28³/₄ in. (60 × 73 cm). Private collection (PV 560)

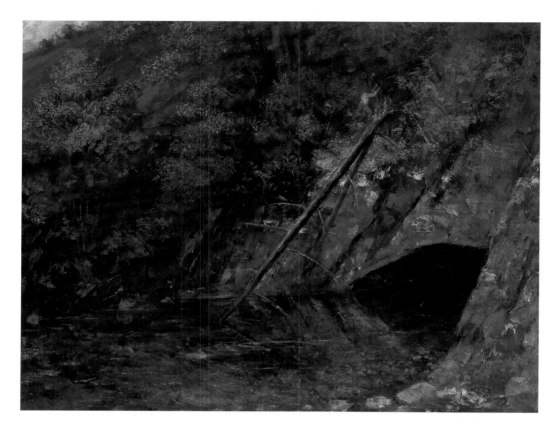

Fig. 140 Gustave Courbet, *The Blue Spring (Lac Saint-Point)*, 1872. Oil on canvas, 32³/₈ × 39 in. (82 × 99 cm). Nationalmuseum, Stockholm (NM 2166)

exhibition. Yet even the bleakest of those, the winter landscape in Budapest (cat. 12), has a humanized and comfortable quality, as if we were looking out of the window. Here we are alone and gazing into a landscape that is difficult to enter, that resists rather than entices us.

We know that Gauguin, like virtually every great artist in Paris, visited the Courbet retrospective held at the Ecole des Beaux-Arts in May 1882, five years after the painter's death. This immense exhibition brought the master of Ornans back firmly into the consciousness of Impressionist Paris, a posthumous return from the exile of the last years of his life. Manet was still alive, and the immensity of his predecessor's—Courbet's—achievement was set forth in a definitive exhibition, perhaps the greatest ever mounted of his work. We can imagine how important this exhibition must have been for artists like Cézanne, Monet, and Pissarro, who had been working to achieve powerfully material pictorial surfaces for decades. It also enabled the Parisian public to gauge the full extent of Courbet's importance as a painter of landscape. The sampling of seascapes and landscapes, painted in both France and Switzerland, was magisterial enough to sway Monet to return to the north coast of France— and Courbet was also in Gauguin's mind when he confronted the abandoned quarries near Pontoise.

Unlike Pissarro and Cézanne, who focused on the distant suburban and rural countryside with its villages and factories, Gauguin made his largest and most important work of that

with his colleagues over lunch and in the evenings. The painting's facture shows a profound debt to Pissarro. After the comparative failure experienced by Gauguin at the 1882 Impressionist exhibition, he seems to have returned wholeheartedly to Pissarro as a mentor, asking him repeatedly for advice and mimicking his landscape aesthetic more closely than he had since 1880. Though continuing to work actively in the landscape, Pissarro had turned increasingly toward the figure, and the majority of his submissions to the 1882 exhibition were figure paintings. Indeed, he seemed to be courting an aesthetic dialogue with Renoir, leaving the business of landscape to Monet. But there is no evidence that Gauguin made any efforts to follow Pissarro

into figure painting. For all its critical success in 1881, *Nude Study (Woman Sewing)* (cat. 19) was to be his only major figure painting until 1884, when he turned again to portraiture.

The greatest of the landscapes made by Gauguin in Pontoise in the summer of 1882 is the Zurich painting. Large, asymmetrically composed, spatially ambiguous, windswept, and empty, it has a majestic visual poetry that recalls Courbet much more than the suburban landscapes of the Impressionists; the artist calls upon us to reflect on the otherness of nature and the ultimate failure of man's efforts to dominate her. It reminds us of the large-scale landscapes Gauguin painted in the summer of 1879 and exhibited in the 1880 Impressionist

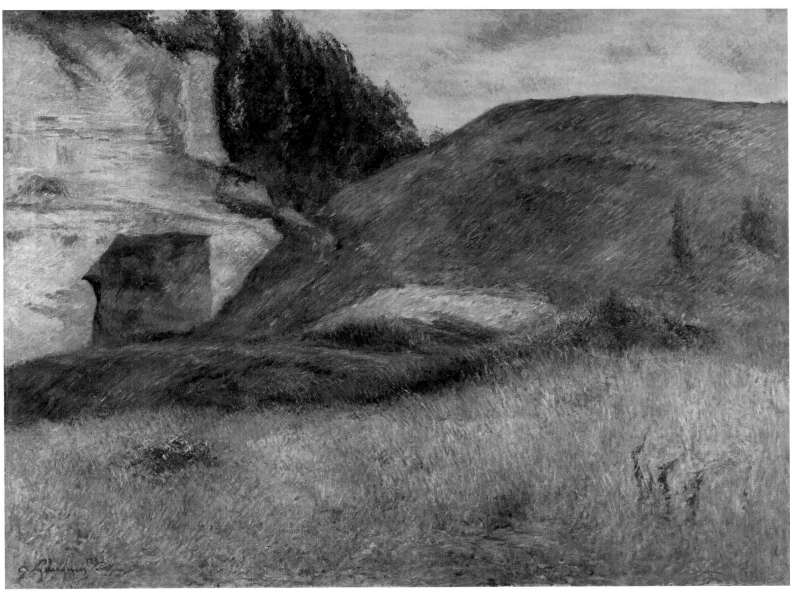

cat. 29

summer a romantically empty landscape in which a soft, grass-covered hill seems almost to roll into the rock wall with its mysterious, clearly manmade opening. We might think of all of Courbet's grottoes, at least two of which were included in the exhibition. More particularly, we might think of *The Blue Spring (Lac Saint-Point)* (fig. 140), which Courbet painted in 1872. With its off-center placement of a large declivity, its dramatic simplicity of composition, its emptiness, and its surging pictorial energy, this was clearly a precedent for Gauguin's mysterious painting. Where Courbet painted deep blue water, Gauguin had no such material and was forced to conceive of his grassy field as an equivalent source of pictorial energy. Gauguin was not alone in his admiration for Courbet, but his admiration had an exceptionally strong foundation in that he had been able to study the Courbets in the collection of his guardian, Gustave Arosa, deeply and repeatedly over a long period of time.—RRB

30

Snow, Rue Carcel I, 1883
Oil on canvas, 23⅝ × 19⅝ in. (60 × 50 cm)
Ny Carlsberg Glyptotek, Copenhagen
WII 97

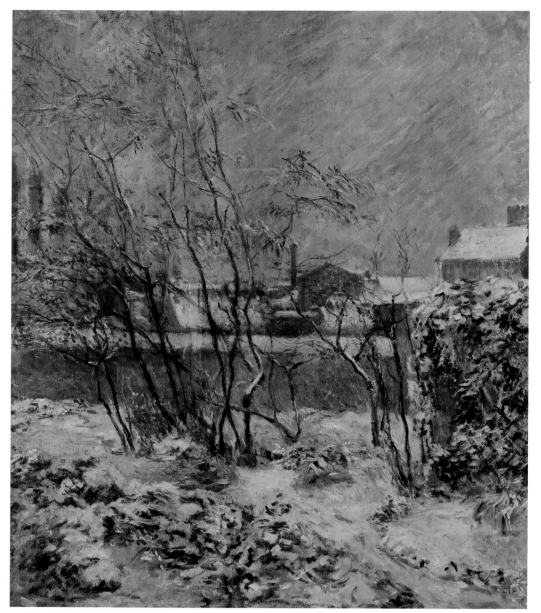

cat. 30

There were three snow storms in the winter of 1882–83, and Gauguin probably painted the first of his Rue Carcel snowscapes during the final one, in March 1883. It represents a view out the back window of the artist's rented apartment, looking toward a wall that separated the garden from the nearby Rue Blomet. Gauguin had already painted the garden in warmer times, taking his paints and easel outside and looking back at the house. From the garden he could see the nearby church of Saint-Lambert in one direction and the three smokestacks of a gasworks in another. Now, in the cold weather, he adopted the same strategy as he had in the winter of 1879 and looked out the window from the warmth of his apartment. He chose a vertical canvas format, which he was to use increasingly. A rarity in midcentury landscape practice, the vertical landscape began to fascinate artists in the 1870s. Cézanne, Pissarro, and Guillaumin all made vertical landscapes in quantity in the early and middle years of that decade, and Cézanne included one in the first Impressionist exhibition in 1874 (no. 44, *Etudes: Paysage à Auvers*, now known as *House of Père Lacroix*, 1873; National Gallery of Art, Washington). None appeared in the 1876 exhibition, but in 1877 Monet, Cézanne, and Pissarro all submitted examples, some of which were large and prominently hung.

When Gauguin studied the snowy scene in the yard in March 1883, he had clearly made advances as a colorist and a painter of winter effects since his first efforts in 1876 and even

since the predominantly blue winterscapes of 1879–80. Here the tones are of much greater variety and complexity, and the facture in the Copenhagen picture suggests that he had studied the snowscapes of Monet with real care. To organize his canvas, Gauguin divided it into halves horizontally with a line—not the horizon line, but the distant roofline across the cityscape. He arranged the walls and building to be strictly parallel to the picture surface, with space-making architecture at both left and right edges—the three receding smokestacks on

the left and the orange-roofed house on the right. In the foreground, the soft, wet snow rests on the garden plants and clings to the curved limbs of the small trees, which are arranged almost to form a bouquet in front of the garden wall. For the sky, Gauguin chose parallel diagonals of paint that suggest the chromatic flickering of cold clouds and snowfall.—RRB

31

Busagny Farm, Osny, 1883
Oil on canvas, $25^{1}/_{2} \times 21^{1}/_{2}$ in. (64.8 × 54.6 cm)
Signed and dated lower right: *1883 / p Gauguin*
Museum of Art, Rhode Island School of Design,
Providence. Helen M. Danforth Acquisition
Fund in honor of Houghton P. Metcalf Jr.
WII 101

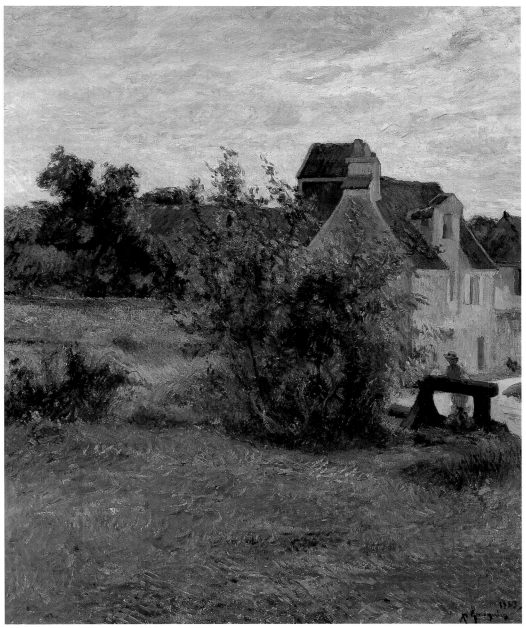

cat. 31

In 1883 Gauguin spent many weekends and one three-week session (June 15–July 5) working with Pissarro in the village of Osny, where the older painter had moved in December of the previous year. The year was a crucial one for the Impressionists, because Durand-Ruel, feeling that the market for their work had improved, mounted a series of major one-man exhibitions in his Paris gallery— Monet in March, Renoir in April, Pissarro in May, and Sisley in June. The Impressionists had worked to promote their individual achievements by showing large groups of work in the Impressionist exhibitions, several of which were hung by artist, but none of them had been presented to the public in the form of a retrospective. Durand-Ruel allowed the artists to be their own curators, at least to an extent. Had he been able to include Degas and Cézanne, he would have created a context for the first intelligent summary of the movement's greatest masters. All the major critics attended these exhibitions; they were hastily installed, but well reviewed. Unfortunately, the reviews have never been collected together like those of the group exhibitions, and the experiment of staging retrospectives of Impressionist painters in succession has yet to be repeated.

With seventy works, Pissarro's was the first major exhibition of his work in his lifetime. Like many of the second-generation Impressionists, Gauguin had a better opportunity to study the work of the

movement's masters in the spring of 1883 than ever before, and study he did. At the same time, like every French person interested in art, he was forced to think retrospectively about the course of modern painting by the death of its preeminent master, Edouard Manet, which occurred on April 30, just before the opening of the Pissarro retrospective. Though unable to attend the funeral service because of an appointment in connection with a stock trade in Chaville, Gauguin followed the event closely

and found himself reflecting on the art of recent times. The allegiances that emerged most clearly for him were to Degas, whom he saw as the successor to Manet, and Pissarro, whose position as a nurturer of the greatest talent of the next generation, including Cézanne, made him the leader of Gauguin's own generation. His sense of Pissarro's importance as a critic and teacher renewed, he spent an increasing amount of time with the oldest Impressionist, and he painted a

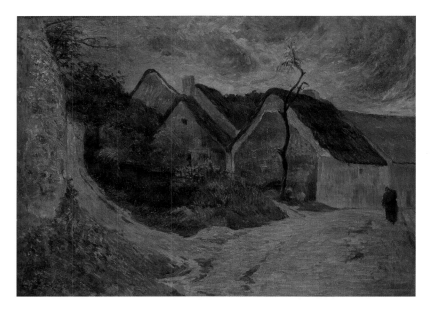

Fig. 141 Paul Gauguin, *Osny, Stormy Weather*, 1883. Oil on canvas, 29⅝ × 39¾ in. (75.5 × 101 cm). Ny Carlsberg Glyptotek, Copenhagen (I.N. 1824) (WII 102)

group of works in Osny in the summer of 1883 that were his closest yet to Pissarro's aesthetic.

Like the related painting in Copenhagen, *Osny, Stormy Weather* (fig. 141), the Providence view at Osny is a complex and difficult representation that does anything but court the viewer. The entire front third of the vertical composition is empty of incident, and the lower two-thirds of the landscape are essentially unlit, in spite of the relatively bright, cloud-streaked sky. The painting seems to be an effect of the end of day or even evening. Pissarro painted the same buildings on a vertical canvas of identical dimensions, using a similar facture, earlier in the year. But the humanistic Pissarro populated the foreground with incident, with the result that his landscape is easily entered and spatially legible. The entire center of the painting is given over to the meandering curves of the stream that take the viewer directly into the landscape space. By contrast, Gauguin's landscape is almost uniformly dark, with reds, browns, and greens of the same value dominating its surface. Its space-giving feature, a light, yellow beige curved path, is pushed to the very edge of the composition, leading us out of rather than into the pictorial realm. Pissarro's figure is a male rural worker who walks through the

water and into the picture from the left foreground. Gauguin's leans listlessly on the lock, looking into the right portion of the middle ground. We read Pissarro's sky as a distant background to a complex variety of forms that are silhouetted in planes in front of it. In the Gauguin the silhouetted forms are all distant from the viewer and make little impact on the sky, which is allowed to dominate the upper third of the canvas without incident. Pissarro's painting is interesting, varied, spacious, and psychologically accessible while Gauguin's is featureless, almost flat, monotonous, and psychically detached.

While it may be tempting to say that Gauguin was simply a poor student of a better painter, the evidence of his own career shows that this was not the case. In fact, he actively sought to make difficult paintings, and in an eloquent letter to Pissarro referred to the work of others as "facile" (easy).[15] In another letter he criticized Pissarro for accepting Durand-Ruel's offer of a retrospective in a commercial gallery.[16] Far less interested in the commercial side of Impressionism than many have accused him of being, he favored the annual group exhibitions, which were free of commercial endorsement and provided a means of measuring "progress" in a collective manner. To him, Pissarro's decision to exhibit with

Durand-Ruel seemed a repudiation of difficult painting.

The intense questioning of loyalties involved in the politics of the 1882 Impressionist exhibition and the one-man exhibitions of 1883 created the conditions for the first full-scale questioning of the aims of Impressionism. In April 1883 the critic J.-K. Huysmans, who had lionized Gauguin in 1881 and written rhapsodically about the *Nude Study (Woman Sewing)* (cat. 19), published a collection of his essays under the general title *L'Art moderne*. This renewed the debate among the Impressionists about their directions, memberships, and alliances. Its intensity was such that none of them could continue to paint as usual. Gauguin threw himself into the debate not with words—he had yet to begin writing about art except in his letters to other artists—but in paint.

His Osny landscape in Copenhagen is a work of almost extreme difficulty for a landscape painter. He made two roads into a single motif—one of them leading steeply up and out of the painting on the left and the other leading apparently nowhere on the right. As we have seen in his earlier Vaugirard landscapes, not a single opening allows us psychic access to the thatched dwellings. Even the figure, a female peasant who moves into the landscape, is given no destination and no relationship to the viewer, although there are two other figures on a rough portion of greenery near the spindly tree that is silhouetted against the house in the middle ground. As if this were not difficult enough, Gauguin arranges the sky into a whirling pictorial storm of color. The painting addresses issues of divergence, alienation, and spatial discontinuity with an almost grim determination. Its subject could almost be described as "the road not taken."—RRB

32

La Groue Farm, Osny, 1883
Signed and dated lower right: *83 / p. Gauguin*
Oil on canvas, 15 × 18^1/$_8$ in. (38 × 46 cm)
The Kelton Foundation
WII 103

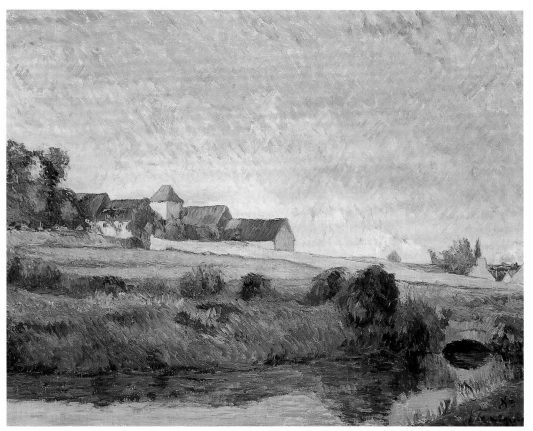

cat. 32

Gauguin made this small painting in the summer of 1883. It must surely date from the longer of the periods when Gauguin and Pissarro worked together in the small village of Osny. Sylvie Crussard has related the work to a view of the same landscape by Pissarro (*View of the Farm at Osny*, PV 583), although the two artists rarely painted the same motif at the same time and the Pissarro is earlier. In fact, *La Groue Farm, Osny* has a good deal more to do with Cézanne, with whom both artists had worked in the summers of 1881 and 1882, than it does with Pissarro. Gauguin was all but obsessed with the system of brushwork developed by Cézanne in the late 1870s and early 1880s, the so-called "constructive stroke." He had seen Cézanne striving to use this over an entire landscape surface in the summer of 1881 and had managed to buy a great Cézanne landscape of 1880 shortly after it was painted (fig. 43).

This painting can be considered Gauguin's first effort to apply the lessons of Cézanne to the landscape, rigorously simplifying the masses of the houses and their roofs. He used the hatched brushstroke with a greater consistency than heretofore and maintained a bright, clear palette of primary hues that also relates more to Cézanne than to Pissarro. He was willing to adopt the palette and facture of Cézanne, but still lacked the nerve to experiment with a Cézannesque geometric approach to composition, preferring to represent the village on a hill in a way that, compositionally, recalls Corot and Daubigny.
—RRB

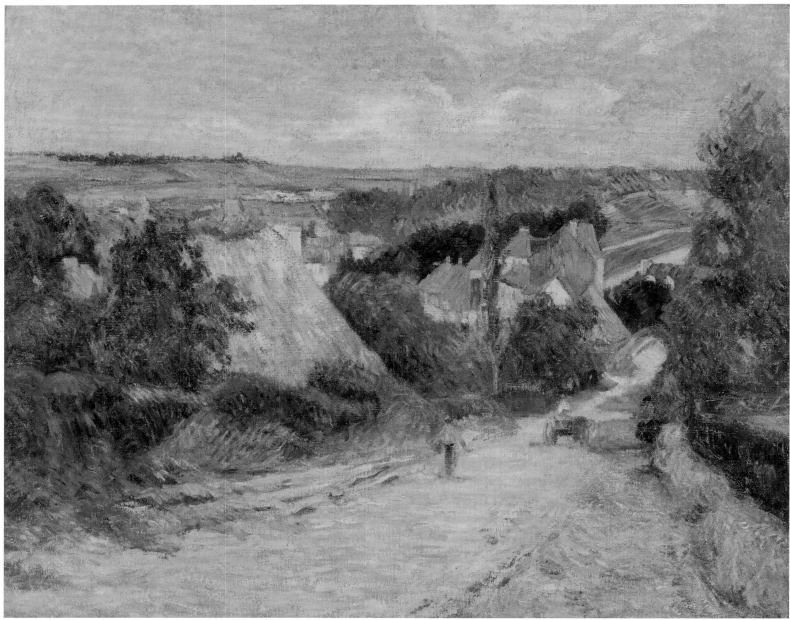

cat. 33

33

Street, Osny, 1883
Oil on canvas, 23⅝ × 28⅝ in. (60 × 72.7 cm)
Museum of Fine Arts, Boston. Bequest of John T.
 Spaulding (48.545)
WII 106

In certain ways the most accomplished of the Osny landscapes of 1883, this painting is unsigned and undated. Gauguin seems to have left it at Osny with Pissarro, though probably not as a gift. He was fond of dedicating works to their recipients when he gave them as gifts, and it is highly unlikely that he would have given this one to Pissarro and failed to so. In any case, Pissarro did not keep the work for long before it entered the collection of the great opera singer and collector Jean-Baptiste

Faure, through Durand-Ruel. It is not clear whether Pissarro took it to the dealer on Gauguin's instructions or, less likely, decided for himself to sell it for money.

Whatever its early history, it is a painting of real accomplishment. It is organized in three horizontal bands, each of which occupies a third of the canvas, with simple bands on the bottom and top that sandwich a more complex interweaving of color, texture, and form in the center. Although the yellow beige unpaved

road that almost fills the lower third of the canvas evokes a deep space, the viewer reaches the middle band with no clear sense of its spatial relationship to the foreground. The middle ground of the landscape is a complex wall of form at the end of a spacious foreground. It is not entirely clear whether the viewer is supposed to walk into the landscape down a long hill or on a flat plane. The sky is a spaceless runner of pale blue with substanceless clouds that press down on the landscape. For all its oddities, however, the painting has the pleasant air of a warm summer day in the country, bringing together the experiments of both Cézanne and Pissarro without troubling too much about either.—RRB

right Paul Gauguin, *Street, Osny* (detail of cat. 33)

34

Portrait of a Woman, 1883
Oil on canvas, 12³/₄ × 9⁵/₈ in. (32.5 × 24.5 cm)
Signed and annotated middle right: *souvenir / à*
 [or *d'*] *Ingeborg / p G.*
Private collection. Courtesy of Wildenstein and
 Co., Inc.
WII 109

35

Double Portrait of a Young Girl, 1883
Oil on canvas, 12 × 18⁵/₈ in. (30.5 × 47.5 cm)
Signed and dated lower left: *P. Gauguin / 83*
Carouso Family Revocable Trust
WII 110
Kimbell only

Gauguin's small portraits are among his most
fascinating works. Rarely exhibited in his
lifetime, they seem to have been made both as
an investigation of his family and friends and,
in the case of the portraits here, as gifts or
"souvenirs" of times spent together. Like the
small-scale still lifes of the early 1880s, they
are Impressionist "miniatures" in which the
artist confined his inventiveness to such a small
surface that he minimized his risk of failure.
Perhaps for that reason, they are often highly
experimental. Whereas the figure compositions
that Caillebotte, Pissarro, and Renoir showed
in the Impressionist exhibition of 1882 have
the air of "exhibition paintings," made from
posed figures as part of a study of
contemporary society, such works by Gauguin
resemble the portraits and portrait/genre
paintings of Cassatt and Morisot, resolutely
private or personal in their aims.

The *Portrait of a Woman* is inscribed as a
"memory of Ingeborg," the first name of
Ingeborg Thaulow, Mette Gauguin's sister and
wife of the Norwegian painter Frits Thaulow.

cat. 34

For Sylvie Crussard, whose entry on the
painting in the recent Wildenstein catalogue
raisonné is a trove of biographical data on the
Thaulow and Gauguin families, this
identification proved difficult to accept. Is the
sitter actually Ingeborg or a nanny shared by
the Thaulow and Gauguin families? Who is the

child? Where was the painting made—in the
Thaulow's studio at 136 Avenue de Villiers or
at the Gauguin apartment?

Given the fact that the painting is inscribed
to Ingeborg and was a gift to her from
Gauguin, it seems likely that she, rather than
the nanny, was the sitter. She appears dressed

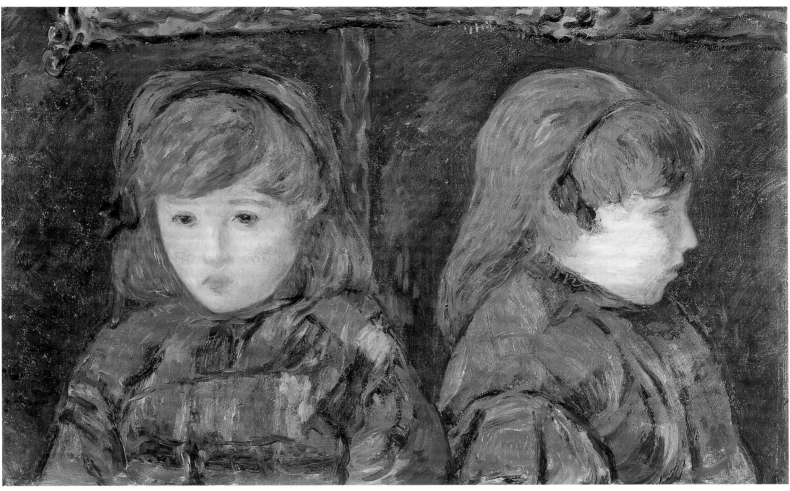

cat. 35

in black, wearing a hat and coat, and sitting bolt-upright on a divan in an artist's studio. Perhaps she is visiting the Gauguin household; perhaps she is dressed and about to go out of her husband's studio. We know that the Thaulow marriage was crumbling at the end of 1882 and beginning of 1883, when they decided to divorce, and it is even possible that the painting was made after their separation, when Ingeborg would have spent a good deal of time with her sister's family. Gauguin's own marriage was at a rocky point, as we know from letters and the atmosphere of his large *Interior, Rue Carcel* (cat. 25), and the timing of this painting in the life of its sitter reflects his awareness of the psychic traumas of conventional bourgeois marriage for an artist. The easel is empty, and two unidentifiable paintings in plain wooden frames hang on the

wall in a way that pushes its plane so close to the surface of the painting that one cannot reconcile it with suggestions of interior space behind the divan and around the easel. As is so often the case with Gauguin, mysteries abound—of identity, of marital convention, of motherhood, of space, of occupation.

The double portrait of a girl is equally enigmatic. In 1967 Bodelsen identified the sitter as Aline Gauguin,[17] but Crussard disputed this with verve, identifying her as the daughter of a M. Gaston Lafuite—with whom Gauguin traded this picture for an unspecified other work.[18] Does the painting actually represent the same girl, in full face and profile, or twins? The former would make greater sense if Gauguin had used the device of a mirror. The two figures are shown in the space in front of a wall defined by a hanging textile

at the top and near the picture plane. The contrast between the red plaid of the seemingly quilted jacket or dress and the bright red orange of the hair animates the picture, and we are asked by the artist to move our eyes back and forth in two senses—from the dress to the hair and from one figure to the other. Again, Gauguin seems to have been fascinated with doubleness, turning a seemingly straightforward portrait into another series of mysteries. Of his colleagues, only Degas could approach him in psychological complexity. —RRB

"THE MANIA FOR SCULPTURE IS REALLY developing," Gauguin wrote to Pissarro in the fall of 1882. "Degas (it seems) is making sculptures of horses, and you are doing cows." Pissarro had asked his advice on iron armatures. Gauguin replied that he knew no more about the subject than Pissarro himself, but the fact that Pissarro consulted him shows that he was supposed to have some practical knowledge of this sculptural technique. He added: "I arrange things to suit my needs as best I can and almost always badly."

Gauguin was writing at the end of October or the beginning of November 1882, by which time we already have clear evidence of his interest in plastic art. The reference to his experience with iron armatures—the skeletons of sculpture—is evidence of other sculptures by him, in soft materials that required reinforcement inside, that have been lost. The letter also demonstrates that people at that time—or at least Pissarro—were well acquainted with Gauguin's talents and skills in this field. Despite his reservations he did in fact give his teacher a piece of advice accompanied by a small sketch: "Meanwhile, I think that the most practical thing would be for you to buy some of those small tin-plate tubes that are sold for wind chimes. You can twist them as you like and they will stand quite firm and give far less than wire. Of course, you should only make a basic body—otherwise you get into the whole science of modeling in wire."[19] In a letter to Pissarro of November 9, Gauguin announced that he would take a trip out to Pontoise to visit him on the following Sunday: "I will bring some small tin-plate tubes with me," he wrote, "and try to make you a maquette for your cow. I will try to do a professional job, but do try to get hold of a small board to fix the mounting to."[20]

Sculpture became the subject of keen interest during Impressionism's "crisis period" at the beginning of the 1880s. The artists again turned to the study of form. As Gauguin wrote, Pissarro made cows—though these are not known today[21]—and Degas made horses. (He added "it seems," which might confirm that he was not a regular visitor to Degas's studio at this time). During the same months, Gauguin himself created a work that is the essence of these efforts. In November 1882, in the midst of considering how Pissarro could solve the problem of his cow, he went to the railway station to send his friend one of his own sculptures. It was the wooden relief today known as *La Toilette* (fig. 143). It was a gift, and inscribed "To my friend Pissarro / P Gauguin 82."[22] That it was to Pissarro's taste emerges from the letter of November 9: "I am quite confused and blushing on reading your compliments on the wood carving I sent you; I am happy that you like it."[23]

Gauguin experimented in all manner of media around this time, and with *La Toilette* tried his skill with a bas-relief that, as Félix Fénéon was to point out regretfully, is monochrome. Not painted, not gilded. With this carefully finished and harmonious work Gauguin summed up some of his experiences in sculpture and solved some of the problems with which he was struggling in his paintings. They were problems to do with figure and anecdote that had revealed themselves not least in the ambitious *Nude Study (Woman Sewing)* (cat. 19). Huysmans noted the anecdotal naturalism of this work in

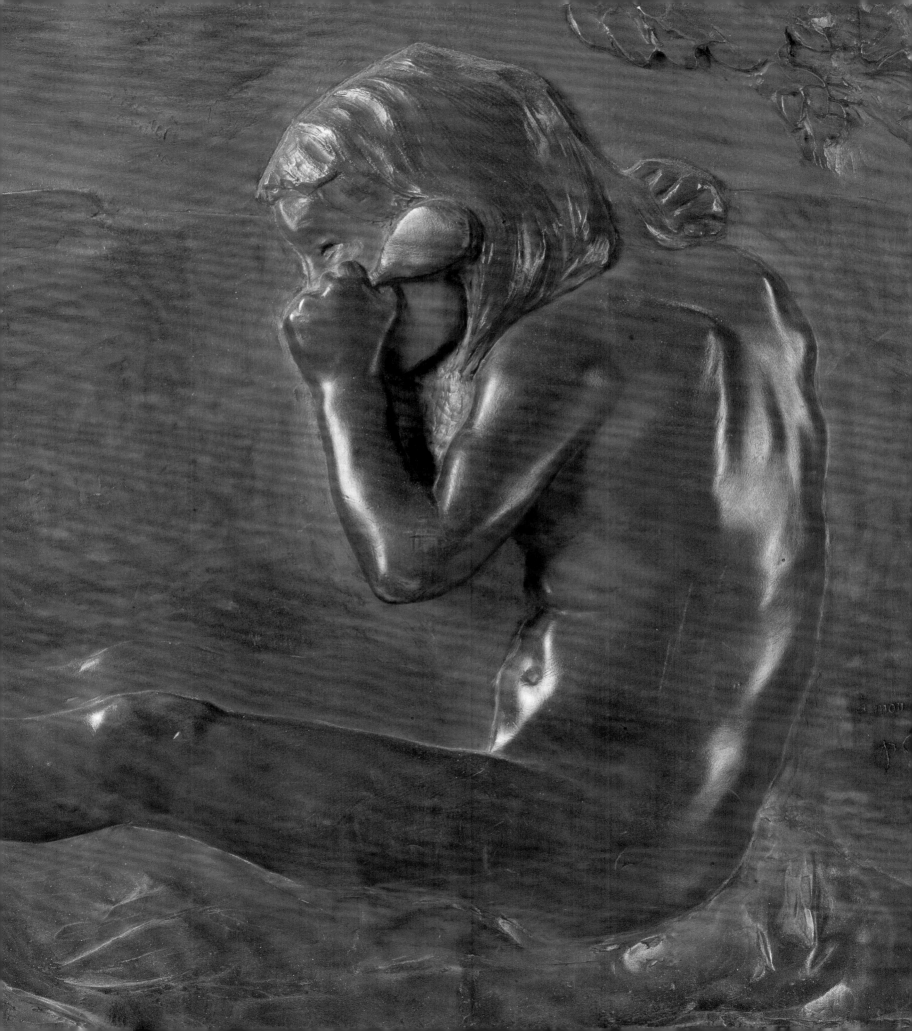

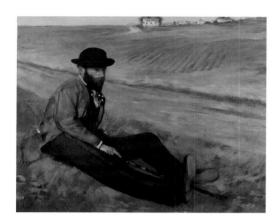

Fig. 142 Edgar Degas, *Portrait of Eugène Manet.* Oil on canvas, 25³/₄ × 31⁷/₈ in. (65.2 × 81 cm). Private collection

L'Art moderne—to the regret of Gauguin.[24] *La Toilette*, a further experiment with the nude theme, was a reaction against such anecdotal qualities. The motif was totally divorced from modern life. It referred partly to early Renaissance sculpture and partly to the poetical and Arcadian paintings of Corot that the artist knew in the Arosa collection.[25] But with regard to composition, the most obvious inspiration was again Degas. At the second Impressionist exhibition in 1876, Gauguin must have seen Degas's idiosyncratic portrait of Eugène Manet sitting awkwardly in a landscape (fig. 142).[26] This was one of Degas's clearest attempts at interpreting figure and landscape as a single entity. Gauguin's relief is like a mirror image of the composition, repeating the pose of the figure, the unusual rectilinearity of which—reminiscent of Egyptian art—was to be emphasized by Félix Fénéon. Gauguin's figure is no fully clothed man, like Degas's, however, but a nude, pubescent child, a figure appearing for the first but not the last time in his artistic universe. The nascent sexuality of the figure is obvious; the brush by her ear hints at a *vanitas* theme, and the fruits in the branches above her head raise the question of whether she is an early representative of a major theme in Gauguin's work, that of Eve.[27]

In the relief, archaic features are for the first time integrated into a homogeneous and harmonious whole: it represents not the paraphrasing of a style but the acquisition of a view of art. It was sculpture that moved Gauguin this step forward in his development. For the first time he succeeded in establishing the idiosyncratic synthesis in his work between figure and landscape—in incorporating the human figure into a kind of timeless union with nature.

In the midst of the crisis within the Impressionist movement, Pissarro could see the rejuvenating possibilities of the relief. So could Gauguin himself, and immediately before the opening of the eighth—and last—Impressionist exhibition in 1886 he wrote to Pissarro: "When you send your pictures to the exhibition, would you be so kind as to include the little bas-relief in wood that you have by me. I would like to exhibit it as long as it's no trouble for you."[28] This must have come at the last moment, and the relief does not appear in the catalogue. We know for sure that it was included in the exhibition since, as we have already seen, Fénéon discussed it in his review: "This year, carved in pearwood and regrettably monochromatic, his nude female arises in semi-relief, her hand in her hair, sitting at right angles in a landscape: it is a sincere and delicate model and certainly one of the attractions of the galleries."[29]

Looking for radical features, Fénéon regretted that the relief was neither painted nor gilded. However, there is little doubt that the work's intrinsic harmony is linked to its lack of color. Men whom Gauguin respected highly had spoken out against polychromy in sculpture. Delacroix believed that sculpture ought to concern itself with form,[30] while Charles Blanc warned against the pitfalls of illusionism[31]—an issue that had become central in the duel between Degas and Gauguin in the field of plastic art. Gauguin was already aware of the problematic nature of polychromy and was to show great caution in its use—which in any case became more and more sporadic in his work.

While Fénéon had his reservations, another of the visitors to the exhibition was more enthusiastic. This was the ceramist Ernest Chaplet, who saw the relief, realized

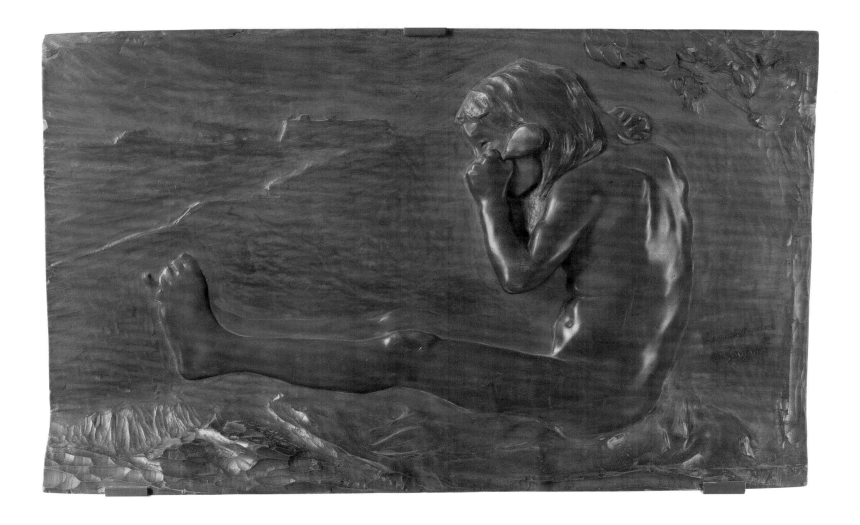

Fig. 143 Paul Gauguin, *La Toilette*, 1882. Pearwood,
13¹⁄₂ × 21³⁄₄ in. (34.1 × 55 cm). Musée d'Art Moderne et
Contemporain, Strasbourg

Gauguin's decorative talent, and hired him to work for him. In one of Gauguin's letters to Mette from the beginning of June 1886, he described Chaplet as "a ceramic artist who intends to make artistic vases" and continued: "Delighted by my sculpture, he has asked me to make some things for him this winter according to my own ideas, the profits from which we would share half-and-half. This could be a great source of income in the future. Aubé worked for him on those jars that he was able to live from, and this is a considerably bigger thing."[32] Thus *La Toilette* came to mark the start of the next chapter of Gauguin's work in three-dimensional art—the ceramic works from the winter of 1886–87.

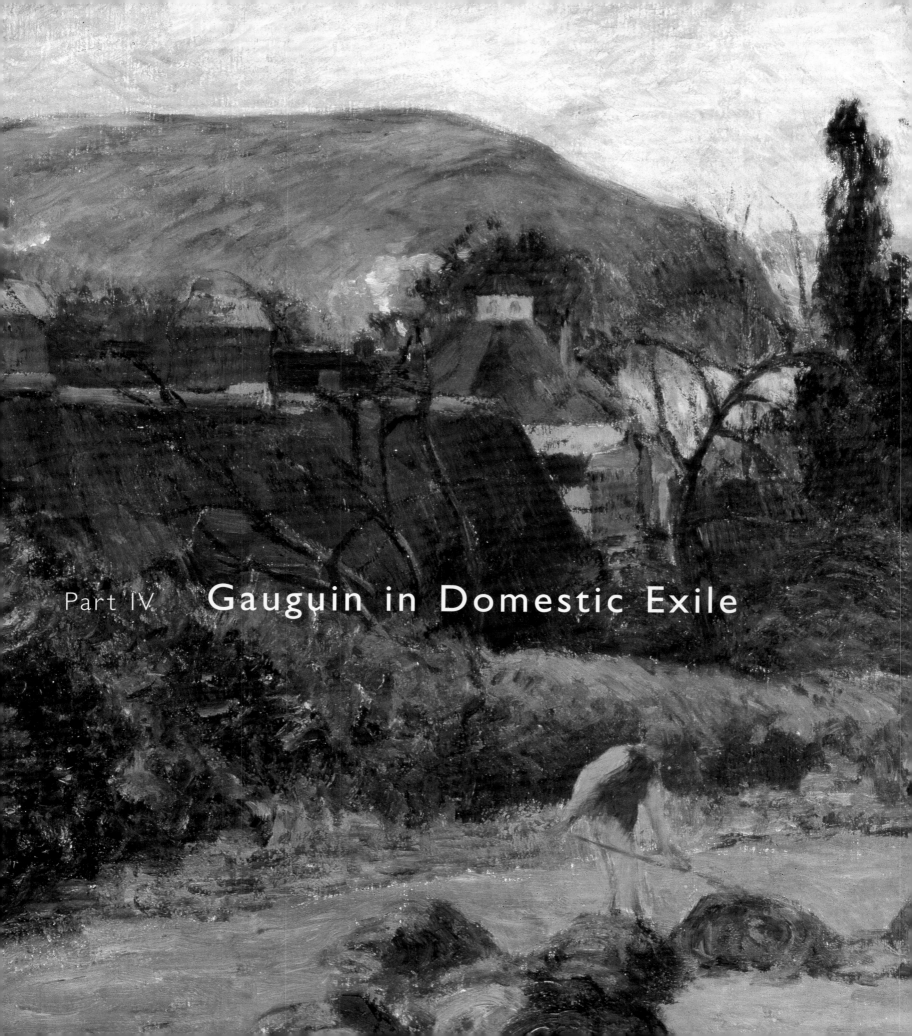

Part IV Gauguin in Domestic Exile

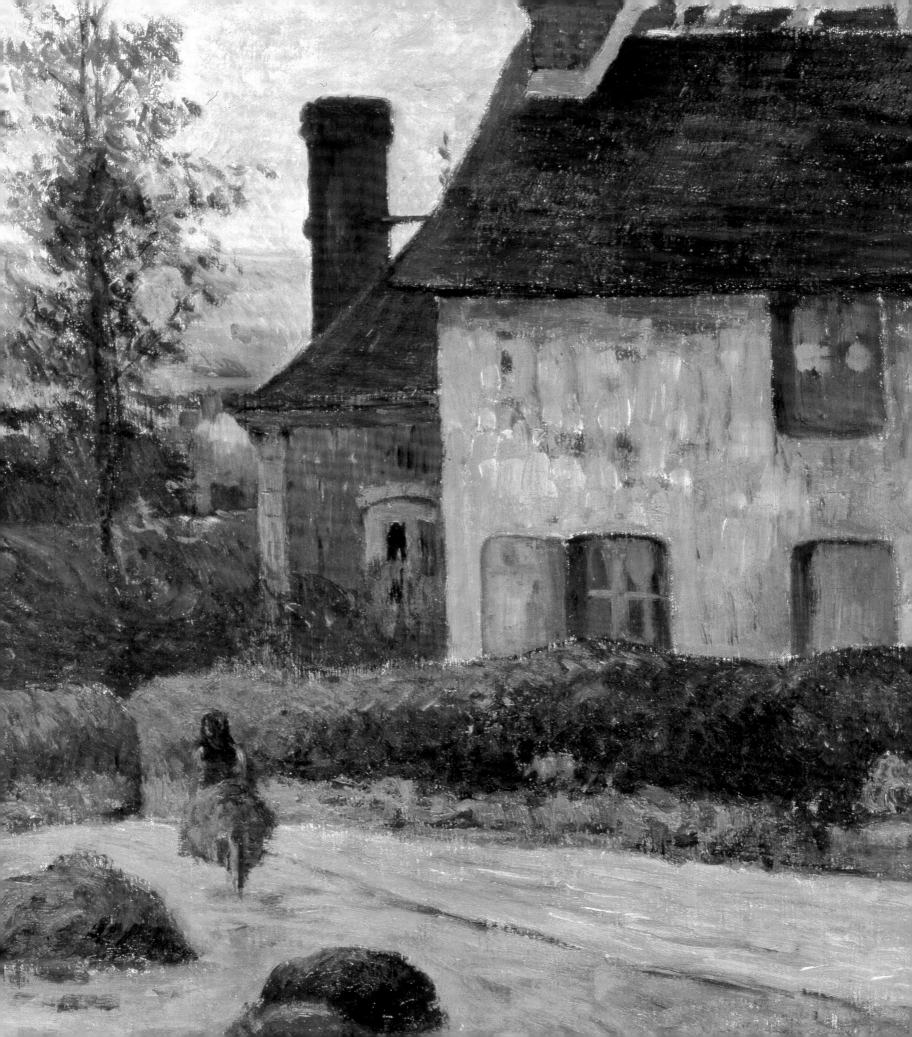

"**Y**OU'RE SO LUCKY, BEING ABLE TO PAINT every day," complained Gauguin in a letter to Pissarro in August of 1883. "I am bored to death in the office. I do nothing all day long when I could be spending the time studying my art."[1] He was soon to have the opportunity to do so, although the moment was not of his own choosing. Contrary to the insistent, romantic myth about his heroic abandonment of the bourgeois life, the truth is that during the summer of 1883, probably in August, he was given notice of dismissal to take effect at the end of the year.[2] This was a result of a major crisis in the world of finance in 1882. The letters Gauguin wrote during the period after he received his dismissal notice reflect his desperate but fruitless attempts to find a new job, and for several years to come he still sought to pursue a career in business.

In dire financial straits with a growing family to provide for (there was a fifth child on the way), Gauguin's only way out was to reduce living expenses by leaving Paris. That he should choose to move to Rouen was undoubtedly connected with the fact that Pissarro had spent some time painting there. Gauguin wanted to establish business connections in the town and imagined that he would be able to sell his work to wealthy businessmen there: "With a bit here and a bit there I can keep going for a year."[3] He moved to Rouen on January 4, 1884, together with his family,[4] which now included his and Mette's fifth and last child, the one-month-old Paul Rollon. The boy's birth certificate recorded the father's profession as "artiste–peintre."

Both in a business and an artistic sense, Gauguin had to go through a period of change, which was always difficult for him. He was now isolated from the artistic world in Paris. It says much about his situation that he heard nothing about the planning of the uncensored *Exposition des Indépendants* that was to open in Paris on May 15 with more than four hundred exhibitors, including several of the future Pointillistes, Odilon Redon, and his own friends Schuffenecker and Guillaumin. He found out about this during the first half of May and immediately wrote to Pissarro: "I've just seen in the newspapers an exhibition of the *indépendents*. What does that mean?"[5] (In fact, Pissarro was not participating either and knew scarcely more than Gauguin himself.) In Rouen Gauguin was for the first time standing on his own feet artistically and compelled to paint without his tutor. Several times he invited Pissarro to Rouen but he was never to succeed in persuading him to pay a visit.

As always, Gauguin had to accustom himself to his new environment before he was able to give artistic form to any new motifs. He had to go through a kind of artistic incubation period, and at first we see him painting tentative and rather cautious views of his closest surroundings. The family home was in the hills in the northern part of Rouen. The address was 5 Impasse Malherne, "at the top end of the Rue de la République."[6] The narrow little street opened at one end onto the Rue du Nord, close to the Rampe Beauvoisine—from which there was a magnificent view of the city and the surrounding countryside, intersected by the Seine and encompassed by wooded hills, ravines, and unspoiled villages. It was most pleasant to work in and near the new home, and he painted Mette with the children out in the street immediately outside the front

previous pages Paul Gauguin, *Manuring* (detail of cat. 37)

facing page Paul Gauguin, *Basket of Flowers* (detail of cat. 42)

Fig. 144 Richard Parkes Bonington, *Rue du Gros-Horloge, Rouen*, 1824. Lithograph on chine collé, 9⅝ × 9¾ in. (24.5 × 24.7 cm). Iris & B. Gerald Cantor Center for Visual Arts at Stanford University, Stanford, Calif.

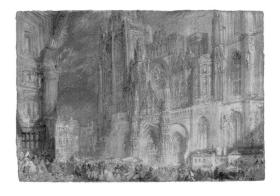

Fig. 145 J. M. W. Turner, *The West Front of Rouen Cathedral*, c. 1832. Gouache and watercolor on paper, 5½ × 7⅝ in. (14 × 19.4 cm). Tate, London

Fig. 146 *(facing page)* Paul Gauguin, *Blue Roofs, Rouen*, 1884. Oil on canvas, 29⅛ × 23⅝ in. (74 × 60 cm). Collection Oskar Reinhart "Am Römerholz," Winterthur (1931.6) (WII 116)

door.[7] There are views of the steep streets with the provincial houses and bare trees,[8] such as *Rue Jouvenet, Rouen* (cat. 36), slightly melancholy scenes painted on small, unpretentious canvases. Among the first ventures in a larger format was *Blue Roofs, Rouen* (fig. 146),[9] in which the artist used meticulous brushstrokes to describe the suburban geography of one of the hills in northern Rouen. This was the canvas size that Gauguin was to prefer for many of the paintings he made during this stay.[10] The painting provides an accurate account of the topographical details, including every little chimney and dormer. It is painted in a painstakingly accurate manner, and the effect is almost photographic.

Rouen had attracted painters throughout the nineteenth century, and there was already a well-established artistic tradition within which to interpret local sites. The English Romantic painter Richard Parkes Bonington had focused on the many Gothic churches, the well-preserved medieval houses, and the picturesque quays. Several of his lithographs of Rouen views appeared in Baron Taylor's *Voyages pittoresques et romantiques dans l'ancienne France* (1820–78), a publication much admired by the Impressionists (fig. 144). Another English artist, J. M. W. Turner, drew the cathedral portal for a plate in his print series *The Rivers of France* (fig. 145). Corot and Jongkind painted the ships and small factories along the quays, and Monet—later to paint his legendary Rouen Cathedral series—settled there for the first time in 1872. Rouen was one of the greatest industrial cities in France, and Monet painted its smoking chimneys, the railway, and the lively traffic on the Seine. Pissarro—who was fascinated by the place throughout his life—considered that the beautiful motifs in Rouen were the ships and the hills but also painted the medieval town center with its Gothic houses, its old market, and the quays. Gauguin painted neither the medieval town center nor, apart from the occasional chimney, the modern industrial city. He had turned his back on the modern world and was to concentrate on the landscape. In effect he followed the advice he had given Pissarro—partly to comply with the demands of the art dealer Durand-Ruel to paint "landscapes and more landscapes." His other Rouen paintings, especially from the second half of his stay, were to be highly experimental portraits and still lifes.

Gauguin missed Pissarro's advice and help and virtually begged him to come to Rouen or at least meet him in Paris. He longed to hear his opinion on the things he was painting now. He would hear it, but only after Pissarro had the chance to see them at Durand-Ruel's in Paris. Gauguin left seven of his most recent canvases with Durand-Ruel in April but had to fetch them back again in July—all but one unsold. Some of these works remain unidentified, but we know the types of subject from the titles.[11] There were views from early in the Rouen period, including *Rue du Nord, Rouen* and perhaps *Blue Roofs, Rouen* (fig. 146). There were pictures of gardens such as *Abandoned Garden* (fig. 161), *Rouen, Spring* (fig. 147), and *Garden View, Rouen* (see cat. 38); and there was a "White House" that might have been *Manuring* (see cat. 37).

Pissarro's long-awaited reaction to the paintings was to go to the heart of Gauguin's artistic problems at this time. His letter to Gauguin does not survive, but from Gauguin's reply we know that he criticized the execution of the paintings as being too

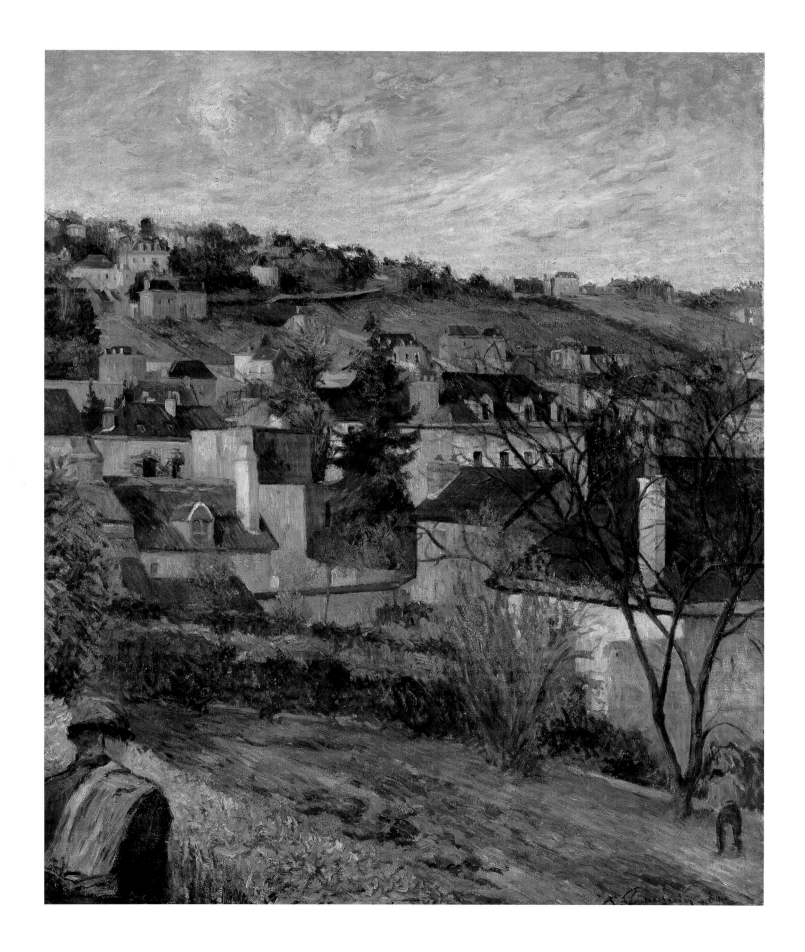

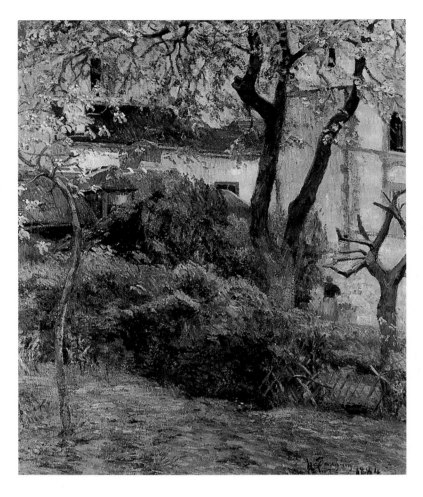

Fig. 147 (*right*) Paul Gauguin, *Rouen, Spring*, 1884. Oil on canvas, 28⁵/₈ × 23⁵/₈ in. (72.5 × 60 cm). Private collection (WII 119)

Fig. 148 (*facing page top left*) Paul Gauguin, *The Church of Saint-Ouen, Rouen*, 1884. Oil on canvas, 35¹/₂ × 28³/₄ in. (90 × 73 cm). Private collection (WII 124)

Fig. 149 (*facing page top right*) Paul Gauguin, *Notre-Dame-des-Anges, Rouen*, 1884. Oil on canvas, 28³/₄ × 23⁵/₈ in. (73 × 60 cm). Private collection, Switzerland (WII 130)

Fig. 150 (*facing page bottom*) Paul Gauguin, *Two Cows in the Meadow*, 1884. Oil on canvas, 13³/₈ × 10¹/₄ in. (34 × 26 cm). Private collection (WII 139)

petty and monotonous. Gauguin wrote: "The observations you make about my painting are correct. Unfortunately, pointing something out is not the same as putting it right. As I had written to you, those very things were driving me to despair because I could see them myself and had to wait and overcome them through practice. What I have at home at the moment is better in this respect, and I expect to be able to paint very broadly and not monotonously, although I have the idea that things in nature are simple in the way they go together."[12]

"In far better form" By April, Gauguin was beginning to feel acclimatized to life in Rouen. "I'm far more satisfied with my work at the moment. I'm beginning to get going and am more used to nature here. Whether or not it's the effect of spring, I'm in far better form."[13] His incubation period in Rouen was at an end, and the difficulties that had beset his first works there were giving way to a new vitality.

The artistic order of the day was to paint "very broadly and not monotonously,"[14] and he duly increased the size of his canvases over those of the early months. In the most ambitious of the views with churches as their motifs, *The Church of Saint-Ouen, Rouen* (fig. 148), he painted the church with the Rouvray Hills in the background from somewhere quite close to his house. He composed the painting with great care, and for the sake of balance took the liberty of removing the city's cathedral, which from his

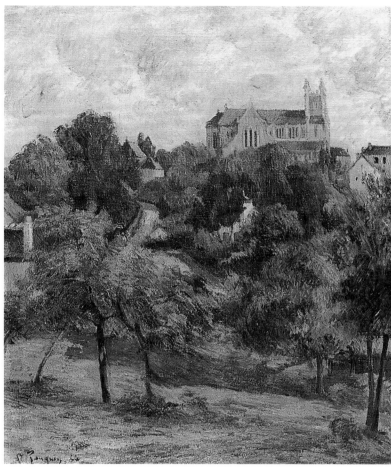

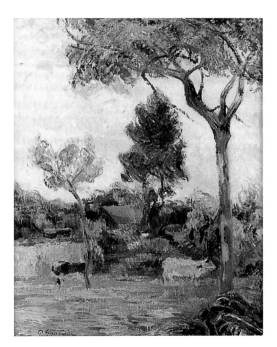

vantage point stood to the right of the church of Saint-Ouen.[15] In another, more meticulously painted view, he turned in the opposite direction, toward Bihorel Hill, where Notre-Dame-des-Anges lay in the midst of a field of green (fig. 149). It was possibly this painting of which Pissarro remarked a year later: "It is still a little dull, the greens are not luminous enough."[16] The same view toward the church, but from rather further to the south, features in *Orchard below Bihorel Church* (see cat. 40); this is a more powerful, painterly interpretation on a smaller canvas, painted with broader, bolder brushstrokes—and less "monotonous" in its execution. The cow grazing between the trees, which is reminiscent of later motifs in Brittany, appears repeatedly, sometimes in reverse, in other compositions—for instance *Three Cows*[17] and the small *Two Cows in the Meadow* (fig. 150). Here we see the beginning of that systematic reuse of motifs that was to become so typical of Gauguin's working method.

In one of his more ambitious canvases of this spring, Gauguin again turned his gaze to the south, over a broad panorama including the city, with the cathedral and Saint-Ouen, in front of the meandering line of the Seine and the Canteleu Ridge in the distance (fig. 151). By its size ($28^3/_4 \times 36^1/_4$ inches), *Street, Rouen* (cat. 39), with its curious diagonal composition, belongs among his most important efforts of the time. This was also a view from close to his own address, while other, more rural motifs perhaps reflect excursions further away. One such was *The Road Up* (fig. 152), which he was to select for the eighth Impressionist exhibition in 1886.

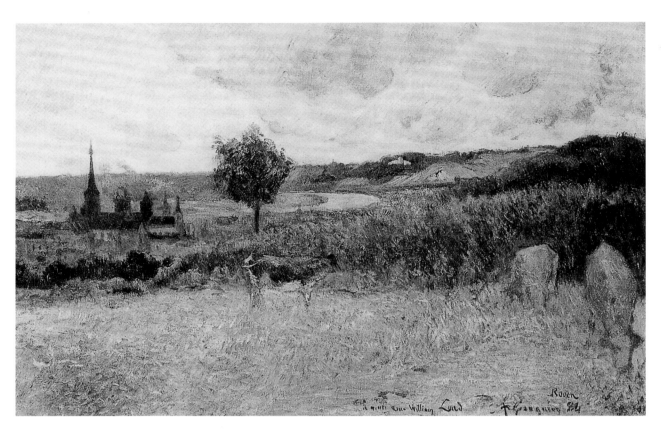

Fig. 151 (*above*) Paul Gauguin, *View of Rouen*, 1884. Oil
on canvas. 22^1/$_2$ × 34^1/$_4$ in. (57 × 87 cm). Private collection
(WII 123)

Fig. 152 Paul Gauguin, *The Road Up*, 1884. Oil on canvas,
18^3/$_8$ × 15 in. (46.5 × 38 cm). Foundation E. G. Bührle
Collection, Zurich (WII 127)

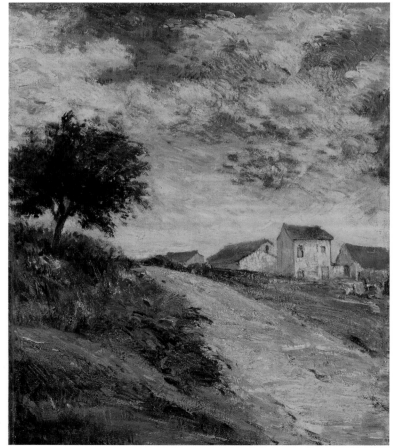

By the middle of May Gauguin had finished several works, that, again, he wanted to show to Pissarro, but again Pissarro excused himself because he did not have the time.[18] The paintings must have been those in which he had attempted "to paint very broadly and not monotonously."[19] His means of expression had become a problem to him. He had to struggle to master the language of his lines and colors. In the same letter he concluded: "To express your thought you must be sure of its execution, and in that I have not yet arrived where I want to be. I must chafe a little longer yet."[20]

"Extra strong" During the spring of 1884 Gauguin's crisis was to intensify in all respects, and he "chafed" in both his art and his personal life. He had to struggle with the recalcitrance of his painting and also with the conditions under which his family was living. The hopes and expectations that he had invested in Rouen and its affluent and art-loving public—which Pissarro had called naive from the start—had soon been disappointed. His attempts to make his way in business came to nought, and generally his paintings were not selling. The crisis in the Parisian art market, which grew worse during the spring, could not have come at a more unfortunate time for anyone aspiring to make a living as an artist. Gauguin's finances dried up, his marriage was in difficulties, and at the end of July Mette went home to Denmark to explore the possibility of establishing the family there. Aline and the youngest child, Paul Rollon, went with her while Gauguin remained behind with the nursemaid and the other two children, Clovis and Jean René.[21]

However, it is typical of Gauguin's personality and art that not many months after the artistic dearth of his early period in Rouen, he found himself in the midst of one of his most vigorous periods of development. Alone in Rouen he had time to think and paint and, as so often, adversity brought out his fighting spirit and had a remarkably fruitful effect on his creativity. It was now that he created some of his most radical works to date. In a letter of July, Gauguin talks of his artistic strategy this summer: "Now that I have enough paintings in Paris to show, I am settling down with regard to painting. Now I am painting only for myself, without rushing, and I can assure you that it is extra strong this time. I think it will be very good for me, and even though I might make mistakes (it is even probable that I shall make mistakes), I will always be able to learn something. When you are experimenting you often go off track, but you get to know yourself and how far you can go, or rather you try your strength."[22]

What were these works that Gauguin was painting for himself and referred to as "extra strong," pointing up the radical and avant-garde qualities at which he was aiming? It seems probable that they included the eight of his "strongest" works that he selected in August for an exhibition in Norway in which he was invited to participate through his brother-in-law, the painter Frits Thaulow.[23] He describes these works as being among the toughest ones. Some of these were set aside on their arrival in Norway, presumably by the exhibition jury. The three paintings listed in the exhibition catalogue—a portrait and two still lifes—were probably *Mette in Evening Dress* (fig.

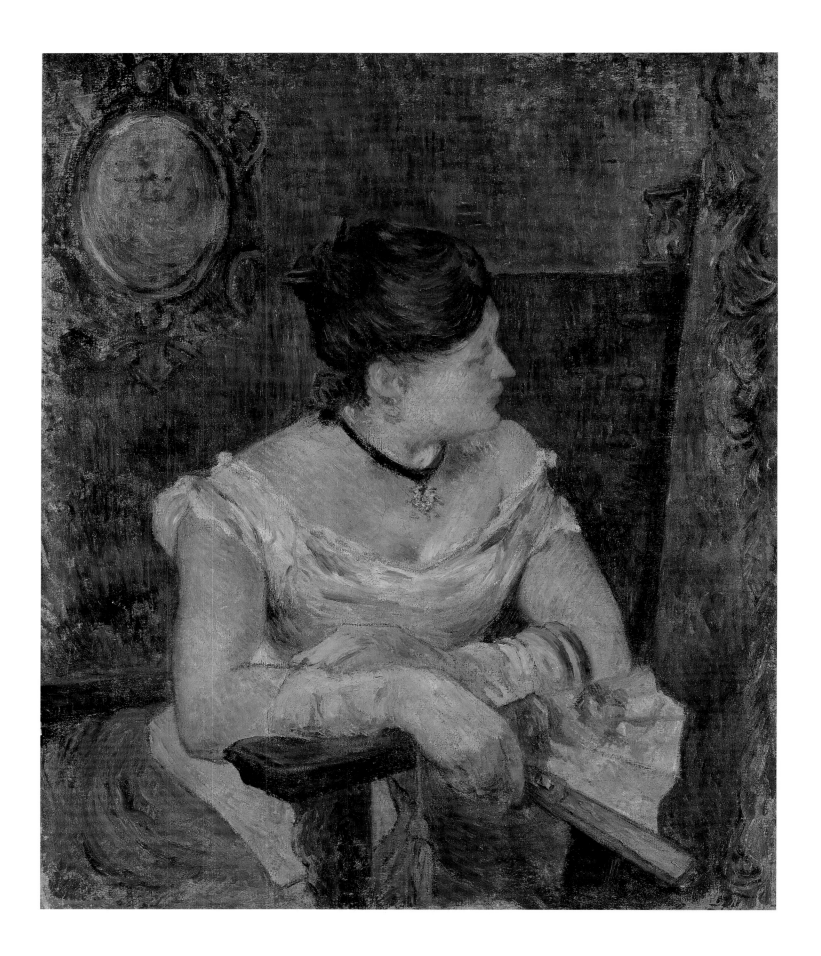

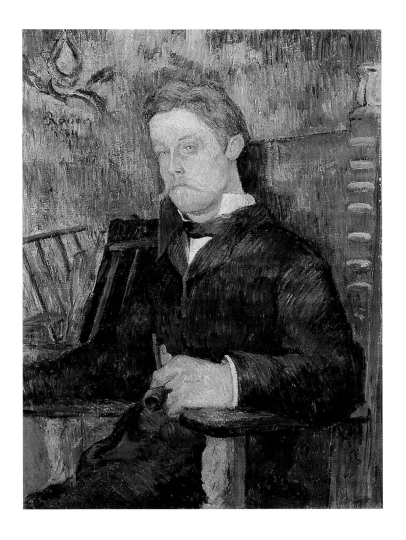

Fig. 153 (*facing page*) Paul Gauguin, *Mette in Evening Dress*, 1884. Oil on canvas, 25⅝ × 21¼ in. (65 × 54 cm). National Museum of Art, Architecture, and Design, Oslo (771) (WII 154)

Fig. 154 (*right*) Paul Gauguin, *Portrait of a Man*, 1884. Oil on canvas, 25⅞ × 18⅛ in. (65.5 × 46 cm). Private collection (WII 153)

Fig. 155 (*below*) Paul Gauguin, *Portrait of Isidore Gauguin*, 1884. Oil on canvas, 10⅝ × 7⅜ in. (27 × 18.5 cm). Dallas Museum of Art. The Wendy and Emery Reves Collection (1985.R.29) (WII 156)

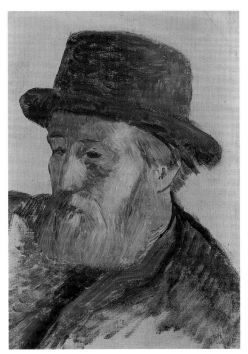

153), *Nasturtiums and Dahlias in a Basket* (fig. 156), and the mysterious *Clovis Asleep* (see fig. 71).[24] The first and the last of these are certainly radical in content, and they share a distinctive painting technique inspired by Cézanne's brushwork and the views on color of the Romantics and Delacroix. They must represent part of that summer's "extra-strong" work. But it is almost inconceivable that Gauguin did not also send some of the summer's landscapes to his Norwegian audience.

The compelling portrait of Mette—viewed in profile and wearing the magnificent evening gown that, according to Gauguin, she took the liberty of buying on credit despite the family's strained financial circumstances[25] shows the same broad, powerful brushstrokes as a closely related portrait of an unknown man whose blue eyes and fair hair suggest that he belonged to the family's Scandinavian circle (fig. 154).[26] The two portraits are similar in size (they are the same height), in their formal or representational nature, in their accessories (the subjects are seated on the same chair), and in their rather diagonal compositions. It is tempting to see them as companion pieces and speculate that the unknown man belonged to the family's most intimate circle. Their formal character is something of an enigma, unless we are to see them as practice pieces in portraiture, perhaps made with a view toward making a living in this field.[27] We see the same concise quality of interpretation in the start of a portrait of the artist's Uncle Sisi, who visited him during his time alone (fig. 155).

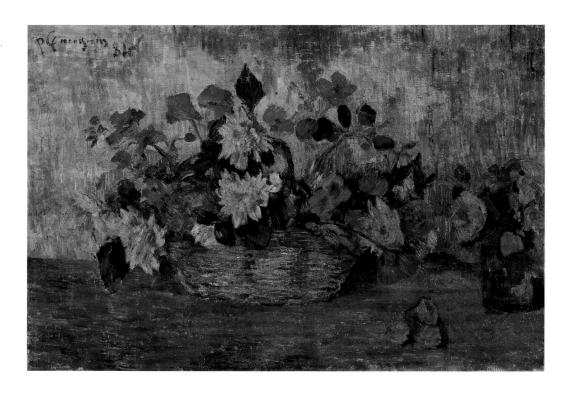

Fig. 156 Paul Gauguin, *Nasturtiums and Dahlias in a Basket*, 1884. Oil on canvas, 18¹/₈ × 25⁵/₈ in. (46 × 65 cm). National Museum of Art, Architecture, and Design, Oslo (770) (WII 150)

Fig. 157 Paul Gauguin, *Vase of Peonies II*, 1884. Oil on canvas, 18¹/₈ × 21³/₄ in. (46 × 55 cm). Location unknown (WII 146)

Clovis Asleep is the most radical[28] of the works Gauguin described as "extra strong," not least because of the bold manner in which it mixes two traditional genres, the portrait and the still life. The themes of sleeping and dreaming, represented by the doll in the foreground and the decorative birds taking flight across the blue of the background, are reminiscent of *The Little Dreamer* of 1881 (cat. 26). But in this new picture Gauguin imbued the sleeping child with a more enigmatic dimension, both through the unexpected combination of genres and through the presence of the large Norwegian lidded wooden vessel that acts as a mysterious counterpart to the child's head (see fig. 72). With its considerable size in relation to the child's head and its glowing golden color, this container with unknown contents possesses an aura of strangeness. It plays a role—the role of the work of art—corresponding to that of Gauguin's own ceramic jar in the epoch-making *Still Life with Laval's Profile* (cat. 75) of 1886, which *Clovis Asleep* anticipates in every sense of the word.

The background with the birdlike and plantlike decoration and the suggestive blue, which achieves its vibrant effect through the application of many related nuances, also appears in a still life from this period—as though it were the echo of a jumbled bouquet of peonies (fig. 157). The bouquet was in turn to recur in an intensely colored version with works from Gauguin's art collection in the background (see cat. 36). The iridescent vase is another feature common to some of the works in this group, which also includes the Cézannesque *Apples, Jug, Iridescent Glass*.[29] The expressiveness of both color and

line ties these works to each other. The same qualities are evident in the curiously living still life *Basket of Flowers* (cat. 42).

In Gauguin's solitude and his isolation from the Parisian artistic milieu, his own art collection began to play the role that culminated during his stay in Copenhagen, providing him with models of painting technique, motif, and composition. It became a replacement for the adviser that Gauguin no longer had, as Pissarro declined his repeated invitations. His works by Cézanne took on the greatest significance of all. Almost all the paintings he made during his stay in Rouen confront, to a greater or lesser extent, the fundamental challenge of Cézanne and his enigmatic "formula." The accumulation of structured material in the landscapes, the dense network of motifs across the surface, the systematic and parallel brushstrokes, all reveal his intense study of the Cézannes hanging on his walls. Through his own work Gauguin sought to penetrate the nature and essence of his Cézannes and to coax their secrets from them.

He engaged with Cézanne's "formula" in a number of early works from the Rouen visit, not least the garden subjects (figs. 147, 150, 161), but integrated it more successfully in the summer landscapes with trees and cows (figs. 159, 160) and a hay cart.[30] In a painting he made on the outskirts of the city, the ridges of roofs among the treetops make for a picture surface that is about structure very much in the manner of Cézanne (fig. 158). Here he was responding to one of the two Cézannes that he had managed to wrest from the dealer Tanguy—the mountain landscape from l'Estaque (see fig. 42), which he described as "unfinished but nevertheless very advanced. Blue, green, and orange . . . quite simply a marvel."[31] In his own paintings he sought to capture the musical quality of Cézanne in the interplay between the organic forms of trees and the geometric shapes and lines of buildings. He emphasized the broad outlines of the motif at the expense of detail, correcting the fault that Pissarro had seen in the series of canvases deposited with Durand-Ruel. The effect of Cézanne was now more structural. The pictures were not merely an exercise in Cézanne's "constructive" stroke; they approached the crystalline purity of his pictorial universe. The brush follows the shapes of the houses and the structure of the foliage in parallel sequences. The physical features of the landscape, its hills and dales providing elevated viewpoints and high horizons, encouraged this tendency. Gauguin filled the picture surface with the motif, and gave many of his paintings a dense, accumulated quality—as, for instance, in *Sunken Path, Wooded Rise* (fig. 160), which is viewed from above, looking down on a stream, the terrain rising steeply on the other side. Another painting of similar structure, *Rouen, Spring* (fig. 147), shows a corner of an overgrown garden, behind an urban house, with fruit trees in blossom; here again the sky is unseen. The painting is filled to overflowing with the red building, a hedge with a host of greens, and the blossoming tree, which reaches the "ceiling" of the composition with its many hanging branches spread decoratively over the picture surface. The compressed structure of the work is almost claustrophobic.

A painting such as *Sunken Lane* (fig. 162) relates to Gauguin's Cézannes on several levels. It is a variation on no fewer than three works in the collection. The structure of

Fig. 158 Paul Gauguin, *Near Rouen*, 1884. Oil on canvas, 28³/₄ × 23⁵/₈ in. (73 × 60 cm). Private collection (WII 140)

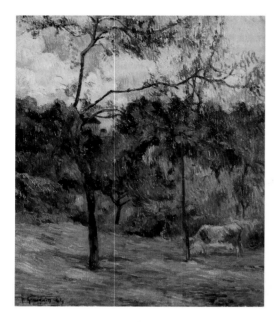

Fig. 159 Paul Gauguin, *Cow in Meadow, Rouen*, 1884. Oil on canvas, 21¼ × 17¾ in. (54 × 45 cm). Private collection (WII 138)

Fig. 160 Paul Gauguin, *Sunken Path, Wooded Rise*, 1884. Oil on canvas, 21⅞ × 18¼ in. (55.5 × 46.1 cm). Museum of Fine Arts, Boston. Gift of Lawrence and Lorna J. Marshall (64.2205) (WII 135)

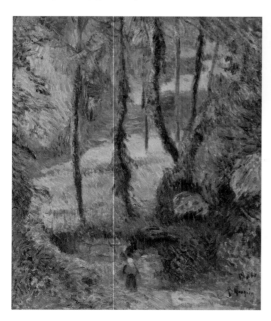

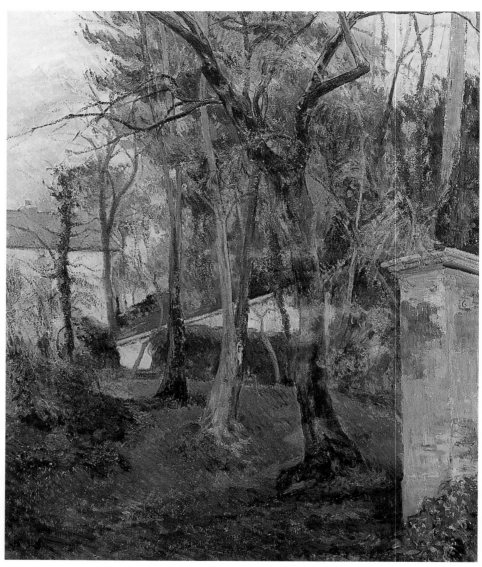

the pictorial space, with a road leading diagonally into depth, derived from *Avenue* (see fig. 204)—whose composition, "with trees lined up like soldiers and shadows stepped like a staircase," had so excited Gauguin when he bought it from Tanguy.[32] The great curve in the foreground, which frames the composition as in a piece of hollow glassware and makes it into an unbreakable whole, came from the Estaque landscape that he owned, and the systematic technique is close to that of *The Château of Médan* (see fig. 43).[33] Gauguin has learned crucial lessons from Cézanne and yet his painting remains a genuine Gauguin: it is enclosed within itself and expresses a peace and immutability characteristic of his paintings of this period.

Fig. 161 (*facing page right*) Paul Gauguin, *Abandoned Garden, Rouen*, 1884. Oil on canvas, 25⅝ × 21¼ in. (65 × 54 cm). Private collection, Paris (WII 118)

Fig. 162 (*right*) Paul Gauguin, *Sunken Lane*, 1884. Oil on canvas, 29 × 23¾ in. (73.6 × 60.3 cm). Private collection, USA (WII 128)

Fig. 163 Paul Gauguin, *Tree-Lined Road, Rouen I*, 1884. Oil on canvas, 36⅝ × 20⅞ in. (93 × 53 cm). Private collection, France (WII 125)

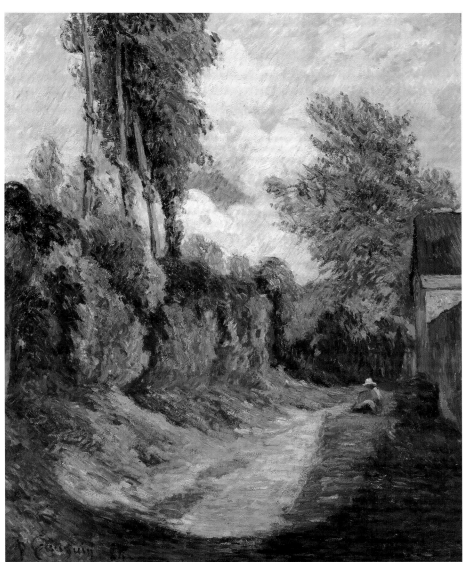

The inspiration of Cézanne's painting of the avenue is also evident in Gauguin's attempt at a similar motif, *Tree-Lined Road, Rouen I* (fig. 163), one of the biggest and most ambitious works of his Rouen period and painted on a canvas of unusually tall format.[34] Judging from the many shades of red in the trees in the replica that he made after moving to Copenhagen, *Tree-Lined Road, Rouen II* (cat. 47), it must have been executed in the early autumn.

36

Rue Jouvenet, Rouen, 1884
Oil on canvas, 21⁵/₈ × 19³/₄ in. (55 × 50 cm)
Carmen Thyssen-Bornemisza Collection on loan
 at the Museo Thyssen-Bornemisza, Madrid
WII 115

This fascinating small painting resembles more
the Fauvist street views of Maurice de
Vlaminck, Raoul Dufy, and Albert Marquet
(fig. 164) painted around 1904–6 than
anything by an Impressionist painter. It glories
so strongly in the geometries of the
architecture that Gauguin was surely thinking
of Cézanne. Yet the palette—with brilliant
reds, blues, greens, oranges, and yellows—and
the scumbled facture bear no relationship to
Cézanne at all. The work belongs to a small
group of suburban Rouen views that seem to
forecast the future of painting even beyond
Gauguin's death in 1903.

It is a study in alienation. The figures move
through the streets like zombies. A jaunty
military man lights his pipe or cigarette and
turns from the viewer. A small dog sniffs the
edge of the pavement. A scarved woman
moves into the picture's constricted space from
the lower-right corner as if entering a film noir.
In its connection of bright colors with
suburban anomie, the painting is modern in its
sheer ambivalence. Only one canvas by any of
Gauguin's Impressionist colleagues closely
relates to it, Pissarro's *Street, Osny* (fig. 165)—
which the older artist painted in 1884 after
returning from Rouen.

The site, a few minutes' walk from
Gauguin's rented house, has been identified by
Sylvie Crussard.[35]—RRB

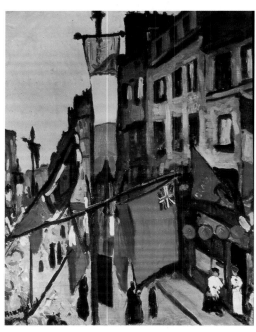

Fig. 164 Albert Marquet, *July 14 at Le Havre*, 1906.
Oil on canvas, 31⁷/₈ × 25⁵/₈ in. (81 × 65 cm). Musée
Albert-André, Bagnols-sur-Cèze, France

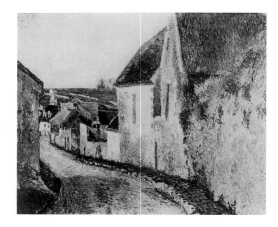

Fig. 165 Camille Pissarro, *Street, Osny*, 1884. Oil on
canvas, 17³/₄ × 25⁵/₈ in. (45 × 65 cm). Private collection
(PV 627)

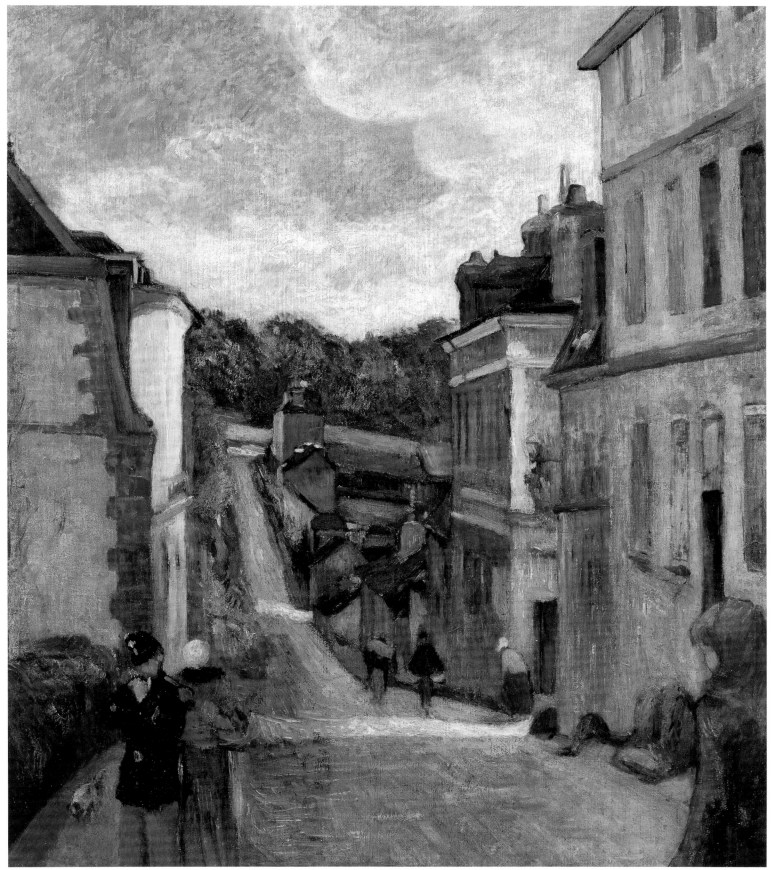

cat. 36

37

Manuring, 1884
Oil on canvas, 23⅝ × 29⅛ in. (60 × 74 cm)
Signed and dated lower right: *p Gauguin / 84*
Wallraf-Richartz-Museum, Fondation Corboud,
 Cologne
WII 117

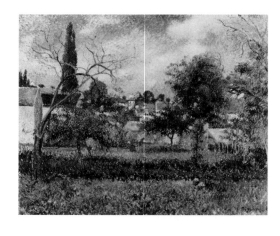

Fig. 167 (*right*) Camille Pissarro, *Kitchen Gardens, Pontoise*,
1881. Oil on canvas, 23⅝ × 29⅛ in. (60 × 74 cm). Private
collection (PV 514)

Fig. 166 (*below*) Camille Pissarro, *The Garden of Les
Mathurins at Pontoise*, 1876. Oil on canvas, 44⅝ × 65⅛ in.
(113.4 × 165.4 cm). The Nelson-Atkins Museum, Kansas
City. Purchase: Nelson Trust (60–38) (PV 349)

This imposing suburban landscape represents a
field on one of the dramatic hilltops around
the city of Rouen. The season is late autumn,
and the light has the haziness that comes from
domestic smoke in cold air. In the foreground
a rural worker divides manure into piles, while
another pushes a wheelbarrow full of dead
leaves or straw uphill toward them. Manure
could be mixed in different combinations for
different uses, and would be dug into fallow
fields, vegetable gardens, and floral borders for
the winter. Gauguin paints the figures as small
and chromatically indistinguishable from the
space in which they work, forcing us to pay
closer attention to the pair of houses on the
right and to the beautifully painted view of
roofs descending the hill toward the distant
Seine. There is a rigorous spatial separation of
foreground and background, and green hedges
make it impossible for us to imagine entrance
even to the closest of the houses.

Brooding and mysterious, the work cannot
be classified as either Impressionist or
Symbolist. When compared to a somewhat
earlier work by Pissarro such as *Kitchen
Gardens, Pontoise* of 1881 (fig. 167), its
discontinuities are evident in spite of many
similarities of technique. Gauguin's surface
lacks the "all-over" facture of Pissarro's, and
the younger artist seems to have represented
the human activity as a kind of rite. He also
allowed the closest house to dominate the
composition to such an extent that we feel
constrained by its presence from entering the
satisfying depths that the painting otherwise
evokes. In many ways, it seems to be an
inversion of Pissarro's summer gardenscape of
1876, *The Garden of Les Mathurins at
Pontoise* (fig. 166), which Gauguin knew from
the collection of Georges de Bellio.

There is evidence to suggest that this
landscape was one of seven deposited by
Gauguin at Durand-Ruel's gallery in April
1884.[36] Its first known owner was the Danish
collector Wilhelm Hansen, founder of the
Ordrupgaard and one of the greatest collectors
of modern French painting in the world.—RRB

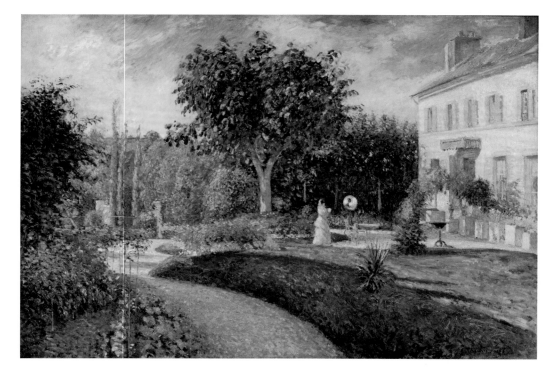

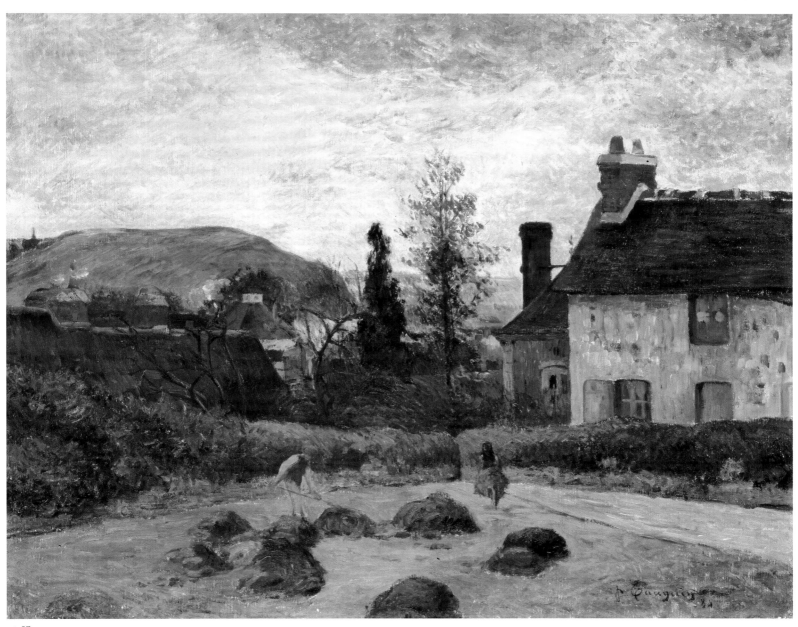

cat. 37

38

Garden View, Rouen, 1884
Oil on canvas, 21¼ × 25⅝ in. (54 × 65 cm)
Private collection
WII 120
Kimbell only

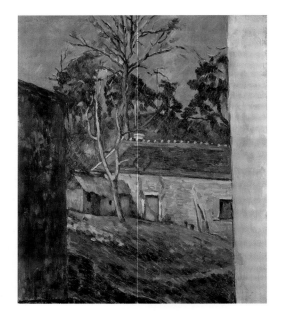

Garden View, Rouen was another of the paintings Gauguin made in Rouen in 1884 and probably left with Durand-Ruel in April of that year.[37] Rarely in his career did he attempt to meld the aesthetics of Cézanne and Pissarro more successfully than he did in this masterful suburban landscape. Its subject, a kitchen garden in winter, relates to many similar scenes painted by Pissarro around l'Hermitage, Valhermeil, and Le Chou, near Pontoise, in the 1870s and early 1880s. Yet its composition is utterly unlike any in the older Impressionist's work. There is no horizon line and no sky, the empty windows of the distant white house hang like flags from the top edge of the composition, and the black outlines around the windows and the blue-roofed garden house that anchors the painting are essentially unprecedented in Impressionist practice.

It is fascinating to compare the painting to works by Pissarro and Cézanne owned by Caillebotte and therefore accessible to Gauguin before 1884: Pissarro's *Red Roofs, Village Corner, Impression of Winter* (fig. 168), which had been in the Impressionist exhibition of 1877, and Cézanne's *Farm Courtyard in Auvers* (fig. 169). The treatment of architecture connects firmly to Caillebotte's Cézanne and the facture and complex palette to his Pissarro.—RRB

Fig. 169 (*right*) Paul Cézanne, *Farm Courtyard in Auvers*, c. 1879–80. Oil on canvas, 25⅝ × 21¼ in. (65 × 54 cm). Musée d'Orsay, Paris. Bequest of Gustave Caillebotte, 1894 (RF 2760)

Fig. 168 (*below*) Camille Pissarro, *Red Roofs, Village Corner, Impression of Winter*, 1877. Oil on canvas, 21½ × 25⅝ in. (54.5 × 65.6 cm). Musée d'Orsay, Paris. Bequest of Gustave Caillebotte, 1894 (RF 2735) (PV 384)

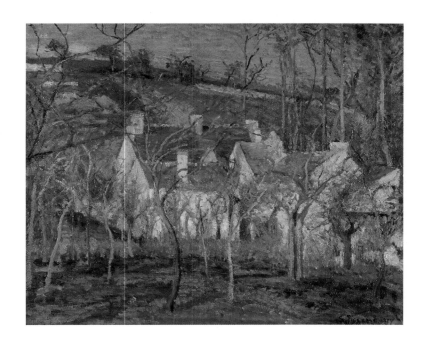

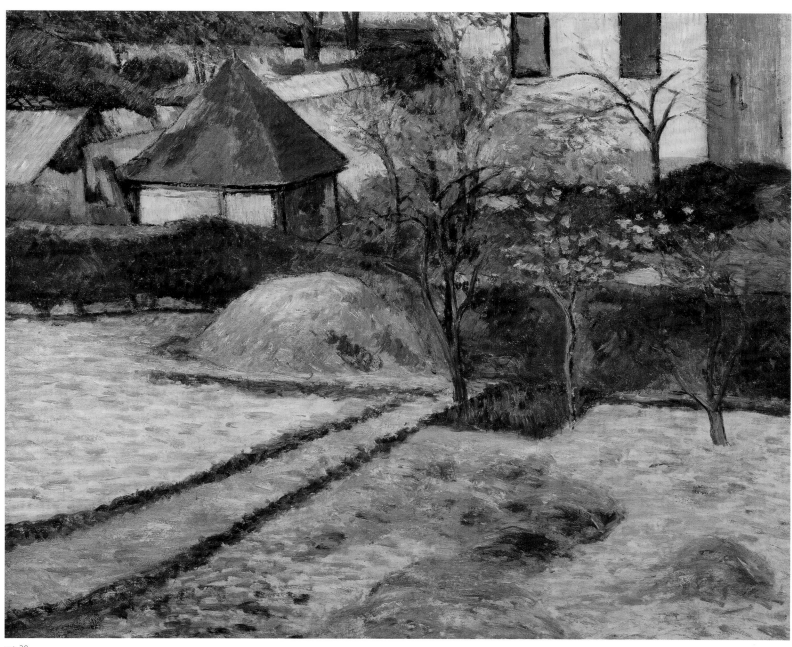

cat. 38

39

Street, Rouen, 1884
Oil on canvas, 28³/₄ × 36¹/₄ in. (73 × 92 cm)
Signed and dated lower right: *p Gauguin 84*
Museo Thyssen-Bormemisza, Madrid
WII 122

Gauguin painted two canvases of the same large size in Rouen in 1884, this one horizontally, in the traditional landscape format, and the second, *The Church of Saint-Ouen, Rouen* (see fig. 148), turned so that it is vertical. In a sense, they are among the most conventional of his works that year, indicating that he most likely made them for exhibition and sale rather than as part of his private pictorial experimentation. The space of the Madrid composition is directed assymmetrically toward the left edge of the canvas, forcing the viewer into a peripheral role and recalling earlier experiments in peripherality by Manet, Degas, and Caillebotte. Again, the subject is unremarkable—there are no important buildings or particularly distinctive trees, and the painter seems more interested in the application of a kind of graphic facture used by Pissarro and Sisley than in any daring compositional devices. Yet the sheer emptiness and lack of pictorial incident in the foreground imply a psychic distance between the viewer and the landscape that links the painting to Cézanne. The latter's most comparable work, conventionally dated 1881–82, is *Bend in the Road near Valhermeil* (fig. 170).

Sylvie Crussard has identified the site as the Rue des Sapins, near the monumental cemetery up the hill from Gauguin's house.[38] If she is correct, Gauguin clearly chose to underplay the association of the place with mortality.—RRB

Fig. 170 Paul Cézanne, *Bend in the Road near Valhermeil*, 1881–82. Oil on canvas, 23⁵/₈ × 28³/₈ in. (60 × 72 cm). Private collection (R 492)

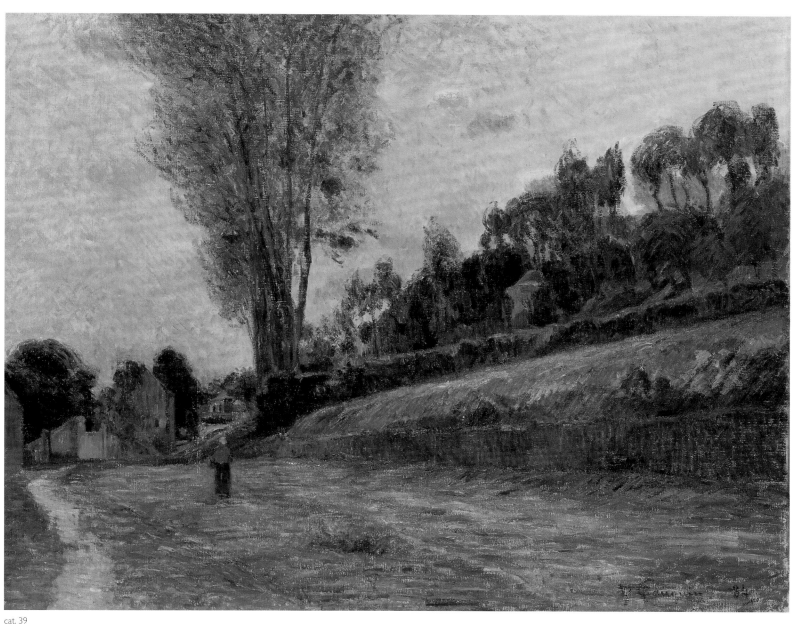

cat. 39

40

Orchard below Bihorel Church, 1884
Oil on canvas, 25³/₄ × 18¹/₈ in. (65.5 × 46 cm)
Signed and dated lower left: *p Gauguin 84*
Carmen Thyssen-Bornemisza Collection on loan
 at the Museo Thyssen-Bornemiza, Madrid
WII 132

Gauguin painted this boldly composed, decidedly Cézanne-like landscape in the summer of 1884 near Rouen. Its planar organization and obsession with the structure of a fruit tree link the work to paintings he knew by both Cézanne and Pissarro. It is particularly close to Cézanne's 1877 painting of an orchard in Pontoise (fig. 171), a work owned by Pissarro and therefore easily accessible to Gauguin.

There are also fascinating points of comparison with an almost identically sized early Cézanne, *The Orchard (Hattenville)* (fig. 172). This was first owned by Victor Choquet and may also have been seen by Gauguin before he made his painting. For Cézanne the attention to structure is absolute, and no figures are allowed to disrupt the idea of the picture as a sustained meditation on nature by the painter as opposed to the evocation of an independent social landscape. In his decision to people his landscapes, Gauguin was more like Pissarro even when he approached Cézanne most closely.

Throughout his composition he created deftly interlocking segments and to hold the right edge used one of his first strictly profile cows. The four children—two seated, one standing behind a small tree, and one reclining lazily in the foreground—are not at all like the rural workers who populate Pissarro's landscapes; they are carefully positioned bourgeois children out of school during the summer. Since at least two of the figures are

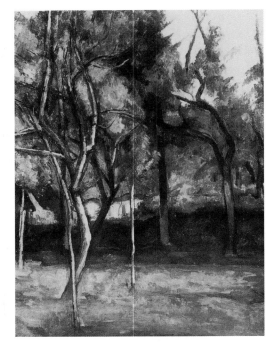

Fig. 172 Paul Cézanne, *The Orchard (Hattenville)*, 1882. Oil on canvas, 23⁵/₈ × 19¹/₂ in. (60 × 49.5 cm). Private collection (R 506)

girls, we know that they cannot all be Gauguin's own children; he had only one daughter, Aline. It seems likely that the painting records an outing on which the artist was joined by his children and one or more of their friends. It probably dates from before Mette left for a two-month holiday in Copenhagen with Aline and Paul in July 1884.—RRB

Fig. 171 Paul Cézanne, *The Garden of Maubuisson, Pontoise*, 1877. Oil on canvas, 19³/₄ × 24 in. (50 × 61 cm). Mr. and Mrs. Jay Pack, Dallas (R 311)

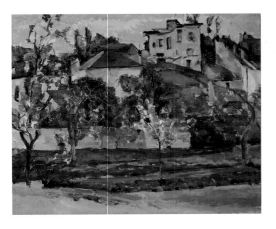

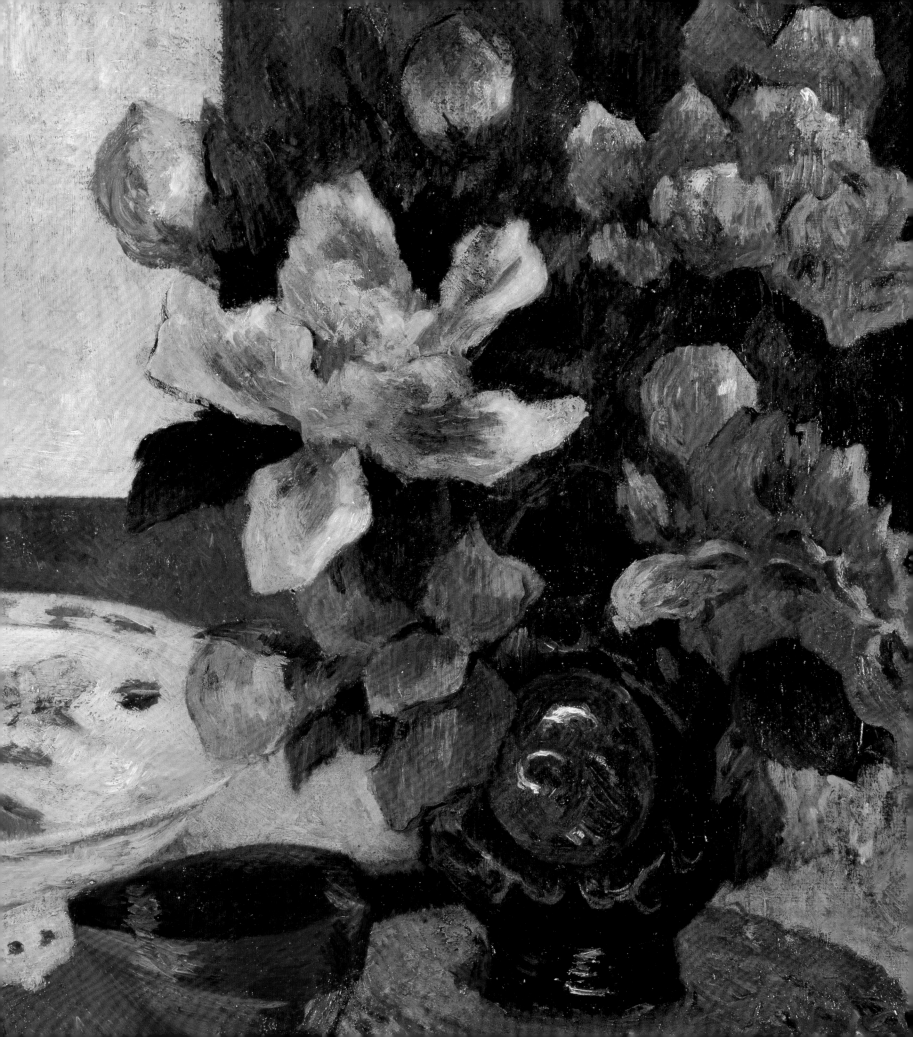

Fig. 183 Frederiksberg Allé 23, 21, 19. The Royal Library, Copenhagen

innovation of the Impressionists. He had wondered at the fact that their skies were often so dark, sometimes darker than objects on the ground. This conflicted with all academic doctrines. Students at the Academy were taught that "those things that were brightest must be brightest."[70] Krohg noted that the Impressionists disregarded this principle completely.

Gauguin especially touched on the subject of the skies in a letter from the period when he created the winter scenes. He commented on Pissarro's observations of some weaknesses in a painting that he had left with him on leaving Rouen—as a memento but also in the expectation that Pissarro would express a critical opinion.[71] Pissarro made some observations similar to those he had made on his paintings of April 1884—which he had found monotonous. In response Gauguin underlined his efforts to imbue his skies with a radiant transparency even though they were dark. "In my new efforts it is the skies that are difficult. I try to keep things very simple and yet very divided in tones; my new technique, in which the brushstrokes seldom cross—with large stopping points—very much fits in with this. The sky is always very luminous, without extremes; because of its essential limpidity and humidity, it can't have the grainy roughness of a wall however matte. I well know that great precision of tone ought to give me what I want. I need practice, and so far I've had very little compared with all of you. We'll see."[72]

In his artistic isolation Gauguin had the opportunity to test his theories in practice. They came through both in the working method he was to develop during his Copenhagen exile and in several of his motifs. He set himself an ambitious task. He wanted to paint a large picture reintroducing the figure, which had played no important part in his landscapes since *Snow, Rue Carcel II* of 1883 (see fig. 133).[73] The new painting was also to be a winter scene (fig. 184),[74] in which he would test his theory by

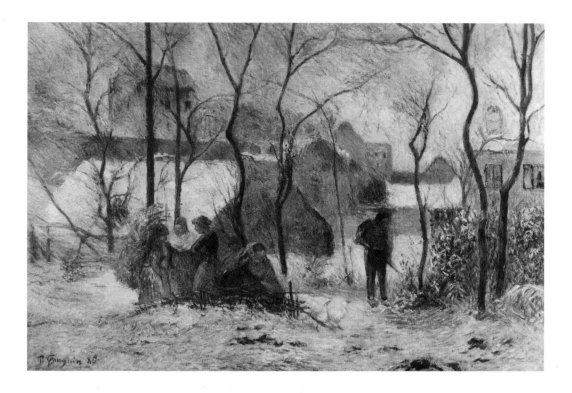

Fig. 184 Paul Gauguin, *Winter*, 1885. Oil on canvas, 28³/₈ × 39³/₄ in. (72 × 101 cm). Private collection (WII 162)

Fig. 185 Paul Gauguin, *Snow at Vaugirard I*, 1879. Oil on canvas, 16³/₈ × 19¹/₄ in. (41.5 × 49 cm). Ny Carlsberg Glyptotek, Copenhagen (WII 56)

distancing himself from nature and synthesizing earlier paintings, some by himself and some by others.[75] He took components from his old winter scenes in Paris—but also from the works by other Impressionists hanging on his walls. The houses and trees of the background came from the Vaugirard snow scene (fig. 185), while the girl bending down to tie her shoe and the snow-covered hedge came from *Snow, Rue Carcel II*.[76] He borrowed the other figures from Pissarro and Guillaumin.[77] The single feature that may be painted from immediate observation is the apartment house behind the hedge on the right, which could well have been a building in Copenhagen.[78]

Gauguin pieced the composition together like a collage from what was available. The group of four women resembles a flat in some stage set. Clearly the women do not belong in such surroundings, but the artist made no attempt to cover this up. They are peasant girls making an appearance in the suburbs that is as absurd as the sight of a man raking near a snow-covered bush on a winter's day. Such departures from reality anticipated Gauguin's later method. When painting the *Human Misery* of 1888 (Ordrupgaard, Copenhagen), he said that it represented a "vineyard effect" he had seen at Arles, with some Breton women added: "Never mind about accuracy."[79]

To quote Gauguin's words about Cézanne, the winter scene was "just as much fantasy as reality." It was an attempt to free the motif from straightforward depiction and allow the medium of the picture to speak for itself. It was a fulfillment of the theory that more should be painted in the studio—in order to break with the mimicry

Fig. 186 (*right*) Paul Gauguin, *Landscape after Cézanne*,
1885. Fan, gouache on canvas, 11 × 21⅞in.
(27.9 × 55.5 cm). Ny Carlsberg Glyptotek, Copenhagen
(I.N. 1950)

Fig. 187 (*below right*) Paul Gauguin, *Snow with Motifs from
"Winter,"* 1885. Fan, gouache on linen, 9⅝ × 20¾in. (24.2
× 52.5 cm.) Private collection

of nature, concentrate on the artistic process, and achieve a synthesis of impressions.
With this, he took another tentative step on the road to the nonliterary figure painting
that he had started to sense as his objective and which was to be the mainstay of the
Synthetic-Symbolist painting of the Breton and Tahitian periods.

The genesis of the painting was furthered by his situation. The original optimism with
which he embraced his new life in a new country had already vanished. He was feeling
depressed and isolated in the alien environment. He was not doing well in business, and
in his distress he wrote to Pissarro several times to ask him to arrange that Durand-Ruel
sell his paintings. In March 1885 he had to sell a Manet from his collection, and even
then he was short of money for canvases and paints. He and Mette had to give lessons
in French, and his business could not be expected to show a profit for at least six
months: "Meanwhile I am without a penny and up to my ears in shit, so I console
myself by dreaming." So he wrote to Schuffenecker in his January letter.[80]

He remained a morose figure indoors. The Scandinavian winter, which had fascinated
him at first sight, had turned to thaw and sleet. The "picturesque" motifs had melted
away, and in the joyless darkness of winter he surrendered in reverie to the paintings by
his Impressionist friends in his collection. This resulted in a number of "paraphrases"

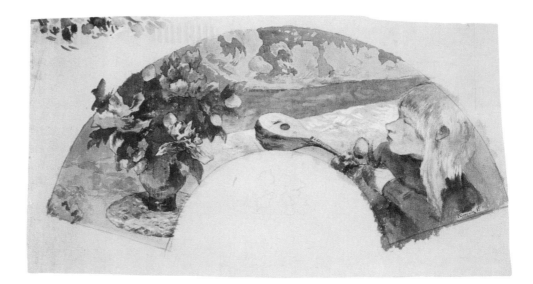

of them, including *Snow, Copenhagen* (fig. 181) and *Tree-Lined Road, Rouen II* (cat. 47).[81] The motif of the latter painting also appears on one of the fans that Gauguin painted during his time in Copenhagen. Pissarro produced a large number of painted fans, on which he often paraphrased old motifs. With Gauguin, however, the fan was to become a synthesis of borrowed and freely invented elements, of old and new, woven together into an artistic whole. He took the themes of a couple of the fans from paintings by Cézanne he owned. One shows elements from *The Harvest* (see fig. 41),[82] while another (fig. 186) is an almost direct copy of the painting on which he lavished such poetical turns of phrase in his letter to Schuffenecker of January 1885, *Mountains, l'Estaque* (see fig. 42).[83] He derived other designs from Pissarro, who had sent him some of his etchings with motifs from Rouen.[84] Some are paraphrases of Gauguin's own paintings and motifs painted from memory. There is a fan with a snow motif (fig. 187) related to *Winter* (fig. 184)[85] while another represents flowers and a summer landscape from Rouen.[86] Then there are fans with various elements from still lifes—a basket of asters from an older painting[87] and *Fan Decorated with a Portrait of Clovis and a Still Life* (fig. 188),[88] and elements from one of the still lifes that Gauguin was to paint in Copenhagen, the *Still Life with Chinese Peonies and Mandolin* (fig. 190).[89]

Both the fans and the larger snow picture should be viewed in conjunction with Gauguin's theoretical texts of this period. He sought to develop his painting by divorcing the painting process from the imitation of nature and devoting himself to the language of line and color. He believed that the artist reached the essence of things through dreaming, and mentioned dreams and dreaming in several letters he wrote in Copenhagen. In the letter to Schuffenecker he advised him: "a great feeling can be immediately translated—dream freely and seek its simplest form."[90] Here we see Gauguin's idiosyncratic artistic method developing: a central feature of his later work was to be the recurrence of motifs, and he had already started creating the archetypes of his art. His reflections on aesthetics at this time were also to be manifested, more immediately, in a couple of still lifes whose theme seems to be art itself.

As he said in his January letter to Schuffenecker, Gauguin was more than ever tormented by his art, and in his works he was increasingly preoccupied with art as a subject. In a couple of still lifes, the work of art itself was introduced as one of the

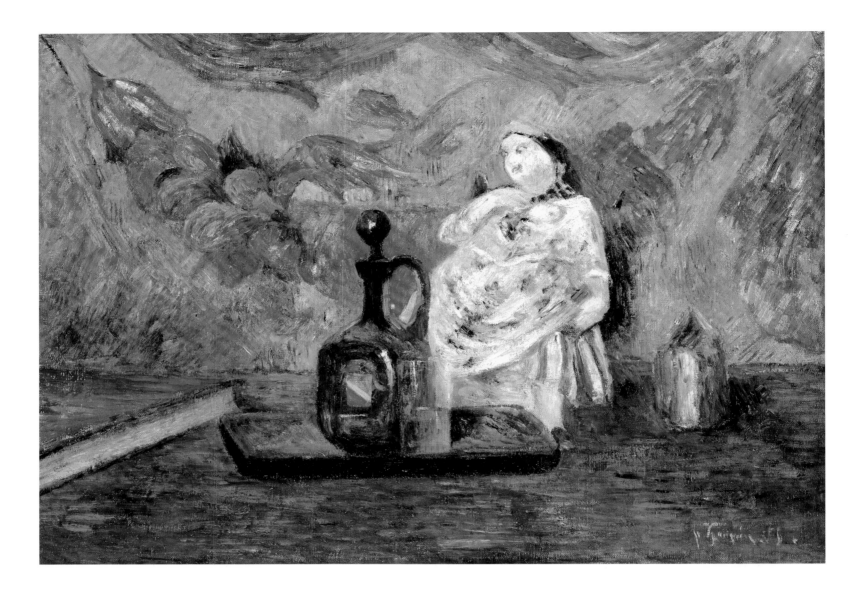

Fig. 189 Paul Gauguin, *Still Life with Carafon and Figurine*, 1885. Oil on canvas, 18¹/₈ × 25⁵/₈ in. (46 × 65 cm). Private collection (WII 171)

Fig. 190 *(facing page)* Paul Gauguin, *Still Life with Chinese Peonies and Mandolin*, 1885. Oil on canvas, 24 × 20¹/₈ in. (61 × 51 cm). Musée d'Orsay, Paris (MNR 219) (WII 169)

components in the arrangement. In one of these he humorously enthroned a small porcelain figure among such effects as an Oriental lacquered tray and a Danish schnapps bottle set in front of a decorative background containing a festoon (fig. 189).[91] In another he introduced one of the pieces from his own art collection as a picture within the picture and set the work in interplay with a magnificent bunch of pink peonies and the mandolin that was a repeated prop in his early compositions (fig. 190).[92] The *Vase of Peonies I* (cat. 41),[93] in which he also included items from his collection, perhaps for the first time, is traditionally dated to the Rouen period but could well belong among the experimental paraphrases he made in Copenhagen.[94] In *Still Life with Chinese Peonies and Mandolin*, he used the picture within the picture not only in a more sophisticated compositional manner, but also with an awareness of its symbolism. Remarkably, he afforded the broad, white frame a more prominent role in the composition than the work it surrounds—which is an oil by Guillaumin, *The Orchard* (fig. 185). The white frame was the very emblem of Impressionism, and Gauguin was very conscious of its radical significance. He claimed that when he submitted one of his paintings for an exhibition in Rouen the jury "snorted at the sight

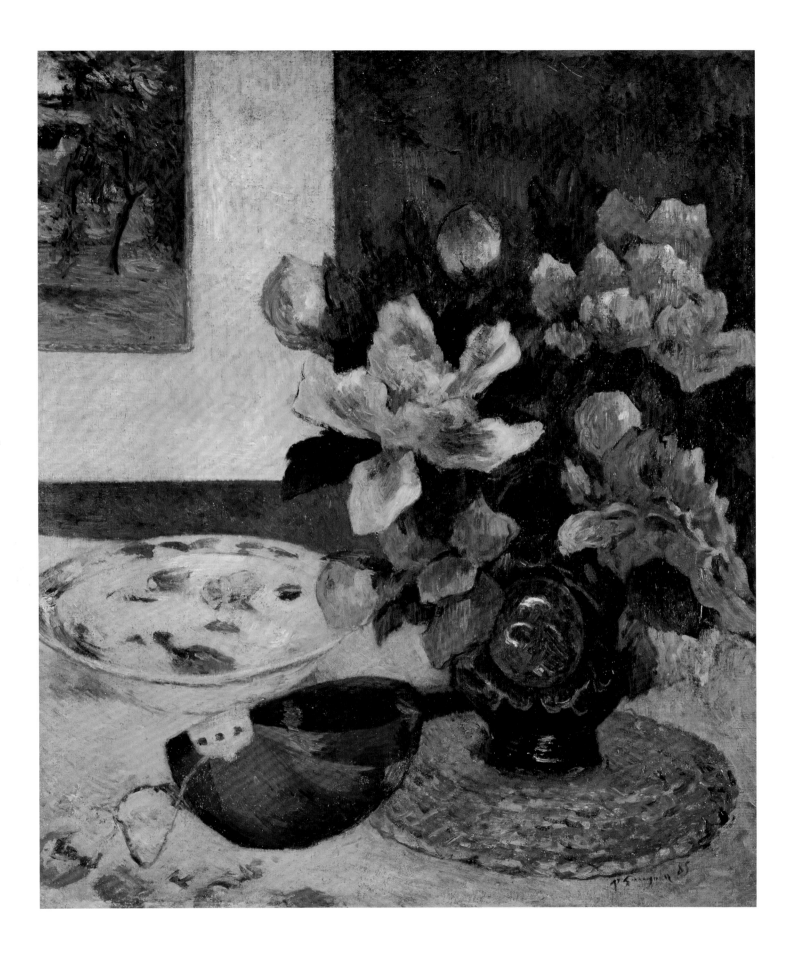

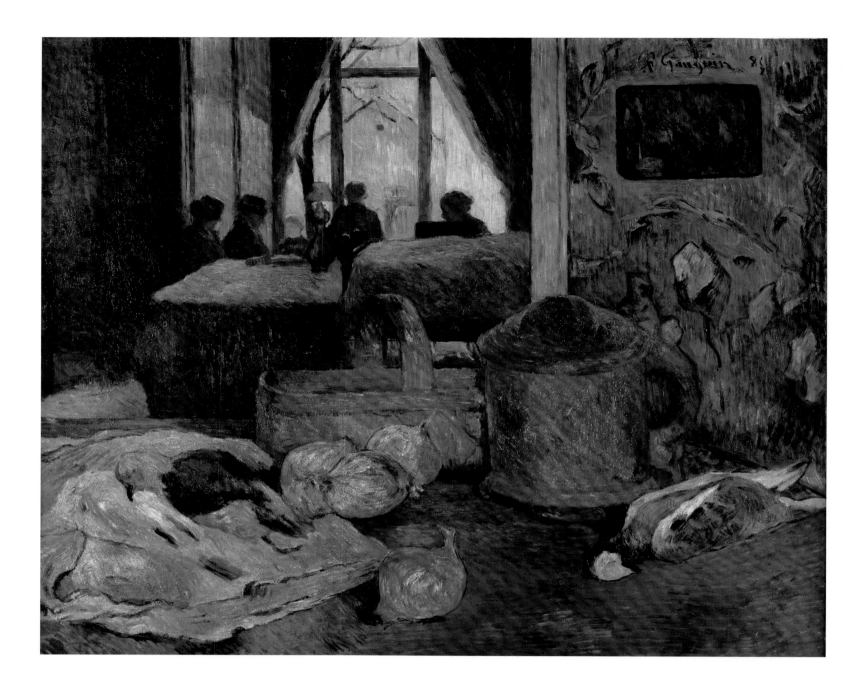

Fig. 191 Paul Gauguin, *Still Life, Interior, Copenhagen*, 1885. Oil on canvas, 23⅝ × 29⅛ in. (60 × 74 cm). Private collection (WII 164)

of a white frame,"[95] and that in Copenhagen the framemakers would lose their other clients if they worked for him.[96] As an element of the still life, the white frame signaled the refusal to compromise that was beginning to assert itself in his work and attitudes at this time. In a letter to Schuffenecker he wrote: "I hope you're going to make progress in intransigence—you'll only make it in art that way, and above all by extremes."[97]

The work of art within the work of art was to become a major theme for Gauguin. In another painting from Copenhagen, it was given an existential perspective. Like *Clovis Asleep* (see fig. 71),[98] the subtle *Still Life, Interior, Copenhagen* (fig. 191)[99] is a profoundly original mixture of two genres. On the one hand there is the still life and on the other the background genre scene, and each acts as a commentary on the other. What is dead and what is alive—the bourgeois life represented by the curiously timid

gathering of Danish ladies on a visit, or art as represented by the still-life arrangement in the foreground? The artist's answer is clear: the foreground—the sphere of art—is vibrant with all the life that is lacking in the melancholy scene behind. The magical Norwegian lidded wooden container or *tine* appears—for the last time—with special intensity, and the homage to Cézanne is underlined by the icon for this artist in Gauguin's work, the bluish wallpaper pattern on the wall to the right.

The divided world of the painting is about art and existence. In Gauguin's real life, too, a choice was forcing itself upon the artist. The antithesis between life and death reflected his situation in the dark, Danish winter months, and in his letters he talks of going up and hanging himself in the attic—to which he is said to have been relegated to paint. It was there that he portrayed himself (cat. 48) in a work that was somber in every sense of the word, painted in gloomy colors—with ironical references perhaps to the idea of "the artist in the garret" and to Degas's theories about art without food.

One of the most remarkable works of Gauguin's Copenhagen period, which has as its theme the big questions of art and existence, is not a painting but an object—the box he carved out of a block of wood, furnished with carved figures, and painted (cat. 43).[100] The dancers on the lid and on the front of the box are paraphrases of Degas's dancers. One of the dancers also appears in another small piece of wood carving from this period, a handle for a fan that was painted in red and green (cat. 44). The box was his first truly Symbolist and primitivist work—the result of an enormous need to express himself in the face of his existential problems during the stay in Copenhagen, which was also expressed in the *Frame with two "G"s and Photo of Paul Gauguin* (cat. 45).

Gauguin's attitudes were being resolved, and the time for departure was near. As the spring of 1885 approached, his situation in Denmark became more precarious. There was no business in sight. He was more and more at odds with Mette's family and with the Danes in general. His first-ever solo exhibition, at the Copenhagen Society of Fine Arts in May, was a fiasco that resounded in several of his writings including *Avant et après*. The jury for the spring exhibition at Charlottenborg refused to accept a painting by which he set great store, the Copenhagen paraphrase of *Tree-Lined Road, Rouen II* (cat. 47). He could sell nothing, "neither drawings nor paintings, not even for 10 francs," and intended before long to send several things to Paris; he hoped Durand-Ruel would take some of them, "at whatever price," so that he could at least buy some paints.[101]

In addition to the winter's paraphrases, these last could have included the spring paintings he executed after the family moved to an apartment closer to the city center, at 51 Nørregade, at the end of April.[102] His nearest green areas were now the old ramparts. A painting in which great curving brushstrokes reflect wind and weather shows the angular ramparts (fig. 192).[103] Another with a denser structure shows the subsequently demolished Queen's Mill in the Østre Anlæg park (figs. 193, 195).[104] The man walking along the ramparts in the latter is surely a quotation from a small gouache by Pissarro that Gauguin owned (fig. 194).[105] The picture is thinly painted and could have been done with the "miserable" German paints that he had to be content with in May.[106]

Fig. 192 (*right*) Paul Gauguin, *Østervold Park, Copenhagen*,
1885. Oil on canvas, 23⅝ × 28¾ in. (60 × 73 cm).
Glasgow Museums, Art Gallery and Museum, Kelvingrove;
Glasgow City Council (Museums) (2465) (WII 173)

Fig. 193 (*below*) Kastellet, from the ramparts. The Royal
Library, Copenhagen

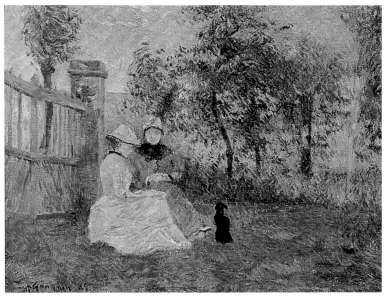

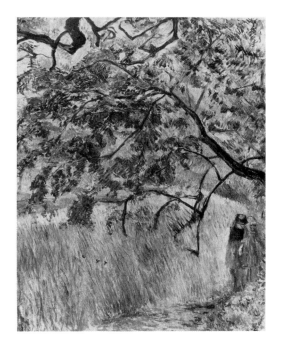

Fig. 198 *From the Opening of an Exhibition at The Royal Akademy of Fine Arts, Copenhagen*, 1883. The Royal Library, Copenhagen

Gauguin referred to his spring pictures in a letter to Pissarro. He felt he had made progress during the winter, and the letter is almost like an answer to Pissarro's earlier criticism of his monotonous colors. His series of paintings made in Rouen, which Pissarro had discussed, was only "a passing phase," he wrote, "or rather the foundation for what I have glimpsed, that is to say a very matte painting without obvious contrasts—and the subdued quality does not put me off, feeling as I do that it was necessary for me."[107] He might be referring to the paintings from the ramparts and some in a garden (figs. 196, 197)[108] when he wrote that, without exerting himself or being too determined to paint clearly and brightly, he had arrived at a result in his plein air work that was different from what he did in Rouen. "I think I can say that there has been a huge step forward; this is what I feel; it is more supple, clearer, and more luminous without my having changed my method, with very slightly varied tones side by side. In Rouen there was a lack of cool tones in the sky, vegetation, and earth."[109]

In May 1885, Gauguin told Pissarro that Danish art did not terrify him (fig. 198). "On the contrary," he assured him, "its lack of vigor has filled me with such a revulsion that I feel more than ever convinced that there is no such thing as *exaggerated art*. Indeed, I think there is only salvation in the extreme—every middle way is mediocre."[110] His difficult times in Denmark led to a resolution, and in June he was once more in France.

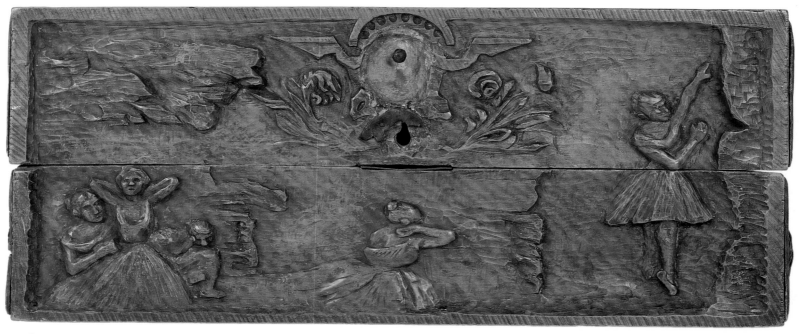

43

Wooden Box, 1884
Pearwood with iron hinges, leather, red stain,
 inlaid with two netsuke masks,
 $8^5/_8 \times 5^7/_8 \times 20^1/_4$ in. (22 × 14.8 × 51.5 cm)
Signed on the back: *1884 / Gauguin*
The Kelton Foundation

The remarkable box that Gauguin carved out of a block of wood, furnished with carved figures, and painted was the first example of Symbolism in his work.[111] It related back to the wooden carvings of the period between 1878 and 1882. More recently a couple of still lifes showed his fascination with a wooden carving in his home, a Norwegian lidded wooden container—or *tine*—with lion motif reliefs and metal fittings (see cat. 13 and figs. 71, 191).[112] Now, for the first time, he himself began to make reliefs encompassing a void. The box was the first of many containers in his work,

including his ceramics. Works in wood were to be a crucial factor in his development and a source for the rejuvenation of his painting. It was also in his wood carving that he was to reintroduce the figure, which had been absent from his major paintings since *Nude Study (Woman Sewing)* (cat. 19). During his work on this painting he had been confronted with the problem of the literary or anecdotal associations of the figure. He had made an

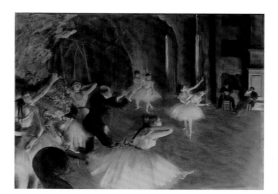

attempt to overcome the difficulties and reintroduce the figure with the wood relief *La Toilette* (fig. 142),[113] and with the box he was again to take up this fundamental challenge.

Starting out from the mummified figure on the bottom, the themes of the box have usually been interpreted as vanity and transience—a dualism between life and death.[114] With its cowhide at its feet, the mummified figure was clearly inspired by Danish Bronze Age oak coffins and the corpses inside.[115] The sight of coffins several thousand years old in the Old Norse Museum in Copenhagen made an

Fig. 199 Edgar Degas, *The Rehearsal on the Stage*, 1874. Pastel over brush-and-ink drawing on thin cream-colored wove paper, laid down on bristol board and mounted on canvas, 21 × 28¹/₂ in. (53.3 × 72.3 cm). The Metropolitan Museum of Art, New York. H. O. Havemeyer Collection, Bequest of Mrs. H. O. Havemeyer, 1929 (29.100.39)

impression on Gauguin comparable to that of the Peruvian mummy that was to preoccupy him in many of his later works (figs. 200, 201).[116] Indeed, the ancient Scandinavian corpse was the catalyst for the reintroduction of the figure in his work. Further figures, including dancers, appear on the lid and front of the box. Gauguin's dialogue with Degas was still as alive as ever, and he took models from several of Degas's opera and ballet scenes.[117] He brought a photograph of Degas's *Rehearsal on the Stage* (fig. 199) with him to Copenhagen and used it, like the actual paintings by other artists in his collection, as a source of ideas for his own work.[118] The dancer of the Degas composition, standing with her arm raised, was used not only for the box but also for another small piece of wood carving from this period, a fan handle painted in red and green (cat. 44).

We have earlier seen examples of Gauguin's epoch-making adaptation of found objects in his work in wood. The box provides a further example.[119] On the back he fixed Japanese netsuke masks, generally considered to be a "primitive" form of art at this time. They are a radical and direct incorporation of works of art into the work of art.

The box was a synthesis of all the trends we have seen in Gauguin during these early years and culminating in the time he spent in Denmark—in wood carving as well as in painting. The close relationship between his works and the models he used in them is essential to an understanding of his aims and indeed all his artistic activity from this point onward. In his voracious consumption of the work of others he saw nothing exceptionable, an attitude in which he was far ahead of his time. As he said in 1884, "because you love the masters, you *copy them*."[120]—A-BF

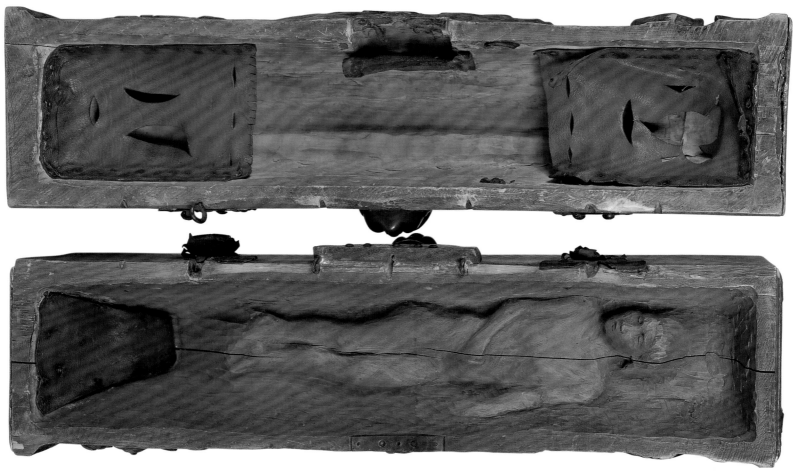

cat. 43

Fig. 200 Oldnordisk Museum, c. 1885. The National Museum of Denmark, Copenhagen

Fig. 201 *Danish Bronze Age Coffin from the Fourteenth Century B.C.* The Royal Library, Copenhagen

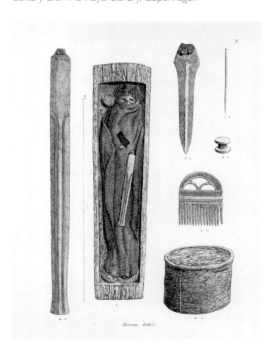

44

Fan Handle with Degas Dancer, 1884–85
Painted wood, height 11 in. (27.9 cm)
The Kelton Foundation

During his stay in Copenhagen in the winter of 1884–85, Gauguin painted several fans.[121] He used gouache and watercolor on a fine canvas or paper, repeating motifs from his paintings and those of his Impressionist friends. He also made the present fan handle, which he carved in wood and then painted.[122] It is a unique work in his oeuvre and an early example of his habit of decorating articles of everyday use. The handle has two parts, a short one at the bottom and a longer one at the top. It is of a type called a folding fan, consisting of a semicircular leaf that is mounted on sticks and folded when the fan is closed.

On the narrow surface Gauguin carved foliage with slim, dark green leaves from which rises the figure of a little dancer. The background is painted red, and over the dancer's head there are two small flowers in a childlike style. With her posture and lifted arm the dancer is a quotation from one of the ballet dancers in Degas's *Rehearsal on the*

Stage (fig. 199), of which Gauguin had a photograph.[123] He also repeated the figure on his own *Wooden Box*, which he also made in Copenhagen (cat. 43).

Invented in China and Japan, folding fans of this type had been in use in Europe since the sixteenth century.[124] The handles were made of ivory, bone, horn, or wood and the leaves of the finest kid, vellum, silk, or paper. Often they were decorated with motifs copied from famous works of art. A French fanmakers' guild was founded as early as 1685, and by the nineteenth century France had become a great producer of fans, which were sold as articles of luxury around the world. At the Great Exhibition in London in 1851, French fans established a reputation as the finest fans in the world, and in 1875 Spire Blondel published his *Histoire des éventails chez tous les peuples et à toutes les époques*. The most famous artists of the century, including Ingres, Corot, and Narcisse Diaz, painted fan leaves.

Following the French-Japanese commercial treaty of 1858 and the spread of japonism, the fan became popular among the Impressionists. An entire room of the fourth Impressionist exhibition in 1879 was devoted to fans—by Degas, Pissarro, and Morisot as well as Forain and Marie Bracquemond.[125] Some of the works were sketches of fans; others were actual fans made to be used. Gauguin was familiar with Pissarro's work in this genre and owned one of the fans that the older artist had shown at the 1879 exhibition.[126] Shortly after the exhibition he informed Pissarro that one of his fans had been sold by Mme Latouche.[127] It is likely that Pissarro was the one who taught Gauguin the special technique of painting with gouache on fine canvas or silk.

There was also an economic reason for artists' interest in the fan. The art dealer Durand-Ruel had encouraged them to work

with this decorative genre for commercial reasons, and one of the reasons why Pissarro did so many fans was apparently pecuniary distress. More than fifty of his sketches for fans are known, and a considerable number date from 1885. Gauguin had already shown an interest in fan painting in 1880 when he made a preparatory sketch for one, and he was to produce a good number of them in the ensuing years.[128]

It was not so much the fan per se that interested the Impressionists as the compositional challenge of its semicircular shape. But Gauguin was fascinated by objects and interested in the fan as such. His roughly carved, almost "primitive" fan handle, with its simplified color scheme, can be seen as a reaction against the decadent refinement into which the art of fans had sunk during the time of Napoleon III. The red and green coloring was to be typical of Gauguin's painted wood carvings in his Brittany period.—A-BF

45

Frame with Two "G"s and Photo of Paul Gauguin, 1884–85

Sculpted walnut wood with cutting from the last photo taken of Paul and Mette Gauguin, by Julie Laurberg & Gad, Copenhagen, 1885, $7^3/_8 \times 13^1/_4 \times {}^3/_8$ in. (18.9 × 33.6 × 1 cm)
Musée d'Orsay, Paris. Donation from Corinne Peterson (Inv. OAO 1420)
Ordrupgaard only

This frame is a recent discovery.[129] It bears witness beautifully to Gauguin's passion for the Arts and Crafts Movement. Like the other Impressionists, he was interested in the frame and its meaning as a part of the overall expression of a work of art. In 1882, he complained about the difficulties of getting a framemaker to produce "a simple frame of an *unknown design,*"[130] and, like the other painters in the group, he insisted on white frames for oil paintings. This is evident from a letter relating to his period in Rouen.[131] The importance he attached to the frame as an integral part of the work is also evident in the portrait of his daughter, Aline, that he made in Rouen—with oil colors, brush, and carving tools. He painted his daughter's features in profile on a small wooden plate, and carved its edges to form a frame with decorative patterns (fig. 202).[132]

The present frame is of a different character. With its incorporated photograph it relates to the frames around portrait photographs of the time. But the photo is only a minor part of the whole, which consists primarily of a relief with carved figures. Indeed, the frame is more than a frame: it takes on the character of an object and becomes a work of art in its own right. Gauguin was a master at breaking down the boundaries between art forms and genres. With the photograph incorporated into the

cat. 44

cat. 45

Fig. 202 Paul Gauguin, *Portrait of Aline*, 1884. Oil on a panel of wood whose edge has been carved and, in places, colored, 7⁷/₈ × 5¹/₂ in. (20 × 14 cm). Private collection (WII 155)

piece, he crossed the line between the Arts and Crafts object and the work of fine art in a way that was beyond the nineteenth century's general notion of art. The result resembles the transcendent experiments along these lines that took place in the twentieth century, for instance with the art objects of the Surrealists.

The monogram on the frame, its small figures, and the photograph can be seen as an overall statement, an allegory to be read from right to left with the direction of the bodies of the figures. Pola Gauguin has explained that the monogram with the two interlaced "G"s represents the family names of his parents— Gauguin and Gad. The female figure in the center, elegantly dressed with a hat, is his mother Mette while the figure between her and the photo represents "M. Prudhomme"—a literary figure invented by the author and artist Henry Monnier as the personified petit-bourgeois attitude.[133] On the male figure to the left of the photograph, who looks like a caricature with his starved face and much too big coat, Pola Gauguin observed that "he seems to have been inspired by one of the drawings of the German draughtsman

Busch."[134] Pola must have been thinking of the draughtsman, painter, and writer Wilhelm Busch (1832–1908), who became known for his caricatures of different social types, including artists. He was also known for his cartoonlike *Max und Moritz* stories, published in 1865 in the magazine *Fliegende Blätter*. With their sticklike figures and simplified expressions, these became his most popular works.

Gauguin probably made the frame in Copenhagen,[135] and it belongs with other works from this period in which he touches upon existential issues. As in the *Wooden Box* (cat. 43), the theme is the choice between the bourgeois life and the artist's life. The starting point was the critical situation in which Gauguin found himself at the time: the need to make a final choice, which had put increasing pressure on him for years, was now inevitable. His placing of the photo in the frame shows him divided between the family on the one hand—his marriage to Mette and the bourgeois life—and the free life of the artist on the other. With the *Wooden Box*, the frame is one of his earliest Symbolist works.—A-BF

46

Skaters in Frederiksberg Park, late 1884
Oil on canvas, 25⅝ × 21¼ in. (65 × 54 cm)
Ny Carlsberg Glyptotek, Copenhagen
WII 161

This unsigned and undated painting was made in the winter of 1884–85 in the park of Frederiksberg Have near Copenhagen. The family lived near the park, and Mette's mother lived adjacent to the north entrance. Here Gauguin represented a frigid landscape using a palette dominated by the colors of fire— brilliant oranges, russets, yellows, and ivories—which flicker through the dense foliage of the park's trees. The central tree leans at a precarious angle, becoming as much the motif of the painting as the pond and its skaters, one of whom has taken a tumble and is being helped up by a companion. How different this painting is from Renoir's blue gray painting of skaters in the Bois de Boulogne or Manet's gently comic scene of roller skating.[136] The true subject of the Renoir and the Manet is the luxurious realm of bourgeois Paris, and both artists pay generous homage to the fashionable attire of the female skaters. By contrast, Gauguin's skaters are all male and dressed in various browns that seem more akin to the trees than to the world of fashion. They weave about in an almost drunken comedy of motion and balance while the painter lavishes his real attention on the trees. The brilliance of the orange in the painting suggests that he began the work in late autumn, when the orange brown leaves still blanketed the ground, and before the snows that dominate his winterscapes dated 1885.—RRB

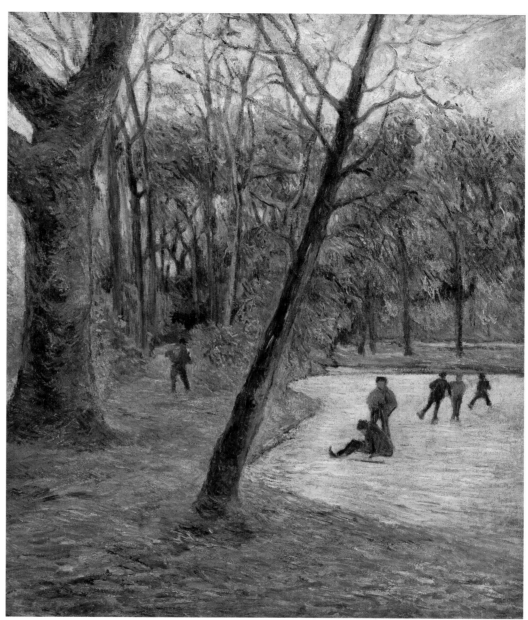

cat. 46

47

Tree-Lined Road, Rouen II, 1884–85
Oil on canvas, 22¹/₂ × 15³/₄ in. (57 × 40 cm)
Signed and dated lower left: *P. Gauguin 85*
Ny Carlsberg Glyptotek, Copenhagen
WII 163

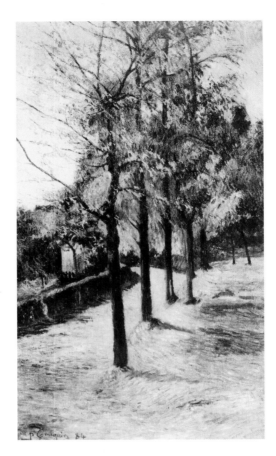

Fig. 203 (*left*) Paul Gauguin, *Tree-Lined Road, Rouen I*, 1884. Oil on canvas, 36⁵/₈ × 20⁷/₈ in. (93 × 53 cm). Private collection (WII 125)

Fig. 204 (*below left*) Paul Cézanne, *Avenue*, c. 1880–82. Oil on canvas, 29 × 23⁷/₈ in. (73.5 × 60.5 cm). Göteborgs Kontsmuseum, Göteborg, Sweden (GKM 946) (R 409)

Although its date and provenance suggest that this work was painted in Copenhagen, it represents a landscape in Rouen—one that Gauguin had painted on a larger scale in 1884 (fig. 203). Both compositions seem to have been part of a pictorial meditation on the landscapes of Cézanne and particularly the *Avenue*, which Gauguin had purchased at the end of July 1883 (fig. 204). Crussard theorizes that Gauguin took the earlier and larger painting with him to Denmark and made the present reduced version there in 1885.[137] Although this is entirely possible, it does not accord well with the painter's habit of making versions of a composition as a set, as with the views of the orchard or the quarry near Pontoise dating from 1880–81. It is more likely that he brought the present version with him to Copenhagen and only *completed* it there in 1885, for display in an exhibition.[138]

Gauguin painted the larger version of the composition on a canvas of 93 by 53 centimeters, a size he had never used before and which is more suggestive of paneling than conventional easel painting. Unfortunately, the work has no nineteenth-century provenance and was unpublished until the Wildenstein catalogue of 1964, so we cannot speculate further about its original function. The present version has more conventional proportions. It is even possible that it was made earlier, abandoned, used as the basis for the larger version, and subsequently completed for the Copenhagen exhibition.—RRB

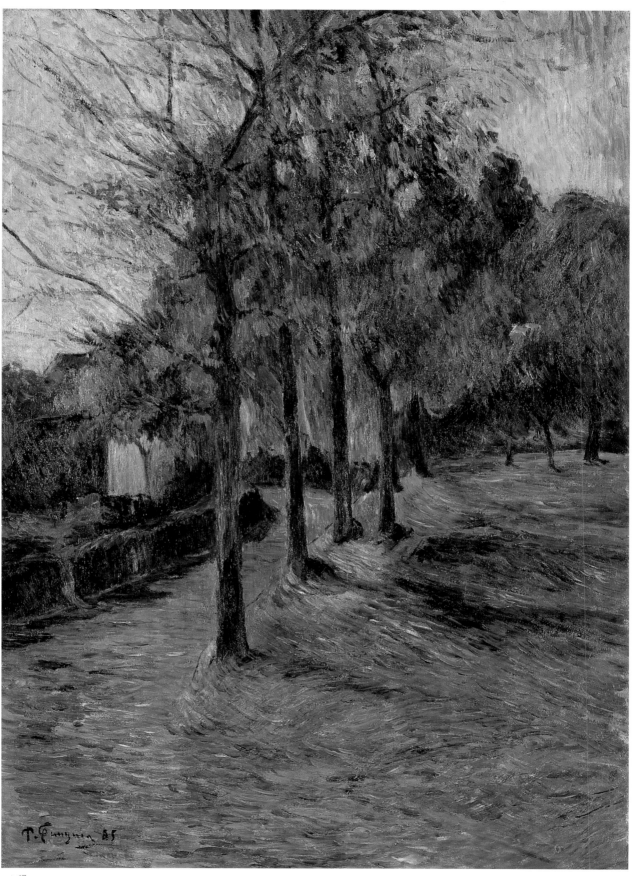

cat. 47

48

Self-Portrait, 1885
Oil on canvas, 25³/₄ × 21¹/₂ (65.5 × 54.5 cm)
Signed upper right, diagonally: *p. Gauguin*
Kimbell Art Museum, Fort Worth
WII 165

Fig. 205 Camille Pissarro, *Portrait of Cézanne*, 1874. Oil
on canvas, 28³/₄ × 23⁵/₈ in. (73 × 60 cm). Private collection,
on loan to the National Gallery, London (PV 293)

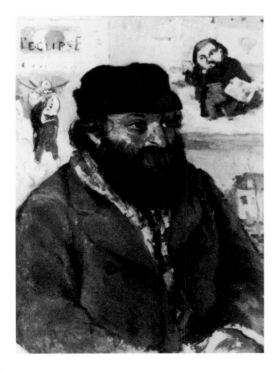

Gauguin's youngest son, Pola Gauguin, wrote movingly about this important self-portrait in his memoir-cum-biography of 1938: "In his home, Gauguin retreated more and more into the background. He sought refuge in the smallest rooms because the Salon was reserved for his wife and her students, many of whom came from the best families in Denmark. His only natural light was a transom . . . the single model at his disposal was himself."[139] Thus the Kimbell painting has been characterized as an "abject" self-portrait, as a study in the alienation and despair of the artist in bourgeois society, and there is much visual evidence to support the claim. Gauguin is absolutely alone in a tiny room with no decoration. He is squeezed between the diagonal wooden beam of an attic and the canvas on which he works, his hand hovering over his awkwardly placed palette. He wears a heavy winter coat, which compounds his misery by reminding us of the frigid Danish winter—as well as Pissarro's 1874 portrait of Cézanne, also bundled up against cold weather (fig. 205), which, as Françoise Cachin has demonstrated, he certainly knew.[140]

Gauguin's miseries in Copenhagen are revealed in the abject letters he sent to his French friends.[141] Writing to Pissarro on January 30, 1885, he complained of his linguistic isolation among what must have seemed to him chattering Danes and the low esteem he was afforded in his wife's family ("less than zero"). In another letter he told Pissarro that his only consolation lay in dreaming. Writing again to Pissarro in May 1885, he openly discussed suicide for the first time. Each day, he wrote, he considered going to the attic to hang himself. This powerful passage—and its use of the word "grenier" (attic)—may incidentally help us to locate Gauguin in the present painting. Because the

letter dates from after he and his family had moved to a second apartment in Copenhagen on April 22, it is tempting to assume the setting of the painting to be this same attic and therefore to date the painting to the chilly Danish spring of 1885. The first apartment, in which the family lived in the winter of 1885, was indeed a seven-room flat on the ground floor facing the street. On the other hand it is likely that both apartments had access to rooftop attic spaces. Given the artist's frantic correspondence from the early months of 1885 onward, it is perhaps wise to settle on a more open dating of January–May 1885.

In her essay on Gauguin's self-imaging, Françoise Cachin considered the Kimbell painting to be Gauguin's first self-portrait and related the work to earlier artist portraits by Courbet and Pissarro.[142] The possible connection to Courbet's many self-portraits is especially tempting to pursue. Gauguin's later series of self-portraits, with their layered identities, are those of a "poseur" not at all unlike Courbet—who represented himself as a hunter, a wounded man, a screamer, a prisoner, a hiker, and a host of other characters in addition to that of a painter. If Gauguin had seen the vast Courbet retrospective held posthumously in 1882, however, he failed to mention it. He had just made the first of his two visits to Montpellier to see the Bruyas collection, which contained a small group of Courbet self-portraits, but none of these correspond with the Kimbell self-portrait in any but the most generic of ways.

Pola Gauguin hinted that Gauguin painted himself simply because he lacked other models, but this was surely not the case. His children had served him well in that capacity already, and they were no less likely to have been willing models for their father in 1885 than they had been in earlier years. In fact,

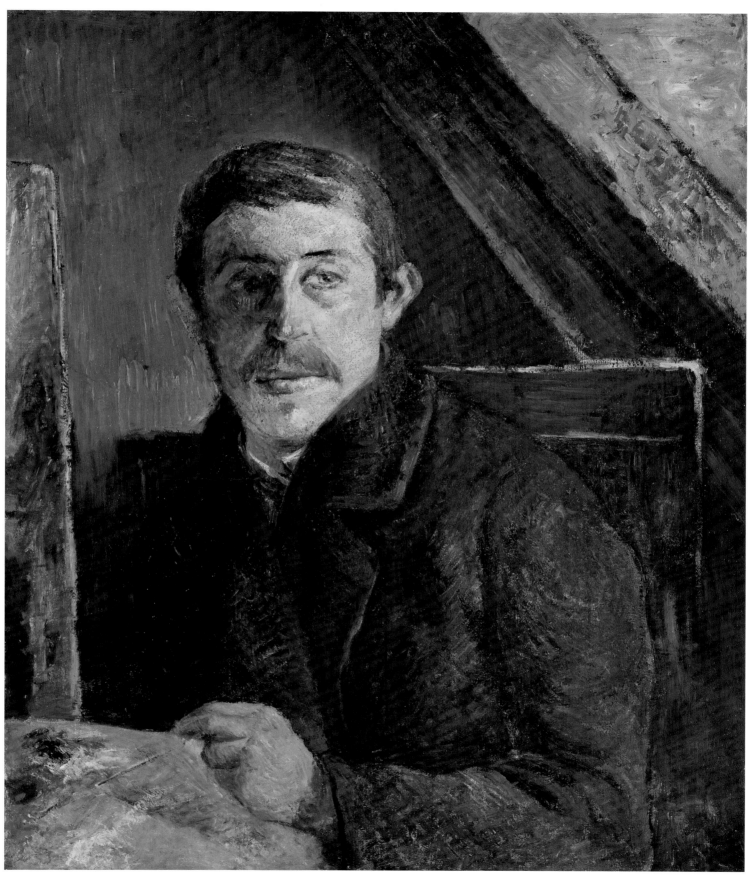

cat. 48

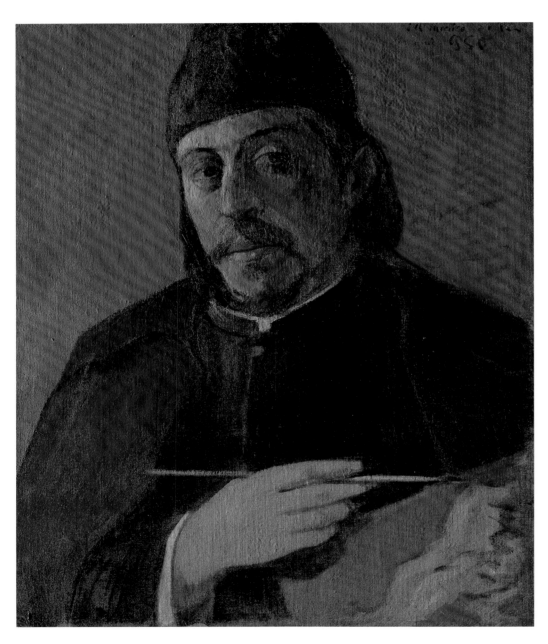

Fig. 206 Paul Gauguin, *Self-Portrait with a Palette*, c. 1894. Oil on canvas, 21⅝ × 18⅛ in. (54.9 × 46 cm). Private collection

Gauguin's first important self-portrait was the product of numerous psychological factors. Having failed absolutely as a businessman, with no success in his attempts to revive his financial fortunes, Gauguin had no real professional identity other than "artist"

available to him. He had also failed miserably in his role as husband and father, a fact that his practical Danish relatives made perfectly clear to him. For a man as proud as Gauguin, it must have been galling to admit that his wife had become the breadwinner in the family through her teaching and the charity of her family. As his letters show, failure forced him to turn increasingly to himself and to an analysis of his own nature, and the obsession with death that is evident in both the letters and the great *Still Life, Interior, Copenhagen* (figs. 191, 268) force us to recognize the depths of his dejection. In an eloquent letter to Pissarro he referred to what his family called "cette maudite peinture" ("this cursed painting"), which is precisely what he enacts in the Kimbell self-portrait.[143]

Cachin sees some degree of hope in this abject self-portrait—in the artist's right eye. "Only that piercing eye—perfectly clear and lucid as it gazes toward an uncertain future—contains any hint of the self-assurance that Gauguin was shortly to acquire."[144] She is surely right about its lucidity and its piercing intensity, yet it is also oddly evasive. We all know the normal mechanics of a self-portrait—the painter looks closely at himself in a mirror and "translates" the image with paint and brushes onto the canvas. The vast majority of self-portraits in the history of art represent artists who stare fixedly—one might say fearlessly—at themselves. Whether by Dürer, Rembrandt, Chardin, Goya, Cézanne, or van Gogh, the self-portrait seems almost a mirror into which the artist stares for inspiration. It is physically impossible for an artist to observe himself with eyes askance unless he sets up a system of two mirrors, or works from a photograph or some other portrait. Here Gauguin represents himself with his light brown green eyes looking off the canvas to

the right—not at the mirror, but at some unknowable person or object.

This act of self-evasion was to be the first—and by no means the last—in Gauguin's series of self-portraits. He painted, drew, modeled, and sculpted himself at more or less regular intervals throughout the remainder of his life as an artist. In only one other self-portrait, painted from a photograph, does he show himself actually painting (fig. 206), and in only a minority does he look at himself in the mirror. He preferred both to look askance and to adopt other identities—Jean Valjean, Christ, Adam/Eve, a thumb-sucking infant, an incinerated victim of hell, a disembodied head, a collector, a cellist, a hospital patient, a witness to the death of Christ at Golgotha, and a Polynesian god. We see almost no potential for such active role-playing in the Kimbell self-portrait; the "roles" here are those of a failure and an artist posed as if to be painted by someone else. But this subtle form of evasion opened up fruitful possibilities. The condition of being almost empty of identity in Copenhagen in 1885 seems to have spurred Gauguin to create multiple identities in the future.—RRB

Part V **Unbecoming an Impressionist**

Richard R. Brettell Painting Alone in France: Before the Final Impressionist Group Exhibition

Gauguin announced his return from Copenhagen to Paris in a short letter to Pissarro datable to June 1885: "I have returned to Paris, all alone, impossible to stand the tempest in Denmark. I'll have lots to tell you and can't come to Eragny. When you come to Paris, please leave time for me. I am with the Shuffeneckers."[1] Gauguin also intimated to Pissarro that he wanted to talk about Impressionism. The clues as to what he anticipated from such a conversation are so slight that they merely frustrate us; we yearn for Pissarro's reply or further, more substantive letters by either man from that summer. Because of Pissarro, we know a good deal of Gauguin's thoughts, but having the older painter's measured replies would have helped us even more.

Gauguin's letters from the summer of 1885 are very different in tone from those of the previous six months in Copenhagen. Gone are the black moods, the despair, the hint of suicide. They are replaced by the beginnings of an attitude that developed into defiant mockery of all that stood in the way. We soon learn that he survived his psychological ordeal and that, separated from Mette and her family, he was once again able to find a way for himself through the familiar territories of Paris and its tentacular landscapes. He was completely broke, and a letter to Durand-Ruel of June 22 reveals that he was willing to sell paintings by Manet and Renoir from his collection in order to get some money.[2] Numerous letters from the second half of the year tell of a peripatetic life, going from the charity of one friend to that of another and negotiating with Mette for the return of the belongings—clothes, supplies, and paintings—that he left behind in Denmark.

Gauguin's son Clovis was sent to Paris for the summer and stayed with the artist's wealthy sister, Marie Uribe, who lived with her two children in a sumptuous apartment overlooking the Parc Monceau.[3] The contrast between the bourgeois wealth of the Uribe family and his own poverty must have gnawed at the proud artist. Although he maintained an air of self-possession in his letters, Gauguin's mental health cannot have been very good, given the precariousness of his situation. He spent three months of the summer (July through much of September) staying with an unknown friend in the northern coastal city of Dieppe. There he had a chance meeting with Degas, who invited him for a visit at the home of a fellow artist, Jacques-Emile Blanche. "Naturally I went—two days later—and I saw Degas at work in the studio of Blanche's son," he wrote in a letter to Pissarro, "but when I rang the bell, the maid told me quite specifically that Degas and the young Blanche had gone out."[4] To the abject Gauguin, the world of privilege inhabited by Degas and the wealthy Blanches was not to be opened.

It is a great frustration for students of Gauguin not to know where and with whom he lived in Dieppe in the summer of 1885. In a letter to Pissarro of October 2, he described the person simply as "a friend who has given me hospitality."[5] The omission of his friend's name is curious, probably indicating that it was someone Pissarro did not know. Was it a friend from his days in business? Our desire to speculate is only increased when we read his letters of this period to Mette, which are also silent as to his exact whereabouts and the identity of his host. Given that, between them, Pissarro and

Mette knew practically everyone in Gauguin's life, the mystery of his host deepens. Whatever the circumstances of their creation, however, the paintings Gauguin made in Dieppe and its vicinity attain a level that, with a few exceptions, had eluded him in Copenhagen. Considered as a group, the square Dieppe seascape and the five vertical landscapes from that summer (see cat. 51), are of real ambition and originality—compositionally, chromatically, and iconographically.

Perhaps the greatest ignominy for Gauguin in the second half of 1885 was that he had no place of his own in which to work. In October 1885 he managed to rent a small apartment on the Rue de Cail, not far from the Gare du Nord. But he shared it with Clovis, who remained in Paris, and there were only two rooms, with no designated space in which to work. It is clear from Gauguin's letters to Mette from the summer of 1885 that he had not told her whether he intended to remain in France or return to Denmark in the winter months of 1885–86. Yet his letters to Pissarro and Schuffenecker suggest by their tone that he was determined to make his own way in France. Had he been in a stronger situation, financially and psychologically, he might well have profited more from the extraordinary artistic ferment then going on in Paris. It was in October 1885, the month of Gauguin's return to the capital, that his friend and mentor Pissarro first made the acquaintance of the young Georges Seurat and, shortly afterward, the even younger Paul Signac. In late 1885 and early 1886, the bond among these three artists became intense, and there is evidence that even Guillaumin was included in their discussions. Gauguin either deliberately resisted involvement with Seurat or, more likely, simply remained on his own, too proud to allow his financial and personal failures to be known to others.

For Pissarro the Neo-Impressionist adventure was paramount, and he seems almost to have thrown over his former protégé, Gauguin, for Seurat and Signac. We know that Pissarro played an advisory role in the repainting of Seurat's *A Sunday on La Grande Jatte* (1884–86; see fig. 218) in late 1885 and early 1886. We also know that the older artist communicated all the latest ideas about pictorial construction and color theory to his son Lucien, who was, like his father, an enthusiastic convert to this form of what was called "Scientific Impressionism." Pissarro may even have sent equally fervent letters on these subjects to Gauguin but, even if he did, they do not survive—and there is certainly no pictorial evidence of any "conversion" on Gauguin's part. Gauguin's personal situation, his frantic attempts to earn money from the sale of art (his own and that of others), and his other business ventures made him wary of sharing news of his "progress" with other artists. Pissarro worked to recreate an Impressionist exhibition and secured promises to exhibit from the ever-difficult Monet and Renoir, although in the end his enthusiasm for Neo-Impressionism alienated them and neither elected to participate. Gauguin, who was openly critical of Renoir and suspicious of Monet's motivations, did join the group. But he found himself so much at odds with the "Néos" (Seurat, Signac, and the Pissarros) that after the exhibition closed, he fled both Paris and Impressionism.

facing page Paul Gauguin, *Red Roof by the Water* (detail of cat. 51)

49

Beach, Dieppe, 1885
Oil on canvas, 28¹/₈ × 28¹/₈ in. (71.5 × 71.5 cm)
Signed and dated lower left: *P Gauguin 85*
 Dieppe
Ny Carlsberg Glyptotek, Copenhagen
WII 178

This odd and awkward painting is one of the most important and original works of Gauguin's Impressionist career. It represents a summer seascape like that painted literally hundreds of times by Boudin, Monet, Morisot, and Renoir, but in a stylized and self-conscious manner that would have made any of these other artists wince. With a comparatively high horizon line and a square format unusual for a seascape, the painting has the quality of a decoration intended for a particular place in

an interior. It was perhaps this aspect that led Theo van Gogh to take the painting on consignment for sale at Boussod et Valadon in December of 1887.

Almost any direct comparison with a painting of a similar subject by another artist makes us wonder about Gauguin's intentions. In Monet's numerous seascapes of the early 1880s, for example, he painted similar tidal fishing nets to those shown here on the far right. His *Fishing Nets at Pourville* (fig. 207) shows some of them seeming to dance rhythmically above the dark rocks along a similar beach. On other occasions he painted boats and clouds with an equally dancing grace. But never did he combine bathers, nets, boats, beach, and clouds within a series of compositional bands as Gauguin did in the summer of 1885. Perhaps this was partly because the older Impressionist preferred the beach in the less busy seasons of fall and winter. But even if we compare Gauguin's painting to the summer seascapes with bathers and tourists painted by Renoir on Guernsey or Morisot on the Isle of Wight, his group of darkly clad women in the foreground look more like rocks than Impressionist figures on a summer outing.

The painting has a wide variety of pictorial incident contained in its banded composition. We see five fishing boats, one leisure sailboat, a smaller boat, and a distant ship further offshore, its sails furled. Three female bathers

Fig. 207 (*above left*) Claude Monet, *Fishing Nets at Pourville*, 1882. Oil on canvas, 23⁵/₈ × 31⁷/₈ in. (60 × 81 cm). Collection of the Gemeentemuseum Den Haag, The Hague (15.1932)

Fig. 208 (*left*) Georges Seurat, *The Roadstead at Grandcamp*, 1885. Oil on canvas, 25⁵/₈ × 31¹/₂ in. (65 × 80 cm). Private collection

cat. 49

cavort in the waves in the middle ground, while two skimpily clad male bathers, one wearing an eye-catching red swimsuit, seem more hesitant to brave the cold water. The three women with hats in the foreground, all turned with their backs to the prevailing wind, work concertedly on their sewing in avoidance of the sea and scenery. The clouds roll by in the background, threatening no rain but adding incident to Gauguin's carefully planned background.

Gauguin succeeds completely in conveying a sense of deliberation. The painting is decidedly not spontaneous; it departs dramatically from the casual and seemingly immediate kind of Impressionist painting done in response to a particular sensation. One senses it was not painted from life in one or two sittings. Every aspect seems carefully considered. The painter worked with small brushes to achieve a series of effects, synthesizing various discreet acts of observation. What is startling is that the work looks more like an almost precisely contemporary seascape by the young Georges Seurat (fig. 208) than anything by Monet or Renoir. Even the comparative regularity of its facture suggests a parallel with Seurat.

In the summer of 1885, however, Gauguin had no knowledge of Seurat or his work; his departures from Impressionism were made independently. He was less successful than Seurat in promoting "studio Impressionism" because he was unable to paint a whole series of "new" seascapes whereas Seurat painted two in 1885 and four the next summer. But he had no need of Seurat's example to order his facture and regularize his compositions since he had learned these things from Pissarro and Cézanne. Indeed, he only saw Seurat's contemporary seascapes for the first time in the Impressionist exhibition of 1886—in which he showed *Beach, Dieppe*.[6]—RRB

50

Geese in the Meadow, 1885
Oil on canvas, 22 × 39³/₈ in. (56 × 100 cm)
Signed, dated, and dedicated lower right: à *M. Schuffeneker P Gauguin 85*
Portland Museum of Art, Maine. The Joan Whitney Payson Collection at the Portland Museum of Art. Promised gift of Joan Whitney Payson
WII 184

This landscape—at once spatially closed and panoramic—was Gauguin's largest submission to the Impressionist exhibition of 1886 and one of his most conventionally successful works from the summer of painting in and around Dieppe in 1885. It relates clearly to similarly composed works by his old friend Guillaumin, particularly to the even larger *Twilight at Damiette*, which Guillaumin painted in the same summer and also submitted to the 1886 exhibition (fig. 209). Indeed, the two paintings are so closely analogous that one is tempted to suggest that they were made with full knowledge of each

other, although no letters between Gauguin and Guillaumin survive to provide evidence one way or the other.

Both works are composed on a long horizontal canvas like those used by Daubigny for similar subjects throughout the 1860s and 1870s. Both are scaled for public exhibition. Gauguin had not painted on such a scale since the early part of the decade and clearly made this work for exhibition and sale. Conventional in its safely rural subject and its almost Barbizon format, the painting is, nevertheless, original in its facture and composition. Unlike Guillaumin, who constructed his village landscape with a large, curved road, a scale-giving figure on the road, and open doors and windows in the middle-ground buildings, Gauguin allowed his viewer access only to a spatially limited foreground, with geese, a seated cow, and a figure whose back is turned. We move across rather than into the landscape space, rebuffed by a tangle of vegetation and a mélange of rural architecture more reminiscent of Cézanne than Guillaumin. Gauguin himself owned a similarly

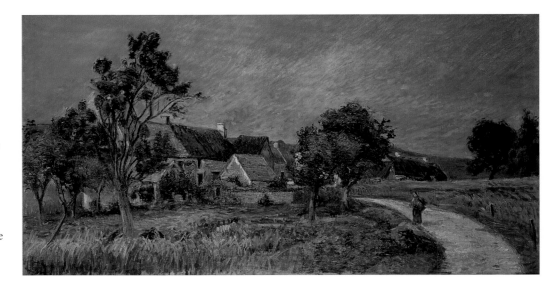

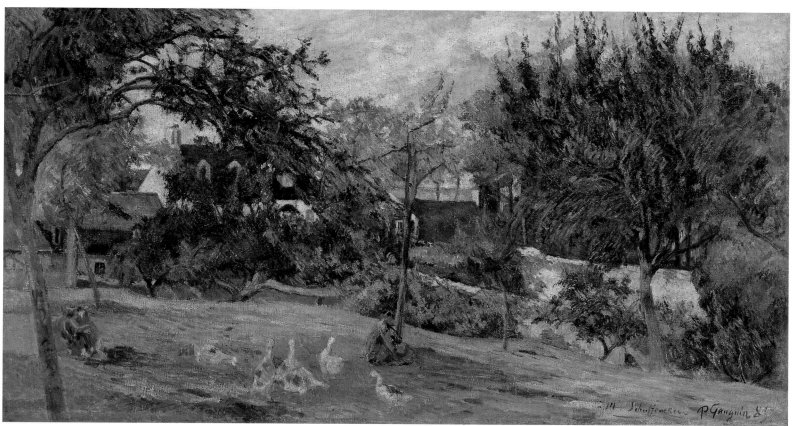

cat. 50

banded and spaceless landscape painted by Cézanne in 1880 while visiting Zola (see fig. 43), and he had seen many other, similar Cézannes when the two painters had worked together with Pissarro and Guillaumin in and around Pontoise (see fig. 171). There are also many links between this painting and the rural landscapes with architecture viewed through screens of vegetation painted by Pissarro in the late 1870s and early 1880s, when Gauguin was closest to him.—RRB

Fig. 209 (*facing page*) Armand Guillaumin, *Twilight at Damiette*, 1885. Oil on canvas 28³/₈ × 54³/₄ in. (72 × 139 cm). Musée du Petit Palais, Modern Art Foundation, Geneva (9401)

51

Red Roof by the Water, 1885
Oil on canvas, 32¼ × 26 in. (82 × 66 cm)
Signed and dated lower left: *85 P Gauguin*
Rudolf Staechelin Collection, Basel
WII 193

Gauguin painted five identically sized vertical landscapes in the summer of 1885, most of which were probably included in the 1886 Impressionist exhibition. Three of them show different views of a red-roofed farm building adjacent to a small pond—a new kind of "series" in which the artist shows his virtuosity by creating different compositions from the same subject (figs. 210, 211). It is tempting to imagine these shown in a row to make a collective impression on the viewer. We know, of course, that Monet had shown a series of paintings of a single motif in Impressionist exhibitions from 1877 onward, and that Gauguin had seen them. At the exhibition of 1879, for instance, there was a virtual pair of vertical cityscapes representing the Rue Montorgueil and the Rue Saint-Denis on June 30, 1878 (with the places and dates in the titles) as well as other trios and pairs of paintings of identical subject and dimensions.

Fig. 210 (*below left*) Paul Gauguin, *Cows at the Watering Place*, 1885. Oil on canvas, 31⁷⁄₈ × 25⁵⁄₈ in. (81 × 65 cm). Galleria Civica d'Arte Moderna, Grassi Collection, Milan (NG54) (WII 192)

Fig. 211 (*below right*) Paul Gauguin, *Père Jean's Path*, 1885. Oil on canvas, 31⁷⁄₈ × 25⁵⁄₈ in. (81 × 65 cm). Museum of Mohamed Mahmoud Khalil and His Wife, Giza (WII 195)

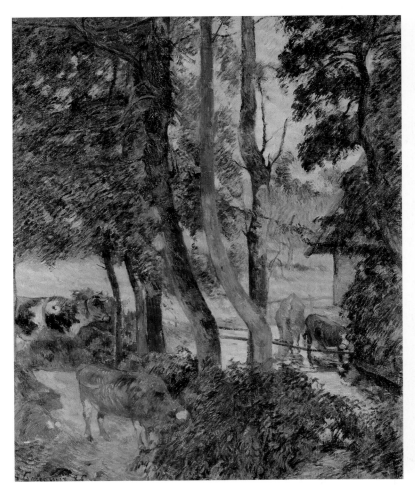

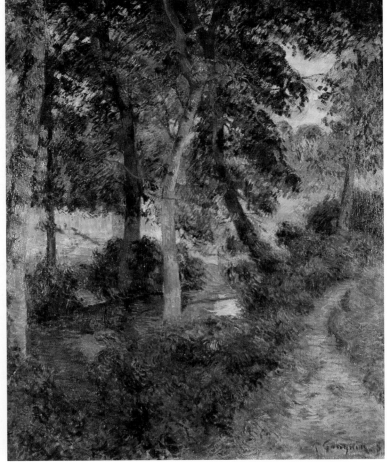

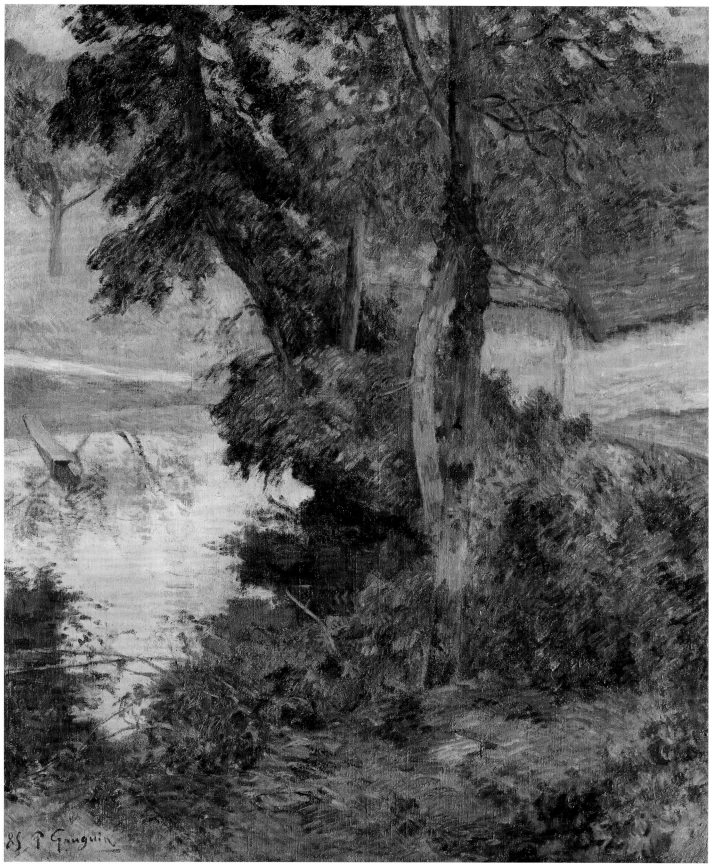

cat. 51

Yet Gauguin's series of 1885 cannot be read as a direct homage to Monet; his aim was completely different in that the dimension of time, so central to Monet's series, is completely absent. The younger painter's main concerns were color, composition, and mood. The viewer is encouraged to go back and forth among his three paintings, comparing them from these points of view. He used the gently curved trunks and branches of tall trees as elements of what we might call natural drawing and as spatial foils for bands of pure color that saturate his backgrounds. The white-shot blue of the pond and the lime green of the distant field on the left of the Basel

landscape is balanced by the solar orange and brilliant yellow of the farm building on the right. Gauguin was just as aware of the principle of simultaneous contrast as was Seurat, although his use of color was emotional and expressive rather than "scientific."

In the summer of 1885, Gauguin made a serious study of cattle, horses, and donkeys, perhaps taking his cue from a pair of small paintings by Octave Tassaert formerly in the collection of his guardian, Gustave Arosa (figs. 212, 213). He included five variously posed cattle in the Milan landscape, three in the shade and two standing in the reflecting water

of the pond. Although there are affinities in pose with the cattle in the Arosa Tassaerts, Gauguin drew none of the animals directly from reproductions as he would later in his career—when he included cattle in Tahitian landscapes without the benefit of models. Clearly, he had plenty of models in the countryside around Dieppe.

Two of the five vertical paintings of that summer show an identically posed donkey in a similar setting. In one of these (fig. 214) Gauguin courted aesthetic disaster by selecting a landscape motif dominated by greens within a narrow range of value. Indeed, he pushed the envelope even further by allowing the green

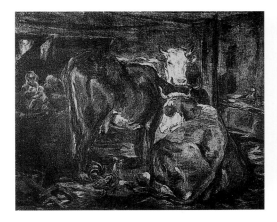
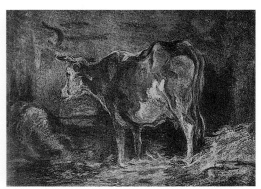

Fig. 212 (*far left*) Octave Tassaert, *Interior of a Stable*, 1837. Oil on canvas, 14⅝ × 17⅜ in. (37 × 44 cm). Location unknown

Fig. 213 (*left*) Octave Tassaert, *Cow in a Stable*. 9⅛ × 11⅞ in. (23 × 30 cm). Location unknown

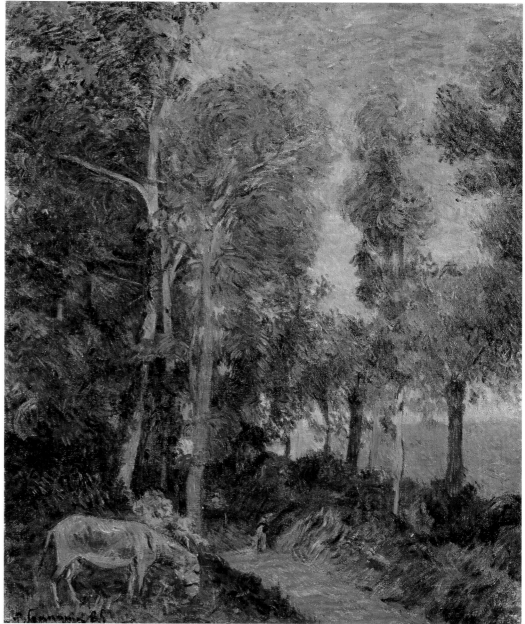

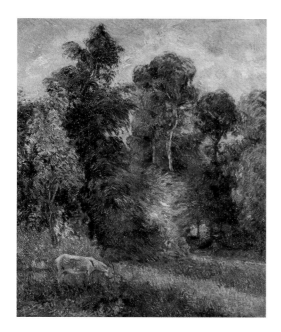

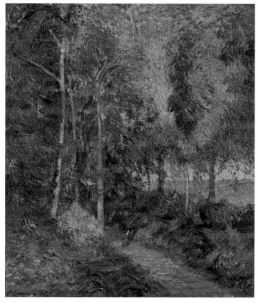

vegetation to fill more than three-quarters of the composition. Pissarro had tried many times to achieve an aesthetically passable landscape composed almost solely of greens, but had rarely succeeded. Gauguin created the second composition by reprising a landscape he had painted from life in a smaller painting (fig. 215), adding the donkey, and introducing a wider range of oranges, yellows, and blues. This work was to be owned by no less a connoisseur of chromatic modernism than the great Dutch collector Frau Kröller-Müller, in whose museum it resides today (fig. 216).

Never before had an artist shown such a large group of works painted from a single landscape on canvases of identical dimension in an Impressionist exhibition. By wringing a series from such an unpromising landscape Gauguin was laying bare Impressionist practice. Unfortunately, to succeed at that game in the aesthetic cauldron of avant-garde Paris was no longer possible.—RRB

52

Dahlias in a Copper Vase, 1885
Oil on canvas remounted on panel,
28¼ × 23⅛ in. (71.5 × 58.5 cm).
Signed and dated lower right: *p Gauguin 85*
Thomas Gibson Fine Art Limited, London
WII 201
Kimbell only

Gauguin's 1885 still-life paintings are difficult to place precisely within this crucial year. The present work, a patient essay in color, probably dates from after his departure from Copenhagen; it has no trace of the Danish provenance common to the majority of the works made there. Gauguin conceived a composition of almost startling simplicity that recalls similar works by Cézanne and Pissarro from the 1870s (see figs. 16, 18, 19). He centered the composition on a varnished, blond wood table set in front of a pale blue gray plaster wall and placed what may be a ceramic pot with a metallic glaze or, more likely, one made of copper directly in its center. In this container he shoved a bunch of pink, white, and red dahlias, making little if any attempt at artistry in his arrangement. Two dahlias lie dying on the shiny surface of the commode, which Gauguin might actually have extended on the right from its nearly square original shape for compositional purposes. He handles the play of light and shade on the wall with wonderful subtlety, evoking a patchwork of colored zones that derive their shapes from the dahlias.

In many ways, the work is a repudiation of the lusciously sensual still lifes by Monet and Renoir in the 1881 Impressionist exhibition (see fig. 124). In these, the flowers fill almost the entire visual field with their pulsating color and softly evocative shapes. By contrast, Gauguin selected small, tightly ordered flowers, which he surrounded with a relatively large expanse of unadorned wall, giving the entire painting a sense of bourgeois reserve and neatness of the kind that he had just experienced in Denmark. The color and treatment of the wall are virtually identical to those in his portrait of Clovis (cat. 55), and the "found object" still-life element placed in back of Clovis's head in that painting has an almost uncanny similarity to the real flowers here.—RRB

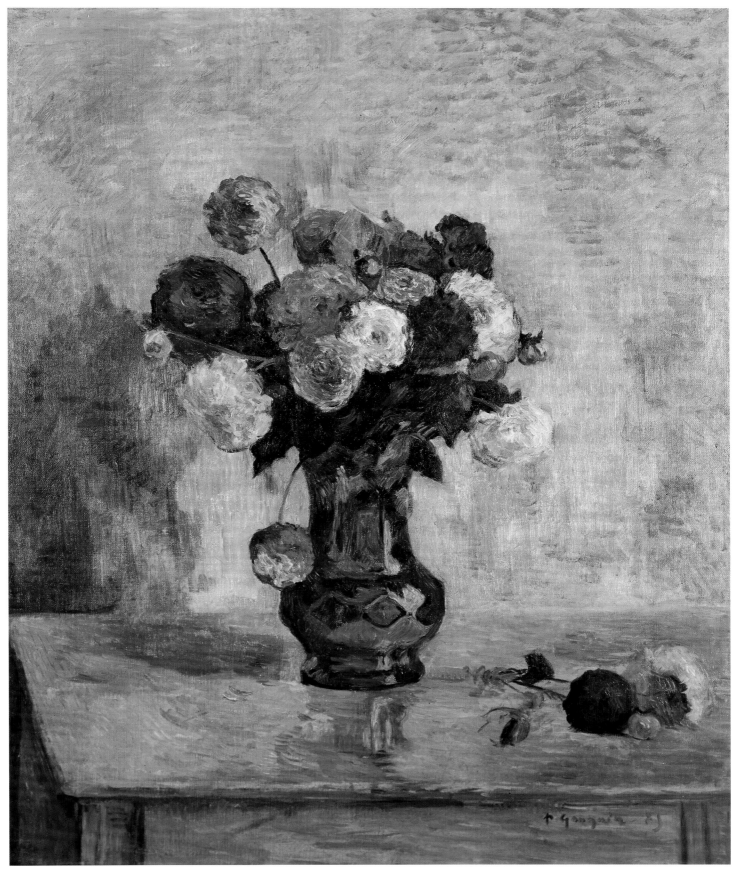

cat. 52

53

Portrait of Achille Granchi-Taylor,
Oil on canvas, 18¼ × 21⅞ in. (46.5 × 55.5 cm)
Signed and dated lower right: *P Gauguin 85*;
 there is a trace of dedication above the
 signature: *à il Signor Achille / amicalement*
Kunstmuseum, Basel (1551)
WII 205

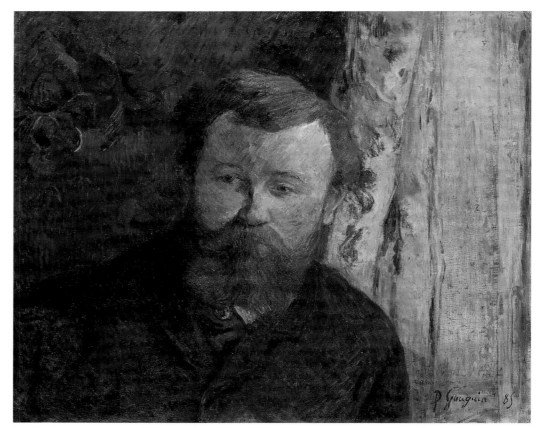

cat. 53

As his name suggests, Achille Granchi-Taylor was a Frenchman of Italian and English origin; he was born in Lyon. Like Gauguin he worked as a stockbroker while pursuing his avocation of painting. He exhibited at the Salon in 1888 and was a pupil of the academic painter, Fernand Cormon.[7] Gauguin and Granchi-Taylor maintained a long friendship. The latter spent a good deal of time in Brittany in the late 1880s and 1890s and was also on close terms with several of Gauguin's friends, including Emile Bernard. We know from a Gauguin letter to his wife as well as a later letter written by Granchi-Taylor himself that this small portrait dates from December 1885 and that, in return for it, Granchi-Taylor purchased a supply of oil paint for his impoverished friend. There were eight sittings.

Gauguin's characteristic originality comes through in the painting's unusual format. Virtually every portrait painting in the history of art is on a vertical canvas that corresponds in proportion to the head, upper body, or full figure of the sitter. Gauguin placed Granchi-Taylor near the window of his small Parisian apartment so that his full face could be well illuminated and painted him on a horizontal canvas, a format more associated with landscape painting than portraiture. By selecting this format, he avoided having to paint his sitter's hands, deciding instead to concentrate entirely on his round face and his bright red orange hair and beard. Granchi-

Taylor looks away from Gauguin and from us, and the painter gives us no clue as to whether he is seated or standing. The upper-left portion of the portrait is dominated by a darkened version of the kind of wallpaper used often by Cézanne in the late 1870s and early 1880s. As we have seen, Gauguin took even greater liberties with wallpaper designs than Cézanne, and here we see leaves, painted lines, and tendrils that seem closer to the later paintings of Odilon Redon. As is often the case with Gauguin, he used the simple primed canvas to represent the light from the curtained window, devoting much of the remainder of the canvas to a study in what might be called the chromatics of black and gray.—RRB

54

The Boss's Daughter, 1886
Oil on canvas, 21⅞ × 18⅛ in. (55.5 × 46 cm)
Signed and dated center left: *p Gauguin / 86*
Musée Départemental Maurice Denis, Saint
 Germain-en-Laye, France
WII 207

If Gauguin allowed himself to be compositionally experimental in the horizontal portrait of his friend Achille Granchi-Taylor, here he used a canvas of the same size vertically in a thoroughly conventional portrait format. It seems as if he sought to solve different pictorial problems using format and color as variables. One portrait is horizontal, the other vertical. One is dominated by black and gray, the other by brilliant red, pink, and blue. One is psychologically evasive and the other direct.

Not even the persistent Sylvie Crussard has determined the identity of this portrait's sitter. As we learn from letters from Gauguin to

Mette of December 1885 and January 1886, he worked for a time for a publicity company (most likely the Société anonyme de publicité diurne et nocturne), first as a bill-poster, then as an administrative secretary and inspector.[8] So he did actually have a boss at this time—whose daughter, Crussard suggests, may have sat to him for a portrait. Unfortunately, there is no further evidence for this, even in the painting's early history. The dealer Amboise Vollard purchased the work between 1899 and 1904 from a Mme Bernard, and it was probably while in Vollard's possession that it was first known as *The Boss's Daughter*. Crussard suggests that Mme Bernard may have been a relative, possibly the mother, of the painter Emile Bernard. But the name Bernard is so common in France that it could just as easily have been that of the anonymous boss of the title.

Whomever it represents, the painting is a delightful study of female adolescence by an artist who had been separated from his favored daughter, Aline, for more than six months when he painted it early in 1886. The sitter seems to be in her early teens. At first glance she appears to wear her hair in the cropped, boyish fashion that Mette had earlier adopted for Aline. Yet it is just as likely that she has pulled it into an informal—and now invisible—ponytail for the portrait. She wears a brilliant red scarf over a dark gray jacket. A lace or ruffled collar peeks out behind the red folds. As in the portrait of Granchi-Taylor, we are given no clue as to whether she is sitting or standing, and the hands, which gave the artist trouble in earlier portraits, are again omitted. Gauguin must have stared unabashedly into the eyes of the young girl, presumably through as many sittings as those given by Granchi-Taylor, and in this sense the work was the first in a series of portraits of adolescent girls that were to include his teenage Tahitian mistresses

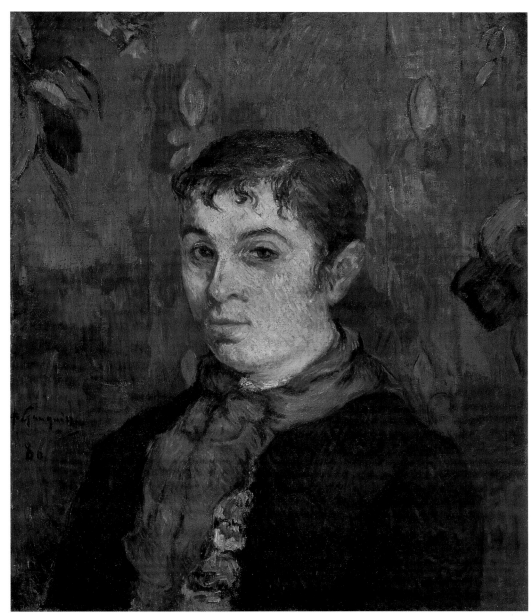

cat. 54

and later his Javanese mistress. The direct eye contact between the teenage girl and her painter is all the more disturbing because the portrait is otherwise so utterly conventional. Though not overtly sexual, the portrait suggests a curious interchange of identities, between a teenage girl and an unrelated man nearing forty years old.—RRB

55

Clovis, 1886
Oil on canvas, 22¹/₄ × 16 in. (56.5 × 40.5 cm)
Initialed center right: *P G*
The Newark Museum. Gift of Mrs. Lloyd
　　Westcott, 1960
WII 208

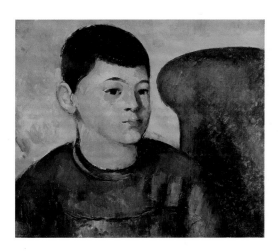

Fig. 217　Paul Cézanne, *The Artist's Son in a Red Armchair*,
c. 1880. Oil on canvas, 13⁷/₈ × 15 in. (35 × 38 cm). Musée
de l'Orangerie, Paris (RF 1963–59) (R 465)

Gauguin painted this wonderfully strong portrait of his son Clovis in the early months of 1886, perhaps even in honor of the boy's seventh birthday on May 10. Although Gauguin told Pissarro that he had arrived in Paris alone in May 1885, he might well, in fact, have brought Clovis. Certainly Clovis was in Paris before long, staying with his aunt, Marie Uribe, so that he could get to know his wealthy cousins. Father and son were reunited in the fall of 1885 (most likely not by choice, but because Marie Uribe insisted on the boy's return), and Gauguin provided a modest apartment where the two lived from mid-October of that year until well into 1886. We know from Gauguin's letters that Clovis was an uncomplaining child who played alone for hours, who was often left with the concierge, and who endured with his father the freezing conditions of the tiny apartment in the winter months. It was Clovis's sickness and fever in December 1885 that prompted Gauguin, keen to support his son properly, to get a job.

The artist's letters to his wife show that he was an enthusiastic and interested parent, in spite of the fact that he spent more time away from them than with them. Indeed, the months he spent with Clovis in 1885–86 were probably the most intimate and involving of his entire life as a father. In his later works, when separated from his children, he "replaced" them by painting other children and young people at analogous ages, as if attempting to use art as a mode of psychic parenting. He had no need to turn to others in 1886, when he painted this portrait of Clovis. Father and son spent a good deal of time together, and, perhaps for that reason, this is Gauguin's most direct portrait of one of his children. Elsewhere the children appear obliquely, almost as if they were anonymous figures in ambiguous genre scenes rather than

the subjects of true portraits, which has often led to their being misidentified.

The bright colors and comparatively strong lighting of the portrait suggest that it was painted during daytime hours, either on the weekend or on days when Gauguin was not directly involved in his various work-related projects. It represents the boy as a self-aware and ambitious young reader, who looks up from his large book to confront his father's gaze directly. Clovis attended a school just next door to the small apartment Gauguin rented in a relatively new building on the Rue Cail in the Saint-Denis quarter of Paris,[9] and he was relatively self-sufficient—under the occasional watchful eye of the concierge or a neighbor. The portrait is especially interesting in that it is so decidedly not a genre scene of a child reading. Had Gauguin chosen that path, he would surely have represented Clovis with his head down, absorbed in the book. Instead, he seems almost to pose with the book as a prop signifying his seriousness and maturity.

The strongly volumetric quality of the head and body as well as the disciplined facture have led many to compare the painting to Cézanne's portraits of his son, Paul. It has been related in particular to *The Artist's Son in a Red Armchair* (fig. 217), although it is unlikely that Gauguin knew this painting or any of the other, similar portraits of Paul that Cézanne made in his Paris apartments on the Rue de l'Ouest. Gauguin never owned a Cézanne portrait and was never able to study the older painter's manner of constructing the human head and upper body. Still, the comparison tells something about the aesthetic connections that existed between Gauguin and Cézanne—in spite of the fact that they had not seen each other for more than three years.

In the portrait, Clovis wears a long-sleeved blue sweater and brown trousers and has his

reddish brown hair closely cropped. The long golden curls of his younger days were gone; in this respect he was becoming more like his dark-haired father than his Scandinavian mother, although his features still resembled his mother's more than his father's.[10] Gauguin placed the young boy in a simple, leather-backed chair similar but not identical to those he had painted earlier in the family apartments (see fig. 83 and cat. 25). Behind the chair he covered a chest or table with an orange cloth with a woven pattern, on top of which he placed what Anne-Birgitte Fonsmark and others have identified as a "found object" from Denmark—a carved, wooden basket of fruit that Gauguin probably painted so as to make his own (see cat. 14). The portrait is a carefully calibrated interplay among four elements—Clovis's head, his book, the cloth, and the carved fruit. In this sense, it is considerably more complex pictorially than the Cézanne.

If the portrait was a sample or model to demonstrate Gauguin's skill as a portrait painter, he seems never to have used it as such. If it was made in honor of Clovis's birthday, it may even have been painted a little too late to have been included in the 1886 Impressionist exhibition, although, as we shall see, he did submit one work entitled simply "portrait" to that exhibition. What seems most likely is that he painted it for Mette, from whom Clovis had been absent for almost a year. Yet there is no evidence that Mette ever owned or even saw the portrait, the provenance of which begins with the dealer Vollard. Had it come from Mette, Vollard would surely have indicated its origin in his stock books. Indeed, his earliest record of the painting calls it *Le Liseur* (The Reader), with no indication that he even knew that Clovis was its sitter.—RRB

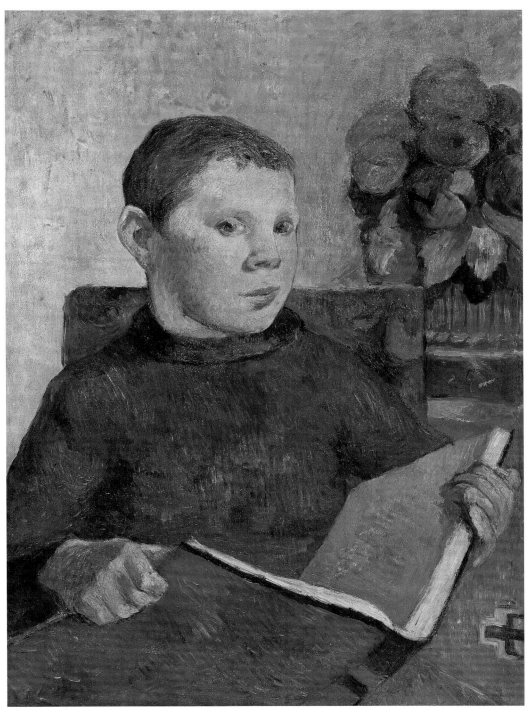

cat. 55

56

Suburb under Snow, 1886
Oil on canvas, 30½ × 22⅛ in. (77.5 × 56 cm).
Signed and dated lower right: *P Gauguin 86*
The Fred Jones Jr. Museum of Art, University of
 Oklahoma, Norman. The Aaron M. and Clara
 Weitzenhoffer Collection, 2000
WII 210
Kimbell only

This wonderfully composed and subtle
painting is the best candidate for identification
as the work called simply *Winter Landscape*
that Gauguin showed in the final Impressionist
exhibition of 1886. Its Danish provenance
might tempt us to identify it as a work done in
Copenhagen but this cannot be the case since
Gauguin left Denmark in mid-1885 and did
not return at all in 1886, the year in which he
signed and dated the work. Where, then, was
this suburban landscape painted? There is little
evidence in the scant documentary record of
Gauguin's life in the early months of 1886 to
help us to identify the location. He was living
in a large building that was part of a dense,
newly constructed section of Paris near the
Gare du Nord. Unfortunately, there is nothing
in the landscape—no church tower or
historical building—that enables us to identify
the site, and it has no direct relationship to
other similar views by Gauguin or other artists
close to him. Gauguin's letters from the early
months of 1886 were written from Paris itself,
and there are no records of visits to the
suburbs. Yet the position of his apartment near
the Gare du Nord makes it easy for us to
imagine him simply taking the train on a
winter day to compose a suburban landscape
in the manner familiar to him from the oeuvres
of Cézanne and Pissarro. If anything, this work
was made in quiet homage to the tradition of
Impressionist winter landscapes to which

Gauguin himself had already made major
contributions. It must have looked both sad
and out of date when it made its debut in the
spring of 1886 in the company of the highly
controlled and "dotted" landscapes of Seurat,
Signac, and the Pissarros, father and son.

Like all of Gauguin's works in the
Impressionist mode, it was meant to be
patiently studied rather than grasped in a
single glance as one scanned a wall of
paintings in a public exhibition. Everything
about it is subtle, controlled, and frustratingly
unyielding to interpretation. The figures are so
tiny and distant that they do little more than
make the landscape seem even larger and
emptier than it first appears, and the main
couple—a man in a short blue coat and a
woman with a red striped skirt and a black
shawl or cape—walk away from us, having
already negotiated the curve in the path. They
have no clear destination, yet the cold gray
weather makes it clear that they are not out
for a leisurely stroll. Indeed, the painting seems
to be a study in alienation—of Gauguin from
suburban Paris and of the viewer from the
pictured realm. The single tree to the left
emerges from a stuccoed wall and, although its
dense branches are shot through with color, it
remains steadfastly black, the single color that
the Impressionists had repudiated. There is
little to conclude from this uningratiating
painting than that Gauguin's intention was to
paint not so much the landscape in itself as his
isolation from it.—RRB

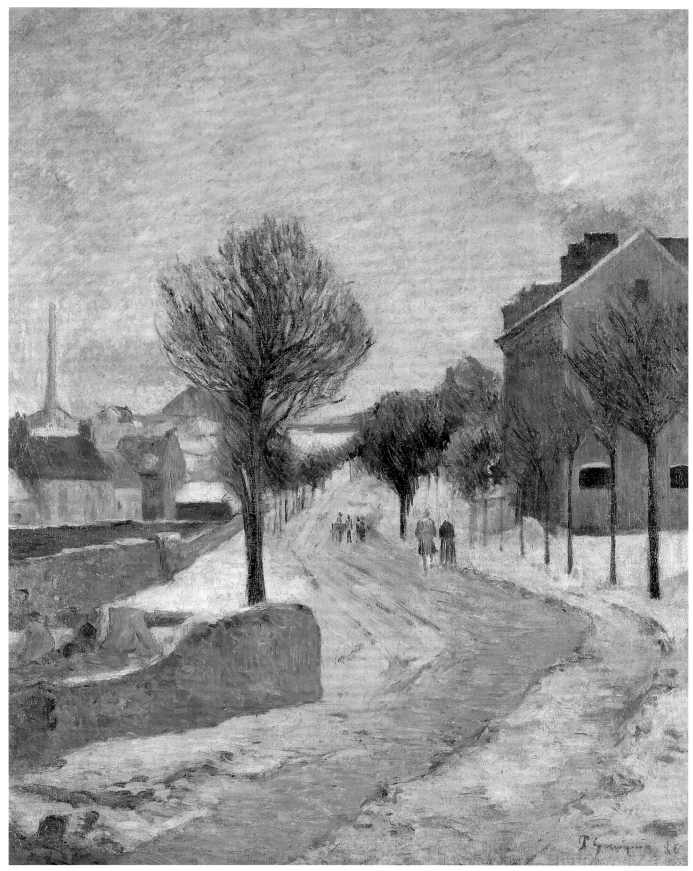

cat. 56

Richard R. Brettell Gauguin's Humiliation as an Impressionist:
The 1886 Exhibition

O N MAY 15, 1886, AN EXHIBITION ENTITLED SIMPLY *The Eighth Exhibition of Paintings* opened to the public in rented rooms on the Rue Lafitte in Paris. Only those "in the know" would have suspected that, after a hiatus of four years, the rag-tag coalition of artists commonly known as the Impressionists had reformed for what was to be their last group exhibition. Since John Rewald published his *History of Impressionism* in 1946, scholars have agreed that this final exhibition resulted from a profound crisis in the movement. Certain of the artists—including Monet and Renoir—had elected to exhibit at the Salon as early as 1879, infuriating Degas and his coalition of urban realists and placing Pissarro and his friends Gauguin, Guillaumin, and Cézanne in a conciliatory or compromising position between the two camps. Late in 1885, Pissarro was courting Monet and "Renoir and Company" (as Gauguin called them) to exhibit with the young artists Seurat and Signac as well as Degas and his friends. In spite of all his political maneuvering, neither Monet, Renoir, Sisley, nor Caillebotte—the artists who were, with Pissarro, the central figures of Impressionism in the mind of the critics and the public—were to take part.

The 1886 Impressionist exhibition consisted of more than 230 works by seventeen artists. Although the majority of the works in the exhibition could be called "Impressionist" by the standards of the three group exhibitions of 1880–82, it was the room of "Neo-Impressionist" paintings, dominated by Seurat's *A Sunday on La Grande Jatte* (1884–86) (fig. 218) that received the lion's share of critical and public attention. Gauguin worked hard to complete a group of nineteen canvases representing his work in Rouen, Copenhagen, Dieppe, and Paris, none of which had been seen in the French capital. Durand-Ruel had taken a group of his paintings in 1884 but returned all but one of them, and there is no evidence that any were ever exhibited in the galleries. Given the fact that Gauguin had not had a proper studio in Paris since he left for Rouen, it is unlikely that even his painter-friends had seen his recent work. Only the provincial publics of Rouen and Copenhagen had had even a glimpse of his painting since the Impressionist exhibition of 1882.

For all these reasons, the 1886 exhibition was crucial for Gauguin. It was his first Parisian exhibition since he had formally renounced his business career and become an artist. He most likely knew from Pissarro and Guillaumin that Seurat, Signac, and the young Lucien Pissarro were submitting work and that the older Pissarro had been rejuvenated as a "Scientific Impressionist." Gauguin had been struggling with the concept of Impressionism for some years but had never abandoned it, so for him the aesthetic and political stakes were high. Which of his own works did he choose for this critical exhibition? The most systematic attempts to answer this question have been made by Ruth Berson and her colleagues between 1986 and 1996 and Sylvie Crussard in the recent Wildenstein catalogue raisonné.[11] There are plausible suggestions for all but three of the works, although the two sources disagree on a number of the works. However, Crussard's suggestions are based on clearer reasoning and, when there is a disagreement between the two sources, Crussard's suggestions are more acceptable.

Their conclusions can be summarized as follows (using the numbers and titles under which the paintings appeared in the exhibition catalogue):

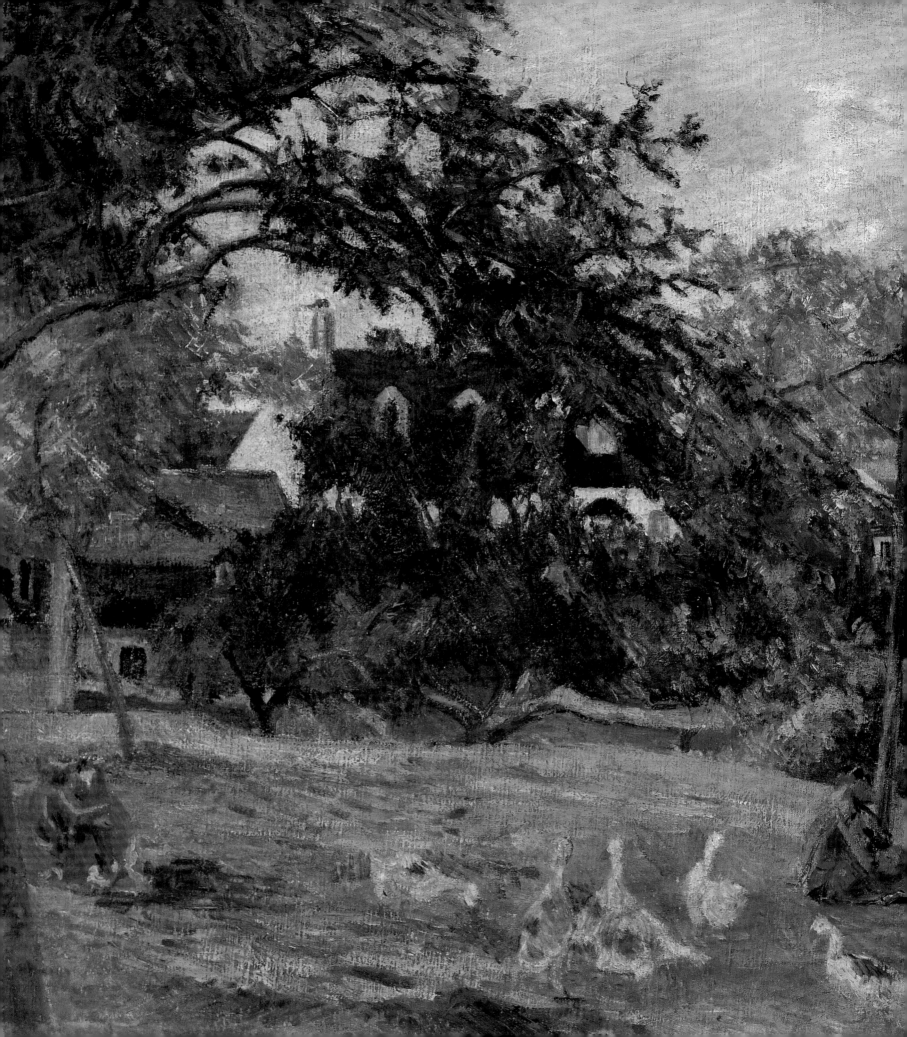

42. *Nature Morte.* In his review of the exhibition, Jean Ajalbert mentioned that this painting featured oranges. Berson and Crussard identify the work as *Still Life with Oranges* (see fig. 69; WII 59). But perhaps Ajalbert mistook some apples for oranges, in which case it may have been the Cézannian still life *Apples, Jug, Iridescent Glass* (private collection; WII 144).

43. *Vaches au repos.* Berson suggests *Cows near Dieppe* (Museum Boijmans Van Beuningen, Rotterdam; WII 191). Crussard, using Fénéon's review, suggests *Cows at the Watering Place* (see fig. 210; WII 192).

44. *Vache dans l'eau.* Berson suggests *Watering Place I* (private collection; WII 194), with which Crussard agrees as an alternate to the more plausible *Cows near Dieppe* (WII 191).

45. *Un Coin de la mare.* Berson suggests *Cows at the Watering Place* (WII 192), but Crussard is more persuasive with *Red Roof by the Water* (see cat. 51; WII 193). Crussard also mentions *Boy by the Water* (private collection; WII 196) as a possibility.

46. *Les Saules.* Both Berson and Crussard are forced to accept *Stream, Osny* (private collection; WII 100) in spite of its relatively early date of 1883. Ajalbert mentioned turkeys in the scene, making this painting the most plausible candidate. Crussard

mentions the additional possibility of *Willows* (on loan to the Musée Départemental Maurice Denis, Saint Germain-en-Laye, France; WII 200).

47. *Près de la ferme*. Both Berson and Crussard suggest *Geese in the Meadow* (see cat. 50; WII 184), but Crussard rightly points out that there are many other canvases that would work equally well with the title and that no reviewer singled out the painting with particular mention. The large scale and recent date of *Geese in the Meadow* make it a likely candidate.

48. *Paysage d'hiver*. Both Berson and Crussard reluctantly accept *Suburb under Snow* (see cat. 56; WII 210).

49. *Le Château de l'anglaise*. Berson gives up, but Crussard plausibly suggests *White House* (private collection; WII 183), painted in Dieppe in 1885.

50. *L'Eglise*. Both plausibly suggest *Notre-Dame-des-Anges* (see fig. 149; WII 130).

51. *Vue de Rouen*. Berson implausibly suggests *The Church of Saint-Ouen, Rouen* (see fig 148; WII 124). Crussard disagrees, but suggests no alternative. The closest work from the point of view of subject is *View of Rouen* (see fig. 151; WII 123), but this painting seems to have been in Denmark in 1886. One could also propose *Manuring* (see cat. 37; WII 117).

52. *Avant les pommes*. Berson is stumped, but Crussard found an unpublished photograph of a fascinating, apparently unfinished painting that she identifies as the exhibited work: *Before the Apples* (see fig. 197; WII 177). Here Gauguin approached Monet more closely than in any other painting. He most likely painted it in the summer of 1885 outside Dieppe.

53. *Les Baigneuses*. Berson wrongly identifies this as *Women Bathing, Dieppe* (see fig. 250; WII 179). Crussard realized that Paul Adam's short description of the painting in the exhibition accords much better with *Beach, Dieppe* (see cat. 49; WII 178).

54. *Fleurs, fantaisie*. Both Berson and Crussard favor *Basket of Flowers* (see cat. 42; WII 148). There is, however, no definitive evidence for this identification, and *Still Life with Chinese Peonies and Mandolin* (see fig. 190; WII 169) seems to accord better with the word "fantaisie." Gauguin painted the latter in Copenhagen, so one wonders whether or not he had it with him in Paris.

55. *Route de Rouen*. Berson implausibly suggests *Tree-Lined Road, Rouen I* (see fig. 203; WII 125). Crussard favors *Street, Rouen* (see cat. 39; WII 122), which is larger and more ambitious and works just as well with the title.

56. *Parc, Danemarck*. Berson makes two suggestions, *Østervold Park, Copenhagen* (see fig. 192; WII 173) and *Windmill (Dronningens Mølle) Østervold Park* (see fig. 195; WII 174). But Crussard is undoubtedly correct in accepting only the former, on the grounds that Gauguin is known to have taken the work with him from Copenhagen to France.

57. *Conversation*. Both Berson and, more reluctantly, Crussard identify this as *Conversation* (see fig. 196; WII 175). The only other possibility is *Snow, Rue Carcel II* (see fig. 133; WII 98), which could conceivably have appeared as either no. 48 or no. 57 but was most likely still in Copenhagen with Mette.

58. *Chemin de la ferme*. Berson identifies this as *Donkey by the Lane* (see fig. 216; WII 199) but with no supporting evidence. Crussard plausibly suggests *Père Jean's Path* (see fig. 211; WII 195), but it could equally well have been *Boy by the Water* (private collection; WII 196).

59. *Falaises*. Berson suggests *Cliffs at La Bouille* (private collection; WII 143), painted in Rouen. Crussard rejects this notion and creates a new catalogue number, WII 182, just for this painting (*Cliffs*, disappeared). It was mentioned by both Ajalbert (as "petite marine très claire") and Fénéon (only by title). Ajalbert's description rules out Berson's choice completely.

60. *Portrait*. Berson and Crussard both suggest *The Boss's Daughter* (see cat. 54; WII 207), but Berson is also open to the possibility of *Clovis* (see cat. 55; WII 208).

All in all, this was not an inspiring group of paintings and, perhaps for that reason, most of the critics associated Gauguin's contribution neither with the major artists in the exhibition—Pissarro and Degas—nor with the young rebels Seurat and Signac, but with his old friend Guillaumin. Guillaumin submitted seventeen paintings and four pastels to the exhibition. The critics who wrote about them tended to remark upon their bizarrely vivid coloration and to connect them, mostly unflatteringly, to Gauguin's chromatic experiments. Even against Guillaumin, Gauguin often lost out in the comparison and can scarcely have been pleased. Indeed, if we compare the works he submitted to the 1886 exhibition to those he submitted to the previous three Impressionist exhibitions, it is clearly the least distinguished group—even if we assume the best in cases where there are two or more candidates for identification as the exhibited work.

His submission seems to have included work from 1883 through early 1886, as if he wished to represent his evolution since the 1882 exhibition with a certain fidelity. We know that he left a good many works of art in Copenhagen, and there is no letter from him to Mette informing her about the exhibition and asking her cooperation in sending important works to Paris to be shown in it. Since so many of Gauguin's letters to Mette have survived, the absence is a significant one. In all likelihood major works that Gauguin took with him to Denmark such as *Snow, Rue Carcel II* (see fig. 133), were unavailable. The winter landscape that was no. 48 in the 1886 exhibiton was a smaller, inferior work. Similarly, the portrait that was no. 60 was not the Kimbell self-portrait, and the still life that was no. 42 was not the great *Still Life, Interior, Copenhagen* (see fig. 191). Even if Gauguin's submissions were installed with the best of Guillaumin's (as the reviews suggest), the room or walls would have paled by comparison with Degas's nudes, Morisot's and Cassatt's figure paintings, the Neo-Impressionist paintings of Pissarro and company, and even the extraordinary prints by Pissarro and his son Lucien. Even Odilon Redon's first and only submission to an Impressionist exhibition, which consisted of fifteen works (largely unidentified), was more original and important than Gauguin's. By any criterion Gauguin's final appearance with the Impressionists was a profound humiliation—at a time in his career when he needed a real boost.

Did Gauguin actually want to fail as an Impressionist? The answer is most probably yes. He was certainly not blindsided by the Neo-Impressionists—indeed, he briefly flirted with their aesthetic, although he seems to have rejected it even before the end of the exhibition. He attended a huge banquet organized by Pissarro for art critics and painters at the end of May and was already talking about undertaking long voyages to further what he considered to be his aesthetic research. His various forms of flight—personal, artistic, and physical—came together again in the spring and early summer of 1886. In his own mind, he had no choice but to reinvent himself as an artist. Almost all the positive reinforcement he received as a result of the exhibition pushed him in the direction of ceramics and tapestries rather than painting.

Albeit part of an unconscious plan of reinvention, Gauguin's humiliation as an Impressionist was not total. The group of vertical landscapes that he painted near Dieppe in the summer of 1885 were no less adventurous in palette, composition, or facture than the landscapes he was to make in Brittany in 1888, and the group of floral still lifes and portraits he made in 1884–86 remain central to his oeuvre even today. What he most lacked to spur his internal development was access to models, and in the two years before the 1886 exhibition he produced no major figure paintings apart from portraits. This does not seem surprising, perhaps, when we consider that he produced only one major figure painting in the first decade of his career as an Impressionist, *Nude Study, Woman Sewing* (see cat. 19). Yet the sheer quality and ambition of that painting force us to ask why he failed to attain the same level again until *Breton Women Chatting* (see fig. 253) of late 1886. Perhaps, he needed the kind of push provided by the success of the ambitious, large-scale figure paintings shown by Seurat, Signac, and Pissarro in the 1886 exhibition.

Another factor in Gauguin's personal Impressionist crisis was the publication of Emile Zola's novel *L'Oeuvre* (*The Work*) in March 1886. Zola sent copies to several of his artist friends, including Cézanne and Pissarro. Cézanne wrote a polite letter to his friend acknowledging receipt of the book and thanking him for his kindness; it was to be their last communication. Pissarro wrote to Monet at the beginning of April saying that he was only halfway finished but already dissatisfied with Zola's "romantic" conception of the artist. Gauguin also read the book and described it in a letter to his wife as Zola's worst. Nonetheless, Mette made a Danish translation, which she worked hard to complete in June—clearly in the hopes that translating one of the most famous French novelists alive would be lucrative. In spite of Gauguin's low opinion of the book (which he shared with most other artists), it is difficult to imagine that he was unaffected by its remorselessly critical tone and its indictment of the modern painter, the Impressionist.

57

Still Life with Horse's Head, 1886
Oil on canvas, $19^{1}/_{4} \times 15$ in. (49×38 cm)
Signed lower right: *Paul Gauguin* (the signature
 has been strengthened or, perhaps, added later)
Bridgestone Museum of Art, Tokyo (WP-168)
WII 216
Ordrupgaard only

The great Gauguin scholar Françoise Cachin
has never been convinced of the attribution of
this curious painting to Gauguin, and one can
easily see why.[12] Its signature has been either
strengthened or added after the painting's
completion; its style and composition little
resemble any accepted painting by Gauguin;
and it has no documented place in his career,
being unrecorded in any letters, dealer
archives, reviews, or exhibitions before his
death late in 1903. It has been published as
by Gauguin frequently since that time, and
included as an authentic work in major
exhibitions. No less a scholar and connoisseur
than Robert L. Herbert included it in his
monumental exhibition *Neo-Impressionism* in
1968[13] and it appeared in the Royal Academy's
landmark *Post-Impressionism* exhibition of
1979–80.[14] However, the organizers of what
remains the definitive twentieth-century
Gauguin retrospective, held in 1988–89—
including Françoise Cachin, Charles F. Stuckey,
and the present author—decided against its
inclusion. Daniel Wildenstein and Sylvie
Crussard were well aware of the differences of
opinion about this painting when they elected
to include it in the 2001 catalogue raisonné,
and afforded the work an entry so magisterial
that it has essentially erased all doubt.[15]
Convinced by the sheer weight of their
reasoning, we have elected to present it in this
exhibition as a unique example of Gauguin's
fleeting encounter with Neo-Impressionism.

Scholars have dated it to 1885 (flattering
Gauguin with an aesthetic prescience) or to
1886, when he is known to have met Seurat
and Signac; the latter date is surely correct.

One of the most compelling arguments for
Gauguin's authorship is the sheer originality of
the painting as an essay in Neo-Impressionism.
Let us begin with its subject—an "artistic" still
life. If we consider the oeuvre of any major
Neo-Impressionist painter, we find that still-life
painting is all but completely absent. Only a
handful of the works selected by Herbert for
the Neo-Impressionist exhibition of 1968 are
still lifes. Indeed, an exhibition specifically
devoted to still life in the movement would
scarcely fill a single room. Gauguin surely
selected this subject to make a point—that the
most important aspects of Neo-Impressionism
were not its theories of light and perception
(otherwise he would have painted a landscape
or an outdoor figure painting), but its
artificiality, its regularization of facture, and its
interest in color as such.

In arranging his curious still life, he decided
to include a reduced-scale plaster reproduction
of the so-called *Horse of Silene* from the Elgin
Marbles at the British Museum. He was later
to turn again to the Elgin Marbles, using
photographic reproductions as sources for the
poses of horses in paintings he made in Tahiti
and Martinique, and the present work is the
earliest evidence of his interest in them. It
seems unlikely that Gauguin himself owned the
reproduction. He lived with so little furniture
on the Rue Cail and had so little money that
he surely would not have splurged on such an
item. He had been to London for at least eight
days in September 1885, during which time he
may well have seen the head itself and,
possibly, purchased a reproduction. But he is
more likely to have borrowed it from
Schuffenecker or some other wealthy friends—

the Favres, the Granchi-Taylors, perhaps even the Uribes.

Gauguin places a reproduction of a classic of Greek sculpture on a table with a book of prints or, more likely, photographs of other works of art. If these elements embody the arts and technologies of the West, they are juxtaposed with an array of Japanese fans, both painted and plain, and an articulated Chinese doll. East and West are presented as equally important for the modern artist. Gone are the traditional fruits, flowers, fish, and game that fill literally thousands of European still lifes made before this. It is only a pity that Gauguin failed to finish the work before May 1886, when the final Impressionist exhibition opened. Unprecedented in its sheer inventiveness, it would surely have given Adam and Fénéon pause.

We have seen how Gauguin followed the leads of Pissarro and Cézanne in attempting to regularize his facture into short, almost grammatical strokes that collectively form a painting. This is apparent in certain paintings that seem almost to prefigure Neo-Impressionism, most vividly in *Vaugirard Church by Night* (see cat. 20) and the sky of *La Groue Farm, Osny* (see cat. 32). Yet none of these prepares us for the surface effects in the Tokyo still life. Diagonal hatchings of various lengths but a single, marshaled angle represent still-life elements that are themselves arranged in an interplay of diagonal and curved compositional lines, creating a subliminal pattern in which forms link to facture.—RRB

cat. 57

Anne-Birgitte Fonsmark A Painter–Sculptor Makes Ceramics

"55 pieces in good order"

B Y THE TIME OF THE EIGHTH AND LAST Impressionist exhibition in the early summer of 1886, Gauguin had made a name for himself as a painter and sculptor. Now the opportunity arose to express himself through ceramics. It was the first time he made anything to a commission, and this came as a great reassurance to him at a time of personal difficulties and pressure to come to terms with the new alliance of Seurat, Signac, and Pissarro. It could also be of financial significance, and once more Gauguin felt that he had hopes of a career in art. There was much at stake, and he was entering into completely unfamiliar territory; he was not conversant with ceramic techniques and had no experience of them. Nevertheless, he was to create a series of epoch-making works, drawing upon a variety of sources but without any real predecessors or successors.[16]

Gauguin's venture into the world of decorative art began with a chance connection. Félix Bracquemond, the artistic director of Charles Haviland's ceramic workshop at Auteuil, greatly admired Gauguin's wood relief *La Toilette* of 1882, which he saw at the eighth Impressionist exhibition (fig. 143).[17] He put Gauguin in touch with his old friend and collaborator, the ceramicist Ernest Chaplet, who at that time was seeking to persuade artists to participate in the creation of artistic stoneware in his factory in the Rue Blomet at Vaugirard. There had been talk of Jules Dalou, but he had refused,[18] and this apparently gave rise to the offer to Gauguin. "I have achieved great success among the artists," he wrote to his Danish wife, Mette, during the first half of June, about the time when the exhibition closed. "The engraver Braquemont [*sic*] enthusiastically bought a painting by me for 250 francs and put me in touch with a ceramicist who intends to produce artistic vases. Captivated by my sculpture, he has begged me to make things for him this winter according to my own ideas, saying we would share the profits half-and-half when they were sold. Perhaps this will be a major source of income in the future. Aubé worked those pots for him and lived on the proceeds, and this is a much bigger thing."[19]

Such was the starting point for the ceramic work that Gauguin was to undertake during the winter of 1886–87. He discussed his plans in another letter to Mette: "I shall take a small workshop near the church in Vaugirard, where I'll work for ceramics, sculpting pots as Aubé used to do. Mr. Braquemond [*sic*], who has taken to me on account of my talent, obtained the work for me and said that it could become lucrative. Let us hope that I have talent for sculpture as well as for painting."[20] He was to continue to refer to his ceramics as "sculpture" rather than decorative art.

Many painters and sculptors of the nineteenth century had been concerned with ceramics in one way or another, sketching decorations or creating models for designs. Artists such as Ingres, Delacroix, François-Joseph Bosio, and Antonin-Marie Moine had worked for Sèvres.[21] Albert-Ernest Carrier-Belleuse played a major role in the factory's activities, and between 1879 and 1882 Rodin collaborated in his work by making decorations for vases.[22] Undoubtedly Gauguin saw his ceramic work as following in this tradition. When he left on his planned summer visit to Brittany in mid-July,[23] his main objective was painting, but the ceramic project of the following winter was already in

facing page Paul Gauguin, *Jardinière with Motifs from the Breton Women Chatting* (detail of cat. 58)

his thoughts, and we know that he did some preparatory work before leaving Paris. On the close of the Impressionist exhibition on June 15 he made a drawing of the wood relief that had attracted Bracquemond before it was returned to the lender, Pissarro (fig. 219). Whether or not he was firing ceramic pieces before leaving—we know that he visited the workshop in the Rue Blomet—is a question to which we shall return.[24]

After a long summer in Brittany, he returned to Paris with a large number of sketches to be used both in his painting and in his ceramics. In a letter to Bracquemond—which he must have written in October or November 1886—he elaborated on his work for Chaplet: "I am working like a black and do not think you will be unhappy with my efforts."[25] On December 26 he wrote to Mette: "I am making ceramic sculptures. Schuff [Schuffenecker] says they are masterpieces and so does the manufacturer, although they are probably too artistic to sell. Nevertheless, he says that before long, this coming summer at the exhibition of industrial arts, they will be a great success. May the Devil grant him that!"[26] Gauguin soon had a considerable number of ceramic works finished and proudly invited Bracquemond to see them: "If you are curious to see all the newly fired little products of my great madness, then it is now—55 pieces in good order. You will undoubtedly cry out at the sight of these monstrosities, but I am sure they will interest you."[27]

The Challenge of Ceramics

How had Gauguin approached these "55 pieces"—in relation to the expectations of his client and to his own starting point? Bracquemond's expectations were closely linked to a single work, *The Toilette*, which Gauguin drew immediately after the exhibition, presumably with a view to using the composition for a ceramic piece. These expectations were no doubt in line with the nineteenth-century tradition of ceramic work as a purely decorative undertaking for a fine artist. In this context, Gauguin's lack of experience of ceramic techniques was relatively unimportant. The manufacturer made available to him established methods of production that had been developed over the immediately preceding years.

Félix Bracquemond had been head of the painting studios at Sèvres since 1871–72 and had assumed the artistic directorship of the Atelier d'Auteuil when it was founded by Haviland de Limoges, as a studio for artistic development, in 1873. In the mid-1870s he had brought Ernest Chaplet into the enterprise to be in charge of the manufacture of barbotine ceramics.[28] In 1881 Chaplet learned a new technique of stoneware production in Normandy, and the following year Haviland gave him the means with which to establish a small stoneware factory at Vaugirard with himself as artistic director. The address was 153 Rue Blomet. Little is known of the composition and firing of the stoneware Chaplet produced, but Christophe Haviland explained something of the technique of decoration in a letter: "When the vase is thrown, the decoration is cut deep into the mass by hand, and the brown clay removed in this way is replaced by colored clays; all the engraving and sculpting is done by artists such as Hexamer, whose reputation is as great as that of Aubé. Next the vase is fired at the same temperature as

porcelain but without being enameled. Its originality stems from its being decorated with tinted clays that could never have been fired at such a high temperature without becoming discolored."[29] Gauguin must have known Chaplet's workshop from the beginning because since 1880 he had lived in the Rue Carcel, where his garden door opened onto the Rue Blomet.

Stoneware went back to fourteenth- and fifteenth-century Germany and France but over the years had gone out of use in most of the original areas of production. It was one of the old forms of art "rediscovered" in the second half of the nineteenth century and reinterpreted alongside the arts of Japan. This was owing to Chaplet more than anyone else. After moving to the Rue Blomet, he started producing articles for everyday use such as vases, jugs, and beakers in simple, traditional shapes. They were made in clay of a particular brown color and left with a rough surface.[30] Chaplet was the first to be interested in the rough quality of the material and a pioneer in exploiting the brown ground aesthetically in the decoration.[31] Before, the clay had served only to provide the shape of the piece, after which it was covered by decoration. The ceramics created in Chaplet's workshop in the period 1882–85 were characterized by a blend of Japanese and Western aesthetics, an interplay between decorated and "bare" areas, and by a respect for the material. They were a fine starting-point for Gauguin as he embarked on his ceramic work.

The techniques of ceramic may have been unfamiliar to Gauguin but ceramic art was not. In his autobiographical work *Avant et après*, he wrote nostalgically of the collection of Peruvian vases that his mother had owned but lost in a fire.[32] She died in 1867 when he was still young, and his early memory of this family treasure associated with her was a special impetus to take an interest in ceramic art when he got the opportunity of getting acquainted with it in the house of his guardian, Gustave Arosa. Arosa's home contained a large and remarkable collection of ceramics, ranging from porous earthenware and faience to the denser materials of stoneware and porcelain. There were examples from Nevers, Rouen, and Delft, from Italy and Spain—including Moorish Spain—from Persia and Rhodes, from China and Japan. The collection also contained some Peruvian and other Precolumbian pottery. The works are known from the auction of the collection in 1878[33] and from phototypes—made by none other than Arosa—in Auguste Demmin's two-volume work on the history of ceramics, published in 1875 (fig. 220).[34] Gauguin could also have seen splendid examples of pottery from non-European cultures in the Musée Ethnographique du Trocadéro, which had been opened to the public in 1878; the American collections alone contained thousands of objects.[35]

Fig. 220 Collage of ceramic objects, from the collection of Gustave Arosa, from Auguste Demmin, *Histoire de la céramique en planches phototypiques inaltérables* (Paris, 1875). Black and white photographs mounted on board, 49 1/4 × 39 3/8 in. (125 × 100 cm). The Art Institute of Chicago. Gustave Arosa Collection

Rue Blomet: The First Attempts

Probably around the turn of 1886–87 Gauguin was able to tell Bracquemond that he had finished fifty-five pieces. But Bracquemond was obviously not convinced of their quality. Pissarro told his son Lucien that he and Bracquemond had had a conversation on the matter: "He told me that some of the models he has made are good, while others are not up to anything. In short, he seemed to be telling me that it was sailor's art, a bit

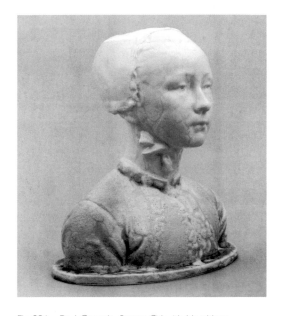

from here and a bit from there."[36] Since, in addition, it proved to be impossible to sell the ceramics,[37] it is scarcely likely that Gauguin continued his collaboration with Chaplet at this time. The fifty-five pieces form a first group within his ceramic oeuvre.[38]

How did Gauguin set about creating ceramics?[39] There is much to suggest that his original idea was to transfer motifs from his paintings and wood sculptures. His drawing for *La Toilette* (fig. 219) seems to indicate as much. It would hardly be surprising if Bracquemond, who so admired the original relief (fig. 143), actually specified the use of this motif. At all events, it appears on one of the oblong "jardinières" that Gauguin made in the course of his first period of close collaboration with Chaplet. On one of the long sides is the nude youth of the relief ("sitting rectangularly in a landscape," as the author Félix Fénéon had written in a review of the exhibition),[40] and on the other the little shepherdess with a cow from the painting *Breton Shepherdess* (see figs. 237, 238).[41]

It is tempting to see these ambitious jardinières as Gauguin's first venture into ceramic, but they could in fact have been made at a later date. An alternative candidate would be the little bust *Breton Girl with Headdress*, which is thought to have been modeled by Gauguin and then cast by Chaplet in porcelain—perhaps as an experiment, perhaps to try out the way in which they were to collaborate (fig. 221).[42] In that case, the bust could be seen as an extension of the sculpture Gauguin had made in both marble and wood over the preceding years, and the character of the collaboration as a parallel to his work with Bouillot. Just as Bouillot introduced him to sculptural technique, Chaplet introduced him to ceramic technique. Like the *Bust of Clovis* (figs. 93, 112), the bust of the Breton girl recalls portrait sculpture of the early Renaissance in the innocence of the subject's expression.

On the basis of a letter of June 24, 1886, in which Gauguin said that he had been the previous day at Rue Blomet, where ceramics were fired, Douglas W. Druick and Peter Kort Zegers believe that the only ceramic that he modeled and fired before his visit to Brittany was *The Faun* (fig. 222).[43] Here the inspiration was clearly the work of Jean-Paul Aubé, whom Gauguin had met in 1877 when both were renting space from Bouillot. For years Aubé had earned his living by collaborating with the professional ceramicist at Haviland's.[44] In the late 1870s he had begun to model female nudes in white plaster as a decoration for Haviland vases (fig. 223),[45] one of which appears in Gauguin's pastel portrait of him, made in 1882 (fig. 224).[46] In a sketchbook Gauguin drew a design for a decoration consisting of a freely modeled female nude who occupies the shoulder of a vase of the same type that Aubé decorated (fig. 225). Several of Gauguin's vases show a similar combination of figure and vase body, undoubtedly inspired by Aubé's designs, and *The Faun* is a case in point. The Roman god of shepherds sits on a slope that is perhaps a vestige of the upper part of a vase. The work is among Gauguin's most satirical: the features of the faun (a symbol of unrestrained sexuality) are said to be those of his Danish brother-in-law, the politician and author Edvard Brandes. Supposedly Brandes snubbed Gauguin and concentrated his attention on the ladies during a visit to the Salon in the previous year.[47]

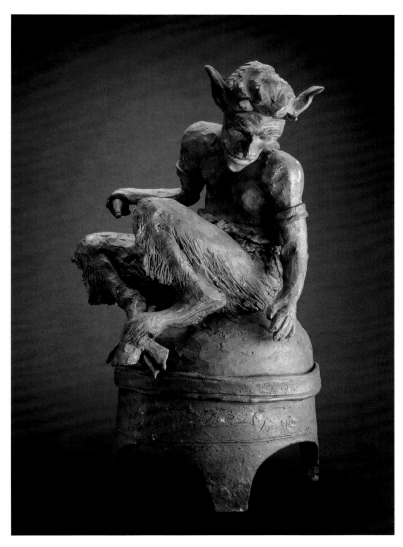

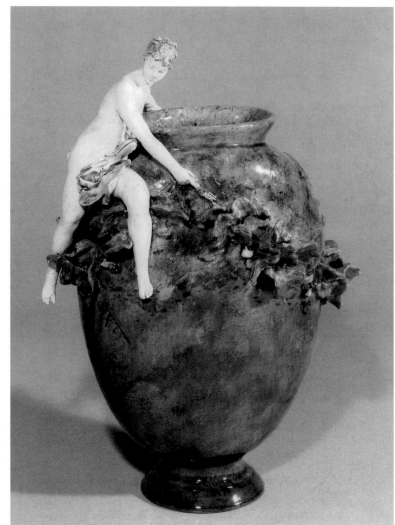

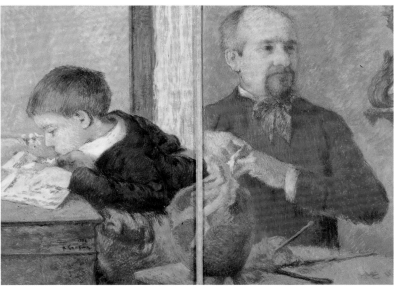

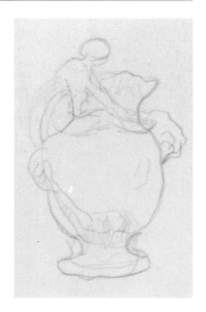

The collaboration between Gauguin and Chaplet was rooted in a working practice that was well established in the nineteenth century: one added decorations to a vase shaped by the other. The jardinières were made in this way and so was the so-called Brussels vase (fig. 239).[48] The decoration of the latter consists mainly of a broad, horizontal belt around its cylindrical form. This is interrupted by the elegant lines of some trees and by one of the small, blue clouds, the contours of which are drawn in gold in Japoniste fashion. As in the case of one of the jardinières, Gauguin started out from the most outstanding of his works from Brittany, *Breton Women Chatting*, although here it was the two central figures that he reused (fig. 253).[49] He drew the characteristic lines of the dresses and headdresses in a simple, decorative contour that Merete Bodelsen called "the missing link" in his development toward Cloisonnism.[50]

In works such as these, Gauguin "folded" two-dimensional works around three-dimensional ones—or, to put it another way, he inserted the cylindrical vase and the angular jardinières into paintings and drawings. Here and there, the surface comes forward into relief. Pictorial elements such as the chatting Breton wives, conceived in two dimensions, are lifted into the third and given sculptural form—creating an effortless transition from surface to spatiality.

But soon Gauguin lost interest in decorating the ceramic works of others and wanted to create and shape his own. He developed the view that the art of pottery—in the case of Sèvres, for instance—had fallen into a pit of decadent eclecticism. Only in the most distant epochs and cultures, far from European civilization, did he find an unspoilt originality from which the art of the West could derive a new dynamism. "Ceramics are not a dead end," he wrote in 1889. "In the most distant epochs, among the Indians in America, we find that this form of art constantly finds favor. God created Man from a little mud. With a little mud one can make metal and precious stones—with a little mud plus a little genius."[51] He was familiar with Oriental and Precolumbian pottery from the homes of both his mother and his guardian. These non-Western traditions were the fertile ground in which his ceramic works had their roots—works that the leading critic Albert Aurier was to describe as "strange, barbaric, and savage ceramics, in which the sublime potter has kneaded more soul than clay."[52]

As soon as he had gained a greater understanding of how to exploit clay as his material, Gauguin started modeling his works manually, in contrast to Chaplet's vases, which were turned on a potter's wheel. He wanted to give them "a new thrust through the creation of new forms by hand."[53] He wanted to break with established workshop tradition, "replacing the potter's wheel with intelligent hands that can imbue the vase with the life of a figure."[54] Gauguin approached his first entirely autograph works in ceramic with an immediacy and spontaneity that have been compared to that of children modeling in playdough. He used sausages of clay to build up the vases, bringing forth highly imaginative and baroque shapes on circular, heart-shaped, and rectangular bases. Many of the early ceramics have several openings as though jars were grown out of other jars in some uncontrolled, organic budding process. With roughly shaped sausages of clay the artist formed bizarre and clumsy handles with no function, undulating ornaments, and small figures. His first ceramics are experiments in throwing

Fig. 226 Paul Gauguin, sketch of a pot in Gauguin's letter
to Mette, December 6, 1887

off all yokes, standing free of all constraints. They seem to add new life to the tradition they reject—at the same time tending toward the playful, artistic form of the paraphrase. They are sculptural variations on familiar themes: "vases" that look like vases but are not; "drinking bottles" with small "fittings" for carrying straps or strings; a "jug" with an open "lid" that are neither jug nor lid (cats. 61 and 66). All are sketched in the clay as light, casual suggestions. They contain a variety of allusions to the art of the past, but the influence of Precolumbian pottery is clear.[55] They seek to reestablish contact with more "primitive" cultures, but perhaps also to primal layers of the human mind. In some of the ceramics Druick and Zegers see references to the functions and openings of the human body.[56]

One of the most fantastic and most sculptural works is known today only from a painting, the *Still Life with Laval's Profile* (cat. 75).[57] This probably belonged to the first group of ceramics, but should be regarded as one of the most mature;[58] indeed, it marked a complete breach with everything known in ceramics. The fact that Gauguin chose it from among his fifty-five pieces as a motif in that mysterious painting suggests that he himself saw it as a successful expression of his intentions. He also mentioned it in a letter to Mette, whom he suspected of having taken it to Denmark with her: "Take good care of it for me. I'm holding onto it unless you find an opportunity to sell it (a good price, 100 francs)" (fig. 226).[59]

Most of Gauguin's early ceramics are in hard-fired, reddish brown stoneware clay, and the surface has been left rough. He was deeply fascinated by the severe, rustic material that was fired at more than 1,300 degrees, always believing that "the quality is in the firing."[60] Throughout his life he was to remain faithful to stoneware as he was to wood. As a rule the works in the early group of ceramics are not glazed; the exceptions include the *Jug with Seated Shepherd Girl, Lamb, and Goose*, which has a thick, shiny glaze (cat. 63). The decorations on them are modeled in relief or inscribed in the soft clay with a sharp instrument. Here and there a little matte glaze or clay slip has been added in a small number of colors—white, blue, green, and yellow—and many small details are picked out with a little gold.

In some of the pieces Gauguin used the working method that he had developed during his time in Copenhagen in particular, borrowing freely, both from his own works and from those of others. His fascination with Delacroix, Cézanne, and Degas continued to manifest itself. A relief of an Arab horseman can just be made out behind the handles on an idiosyncratically shaped jar (cat. 61). On another jar, motifs from Cézanne's *La Moisson (The Harvest)* are taken apart and used as random quotations, like graffiti on a wall beneath the admonitory heads further up (cat. 62). The ubiquitous Degas and his scenes of Parisian night life are remembered on a jar adorned with a delicately modeled female figure resembling a dancer or singer (cat. 59).

But he derived most of his motifs from the mass of material he had brought home with him from Brittany—mainly for his paintings, though undoubtedly with the approaching challenge of his ceramic work in mind. Inspired by Pissarro's peasants, his

shepherdesses and shepherd boys looking after their sheep and geese signal an originality corresponding to the originality of stoneware as a material. The pastoral scenes are often idyllic, and have generally been seen as an extension of the motifs beloved of the Impressionists, although the presentation of the Breton girl on the shoulder of the *Jug with Seated Shepherd Girl, Lamb, and Goose* as an Eve after the Fall is unmistakably a step toward Symbolism (cat. 63).[61] Similarly, the linear emphasis in such works as the Brussels vase points forward to the simplified idioms of Synthetism and Cloisonnism (fig. 239).

Gauguin created a distinctive style in which small, naturalistically formed figures with sheep, goats, cows, and geese alternate with various kinds of ornamentation against the clay's own brown ground. He did so on the basis of traditions created over the immediately preceding years by Chaplet and his colleagues. The mixture of figures in a naturalistic or impressionistic presentation with decorative details was a hallmark of the Rue Blomet workshop. Along with Aubé and others, including Jules Dalou, Désiré Ringel d'Illzach, and Albert-Louis and Edouard Dammouse, Chaplet had combined a form of Japonisme for the natural elements with a more lifelike style for the figures[62] ever since his time in Auteuil. Dalou had become especially famous for his naturalism.[63]

Gauguin's inspiration was multifarious. Perhaps that is what Bracquemond was thinking of when, according to Pissarro, he spoke of the first ceramics as though they were "sailor's art, a bit from here, a bit from there"—a scarcely concealed reference to Gauguin's seafaring past.[64] Gauguin's reuse of his own and other artists' motifs, and the inspiration for the shapes of vases that he took from non-European cultures, as well as from old German and French stoneware, were obvious. The practice of reusing motifs, which began in the paintings, fans, and wood carvings of his Impressionist years, was becoming systematized in his ceramics. What had perhaps originated as an amateur's short cut to acquiring the skills of a trained artist turned into an artistic principle—an essential element in Gauguin's confrontation with Impressionism and search for a new path.

He took figures and other elements out of their first contexts and incorporated them into new ones in a process by which the individual characteristic gave way to an attempt at something universal or typical. This is seen with particular clarity in the way in which Gauguin develops the recurrent motif of the little Breton girl standing with her back to us. Here it was Degas who provided the inspiration. His eccentric painting of *Peasant Girls Bathing in the Sea at Sunset* was in the second Impressionist exhibition in 1876 (fig. 248).[65] Although it is a long way from Degas's sequence of elegant figures to Gauguin's awkward little Breton girl, the feeling of homage is obvious; indeed it had already asserted itself in a charcoal drawing of bathing women that Gauguin made in Dieppe in 1885 (fig. 249).[66] The Breton girl is a recurrent figure in Gauguin's ceramics. She is portrayed singly in a way in which she typically supports the vase, but she is also portrayed two or even three times in one and the same work, and here the motif carries reminiscences of Degas's chain composition. The repetition acquires a strangely automatic character, turning the figure into a stereotype (cats. 66–68). It reminds one of

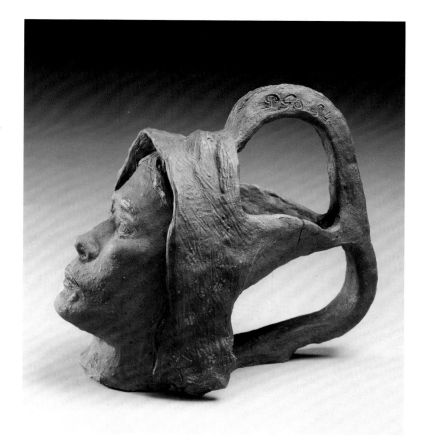

Fig. 227 Paul Gauguin, vessel in the form of the *Head of a Breton Girl*, 1886–87. Unglazed stoneware decorated with black slip and gold paint, height 5¹/₂ in. (14 cm). Private collection, USA

Rodin, who at this time was developing a small repertoire of recurrent figure types that could be endlessly reused and recombined to assume new meanings—figures devoid of individual characteristics and filled with a universal content. Gauguin was also developing the archetypes of his work, and ceramics were an important element in this process taking him from Impressionism towards Synthetism.

Gauguin's ceramics never became real ceramics in the functional sense. His vases, jars, and pots are more like paraphrases of vases, jars, and pots than real ones. From the start they were sculpture, which was precisely the term Gauguin always used for them. In a work like the *Vessel in the Form of the Head of a Breton Girl*, his intentions and attitudes find a clear and concrete expression (fig. 227).[67] He did not work it as a hollow form from the start like most of his early ceramics but from a lump of clay that he hollowed out afterwards. It was the first of his anthropomorphic vases with a backward tilt to the head, inspired by Peruvian pottery and recalling the *Bust of Jean Gauguin* (cat. 23), but also looking forward to the Symbolist *Self-Portrait Vase* of 1889 (fig. 94).[68]

The Work of Art in the Work of Art

Just as we have seen Gauguin quoting from his heroes—for instance, in reusing motifs from Cézanne's *The Harvest* on one of the vases (cat. 62)—he also started quoting himself, introducing his works into this process. Gauguin expressed a typical fascination with his own work as subject-matter in a watercolor of a couple of ceramics that he made after his visit to Martinique (fig. 228).[69] At the same time this underlines his

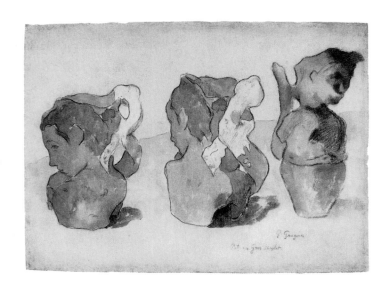

Fig. 228 Paul Gauguin, *Drawing of Portrait-Vases*,
c. 1887–89. Gouache, watercolor, and charcoal,
12¹/₂ × 16³/₈ in. (31.8 × 41.6 cm). Collection of the Frances
Lehman Loeb Art Center, Vassar College, Poughkeepsie,
N.Y. Bequest of Sarah Hamlin Stern, class of 1938, in
memory of her husband, Henry Root Stern, Jr. (1994.2.1)

Fig. 229 Paul Gauguin, *Horned Rats*, detail of *Studies and
Sketches for Ceramics*, from *Album Briant*, p. 20 (recto).
Musée du Louvre, Paris, Département des Arts
Graphiques (RF 30273, 9)

Fig. 230 (*right*) Paul Gauguin, *Portrait of Madame
Alexander Kohler*, 1887. Oil on canvas, 18¹/₄ × 15 in.
(46.3 × 38 cm). National Gallery of Art, Washington.
Chester Dale Collection (1963.10.27.(1691)) (WII 258)

Fig. 231 (*far right*) Paul Gauguin, *Still Life with Fan*,
c. 1887–88. Oil on canvas, 19³/₄ × 24 in. (50 × 61 cm).
Musée d'Orsay, Paris (RF 1959–7) (WII 259)

awareness of three-dimensionality in working in ceramics—the changing angles from which the work is viewed. As we turn it in our hands, new works appear in an endless metamorphosis. The fascination that Gauguin felt with his own ceramic work, however, emerges principally from the still lifes, where he has portrayed them as though they were alien, magical objects, created outside his field of vision. They can be compared with the way in which he had earlier painted a couple of favorite objects on his canvases. He invested them with an aura like that of the Norwegian *tine* in enigmatic still lifes of earlier date (see figs. 71, 130, 191, and cat. 13), and the painted wood carving of a basket of fruit in the portrait of Clovis (cats. 14 and 55). The ceramics appear within the paintings with all the fascination of the alien and unintelligible, a strange unapproachability, a compelling distance. It is as if the artist were viewing them with the same intensity as his friend Laval views the now-lost one in the mysterious *Still Life with Laval's Profile* (cat. 75).[70]

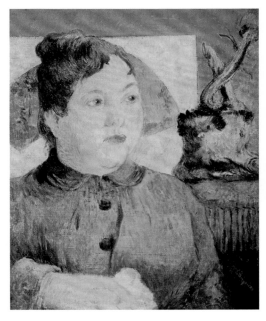

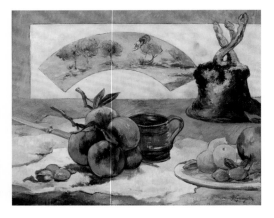

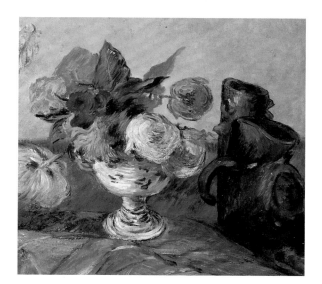

Fig. 232 Paul Gauguin, *Pots and Bouquets* (detail of fig. 256)

Another ceramic work that is known only because Gauguin painted it is the organic *Horned Rats*, in which some rats' heads are incorporated into the pot's broad base and crowned with hornlike excrescences (fig. 229). It appears in two paintings, probably from about 1887–88, in each case shown with one of the rat's faces turned out towards us.[71] One is the *Portrait of Madame Alexander Kohler*, where the figure of the sitter has to compete with the ceramic work for the viewer's attention (fig. 230).[72] The other is the *Still Life with Fan*, in which the pot is the unsettling focus of the entire composition (fig. 231).[73] Gauguin asked Schuffenecker to send this work to him during his stay in Arles in 1888, wishing to have it in the house that he was sharing with van Gogh at the time.

Curiously, a ceramic of 1887–88, the *Double Vessel with Mask of a Woman*, features in a still life of 1886, *Pots and Bouquets* (fig. 232).[74] The explanation for this is that, having finished the ceramic, Gauguin simply added it into an existing painting. He squeezed it into the composition near the right-hand border, imparting to an otherwise rather innocuous still life something of the disturbing quality of which his ceramics are so supremely possessed.

Jardinière with Motifs from the **Breton Women Chatting**, 1886–87
Stoneware decorated with colored glaze,
 $10^5/_8 \times 15^3/_4 \times 9$ in. (27 × 40 × 23 cm)
Signed: *P. Gauguin*, stamped with Chaplet's seal
Association des Amis du Petit Palais, Musée d'Art
 Moderne, Geneva
Not in exhibition

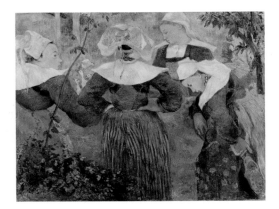

Fig. 233 Paul Gauguin. *Breton Women Chatting*,1886. Oil on canvas, $28^3/_8 \times 35^7/_8$ in. (72 × 91 cm). Neue Pinakothek, Bayerische Staatsgemäldesammlungen, Munich (8701) (WII 237)

This large jardinère is one of the ceramics that Gauguin made in the winter of 1886–87 in Chaplet's workshop in the Rue Blomet, Paris.[75] It has been thoroughly restored after damage sustained during the Second World War but retains the main elements of its decoration.[76] Like Gauguin's other large jardinière, it was made after the summer of 1886 and has motifs from his first visit to Brittany (fig. 237).[77] Of the two, this is thought to be the first, partly because the technique is more uncertain and tentative, partly because Chaplet's mark, a rosary with "H & Co" (Haviland and Company) at the center, is found under its base. The jardinière is an example of the cooperation established between Chaplet and Gauguin in which Chaplet shaped the pot and Gauguin decorated it. Four works bearing the signatures of both men are known,[78] all made before Chaplet stopped working for Haviland's in 1887.

The piece is one of the clearest examples of Gauguin's strategy in his early ceramics. He used his experience in the media with which he was familiar—painting, drawing, and wood carving—transferring motifs from them to the new medium of ceramic. In the jardinière he used a mixture of "painting," low relief, and "drawing" in the form of incised lines. The principal source of the decoration was the large painting *Breton Women Chatting* of 1886 (figs. 233, 253).[79] Gauguin used the two

Fig. 234 Paul Gauguin, *A Grazing Cow; Head of a Woman, Head of a Man* (verso) (detail), from Rouen sketchbook, 1884–88. Pen, brown ink, and graphite on wove paper, $6^5/_8 \times 8^7/_8$ in. (16.9 × 22.5 cm). National Gallery of Art, Washington. The Armand Hammer Collection (1991.217.56.b)

outermost figures of the composition—for which no sketches are known—and placed one on each long side. The end piece's little boy with the red jug is a motif he reused from a colored chalk drawing in one of his sketchbooks (fig. 236),[80] while the cow on one long side relates to some other sheets in the

same sketchbook (fig. 234). One of the two women—seen in profile to the left—is also found in another ceramic work, the *Vase with Breton Girl*, probably from about the same time (fig. 235).[81]

Though starting out from the familiar, Gauguin grasped the potential of his new medium and allowed the third dimension to grow out of the others, raising the motif and unfolding it three-dimensionally. Painting became relief. The Breton girls sit sculpturally—fashioned on the corners of the jardinière—and effect the transition to the next panel of the decoration, on the end piece. The movement from panel to panel is broken up in a sophisticated manner that can be compared to the way in which, in his pastel portraying Aubé, he united the transition between its two

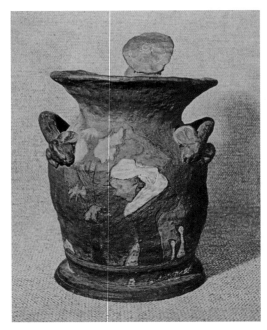

Fig. 235 Paul Gauguin, *Vase with Breton Girl*, 1886–87. Reddish brown stoneware, unglazed, decoration scratched on body and painted with slip, height $10^1/_4$ in. (26 cm). Private collection

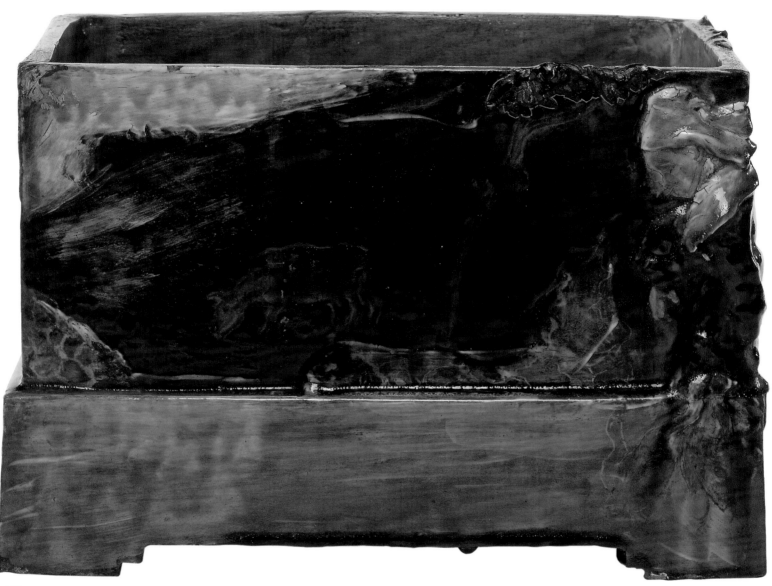

cat. 58

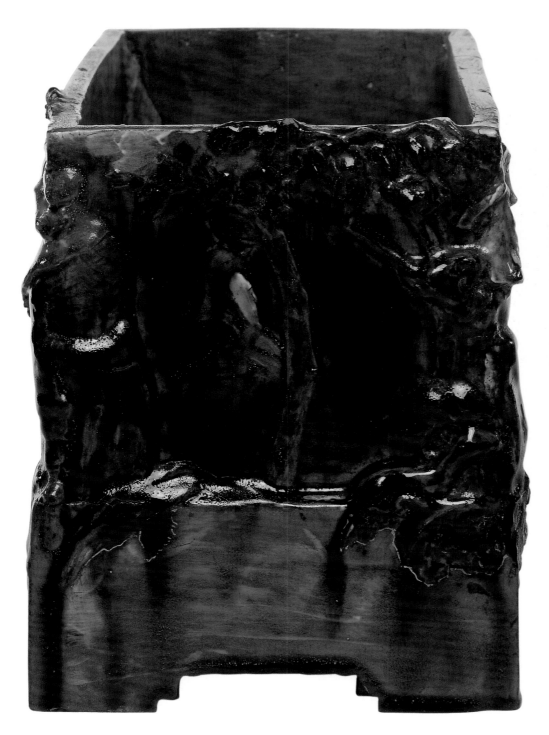

Fig. 236 Paul Gauguin, *A Breton Boy with a Jug; Five Animal Forms* (verso) (detail), from Rouen sketchbook, 1884–88. Crayon and graphite on wove paper, 6⅝ × 8⅞ in. (16.9 × 22.6 cm). National Gallery of Art, Washington. The Armand Hammer Collection (1991.217.52.b)

left Paul Gauguin, *Jardinière with Motifs from the* Breton Women Chatting (alternative view of cat. 58)

separate sections by a piece of art, a vase (fig. 224).[82] The motifs in the jardinière are painted with slip or colored glaze in a thick, glossy coat and seen against a dark background with colors ranging from deep greenish blue to shades of brown. The foliage is dark green, and several of the contours have been brought out in gold. The glazing ran during the firing, however, so we must bear in mind the fact that the colors might have changed from the artist's original intentions.

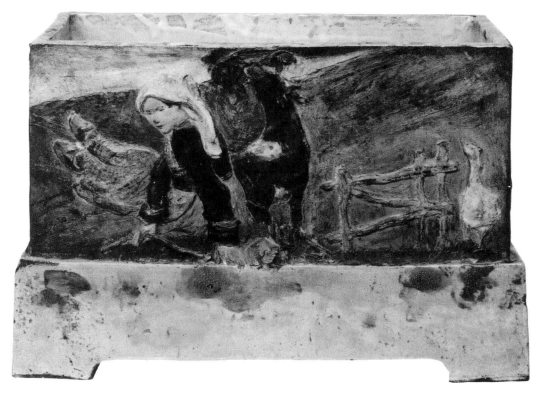

Breton Women Chatting—the so-called Brussels vase—in which he controlled the paint by a system of "cloisons," based on a technique developed in 1874 by the ceramicist Theodor Deck under the name of "émaux cloisonnés" (fig. 239).[84]

Merete Bodelsen has pointed out that the *Vase with Breton Girl* (fig. 235), which also contains motifs from *Breton Women Chatting*, is a "deliberate counterpart" to the Brussels vase and represents a further step forward in the direction in which Gauguin wanted to take his ceramics.[85] Instead of covering the clay with a white slip, here he leaves it in its own reddish brown color. For a time he was to use this as the background for decorations in colored slip that he left matte and unglazed during firing.[86]—A-BF

Fig. 237 (*above*) Paul Gauguin, *Rectangular Jardinière Decorated in Barbotine*, 1886–87. Stoneware decorated with barbotine and glaze, 10⅝ × 15¾ × 8⅝ in. (27 × 40 × 22 cm). Private collection

Fig. 238 (*left*) Paul Gauguin, *The Breton Shepherdess* (detail of cat. 72)

Fig. 239 (*right*) Paul Gauguin, *Vase Decorated with Breton Scenes*, 1886–87. Chocolate-colored stoneware decorated with colored glazes, incised outlines, and lines in gold, height 11⅝ in. (29.5 cm). Musées Royaux d'Art et d'Histoire, Brussels

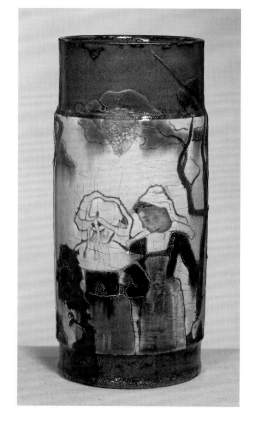

The other large jardinière (fig. 237), in which Gauguin combined motifs related to *Breton Shepherdess* (fig. 238 and cat. 72) with a repetition of the composition from the wood relief *La Toilette*, is technically more advanced, and the use of barbotine decoration prevented the color from running during the firing.[83] Gauguin demonstrated even greater mastery with the glazing technique on the cylindrical vase, likewise decorated with motifs from

59

Vase Decorated with the Half-Length Figure of a Woman, 1886–87
Brown, unglazed stoneware; the dress of the figure painted in white slip, the necklace dark blue, and the leaves green; height 8$\frac{1}{2}$ in. (21.6 cm)
Signed: *P Go*; numbered: *19*
The Danish Museum of Decorative Art, Copenhagen (B17/1943)

The vase belongs to the early group of ceramics that Gauguin modeled in a primitive manner by hand—without the use of a potter's wheel—in a hard-fired stoneware clay that he left unglazed in the material's own reddish brown color.[87] It is one of the rare pieces that still bear the artist's original numbering—in this case 19, the lowest of the surviving numbers. This delicately modeled and highly sophisticated work must have been among the earliest in the first firing. It is an important example of Gauguin's ongoing dialogue with his sources. The bust of a woman is clearly reminiscent of a Degas ballet dancer,[88] as well as Gauguin's own wood relief *The Singer*, of 1880 (cat. 21). The figure's bodice is painted in white slip, the necklace is dark blue, and the foliage green.

This vase should be seen in relation to the succeeding one, number 20, which has also retained its original numbering: the *Vase Decorated with a Fishing Scene* (cat. 60). Both are relatively simple in shape, with sculpturally executed figures. Neither is decorated with obviously Breton motifs, and so we cannot exclude the possibility that they were made before the summer Gauguin spent in Brittany.[89] On the other hand, this would imply that a considerable part of the first firing of fifty-five works might similarly have been made before that summer, which is scarcely probable in view of the dominance of Breton motifs in works of 1886–87.—A-BF

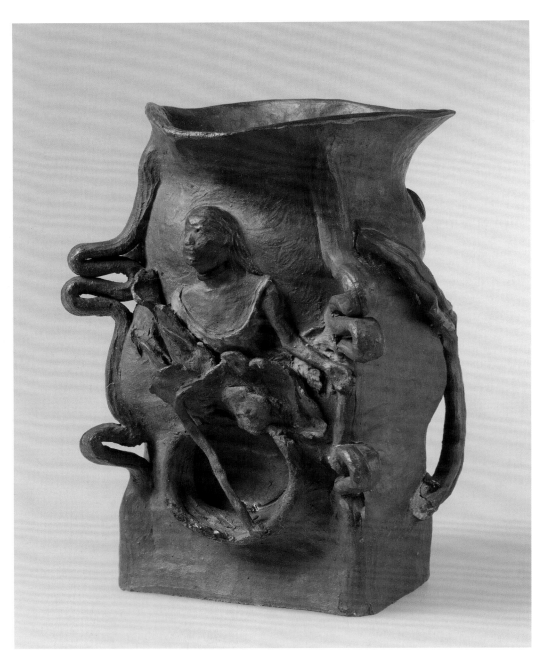

cat. 59

60

Vase Decorated with a Fishing Scene, 1886–87
Coffee-colored, unglazed stoneware; the woman's
 hat is painted in a darker brown slip, the
 foliage of the tree in gray blue barbotine; on
 the reverse of the pot there are three bonnets
 painted in white slip; height $5^7/_8$ in. (15 cm)
Signed: *P Go*; numbered: *20*
Musée d'Orsay, Paris. Gift of Lucien Vollard,
 1943 (AF 74329–4)

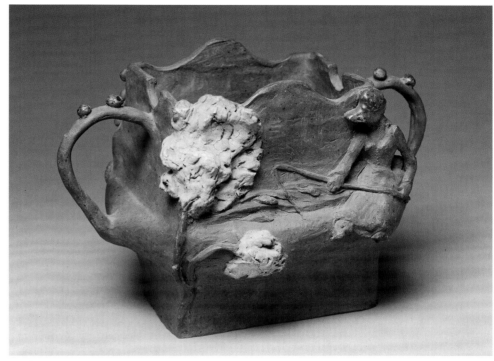

cat. 60

Like the *Vase Decorated with the Half-Length
Figure of a Woman*, this is one of the rare
ceramics to have retained the number that
Gauguin added before and after firing.[90] As
number 20 it must belong to the first firing he
carried out in Chaplet's workshop in the Rue
Blomet, Paris, during the winter of 1886–87. It
is relatively simple in shape and, with its little
fisher girl, belongs to a group that does not
have specifically Breton motifs. Gray therefore
placed it among the very earliest works.[91] This

Fig. 240 (*right*) Paul Gauguin, *Geese; Girls in Bonnets,
Geese* (recto) (detail), page from Rouen sketchbook,
1884–88. Graphite on wove paper, $6^5/_8 \times 8^7/_8$ in.
(16.9 × 22.6 cm). National Gallery of Art Washington.
The Armand Hammer Collection (1991.217.31.a)

below Paul Gauguin, *Vase Decorated with a Fishing Scene*
(back view of cat. 60)

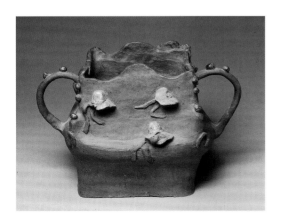

would imply that Gauguin made at least
twenty ceramic works between making his
arrangement with Chaplet and his departure
for Brittany in July 1886, which seems
unlikely. In principle, however, the vase could
have been made either before or after the
Breton summer.

The motif is typical of Gauguin's
Impressionist friends, presenting modern, open-
air life in idyllic form: a lady fishing, protected
from the rays of the summer sun by her
bonnet. With the water flowing past and the
movement in the top of the small tree caused
by the wind, the motif is one of great poetical
charm; on the reverse are three bonnets caught
by a gust of wind—stylized, abstract forms and
at the same time symbols of a delightful day in
the countryside. The use of a thrice-repeated
motif as a compositional principle was a
recurrent phenomenon in several of the

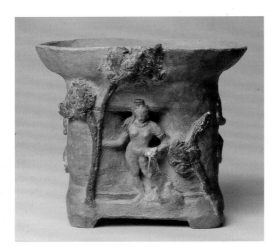

Fig. 241 Paul Gauguin, *Pot Decorated with the Figure of a Woman under a Tree*, 1886–87. Buff-colored stoneware, unglazed; the hair of the woman, trees, and leaves painted with brown slip, the woman's robe grayish blue green, accents in gold, height 5³/₈ in. (13.5 cm). Musée d'Orsay, Paris

ceramic works.⁹² There is a sketch for the bonnets in one of Gauguin's early sketchbooks (fig. 240).⁹³ The vase is mainly unglazed and decorated with both slip and a thicker, barbotine-like clay that has been used to fashion colored elements such as the tree.⁹⁴

Other ceramics can be related to this and the preceding work (cat. 59), including the *Pot Decorated with the Figure of a Woman under a Tree* (fig. 241). It is similarly simple in conception, with a more traditional pot shape,⁹⁵ contains no Breton motifs, and was made using a technique reminiscent of relief sculpture, without any significant engraving. —A-BF

61

Jug with Delacroix Motif of Algerian Horseman, winter 1886–87
Unglazed stoneware, decorated with slip, glaze, and gold; height 7¹/₈ in. (18 cm)
Signed above the entwined rings, with an engraving in the clay: *P Go.*
Ny Carlsberg Glyptotek, Copenhagen (I.N. 3546)
Ordrupgaard only

Here Gauguin's choice of an Orientalist motif pays tribute to Delacroix in the same way the *Vase with Motifs from Cézanne's La Moisson (The Harvest)* (cat. 62) pays tribute to Cézanne.⁹⁶ The jug is made in unglazed, reddish brown stoneware clay, which is decorated with a small amount of glaze and gold. It belongs to a group of ceramics with a complex appearance, but which in reality are based on a relatively simple principle. It is constructed as though one oval pot (without a bottom) had been placed above another, larger pot of the same shape, producing a pot with bulges or pockets on the sides and three openings on two levels.⁹⁷ Small rolled clay sausages on one side of the pot recall the fittings for straps on traditional flasks.

Gauguin provided his pot with three vertical handles, one of which is supported by interwoven rings that constitute the decoration on that side. On the other side is the pot's principal motif, a Delacroix-like Arab on horseback. Modeled in low relief and partly hidden behind two of the handles, this figure is very much in the nature of a memory or vision. Above, a radiant sun is seen together with a recumbent crescent moon. The sun is a recurring motif among the ceramics (fig. 241).⁹⁸ Here, combined with the moon, it could relate to Delacroix and symbolize the great Romantic painter's infatuation with the Oriental.

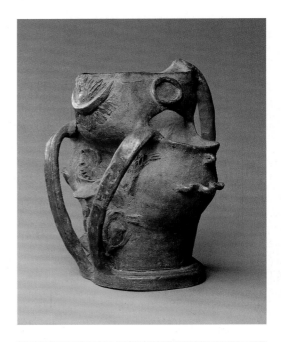

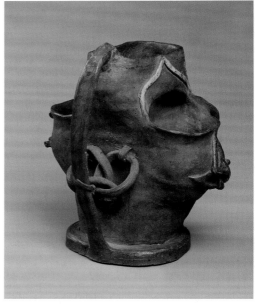

above Paul Gauguin, *Jug with Delacroix Motif of Algerian Horseman* (alternative views of cat. 61)

There are traces of a grayish brown glaze on the handles. The pointed, archlike decoration above one of the pockets is painted with white slip, and the circle above the other with a brown glaze. Here and there, the ornament shows a brown glaze or a little white and blue black slip; there are also traces of gilding. The remains of Gauguin's original label can be seen under the base. —A-BF

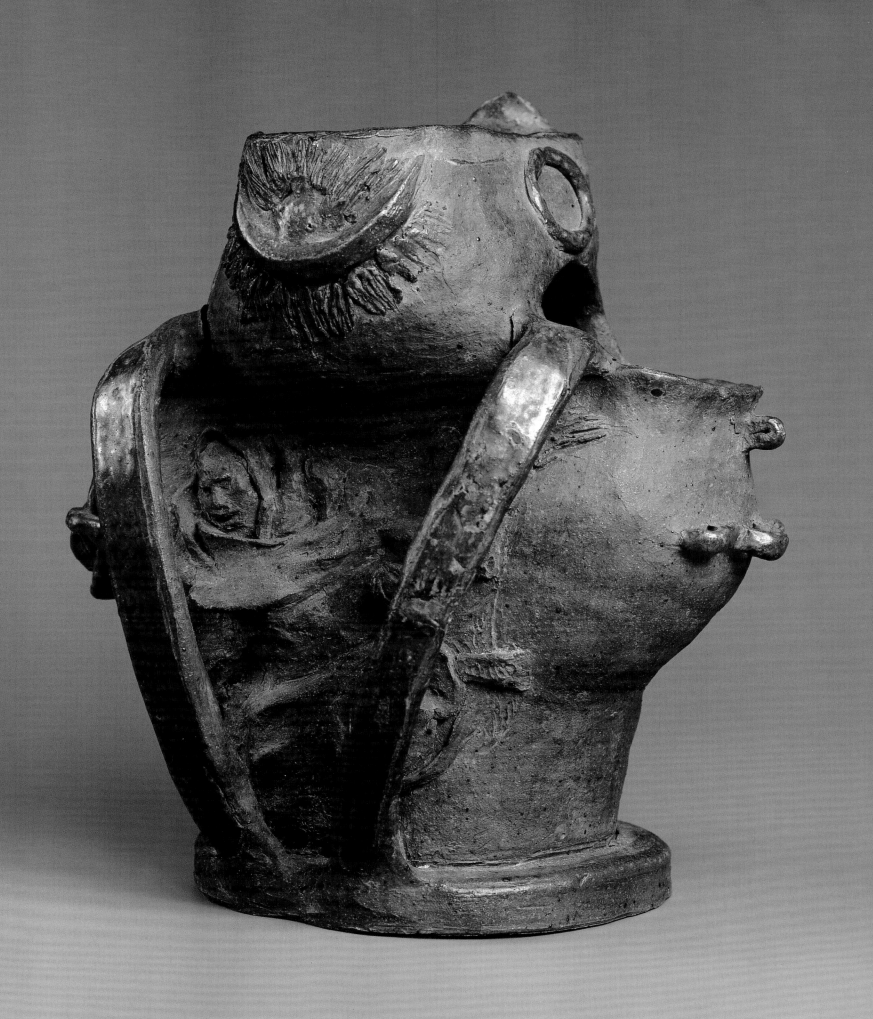

62

Vase with Motifs from Cézanne's **La Moisson**
 (The Harvest), winter 1886–87
Unglazed stoneware, decorated with slip and gold;
 height 6¼ in. (16 cm)
Signed to the left of the straw hat: *P Go*
Ny Carlsberg Glyptotek, Copenhagen (I.N. 3549)

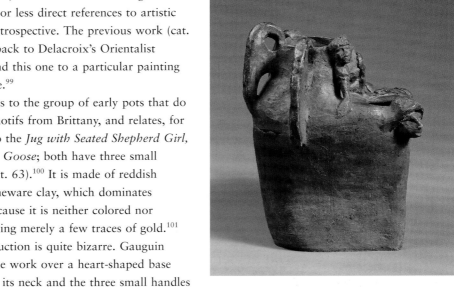

Gauguin's ceramics are innovative, experimental, and at the same time—given their more or less direct references to artistic models—retrospective. The previous work (cat. 61) looks back to Delacroix's Orientalist imagery, and this one to a particular painting by Cézanne.[99]

It belongs to the group of early pots that do not have motifs from Brittany, and relates, for instance, to the *Jug with Seated Shepherd Girl, Lamb, and Goose*; both have three small handles (cat. 63).[100] It is made of reddish brown stoneware clay, which dominates visually because it is neither colored nor glazed, having merely a few traces of gold.[101] The construction is quite bizarre. Gauguin modeled the work over a heart-shaped base and placed its neck and the three small handles asymmetrically beside two openings on its shoulder. This provided a space in which to model the principal motif of a reclining girl with long, flowing hair. She wears a dress with puff sleeves, and in one hand holds the golden ribbons from her straw hat, which appears on the shoulder of the jar between the two

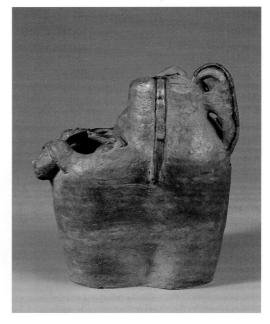

above Paul Gauguin, *Vase with Motifs from Cézanne's La Moisson (The Harvest)* (alternative views of cat. 62)

Fig. 242 Paul Gauguin, *Sketches of Pots and Figures*, from *Album Briant*, p. 25 (recto), 1886. Pencil. Musée du Louvre, Paris, Département des Arts Graphiques (RF 30273, 14)

openings—themselves surrounded by small ribbons painted in a little gold. As on several other ceramics—for instance, the two large jardinières (cat. 58 and the *Rectangular Jardinière Decorated in Barbotine*, fig. 237)[102]—the artist emphasized the corners with decorations in relief. In this case they are small female heads reminiscent of the decorative heads on medieval buildings.

The motif that gives the vase its name appears on its sides. Here we see rural scenes taken from Cézanne's *La Moisson (The Harvest)* and incised in the clay with a much-simplified contour (see fig. 41).[103] The side of the jar beneath the reclining girl is almost filled with this incised drawing. Van Gogh was also interested in Cézanne's *The Harvest*, but it was the painting's mood that appealed to him whereas Gauguin was "fascinated by the ornamental aspect of the combination of figures," copying and paraphrasing individual elements as he pleased for his own purposes.[104] It is likely that Gauguin himself owned this painting, and he used elements from it for a fan decoration while living in Copenhagen.[105]

Merete Bodelsen has shown that working on this vase, as with the Brussels vase (fig. 239)[106]—helped Gauguin toward the simplification of line that was to be the basis of his Cloisonnism.[107] The figures of the man swinging a scythe in the foreground and the woman binding sheaves of corn are reduced to bold outlines.

There is a drawing of the vase in one of Gauguin's sketchbooks, probably made as some kind of documentation of the features of the work before a possible sale (fig. 242).[108]
—A-BF

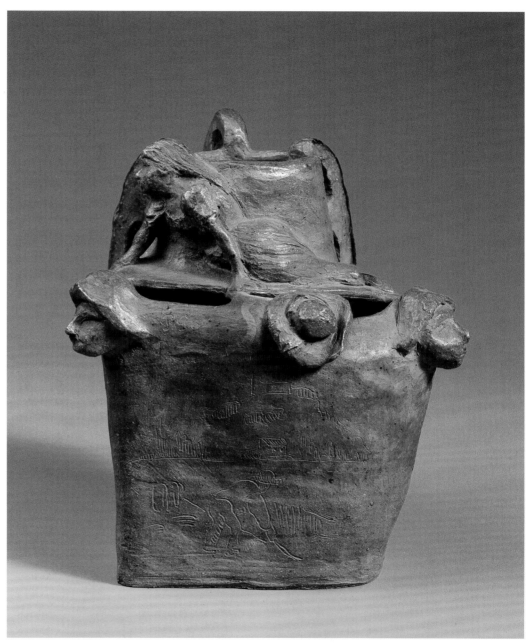

cat. 62

63

Jug with Seated Shepherd Girl, Lamb, and Goose, winter 1886–87
Glazed stoneware; height 7¼ in. (18.5 cm)
Signed to the left of the left handle: *P Go* (in
 gold); scratched on bottom of the base: *47*
Ny Carlsberg Glyptotek, Copenhagen (I.N. 3547)
Ordrupgaard only

Some of Gauguin's ceramics from the productive winter of 1886–87 constitute a remarkable exploration of technical boundaries. This certainly applies to a work such as *Jug with Seated Shepherd Girl, Lamb, and Goose*. In its style and motifs this clearly belongs with the first ceramic group, although it is among the few that have a thick, glossy glaze and golden ornamentation.[109] The signature on the jug (P Go) is applied in gold on top of the glaze, and the number 47 is incised under the base, placing the work among the later ones in the group of fifty-five.

In structure, the jug is related to the *Vase with Motifs from Cézanne's La Moisson (The Harvest)* (cat. 62). It too has three handles and the classical motif of a female figure reclining in a landscape, modeled in relief. Here, it is a Breton girl reclining on the jug's shoulder. Her dark blue bodice is partly painted in gold. To the left of her there is a sheep, to the right a tree with a dark, green glaze, and on the opposite side a goose drawn in gold.

The glaze, which also covers the inside, is dominated by shades of gray, yellow, and brown dotted with a little red; white, blue, green, and gold have been used for the decoration.[110] The glazes and colors are apparently of the same type as those found on the early Brussels vase, of which the jug is in many ways a further development (fig. 239).[111]

The jug's theme has been related to the erotic content of Gauguin's Breton works.

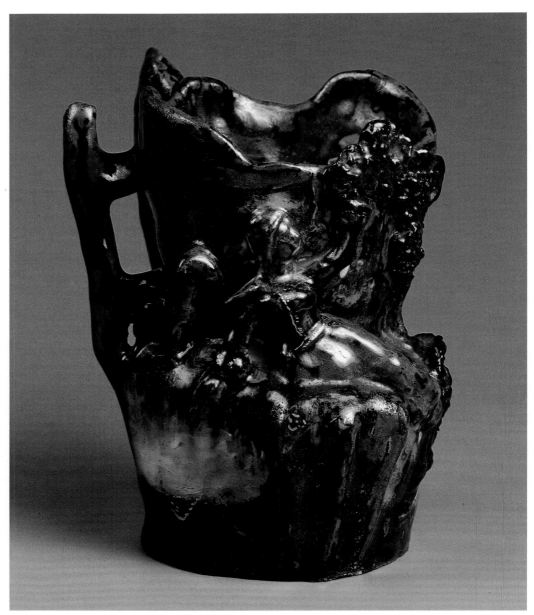

cat. 63

According to Henri Dorra, the shepherd girl is in reality on the road to eternal damnation, and a better title for the jug would be *Vase mit halbbekleideter bretonischer Eva (Vase with Half-Clothed Breton Eve)*. He believes the girl is wearing only an undergarment, with legs as naked and "splattered with bloodlike spots."[112] With her left hand she plucks a piece of fruit from the tree of knowledge, while with the first finger of her large right hand she points to the depths of hell. Gauguin is ironically relating the idea of carnal sin, Dorra

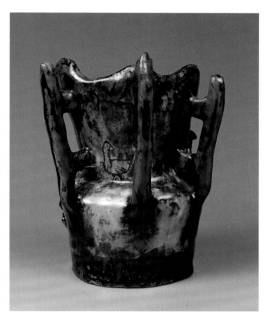

64

Jar with Breton Girl and Sheep Modeled on Lid,
winter 1886–87
Unglazed stoneware, decorated with colored slip;
height 6¼ in. (16 cm)
Signed on top of the jar, alongside one of the
cornets: *P Go*
Ny Carlsberg Glyptotek, Copenhagen (I.N. 3545)
Ordrupgaard only

This is one of a small group of ceramics with
fantastic, hornlike shapes that emerged with
the cornet as their starting point, all complex
in structure and decorated with Breton girls.[114]
Druick and Zegers have described the group as
Gauguin's most extreme, observing that they
"evoke the pre-industrial, even the pre-
linguistic, with their emphasis on tactility and
their associative—and occasionally formal—
suggestions of bodily functions and orifices."[115]

*Jar with Breton Girl and Sheep Modeled on
Lid*—which is mainly unglazed—is highly
articulated and has no fewer than five
openings.[116] It has two pocketlike bulges on
one side and on the opposite side two large
horns held in place by some branches and
foliage painted with a light green slip. The
central decoration is the Breton girl, who is
resting on the lid of the jar looking upwards
and surrounded by her sheep. This kind of
figure became a recurrent motif in Gauguin's
works of this time, an early archetype in his

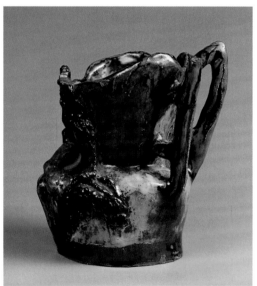

above Paul Gauguin, *Jug with Seated Shepherd Girl, Lamb,
and Goose* (alternative views of cat. 63)

concludes, to the Parisian avant-garde's belief
in sexual freedom. The motif anticipates later
works such as the wood relief *Reclining
Woman with a Fan* of 1887.[113]—A-BF

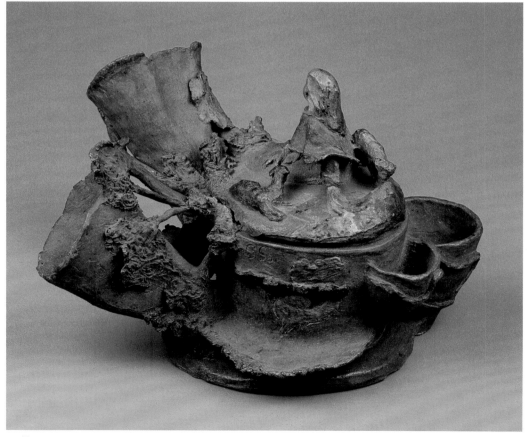

cat. 64

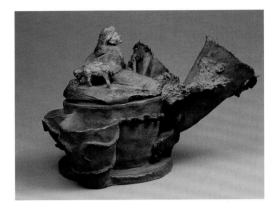

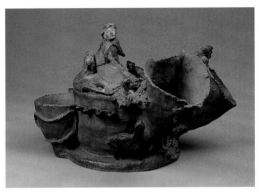

above Paul Gauguin, *Jar with Breton Girl and Sheep Modeled on Lid* (alternative views of cat. 64)

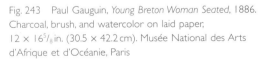

Fig. 243 Paul Gauguin, *Young Breton Woman Seated*, 1886. Charcoal, brush, and watercolor on laid paper, 12 × 16⁵/₈ in. (30.5 × 42.2 cm). Musée National des Arts d'Afrique et d'Océanie, Paris

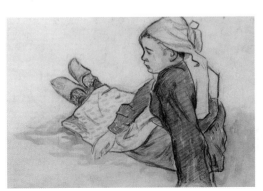

oeuvre. It also appears in the charcoal drawing with watercolor and pastel (fig. 243) that was the model for the painting *Breton Shepherdess* of 1886 (fig. 238) and one of the two large jardinières (fig. 237). On its other side, the jardinière shows a repetition of the composition with the nude girl in puberty, which Gauguin had carved in 1882 for his wood relief *La Toilette* (fig. 143).[117] Here the figure was to undergo a metamorphosis from the two-dimensional to the three-dimensional, raised from a plane surface and given plastic form. During this process, some features from a related figure, especially the upward-looking head, were brought in. This figure is known from a large study drawing in charcoal and pastel, and it was, among other things, used as the pattern for the decoration of the Brussels vase (fig. 239).[118]—A-BF

Fig. 244 (*left*) Paul Gauguin, *Five Sheep; Head of a Woman and Head of a Bearded Man* (recto) (detail), from Rouen sketchbook, 1884–88. Pen, brown ink, and graphite on wove paper, 6⁵/₈ × 8⁷/₈ in. (16.9 × 22.6 cm). National Gallery of Art, Washington. The Armand Hammer Collection (1991.217.59.a)

65

Vase with Bretons and Sheep, 1886–87
Unglazed stoneware, motifs modeled and incised;
 height 8¼ in. (21 cm)
Signed: *P Go*
Département de la Réunion, Musée Léon Dierx,
 Saint-Denis, La Réunion (MLD 47.01.50)
Not in exhibition

This pot epitomizes Gauguin's aims in the ceramics he made in Chaplet's workshop in the Rue Blomet.[119] It is modeled in a primitive style in a hard-fired stoneware clay that is left unglazed in the material's own reddish brown color, with decorations added in relief, in the glazing, with slip, or by incision. It is constructed on a circular basis with three organically shaped openings—or spouts—that are placed regularly around its shoulder. Between the openings, Gauguin modeled some figures—a boy and a girl in traditional costumes—in addition to some sheep that are recognizable from early sketchbooks (fig. 244).[120] The girl is related to the Breton girl standing with her back to us—one of the archetypes of this group of works—but here she has been turned round and is seen frontally, her arms resting on the belly of the pot.[121] The decoration is organized as a circlet around the pot and underlines its regular, rounded shape.[122]—A-BF

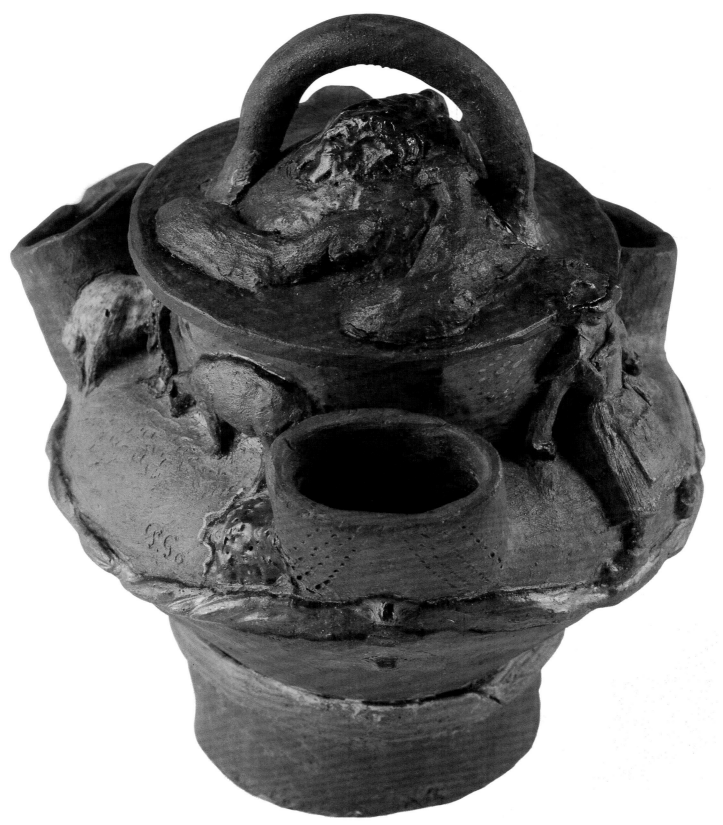

cat. 65

66

Vase with Medallion, 1886–87
Stoneware, decorated with incised lines and
 colored slip, unglazed, height 9⅝ in. (24.4 cm)
Signed: *P Go*
The Danish Museum of Decorative Art,
 Copenhagen (B 16/1943)

This work is reminiscent of a tankard with an
opened lid and fittings to fix a strap for
carrying.[123] It is modeled in a cylindrical shape
on a circular base. On the open "lid" there is a
crablike object, and beneath is the "medallion"
that has given the work its name. On a white-
painted ground there is a decoration with two
geese. They are laterally inverted in relation to
each other and are drawn in a simplified,
incised contour, the lines of which are
interlaced. The result is an arabesquelike

Fig. 245 Hokusaï, *Geese*. Illustration from *Ippitsu gafu*,
c. 1816. Print

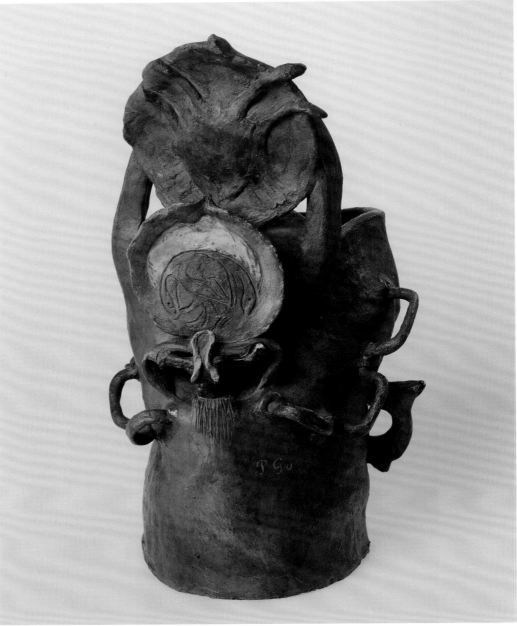

cat. 66

ornament that seems Japanese in character
(fig. 245).[124]

 One of the recurrent motifs of Gauguin's
early ceramics was a Breton girl standing with
her back to us and arms outstretched; the
figure appears in several of his early
sketchbooks: *Breton Girl and Goose* (fig. 246);
Vase with Breton Girls (fig. 252); and *Two
Breton Girls* (fig. 247).[125] She is a naïve and
rustic version of some bathers with their backs
to the viewer in a painting by Degas that

Gauguin found especially fascinating (fig.
248).[126] Paraphrases of the same figures appear
in both paintings and drawings from his visit
to Dieppe in the summer of 1885 (figs. 249,
250).[127] In the *Vase with Medallion*, the Breton
girl is immediately beneath the medallion,
where she looks as though she is supporting or
carrying it. The figure shows a sophisticated
juggling with the various techniques of ceramic
decoration. Gauguin indicates her skirt with a
few incised lines, the upper part of her body

with a little blue paint, and her headdress in three dimensions, modeled in a little clay.

The figure was to appear again on several of the ceramics, including the *Vase Decorated with Three Breton Girls* (fig. 251), the *Pot with Three Breton Girls and Geese* (cat. 68), and the *Vase Decorated with the Figure of a Breton Woman* (cat. 67).[128] It was later used for the decoration on a pair of clogs.[129]—A-BF

Fig. 246 Paul Gauguin, *Breton Girl and Goose*, detail of *Profile of Man and Four Caricatures* (recto), from Rouen sketchbook, 1884–88. Graphite and crayon on wove paper, 6⅝ × 8⅞ in. (16.9 × 22.5 cm). National Gallery of Art, Washington. The Armand Hammer Collection (1991.217.56.a)

Fig. 249 (*above*) Paul Gauguin. *Bathers at Dieppe*, 1885. Crayon, charcoal, and black ink on paper, 12¼ × 18⅝ in. (31 × 47.2 cm). Musée Léon Dierx, Saint-Denis de la Réunion (MLD 47.01.54)

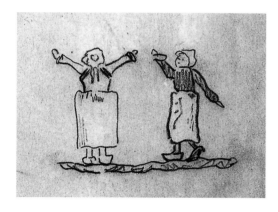

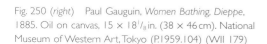

Fig. 247 Paul Gauguin, *Two Breton Girls*, detail of *Sketches of Pots and Figures*, from *Album Briant*, p. 25 (recto). Musée du Louvre, Paris, Département des Arts Graphiques (RF 30273, 14)

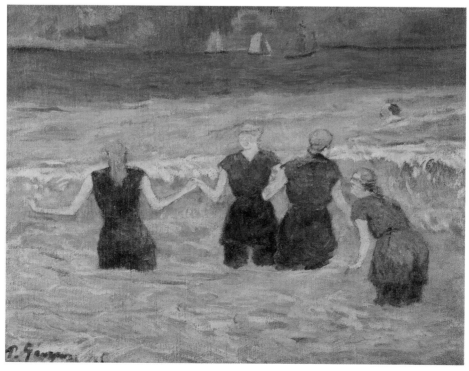

Fig. 250 (*right*) Paul Gauguin, *Women Bathing, Dieppe*, 1885. Oil on canvas, 15 × 18⅛ in. (38 × 46 cm). National Museum of Western Art, Tokyo (P.1959.104) (WII 179)

67

Vase Decorated with the Figure of a Breton Woman, winter 1886–87
Brownish red unglazed stoneware, height 5¹/₂ in. (14 cm)
Signed beneath the left handle: *P Go*; numbered: *49*
The Danish Museum of Decorative Art, Copenhagen (B15/1943)

Modeled by hand in a reddish brown stoneware clay, this rustic vase is primitive in shape, massive and simple in structure, and furnished with three thick handles made of round clay sausages.[130] Its symmetry is underlined by the little Breton girl who, with her back to us and raised arms, appears to be supporting two of the handles. The same figure appears, incorporated into various contexts, in several other works.[131] Here she seems to be guarding the entrance to the vase. As elsewhere, Gauguin introduced a sophisticated technical flourish: he modeled the figure in the clay, but represented her feet simply with incised lines and the ground on which she stands with a strip of black paint.

Along the upper edge there is a sunburst—another motif that recurs a number of times in the ceramics, including the *Jug with Delacroix Motif of Algerian Horseman* (cat. 61). Gauguin indicated the sunrays with a childlike enthusiasm, and they undoubtedly carry a symbolic meaning in the context.[132]

This is one of the relatively few ceramics that retain the artist's original numbering. As number 49 it was one of the later works in the series of fifty-five that Gauguin reported finished to Bracquemond.[133]—A-BF

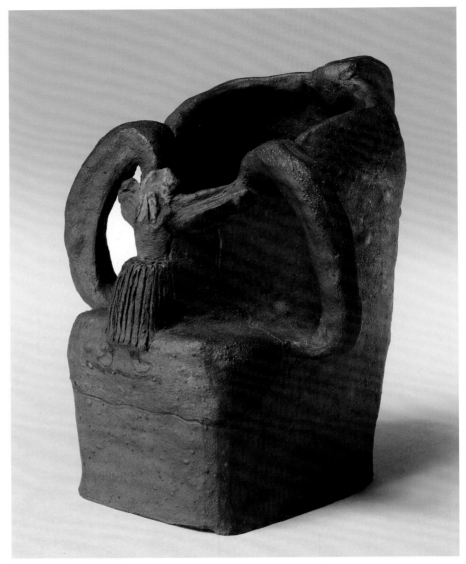

cat. 67

68

Pot with Three Breton Girls and Geese, winter 1886–87
Unglazed stoneware, decorated with slip, glaze, and gold, height 5⁷/₈ in. (15 cm)
Ny Carlsberg Glyptotek, Copenhagen (I.N. 3551)
Ordrupgaard only

The logic behind this free and impressionistic little pot is the number three.[134] It has three sides and a tripartite handle, and is modeled on a heart-shaped base supported by three thick legs. Its decorative motif is a threefold version of the little Breton girl with her back to us and lifted arms that Gauguin was fond of repeating from one ceramic to the next.[135] The girls are supporting the regularly placed handles, which divide to their sides into narrow bands going down to the base. Gauguin decorated the bands with a primitive zigzag pattern and partly gilded them. He used a green slip for the girls' skirts and white for their headdresses. Around the sides of the pot he inscribed some of his beloved geese, and along the top edge he repeated the zigzag pattern. This ceramic shows in canonical fashion how Gauguin gradually recast his Breton-girl motif in a less Impressionist and more Synthetist mode.

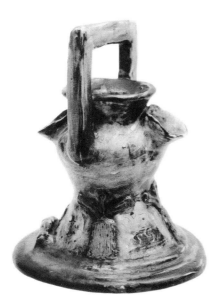

Fig. 251 *Vase Decorated with Three Breton Girls*, 1886–87. Glazed stoneware, decorated with colored slip. Private collection

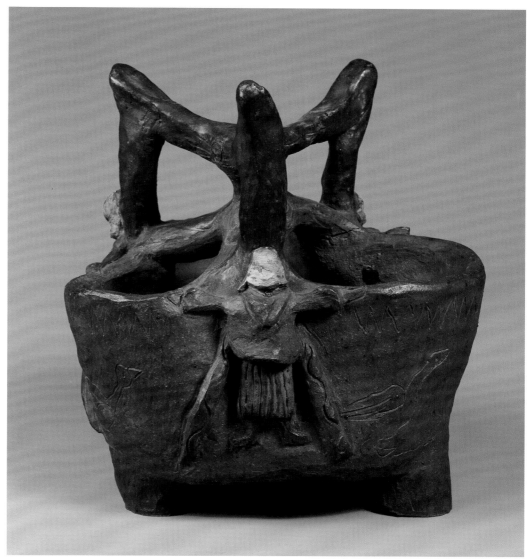

cat. 68

Fig. 252 Paul Gauguin, *Vase with Breton Girls*, detail of *Studies of Jugs and Vases* (recto), from Rouen sketchbook, 1884–88. Graphite and crayon on wove paper, 6⁵⁄₈ × 9 in. (16.9 × 22.8 cm). National Gallery of Art, Washington. The Armand Hammer Collection (1991.217.61.a)

In its basic conception, it relates closely to the idiosyncratic *Vase Decorated with Three Breton Girls* (fig. 251), although the effect is quite different. With its symmetrical and awkward shape and its violent, yellow glaze, the latter is unique among Gauguin's ceramics.[136] Three regular openings finish off the globular belly, to which is attached a strong, square handle. Around the broad base the little Breton girl with her back to us appears three times at regular intervals. Here the repetition of this motif is integral to the overall idea of the work: the girls stand like small caryatids supporting the belly of the vase. The effect can be compared with Rodin's repetition of *The Shadow* (among others, at the Musée Rodin, Paris), and Gauguin manages to give his archetype a new dimension purely by virtue of repetition; it becomes less individualized and more ornamental. He made a drawing of a vase that comes close in design to this one in one of his sketchbooks (fig. 252).[137]—A-BF

IN EARLY JUNE 1886 GAUGUIN WROTE to Mette that he planned to leave Paris for Brittany—even before the close of the 1886 Impressionist exhibition—and that he was even considering an offer of work in Oceania; exactly where he does not say.[138] If ever an artist had expertise in "wanderlust," it was Gauguin. His childhood, later adolescence, and young adulthood were among the most peripatetic in the history of art, and there is even a period of several months during which we have no clear idea where in the world he was.

From his return to Paris after his mother's death and his decision to enter the world of business under the patronage of his guardian, Gustave Arosa, his life had revolved around Paris. He lived and worked in the city, married there, spent most of his married life there, fathered most of his children there, and learned to paint, sculpt, and exhibit in the embrace of its fabled art world. For him, Paris would remain the capital of both art and business. Even on what proved to be his final trip to the South Seas, he was to sign the guest book at the museum in Auckland, New Zealand, as "Paul Gauguin de Paris." But from January 1884, when he and his family moved to Rouen, and even after October 1885, when he and Clovis returned to Paris, we see him gradually pulling away from the idea of Paris as the center of his world. The failure of his participation in the last Impressionist exhibition in May and June of 1886 made it clear that his problematic career as a painter was not going to be cured by returning there. Indeed, his period of isolation—what we have called "domestic exile"—had demonstrated that he had to find internal strength far from the complex and involving life of his wife and children. In effect, he had learned the necessity of family irresponsibility for the future of his art.

Gauguin started his departure easily in July 1886, by taking the train from Paris to Brittany with his friend Achille Granchi-Taylor. He began what was to be the first important anti-Parisian phase of his career in the now famous Pont-Aven, a town already known as a gathering place for artists. By 1888, when he returned for a longer period, his art had definitively pulled away from the aesthetic of Impressionism. But in the summer season of 1886 he painted a group of works of art that, had he completed them earlier, would have cemented his place as one of Impressionism's subtlest practitioners. He managed to repudiate the Divisionist techniques and hieratic compositions of Seurat and Signac, which he had flirted with brilliantly in his *Still Life with Horse's Head* (see cat. 57), preferring to tap the wellspring of that particular mode of Impressionism associated with Pissarro and the "School of Pontoise." Like Pissarro, he painted female workers in the countryside and made carefully controlled compositions of the traditional landscape surrounding the town.

The greatest painting of the summer of 1886, *Breton Women Chatting* (fig. 253), has been judged too fragile to travel for the present exhibition, as it was for the great Gauguin retrospective of 1988–89. It is a remarkable work for, amongst other things, the extent to which Gauguin grappled with the figural aesthetic of his mentor, Pissarro. In the Impressionist exhibition of 1882—the first of Gauguin's disappointments— Pissarro showed a large group of figure paintings of peasant women working, chatting,

facing page Paul Gauguin, *Still Life with Laval's Profile* (detail of cat. 75)

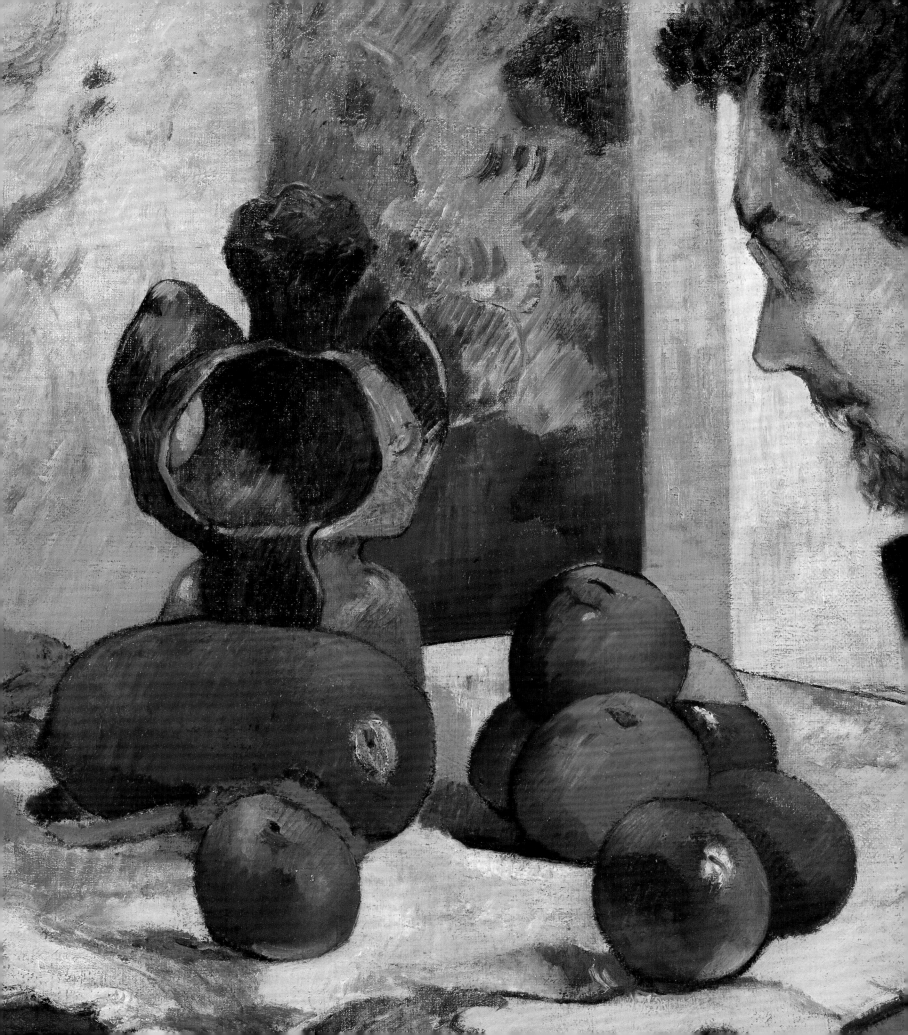

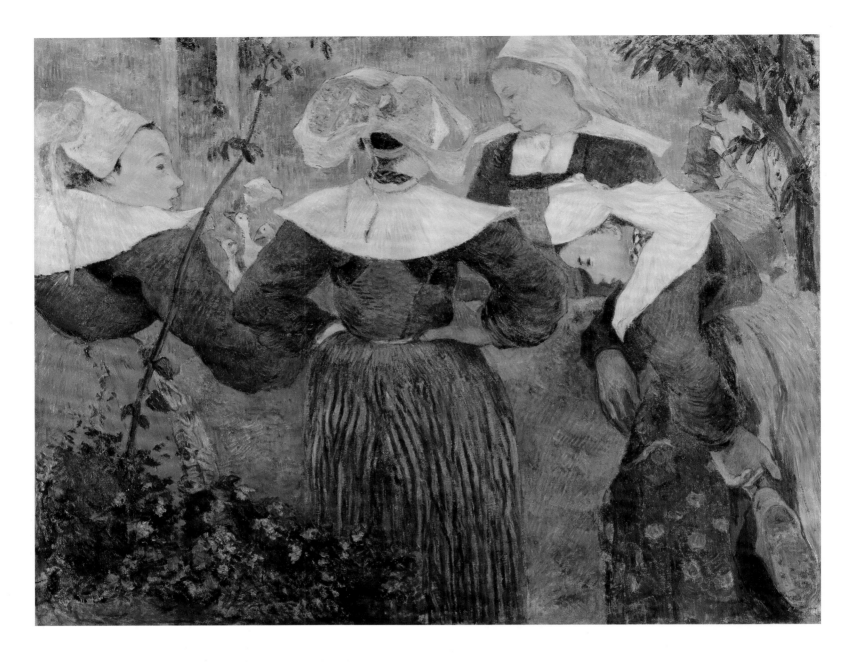

Fig. 253 Paul Gauguin, *Breton Women Chatting*, 1886. Oil on canvas, 28³/₈ × 35¹/₂ in. (72 × 90 cm). Neue Pinakothek, Bayerische Staatsgemäldesammlungen, Munich (8701) (WII 237)

and resting that formed a counterpoint to the bourgeois figure paintings, urban and suburban, of his rival, Renoir. There is no doubt that Gauguin haunted the vast room of that exhibition and that he must have felt, by contrast, the failure of his own *Interior, Rue Carcel* (see cat. 25). Pissarro's superb figures were by no means lost on him, and now he sought to compete with his mentor by attempting a figural group showing rural workers in Pont-Aven.

Many have pointed out the similarities in approach—pictorial and preparatory— between the *Breton Women Chatting* and the figure paintings of Pissarro. It need hardly be said that it was essentially the first figure painting that Gauguin had painted since the *Nude Study (Woman Sewing)* of 1880 (see cat. 19). In the meantime, he had worked hard in the three bourgeois genres of landscape, portraiture, and still life. But clearly he conceived this genre scene in a spirit of competition with Pissarro, who had deserted him for the younger Seurat. Gauguin, who was known for outbursts and sarcasm, rarely

Fig. 254 (*right*) Camille Pissarro, *The Hoers, Pontoise*, 1882. Oil on canvas, 24⁷/₈ × 30³/₈ in. (63 × 77 cm). Private collection

Fig. 255 (*below*) Camille Pissarro, *The Chat* or *Two Young Peasant Women*, 1892. Oil on canvas, 35¹/₄ × 45⁷/₅ in. (89.5 × 116.5 cm). The Metropolitan Museum of Art, New York. Gift of Mr. and Mrs. Charles Wrightsman (1973.311.5) (PV 792)

painted a work more consciously in homage to his mentor than this one—and it came at a point of maximum tension in their relationship. It connects closely to paintings by Pissarro such as *The Hoers, Pontoise* (fig. 254), and anticipates Pissarro's own later and larger response to it, *The Chat*, completed in 1892 but undoubtedly begun earlier

(fig. 255). We shall never know whether Pissarro was able to study Gauguin's most intelligent response to his own figure painting, only that he had the opportunity to do so in 1887–88.

A rigorously composed floral still life is perhaps Gauguin's most formal painting of 1886 (fig. 256). Although it includes the small Quimper pitcher that he used in Brittany during the summer, the presence of one of his own ceramics on the far right (apparently a lost work) suggests a later time of year. As we have seen, his earliest experiments with ceramics date from the winter of 1886–87. On the other hand, all the surviving ceramics that look like this mysterious vessel were made later, during the winter of 1887–88. Crussard has pointed out that the section of the composition with the pitcher is a faithful copy of a smaller painting from the summer of 1886 (*Summer Bouquet and Clogs*, location unknown; WII 219), which might lead us to interpret the present painting as a kind of "pastiche" of Gauguin's own work. Hence Crussard has also suggested that the vessel was a later addition—which would certainly explain its oddly peripheral location.

Clearly Gauguin derived the compositional mode from Cézanne. The wall behind the commode runs strictly parallel to the picture surface, the drawer opened slightly to encourage us to touch, the wall hanging and the fringed textile on the table placed in visually rhyming positions. The painting is larger than the famous Cézanne still life that Gauguin owned (see fig. 269) and dates from a time when he had little access to other Cézannes. Interestingly, he chose orange, pink, and red ranunculas and a striped orange textile, creating an orange-brown-dominated painting that is almost the chromatic opposite of the blue-dominated Cézanne he owned—and his informal arrangement of flowers has no Cézannian precedent.

Considered from the point of view of function, the painting has an odd ambivalence. Its size and formal composition suggest that it was made for ready sale. Yet its inclusion of the conventionally ugly Gauguin ceramic and its haphazard arrangement of flowers would have made it anathema to the sort of proper bourgeois household for which it seems, at first glance, to be aimed. Was Gauguin thumbing his nose at conventions of taste? Unfortunately, there is no contemporary evidence to help us. Not even Wildenstein and Crussard have been able to track down the identity of the first owner, a M. Pearson of Paris.

The last great work of Gauguin's Impressionist years was the enigmatic *Two Women Bathing* (fig. 258). Dark and complex, it attracted the admiration of Félix Fénéon when it appeared at Boussod et Valadon's gallery in 1888 and has become one of the most famous (and least accessible to Europeans and North Americans) of all the major paintings by Gauguin from the year following his personal "crisis of Impressionism." It was the first of three identically sized bather compositions that punctuated his career in 1887–88 and stood as a kind of talisman for his conflicted relationships with his most important mentors, Cézanne and Pissarro. The major figure is as androgynous and antierotic as any female bather in the history of art to this point, and her stance as ambiguous as that of Courbet's great bather of 1853 in Montpellier, which Gauguin

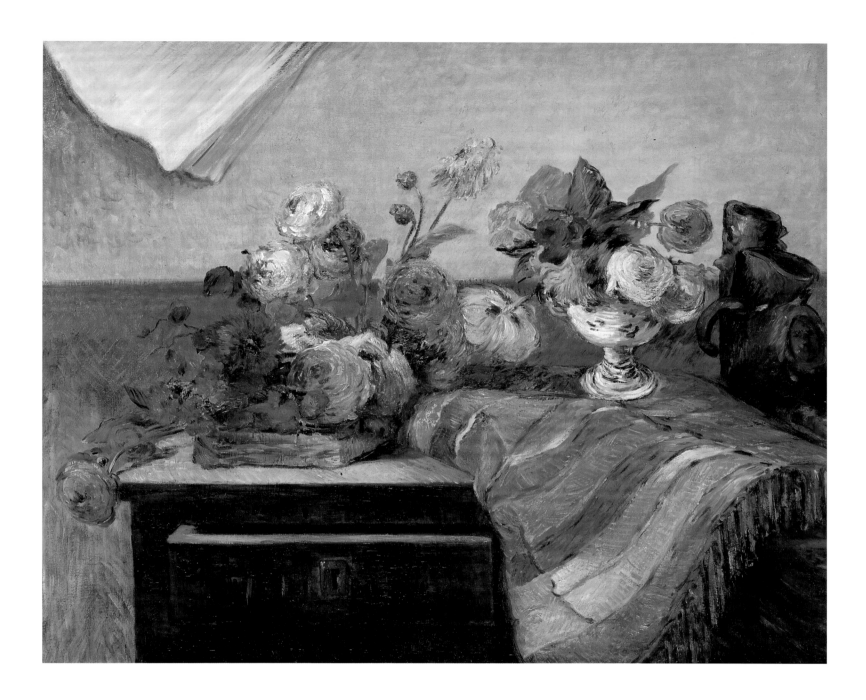

Fig. 256 Paul Gauguin, *Pots and Bouquets*, 1886. Oil on canvas, 23³/₈ × 28³/₄ in. (59.5 × 73 cm). Private collection (WII 239)

knew well (fig. 257). Gauguin had already paid the first of his two documented visits to Montpellier, and in the *Two Women Bathing* he created a work that is both respectful to and subversive of Courbet's immense masterpiece. There is no painting by Cézanne that can act as anything more than a general prototype, and Pissarro, toward whom the painting comes close to showing an active contempt, was not to paint nude bathers until the mid-1890s. Here again, Gauguin asserted his own territory while acknowledging his sources—a deft and calculating game.

This period of what we have called anti-Parisian painting was to serve as a springboard for Gauguin's first long trip to a distant landscape. It prepared him psychically to travel to Panama and Martinique in 1887. While it is easy to consider the first exotic trip of his artistic maturity as a prelude to the famous trip to Tahiti in

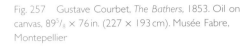

Fig. 257 Gustave Courbet, *The Bathers*, 1853. Oil on canvas, 89⁵/₈ × 76 in. (227 × 193 cm). Musée Fabre, Montepellier

Fig. 258 (*facing page*) Paul Gauguin, *Two Women Bathing*, 1887. Oil on canvas, 34¹/₂ × 27³/₈ in. (87.5 × 69.5 cm). Museo Nacional de Bellas Artes, Buenos Aires (7963) (WII 241)

1891–93, this is not really the case. Gauguin's aim in going to Panama (his intended destination) was to make money painting portraits of the wealthy French bourgeoisie involved in the creation of the Panama Canal. His brother-in-law and sister were already there and paved the way for him and his traveling companion, the young painter Charles Laval, to meet the wealthiest of the expatriates. Gauguin seems never to have intended to paint "native" peoples in local landscapes on this trip. Yet, failing in his portrait adventure, he retreated to Martinique and did just that. The result was one of the most important groups of paintings, both landscapes and figure compositions, ever created in the Caribbean.

69

The Moulin de Bois d'Amour Bathing Place,
 1886
Oil on canvas, $23^5/_8 \times 28^3/_4$ in. (60 × 73 cm)
Signed and dated lower left: *P Gauguin 86*
Hiroshima Museum of Art, Japan
WII 221
Kimbell only

Made in late July and early August 1886, this painting established Gauguin as the leader of a group of young artists working in Pont-Aven. When he arrived, he was virtually unknown among the painters there, but shortly afterwards he became the embodiment of innovative painting as against the academic artists who dominated the town. Crussard deftly retells the story of the attack on Gauguin made by a somewhat younger Dutch painter, Hubert Vos, who had won a medal in the Salon of 1886 and was the de facto leader of the community of academic artists from abroad.[139]

This hieratic figure composition was Gauguin's first attempt since 1881 to paint the nude. Too poor this time to hire models (and most of the Brittany models posed "in costume"), he found his subject at the nearby Aven river, where the adolescent boys of the town bathed during the summer. Undoubtedly he studied the boys from a respectable distance with his sketchbook in hand and then grouped the figures in an almost classical manner in the foreground plane of his contrived composition. The painting is divided into three roughly equal horizontal bands, the foreground dominated by yellow, the middle ground by the variegated water of the Aven as it plunges over a small dam, and the distance by the stone architecture of the mills lining the river. The middle and foreground bands merge into a veritable symphony of colored grays enlivened by white, orange, blue, and green. The three boys that dominate the center of the composition appear to be roughly the same age (about twelve) and have contrasting hair

colors—red, blond, and brunette. One pulls on his swimsuit, another appears to be toweling his companion's back, and the third sits wistfully on the grass as if lost in thought.

This is the first of several attempts by Gauguin to mine the territory that Cézanne had defined for himself with his various compositions of male bathers. Although Gauguin never owned a Cézanne of this type, Pissarro did,[140] and there is little doubt that Gauguin was familiar with the great male bathers that Cézanne exhibited in the Impressionist exhibition of 1877 (fig. 259). Though smaller than the latter, Gauguin's bather composition has similarly monumental aims. Its composition is clearly anti-Impressionist—created rather than observed—and its facture is so meticulously organized that each tiny stroke seems placed after careful consideration of its position, hue, and scale.

It is tempting to consider the painting as an expression of Gauguin's suppressed parental desires. He had not seen the four of his children left in Denmark for more than a year, and Clovis had been living away from him for nearly three months. Four of his five children were boys, and the eldest of them, Emil, was to be twelve years old on August 31, 1886, a particularly important age for young boys. It hardly seems a stretch to think that Gauguin studied these Breton boys, the age of his oldest son, with a parental curiosity, turning his art to the service of his psyche—all the while making a work in homage to Cézanne.—RRB

Fig. 259 Paul Cézanne, *Bathers at Rest*, 1875–76. Oil on canvas, $32^1/_4 \times 39^7/_8$ in. (82 × 101.2 cm). The Barnes Foundation, Merion, Pennsylvania

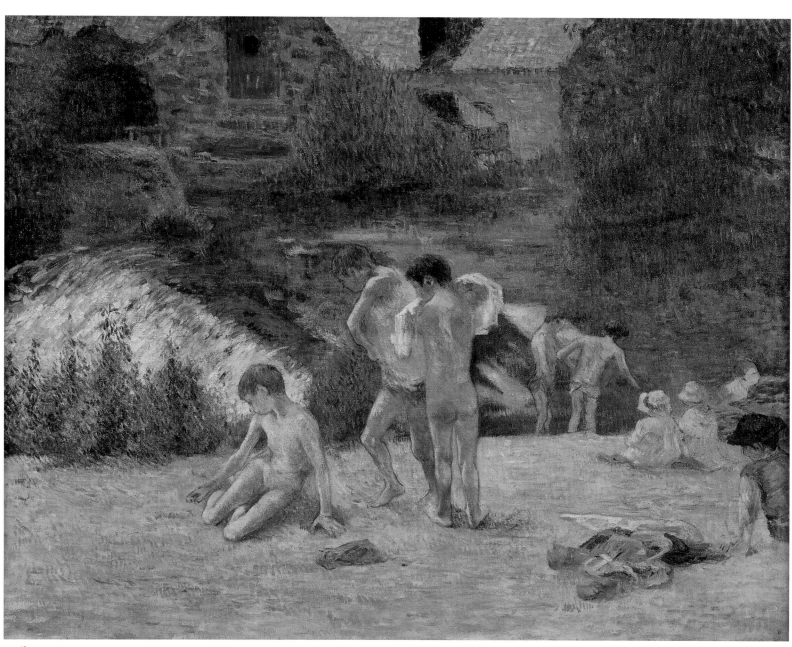

cat. 69

70

Lollichon Field, 1886
Oil on canvas, 28³/₈ × 36¹/₄ in. (72 × 92 cm)
Signed and dated lower right: *P. Gauguin 86*
Los Angeles County Museum of Art. Hal B.
 Wallis Bequest (M86.276)
WII 226

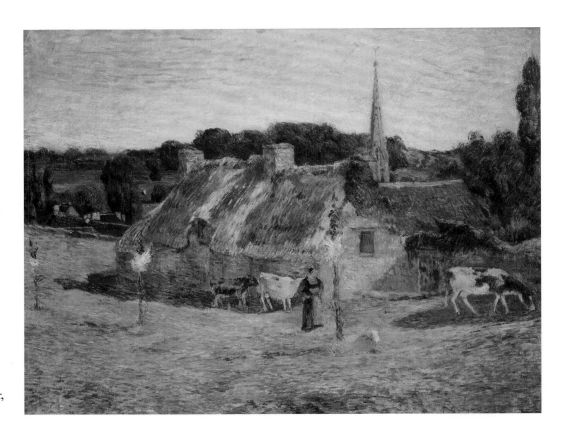

This and another landscape, *Lollichon Field and Pont-Aven Church* (fig. 260), represent a field in Pont-Aven a short walk away from Gauguin's pension. They are painted on standard canvases of virtually identical dimension and seem almost to have been conceived as a pair. They present slightly contrasting compositional strategies—the canvas in the private collection centers the thatched cottages as the motif of the composition, while the Los Angeles canvas places them laterally, balanced by a large clump of trees. The angle of the light is similar, indicating that Gauguin worked on both during the same part of the day; perhaps he alternated his work by moving from one to the other. In this way they are analogous to the three vertical landscapes that he painted from the same landscape near Dieppe in the summer of 1885 (cat. 51 and figs. 210, 211).

Because it has been included in many important exhibitions devoted to Gauguin's Brittany period and his adoption of the radically decorative style called Cloisonnism, Synthetism, and/or Post-Impressionism, the landscape in the private collection (fig. 260) is well known. A curious feature of the scene is the bright yellow hay tied in clumps just below the tender foliage of some fruit trees to prevent the cattle from destroying them. The newly mounted earth beneath the trees makes it clear that they were planted shortly before Gauguin began the painting, perhaps providing the

occasion for focusing on this particular landscape.

The Los Angeles canvas is much less well known; it last appeared in a major exhibition in 1951 and has not been subject to the same scholarly scrutiny as its companion. The composition has affinities to landscapes by both Pissarro and Cézanne, particularly Pissarro's *Cottages at Valhermeil (with a Figure)* (private collection; PV 511), which Gauguin had seen in the Impressionist exhibition of 1881, and Cézanne's *The Hanged Man's House* (fig. 261). Yet one could never mistake this painting for a work by either of those masters. Gauguin was fascinated by the decorative possibilities of rural landscape arranged almost like a mosaic of colored patches, each represented by even smaller

touches of paint. The facture of the painting owes a good deal more to Cézanne than to Seurat, whose scientifically motivated dots it repudiates.

It is fascinating to compare both of Gauguin's Lollichon landscapes with an exactly contemporary landscape by Pissarro. Recently acquired by the Indianapolis Museum of Art, *The House of the Deaf Woman and the Belfry at Eragny* (fig. 262), was painted throughout the summer of 1886 in response to the landscapes of Seurat and Signac. Until recently, it has been known only through the black-and-white photograph in the Pissarro-Venturi catalogue raisonné[141] and little discussed in the ample literature devoted to Neo-Impressionism. With its recent publication, it can now be properly compared with

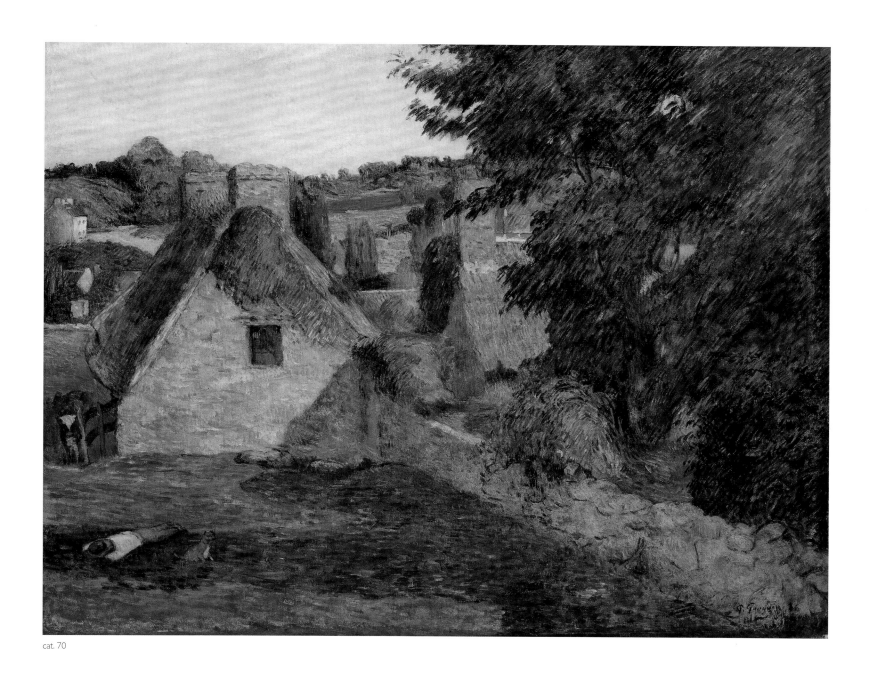

cat. 70

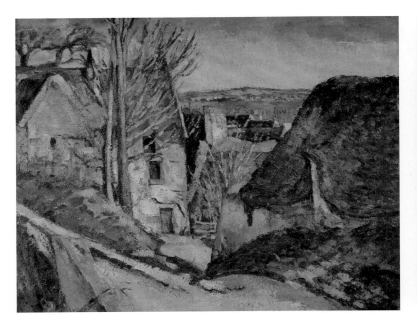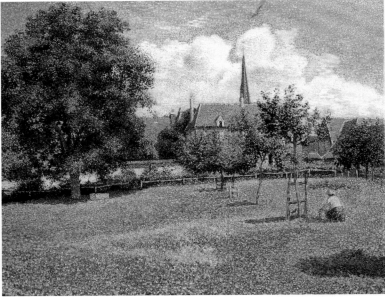

Fig. 261 (*above left*) Paul Cézanne, *The Hanged Man's House, Auvers-sur-Oise*, 1873. Oil on linen, 21³/₄ × 26 in. (55 × 66 cm). Musee d'Orsay, Paris. Count Isaac de Camondo Bequest, 1911 (RF 1970) (R 202)

Fig. 262 (*above right*) Camille Pissarro, *The House of the Deaf Woman and the Belfry at Eragny*, 1886. Oil on canvas, 25⁵/₈ × 31⁷/₈ in. (65.1 × 81 cm). Indianapolis Museum of Art. Anonymous gift (IMA 2002.76) (PV 702)

contemporary paintings by Gauguin, particularly the Lollichon landscape in the private collection (fig. 260). The compositions are virtually identical, particularly in the positioning of the church tower and the almost fetishlike attention to the newly planted fruit trees in the foreground. Yet, where Pissarro completely regularized his facture and restricted his chromatic incidents to a thin band running through the center of his composition, Gauguin allowed the motif great spatial and chromatic variety, expressed in a wide range of directional brushstrokes.

It is clear that Gauguin's summer in Pont-Aven allowed him to raise his structured Impressionist landscape aesthetic to new heights of achievement. Equally clear is his reliance on ideas of landscape painting that he had explored earlier in the decade.—RRB

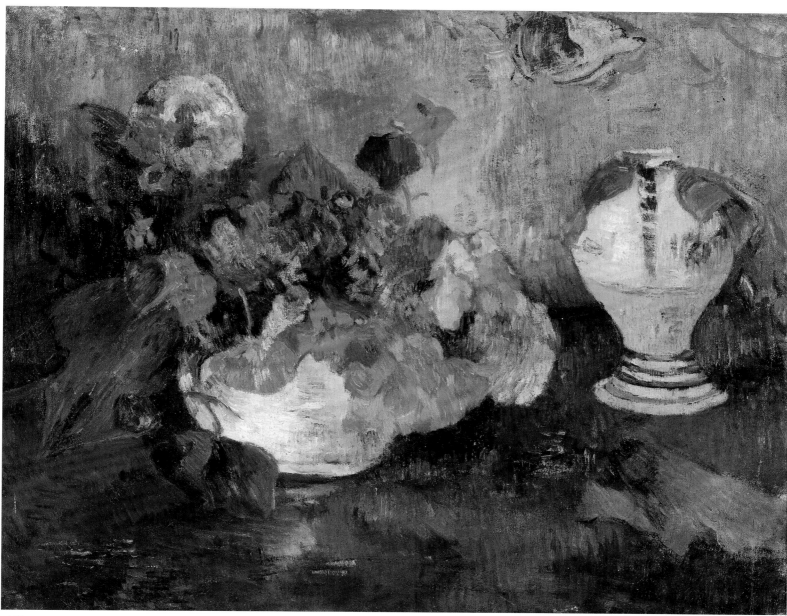

cat. 71

71

Vase of Nasturtiums, 1886
Oil on canvas, 13 × 16¹/₈ in. (33 × 41 cm)
The National Gallery of Canada, Otttawa
WII 218

This small still life must have been painted in the summer of 1886, when Gauguin included the same vase in two other paintings, one of which, *White Tablecloth* (private collection; WII 217), is signed, dated, and inscribed "Pension Gloanec," the name of the small inn where he stayed that summer. Like many of his small-scale still lifes of the 1880s, the work is highly experimental in facture and composition, and the solid objects of the vase and the small pitcher seem almost to float in a sea of colored marks. The "real" flowers merge with the wallpaper flowers, and the marks at the top of the painting thrust its plane forward to the surface, countering our ability to read the picture as an effective alternative space. Gauguin also used clusters of marks similar to the "constructivist stroke" of his hero Cézanne, though without the same structural logic. They tend to be verticals or horizontals rather than the bunched diagonals favored by Cézanne, and, for that reason, they reinforce the picture in itself, refusing to play a role in the construction of space. In creating this magical pictorial realm, Gauguin anticipated the dreamy floral still lifes by Odilon Redon by more than a decade.—RRB

72

Breton Shepherdess, 1886
Oil on canvas, 23$^7/_8$ × 28$^7/_8$ in. (60.5 × 73.5 cm)
Signed and dated lower left: *P Gauguin 86*
Laing Art Gallery (Tyne and Wear Museums),
 Newcastle-upon-Tyne
WII 233
Kimbell only

Though smaller than the pair of brilliant
landscapes that Gauguin made in Pont-Aven
during the summer of 1886 (see cat. 70), as a
figure painting the *Breton Shepherdess* is more
ambitious. Like the identically scaled painting
of male bathers (see cat. 69), it is a study in
the relationship between the human figure and
the landscape, and it is even possible that the
two were made together as part of a larger
project of aesthetic research. We know that,
like Pissarro and Cézanne, Gauguin conceived
of painting as a form of research, in which
individual works sought to solve pictorial
problems of varying degrees of difficulty. He
rarely shied away from even the thorniest such
problems, and, for all its affinities with the
peasant genre paintings made and exhibited
by Pissarro in the early 1880s, the *Breton
Shepherdess* is a good deal more complex than
any of them. Gauguin chose a decorative
landscape with overlaid elements of
architecture and vegetation. He also elected to
describe this intricate spatial world from a
high vantage point. We see a peasant girl
seated on a rocky hillock next to a large black
cow, also seated. The cow contents itself by
nibbling the accessible vegetation, while the
girl looks abstractedly over a lower field with
black and white sheep. Above her head, the
vegetation in a tree turns golden orange,
suggesting the coming of fall. Below the field
of sheep is a mélange of roofs with thatch and
blue and red tile. A peasant boy with a straw

hat walks along a lower path at the far left
edge of the composition, apparently as
unaware of the shepherdess as she is of him.

The pictorial problems that Gauguin set
himself were considerable—a complex
composition, a posed figure to integrate into a
landscape, and a wide range of hues and
values. He seems to have been intent on
dealing powerfully with the difficulties of
painting black and white, which, in the
perceptually sophisticated rhetoric of Neo-
Impressionism, were understood to be defined
by color. He derived the poses of most of the
animals and the girl from drawings, including
various slight animal studies in a sketchbook
he used that summer;[142] there is an equally
slight drawing closely related to the male
peasant in the same sketchbook. He also made
a fully formed pastel of the girl (fig. 243), for
which he clearly hired a model and posed her
for detailed study. At least seven drawings for
this figure survive, all probably made from the
same model. Following the practice of Pissarro,
Gauguin made the most of this inexpensive
model, drawing her in two different costumes
and making detailed studies that he could use
in various contexts.[143] Some are of similar
dimensions, perhaps pages from another, larger
sketchbook, perhaps loose sheets.[144] This is the
first time in his career that Gauguin seems to
have turned so completely to Pissarro's
pictorial practice, in spite of the fact that the
two men had essentially severed their
relationship over differences to do with the
young "Néos," Seurat and Signac.

Again, however, Gauguin emulated Pissarro
to surpass him. His aim was not to be a
faithful follower but to become a master in his
own right, accepting the terms set earlier but
complicating and enriching them. In the
summer of 1886 Gauguin was no follower of
Pissarro but the master of a new school of

avant-garde painters, many of whom were
some years younger. It was that summer that
he met the eighteen-year-old Emile Bernard
and the slightly older Charles Laval, beginning
a new phase of his life as an artist-mentor on
the model of his own mentor, Pissarro. He had
successfully made the transition from amateur,
to businessman-artist, to artist-businessman, to
artist, to master.—RRB

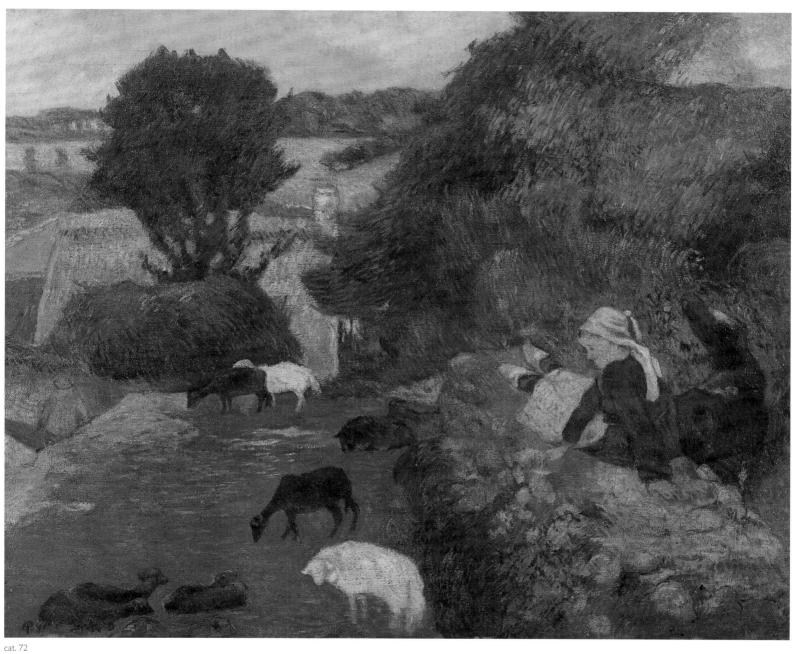

cat. 72

73

Cowherd, Bellangenet Beach, 1886
Oil on canvas, 29¹/₂ × 44¹/₈ in. (75 × 112 cm)
Signed and dated lower left: *P Gauguin 86*
Artrix International Inc.
WII 234

74

Rocky Coast, 1886
Oil on canvas, 28 × 36¹/₄ in. (71 × 92 cm)
Signed and dated lower right: *P Gauguin 86*
Göteborgs Konstmuseum, Göteborg, Sweden
WII 235

Gauguin painted his imposing seascape of the beach at Bellangenet, Brittany, on the largest canvas he had used in more than four years. Not since 1882, when he painted the glowering landscape of an abandoned quarry near Pontoise (cat. 29), had he attempted such a monumental composition, and never before had he painted the sea with such ambition. This and two somewhat smaller seascapes, *Rocky Coast* (cat. 74) and *Rocks, Sea* (private collection; WII 236), are the sole evidence of a period of at least two weeks that he spent in the Breton fishing village of Le Pouldu, where he was later to work productively with Meyer de Haan. The drawing of the rocks in the middle ground, published by Crussard in her entry in the Wildenstein catalogue,[145] is not detailed enough to have served him as an aide-mémoire while he worked on the painting in the larger town of Pont-Aven, and Le Pouldu was far enough from Pont-Aven that he could not have gone there and back in a day. He must have stayed in Le Pouldu itself, walking at least two kilometers to the section of the beach he chose to paint, and spent long enough there to make significant progress on three large canvases.

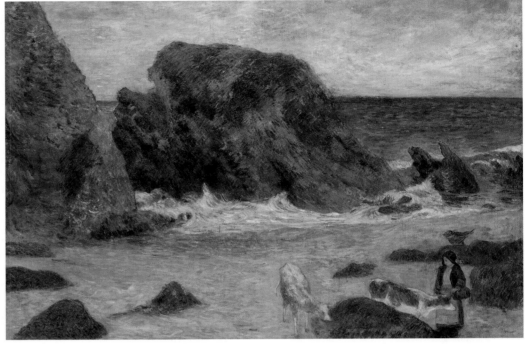
cat. 73

Although he had painted the sea at several earlier points in his career and, as a former merchant marine, knew it better than any other painter of his generation, Gauguin was not an experienced seascapist. It seems that he pushed himself to succeed in new ways during his liberating summer and early autumn in Brittany, not just with large rural landscapes and figural compositions, but also with seascapes. It is fascinating to remember that, at the same time as Gauguin was painting the coast in Brittany, so was Claude Monet, who worked on the islands called the "Belles-Iles." Monet stayed on these islands for somewhat more than two months, and more than thirty completed paintings survive from that intensely productive campaign (figs. 263, 264).

Whereas Monet selected a small group of motifs and compositions and repeated them in slightly differing climatic and diurnal conditions, creating subseries of identically scaled canvases within the larger group of Belles-Iles seascapes, Gauguin conceived of each canvas as a completely independent composition. None of Monet's paintings has figures or boats, and all are made from an elevated viewpoint, creating a form of psychological detachment from the motif. By contrast, Gauguin chose strongly horizontal compositions and contrived them so that the painter-viewer seems to be slightly above the rocky beach, whose spacious foreground encourages our entry. Only the Göteborg canvas is unpeopled, although Gauguin included an undeniable human profile in the forms of the rocks on the right of the composition. The cowherd painting has two figures (the female herder and a male figure at work just behind her) and two cows, who are

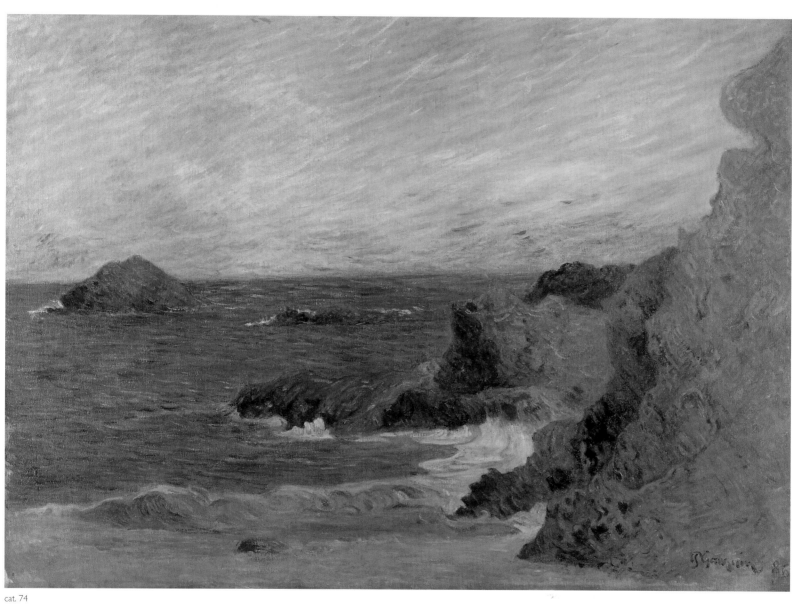

cat. 74

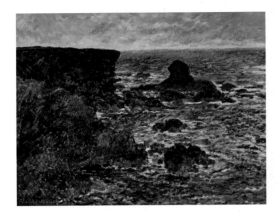

Fig. 263 Claude Monet, *Rocky Coast and the Lion Rock, Belle-Ile*, 1886. Oil on canvas, 26 × 32¹/₂ in. (66 × 82.6 cm). Des Moines Art Center. Purchased with funds from the Coffin Fine Arts Trust; Nathan Emory Coffin Collection of the Des Moines Art Center (1961.42)

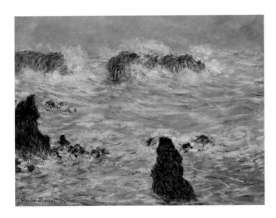

Fig. 264 Claude Monet, *Storm off the Belle-Ile Coast*, 1886. Oil on canvas, 25⁵/₈ × 31⁷/₈ in. (65 × 81 cm). Musée d'Orsay, Paris (RF 3163)

on the beach to eat salt grasses and seaweed gathered by the male worker, of which there are several piles. The woman carries a basket and might be gathering shellfish.

In spite of the similarities in their subjects, the contrast between Monet and Gauguin could not be greater. Monet's theme is the drama of the sea and the intensity of its

crashing waves, the eternal battle between sea and earth. The world of man is far from his concern. Gauguin is not unaware of the elemental aspect of his subject, but he deemphasized it by representing the sea at moments of relative calm and by concentrating attention on the figures. Although Boudin often painted cattle near the water, this was a subject rare in Impressionist iconography. As "modern" painters, the Impressionists preferred to stress the bathing and strolling urbanites who temporarily inhabited the coastal landscape while on vacation.

The signatures and dates on all three of these ambitious paintings indicate that Gauguin completed them before the end of 1886, making his summer painting experience in Pont-Aven one of the most powerful of his career. But by the autumn of that year he was beset by personal misery as great as that of the preceding winter.[146] Because the Impressionist movement more or less collapsed after the 1886 exhibition, he had no clear prospect of exhibiting the results of his past few months' hard work. His decision to burn his bridges with the "Néos" left him out of that aesthetically effective brotherhood, and his own network of young followers, which he had begun to establish with Bernard, Laval, and others in the summer, was yet to work as strongly in Paris as it would by the following year.

When Gauguin painted his Atlantic seascapes in Brittany in the late summer of 1886, his sympathies were firmly with the land rather than the sea. But he had already hinted at the prospect of Oceania in his earlier letter to Mette, and less than a year after these paintings, he would be with Laval on board a ship bound for Panama.—RRB

75

Still Life with Laval's Profile, 1886
Oil on canvas, 18¹/₈ × 15 in. (46 × 38 cm)
Signed and dated lower left: *P Gauguin 86*
Indianapolis Museum of Art. Samuel Josefowitz
 Collection of the school of Pont-Aven, through
 the generosity of Lilly Endowment Inc.,
 the Josefowitz Family, Mr. and Mrs. James M.
 Cornelius, Mr. and Mrs. Leonard J. Betley,
 Lori and Dan Efroymson, and other friends of
 the Museum (1998.167)
WII 238

Scholars have long worried about the date of 1886 on this superb painting. When compared with other works by Gauguin from that year, it seems to some to be simply too advanced aesthetically, too interesting, or too accomplished to have been painted in that year. Such doubts are baseless. Gauguin was fully capable of painting like this in 1886; he met Laval in that year and the two men began an important, if mysterious friendship that resulted in their trip together to Panama and Martinique in 1887.

Claire Frèches-Thory was not the first to point out the work's dual debts to Cézanne and Degas.[147] Gauguin had owned Cézanne's great Parisian still life (see fig. 269) for several years by the time he painted this pictorial hymn in its praise, although it was probably with Mette in Copenhagen, not with Gauguin in either Pont-Aven or Paris, when this painting was made. The debt to Degas lies in the unexpected placement of Laval's head. Yet it is, in fact, difficult to find any earlier portrait in Degas's enormous oeuvre on this level of compositional eccentricity. Perhaps only the *Woman Seated Beside a Vase of Flowers* at the Metropolitan Museum of Art sustains the comparison (fig. 265).

The work first appeared in public—in a large exhibition of modern French painting

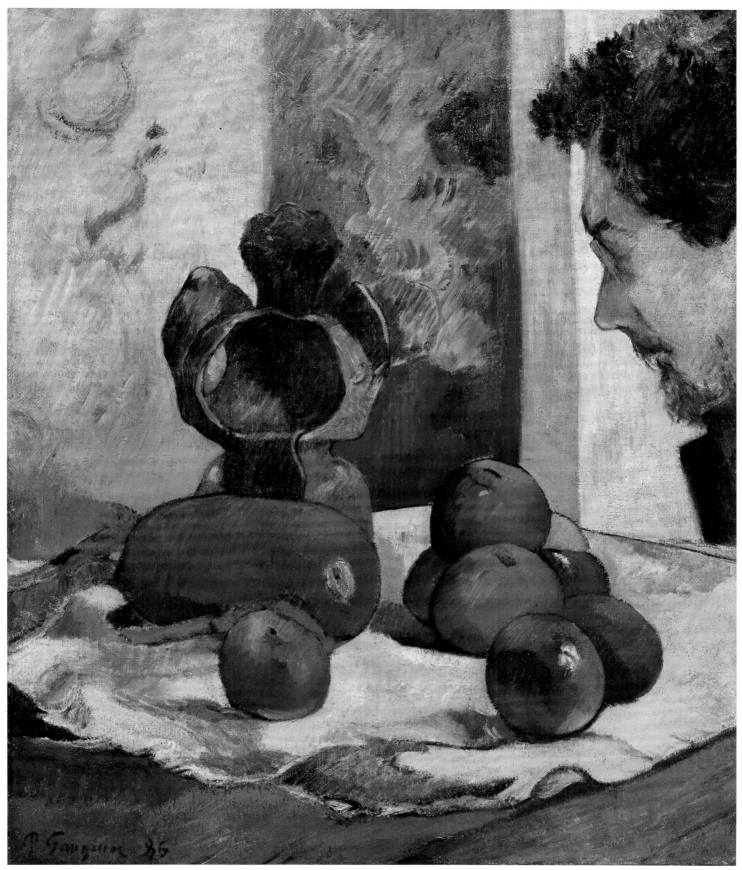

cat. 75

that traveled to various German cities in 1906–7—as *Still Life with the Profile of the Painter Laval*.[148] It was presented not as a portrait but as a still life with a profile, and one can imagine Gauguin, long interested in provocative titles, insisting on this point to Laval when he gave him the painting. As a gift from Gauguin to Laval, it was a forerunner of the most fascinating sequence of portraits of artists and self-portraits in the history of modern art—that begun by Gauguin, van Gogh, Bernard, and Laval in 1888.

A gift to Laval and at the same time an homage to Cézanne and Degas, the painting reads as a meditation on artistic interrelationship. Dressed in black, his hair coarsely cropped, his beard straggly, and wearing a pince-nez, Laval leans into the composition, seemingly to look at the still life but almost becoming a still-life element himself. The most imposing and chromatically important part of the painting, the still life is an arrangement of fruits (most likely apples, but not unambiguously so), set deliberately on

a clean white cloth placed on a wooden chest or drop-leaf table. Behind one green fruit, Gauguin placed what seems to be a piece of brilliant orange cloth. The large ovoid object behind that is an enigma. Is it a loaf of crusty bread (its shiny highlight seems to rule this out)? An unripe papaya (a tempting possibility)? A wooden bowl on its back? A purse or container made of a coconut shell to which the orange cloth and the yellowish ropes are linked? Mysteries compound as we enumerate the possibilities. As is often the case with Gauguin, all are at least partially acceptable, even if none is definitive.

The work is one in which Gauguin accepted aesthetic slippage with ease and courted ambiguity by conflating genres and modes of painting. It is both still life and portrait—just as the large interior originally called *Fleurs* (see cat. 25) is both still life and genre, and the sewing figure originally called *Etude de Nu* (see cat. 19) is both genre and allegorical nude. Even the wallpaper behind Laval, which some have considered to be a prefiguration of the later oil paintings of Odilon Redon, comes as much out of Gauguin's tinkering with Cézanne's practice as out of anything he had seen in the various "noires" exhibited by Redon in the 1886 Impressionist exhibition. What is important about this painting—and similarity of size prompts us to link it with the equally ambitious *Still Life with Horse's Head* (see cat. 57)—is that it is actually *about* art. What makes it completely new is the inclusion of a strangely shaped ceramic object that Gauguin himself had made. He took a step beyond the traditional still life, in which the artist arranges various objects to paint, and actually made one of them—a very enigmatic one at that.

The winter of 1886 was chiefly important for Gauguin because he discovered the power

of ceramics and worked with real determination to learn the craft from Ernest Chaplet, one of the greatest ceramic artists of the age. This new medium lead to another of the artist's many reinventions—just as wood carving had done after 1880, lithography was to do in 1888, and woodcut in 1894. Gauguin practiced his art through medium in a way that was essentially unprecedented in the nineteenth century. When he carved wood, he practiced the ancient art of subtraction. When he created ceramics, he approached God himself in working with the earth and making forms from nothing. Later he fetishized the oven, equating it with hell itself and creating glazes that looked to everyone like blood. The sheer power of these three-dimensional media took hold of him, and he felt none of the intimidation through precedent that he felt with the medium of painting.—RRB

cat. 76

76

Martinican Meadow, 1887
Oil on canvas, 26¹/₂ × 45 in. (67 × 114.5 cm)
Private collection, United States. Courtesy of
 Kristin Gary Fine Art
WII 247

Unpublished until the 2001 Wildenstein catalogue raisonné, this landscape was one of its stunning discoveries. Of commanding dimension, it seems to have survived because it was stretched behind a later painting, also unpublished, that languished in a private collection in Norway. Because of its late entrance into the Gauguin literature, several scholars, including the present writer, were suspicious of its authenticity. When examined first hand, however, there is little doubt that it is, in fact, among the most original and important of the landscapes Gauguin painted during his brief sojourn with Charles Laval in Martinique in 1887. We include the work in the present exhibition because it is, in many ways, the one from that period that seems most to engage with the landscape aesthetic of Impressionism. Its humid atmosphere, its fluttering vegetation, its peripherally placed figures—all remind us of the paintings of

Monet and Degas, suggesting that, even after the shame of the 1886 Impressionist exhibition, Gauguin continued to grapple with the basic formal and compositional tenets of Impressionism. Even more importantly to us here, he did so rather than engaging—as he had briefly in 1886–87—with those of Seurat and the Neo-Impressionists. If there is evidence of Gauguin's continuing, indeed lifelong fascination with the forms of pictorial engagement practiced by the Impressionists, it is this painting—and its fidelity to its subject was such that Crussard and her colleagues were able to find the very spot from which it was painted.

The principal oddity of the work is its pale palette—the pastel yellows, light oranges, and mint greens of the foreground and middle ground are a marvelous foil for the deep greens and browns of the middle ground. Gauguin managed to create both a shallow

decorative surface and a satisfyingly deep
pictorial space without seeming in the slightest
to be aware of the tensions between these
objectives. In this way, the painting resembles
his single most famous landscape painted in
Martinique, the superb *Tropical Vegetation* in
the National Gallery of Scotland (fig. 266). If
the Edinburgh painting is a vertical decoration
that mimics a tapestry, the newly discovered
work is a horizontal one that straddles
Cézanne and Redon.

Gauguin's "Impressionist" masterpiece from
Martinique reminds us both of Cézanne and of
the Monet of the late 1880s. Among the
"travel pictures" that Monet made in Antibes
in 1888 or the superb Giverny field paintings
of 1890, parallels abound. Monet used the
same Cézannian stroke in *Bend in the Epte
River near Giverny* of 1888 (fig. 267) and the
same spatially unfolding composition in *Oat
and Poppy Field* (fig. 268). While Gauguin
was not seeking directly to emulate Monet,
the parallels show his fundamental debt to
Impressionist landscape practice.—RRB

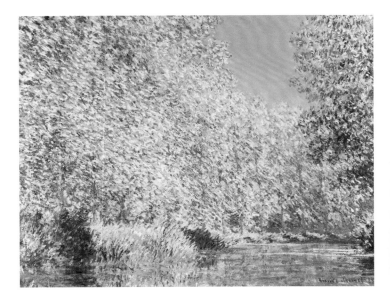

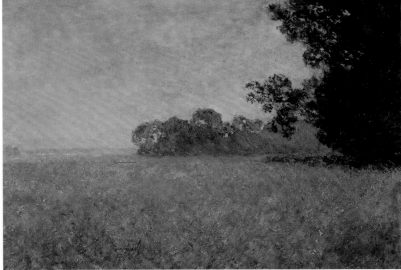

Still Life with Mangoes and Hibiscus, 1887
Oil on canvas, 12³/₄ × 18¹/₂ in. (32.5 × 47 cm)
Signed and dated lower left: *P Gauguin 87*
James E. Sowell Collection
WII 256
Kimbell only

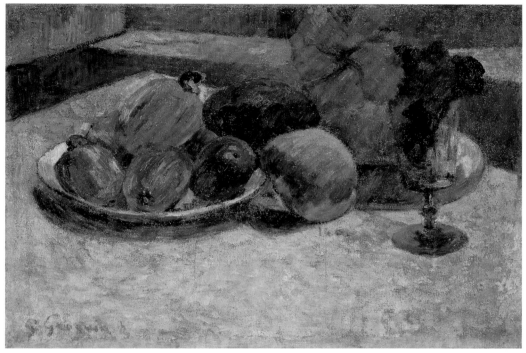

cat. 77

Fig. 266 (*facing page top*) Paul Gauguin, *Tropical Vegetation*, 1887. Oil on canvas, 45³/₄ × 35¹/₈ in. (116 × 89 cm). The National Gallery of Scotland, Edinburgh (NGS 2220) (WII 248)

Fig. 267 (*facing page bottom left*) Claude Monet, *Bend in the Epte River Near Giverny*, 1888. Oil on canvas, 28³/₄ × 36¹/₄ in. (73 × 92 cm). Philadelphia Museum of Art. The William L. Elkins Collection (E.1924.3.16)

Fig. 268 (*facing page bottom right*) Claude Monet, *Oat and Poppy Field*, 1890. Oil on canvas, 25⁵/₈ × 36¹/₄ in. (65 × 92 cm). Musée d'Art Moderne et Contemporain, Strasbourg (1750)

This wonderfully compact still life was signed and dated in 1887, when Gauguin spent nearly six months in Martinique. Because it features tropical fruits and a hibiscus, it has traditionally been identified as one of the small group of paintings that he made during his Martinique visit. Yet it shares little of the compositional and chromatic experimentalism of his known Martinique works. Indeed, its compositional obsessions lie firmly with Cézanne, and, in addition, it relates to the series of small-scale still lifes that Gauguin made in Paris beginning in 1880 (see particularly figs. 69, 82, 83). Gauguin returned to Paris from Martinique in mid-November 1887, moving immediately into the delightful *pavillon* of the Schuffenecker family in the 14th arrondissement.[149] There he began a group of still-life paintings that culminated in a canvas of 1887–88 in the Musee d'Orsay, *Still Life with Fan* (see fig. 231). Given that it would hardly have been difficult for him to buy tropical fruit or to find hothouse hibiscus in Paris during the 1880s, it seems most likely that he in fact painted the present work at the Shuffeneckers in dreary December 1887—recovering from his tropical illnesses and dreaming of the warmth of another place.
—RRB

Conclusion

Gauguin had been an Impressionist artist for six years when, in the early months of 1885, he painted the extraordinary *Still Life, Interior, Copenhagen* (fig. 191 and facing page). He had mastered the three "bourgeois" genres—still life, portraiture, and landscape; he had sculpted, drawn, and painted, and had begun to put his prodigiously developing aesthetic ideas into words. He was also at one of the numerous points in his life in which there was nowhere to go but up. Reviled by his in-laws, distrusted by his wife, rejected by the Danish business community, and distant from the fertile artistic fields of Paris, he was, as we have seen, even suicidal. In the language of recovery, he had "reached bottom"—for the first, but certainly not the last time in his career as an artist.

What is extraordinary about Gauguin is that he worked his way out of the situation not through friendship, family, therapy (not available at the time!), or alcohol, but through art. The Kimbell self-portrait (cat. 48), the Kelton box (cat. 43), and the Copenhagen still life grapple with the nature of identity, family, and personal suffering in ways that are among the most powerful in the history of art. There is little doubt that Gauguin thought about—and studied—the superb still-life painting by Cézanne in his own collection, the *Still Life with Fruit Dish* (fig. 269). Yet in his abject and thoroughly autobiographical *Still Life, Interior, Copenhagen*, all the classical balance and clarity of the Cézanne—all those qualities of form that were to make it *the* Cézanne for the future of French painting, as exemplified in Maurice Denis's later *Homage to Cézanne* (fig. 270)—are absent.

Gauguin used the mediums of artistic expression to clarify not the outside world, but his own troubled responses to it. The *Still Life, Interior, Copenhagen* is literally the opposite of either an Impressionist still life by Monet or any still life by Cézanne. It neither glories in nor rationalizes visual reality. It assembles elements of that reality into a new and completely personal world that has more to do with the emotions of the artist than with "the visual." This painting along with the Kimbell and Kelton works, also executed in Copenhagen, demonstrate that Gauguin had finally become an artist in his own right and that his *only* means of understanding his troubled emotional world were to be found in art.

Gauguin's Impressionist journey began in well-meaning, but aesthetically advanced amateurism and concluded with a profoundly original and thoroughly professional body of works that has few real precedents in the history of Western art. He struggled, both as an artist and as a man, to free himself from bourgeois conventions and to communicate his ideas and emotions with the rare combination of clarity and enigma that are central to his subsequent career. When he died in 1903, fewer than twenty years after the Impressionist movement formally disintegrated, he was infamous in Paris, and his final exhibition at the Vollard gallery, held six months after his death, was attended by the greatest artists of his own and the subsequent generation, including Degas, Matisse, and Picasso.

Almost everything Gauguin did as an artist was rooted in his experiences as a member of the Impressionist group. He applied the lessons of competitive camaraderie

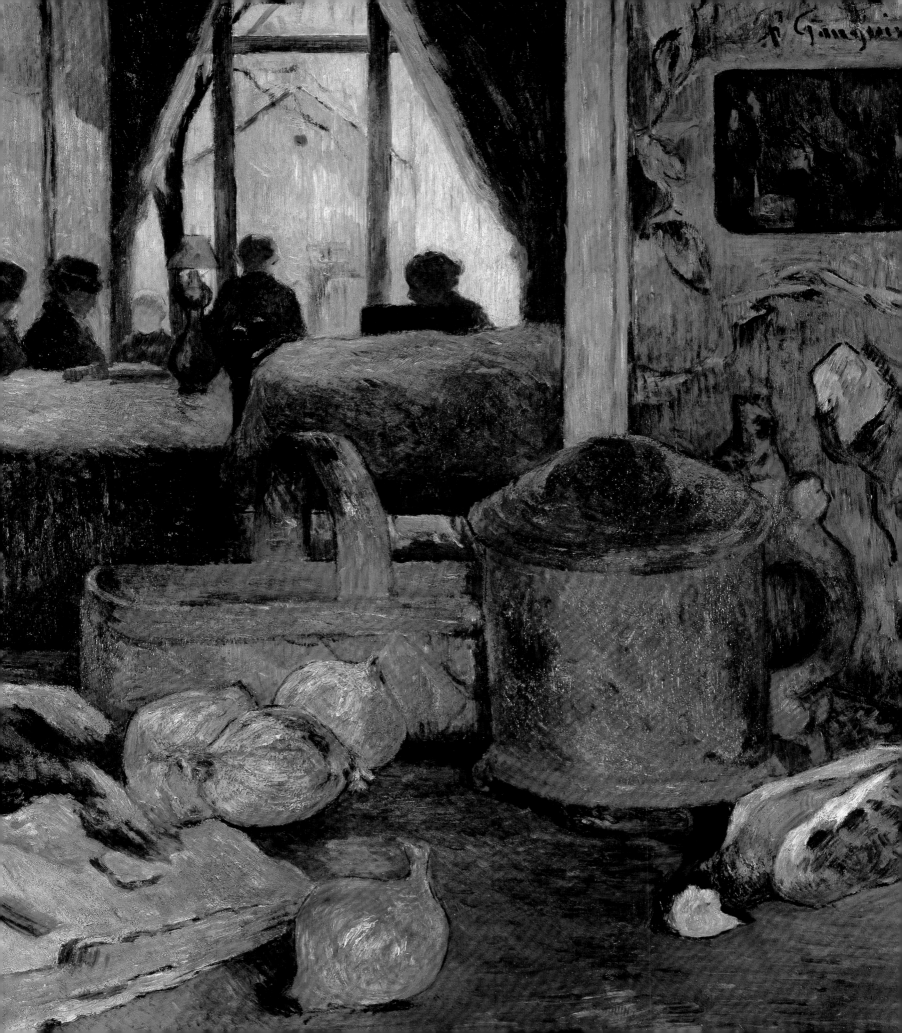

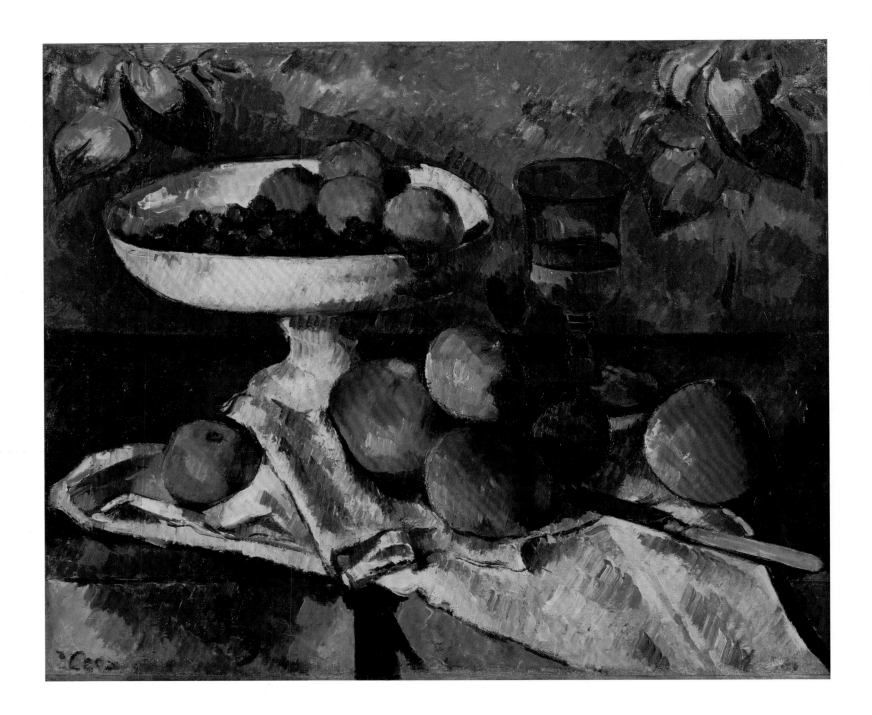

Fig. 269 Paul Cézanne, *Still Life with Fruit Dish*, 1879–80.
Oil on canvas, 18¼ × 21½ in. (46.4 × 54.6 cm).
The Museum of Modern Art, New York. Fractional gift of
Mr. and Mrs. David Rockefeller (69.1991) (R 418)

learned at the feet of Pissarro to found subsequent "schools" of artists who looked to
him as an exemplar. He thoroughly learned the nongovernmental dealer-critic system of
art exchange and promotion and used it to his advantage throughout his working life
(he even kept a "clipping book" of the criticism of his 1893 Durand-Ruel exhibition).
But more than any of that, he adopted the central tenet of the Impressionist
movement—that art is at once a continuous struggle of self-definition and a lifelong
experiment rather than the skillful application of lessons learned in art school. Like
many of his colleagues in the Impressionist movement, Gauguin was defiantly self-
taught, but he developed his art in competition with the very best of his contemporaries,
never flinching from comparing his own production directly with those of his ablest
colleagues.

Fig. 270 Maurice Denis, *Homage to Cézanne*, 1900. Oil on canvas, 70⁷/₈ × 94¹/₂ in. (180 × 240 cm). Musée d'Orsay, Paris. Gift of André Gide, 1928 (1977–137)

What is unique about Gauguin's experiments as an Impressionist is that they were so varied. He worked with marble, wood, plaster, clay, oil paint, pastel, ink, watercolor, and graphite to produce works of art that, when assembled, look like the production not of one, but of several artists. He was unafraid to mimic stronger artists like Pissarro, Cézanne, and Degas, and seems to have been unimpressed by the comparatively narrow physical and emotional range (we might say "focus" today) of others like Monet, Renoir, Caillebotte, Morisot, and Sisley. He was, in short, unafraid to fail, and, for that reason, both he and we learn from his experiments in artistic communication. Like Courbet, in the previous generation, he was defiant and almost ruthlessly self-reliant, creating a life as independent from authority as any artist in the history of Western art. Like Pissarro, his truest mentor, he was open to the ideas, mediums, and inventions of others and not afraid to adapt and change. Like Pissarro and Degas, he was committed to a carefully crafted and cerebral mode of production that was, in many senses, antithetical to the informality and speed of other Impressionists. For him, making an "impression" was a highly mediated and theorized process rather than a simple act.

As a full participant in a movement that has, since its beginnings, been associated with the transient and direct aspects of modernity, Gauguin sought the opposite— persistence and mystery. He courted the enigmatic, and, in this respect, many of the works he submitted to the Impressionist exhibitions were profoundly different from those of artists like Monet and Renoir. In attempting to reconcile this apparent contradiction, we must remember that the word "Impressionist" was applied to the group not by the artists, but by a hostile critic. Although they eventually adopted it to distinguish themselves from other artists, they never did so with real enthusiasm, and all of them knew the shortcomings of the word "Impressionism" as an indicator of their aesthetic system.

The group started as a corporation (a self-styled "société anonyme") of artists with diverse individual sensibilities wanting to take their production directly to the public without an intermediary. As such, they harbored diverse aesthetic tendencies from their first exhibition in 1874 until their last in 1886, and no two of their eight group exhibitions had the same group of artists. By 1877, they had caved in to public pressure and actually called themselves "Impressionists," and many of the members, including Gauguin, continued to use the word as a matter of convenience well after 1886. The word "Post-Impressionism" was coined in the early twentieth century by the English critic Roger Fry, who recognized that the aesthetic experiments of Cézanne, Gauguin, and Seurat, all of whom exhibited with the Impressionist coalition, were much more profound and complex than the word "Impressionist" implies.

Scholars have long realized that the Impressionist movement harbored its own forms of "anti-Impressionism" and that artists associated with the group were a widely varied lot associated more by their "independence" than their "Impressionism." Indeed, the word "independent" is much more in keeping with the political and aesthetic aims of the movement than "Impressionist." Gauguin himself was fully cognizant of this when he developed his own methods of artistic production, none of which involved the kind of spontaneity and directness normally associated with a movement named for Monet's *Impression, Sunrise*. If Degas was the artist whose group of gritty urban naturalists was seen as antithetical to the "Impressionism" of Monet and Renoir, there was a powerful third camp within the movement led by Pissarro and known today as the "school of Pontoise." Gauguin, Cézanne, and Guillaumin were the most prominent members of this subgroup, which has been more fully studied in France than in the United States or Great Britain. On the other hand, when we look at the Impressionist production by Gauguin assembled in this exhibition and catalogue, it becomes clear that he was far too complex and potent an artist to be defined by membership in something called the "school of Pontoise."

Gauguin's adaptability and his penchant for experiment surely had their origins in his complex, rootless, and multinational childhood, and his skillfull navigation among the various subgroups of Impressionists was made easier for him by his familiarity with the factionalized world of the Parisian financial and business markets. Indeed, Gauguin brought skills and connections to the Impressionist movement that enabled it to last as long as it did, and his role in negotiating the 1882 Impressionist exhibition was critical to the fortunes of the group in the early 1880s. Of course, if his contributions to the movement were limited to interpersonal skills and financial acumen, we would not remember Gauguin today. It is the works of art from which this exhibition has been chosen that make a case for both him and the movement—and a new understanding of each helps enrich that of the other.

We know from the patient research of Robert L. Herbert, Françoise Cachin, and others the full extent of Seurat's debt to the Impressionist movement in the creation of what became for him a "New Impressionism." We also have learned from Joachim Pissarro and others about the critical role that the movement—and its oldest

practitioner, Camille Pissarro—played in the development of Cézanne's particular form of Impressionism in the 1870s and early 1880s. With these links firmly in our minds, it is easier to place Gauguin at the center of Impressionism, particularly after 1879, than to read his early career as a minor part either of his own career or of the Impressionist movement. This is particularly clear when we consider his sculpture and ceramics, both of which come out of his interaction with other artists, most notably Degas and Pissarro.

There is, in the end, no artist associated with Impressionism who experimented with a broader range of mediums and who, indeed, considered the materials of the artist as just that—mediums of self-expression. We can see that he made works of certain types and in certain mediums in concentrated periods of production. When he had played out the potential of a particular medium, he would simply drop it—albeit temporarily—and take up another. This pattern was to continue throughout the rest of his life. When he carved his first marble sculpture of his son Emil in 1878, he had never before worked with the medium. The same can be said for his first wood carvings, ceramics, lithographs, woodcut prints, monoprints, and the like. He later tried his hand as a writer, first of art criticism, then of fiction, and finally of the memoire, and these forms and mediums of expression were to become as important to his process of self-invention through art as oil paint or pencil.

This exhibition and its publication have attempted to define the contribution of Gauguin to Impressionism by presenting the best of his oil paintings, wood sculptures, and ceramics produced in the years 1875–87. On the walls of the Ordrupgaard in Copenhagen and the Kimbell Art Museum in Fort Worth, these works are allowed to speak for themselves. Here they have been placed in three important artistic contexts— (1) the private art collection of his guardian, Gustave Arosa; (2) the work of his colleagues in the Impressionist movement; and (3) the works of art in his own private collection. The experience of Gauguin's own Impressionism in the exhibition is closely tied to the larger one evoked in this publication. The curators of the exhibition and authors of the catalogue hope that, as a result of both, Gauguin will always be considered an "Impressionist" and that, whenever the movement is discussed, his name will be linked directly to it.

Checklist of Gauguin's Collection

See Bodelsen 1970

1 Eugène Boudin, French, 1824–1898
 Unidentified

2 John Lewis Brown, French, 1829–1890
 Unidentified

3 Mary Cassatt, American, 1844–1926
 Woman with a Fan
 Pastel, 25⁵/₈ × 20⁷/₈ in.
 (65 × 53 cm)
 Private collection

4 Paul Cézanne, French, 1839–1906
 Female Nude, before 1870
 Oil on canvas, 51 × 64 in.
 (130 × 162 cm)
 Location unknown

5 Paul Cézanne, French, 1839–1906
 The Harvest, c. 1877
 Oil on canvas, 18 × 21³/₄ in.
 (45.7 × 55.2 cm)
 Private collection
 (Fig. 41)

6 Paul Cézanne, French, 1839–1906
 The Château of Médan, 1880
 Oil on canvas, 23¹/₄ × 28¹/₂ in.
 (59.1 × 72.4 cm)
 Glasgow Museums, The Burrell
 Collection; Glasgow City Council
 (Museums)
 (Fig. 43)

7 Paul Cézanne, French, 1839–1906
 Still Life with Fruit Dish, 1879–80
 Oil on canvas, 18¹/₄ × 21¹/₂ in.
 (46.4 × 54.6 cm)
 Museum of Modern Art, New York.
 Fractional gift of Mr. and Mrs. David
 Rockefeller (69.1991)
 (Fig. 269)

8 Paul Cézanne, French, 1839–1906
 Avenue, c. 1880–82
 Oil on canvas, 29 × 23⁷/₈ in.
 (73.5 × 60.5 cm)
 Göteborgs Konstmuseum, Göteborg,
 Sweden
 (Fig. 204)

9 Paul Cézanne, French, 1839–1906
 Mountains, l'Estaque, c. 1879
 Oil on canvas, 21¹/₈ × 28¹/₂ in.
 (53.5 × 72.4 cm)
 National Museums and Galleries of
 Wales, Cardiff
 (Fig. 42)

10 Honoré Daumier, French, 1808–1879
 At the Exhibition
 Charcoal and black crayon on paper,
 6¹/₈ × 8¹/₂ in. (15.5 × 21.5 cm)
 Ordrupgaard, Copenhagen

11 Honoré Daumier, French, 1808–1879
 *Don Quixote and Sancho Panza
 behind a Tree*
 Black crayon on paper, 3¹/₄ × 2 in.
 (8.2 × 5.2 cm)
 Statens Museum for Kunst,
 Copenhagen

12 Edgar Degas, French, 1834–1917
 Dancer Adjusting Her Slipper, 1880
 Pastel on paper, 23⁵/₈ × 18¹/₈ in.
 (60 × 46 cm)
 Ordrupgaard, Copenhagen
 (Fig. 174)

13 Jean-Louis Forain, French, 1852–1931
 *Portrait of Cabaret Singer Valéry
 Roumy*, c. 1880
 Pastel on paper, 10¹/₈ × 10¹/₄ in.
 (25.7 × 25.8 cm)
 Statens Museum for Kunst,
 Copenhagen
 (Fig. 96)

14 Jean-Louis Forain, French, 1852–1931
 At the Circus
 Pen and watercolor on paper
 Private collection

15 Amand Gautier, French, 1825–1894
 Unidentified

16 Armand Guillaumin, French, 1841–1927
 Autumn Landscape, c. 1876
 Oil on canvas, 70⁷/₈ × 48¹/₂ in.
 (180 × 123 cm)
 National Museum of Art, Architecture
 and Design–National Gallery, Oslo

17 Armand Guillaumin, French, 1841–1927
 L'Allée des capucines, c. 1880
 Oil on canvas, 31¹/₄ × 25 in.
 (79.5 × 63.5 cm)
 Ny Carlsberg Glyptotek, Copenhagen

18 Armand Guillaumin, French, 1841–1927
 *Garden behind Old Houses,
 Damiette*, c. 1882
 Oil on canvas, 23 × 28³/₈ in.
 (58.5 × 72 cm)
 Ny Carlsberg Glyptotek, Copenhagen

19 Armand Guillaumin, French, 1841–1927
 *View towards the Panthéon from a
 Window on the Ile Saint-Louis*, 1881
 Oil on canvas, 31³/₈ × 17³/₄ in.
 (79.5 × 45 cm)
 Ny Carlsberg Glyptotek, Copenhagen
 (Fig. 48)

20 Armand Guillaumin, French, 1841–1927
 Woman Reading in a Landscape,
 c. 1880–82
 Pastel on paper, 18³/₈ × 11⁷/₈ in.
 (46.5 × 30 cm)
 Ny Carlsberg Glyptotek, Copenhagen
 (Fig. 49)

21 Armand Guillaumin, French, 1841–1927
 Quai Sully (Quai Henri IV), c. 1878
 Oil on canvas, 22⁵/₈ × 28¹/₈ in.
 (57.5 × 71.5 cm)
 Musée du Petit Palais, Geneva

22 Armand Guillaumin, French, 1841–1927
 Quai Henri IV
 Pastel, 19¹/₈ × 23³/₈ in.
 (48.5 × 59.5 cm)
 Private collection

23 Armand Guillaumin, French, 1841–1927
 Figures in a Garden, c. 1885
 Oil on canvas, 19⁵/₈ × 24 in.
 (50 × 61 cm)
 National Museum of Art, Architecture
 and Design–National Gallery, Oslo

24 Armand Guillaumin, French, 1841–1927
 Landscape
 Oil on canvas, 15 × 21⁵/₈ in.
 (38 × 55 cm)
 Private collection

25 Armand Guillaumin, French, 1841–1927
 Trees, c. 1878
 Oil on canvas, 21 × 26 in.
 (53.5 × 66 cm)
 Private collection

26 Armand Guillaumin, French, 1841–1927
 The Orchard, c. 1880–82
 Oil on canvas, 21¼ × 25⅝ in.
 (54 × 65 cm)
 Location unknown

27 Johan Barthold Jongkind, Dutch,
 1819–1891
 The Port of Le Havre
 Pencil and watercolor on paper,
 9 × 11⅜ in. (23 × 29 cm)
 Ny Carlsberg Glyptotek, Copenhagen

28 Johan Barthold Jongkind, Dutch,
 1819–1891
 Marine I
 Unidentified

29 Johan Barthold Jongkind, Dutch,
 1819–1891
 Marine II
 Unidentified

30 Édouard Manet, French, 1832–1883
 View in Holland, 1872
 Oil on canvas, 19¾ × 23¾ in.
 (50.2 × 60.3 cm)
 Philadelphia Museum of Art
 (Fig. 46)

31 Édouard Manet, French, 1832–1883
 Woman Sitting in the Garden or
 Knitting
 Pastel, 22 × 18⅛ in. (56 × 46 cm)
 Private collection

32 Camille Pissarro, French, 1830–1903
 Cowherd, Montfoucault, 1875
 Oil on canvas, 11 × 16⅛ in.
 (28 × 41 cm)
 Location unknown (PV 323)

33 Camille Pissarro, French, 1830–1903
 Landscape near Pontoise, 1878
 Oil on canvas, 15⅜ × 22 in.
 (39 × 56 cm)
 Oskar Reinhart Collection "Am

Römerholz," Winterthur, Switzerland
(PV 453)

34 Camille Pissarro, French, 1830–1903
 Woodland Scene, Spring, 1878
 Oil on canvas, 28¾ × 21¼ in.
 (73 × 54 cm)
 Ny Carlsberg Glyptotek, Copenhagen
 (PV 480)
 (Fig. 51)

35 Camille Pissarro, French, 1830–1903
 Landscape from Pontoise, c. 1880
 Tempera on canvas, 12 × 8¾ in.
 (30.3 × 22.2 cm)
 Ny Carlsberg Glyptotek, Copenhagen
 (PV 1331)
 (Fig. 194)

36 Camille Pissarro, French, 1830–1903
 *Landscape near Auvers with a
 Peasant Riding a Donkey*, 1879
 Oil on canvas, 21¼ × 28¾ in.
 (54 × 73 cm)
 Private collection (PV 494)

37 Camille Pissarro, French, 1830–1903
 Woodcutter, 1879
 Oil on canvas, 35 × 45¾ in.
 (89 × 116.2 cm)
 Private collection (PV 499)
 (Fig. 50)

38 Camille Pissarro, French, 1830–1903
 Peasant Women Chatting, c. 1881
 Oil on canvas, 13¾ × 10⅝ in.
 (35 × 27 cm)
 Private collection (PV 530)

39 Camille Pissarro, French, 1830–1903
 Road Leading to Osny, 1883
 Oil on canvas, 21¾ × 18⅛ in.
 (55 × 46 cm)
 Musée des Beaux-Arts, Valenciennes
 (PV 585)
 (Fig. 52)

40 Camille Pissarro, French, 1830–1903
 Peasant Woman Warming Herself,
 1883
 Oil on canvas, 28¾ × 23⅝ in.
 (73 × 60 cm)
 Private collection (PV 619)
 (Fig. 53)

41 Camille Pissarro, French, 1830–1903
 Landscape with Haystacks, Osny,
 1883
 Oil on canvas, 18⅛ × 21⅝ in.
 (46 × 55 cm)
 Private collection (PV 589)

42 Camille Pissarro, French, 1830–1903
 Possibly *Landscape, Plain with
 Haystacks on the Left*, 1873
 Oil on cradled panel,
 11½ × 20⅝ in. (29.2 × 52.2 cm)
 Private collection (PV 233)

43 Camille Pissarro, French, 1830–1903
 Winter, Return from the Fair,
 c. 1884–85
 Éventail (fan), 9⅞ × 21¼ in.
 (25 × 54 cm)
 Location unknown (PV 1626)

44 Camille Pissarro, French, 1830–1903
 The Port of Rouen, 1883
 Etching, 4⅝ × 5⅞ in.
 (11.8 × 14.9 cm)
 Statens Museum for Kunst,
 Copenhagen

45 Camille Pissarro, French, 1830–1903
 *Landscape at Rouen (Côte
 Sainte-Catherine)*, 1885
 Etching, 5⅛ × 7 in. (13 × 17.7 cm)
 (Delteil 1999, no. 55)

46 Pierre-Auguste Renoir, French, 1841–1919
 Women by the Sea
 Unidentified

47 Pierre-Auguste Renoir, French, 1841–1919
 Landscape: Street in Algiers
 Unidentified

48 Alfred Sisley, French, 1839–1899
 Saint Cloud
 Location unknown

49 Alfred Sisley, French, 1839–1899
 The Railroad Station, Meudon
 Oil on canvas, 19⅝ × 24 in.
 (50 × 61 cm)
 Private collection

50 Victor Vignon, French, 1847–1909
 Unidentified

Notes

Introduction Was Gauguin an Impressionist? A Prelude to Post-Impressionism

1 Washington–Chicago–Paris 1988–89, p. 11.
2 Sweetman 1995, p. 89.
3 See the famous negative review by Merete Bodelsen, Bodelsen 1966.
4 Malingue 1949, p. clxxiii, quoted in Washington–Chicago–Paris 1988–89, p. 11.
5 Berson 1996.
6 The publication of these texts is always in the original language, making it difficult for the average English-speaking amateur to have access to this rich material.

Part I Becoming an Artist-Collector

1 Curiously, Gauguin's grandmother, Flora Tristan, had visited the palace in 1834, describing it in some detail in her book: "The Presidential palace is vast, but badly built and badly situated." Tristan 1986, p. 265.
2 Flora Tristan made specific mention of pre-Hispanic material in her discussion of a visit she made to the museum in Lima in 1834: "The collection comprises four Inca mummies still apparently in their original condition, though less carefully prepared than their counterparts in Egypt, a few stuffed birds, and a small number of shells and mineral samples. What I found most interesting was a large assortment of ancient vases used by the Incas. These people gave their vessels grotesque shapes and engraved them with symbolic figures." Tristan 1986, pp. 263–64. Tristan wrote volubly about the quality of the religious architecture in Lima and made particular mention of the interior carvings of the choir. Tristan 1986, pp. 260–61. She also remarked on the pageantry of the mass and other church spectacles in Lima, particularly the singing of the numerous caged birds who surrounded the altars during the mass. Tristan 1986, p. 277.
3 A concise and well-documented discussion of the relationship of Clementine de Bussy and the Arosa family can be found in Marcel Dietschy, *A Portrait of Claude Debussy*, trans. William Ashbrook and Margaret G. Cobb (Oxford, 1990), pp. 7–16. There can have been no direct connection between Paul Gauguin and the much younger Debussy, and, by the time both men became relatively famous, the Arosas were long dead and even the indirect connections forgotten.

4 Druick and Zegers 2001, p. 25.
5 For a detailed discussion of the palace in Lima, see Tristan 1986, p. 265, and Sweetman 1995, pp. 24–25. For a plan of the house, see Druick and Zegers 2001, p. 26.
6 Paris 1878, p. iii.
7 These have been identified by Lee Johnson (who mistakenly refers to Gustave Arosa as Georges Arosa) in Lee Johnson, *The Paintings of Eugène Delacroix: A Critical Catalogue*, 6 vols. (Oxford, 1981–89): no. 19, *Portrait of Suzanne Fourment, after Rubens*, 1825–28, A. K. Solomon, Cambridge, Mass.; no. 139, *Tam O'Shanter Pursued by Witches*, c. 1829, Mrs. Charlotte Bührle, Zurich; Johnson doubts the attribution of the copy after the *Landing of Marie de' Medici at Marseilles, after Rubens* (R16); no. 179, *Lion Devouring a Goat*, 1847, J. Barry Donahue collection, New York (although there is a photograph of this painting in Gustave Arosa's sale catalogue, there is no entry or lot number; it was likely in the collection of his brother, Achille, at the time); no. 228, *Marshal de Tourville* (sketch), c. 1835, whereabouts unknown; no. 304, *Desdemona and Emilia*, 1849–53, whereabouts unknown; no. 329, *Rebecca and the Wounded Ivanhoe*, 1858, whereabouts unknown; no. 364, *Encampment of Arab Mule-Drivers*, c. 1839, Milwaukee Art Museum (fig. 3); no. 396, *Moroccan Mounting His Horse*, 1854, private collection, Berne; no. 412, *Moroccan Landscape*, 1850s (?), Kunsthalle, Bremen (not in the index under Arosa) (fig. 4); no. 423, *Christ on the Cross*, sketch, 1837 (?), whereabouts unknown; no. 430, *St. Sebastian Tended by the Holy Women*, 1844, whereabouts unknown. Johnson does not account for the remaining works in the 1878 catalogue but mentions "thirty-one sheets of studies listed as for the *Liberty* passed in Delacroix's posthumous sale under lot 319, twenty-one probably going to Arosa and later to pass in his sale as part of an album (27 Feb. 1864, lot 165*bis*, to Dr. Suchet)" (ibid., vol. 1, p. 149). How fascinating that Gauguin could have seen these! Arosa also bought a study of a nude woman at the February sale, lot 200, "*Assorted Studies and Academy Figures*" (ibid., p. 177), which was in neither his sale nor his brother's.
8 These were *Le Premier Bain*, Maison I-55, Detroit Institute of Arts (fig. 6); *Don Quixote et Sancho Pansa sous un arbre*, Maison I-174, Ny Carlsberg Glyptotek, Copenhagen (fig. 5); *Après le Bain* (now called *Baigneur*), Maison I-16, Rose Art Museum, Brandeis University (Gift of Mr. and Mrs. Albert J. Dreitzer, 1964), and *Faunes et Satires*, now known as *Silène et deux faunes*, Maison I-59, Hahnloser collection, Berne. See K. E. Maison, *Honoré Daumier: Catalogue Raisonné of the Paintings, Watercolours, and Drawings* (New York, 1968), vol. 1.
9 There was only one painting in the illustrated catalogue (though not the printed sale portion) of Gustave's collection that was also in the 1891 Arosa sale—Delacroix's *Lion devorant un chamois* (Paris 1891, no. 12, pp. 20–21, and Paris 1878, no. 27, n.p.). It is possible, however, that Achille purchased a Courbet landscape from his brother's sale; the single Courbet landscape in the 1891 sale has an almost identical dimension to one in the 1878 exhibition (Paris 1878, no. 18, p. 9, and Paris 1891, no. 8, p. 16).
10 Merlhès 1984. There are only two problems with this indispensable book: it is unindexed and stops at the end of 1888. We eagerly await M. Merlhès's second and perhaps third volumes.
11 Marie Heegaard to her sister Louise, mid-July 1873, in Merlhès 1984, no. VII, p. 5 (translation by the present author).
12 See Berson 1996, vol. 2, IV–179, p. 118.
13 See also *Vase with Anemones and Anthemis* (private collection; WII 33) and *Bouquet of Peonies on a Musical Score* (private collection; WII 34).
14 Wildenstein 2002, vol. 1, p. 16.
15 Robert Hellebranth, *Charles-François Daubigny, 1817–1878* (Morges, 1976).
16 Wildenstein 2002, vol. 1, p. 15.
17 For a list of entries at the Impressionist exhibitions, see Berson 1996, vol. 2.
18 See Wildenstein 2002, vol. 1, nos. 16–19, pp. 18–21.
19 Ibid., pp. 21–22.
20 Ibid., p. 33.
21 Sweetman 1995.
22 My thanks to Richard Kelton for our stimulating conversations about the interpretation of this and other early Gauguins in his collection.
23 Marie Heegaard to her family, late July–early August 1873, in Merlhès 1984, no. VIII, p. 5.
24 Gauguin to Pissarro, April 3, 1879, in Merlhès 1984, no. 6, p. 12.
25 Berson 1996, vol. 1, p. 219.
26 It can be compared favorably with an equally large vertical landscape most likely exhibited in the 1877 exhibition as no. 166. Now called *Le*

Jardin à Pontoise, PV 394, it is in a private collection in Paris.

27 Henry Havard, *Le Siècle*, April 27, 1879, p. 3, in Berson 1996, vol. 1, p. 223.

28 For an analysis of this exhibition and Monet's contribution to it, see Ronald Pickvance, "Contemporary Popularity and Posthumous Neglect," in San Francisco 1986, pp. 243–65.

29 For a listing, see Paul Gachet, *Paul Gachet: Le Docteur Gachet et Murer, Deux Amis des Impressionistes* (Paris, 1956), p. 171.

30 Only one other attempt has been made to suggest which works were lent by Murer. See Bailly-Herzberg 1980, vol. 1, p. 135. This author agrees with only one of her tentative identifications.

31 Gauguin to Pissarro, May–July 1880, in Merlhès 1984, no. 12, p. 18.

32 Nos. 167 *Le Pont de Pontoise*; PV443 (definite)
 168 *Lisière d'un bois*; PV455 (highly likely)
 169 *Chemin sous bois*; PV416 (Musée d'Orsay) (highly likely)
 170 *Effet de neige (Côté du Palâis Royale)*; lost
 171 *Effet de neige et glace (Effet de soleil)*; PV477 (definite)
 172 *Effet de Soleil, Boulevard Clichy (Esquisse)*; lost
 173 *Sous bois en été*; PV489 (definite)
 174 *Le Verger de Maubuisson*; M. M.; PV345 or PV496 (possible)
 175 *Château des Mathurins (Soleil couchant)*; M. M.; PV397 (definite)
 176 *Automne (Soleil couchant)*; M. M.; PV440 (definite)
 177 *Les Peupliers (Matinée d'été)*; M. M.; PV466 (highly likely)
 178 *Paysage en fevrier (Femme revenant de la Fontaine)*; M. G.; PV480 (definite)
 179 *Les Meules*; M. G.; PV233 (highly likely)
 180 *Le Potager*; Mlle. T.; PV437 or 447 (not possible to identify more precisely)
 181 *L'Hermitage: Vue de ma fenêtre*; M. G. C.; PV350 (possible)
 182 *Vue de l'Hermitage*; M. G. C.; PV407 (highly likely; no photograph)
 183 *Printemps: Pruniers en fleurs*; M. G. C.; PV387 (highly likely), possibly PV383
 184 *Petit bois de peupliers en plein été*; M. G. C.; PV406 (highly likely)
 185 *Planteurs de choux*; M. G. C.; PV493 (highly likely)
 186 *Port-Marly*; M. G. C.; PV122 (highly likely, though no evidence of M. G. C. ownership)
 187 *Petit bois (Poules et canards)*; M. M.; PV441 (definite)
 188 *Côte des Brouettes (Temps gris)*; PV450 (obviously mistaken for the Côte des Grouettes) (highly likely, but possibly PV465)

33 Berson 1996, vol. 1, p. 223.

34 English translation in San Francisco 1986, p. 286.

35 This mode of hanging was practiced in the previous Impressionist exhibition and perhaps too in 1879. See San Francisco 1986, pp. 189–202.

36 These were nos. 148 (*Lavacourt*), 150 (*La Seine à Lavacourt [soleil couchant]*), and 161 (*Lavacourt, temps gris*). See Berson 1996, pp. 115–16, 134, and 136. (These identifications are not secure, however, and were made on the plausible suggestion of Ronald Pickvance.)

37 San Francisco 1986, p. 287.

38 Ibid., p. 288.

39 Ibid.

40 Sweetman 1995, p. 87.

41 This is touchingly demonstrated in Pissarro's letter to his friend and collector, Eugène Murer, written in the summer of 1879. See Bailly Herzberg 1980, vol. 1, pp. 134–35. Pissarro pleaded (probably successfully) to Murer and to Caillebotte to purchase paintings at a very low rate. It is likely that Caillebotte purchased at least two paintings from the 1879 exhibition.

42 Bodelsen 1970. For a checklist of Gauguin's collection based on Bodelsen 1970, see pp. 346–47, in the present volume.

43 Sidney Geist, *Interpreting Cézanne* (Cambridge, Mass., 1988).

44 Wildenstein 2002, vol. 2, pp. 300–301 and 310–11.

Part II Becoming an Impressionist Painter-Sculptor

1 Gauguin to Pissarro, late October—early November 1882, in Merlhès 1984, no. 28, pp. 34–35.

2 Edmond Duranty, "La Quatrième Exposition faite par un groupe d'artistes indépendants," *La Chronique des arts et de la curiosité*, April 19, 1879, pp. 126–28, in Berson 1996, p. 219.

3 Gauguin remembered this time in *Avant et après*: "Un peu plus tard je taillais avec un couteau et sculptais des manches de poignard sans le poignard; un tas de petits rêves incompréhensibles pour les grandes personnes. Une vieille bonne femme de nos amies s'écriait avec admiration: 'Ce sera un grand sculpteur.' Malheureusement cette femme ne fut point prophète." See Paul Gauguin, *Oviri, écrits d'un sauvage*, choisis et présentés par Daniel Guérin (Paris, 1974), p. 277.

4 Cf. Gauguin to Pissarro, May–June 1882, in Merlhès 1984, no. 23, pp. 28–29.

5 See, for instance, Hirota 1998, vol. 1, p. 25.

6 Gray 1963, no. 2.

7 Gauguin expressed his thanks in a letter of April 3, 1879, in which he accepted the exhibition's conditions that he should not show works in the official Salon. Gauguin to Pissarro, April 3, 1879, in Merlhès 1984, no. 6, p. 12.

8 "D'excellents dessins au fusain de M. Lebourg, et une petite sculpture agréable de M. Gauguin, la seule sculpture qu'il ait là, ont excité aussi, les premiers surtout, intérêt de visiteurs"; quoted from Berson 1996, p. 219.

9 Thus Gray argues that the bust of Emil was probably identical to the bust that was exhibited as no. 62, "Buste marbre," in the fifth Impressionist exhibition in 1880. Gray 1963, no. 2, p. 110.

10 Bodelsen 1984, no. 2, p. 46. Here Bodelsen observes that the exhibition catalogue from Den Frie Udstilling ironically also failed to spell the name correctly, spelling it Emile, as in French.

11 Gauguin to Marie Heegaard, September 12, 1874, in Merlhès 1984, no. 5, pp. 10–11.

12 See Bodelsen 1970, p. 601, and n. 32; Washington–Chicago–Paris 1988–89, p. 6; Bodelsen 1968, p. 25.

13 On Emil, see Wildenstein 2002, vol. 1, p. 23.

14 Gauguin to Schuffenecker, March 17, 1885, in Merlhès 1984, no. 75, pp. 99–100.

15 Gauguin to Mette, August 15, 1886, in Merlhès 1984, no. 111, p. 138.

16 Emil is also seen in a few photographs; see Wildenstein 2002, p. 23, perhaps also pp. 72 and 595.

17 Wildenstein 2002, vol. 1, no. 21.

18 Ibid., no. 45.

19 Ibid., no. 45, refers to a wax bust that—according to Bodelsen 1967, pp. 224–25—represents Emil. In all probability, however, this bust is a portrait of Aline and was published as such by Anne Pingeot (see cat. 24).

20 Quoted from Hirota 1998, vol. 1, pp. 19 and 58, n. 3, which refers to Judith Cladel, *Rodin, sa vie glorieuse et inconnue* (Paris, 1936), pp. 127 and 128.

21 See Hirota 1998, vol. 1, p. 20 and n. 4, which refers to Stanislas Lami, *Dictionnaire des Sculpteurs de l'Ecole francaise au dix-neuvième siècle* (Paris, 1914; repr., Nendeln, Liechtenstein, 1970), p. 170.

22 The doubt surrounding this question is partly due to the fact that Pola Gauguin was of the opinion that the bust of Mette was the first one; Gauguin 1937, p. 44.

23 Gauguin to Mette, September 19, 1885, in Merlhès 1984, no. 84, p. 112; see also Gauguin to Mette, on about October 10, 1885, and about July 5–10, 1886, in Merlhès 1984, no. 86, p. 114, and no. 102, pp. 130–31.

24 Merlhès 1984, n. 197, p. 428.

25 Gauguin 1937, p. 44.

26 Merlhès 1984, n. 37, p. 339.

27 Ibid. The bust of Emil has most recently been dated to 1877–78 in New York 2002, no. 9, p. 16.

28 Copenhagen 1893, no. 120: "*Emile, 1878. Buste i Marmor. Tilh. fru Gauguin.*"

29 *Aarhus Amtstidende*, May 1, 1893.

30 *Nationaltidende*, March 28, 1893 (signed "C. H.").

31 See cat. 6 regarding Emil. Gray 1963, no. 1.

32 Wildenstein 2002, vol. 1, no. 154.

33 See cat. 6 (*Bust of Emil*). Had it been executed earlier, Gauguin would doubtless have chosen to show it in the Impressionist exhibition of 1879.

34 Bodelsen 1984, no. 1, p. 45.

35 See Gray 1963, p. 1.

36 Bodelsen 1984, pp. 45–46, mentions that Pissarro's son Ludovic-Rodo said there was a version of the bust of Mette that may have been the original model in his father's house in Osny.

37 See cat. 6 (*Bust of Emil*).

38 Ibid.

39 Gauguin 1937, p. 25.

40 See below, n. 53.

41 Signed "P. Gauguin."

42 This photograph of Mette Gauguin (fig. 57) was taken on the occasion of her engagement; it coincides very largely with the small portrait drawing.

43 Gauguin 1937, p. 36.

44 Bodelsen 1968, p. 15.

45 See Sweetman 1995.

46 Otto Rung, *Fra min Klunketid* (Copenhagen, 1942; 3rd ed., 1945), pp. 88–90.

47 Esther Maria Bredholt, "Mette Gauguin," feature article in *Berlingske Aftenavis*, January 17, 1945.

48 Paul Gachet, *Lettres Impressionnistes* (Paris, 1957), p. 168.

49 Réne Huyghe, *Gauguin* (Näfels, 1988), p. 15.

50 Sweetman 1995.

51 Gauguin to Pissarro, about May 7, 1883, in Merlhès 1884, no. 35, n. 102, p. 43.

52 "pas du tout *indépendants*," M. de Thémines, "Causerie: Beaux-Arts: Les Artistes indépendants," *La Patrie*, April 7, 1880, p. 2, in Berson 1996, vol. 1, p. 310.

53 Henry Trianon, "Cinquième Exposition par un groupe d'artistes indépendants (10, rue des Pyramides)," *Le Constitutionnel*, April 8, 1880, pp. 2–3, in Berson 1996, vol. 1, p. 313.

54 Copenhagen 1893, no. 169; *Nationaltidende*, March 28, 1893 (signed C. H.).

55 Edmond Renoir in *La Presse*, April 9, 1880, p. 3, in Berson 1996, vol. 1, pp. 305–6.

56 Armand Silvestre in *La Vie Moderne*, April 24, 1880, p. 262, in Berson 1996, vol. 1, p. 307.

57 Wildenstein 2002, vol. 1, p. 56.

58 Bodelsen 1970, no. 6, p. 606.

59 Wildenstein 2002, vol. 1, pp. 60–61.

60 Ibid., p. 63.

61 Ibid., p. 67.

62 Gauguin to Pissarro, November 9, 1882, in Merlhès 1984, no. 29, pp. 35–36.

63 Gauguin to Pissarro, January 30, 1885, in Merlhès 1984, no. 68, p. 91.

64 Gauguin to Pissarro, June 1882, in Merlhès 1984, no. 24, p. 31.

65 Gauguin to Pissarro, November 9, 1882, in Merlhès 1984, no. 29, p. 35. Pissarro's letter appears to have been lost.

66 Ibid.

67 Gray 1963, p. 3; Fonsmark 1994, n. 19, points out the similarities between the cabinet and Alphonse Giroux's Japanese-style cupboard (1880), the wood of which is inlaid with bronze, silver, and "cloisonné" enamel work (reproduced in Cleveland 1975, p. 148, fig. 48).

68 For more on the cabinet and on the present author's publication of the newel in Gauguin's collection of folk art, see Fonsmark 1994, pp. 147–69.

69 The fruit and the foliation had strong colors in yellow, red, and green applied to them, while the basket and pineapple were lightly gilded. In color as well as other respects the newel points to Gauguin's later development: the red and green especially were to be seen in many of his own painted works in wood. A technical examination—by the present author and conservator Lars Henningsen—shows that the red pigment and the gilding are identical to what is seen on *The Singer* (cat. 21).

70 The authors of the Wildenstein catalogue are incorrect in stating that Gauguin painted "from life" (Wildenstein 2002, vol. 1, p. 250). He brought the newel with him to Denmark in 1884 and left it behind on his departure in 1885. The inaccuracy of the painting in several respects confirms that it was done from memory.

71 Dated 1740; see Wildenstein 2002, no. 60, p. 67 (ill.).

72 A. Joly-Segalen, ed., *Lettres de Paul Gauguin à Georges-Daniel de Monfreid* (Paris, 1918), p. 190.

73 See Bodelsen 1968 and Bodelsen 1970.

74 Gauguin 1937, p. 46.

75 The jug can be seen today at the Ny Carlsberg Glyptotek, Copenhagen (I.N. 3436). Gauguin used it as a motif in one of his still lifes (Wildenstein 2002, vol. 1, no. 27).

76 See Washington–Chicago–Paris 1988–89, p. 37.

77 Wildenstein 1964, nos. 28, 47, 50, 81, and 176 (ills.).

78 I.N. 3432–3435. I acquired it for the Ny Carlsberg Glyptotek in Copenhagen and published it in Fonsmark 1994, pp. 147–70. I dated the wood carving to the eighteenth century, but attributed the painting to Gauguin. Wildenstein 2002 (no. 208) has commented on my discovery and dates the basket of fruit to the seventeenth or eighteenth century (newel), providing an illustration showing how such baskets of fruit were used (from the Hôtel Richelieu-Bassompierre, Paris; fig. 74), Wildenstein 2002, vol. 1, p. 250.

79 There are two similar baskets of fruit from a newel in Le Musée Départemental des Antiquités, Rouen, both in unpainted oak. The first was made by Jacques Lefébure, c. 1653, and comes from the Monastère des Ursulines, Rue des Capucins, in Rouen; the other is from the time of Louis XIII.

80 Fonsmark 1994, p. 153.

81 This layer of paint is also to be found where the original paint and its priming had peeled off.

82 See Fonsmark 1987A, pp. 29–44 (ill.), and Fonsmark l987B. Pigments examined in connection with my acquisition of the relief for the Ny Carlsberg Glyptotek in 1986.

83 Melissa MacQuillan, *Les Portraits Impressionistes* (Paris, 1986), p. 190.

84 Wildenstein 2002, vol. 1, p. 250.

85 Gray 1963, no. 5.

86 Ibid., and pp. 3–4. See also Bodelsen 1964A, pp. 195–97 (ill.).

87 The basket of fruit was placed on top of the cabinet (see photo in Gray 1963, p. 114). When the photograph was taken, the cabinet was still in the possession of the Gauguin family. It was later sold—minus the basket of fruit—to the Museum für Kunst und Gewerbe, Hamburg, and all four elements of the newel remained in the possession of Gauguin's descendants.

88 See Cleveland 1975, p. 148, fig. 48; Gray 1963, p. 3.

89 According to tradition, the portrait medallions portray Gauguin's sons Clovis and Jean; see Loize 1951, no. 452 (ill. pl. V) and no. 463.

90 Bodelsen 1964A, fig. 141a (photo caption).

91 Ibid., fig. 141b (photo caption).

92 Gray 1963, p. 3, mentions that Gauguin introduced "a bit of rococo-carving" in the cabinet, but without giving any precise details. Under no. 5 there is meanwhile a reference to the basket of fruit as "an old piece from the eighteenth century." About Gauguin's use of "objets trouvés" in his art, see Fonsmark 1994.

93 Even in Gauguin's own day, the cabinet was viewed as a work of art, as is demonstrated by the fact that the management committee of the Gauguin exhibition in Den Frie Udstilling in Copenhagen, 1893, wanted to exhibit the cabinet. However, Mette Gauguin refused to lend it; see Bodelsen 1984, p. 51.

94 Wildenstein 2002, vol. 1, p. 66.

95 Washington–Chicago–Paris 1988–89, no. 3, p. 20.

96 Huysmans 1883, in Berson 1996, vol. 1, p. 352.

97 Berson 1996, vol. 2, p. 181.

98 Huyghe 1952, p. 228.

99 Wildenstein 2002, vol. 1, p. 76.

100 Gauguin 1938, p. 61, reproduced opposite p. 228.

101 Wildenstein 1964, no. 26, p. 13.

102 Huysmans 1883, in Berson 1996, vol. 1, pp. 351–52.

103 Wildenstein 2002, vol. 1, p. 79.

104 Huysmans 1883, in Berson 1996, vol. 1, p. 352.

105 Geffroy 1883, in Berson 1996, vol. 1, p. 343.

106 San Francisco 1986, p. 122.

107 The wording of the reviews suggests that other pieces of sculpture, possibly by different artists, may have been included.

108 Mantz 1881, p. 3, in Berson 1996, vol. 1, p. 358.

109 Claretie n.d., pp. 150–51.

110 Mantz 1881, p. 3, in Berson 1996, vol. 1, p. 358.

111 Cf. Gray 1963, p. 2.

112 Huysmans 1975, pp. 230–31.

113 Bertall, "Exposition des peintres intransigeants et nihilistes," *Paris-Journal*, April 21, 1881, p. 1, in Berson 1996, p. 330. Nina de Villars refers to Degas's dancer as "le morceau capital de cette exposition"; Villars 1881, p. 2, in Berson 1996, p. 371.

114 Mantz 1881, p. 3, in Berson 1996, vol. 1, p. 358. Despite the fact that the statue of the dancer was not seen on the opening day of the exhibition in 1881, it was already the subject of comment: "Monsieur Degas . . . was to exhibit a dancer modeled in wax. So far all we see is the glass case destined to receive and protect the statuette, which is said to be charming." Claretie n.d., pp. 150–51.

115 See Fonsmark 1994, pp. 159–64.

116 Burty 1882, in Berson 1996, p. 382.

117 My discovery of the bust is published in "A New Gauguin" in Ordrupgaard's bulletin, *Ordrupgaard Focus* 1 (summer 2005).

118 Pingeot 2004, pp. 54–55.

119 Gray 1963, no. 65.

120 Hirota 1998, vol. 1, p. 27.

121 From Philippe Burty's review of the exhibition we know that the bust originally had "hair gilded with mercury"; Burty 1882, in Berson 1996, p. 382.

122 Hirota 1998, vol. 1, pp. 25–26.

123 Several artists, including Medardo Rosso, used *objets trouvés* of this type in their sculptures; see Reff 1970, p. 289.

124 On the wax figures of the time, see Reff 1976, pp. 246–47, n. 27.

125 Merlhès 1984, n. 63, and Gauguin to Pissarro, November 11, 1881, no. 18, p. 23.

126 Reff 1976, p. 247 and n. 28.

127 Gauguin to Pissarro, early April 1884, in Merlhès 1984, no. 45, p. 60; see n. 132 concerning Raffaëlli's exhibition.

128 Millard 1976, p. 124, and *Degas inédit*, p. 240.

129 Blanc 1867/1876. The quotation here is from the 1876 edition; see pp. 18 and 432.

130 Gray 1963, no. 3. On this work, see also Fonsmark 1987A, pp. 29–44 (English summary), and Fonsmark 1995, no. 21; Washington–Chicago–Paris 1988–89, pp. 23–25.

131 The cabinet likewise has the relief technique in the sculptural sections and also demonstrates a form of mixed technique in that the heads of the roses must be seen to have been incorporated as *objets trouvés*; see cat. 15.

132 On the work's technique, see Fonsmark 1987A.

133 The sculptural section of the *Cabinet* (including the *Basket of Fruit*) and *Lady Strolling* both represent polychromy, and the former also includes gilding (cats. 14, 15, 22).

134 These pigments and the gilding are also found on the newel that Gauguin, at roughly the same time, acquired, painted, and placed loose on top of the cabinet, which he also made at this time (cats. 14, 15); see Fonsmark 1994 (English summary).

135 See Anne Pingeot, "Sculpture of the First Voyage," *Gauguin Tahiti* (Boston, 2004), pp. 73–77.

136 Gray 1963, p. 3.

137 Catalogue was reprinted in San Francisco 1986.

138 Bodelsen 1967, p. 225; Bodelsen 1968, pp. 98–99; Bodelsen 1984, no. 5.

139 On the basis of stylistic criteria, however, Lillian Browse, *Forain, The Painter, 1852–1931* (London, 1978), no. 21, is of the opinion that the pastel of Valéry Roumy must be dated to 1884–85.

140 Reff 1970, p. 280, and Theodore Reff, *The Notebooks of Edgar Degas: A Catalogue of the Thirty-Eight Notebooks in the Bibliothèque Nationale and Other Collections*, vol. 1 (Oxford, 1976), notebook no. 34, p. 4.

141 Huysmans 1883, pp. 225–27; reprinted in Huysmans 1975, p. 243.

142 Huysmans 1975, p. 231.

143 Charles F. Stuckey, in Washington–Chicago–Paris 1988–89, pp. 23–25; the stylistic influence of Carrier-Belleuse on this work has also been emphasized; see Andreas Blühm et al., *The Colour of Sculpture, 1840–1910* (Zwolle, 1996), p. 51.

144 The critics were Paul Mantz and Henry Trianon; see Beatrice von Bismarck, *Die Gauguin-Legende: Die Rezeption Paul Gauguins in der französischen Kunstkritik, 1880–1903* (Münster, 1992), pp. 22 and 24.

145 Theodore Reff, "More unpublished letters of Degas," *Art Bulletin* 51, no. 1 (March 1969), p. 288, letter no. 8.

146 Especially the large bas-reliefs in the form of medallions by David d'Angers and Auguste Préault; see Millard 1976, p. 80, and Charles F. Stuckey in Washington–Chicago–Paris 1988–89, p. 24.

147 Laurence Madeline, *Ultra-sauvage: Gauguin sculpteur* (Paris, 2002), pp. 46–47 (also refers to a Medusa-head and the shield of Perseus).

148 I am grateful to the archaeologist Miranda Marvin, Wellesley College, Wellesley, Mass.

149 Wilhelm Froehner, *La Colonne Trajane d'après le surmoulage executé à Rome en 1861–62, reproduite en phototypographie par Gustave Arosa* (Paris, 1872), pp. 29 and II, n. 5.

150 Mantz 1881, p. 3, in Berson 1996, p. 358.

151 Trianon 1881, pp. 2–3, in Berson 1996, p. 368.

152 Fénéon 1886, in Berson 1996, vol. 1, p. 443. Gray 1963, no. 4.

153 See Gray 1963, p. 3.

154 Wilhelm Froehner, *Terres cuites d'Asie Mineure* (Paris, 1881); see the preface for an account of contemporary interest in these figures.

155 Gauguin to Schuffenecker, May 24, 1885, in Merlhès 1984, no. 78, p. 105.

156 Gray 1963, p. 3, and Hirota 1998, vol. 1.

157 Reff 1970, p. 287.

158 About this, see Robert L. Herbert, in *Seurat* (Paris, 1991), p. 212.

159 Elie de Mont, "L'Exposition du boulevard des Capucines," *La Civilisation*, April 21, 1881, p. 2, in Berson 1996, vol. 1, p. 361.

160 Trianon 1881, pp. 2–3, in Berson 1996, vol. 1, p. 368.

161 Huysmans 1975, p. 242.

162 Ibid., p. 243.

163 Claretie n.d., pp. 150–51.

164 Villars 1881, in Berson 1996, p. 371. Huysmans, too, associated Degas's statuette with both Spanish art and the clothed figures of saints in church art: "While taking up the method of the old Spanish masters, Monsieur Degas has immediately made something quite special of it, quite modern, thanks to the originality of his talent. Just as with certain Madonnas, made up and dressed in robes, just as with the Christ in Burgos Cathedral—whose hair is real hair, the thorns real thorns, the drapery real material—Monsieur Degas's dancer has real skirts, real ribbons, a real corsage, real hair." Huysmans 1975, p. 228.

165 Bailly-Herzberg 1980, vol. 1, letter no. 190, p. 252.

166 For instance, see *Bust of Meyer de Haan* (1889) and *Cylinder Decorated with the Figure of Hina* (1892), in Gray 1963, nos. 86 and 95.

167 My discovery of the bust is published in "A New Gauguin" in Ordrupgaard's bulletin, *Ordrupgaard Focus* 1 (summer 2005).

168 See Anne Pingeot's publication of the bust of Aline in Pingeot 2004, pp. 54–55; it is here stated that Gauguin's own dating is difficult to read, and with reference to Mette Gauguin's information in the catalogue relating to the exhibition of the bust in Den Frie Udstilling in Copenhagen, 1893, it is there dated to 1882, but, as is also stated, Merete Bodelsen doubted the accuracy of Mette's information; see Bodelsen 1967, p. 226, and Bodelsen 1984, no. 3. In my view it continues to be most probable that the bust was made in 1881 with the two other busts now known.

169 Dominique Jarrassée, *Odilon Redon: Le rêve* (Paris, 1996), p. 14 (ill.).

170 Fonsmark 1988, no. 11, p. 91, and John Rewald, *Degas's Complete Sculpture*, catalogue raisonné, new ed. (San Francisco, 1990), no. XXIX, p. 96.

171 Gray 1963, no. 64.

172 These may be of shellac or possibly liquid wax.

173 Gray 1963, no. 10-A (under attributions; Gray tentatively dates it to 1893–95). Illustrated in color in Francoise Dumont, ed., *Gauguin: Les XX et la Libre Esthètique* (Liège, 1995), no. 37 (*Vase en forme de tête de jeune fille*), and in Madrid 2004, no. 181.

174 Wildenstein, 2002, vol. 1, no. 70.

175 Ibid., no. 79 (1881); other pictures show him at a slightly later stage (ibid., nos. 111, 113, 164).

176 Wildenstein 1964, no. 53; the pastel may be identical with the one that Gauguin showed in the 1882 Impressionist exhibition under no. 25: "Bébé. étude"; J.-K. Huysmans found Gauguin's child studies in the exhibition "curieux."

177 Rostrup 1960, p. 159, fig. 3.

178 Gray 1963, no. 5, contains the information that Pola Gauguin made plaster casts of the two heads in the form of medallions about 1904 (referring to Loize 1951, no. 452). The plaster heads were published and illustrated in Renè Puig, *Paul Gauguin, G. D. de Monfreid et leurs amis* (Perpignan, 1958). It must be Pola Gauguin who added the names "Jean-René" and "Clovis."

179 Sketches on page 25 (recto and verso) are also thought to show Jean-René.

180 Merete Bodelsen identified the bust as a portrait, perhaps of Emil, perhaps of Aline Gauguin. See Copenhagen 1893, no. 3; Bodelsen 1984, p. 47; and Bodelsen 1967, p. 225.

181 Pingeot 2004, pp. 54–55.

182 For instance, the bust of Jean-Paul Laurens, which, like the bust of Aline, was modeled in 1881; see Fonsmark 1988.

183 Gray 1963, no. 6 and p. 4. See also Fonsmark 1987A, pp. 41–43. The bust of Clovis was shown at the seventh Impressionist exhibition in 1882, no. 30, but not mentioned by the press.

184 I am grateful for this information to the dress historians Ingeborg Kock-Clausen and Fritze Lindahl, and to the church historian of the National Museum in Denmark, Marie-Louise Jørgensen.

185 So far this is a hypothesis, as the bust is in a private collection. Fonsmark 1994, pp. 158–64 (with English summary).

186 Villars 1881, p. 2, in Berson 1996, vol. 1, pp. 370–71.

187 For example, the *Self-Portrait Vase* from 1889 (fig. 94); Gray 1963, no. 65.

188 I am indebted to the museum curator Emmanuelle Heran (Musée d'Orsay, Paris) for this information.

189 Among others, Jean-Paul Laurens illustrated Thierry's work. On the medalist Claudius Popelin's tablet for Napoléon III (1865) we see a profile portrait in the form of a medallion of King Clovis with the king's name inscribed; see *L'Art en France sous le Second Empire* (Paris, 1979), no. 103.

190 Rainer Schoch, *Das Herrscherbild in der Malerei des 19. Jahrhunderts* (Munich, 1975), p. 86, ill. 79 and 136.

191 There has often been some uncertainty concerning the identification of Gauguin's child portraits because his sons had long "girl's" hair at times, while his daughter Aline often has her hair cut short like a boy.

192 Gauguin to Mette, end of March 1887, in Merlhès 1984, no. 122, p. 148.

193 On behalf of Mette Gauguin, Daniel de Monfreid had the figure cleaned as early as 1907 (see Loize 1951, pp. 55–56). See color photograph in Gray 1963, pl. 1.

194 Degas's notebook no. 34, p. 208; see Reff 1976, p. 263 (ill.). Degas must have drawn this bust from memory, for the jacket, for instance, is buttoned the other way. Degas either saw it in the seventh Impressionist exhibition in 1882 or at Gauguin's home, for in one of his other notebooks he notes the address "8 rue Carcel," adding "le jardin donne sur la station d'omnibus" (see Bodelsen 1984, p. 51).

195 Degas's bust has been lost. See Reff 1970, p. 294.

196 Gauguin to Pissarro, January 25, 1882, in Merlhès 1984, no. 22, pp. 27–28.

197 Wildenstein 1964, no. 50, p. 23.

198 Rotonchamp 1906/1925.

199 Wildenstein 2002, vol. 1, p. 88.

200 Berson 1996, vol. 1, p. 397.

201 Ibid., p. 406.

202 Wildenstein 2002, vol. 1, p. 91.

Part III An Interlude

1 For a summary of nineteenth-century color theory, see Herbert 1970.

2 Gauguin to Pissarro, May–June 1882, in Merlhès 1984, no. 23, pp. 28–29.

3 Ibid.

4 Ibid., p. 29.

5 Ibid.

6 Gauguin to Pissarro, about July 10, 1884, in Merlhès 1984, no. 49, p. 65.

7 Rewald 1996, nos. 389, 401–3, 407, 410, 434–35, 483–85, 488–93, 496–97, 499–501, and 505.

8 For the most recent and most intelligent discussion of the "Ecole de Pontoise," see Pontoise 2003.

9 Wildenstein 2002, vol. 1, p. 108.

10 *Snow, Rue Carcel II* was exhibited in France only once in Gauguin's lifetime, in Rouen in July 1884; see Wildenstein 2002, vol. 1, p. 110.

11 Wildenstein 2002, vol. 1, nos. 17 and 18, pp. 19–20.

12 Ibid., no. 87, p. 99.

13 Berson 1996, vol. 2, nos. VII–66, 67, 76; pp. 205–6. Wildenstein 1974–91, nos. 648–50.

14 Berson 1996, vol. 2, nos. IV–145, 149–50, 154, 161; pp. 115–16. Wildenstein 1974–91, nos. 469–70, 475–76, 538.

15 Gauguin to Pissarro, December 26, 1882, in Merlhès 1984, no. 31, p. 380.

16 Gauguin to Pissarro, January–February 1883, in Merlhès 1984, no. 32, pp. 39–41.

17 Bodelsen 1967, pp. 225, 226.

18 Wildenstein 2002, vol. 1, pp. 126–27.

19 Gauguin to Pissarro, late October–early November 1882, in Merlhès 1984, no. 28, pp. 34–35.

20 Gauguin to Pissarro, November 9, 1882, in Merlhès 1984, no. 29, pp. 35–36.

21 Washington–Chicago–Paris 1988–89, p. 26.

22 Gray 1963, no. 7. The relief was sold on April 8, 1989, by Drouot-Montaigne, Paris (no. 27). In this connection, I had the opportunity of examining it more closely. At the bottom, the relief has a base that is part of the wooden board. Holes left by nails along the edge and a division into a pale triangle at the back and a darker front suggest, moreover, that the relief once had a frame. There is a large hole for mounting on the back. Here, we also find two adhered labels: "de fer du Nord/Paris/502" and "destination/Pontoise" in addition to a stamp: "Douane central/Paris." So the relief was sent to Pissarro and not taken to him by Mette Gauguin, as is supposed by Merlhès 1984, no. 80, p. 369. Today, the relief can be found at the Musée d'Art Moderne et Contemporain in Strasbourg and was exhibited in Madrid 2004, no. 28.

23 Gauguin to Pissarro, November 9, 1882, in Merlhès 1984, no. 29, pp. 35–36.

24 Huysmans 1975; Berson 1996, vol. 1, pp. 351–52.

25 Washington–Chicago–Paris 1988–89, p. 45.

26 Pissarro's painting *Paysannes gardant des vaches* (1882; coll. Mrs. Paul Mellon, Upperville, Va.) is mentioned as a possible model by Hirota 1998, vol. 1, p. 53. San Francisco 1986, p. 172.

27 Andersen 1971, p. 58.

28 Gauguin to Pissarro, early May 1886, in Merlhès 1984, no. 96, p. 124.

29 Fénéon 1886, in Berson 1996, vol. 1, p. 443.

30 See *La Sculpture française au XIXe siècle* (Paris, 1986), p. 148 and n. 4.

31 Blanc 1867/1876. The quotation here is from the 1876 edition. See pp. 22, 429–30, 433–34, 438, and 573.

32 Gauguin to Mette, first two weeks of June 1886, in Merlhès 1984, no. 99, pp. 126–27.

Part IV Gauguin in Domestic Exile

1 Gauguin to Pissarro, August 13, 1883, in Merlhès 1984, no. 39, p. 52.

2 See Gauguin to Pissarro, late September or early October 1883, in Merlhès 1984, no. 40, pp. 53–54.

3 Gauguin to Pissarro, October 29, 1883, in Merlhès 1984, no. 42, p. 56.

4 Gauguin to Pissarro, January 12–13, 1884, in Merlhès 1984, no. 43, p. 59.

5 Gauguin to Pissarro, May 8, 1884, in Merlhès 1984, no. 47, p. 62.

6 Gauguin to Eugène Murer, January 13–20, 1884, in Merlhès 1984, no. 44, p. 60.

7 Wildenstein 2002, vol. 1, no. 113.

8 Ibid., no. 115.

9 Ibid., no. 116.

10 Canvas size no. 20 = 73 × 60 cm.

11 See Wildenstein 2002, vol. 1, p. 136.

12 Gauguin to Pissarro, mid-May 1884, in Merlhès 1984, no. 48, pp. 63–64.

13 Gauguin to Pissarro, early April 1884, in Merlhès 1984, no. 45, pp. 60–61.

14 Gauguin to Pissarro, mid-May 1884, in Merlhès 1984, no. 48, pp. 63–64.

15 Pointed out by Wildenstein 2002, vol. 1, no. 124, p. 144.

16 Pissarro to Gauguin, second half of May 1885, in Merlhes 1984, no. XXVI, p. 106; Wildenstein 2002, vol. 1, p. 148.

17 Wildenstein 2002, vol. 1, no. 131.

18 Gauguin to Pissarro, mid-May 1884, in Merlhès 1984, no. 48, pp. 63–64.

19 Ibid.

20 Ibid.

21 Gauguin to Pissarro, late July 1884, in Merlhès 1984, no. 50, pp. 65–67.

22 Ibid.

23 Gauguin to Pissarro, late September 1884, in Merlhès 1984, no. 53, pp. 68, 70.

24 A reason for this identification is that these paintings have since been in Norwegian collections. See Wildenstein 2002, vol. 1, nos. 154, 150, and 151; Wildenstein 1964, nos. 81, 95, and 134; Bodelsen 1968, p. 37, n. 51; and Huyghe 1952, p. 227.

25 Wildenstein 2002, vol. 1, p. 176.

26 Ibid., nos. 154 and 153.

27 Gauguin was later to attempt this during his sojourn in Panama.

28 Wildenstein 2002, vol. 1, no. 151.

29 Ibid., no. 144.

30 Ibid., nos. 138, 139, 136, and 135.

31 Gauguin to Pissarro, July 25–29, 1883, in Merlhès 1984, no. 38, pp. 50–51.

32 Ibid.

33 On Cézanne in Gauguin's collection, see Bodelsen 1968, pp. 81–85.

34 Wildenstein 2002, vol. 1, no. 125. Canvas size no. 30.

35 Ibid., p. 135.

36 Ibid., p. 137.

37 Ibid., pp. 136, 140.

38 Ibid., p. 142.

39 Bodelson 1970, no. 12, p. 607.

40 Wildenstein 2002, vol. 1, p. 165.

41 Gauguin to Pissarro, mid-May 1884, in Merlhès 1984, no. 48, pp. 63–64.

42 Gauguin to Pissarro, late May 1885, in Merlhès 1984, no. 79, pp. 106–8.

43 Gauguin to Pissarro, July 10, 1884, in Merlhès 1984, no. 49, pp. 64–65.

44 Ibid.

45 Gauguin to Pissarro, late May 1885, in Merlhès 1984, no. 79, pp. 106–8.

46 Published by Raymond Cogniat and John Rewald; see Cogniat and Rewald 1962.

47 Gauguin to Schuffenecker, January 14, 1885, in Merlhès 1984, no. 65, pp. 87–89.

48 The sketchbook was bought in Rouen, started there or in Copenhagen, and used until the period spent in Brittany; the paintings relating to its sketches were executed before 1888; see Cogniat and Rewald 1962, p. 9.

49 Cogniat and Rewald 1962, p. 49; Gauguin had read Huysmans's book L'Art moderne, 1883, the previous winter.

50 "La peinture est le plus beau de tous les arts," Cogniat and Rewald 1962, p. 57.

51 The January letter (Merlhès 1984, no. 65) is dealt with in my article in Fonsmark 1990.

52 Georges Roque, "Les Symbolistes et la couleur," Revue de l'Art 96 (1992), p. 72.

53 Blanc 1867/1876, p. 570; the book was published in new editions in 1870, 1876, 1881, 1888, and 1895. The 1876 version has been used here. Wildenstein 2002, vol. 1, no. 151.

54 Blanc 1867/1876, pp. 567–68. Wildenstein 2002, vol. 1, no. 154.

55 Gauguin to Schuffenecker, January 14, 1885, in Merlhès 1984, no. 65, pp. 87–89.

56 Merlhès 1984, n. 151, p. 399 (n. 2), which refers to A. Desbarolles and J.-H. Michon, Les mystères de l'écriture (Paris, 1872).

57 Gauguin to Pissarro, October 1884, in Merlhès 1984, no. 54, pp. 70–71.

58 Gauguin to Pissarro, late October or early November 1884, in Merlhès 1984, no. 55, p. 72.

59 Gauguin to Pissarro, late November–early December 1884, in Merlhès 1984, no. 57, pp. 76–77.

60 Gauguin to Schuffenecker, January 14, 1885, in Merlhès 1984, no. 65, pp. 87–89.

61 Fonsmark 1990.

62 Fonsmark 1990, pp. 138–39.

63 Gauguin to Schuffenecker, January 14, 1885, in Merlhès 1984, no. 65, pp. 87–89.

64 Gauguin to Pissarro, late November–early December 1884, in Merlhès 1984, no. 57, pp. 76–77.

65 Gauguin to Schuffenecker, January 14, 1885, in Merlhès 1984, no. 65, pp. 87–89.

66 Fonsmark 1985, p. 38.

67 Gauguin to Pissarro, late November–early December 1884, in Merlhès 1984, no. 57, pp. 76–77.

68 Wildenstein 2002, vol. 1, no. 160.

69 Ibid., no. 161; see Fonsmark l985, p. 35.

70 Christian Krogh, "Impressionisterne," København, November 12, 1889.

71 See Gauguin letters to Pissarro, from October to early December 1884, in Merlhès 1984, nos. 54, 55, and 57, pp. 70–72 and 76–77. At the "Guinea Pig," where Gauguin apparently had placed his paintings, Pissarro could select the paintings he liked best (Merlhès 1984, no. 55).

72 Gauguin to Pissarro, late November–early December 1884, in Merlhès 1984, no. 57, pp. 76–77. See Fonsmark 1985, pp. 36–37.

73 Wildenstein 2002, vol. 1, no. 98.

74 Ibid., no. 162.

75 The following identification of "loans" in the painting is taken from Bodelsen 1968, pp. 152–55 (ill.). See also Fonsmark 1985, pp. 40–41.

76 Wildenstein 2002, vol. 1, nos. 56 and 98.

77 The woman with the bundle of brushwood on her back on the left of the group of figures at the center was taken from a fan with a peasant motif by Pissarro. The same applies to the third woman from the left, who is likewise in profile, while a standing figure is taken from the man with the rake in Guillaumin's Garden (Ny Carlsberg Glyptotek, Copenhagen); see Bodelsen 1968, p. 151–52 (ill.).

78 This might be the same building that is seen on the right in Snow, Copenhagen (fig. 181); Wildenstein 2002, vol. 1, no. 160.

79 Wildenstein 2002, vol. 2, no. 317. "C'est un effet de vignes que j'ai vu à Arles. J'y ai mis des Bretonnes—Tant pis pour l'exactitude." Gauguin to Emile Bernard (?), second week of November 1888, in Merlhès 1984, no. 179, p. 275.

80 Gauguin to Schuffenecker, January 14, 1885, in Merlhès 1984, no. 65, pp. 87–89.

81 Wildenstein 2002, vol. 1, nos. 160, 163.

82 Wildenstein 1964, no. 116.

83 Venturi 1936, p. 490. Wildenstein 1964, no. 147, and Bodelsen 1966, p. 35.

84 See Bodelsen 1968, pp. 138, 140, 155, and Fonsmark 1985, pp. 41–48. Wildenstein 1964, no. 123.

85 Wildenstein 2002, vol. 1, no. 162; on the fan, see Bodelsen 1968, pp. 152, 155, and 150 (ill.). See also Bodelsen 1984, no. 17 (ill.).

86 Wildenstein 1964, no. 119.

87 Wildenstein 1964, no. 179/214 and 180. Bodelsen 1966, p. 29, draws attention to the fact that Wildenstein nos. 179 and 214 are identical. She identifies the Flower Basket with the Bouquet in Wildenstein 2002, vol. 2, no. 239 (Bodelsen 1966, p. 36). The fan remained in the ownership of the Gad family and thus belongs to the group of fans executed in Copenhagen.

88 Wildenstein 1964, no. 180. Washington–Chicago–Paris 1988–89, no. 15.

89 Wildenstein 2002, vol. 1, no. 169.

90 Gauguin to Schuffenecker, January 14, 1885, in Merlhès 1984, no. 65, pp. 87–89.

91 Wildenstein 2002, vol. 1, no. 171.

92 Ibid., no. 169.

93 Ibid., no. 145.

94 Dedicated to Theodor Gad in 1884.

95 Gauguin to Pissarro, late July 1884, in Merlhès 1984, no. 50, pp. 65–67.

96 Gauguin to Schuffenecker, May 24, 1885, in Merlhès 1984, no. 78, pp. 103–5. Also in a later letter, likewise from May 1885, Gauguin says that the glaziers refuse to work for him (Gauguin to Pissarro, late May 1885, in Merlhès 1984, no. 79, pp. 106–8).

97 Gauguin to Schuffenecker, March 17, 1885, in Merlhès 1984, no. 75, pp. 99–100.

98 Wildenstein 2002, vol. 1, no. 151.

99 Ibid., no. 164.

100 Gray 1963, no. 8, pp. 4–5.

101 Gauguin to Pissarro, late May 1885, in Merlhès 1984, no. 79, pp. 106–8.

102 Ibid.; the change of address took place around April 22–25. Gauguin to Schuffenecker, March 17, 1885, in Merlhès 1984, no. 75, pp. 99–100, and Gauguin to Commandant Schonheyder, April 17, 1885, in Merlhès 1984, no. 77, p. 103.

103 Wildenstein 2002, vol. 1, no. 173. Fonsmark 1985, p. 61 (ill.) The painting was exhibited at the eighth Impressionist exhibition, 1886 (Bodelsen 1984, no. 21).

104 Wildenstein 2002, vol. 1, no. 174. Fonsmark 1985, fig. 63 (ill.).

105 See Fonsmark 1985, pp. 61 and 63 (ill.), and Fonsmark 1995.

106 Gauguin to Pissarro, late May 1885, in Merlhès 1984, no. 79, pp. 106–8.

107 Ibid.

108 Wildenstein 2002, vol. 1, nos. 175–77. Several of the spring paintings apparently became part of the eighth Impressionist exhibition, 1886.

109 Gauguin to Pissarro, late May 1885, in Merlhès 1984, no. 79, pp. 106–8.

110 Ibid.; the jury rejected one of Gauguin's paintings for the Charlottenborg Forårsudstilling, and it is probably that exhibition that he mentions in this letter from late May 1885.

111 Gray 1963, no. 8, pp. 4–5.

112 Wildenstein 2002, vol. 1, nos. 60, 151, and 164.

113 Gray 1963, no. 7.

114 Since the publication of Gray 1963, the box has been seen as a jewel case that was intended to be given to Mette as a macabre Christmas present in December 1884 (p. 5). However, it is striking that Pola Gauguin does not call the box a jewel case (Gauguin 1937, p. 67). On account of the figure, it cannot hold very much. A more specific interpretation has been attempted by Wayne Andersen; he interpreted the box's motifs on the basis of a death and vanitas concept and introduced the myth of the Hindu goddess Kali, who slew her husband and decorated herself with decapitated men's heads (Andersen 1971, p. 33). More recently, Charles F. Stuckey, in Washington–Chicago–Paris 1988–89, p. 30, has

interpreted the box on the basis of the theme that the wages of sin are death.

115 Gray 1963, no. 8. Bodelsen 1964B, p. 145. Druick and Zegers 1995, p. 8, figs. 4a and 4b, produce a plate that shows graves with skeletons from a work by Alex Brongniart, *Traité des arts céramiques ou des poteries* (Paris, 1877), atlas, pl. 2, figs. 1 and 3. The leather at the figure's foot in Gauguin's box is clearly a reference to the cowhide found in the Danish coffins.

116 Today in the National Museum, Copenhagen. The Peruvian mummy is at the Musée d'Ethnologie du Trocadéro, Paris; see Wayne V. Andersen, "Gauguin and a Peruvian Mummy," *Burlington Magazine* 109, no. 769 (April 1967), pp. 238, 241. Bodelsen refers to A. P. Madsen's drawings, which illustrate the extensive set of books published in French during these years: *Antiquités préhistoriques du Danemark* (Copenhagen, 1872–96). However, there are no illustrations of these coffins in the books. Bodelsen 1964B, p. 145, n. 5, also refers to Vilhelm Boye, *Fund af Egekister fra Bronze-alderen i Danmark, med 27 Kobbertavler samt Afbildninger i Texten af A. P. Madsen* (Copenhagen, 1896). Here there are illustrations of what Gauguin might have seen during his visit at Oldnordisk Museum (figs. 200, 201). The "young man" from Borum Eshøi lies in the same way as Gauguin's figure and has the same wavy hair.

117 The lithograph *Aux Ambassadeurs: Mlle Bécat* (1877/78; Art Institute of Chicago) and the painting *The Orchestra of the Opéra* (1869/70; Musée d'Orsay, Paris); see Druick and Zegers 1995, pp. 7–8, figs. 2 and 3.

118 In 1879 Gauguin had unsuccessfully attempted to buy the pastel version, which he found "stunning" (see Gauguin to Pissarro, September 26, 1879, in Merlhès 1984, no. 11, p. 16). Françoise Cachin, "Degas et Gauguin," in *Degas inédit*, p. 115, has identified the pastel with Lemoisne no. 498 (see Lemoisne 1946–84); Merete Bodelsen, in Bodelsen 1964B, pp. 146–47, identified the composition of the photograph with Lemoisne no. 340, but it could equally have been no. 498.

119 Fonsmark 1994.

120 Gauguin to Pissarro, January 12–13, 1884, in Merlhès 1984, no. 43, p. 59.

121 Bodelsen 1968 has examined these fans and dated most of them to the stay in Copenhagen. However, Charles F. Stuckey dates several of the fans to the period in Rouen; Washington–Chicago–Paris 1988–89, p. 40. In Gauguin's sketchbook there is a list of his fans from 1888; Huyghe 1952, pp. 222–28. See also Marc S. Gerstein, "Paul Gauguin's Arearea," *Bulletin, The Museum of Fine Arts Houston* 7, no. 4 (1981), p. 6, and Jean-Pierre Zingg, *The Fans of Paul Gauguin* (Pampelonne, 2001).

122 Not in Gray 1963. The fan handle was exhibit-

ed for the first time at the exhibition *Gauguin*, National Museum of Modern Art (Tokyo, 1987), no. 6.

123 See n. 118 above.

124 Grove Art Online.

125 San Francisco 1986.

126 Bodelsen 1968, p. 138, mentions that Pissarro's fan at the fourth Impressionist exhibition in 1879, no. 189, was identical to *L'Hiver, retour de la foire. Eventail*; Bodelsen 1970, p. 612, n. 43.

127 Gauguin to Pissarro, September 26, 1879, in Merlhès 1984, no. 11, p. 16.

128 Washington–Chicago–Paris 1988–89, p. 40. Bjürstrøm 1986, no. 1545.

129 Not in Gray 1963; published by Anne Pingeot, Pingeot 2004, pp. 56–57.

130 Gauguin's emphasis; Gauguin to Pissarro, November 9, 1882, in Merlhès 1984, no. 29, pp. 35–36.

131 Gauguin to Pissarro, late July 1884, in Merlhès 1984, no. 50, pp. 65–67.

132 Wildenstein 2002, vol. 1, no. 155.

133 See note with certificate glued to the back of the frame by Pola Gauguin, 30.12.1927 (see Pingeot 2004 for the entire content of the note).

134 About Wilhelm Busch, see, for instance, Grove Art Online.

135 Pingeot 2004 tentatively dates the frame to 1881, referring to the woman figure's similarity with Gauguin's wooden figure *Lady Strolling* (cat. 22).

136 Renoir's *Skaters in the Bois de Boulogne*, 1868, private collection; Manet's *Skating*, 1877, Fogg Art Museum, Harvard University Art Museums, Cambridge, Mass.

137 Wildenstein 2002, vol. 1, pp. 194–95.

138 Rostrup 1960, p. 159.

139 Gauguin 1938, p. 82.

140 Cachin 1988–89, pp. xvi–xvii.

141 Merlhès 1984, pp. 81–109.

142 Cachin 1988–89, pp. xvi–xvii.

143 Gauguin to Pissarro, end of May 1885, in Merlhès 1984, no. 79, p. 108.

144 Cachin 1988–89, p. xvii.

Part V Unbecoming an Impressionist

1 Gauguin to Pissarro, June (?) 1885, in Merlhès 1984, no. 81, p. 109.

2 Gauguin to Paul Durand-Ruel, June 22, 1885, in Merlhès 1984, no. 80, p. 109.

3 Wildenstein 2002, vol. 2, p. 596.

4 Gauguin to Pissarro, October 2, 1885, in Merlhès 1984, no. 85, p. 113.

5 Ibid.

6 The painting was *Les Baigneuses*, no. 53 in the 1886 Impressionist exhibition catalogue. Moffett and Berson both persist in identifying the exhibited work as the small *Baigneuses* (*Women Bathing, Dieppe*; see fig. 250), but this

is surely not the case. The sole evidence for this identification is a very brief description of the submitted painting by Paul Adam in *La Revue Contemporaraine*. This passage in no way allows us to choose the smaller over the larger of the two paintings as Gauguin's submission, and the fact that Theo van Gogh acted as an agent for the Copenhagen version suggests that Gauguin sent it—the more ambitious of the two—to the 1886 exhibition. See San Francisco 1986, p. 458, and Berson 1996, vol. 2, p. 243.

7 Wildenstein 2002, vol. 1, pp. 242–44.

8 Wildenstein 2002, vol. 1, p. 247.

9 Gauguin to Mette, October 13, 1885, in Merlhès 1984, no. 87, pp. 115–16.

10 See the wedding photographs of the Gauguins in Wildenstein 2002, vol. 2, p. 576.

11 San Francisco 1986, pp. 443–47, with an intelligent essay on the exhibition by Martha Ward, pp. 421–42, and Berson 1996, vol. 2, pp. 242–44; Wildenstein 2002.

12 Oral communication.

13 Herbert 1968, p. 154.

14 London 1979, no. 80.

15 Wildenstein 2002, vol. 1, pp. 262–65.

16 Hirota 1998, p. 91, points out that Gauguin's ceramics had no influence in their own time, possibly because they were too bold in their combination of sculpture and container without being concerned with functionality, thereby creating an interaction between two different practices.

17 Gray 1963, no. 7.

18 Hirota 1998, p. 87.

19 "J'ai eu beaucoup de succès près des artistes. Mr Braquemont [sic] le graveur m'a acheté avec enthousiasme un tableau 250f et m'a mis en relations avec un céramiste qui compte faire des vases d'art. Enchanté de ma sculpture il m'a prié de lui faire à mon gré cet hiver des travaux qui vendus seraient *partagés de moitié*. Peut-être est-ce dans l'avenir une grande ressource. Aubé avait autrefois travaillé pour lui ces pots qui l'ont fait vivre et ceci est autrement important"; Gauguin to Mette, first two weeks of June 1886, in Merlhès 1984, no. 99, p. 126.

20 "Je prendrai un petit atelier près de l'eglise de Vaugirard où je travaillerai pour la céramique à sculpter des pots comme le faisait autrefois Aubé_Mr Braquemond qui m'a pris en amitié à cause de mon talent m'a procuré cette industrie et m'a dit que cela pourrait *devenir* lucrative_Espérons que j'aurai le talent dans la sculpture comme dans la peinture . . ."; Gauguin to Mette, July 25, 1886, in Merlhès 1984, no. 107, p. 134.

21 Hirota 1998, p. 86 and n. 3.

22 Only limited traces of this collaboration have survived; Hirota 1998, pp. 86–87.

23 The visit lasted from July 16 to the middle of October.

24 See Gauguin to Bracquemond, June 24, 1886, in Merlhès 1984, no. 100, p. 129; Claire Frèches-Thory, in Washington–Chicago–Paris 1988–89, p. 58.

25 "Je travaille comme un nègre et je crois que vous ne serez pas mécontent de mes travaux aux colombins"; Gauguin to Félix Bracquemond, end of October or November 1886, in Merlhès 1984, no. 114, p. 141.

26 "Je fais de la sculpture céramique Schuff dit que ce sont des chefs-d'oeuvre et le fabricant aussi mais c'est probablement trop artistique pour être vendu. Cependant il dit que dans un temps donné, cet été à l'exposition des arts industriels celà aura un succès fou. Que Satan l'entende!"; Gauguin to Mette, December 26, 1886, in Merlhès 1984, no. 115, p. 142. Gauguin is here referring to the eighth exhibition of Arts Décoratifs. It was to be held from August 13 to December 4, 1887, in the Palais de l'Industrie, where 350,000 visitors were expected—but when it came to the point, none of Gauguin's ceramic works was actually shown in the exhibition.

27 "Si vous êtes curieux de voir sortis du four tous les petits produits de mes hautes folies, c'est prêt_55 pièces en bon état_Vous allez jeter les grands cris devant ces monstruosités mais je suis convaincu que celà vous intéressera_"; Gauguin to Bracquemond, no. 116, in Merlhès 1984. Here, the letter is dated to the end of November or the end of the year 1886/the beginning of 1887. Bodelsen dates it to mid-January 1887; Bodelsen 1964A, p. 13, n. 8.

28 About Chaplet, see *Ernest Chaplet* (Paris, 1976), and Merlhès 1984, n. 196, pp. 427–28.

29 Quoted from Merlhès 1984, n. 196, p. 427.

30 Hirota 1998, pp. 92–94.

31 d'Albis 1968, pp. 32–42.

32 Gauguin, Paul, *Avant et Après* (Paris, 1923), pp. 174–75.

33 *Collection G. Arosa: Faïences & Porcelaines.* Auction catalogue (Paris, 1878). See Fonsmark 1996, p. 8.

34 Demmin 1875; see Fonsmark 1996, p. 8.

35 Braun 1986, p. 38 and n. 12.

36 "Il m'a dit qu'il y avait quelques modèles qu'il a faits qui étaient bien, mais d'autres qui n'avaient rien. Somme toute, il a eu l'air de me dire que c'était de l'art de matelot, pris un peu partout . . ."; Rewald 1950, p. 131.

37 See Gauguin to Félix Bracquemond, second half of January 1887, in Merlhès 1984, no. 119, p. 144, and Gauguin to Mette, first days of April 1887, in Merlhès 1984, no. 123, pp. 149–50.

38 Bodelsen 1964A, pp. 13–14. It is to be assumed that Gauguin made about one hundred pieces of ceramics altogether. They are divided into four groups: from the winters of 1886–87 and 1887–88, from 1889 and 1890, and also from 1893–95. See Washington–Chicago–Paris 1988–89, p. 57–58.

39 Very few of the numbers with which Gauguin systematically provided his ceramics have survived. Most disappeared, probably in the firing, but a few individual numbers on the bases of the jars have survived. To remedy the lost numbers and signatures, Gauguin sometimes painted them in gold on top of the glazing and also provided the jars with adhered paper labels on which not only the number but also the price is indicated. The missing numbers are one of the reasons why the ceramics are difficult to date, and so it is not surprising that there are such widely differing views, not least in the two most important art-historical works on the subject, Gray 1963 and Bodelsen 1964A.

40 Fénéon 1886, in Berson 1996, vol. 1, p. 443.

41 Gray 1963, no. 44; Wildenstein 2002, vol. 1, no. 233.

42 Hirota 1998, p. 101 and H10. The bust has features in common with "Pot in the Shape of a Man's Head and Shoulders" (Gray 1963, no. 20), which Gray says is perhaps Gauguin's first attempt at ceramics.

43 Merlhès 1984, no. 100, n. 198, and Druick and Zegers 2001, pp. 61–63; no other documentation is given for the dating. According to the authors, it was only at the end of the year that he added the four-legged base with inscribed sheep and cows. The splendidly restrained technique, however, might militate against this early date, while the quotation from the letter, in fact, says only that Gauguin was present in the workshop on the date in question and that ceramics were being fired, but there is no indication as to who had made them.

44 Among those he had worked with was Chaplet; Druick and Zegers 1995, p. 61.

45 d'Albis 1968, pp. 32–42; Druick and Zegers 1995, p. 61, fig. 16.

46 Wildenstein 1964, no. 66.

47 Gauguin to Mette, May 24, 1885, in Merlhès 1984, no. 97, p. 125.

48 Gray 1963, no. 45.

49 Wildenstein 2002, vol. 2, no. 237.

50 Bodelsen 1959 and Bodelsen 1964A, pp. 50–52.

51 "La céramique n'est pas une futilité. Aux époques les plus reculées, chez les Indiens d'Amerique on trouve cet art constamment en faveur. Dieu fit l'homme avec un peu de boue / avec un peu de boue on peut faire du métal, des pierres précieuses, avec un peu de boue et aussi un peu de genie"; Gauguin 1889, p. 84.

52 ". . . ces étranges et barbares et sauvages céramiques où, sublime potier, il a pétri plus d'âme que d'argile? . . ."; Albert Aurier, "Neo-Traditionnistes: Paul Gauguin," *La Plume*, September 1, 1891.

53 "un élan nouveau par la création de nouvelles formes faites à la main"; Gauguin 1895, p. 1.

54 "remplacer le tourneur par des mains intelligentes qui puissent communiquer au vase la vie d'une figure"; Gauguin 1895.

55 Braun 1986, pp. 36–54.

56 Druick and Zegers 2001, p. 69.

57 Wildenstein 2002, vol. 2, no. 238. Another, now lost, ceramic is similarly known only because Gauguin himself made it into a motif, i.e., the jar he called *Horned Rats*. However, this was probably only made during the second period of ceramics (1887–88). See n. 38, above.

58 Bodelsen 1964A, p. 154, and Gray 1963, pp. 12 and 18.

59 Gauguin to Mette, December 6, 1887, in Merlhès 1984, no. 137, p. 166.

60 Gauguin 1889.

61 Fonsmark 1996, no. 3; Gray 1963, no. 25.

62 See Hirota 1998, p. 95.

63 Hirota 1998, p. 87.

64 "Il m'a dit qu'il y avait quelques modèles qu'il a faits qui étaient bien, mais d'autres qui n'avaient rien. Somme toute, il a eu l'air de me dire que c'était de l'art de matelot, pris un peu partout . . ."; Rewald 1950, p. 131.

65 Lemoisne 1946–84, no. 377; San Francisco 1986, no. 27, p. 176 (ill.).

66 Musée Léon Dierx 1999, no. 54 (ill.).

67 Gray 1963, no. 39.

68 Gray 1963, no. 65.

69 Bodelsen 1964A, p. 73, fig. 52. The painstakingly finished watercolor *The Leda Vase*, from two angles, and *Portrait Vase in unglazed stoneware of woman with snakeskin belt* (Fonsmark 1996, no. 8). The watercolor is not dated, but could have been made about the time when Théo van Gogh exhibited his vases. With its documentary character and inscription—"P. Gauguin. Pots en Grès Chaplet"—it is in the nature of a presentation, almost as though it were a sales brochure.

70 Wildenstein 2002, vol. 2, no. 238; on the uncertainty regarding the date of this work, see Washington–Chicago–Paris 1988–89, no. 30, p. 77.

71 With reference to Bodelsen, Sylvie Crussard believes that the pot was possibly made later than the first period of ceramics, i.e., after the winter of 1886–87, but not later than January 1888, because Gauguin then left Paris and a few months later asked to have it sent to Arles as a decoration for the yellow house (Wildenstein 2002, vol. 2, no. 258, p. 358).

72 Wildenstein 2002, vol. 2, no. 258.

73 Wildenstein 2002, vol. 2, no. 259.

74 Fonsmark 1995, no. 12; Bodelsen 1964A, fig. 74; Wildenstein 2002, vol. 2, no. 239.

75 Gray 1963, no. 41; Bodelsen 1964A, no. 19.

76 It is said originally to have been signed "P. Gauguin"; see Gray 1963, p. 151.

77 Gray 1963, no. 44.

78 Andréani 2003, p. 4.

79 Wildenstein 2002, vol. 2, no. 237.

80 Cogniat and Rewald 1962, p. 38.

81 Gray 1963, no. 18.

82 Wildenstein 1964, no. 66.

83 Wildenstein 2002, vol. 1, no. 233, and Gray 1963, no. 44.

84 Gray 1963, no. 45.

85 Bodelsen 1964A, p. 46, fig. 35, no. 15.

86 Bodelsen 1964A, p. 46.

87 Gray 1963, no. 12; Bodelsen 1960, no. 2; Bodelsen 1964A, no. 7.

88 Gray points out that Samuel Wagstaff has indicated a probable model in a Degas drawing of a ballet dancer, though without any precise identification; Gray 1963, p. 125.

89 Gray 1963, p. 19.

90 Gray 1963, no. 13; Bodelsen 1964A, no. 25. The lowest numbers known are 19 and 20 (see Gray 1963, p. 12); see also cat. 59 (Gray 1963, no. 12).

91 Gray 1963, p. 19.

92 See fig. 251 and cat. 68; Gray 1963, no. 33.

93 Cogniat and Rewald 1962; Bodelsen 1964A, p. 230, fig. 143c.

94 Gray 1963, p. 19 and n. 52.

95 Gray 1963, no. 15.

96 Gray 1963, no. 16; Bodelsen 1964A, fig. 6, no. 6; Fonsmark 1996, no. 2.

97 Fonsmark 1996, no. 2.

98 Gray 1963, p. 19.

99 Gray 1963, no. 26; Bodelsen 1964A, fig. 39, no. 18; Fonsmark 1996, no. 2.

100 Gray 1963, p. 25.

101 Fonsmark 1996, no. 5.

102 Gray 1963, no. 44.

103 Venturi 1936, no. 249; Bodelsen 1962, pp. 204–11.

104 Bodelsen 1962, p. 211.

105 Wildenstein 1964, no. 116.

106 Gray 1963, no. 45.

107 Bodelsen 1959, pp. 329–44; Bodelsen 1962, p. 211, figs. 44–47; Bodelsen 1964A, pp. 52, 206.

108 *Album Briant*, Département des Arts Graphiques, Musée du Louvre, Paris; Gray 1963, fig. 9c.

109 Gray 1963, no. 25; Bodelsen 1964A, no. 8; Fonsmark 1996, no. 3.

110 Fonsmark 1996, no. 3.

111 Gray 1963, no. 45.

112 Dorra, Henri, "Von bretonischen Spässen zum grossen Dilemma der Menschheit," *Ausstellungskatalog Paul Gauguin* (Graz, 2000), p. 79.

113 Gray 1963, no. 74.

114 Gray 1963, no. 27, Bodelsen 1964A, no. 1. See also Gray 1963, nos. 28 and 29.

115 Druick and Zegers 1995, p. 69.

116 Fonsmark 1996, no. 1.

117 Bodelsen 1964A, fig. 26; Wildenstein 2002, vol. 1, no. 233; Gray 1963, no. 44; Gray 1963, no. 7.

118 Bodelsen 1964A, fig. 15; for the Brussels vase, see Gray 1963, no. 45.

119 Musée Léon Dierx 1999, no. 55.

120 Bodelsen 1964A, fig. 30.

121 See cat. 64; Gray 1963, no. 31.

122 Andréani 2003, p. 24, and Musée Léon Dierx 1999, no. 55.

123 Gray 1963, no. 31; Bodelsen 1960, no. 3; Bodelsen 1964A, no. 5. The small "fittings" can also be seen in Gray 1963, nos. 10 and 11.

124 Hokusai made decorative compositions containing reproductions of geese in a radically simplified and very decorative style; Andréani 2003, p. 82.

125 In one of the sketchbooks she is seen together with a goose on one page, and in another she appears in two drawings for ceramics (Cogniat and Rewald 1962, pp. 73 and 98; Gray 1963, p. 16, figs. 10c and 10d; Andréani 2003, fig. 72). In *Album Briant* the figure is also seen on two sketchbook pages (*Album Briant*, Département des Arts Graphiques, Musée du Louvre, pp. 4 and 25; Andréani 2003, fig. 71).

126 Lemoisne 1946–84, no. 377.

127 Wildenstein 2002, vol. 1, no. 179, and Musée Léon Dierx 1999, no. 54.

128 The figure can also be seen in Gray 1963, no. 32.

129 Gray 1963, no. 81.

130 Gray 1963, no. 36; Bodelsen 1960, no. 4; Bodelsen 1964A, no. 28.

131 See cat. 64; Gray 1963, no. 31.

132 Other ceramics with the sun motif are Gray 1963, nos. 15 and 28.

133 Gauguin to Félix Bracquemond, late November or late 1886–early 1887, in Merlhès 1984, no. 116, p. 143.

134 Gray 1963, no. 34; Bodelsen 1964A, no. 24.

135 See cat. 64; Gray 1963, no. 31.

136 Gray 1963, no. 34; Bodelsen 1964A, no. 24.

137 Cogniat and Rewald 1962, p. 73; Gray 1963, fig. 10c.

138 Gauguin to Mette, first half of June 1886, in Merlhès 1984, no. 99, pp. 126–27.

139 Wildenstein 2002, vol. 1, pp. 275–77.

140 Rewald 1996, nos. 250 and 455.

141 Pissarro-Venturi 1939, vol. 2, pl. 146, no. 702.

142 Now in the National Gallery of Art, Washington; The Armand Hammer Collection (1991. 217). See Wildenstein 2002, vol. 1, pp. 290–91.

143 Six of these drawings are reproduced and discussed by Claire Frèches-Thory in Washington–Chicago–Paris 1988–89, pp. 63–70; for the seventh, see Wildenstein 2002, vol. 2, p. 301, upper-right corner.

144 They can be found in the Musée National des Arts d'Afriques et d'Océanie, Paris; The Art Institute of Chicago; The Burrell Collection, Glasgow; and several private collections.

145 Wildenstein 2002, vol. 1, p. 294.

146 See the chronology by Martine Heudron in Wildenstein 2002, vol. 2, pp. 602–3.

147 Washington–Chicago–Paris 1988–89, no. 30, p. 76.

148 Wildenstein 2002, vol. 2, p. 308.

149 For a photograph and a detailed description, see Wildenstein 2002, vol. 2, pp. 353–55.

Selected Bibliography

THIS BIBLIOGRAPHY INCLUDES essential works and those cited more than once in the notes. More complete bibliographies are found in Washington–Chicago–Paris 1988–89 and Wildenstein 2002.

d'Albis 1968
d'Albis, Jean. "La Céramique impressionniste à l'atelier de Paris-Auteuil (1873–1885)." *Cahiers de la céramique, du verre et des arts du feu*, no. 41 (1968), pp. 32–42.

Andersen 1971
Andersen, Wayne. *Gauguin's Paradise Lost.* London, 1971.

Andréani 2003
Andréani, Carole. *Les céramiques de Gauguin.* Paris, 2003.

Bailly-Herzberg 1980
Bailly-Herzberg, Janine, ed. *Correspondance de Camille Pissarro*, vol. 1, 1865–1885. Paris, 1980.

Berson 1996
Berson, Ruth, ed. *The New Painting: Impressionism, 1874–1886: Documentation.* Vol. 1, *Reviews*; vol. 2, *Exhibited Works.* San Francisco, 1996.

Bjürstrøm 1986
Bjürstrøm, Per. *French Drawings: Nineteenth Century.* Stockholm, 1986.

Blanc 1867/1876
Blanc, Charles. *Grammaire des arts du dessin.* Paris, 1867. Revised ed. Paris, 1876.

Bodelsen 1959
Bodelsen, Merete. "The Missing Link in Gauguin's Cloisonnism." *Gazette des Beaux-Arts*, 6th ser., 53 (May–June 1959), pp. 329–44.

Bodelsen 1960
Bodelsen, Merete. *Gauguin Ceramics in Danish Collections.* Reprint from *Det danske Kunstindustrimuseum, Virksomhed, 1954–59.* Copenhagen, 1960.

Bodelsen 1962
Bodelsen, Merete. "Gauguin's Cézannes." *Burlington Magazine* 104, no. 710 (May 1962), pp. 204–11.

Bodelsen 1964A
Bodelsen, Merete. *Gauguin's Ceramics: A Study in the Development of His Art.* London, 1964.

Bodelsen 1964B
Bodelsen, Merete. "Paul Gauguin som kunsthåndværker: To arbejder i norsk privateje," with English summary. *Kunst og Kultur* 47 (1964), pp. 141–56.

Bodelsen 1966
Bodelsen, Merete. "The Wildenstein-Cogniat Gauguin Catalogue." *Burlington Magazine* 108, no. 754 (January 1966), pp. 27–38.

Bodelsen 1967
Bodelsen, Merete. "Gauguin Studies," *Burlington Magazine* 109, no. 769 (April 1967), pp. 217–27.

Bodelsen 1968
Bodelsen, Merete. *Gauguin og Impressionisterne.* Copenhagen, 1968.

Bodelsen 1970
Bodelsen, Merete. "Gauguin, the Collector," *Burlington Magazine* 112, no. 810 (September 1970), pp. 590–615.

Bodelsen 1984
Bodelsen, Merete. *Gauguin and van Gogh in Copenhagen in 1893.* Exh. cat. Ordrupgaard, Copenhagen, 1984.

Braun 1986
Braun, Barbara. "Paul Gauguin's Indian Identity: How Ancient Peruvian Art Inspired His Art." *Art History* 9 (March 1986), pp. 36–54.

Brettell et al. 1984–85
Brettell, Richard, Scott Schaefer, and Sylvie Gache-Patin. *A Day in the Country: Impressionism and the French Landscape.* Exh. cat. Los Angeles County Museum of Art; Art Institute of Chicago; Réunion des musées nationaux. Los Angeles, 1984.

Brettell 1986
Brettell, Richard R. "The 'First' Exhibition of Impressionist Painters." In San Francisco 1986, pp. 189–202.

Brettell et al. 1988–89
The Art of Paul Gauguin. Exh. cat. by Richard Brettell, Françoise Cachin, Claire Frèches-Thory, and Charles F. Stuckey, with Peter Zegers. National Gallery of Art, Washington; Art Institute of Chicago; Grand Palais, Paris. Washington, D.C., 1988.

Brettell 1990
Brettell, Richard R., with assistance from Joachim Pissarro. *Pissarro and Pontoise: The Painter in a Landscape.* New Haven and London, 1990.

Brettell 1999A
Brettell, Richard R. *Modern Art, 1851–1929: Capitalism and Representation.* Oxford History of Art. Oxford and New York, 1999.

Brettell 1999B
Brettell, Richard R., with Natalie H. Lee. *Monet to Moore: The Millennium Gift of Sara Lee Corporation.* New Haven and London, 1999.

Brettell 2000
Brettell, Richard R. *Impression: Painting Quickly in France, 1860–1890.* Exh. cat. National Gallery, London; Van Gogh Museum, Amsterdam; Sterling and Francine Clark Art Institute, Williamstown, Mass. New Haven and London, 2000.

Burty 1882
Burty, Philippe. "Les aquarellistes, les indépendants et le Cercle des arts libéraux." *La République française*, March 8, 1882, p. 3.

Cachin 1988–89
Cachin, Françoise. "Gauguin Portrayed by Himself and Others." In Washington–Chicago–Paris 1988–89, pp. xv–xxvi.

Cachin 1990/2003
Cachin, Françoise. *Gauguin.* Translated by Bambi Ballard. Paris, 1990. Revised ed. Paris, 2003.

Claretie n.d.
Claretie, Jules. *La Vie à Paris: 1881.* Paris, n.d.

Cleveland 1975
Japonisme: Japanese Influence on French Art, 1854–1910. Exh. cat. Cleveland Museum of Art. Cleveland, 1975.

Cogniat and Rewald 1962
Cogniat, Raymond, and John Rewald. *Paul Gauguin, A Sketchbook.* Paris and New York, 1962.

Copenhagen 1893
Den Frie Udstilling [Free Exhibition of Modern Art]. Copenhagen, 1893.

Degas inédit
Degas inédit: Actes du Colloque Degas. Musée d'Orsay, April 18–21, 1988. Paris, 1989.

Delteil 1999
Delteil, Loys. *Camille Pissarro: The Etchings and Lithographs, Catalogue Raisonné.* San Francisco, 1999.

Demmin 1875
Demmin, Auguste. *Histoire de la céramique en planches phototypiques inaltérables avec texte explicatif.* 2 vols. Paris, 1875.

Druick and Zegers 1995
Druick, Douglas, and Peter Zegers. *Paul Gauguin: Pages from the Pacific.* Exh. cat., in association with the Art Institute of Chicago. Auckland City Art Gallery, Auckland, New Zealand, 1995.

Druick and Zegers 2001
Druick, Douglas W., and Peter Kort Zegers, in collaboration with Britt Salvesen. *Van Gogh and Gauguin: The Studio of the South.* Exh. cat. Art Institute of Chicago; Van Gogh Museum, Amsterdam. Chicago, 2001.

Fénéon 1886
Fénéon, Félix. "Les Impressionnistes." *La Vogue,* June 13–20, 1886, pp. 261–75.

Fonsmark 1985
Fonsmark, Anne-Birgitte. *Gauguin og Danmark.* Exh. cat. Ny Carlsberg Glyptotek, Copenhagen, 1985.

Fonsmark 1987A
Fonsmark, Anne-Birgitte. "Paul Gauguin: To nyerhvervelser fra hans tidlige år." *Meddelelser fra Ny Carlsberg Glyptotek* 43 (1987), pp. 29–44.

Fonsmark 1987B
Fonsmark, Anne-Birgitte. "Nye Gauguin'er på Glyptoteket." *Carlsbergfondet, Frederiksborgmuseet, Ny Carlsbergfondet, Årsskrift.* Copenhagen, l987.

Fonsmark 1988
Fonsmark, Anne-Birgitte. *Rodin: La collection du Brasseur Carl Jacobsen à la Glyptothèque—et oeuvres apparantées.* Ny Carlsberg Glyptotek, Copenhagen, 1988.

Fonsmark 1990
Fonsmark, Anne-Birgitte. "Lad os lave en Cézanne." In *Gulnares Hus: En gave til Hendes Majestæt Dronning Margrethe den Anden på fødselsdagen, den 16 april 1990,* edited by A. Bistrup, B. Scavenius, M. Winge. Copenhagen, 1990.

Fonsmark 1994
Fonsmark, Anne-Birgitte. "Kunsten at finde ting: Om Gauguin og l'objet trouvé," with English summary. *Meddelelser fra Ny Carlsberg Glyptotek* 50 (1994), pp. 147–70.

Fonsmark 1995
Fonsmark, Anne-Birgitte. *Manet, Gauguin, Rodin . . . Chefs d'oeuvre de la Ny Carlsberg Glyptotek de Copenhague.* Exh. cat. Musée d'Orsay, Paris, 1995.

Fonsmark 1996
Fonsmark, Anne-Birgitte. *Gauguin Ceramics.* Ny Carlsberg Glyptotek, Copenhagen, 1996.

Gauguin 1889
Gauguin, Paul. "Notes sur l'art à l'Exposition Universelle." Parts 1 and 2. *Le Moderniste,* July 4 and 13, 1889, pp. 84–86, 90–91.

Gauguin 1895
Gauguin, Paul. "Une lettre de Paul Gauguin à propos de Sèvres et du dernier four." *Le Soir,* April 23, 1895, p. 1.

Gauguin 1937
Gauguin, Pola. *My Father, Paul Gauguin.* Translated from Norwegian by Arthur G. Chater. New York, 1937.

Gauguin 1938
Gauguin, Pola. *Paul Gauguin, mon père.* Translated from Norwegian by Georges Sautreau. Paris, 1938.

Geffroy 1881
Geffroy, Gustave. "L'Exposition des artistes indépendants." *La Justice,* April 19, 1881, p. 3.

Gray 1963
Gray, Christopher. *Sculpture and Ceramics of Paul Gauguin.* Baltimore, 1963. Reissued, New York, 1980.

Herbert 1968
Herbert, Robert L. *Neo-Impressionism.* Exh. cat. Solomon R. Guggenheim Museum, New York, 1968.

Herbert 1970
Herbert, Robert L. "Seurat's Theories." In *The Neo-Impressionists,* edited by Jean Sutter, with contributions by Robert L. Herbert et al. Greenwich, Conn., 1970.

Hirota 1998
Hirota, Haruko. *La Sculpture de Paul Gauguin dans son contexte (1877–1906).* Thèse de doctorat nouveau régime en histoire de l'art, Université de Paris I, Panthéon-Sorbonne. Vol. 1. Paris, 1998.

House 2004
House, John. *Impressionism: Paint and Politics.* New Haven and London, 2004.

Huyghe 1952
Huyghe, René, ed. *Le Carnet de Paul Gauguin.* [Sketchbook; Israel Museum, Jerusalem.] Paris, 1952.

Huysmans 1883
Huysmans, Joris-Karl. "L'exposition des indépendants en 1881," *L'Art moderne.* Paris, 1883, pp. 225–57.

Huysmans 1975
Huysmans, Joris-Karl. "L'Exposition des indépendants en 1881." Reprinted in *L'Art moderne: Certains.* Paris, 1975.

Lemoisne 1946–84
Lemoisne, Paul-André. *Degas et son oeuvre.* 5 vols. New York, 1946–84.

Loize 1951
Loize, Jean. *Les Amitiés du peintre Georges-Daniel Monfreid et ses reliques de Gauguin.* Exh. cat. Paris, 1951.

London 1979
Post-Impressionism: Cross-Currents in European Painting. Exh. cat. Royal Academy of Arts, London, 1979.

Madrid 2004
Gauguin and the Origins of Symbolism. Exh. cat. Museo Thyssen-Bornemisza, Madrid, 2004.

Malingue 1949
Malingue, Maurice, ed. *Paul Gauguin: Letters to His Wife and Friends.* Translated by Henry J. Stenning. London, 1949. Originally published as *Lettres de Gauguin à sa femme et à ses amis.* Paris, 1946.

Mantz 1881
Mantz, Paul. "Exposition des oeuvres des artistes indépendants." *Le Temps*, April 23, 1881, p. 3.

Merlhès 1984
Merlhès, Victor, ed. *Correspondance de Paul Gauguin: Documents, témoignages*. Vol. 1, 1873–1888. Paris, 1984.

Millard 1976
Millard, Charles W. *The Sculpture of Edgar Degas*. Princeton, 1976.

Musée Léon Dierx 1999
La Collection Ambroise Vollard du Musée Léon Dierx: Les donations de 1912 et 1947. Musée Léon Dierx, Saint-Denis de la Réunion, 1999.

Paris 1878
Catalogue de Tableaux Modernes, Composant la Collection de M. G. Arosa. Paris, 1878.

Paris 1891
Beaux Tableaux Modernes. Paris, 1891.

Pingeot 2004
Pingeot, Anne. "Paul Gauguin." *48/14: La Revue du Musée d'Orsay*, no. 18 (spring 2004), pp. 54–55 ("Aline"); pp. 56–57 ("Cadre aux deux 'G' entrelacés").

Pissarro 2005
Pissarro, Joachim. *Pioneering Modern Painting: Cézanne and Pissarro, 1865–1885*. Exh. cat. Museum of Modern Art, New York; Los Angeles County Museum of Art; Musée d'Orsay, Paris. New York, 2005.

Pissarro and Durand-Ruel Snollaerts 2005
Pissarro, Joachim, and Claire Durand-Ruel Snollaerts, with Richard R. Brettell and Alexia de Buffévent. *Pissarro: Critical Catalogue of Paintings*. Vol. 1, separate French and English editions; vols. 2 and 3, bilingual edition. Milan and Paris, 2005 (forthcoming).

Pissarro-Venturi 1939
Pissarro, Ludovic-Rodo, and Lionello Venturi. *Camille Pissarro: son art, son oeuvre*. 2 vols. Paris, 1939.

Pontoise 2003
Entre ciel et terre: Camille Pissarro et les peintres de la vallée de l'Oise. Exh. cat. Paris, 2003.

Reff 1970
Reff, Theodore. "Degas' Sculpture, 1880–1884." *Art Quarterly* 33 (Autumn 1970), pp. 276–98.

Reff 1976
Reff, Theodore. *Degas: The Artist's Mind*. New York, 1976.

Rewald 1946/1973
Rewald, John. *The History of Impressionism*. New York, 1946. 4th rev. ed. New York, 1973.

Rewald 1950
Camille Pissarro: Lettres à son fils. Edited with the assistance of Lucien Pissarro by John Rewald. Paris 1950.

Rewald 1996
Rewald, John, in collaboration with Walter Feilchenfeldt and Jayne Warman. *The Paintings of Paul Cézanne: A Catalogue Raisonné*. 2 vols. New York, 1996.

Rostrup 1960
Rostrup, Haavard. "Eventails et pastels de Gauguin." *Gazette des Beaux-Arts*, 6th ser., 56 (September 1960), pp. 157–64.

Rotonchamp 1906/1925
Rotonchamp, Jean de [Louis Brouillon]. *Paul Gauguin*. Weimar, 1906. Reprint, Paris, 1925.

San Francisco 1986
The New Painting: Impressionism, 1874–1886. Exh. cat. by Charles S. Moffett et al. Fine Arts Museums of San Francisco; National Gallery of Art, Washington. San Francisco, 1986.

Sweetman 1995
Sweetman, David. *Paul Gauguin: A Life*. New York, 1995.

Trianon 1881
Trianon, Henry. "Sixième Exposition de peinture par un groupe d'artistes: 35, boulevard des Capucines." *Le Constitutionnel*, April 24, 1881, pp. 2–3.

Tristan 1986
Tristan, Flora. *Peregrinations of a Pariah, 1833–1834*. Translated, edited, and introduced by Jean Hawkes. London, 1986.

Venturi 1936
Venturi, Lionello. *Cézanne: Son art, son oeuvre*. Paris, 1936.

Villars 1881
de Villars, Nina. "Exposition des artistes indépendants," *Le Courrier du soir*, April 23, 1881, p. 2.

Washington–Chicago–Paris 1988–89
The Art of Paul Gauguin. Exh. cat. by Richard Brettell, Françoise Cachin, Claire Frèches-Thory, and Charles F. Stuckey, with Peter Zegers. National Gallery of Art, Washington; Art Institute of Chicago; Grand Palais, Paris. Washington, D.C., 1988.

Wildenstein 1964
Wildenstein, Georges. *Gauguin*. Edited by Daniel Wildenstein and Raymond Cogniat. Vol. 1, *Catalogue*. Paris, 1964.

Wildenstein 1974–91
Wildenstein, Daniel. *Monet: biographie et catalogue raisonné*. Lausanne and Paris, 1974–91. 5 vols. Updated ed., *Monet, or the Triumph of Impressionism*. 4 vols. Cologne, 1996.

Wildenstein 2002
Wildenstein, Daniel, with Sylvie Crussard and Martine Heudron. *Gauguin: A Savage in the Making: Catalogue Raisonné of the Paintings (1873–1888)*. 2 vols. Milan and Paris, 2002. First published 2001, *Gauguin: Premier itinéraire d'un sauvage: Catalogue de l'oeuvre peint (1873–1888)*.

Photograph Credits

Index